A Dictionary of
ART TERMS
and
TECHNIQUES

A Dictionary of
ART TERMS
and
TECHNIQUES

by RALPH MAYER

THOMAS Y. CROWELL COMPANY

New York Established 1834

Preface

This volume is designed as an up-to-date reference book that presents, in succinct form, the explanations of terms encountered in the study and practice of the visual arts and in their literature. The areas covered are painting, drawing, sculpture, printmaking, ceramics, and a number of closely allied fields. Each entry contains the kinds of information appropriate to its subject, whether these be definitions, historical accounts, descriptions of periods, schools, or styles of art, or explanations of technical processes and materials. Processes are described in some detail, but instructions are not given, since the dictionary is not intended as a substitute for technical manuals.

Purely architectural terms are not included, because a large volume would be required to deal adequately with so vast a subject. Any attempt at coverage here would necessarily be selective rather than complete. Terms in Oriental art, with the exception of a few that have virtually become part of the English language, have also been omitted because of their special nature. Although there are no biographical entries for artists, authors, and inventors, many are named, with their dates, in entries dealing with styles or techniques with which they are associated.

In order to help advance the cause of a standard nomenclature, special emphasis has been given to accepted terminology. The nomenclature of the arts, and especially that of artists' materials and procedures, is far from standardized; there is confusion of terms, there are survivals of obsolete and archaic terms, and there are errors in adapting foreign terms to American usage. In this book, the names of pigments now used by artists are those established by the Paint Standard, promulgated by the U.S. Department of Commerce, and accepted by artists and manufacturers for the past quarter of a century. The terminology of printmaking is that of the Print Council of America. Chemical and physical designations are in accord with the usage of societies and publications in the field of paint technology.

I am indebted to Charles McCurdy, of Queens College, and to the art historian Louis James for their considerable contributions to this book; also to Lawrence Majewski, of the Conservation Center, Institute of Fine Arts, New York University, and to Andrew Stasik, of the Pratt Graphic Art Center, for frequent counsel. Leon Polansky, Sydney Starr, and Mary Buckley, of Pratt Institute, added much to the entries on sculpture, ceramics, and color, respectively. Martha Albert, of Pratt Institute; George Comptis, painter and gallery director; Ruth Olson, art historian; and Roberta Paine, of the Metropolitan Museum of Art, also gave time to the preparation of the manuscript. I particularly want to thank Patrick Barrett, Dictionary Editor of the Thomas Y. Crowell Company reference book staff, for his constant helpfulness.

A Dictionary of

ART TERMS
and
TECHNIQUES

A

Aaron's Rod. A rounded decorative molding with a motif of an entwined serpent, vines, leaves, and tendrils.

abaculus. A little-used word for TESSERA.

abbozzo. In painting, the first outline or drawing on the canvas; also, the first underpainting. In sculpture, a block of stone, lump of clay, or chunk of wood that has been reduced to a rough form of the ultimate work. The word *abbozzo* is Italian, literally meaning sketch.

ABC art. See MINIMAL ART.

abraum. A red EARTH COLOR used as a mahogany stain.

absolute alcohol or **anhydrous alcohol.** ETHYL ALCOHOL freed of all traces of water by chemical processes; ordinary grain alcohol contains about 6% water. Anhydrous alcohol may be mixed with mineral spirits, turpentine, and a number of other solvents.

abstract art. Any art in which the depiction of real objects in nature has been subordinated or entirely discarded, and whose aesthetic content is expressed in a formal pattern or structure of shapes, lines, and colors. Sometimes the subject is real but so stylized, blurred, repeated, or broken down into basic forms as to be unrecognizable. Art that is partly broken down in this way is called semiabstract. When the representation of real objects is completely absent, such art may also be called nonrepresentational or NONOBJECTIVE, a term first used by Wassily Kandinsky (1866–1944), one of whose watercolors, done in 1910, is considered by some authorities to be the first completely abstract painting.

An abstract element or intention appears in works of art and decoration throughout the history of art, from Neolithic stone carvings onward. But abstraction as an aesthetic principle began in the early 20th century with the development of CUBISM by Pablo Picasso (1881–) and Georges Braque (1882–1963). Other important early stages in the development of abstract art were NEO-PLASTICISM in Holland and SUPREMATISM in Russia. See also ABSTRACT EXPRESSIONISM; ACTION PAINTING; GEOMETRIC ABSTRACTION; OP ART.

abstract expressionism. A style of nonrepresentational painting that combines abstract form and expressionist emotional value. Abstract ex-

pressionism, which developed in New York City in the mid-1940's, became fully established during the 1950's and was the predominant style associated with the New York School. A variety of styles exist within the movement. The paintings are typically bold, forceful, and large in size. The colors tend to be strident, and accidental effects, such as the natural flow of oil colors without restraint, are often present. The movement's single most important figure is Jackson Pollock (1912–1956), a statement by whom gave rise to the term ACTION PAINTING, which is closely related to abstract expressionism. Pollock's fluid paints and enamels were poured, dripped, and spattered onto the canvas; a single color was often used to create a lacy mesh of opaque color over the surface, much like the transparent veil in a conventional oil painting.

Abstract expressionism stems mainly from the European NEO-EXPRESSIONIST painting of Wassily Kandinsky (1866–1944) and others. It was stimulated by the presence in New York, during World War II, of a remarkable group of expatriate European painters, including Chagall, Duchamp, Léger, and Miró. A most important forerunner of the movement was Arshile Gorky (1904–1948), whose surrealist forms and discordant color had great influence on the work of his contemporaries. Among the more prominent abstract expressionist painters are Willem de Kooning (1904–), Adolph Gottlieb (1903–), Mark Rothko (1903–1970), Franz Kline (1910–1962), Philip Guston (1913–), and Robert Motherwell (1915–).

acacia. Pharmaceutical term for GUM ARABIC.

academic. In art, conforming to traditional standards, or to a discipline based on the standards of an official ACADEMY, which are usually conservative. In the 20th century the term has come to be used mainly in a pejorative sense, to characterize a strictly representational type of art that still adheres to the canons of 19th-century taste and technique, although these have long since been challenged by modern developments from Impressionism onward. The modernist does not always condemn all representational art; he usually admires its outstanding examples, while applying the epithet "academic" to what he considers mediocre; repetitive, and inconsequential.

academician. An elected member of an ACADEMY; also; an adherent of ACADEMIC styles and principles.

academicism. Conformance with ACADEMIC standards and precepts. The term also may be used to denote an element of academic influence in work that departs from traditional principles.

Académie des Beaux-Arts. The academy of fine arts of the Institut de France. Its activities include sponsorship of the Ecole des Beaux-Arts (see BEAUX-ARTS, ECOLE DES) and the official salon or art exhibition held annually in Paris. Popularly known as the Academy, it is not to be confused with the French Academy (*Académie Française*), a literary honor society. See also ACADEMY.

academy. A body of artists organized for such purposes as promoting a national art, training artists, and enhancing the professional and economic status of its members through periodic exhibitions and through the conferral of membership as an honor. Academies were founded in Italy as early as the 16th century, in France in the 17th century, in England in the 18th, and in

America in the 19th. Enjoying official or quasi-official status, the academies have consistently maintained conservative standards, excluding from recognition all artists whose works and ideas on art depart from the traditional academic criteria of excellence. Academies are notorious for repeatedly embracing work rejected by a previous generation, while rejecting the innovative work of their own times, which is left for a later generation to recognize and incorporate into a new standard as inflexible as the old.

During the first quarter of the 20th century, the work of artists whose ideas had developed beyond 19th-century academic restrictions had little exposure apart from the one-man show. With the founding of museums of modern art and increasing public and commercial appreciation of abstract and other modern work, innovative artists lost their dependence upon academic approval, and the traditional controversies between academician and heretic became far less virulent. The academies continue to flourish as centers for the work of traditionally or conservatively oriented artists. Among the important existing academies are the ACADÉMIE DES BEAUX-ARTS in Paris, the ROYAL ACADEMY OF ARTS in London, and the NATIONAL ACADEMY OF DESIGN in New York.

academy blue. An unstandardized term for a blue COMPOSITE PIGMENT of a greenish shade, the best grades of which should be made of ultramarine blue and viridian.

academy board. An inexpensive panel used for small oil paintings and sketches. It is made of heavy smooth cardboard coated with a ground that has sufficient tooth for oil paint. Academy board has been largely replaced by CANVAS BOARD and various specialty boards, which may be embossed to imitate a canvas weave.

academy figure. A drawing or painting of a human figure, half life-size, executed as a practice study or for purposes of instruction rather than as creative art. Hence, the term is used as a derogatory designation for any dull or lifeless rendition of the human form in a work of art.

acajou. A name sometimes used for MAHOGANY.

acanthus. A semi-stylized leaf motif that occurs throughout the history of art, notably in capitals of the Corinthian order of Greek architecture and

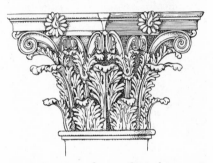

ACANTHUS. Carved on a Corinthian capital.

the Roman Composite order, and in carvings of the 12th century. Named for a plant that is widespread in the Mediterranean area, the acanthus motif is sometimes used in a variant form showing a close resemblance to the leaves of the thistle, dandelion, celery, or parsley.

acaroid resin. See ACCROIDES.

accelerated test. A test of paints, pigments, or other materials used by painters. It is conducted in a laboratory with specialized equipment for subjecting such materials to forces that

simulate those which cause fading, cracking, or other failures to which paintings are liable on long aging. Accelerated test conditions do not duplicate those of natural aging exactly, for they are far more severe and concentrated, but they do give an accurate indication of the comparative resistance of various materials and combinations of ingredients, and make it possible to rate their relative values.

A typical accelerated test is one used to compare the relative resistance of various coating materials to PHOTO-CHEMICAL EMBRITTLEMENT on aging. Thin metal panels are coated with the material with a film applicator; and exposed to ultraviolet light for a predetermined number of hours under scientifically controlled conditions. One panel of each material is then bent over a standard steel rod or mandrel and examined for indications of cracking. The ultraviolet exposure is continued intermittently until sufficiently definite results are obtained. A few days of such exposure will cause embrittlement comparable to the effects of many years of exposure to daylight. See also FADE OMETER, WEATHER OMETER.

accelerator. Any substance which hastens a reaction. In sculpture, the alum used to hasten the setting of plaster of Paris or the material added to Portland cement to speed the development of strength; also, the chemical added to a mixture of polyester resin and hardener to speed the hardening process and allow the hardening time to be controlled. In painting, a chemical DRIER is sometimes called an accelerator.

accroides or **acaroid resin.** A strongly colored RESIN occurring in two different forms, red and yellow, collected from Australian grass trees (genus *Xanthorrhoea*). The resin, known also as gum accroides, has fairly good film-forming properties and has long been used in the manufacture of yellow, red, and orange colored VARNISHES. Despite the development of bright dyestuffs for this purpose, accroides is still employed for certain industrial purposes. Older names for the resin are Botany Bay gum, blackboy gum, and xanthorrhoea. See COLORED RESINS.

acetate. See CELLULOSE ACETATE.

acetic ether. See ETHYL ACETATE.

acetone. One of the most powerful VOLATILE SOLVENTS of the lacquer-solvent or paint-remover type; also called dimethyl ketone. It is one of the least toxic when properly handled. Acetone is highly flammable; its vapors will flash or catch fire even below the freezing point. See also METHYL ACETONE.

acetylene. A gaseous, colorless hydrocarbon. When used in a burner, it gives off nearly fifteen times as much light as ordinary illuminating gas. It contains a triple bond, and polymerizes readily. Acetylene is used for OXYACETYLENE WELDING in a torch or blowpipe that combines acetylene and oxygen.

acetylene black. One of many varieties of CARBON BLACK; similar to BENZOL BLACK.

achromatic colors. White, black, and the grays, as distinguished from the chromatic colors. See CHROMA.

acid bath. In ETCHING, the container or tray of MORDANT in which the object to be etched is immersed. In the etching of metal plates for printing, the tray containing the mordant must be of an acid-resistant material such as

4

porcelain or glass. Sometimes WALLING WAX is used to build a containing wall around the edges of the plate, obviating the use of an acid bath.

acid number or **acid value.** A laboratory measurement used to indicate the amount of free fatty acid contained in a vegetable DRYING OIL —an important consideration in selecting an oil for a given purpose. The acid number represents the milligrams of potassium hydroxide required to neutralize the free fatty acids in a gram of oil. Oils of higher acid number (5 to 10) are preferred for grinding paints, while those of lower denomination (1 to 3) are considered more suitable for use in varnishes and other clear coatings. In the production of artists' oil colors, however, the superior color stability or non-yellowing properties of the lower-numbered varnish oils is a more significant factor than ease of grinding, and consequently such oils are frequently so employed.

acid resist. A RESIST specifically used to block the corrosive action of a MORDANT on a surface.

Acra red. A trade name for the yellowish or "scarlet" shade of QUINACRIDONE RED.

acrolith. A statue, especially of ancient Greece, with head and extremities of marble, supported by a trunk of wood or other material, covered with real or metal-plate draperies, and sometimes gilded.

acrylic brush. See BRUSH, ACRYLIC.

acrylic canvas. Canvas especially prepared with polymer primer for use with POLYMER COLORS. Since these paints have greater and longer-lasting flexibility than oil colors, painting in oils on an acrylic canvas is contrary to

the FAT-OVER-LEAN rule; also, adhesion between an acrylic surface and oil color is of doubtful permanence.

acrylic colors. Artists' colors made by dispersing pigments in a vehicle made from a polymethyl methacrylate (see ACRYLIC RESIN) solution in mineral spirits. They are sometimes called straight acrylic colors or plastic paints to distinguish them from the POLYMER COLORS, which contain acrylic and other resins dispersed in water. Acrylic colors do not yellow; they dry very rapidly; and they are easy to remove with mineral spirits or turpentine. These qualities make them useful for INPAINTING to restore damaged or obliterated areas in conservation work. Acrylic colors with a plasticizer added are sold in tubes under the manufacturer's trade name of Magna colors, as is a special VINYL-RESIN solution called Magna varnish that is insoluble in turpentine and mineral spirits. This serves as an ISOLATING VARNISH, since acrylic paint is so soluble that it cannot be overpainted. Magna varnish may also be used in oil painting for the same purpose.

acrylic resin. Any of a group of synthetic resins made by polymerization of acrylic acid esters. Polymethyl methacrylate is the most important of the group. One form of it is readily soluble in turpentine and mineral spirits; it is available as a heavy solution in mineral spirits under the trade names Acryloid F-10 and Lucite 44. Another type, insoluble in these solvents, is sold as a heavy solution in toluol under the name of Acryloid B-72. Methyl methacrylate or acrylic solutions are used in the manufacture of PICTURE VARNISH and ACRYLIC COLORS, and in lacquers and many other industrial products. Another type of acrylic resin is produced in a water dispersion, polymerized by

emulsification. It is sold under the trade name Rhoplex 34 and is used in the manufacture of POLYMER COLORS. Polymethyl methacrylate in solid form, best known by the trade names Plexiglas and Lucite, is a permanent, non-yellowing, glass-like PLASTIC that is frequently used in modern sculpture and constructions. It may be cast, extruded, machined, and welded or shaped by heating.

acrylic varnish. See PICTURE VARNISH.

Acryloid. See ACRYLIC RESIN.

actinic light. See ULTRAVIOLET LIGHT.

action painting. A form of ABSTRACT EXPRESSIONISM associated with the New York school, sometimes used as a

ACTION PAINTING. Jackson Pollock's *Number 12* (1949), oil on paper mounted on composition board. (*Collection, The Museum of Modern Art, New York, Gift of Edgar Kaufmann, Jr.*)

synonym for abstract expressionism. Action painting is done by applying the paint with rapid, forceful, impulsive brush strokes, or by splashing or hurling it directly onto the surface, in order to create a work which records the force of the artist's feelings as well as the dynamism of the act of painting. The most celebrated action painter is Jackson Pollock (1912–1956). The French equivalent of action painting is *Tachisme.*

additive color. See COLOR.

à deux crayons. A chalk drawing done in two colors, almost always red chalk and black chalk or charcoal.

adhesion of oil paint. To prevent the separation of paint from its ground, fresh colors should be used that have not thickened on the palette and so lost some of their adhesiveness. The ground should have enough absorbency to grip the paint by penetration, although not enough for it to sink in completely. Also, the ground should have a certain amount of tooth, or surface roughness, to afford the paint a mechanical anchorage.

adjustable curve ruler. A ruler that can be bent and held in any curve desired. One type is made of a flat, thin strip of metal, which functions as the straightedge, welded to a flexible

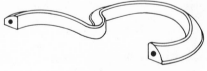

ADJUSTABLE CURVE RULER

metal cable that can be bent into any curve desired and will retain that position. Another type consists of a lead rod encased in a flexible plastic body that has a smooth edge along which

the artist traces with a pencil or ruling pen. Both types of adjustable curve rulers are available in a number of lengths up to about 30 inches. The adjustable curve ruler is used as a ruler in general drafting, either in conjunction with or as a replacement for the FRENCH CURVE. See also SPLINE.

adjustable triangle. A draftsman's TRIANGLE, one side of which has an adjustable arm that can be clamped at various angles. A protractor between the adjustable arm and the side to which it is hinged measures the angle at which it is clamped. The adjustable triangle was designed to obviate the draftsman's need for many differently shaped triangles. See also DRAFTING MACHINE.

Adrianople red. An obscure name for TURKEY RED.

adsorption. Molecular cohesion in which a thin layer of one substance adheres strongly to another as if it were "glued on." Adsorption is distinguished from the more common word absorption, which denotes simply the propensity of a solid to imbibe or soak up a liquid as a sponge soaks up water. All forms of matter—gases, liquids, or solids—can be adsorbed by solid surfaces. The process may be considerably enhanced when a substance is transformed, either chemically or physically, into the colloidal state and when the receiving surface is absolutely clean. The resulting adsorbed layer becomes so firmly attached to the surface of the receiving substance that it can usually be removed only by strong abrasion. An example is seen in lithography, in which the entire process depends upon the ability of the crayon or tusche to produce on the stone or plate an adsorbed layer of fatty acid that will be receptive to the printing ink.

advancing and retreating colors. In painting, the apparent tendency of the WARM COLORS (the reds and oranges) to advance toward the viewer and the COOL COLORS (the blues and violets) to recede. This concept is in part derived from the phenomenon observable in nature that moisture in the atmosphere affects not only the SATURATION, or intensity, of the color of a distant object but also its HUE; that is, an object seen far away will seem bluer or grayer than it does when viewed up close. Accordingly, advancing and retreating colors have been considered an aspect of AERIAL PERSPECTIVE and have been employed in landscapes that attempt to portray recession by using "atmospheric" perspective as well as geometric systems of perspective. The concept of advancing and retreating colors has for over a century been applied with reserve, however, by artists who realize that its strict application in landscape painting would result in such effects as blue sunsets. Because of the erratic behavior of color in nature, the advancing and retreating color theory cannot be considered an infallible rule of thumb in painting.

adze or **adz.** A cutting tool, used in sculpture to rough-shape wood. The simplest form of adze has an arched blade with a slightly curved chisel edge, set at right angles to the handle. Adzes are frequently double-ended tools as, for example, with a gouge bit and a curved bit.

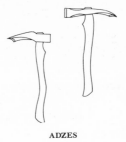

ADZES

7

ae. or **aet.** Abbreviations for the Latin word *aetatis* (genitive of *aetas*), meaning "aged" or "of age." Inscribed with a number on the background or rear of a portrait, it indicates the age of the sitter at the time he was painted. Such inscriptions were fairly common on portraits up to the middle of the 19th century, after which they were rarely used.

Aegean art. Art of the 26th–12th centuries B.C. in mainland Greece and the Greek islands. See MINOAN; CYCLADIC; HELLADIC; MYCENAEAN.

aerial perspective. In landscape painting, an illusion of recession obtained by the depiction of atmospheric effects. When seen through a volume of air, the colors of a distant object or scene appear progressively fainter and, depending on the amount of moisture in the air, progressively cooler or bluer (see ADVANCING AND RETREATING COLORS). This phenomenon dictates that the background of a landscape should be less distinct in both outline and color than its foreground. Chinese painters achieved atmospheric recession in landscapes by interposing mists or clouds, in progressively weaker tones, between middle distances (often hills) and the mountains of the background. Aerial perspective, insofar as it relates to gradation of color and distinctness, is relevant to all conventional landscapes that employ spatial illusion; it is usually an adjunct to LINEAR PERSPECTIVE.

aerugo. Corrosion or rust on metals, especially the green PATINA on copper or bronze; also called verdigris.

aes ustum. An ancient name for the copper oxide or corrosion that constitutes the PATINA on copper and bronze.

African blackwood or **grenadilla.** A hard, close-textured hardwood (from *Dalbergia melanoxylon*) of a dark purple or plum color; also called Mozambique ebony. It has good carving properties. Because it also has good resonance qualities, it is used for clarinets and other woodwind instruments. African blackwood is botanically related to ROSEWOOD.

African cherry. See CHERRYWOOD.

African mahogany. See MAHOGANY.

African rosewood. See BUBINGA.

African walnut. See TIGERWOOD.

African whitewood. See AYOUS.

after. Word used in an artist's inscription to indicate that his picture or sculpture was modeled on the work of another artist. It generally signifies a faithful copy of the original, but may also be used for a work that differs somewhat from the earlier work, as in Van Gogh's drawing after Millet's *The Reapers*. A typical inscription, on the back of a painting, would read: "Portrait of James Smith by Robert Jones, 1898, after Gilbert Stuart, 1793."

after-yellowing. See YELLOWING.

agalma. A term used by the Greeks at first to designate any piece of sculpture, later to mean a statue of a god. Sometimes the term was also used for a painted portrait.

agalmatolite. A soft grayish, greenish, or yellowish stone; also called pagodite. It was used by the Chinese for carving pagodas and images.

agate. A very hard, semiprecious stone with a striped or variegated pat-

tern. Polished gray agate is used to make the BURNISHERS used in gilding, which are sometimes called agates.

agglutinant. Any glue or adhesive, especially a BINDER used in aqueous paints, pastel crayons, and drawing inks.

aggregate. The inert material or materials mixed with cement to make concrete. A fine material such as sand, a material with medium-sized particles such as marble dust, or a coarse material such as crushed rock may be used. Sometimes all three of these materials are used in a mix. The term is also applied to similar inert materials used to create coarse textures in plaster, stucco, and mortar.

airbrush. An implement resembling an oversize fountain pen, with an attached container that holds an ounce or less of fluid paint and a thin hose

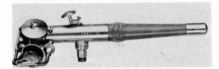

AIRBRUSH (*Courtesy of Paasche Airbrush Co.*)

leading to a source of compressed air or carbonic gas. The airbrush is used to create smooth gradations of tones and colors. It is a delicate miniature version of the SPRAY GUN. Airbrush technique is usually distinguishable from brush painting, and is used much more frequently by commercial artists than by fine-arts painters.

aircraft curve. See FRENCH CURVE.

air drain or **air jet.** See VENT.

air eraser. An implement resembling an oversize fountain pen, with an attached container and a thin hose

leading to a source of compressed air or carbonic gas. The reservoir holds an ounce or less of a finely divided abrasive which removes ink or paint from paper.

à jour or **ajouré.** Decorated with pierced or translucent shapes, letting in the "daylight," as the French names imply. The terms apply to openwork designs in silversmithing and other metalwork (see PIERCING), in woodwork, and in lace and embroidery.

Alabama Cream. A type of American MARBLE, suitable for sculpture. Among the hard, fine-grained, creamy white varieties are Madre Cream and Cream Blanc.

alabaster. A snow-white, translucent or semitranslucent variety of gypsum (calcium sulfate), so soft that it can be blocked with a handsaw and readily carved. It is so easily scratched that it is durable only indoors, under conditions of careful conservation. The alabaster referred to by the ancients is a different and more durable stone, onyx marble.

alabastron. A form of ancient Greek pottery—a small, tear-shaped oil flask with a rounded bottom. It was used for many purposes, for example, by athletes to carry the oil that they rubbed on their bodies. See VASE SHAPES for illustration.

à la Grecque. In the Greek style. This term was long used to describe works of art done in imitation of or strongly influenced by the style of ancient Greek art, particularly of its more obvious characteristics.

Albani stone. See PEPERINO.

Albany slip. A SLIP CLAY obtained near Albany, N.Y. It can produce a

blackish-brown glaze. Albany slip and similar clays from other localities were used by early American potters in making STONEWARE.

Alberene stone. Trade name for a Virginia SOAPSTONE that ranges in color from a medium gray to a fairly deep black.

alcohol. See ETHYL ALCOHOL; METHANOL; ABSOLUTE ALCOHOL; DENATURED ALCOHOL.

alcohol colors. Brilliant liquid colors made from alcohol-soluble aniline dyes in a water-miscible vehicle. The colors are especially designed to be applied with an airbrush and to be used for work that is to be reproduced. They are particularly useful in cartography, and can be used on many surfaces that will not take water paints. Alcohol colors are not sufficiently lightproof to be used for permanent fine-arts purposes.

alembic. Old term for a still. The invention of distillation is generally credited to the physicians of Alexandria in the third century, and the term derives from the Arabic word *al-anbig*, meaning a still, which in turn comes from the Greek *ambix*, meaning a spouted cup.

Alexandria blue or **Alexandrian blue.** Another name for EGYPTIAN BLUE.

Alexandrian art. See HELLENISTIC PERIOD.

alizarin brown. A rather dull, reddish, transparent brown pigment. It is made by a variation of the ALIZARIN CRIMSON process and has the same pigment properties. It may also be the product of an occasional off-color or unsuccessful batch of alizarin crimson.

alizarin carmine. An obsolete term for ALIZARIN CRIMSON.

alizarin crimson. A bright, transparent, red LAKE pigment with a maroon mass tone and a bluish undertone; made from the synthetic dyestuff alizarin (dihydroxy anthraquinone), a derivative of anthracene, a coal-tar product. Although it is not in the same class of absolute permanence as the furnace-made mineral pigments, alizarin crimson is completely acceptable for permanent easel painting under the normal conditions for preservation of works of art. The artist's principal deep-red pigment, alizarin crimson is a clear ruby-red when used transparently, and produces bright, rosy pinks when mixed with white. Careful painters will not attempt to use it full strength for its mass tone in oil, since it tends to crack in a fine alligator pattern when spread out in layers without the structural reinforcement of denser pigments. The superlative type of alizarin crimson available since the 1920's is more brilliant than the older types; it can be freely mixed with all other pigments on the approved list for artists, will not react with white lead, and will not turn brown when mixed with iron-bearing pigments.

Discovered in 1868 by two German chemists, C. Graebe and C. Liebermann, alizarin was the first of the natural dyestuffs to be synthesized. In the ensuing years synthetic alizarin superseded natural alizarin both in pigment manufacture and in textile dyeing, while alizarin crimson soon replaced an older pigment, MADDER LAKE. Alizarin crimson has far greater tinting strength than madder lake, and since it is free from purpurin, which is impermanent, it also has greater color stability. However, the artists' color called rose madder is still available from some European sources. Alizarin crimson or

burnt sienna is sometimes mixed with SEPIA to make Roman sepia. Alizarin carmine is an obsolete term for alizarin crimson.

alizarin violet. A transparent violet pigment made from synthetic PURPURIN; also known as violet madder lake. Alizarin violet is similar to ALIZARIN CRIMSON in pigment properties but not sufficiently permanent for artists' use, since it turns dark or blackish on long exposure to light.

alizarin yellow. A dull, rather brownish, transparent yellow pigment. Made by the same process as ALIZARIN CRIMSON, alizarin yellow has identical pigment properties but is not reliably permanent.

alkaline glaze. A ceramic GLAZE whose FLUX is an alkali, such as borax or soda ash, rather than lead. The alkaline glazes are fired at low temperatures and are capable of producing spectacular effects, such as the Egyptian and Persian blues. Since alkalies are soluble and have a tendency to cake while in a glaze suspension, there are limitations on their use.

alkanet. A red NATURAL DYESTUFF extracted from the root of a European plant, *Alkanna tinctoria* (false alkanet), and also from an Oriental plant, *Lawsonia alba* (true alkanet). Since it fades with relative rapidity, alkanet is no longer used for dyeing textiles or for making lake pigments.

alkyd resins. A group of synthetic resins with excellent film-forming properties, used in fine-quality industrial house paints, enamels, and varnishes since the 1930's. Some use has been made of the alkyds in artists' materials but little has been published about this development. The most successful varieties, which have good retention of color and flexibility, are of considerable promise as ingredients of oil-painting mediums. As vehicles for paints, they are less attractive because of their tendency to form skins through rapid surface-drying. The type in use is known as oil-modified alkyd; it contains a drying oil as part of its makeup. The varieties made with safflower, soya bean, or tobacco-seed oils have greater color retention than those made with linseed oil, which in turn have greater resistance to weathering.

alla prima. A method of oil painting in which the final effects are achieved in the initial application of paint; also called direct painting. *Alla prima* is the alternative to the technique of covering the canvas layer by layer. The French term for *alla prima* is *au premier coup.*

alligatoring or **alligator cracks.** A form of CRACKLE which appears on paintings in a pattern resembling the design of alligator hide.

alloy. A combination of two or more metals which have been melted or fused together. Brass is an alloy of copper and zinc, bronze of copper and tin. Steel, which contains iron and carbon, may also be classed as an alloy, although carbon is a nonmetal. In general, alloys are harder and more fusible, though less malleable, than the substances of which they are made. They also tend to be more resistant to corrosion and to have a lower melting point than the parent metals. The color or appearance of an alloy is different from that of the metals which compose it.

all-purpose ground. See MULTIPURPOSE GROUND.

altarpiece. A decorative screen, a painting, a set of painted or carved

panels, or a structure incorporating painting, statuary, or relief carving, set upon or behind and above an altar. A typical Renaissance altarpiece consisted of a set of religious paintings on hinged panels (often a TRIPTYCH), the frames of which might be finely carved, gilded, or polychromed, or encrusted with jewels. A PREDELLA often appeared below the main panels. The Italian word ancona, the French retable, the English reredos, and the Spanish retablo are used more or less interchangeably as synonyms for altarpiece. Reredos sometimes refers more specifically to an ornamental stone or wood screen or wall behind an altar. The term ancona is used of a panel painting elaborately framed or an ornate polyptych elaborately carved and gilded or polychromed. Some Renaissance Italian altarpieces were made of Della Robbia ware, with figures in high relief. The magnificent "Pala d'oro" altarpiece in the cathedral of St. Mark, Venice, includes gold work, Byzantine enamel, and statuary. The largest and most luxurious altarpieces are those of Spain and Latin America, in the baroque and churrigueresque styles. Carved in wood or stone, and often gilded and painted, these retablos sometimes reach from the floor into the vaulting. Others are made of elaborately worked silver. See illustration at TRIPTYCH.

alto-rilievo. Italian for high RELIEF.

alumina hydrate. Aluminum hydroxide; manufactured in the form of a white, fluffy, lightweight powder, and used as an INERT PIGMENT. Alumina hydrate is valuable as a BASE for LAKE pigments, as it becomes virtually colorless when dispersed in oil. It tends to impart a desirable brushing consistency to oil colors and to assist in stabilizing pigment dispersion.

aluminum. A very lightweight bluish, silver-white metal. Due to a protective oxide which forms on its surface, it has a high resistance to corrosion. It melts at $1220°$ F and can be cast and welded. It is available in a wide variety of colors, and is used when lightness combined with strength is desired. Although aluminum is the most abundant metal in the earth's crust, it was not discovered until 1825 and was not used extensively until the 20th century.

aluminum leaf. A thin leaf used in GILDING for a silvery effect. Because it has a relatively dull, leaden appearance, aluminum leaf is an inferior substitute for SILVER LEAF and PALLADIUM LEAF. It is used chiefly in the commercial arts for such purposes as sign writing and stamping titles and designs on book covers.

aluminum paint. An industrial paint or lacquer pigmented with powdered aluminum metal (see ALUMINUM POWDER). It is used as a protective coating and to create a dullish silvery decorative effect. It should not be used in works of art because its metallic luster is coarse and dull and becomes more so with age, as does the luster of paint made with BRONZE POWDERS.

aluminum powder. A metallic pigment that is mixed with bronzing liquid to make so-called silver paint. Aluminum paint will not tarnish, but it lacks the luster that real silver leaf has when first applied to a surface. Because of this leaden quality and a slightly grainy texture, aluminum paint is not suitable for gilding, but it has wide commercial and industrial applications.

Alundum. Trade name for a form of aluminum oxide used as an abrasive.

amaranth. 1. A hardwood of a rich, purplish color, from trees (genus *Peltogyne*) native to the Guianas and sometimes used for carving; also called purpleheart. It has a close, even texture, and much of it has an interesting, variegated grain.

2. A natural purple dyestuff made from amaranth wood. Named for a mythical unfading flower, its permanence is equally mythical, for pigments made from it fade badly in sunlight.

amasette. French term for a horn spatula formerly used to gather the color while grinding paint. Its modern equivalent would be a stainless-steel spatula or slice.

amber. A fossil RESIN dug from the ground, the most extensive deposits occurring in beds in East Prussia along the shores of the Baltic Sea. Amber is familiar through its use in beads and ornaments, and it has long been considered the varnish resin *par excellence* because it is the hardest of all resins. But it is also the least soluble. Only a small amount can be made to go into solution at high temperatures, even when mixed with oils and other resins, so that amber varnishes actually contain very little amber. Investigators feel that medieval authors who constantly referred to it in their recipes may have confused amber with some other resin, possibly sandarac, and that this may account for its widespread reputation.

American vermilion. A heavy LAKE pigment made on a base of red lead, orange mineral, or chrome red, with a brilliant synthetic dyestuff such as eosine. It is not permanent for use in artists' paints. American vermilion is also known as imitation vermilion and vermilionette.

Amherst sandstone. A pale SANDSTONE from Lorrain County, Ohio. It is available in gray, buff, and variegated colors.

ammonia. A colorless alkaline gas, a combination of nitrogen and hydrogen, commonly used in various concentrations as a cleaner and emulsifier in a solution known as ammonia water. When a recipe used in permanent painting calls for an alkali, ammonia is preferred because it is volatile and therefore leaves no remnant or alkaline by-product.

amorino. See PUTTO.

amorphous. A term used to describe a homogeneous, solid material that has neither a regular crystalline structure nor a sharply defined melting point and that breaks with a conchoidal fracture, that is, with an undulating surface like that of a lump of broken glass or a lump of resin, both of which are examples of amorphous materials.

amphora. An ancient Greek vase form. The amphora is a large, tapering ceramic jar with two handles, which was used for storage of such items as oil, wine, and grain. One type tapered to a foot or base, while another had a point at the bottom and was stored in a rack rather than standing upright. A third type, the neck amphora, had an offset neck. See illustration at VASE SHAPES.

amyl acetate; amyl alcohol. See BANANA OIL.

A.N.A. Abbreviation added to their names by associate members of the NATIONAL ACADEMY OF DESIGN.

anaglyph. A piece of sculpture or a decoration worked in RELIEF, as a cameo or a boss, as distinguished from a DIAGLYPH.

anamorphosis. A painting or drawing that is distorted or unrecognizable except when viewed from a particular angle and distance or with a correcting mirror or lens; also, the technique by which such an image is drawn. Essentially an artistic stunt, anamorphosis was especially popular in the 18th century. It was usually achieved by SQUARING an original drawing done in proper perspective and copying each square into the corresponding area of a distorted grid. The original might also be drawn deformed by copying it with the aid of a distorting optical device, or by perforating lines of the original, shining light through the perforated drawing to a curved surface (or at an angle through the perforations to a flat surface) and then drawing connecting lines between the points of light. Sometimes anamorphosis was used in conjunction with normal perspective: a skillful artist could create what appeared to be an orthodox landscape or still-life that, viewed from an extraordinary angle, became an entirely different subject or was discovered to contain a hitherto hidden element, such as a face.

anastatic printing. A RELIEF PRINTING process in which all but the printing area of the plate is etched, leaving in relief only the lines and areas to be inked. Anastatic printing is distinguished from ETCHING, which is an INTAGLIO printing process. The best known anastatic printing procedure is sometimes called zinc etching. The design to be printed is painted directly on a zinc plate with asphalt varnish. When the varnish has dried, the plate is placed in a MORDANT bath of dilute nitric acid, so that all the nonprinting areas are bitten away (see BITING). William Blake executed both the text and the illustrations of many of his books with this relief-etching process.

ancien. French studio cant or argot for a monitor or senior student in an art class or atelier.

ancient. Dating from the ages before the medieval period; in general, before the 5th century.

ancona. See ALTARPIECE.

androsphinx. See SPHINX.

angular liner. See LINERS AND STRIPERS.

angular perspective. Linear perspective in which a rectangular solid is oriented so that only the set of lines defining one dimension of the object is parallel to an axis of the PICTURE PLANE. Therefore, only two faces of the object will be shown, neither of which is parallel to the picture plane. Thus, both of the surfaces shown recede at angles from the picture plane. These angles may be the same for both surfaces, or they may differ, depending upon the angle at which the object is inclined to the picture plane and the object's position relative to the HORIZON LINE. The defining lines of only two of the object's three dimensions will converge on the horizon line. They will have separate VANISHING POINTS. Because there will be two vanishing points in the depiction of an object in angular perspective, it may also be said to be shown in two-point perspective. See also PARALLEL PERSPECTIVE; OBLIQUE PERSPECTIVE. See illustration at LINEAR PERSPECTIVE.

anhydrous. Completely free from water.

anhydrous alcohol. See ABSOLUTE ALCOHOL.

aniline. One of the INTERMEDIATES derived from BENZENE, which in turn is derived from the distillation of coal tar.

Because all the earliest synthetic dyes and many subsequently developed dyes were made from aniline, synthetic dyes and pigments in general were formerly called aniline colors. Aniline, however, does not enter into the production of many synthetic pigments; moreover, the impermanence of most colors that are made with aniline has given the word a derogatory connotation. Therefore, the more precise term synthetic organic pigment is now used to designate colors produced from coal-tar derivatives.

aniline purple. An obsolete name for MAUVE.

animal black. An infrequently used name for BONE BLACK.

animé. A generic term for any of a group of RESINS otherwise known as East African COPALS.

ankh. Figure in the form of a Latin cross, but with a loop in place of the part of the shaft above the cross arm. This symbol of life is widely used in Egyptian art and, to a lesser degree, in Assyrian art. It is also known as the crux ansata and the ansate or Egyptian cross. See CROSS for illustration.

annatto. A yellow NATURAL DYE-STUFF made from the fruit of the annatto tree (*Bixa orellana*); alcohol- and oil-soluble. No longer considered permanent for pigment use, it has been widely used for coloring butter and cheese. Other names for annatto include orlean and terra orellana.

annealing. The process of heating a material to make it less brittle, so that after it has cooled it will be more easily workable for various purposes. Annealing relieves internal strain on the molecular structure of the material, thereby allowing it to be subjected to increased force during shaping, and making it stronger in its final state. Glass is strengthened and toughened after it is blown by annealing it in a kiln and then slowly cooling it. Metal is made more malleable so that it may be fashioned by such treatments as hammering, twisting, and bending. Since these operations tend to strain-harden metal, repeated annealing is sometimes required to work it beyond a certain point. In some cases, as for glass or steel, the cooling after annealing must be very gradual; in others it may be sudden, as for copper or brass.

anodizing. An electrolytic process in which a metal, made the anode of a cell, is given a protective or decorative coating. The deposition of a uniform layer of aluminum oxide on aluminum by anodizing protects the metal from corrosion and greatly increases its ability to permanently hold paints and other coating materials.

ansate cross. See ANKH.

anthemion. A decorative group of simplified leaf and flower forms. It was used in ancient Greece in stone carving, bronze casting, engraving, and vase painting and has survived as a traditional motif. There are three or

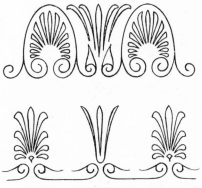

ANTHEMIA

four principal types of anthemia, which may be used singly or in combination with each other. This decorative motif is sometimes called honeysuckle ornament. See PALMETTE.

antic work. Grotesque and fanciful art, especially in groupings of human, animal, and floral figures, sometimes in the form of arabesques. Also, work that has a ludicrous character.

antimony orange; antimony vermilion. Obsolete permanent pigments made of antimony trisulfide in a limited range of reddish-orange and orangy-red hues. Invented and patented by Murdock in Scotland (1847), they are quite dull and pale in the dry state but brilliant in oil. Since they have the undesirable trait of blackening in contact with flake white and other lead pigments, antimony orange and antimony vermilion were replaced in the 1920's by the CADMIUM REDS.

antimony sulfide. A pigment made by pulverizing the gray-black mineral stibnite, the black form of antimony trisulfide; it may also be made by chemical means. The powder, which has little color value, is used exclusively as a camouflage paint; on being photographed with infrared film it has the same reflectance value as green foliage.

antimony white. Antimony oxide coprecipitated with about 70% barium sulfate. Although its properties are similar to those of titanium white, antimony white has been considered unnecessary on the artist's palette, since it is less inert than titanium and tends to turn yellow on exposure to sulfur fumes. Introduced in Britain (1920) under the trade name Timonox, antimony white has had little or no usage in the United States.

antimony yellow. Another name for NAPLES YELLOW.

antiquarianism. Interest in or devotion to art of the past, especially that of ancient times. The term implies admiration of a style or object simply because it is old. It is often employed in a derogatory sense.

antique. 1. Pertaining to the art of ancient times.
2. A work of art or other object made in a bygone era.

antoxidant. Any material which when introduced into an oil paint will prevent or delay the oxidation or skinning over of the surface. See also RETARDANT.

Antwerp blue. A pale variety of PRUSSIAN BLUE containing 75% INERT PIGMENT. It is also known as Haarlem blue and (like several other pigments) as MINERAL BLUE. It is not used for permanent painting.

Antwerp red. Another name for LIGHT RED.

Antwerp school. Flemish painters who worked in Antwerp in the early 16th century. Dominated by Quentin Massys and his followers, they introduced many elements of Italian Renaissance style into their works, without, however, relinquishing their identity as Flemish painters.

anvil. A block on which metal is shaped by hand-hammering or forging. It is usually made of steel-faced iron, and is used especially for forming wrought metal, or metal that has been heated until it is red and malleable and then hammered into shape.

apple wood. See FRUITWOOD.

applied art. Art that is employed in the design or decoration of useful objects and that remains subservient to the function of those objects. Examples are the design of manufactured items, illustrations, and lettering used in advertising. Commercial art may be considered a branch of applied art. The term applied art is used for convenience in distinction to FINE ART, whose chief function is aesthetic, but the line between the two is often difficult to draw.

appliqué. A form of decoration in which pieces of a material are fastened to a surface of the same or another material to form a design. It is most common in sewing, where cloth cutouts are stitched on a cloth background. Appliqué is also used in metalwork, and in paper, where it is called découpage.

appuie-main. French for MAHL-STICK.

apricot gum. A clear, pale gum that exudes from apricot trees. See CHERRY GUM.

aqua fortis. Latin for nitric acid, a dilution of which is the principal MORDANT used in ETCHING. The term aquafortist designates an etcher in the same way that one who works with paint is known as a painter.

aquarelle. The technique of painting in transparent watercolor; also, a work so executed.

Aquatec. Trade name for an American manufacturer's line of acrylic POLYMER COLORS and their adjuncts.

aquatint. An ETCHING technique characterized by the control of tonal areas that produces an unlimited series of gradations from pale gray to velvety black and a pleasing granular effect. The name aquatint is derived from the resemblance of prints made by this method to drawings done with watercolor washes. In aquatint, a copper or zinc plate is dusted in a DUST BOX with a fine layer of powdered rosin. The plate is carefully warmed to fuse the rosin to the metal, so that when the plate is placed in an acid bath, the mordant, usually SMILLIE'S BATH, eats around each minute spot of the acid-resistant dust. This produces in the plate a series of fine pits that, if inked, would print as a uniformly translucent, grainy tone. Varied tones are produced by STOPPING OUT some areas of the plate and biting others more deeply. Stopping out and re-biting are repeated until the desired results are achieved. Areas that are not to be toned, i.e., that are to print completely white, are covered with a resist before the plate is immersed in the mordant. Along with the rosin-dust method, invented by Jean Baptiste Le Prince in 1769, SAND-GRAIN GROUND and STAPART'S GROUND can be used to produce a pitted plate surface. Sublimed sulfur is also used to corrode and pit the plate to produce tones in the prints.

The technique of aquatint is seldom used alone except for color prints, for which it is well suited. In black-and-white printmaking, the plate is usually first given a grained surface with aquatint; it may then be either incised by line ENGRAVING or DRYPOINT or covered again with an etching ground and etched in lines. The majority of Goya's (1746–1828) graphics are done in aquatint with etched and/or drypoint lines. Paul Sandby (1725–1809) was the first English artist to be widely known for the use of aquatint, and Goya was its greatest practitioner. Aquatint continues to be popular among graphic artists today, especially for color prints.

aqueous paint. Any paint that may be diluted with water, as distinguished from oils and other paints that may be thinned only with VOLATILE SOLVENTS. See WATERCOLOR; GOUACHE; TEMPERA; CASEIN COLORS; DESIGNERS' COLORS; POLYMER COLORS; POSTER COLORS; SCENIC COLOR.

arabesque. A style of linear ornament consisting of interlaced lines, sometimes with leaf, fruit, flower, and animal motifs interspersed in the design. Most arabesques are curvilinear

ARABESQUE

and flowing, although some have an angular character. The ancient Greeks and Romans used arabesques, taken perhaps from Oriental or Near East sources. During the Renaissance they were used extensively as decorative embellishments in drawing, painting, low relief, sgraffito, and metalwork. The term should not be confused with Arab styles, which are described as Moresque.

arabic, gum. See GUM ARABIC.

arariba. See BALAUSTRE.

archaic. Belonging to a relatively unsophisticated, but not primitive, period in the development of the art of a particular region. More specifically, the term is used to describe the art of a period immediately preceding one in which artists attained a high level of technical mastery over their media. "Archaic" may be used of works of art that emulate styles and techniques of an earlier period, as well as of those that survive from it.

Archaic period. The fourth phase of HELLENIC ART (600–500 B.C.), following the ORIENTALIZING PERIOD and preceding the CLASSICAL PERIOD. Vase painting reached its peak during the Archaic period. Scenes from mythology and everyday life were painted in animated and naturalistic detail, although the figures were essentially line drawings filled in with flat color. No examples of mural and panel paintings of the time survive, but authorities assume that they displayed a similar technique. The first Hellenic monumental sculpture, and probably the first freestanding sculptures in the history of art, were created during this period. At first the stiff, stylized figures betrayed their Egyptian origin. As the style evolved, however, statues became more graceful and lifelike. The later works were rendered with great attention to anatomy. Even in clothed figures, the drapery had an organic relation to the body. An invariable feature of the Archaic figure was the "Archaic smile," a formal sign of animation. The statues were originally painted, which must have added greatly to their beauty and realism. Since monumental architecture developed concurrently with monumental sculpture, this period saw the rise of relief and of pedimental sculpture, usually freestanding, in stone or terra-cotta.

archaistic. A term applied to art that seeks to emulate art of the past. In Greek sculpture, the term is specifically applied to a period of development, during the Hellenistic era (323–100 B.C.), when the Archaic style was admired and imitated throughout the Hellenistic world, although the imitation was modified by highly developed

stone carving techniques that had evolved during the intervening centuries. Archaistic Greek sculpture, being imitative, is generally regarded as inferior to the work it was modeled on, the character of which was determined, in part, by less sophisticated carving techniques. See ARCHAIC PERIOD; HELLENISTIC PERIOD.

archiepiscopal cross or **archbishop's cross.** See PATRIARCHAL CROSS.

archil. An obsolete ruby-red NATURAL DYESTUFF prepared from various species of lichens. Bluish-violet shades were produced by treatment with alkalies, as in the case of LITMUS and TURNSOLE. Since archil is only moderately lightfast, it was used for dyeing wool and silk and coloring foods and pharmaceuticals rather than for making paint pigments. Other names for archil are cudbear, orchil, and red indigo. French purple (or pourpre français) was a lake pigment made from archil.

architectonic. 1. Relating to architecture, especially to its basic structural principles.
2. A critical term applied to a painting or other work of art which presents an interrelation of parts evidencing a structural unity of the type associated with architectural design. It also applies to any work of monumental qualities suggesting the massiveness of architecture.

architects' rendering brush. A brush, made in several extra-large sizes, that resembles the round, pointed watercolor brush. Many watercolor painters use the brush for broad washes and for finer work with the point. The architects' rendering brush is sometimes made of red sable, but it is more commonly made of ox hair, which is much less expensive and which for most purposes performs better than red sable in a brush of this size.

ARCHITECTS' RENDERING BRUSH

architects' scale. See SCALES, ARCHITECTS'.

architectural sculpture. Sculpture that is intended to form an integral part of a building, or created especially to embellish it, as distinguished from works created for display as independent pieces. This distinction parallels that between easel painting and mural painting. See ATLANTES; CARYATID; TELAMON.

arc welding. The technique of WELDING with electrical equipment, as opposed to oxyacetylene or gas welding. In arc welding, coalescence is produced by heating with an electric arc or arcs. Depending on the method used, pressure may or may not be applied, and a FILLER ROD may or may not be used.

arenato. Italian for the third of the layers of plaster that make up the support of a FRESCO; in English, the SAND COAT.

argilla. Latin for POTTER'S CLAY.

armature. In sculpture, a skeleton construction upon which the sculptor builds up his work in plaster, clay, or another plastic substance. The armatures of small figures are commonly made of stiff wire; those of larger works may be constructed of any rigid and durable material. See also BUST PEG; BUTTERFLY; illustration on next page.

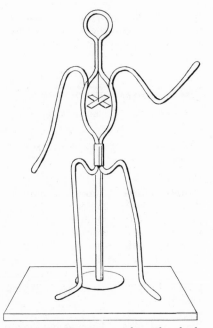

ARMATURE. Hanging within the body cavity is a butterfly, crossed sticks that help support a heavy mass of clay or other plastic material.

Armenian blue. An old name for native ULTRAMARINE BLUE made from lapis lazuli.

Armenian bole. Another name for BOLE.

Armenian stone. The ancient Roman name for AZURITE.

arm palette. An extra-large palette with a flaring curve, designed so that the forearm bears most of its weight. Some artists are particular about its balance and feel, choosing it as a sensitive instru-

ARM PALETTE

ment; others reject it as a romantic affectation or a relic of former times. The arm palette was commonly used in the 19th century.

Arnaudon's green. A variety of hydrated CHROMIUM OXIDE GREEN very similar to VIRIDIAN. It is no longer produced.

Arretine ware. See TERRA SIGILLATA.

arribida red. A native red iron-oxide pigment.

arriccio. Italian term for the second of the layers of plaster that make up the support for a FRESCO; in English, the BROWN COAT.

arris. A sharp, protruding edge or angle formed by the meeting of plane or curved surfaces, especially an edge of a molding or a stria. See illustration at FLUTING.

arsenic orange. Another name for REALGAR.

arsenic yellow. Another name for KING'S YELLOW.

art for art's sake. A phrase used since the 1870's to proclaim the independence of aesthetic values intrinsic in a work of art from storytelling, moral values, or any other purposes or motives. It is often encountered in its French form, *l'art pour l'art.*

Artgum. A well known trademark for a GUM ERASER.

artificial ultramarine. A term used in the 19th century to distinguish the ULTRAMARINE BLUE in standard use from the original native variety obtained from lapis lazuli.

20

artist's proof. One of the PROOFS in a LIMITED EDITION of ORIGINAL PRINTS. An artist's proof must bear the artist's signature or mark and, since the early 20th century, is usually numbered.

art nouveau. A style in art, manifested in painting, sculpture, printmaking, architecture, and decorative design at the turn of the last century. It arose in England in the 1880's and held sway as the avant-garde movement of its day from about 1895 to about 1905. Among its principal characteristics were a cursive, expressive line with flowing, swelling reverse curves, entrelacs or interlaced patterns, and the whiplash curve. In decoration, plant and flower motifs abounded, used for the first time in naturalistic form. Art nouveau had a concurrent phase, prevailing toward the close of the movement, in which straight lines and rectangular motifs predominated.

The style derived from several sources prominent in English culture during the second half of the 19th century: the arts and crafts movement, Celtic art, rococo, Oriental calligraphy, Japanese art, and Japanese architecture. The last of these influences was the strongest in the style's rectilinear phase. From England art nouveau spread rapidly over Europe and America, where it had a great influence on design in all fields of applied arts and decoration. This influence can still be discerned in some modern work in these fields. Its expressive lines appear even in poured-concrete buildings, such as Frank Lloyd Wright's Guggenheim Museum and Eero Saarinen's TWA Terminal at Kennedy Airport, both in New York. Among the many examples of art nouveau in its heyday are the buildings of Antoni Gaudí and Victor Horta, the drawings of Aubrey Beardsley, the glassware of Louis Comfort Tiffany, the architectural ornament and interior decoration of Henri Van de Velde and Louis Sullivan, the furniture of Charles Rennie Mackintosh, and the posters of Al-

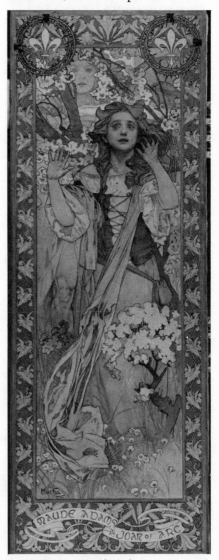

ART NOUVEAU. *Maude Adams as Joan of Arc* (1909), oil on canvas, by Alphonse Mucha. (*The Metropolitan Museum of Art, Gift of A. J. Kobler, 1920.*)

phonse Mucha. The style also has been known as the yachting style in France, JUGENDSTIL in Germany, Sezession in Austria, and STILE LIBERTY in Italy. See also DECADENCE; FIN DE SIÈCLE.

Some art historians have traced connections between art nouveau and the revolutionary movements that succeeded it. The curvilinear phase influenced the work of the Cubists, the rectilinear phase that of the followers of Neoplasticism. The style also left its mark on expressionist painting. Among the outstanding painters and sculptors who were influenced by it were Gauguin, Van Gogh, Toulouse-Lautrec, Rodin, Edvard Munch, and Gustav Klimt.

art rupestre. French term for the mural art of prehistoric cave dwellers.

arts and crafts. 1. In modern usage, the art of forming handmade articles which are usually decoratively designed and often useful or purposeful. The various handicraft skills employed include metalwork, woodwork, weaving, needlework, and manipulation of plastics, as well as techniques such as carving, printmaking, and painting. Arts and crafts is a professionally taught subject in schools, camps, and other institutions, sometimes as a hobby or recreational activity and sometimes as therapy.
2. The name of a movement beginning in England during the last third of the 19th century. Its founding is generally attributed to William Morris, but it was inspired by the doctrines of John Ruskin and Augustus Pugin. The movement was a conscious reaction against the results of the industrialization of design crafts. It fostered a return to handcrafted individuality. The new styles, which appeared in furniture, decoration and ornament, hand-blocked textiles, typography, and book design, broke away from the prevailing Victorian fashions and laid the groundwork for the acceptance of ART NOUVEAU in the late 19th and early 20th centuries.

arzica. Another name for WELD.

asbestine. A species of TALC mined in northern New York State. Asbestine is used as an INERT PIGMENT in house paints, where it prevents rapid settling or caking because of the flat-plate shape of its particles.

asbestos board. Any of various industrial wallboards sometimes employed by artists as supports for painting and decoration. Made of asbestos and Portland cement, asbestos board is fireproof, but rather heavy and brittle. Flat Transite is one of the trade names for a common type of board, in which the proportion of asbestos to cement is 80 to 20.

Ashcan School. See EIGHT, THE.

ash glaze. A ceramic GLAZE utilizing wood or vegetable ashes as the fluxing ingredient. Ash has been used as a glaze material since the Han Dynasty in China. Waste materials such as leaves, vegetable hulls, sawdust, or fireplace remains may be employed. The principal disadvantage of ash glazes is the unreliability of their sources.

askos. An ancient Greek ceramic oil flask. Its form was derived from ancient goatskin containers. See VASE SHAPES for illustration.

asphalt. Any of a fairly large group of black or blackish-brown bituminous substances, classed among the natural RESINS and taken from pits and "lakes" in many parts of the world. Their physical characteristics and performance vary little except for hardness

22

and melting point; some are very soft, others quite hard. All are highly acid-resistant and so are useful for such purposes as RESISTS in etching. Although they have been used in durable, weather-resistant coatings since the earliest recorded times, and by the Egyptians in embalming mummies, they develop surface faults on aging and therefore are not used in artists' paints. Among the soft varieties are Trinidad asphalt, manjak (from Barbados), and California asphalt. Uintaite, commonly known by its trade name, Gilsonite, is a very hard variety from Utah, brittle and lustrous. It is widely used to confer hardness on acid-resistant mixtures that contain softer ingredients.

asphaltum. A dark-brown, transparent, bituminous oil color made by dissolving an ASPHALT in linseed oil; not a true pigment color. Asphaltum is soluble in oils and VOLATILE SOLVENTS and melts at relatively low temperatures; areas of old paintings containing it have degenerated to masses of wide-open fissures. Especially popular in the 19th century, asphaltum was replaced by TRANSPARENT BROWN and UMBER after its bad effects became known. MUMMY is a variety of asphaltum also no longer in use.

assemblage. The technique of creating three-dimensional works of art by combining various elements, especially found objects, into an integrated whole; also, a composition so constructed. An assemblage may be either freestanding or mounted on a panel, and may include elements painted, carved, or modeled by the artist. The first composition so called is Picasso's *Glass of Absinthe* (1914). A more recent assemblage is Louise Nevelson's *Royal Tide V* (1960). See illustrations here and at FOUND OBJECT.

astragal. A small, plain, convex molding, from half to three-quarters round.

asymmetry. The absence of precise symmetry in a work of art. In painting and sculpture, asymmetry for purposes of realism, especially in representations of the human face and figure, is justified by the observation that no two sides of a living form are identical. Asymmetry is also used for aesthetic reasons, since balanced two-sidedness usually makes for a static and superficial composition. To keep a work of art from appearing lopsided, however, the principles of EQUILIBRIUM must always be applied in the execution of an asymmetrical composition.

ASSEMBLAGE. *Kichka's Breakfast* (1960) by Daniel Spoerri. (*Collection, The Museum of Modern Art, New York, Philip C. Johnson Fund.*)

atelier. 1. An artist's or craftsman's workshop. The term is often used to designate a studio where an artist trains his students or where assistants or apprentices work under his supervision. See BOTTEGA.

2. Atelier is sometimes loosely used in France to describe the more exact term, *atelier libre*. The *atelier libre* is a studio which provides a nude model during fixed sessions. There is no teacher and no tuition as such. The

23

most famous of these studios was opened around 1825 in Paris by the model Suisse. It was used by Delacroix, Courbet, Manet, Monet, and Cézanne. The Atelier Julian, which opened in Paris in 1860, was an extension of the atelier concept and provided instruction. Matisse and Léger studied there.

atlantes. Plural of *atlas*, the term used by the ancient Greeks for a column carved in the shape of a man. It is the male counterpart of a caryatid. Named after the giant Atlas, this form of architectural sculpture was called a TELAMON by the Romans. See illustration at CARYATID.

atmosphere. In the pictorial arts, the feeling conveyed or the mood created. Also, three-dimensional space in a composition, especially when achieved with AERIAL PERSPECTIVE.

atomizer. A device used by artists for spraying coatings of thin fluids on a surface in the form of mist. The typical atomizer consists of a glass jar, brass- or chrome-plated tubes, and a rubber bulb. Atomizers are used for spraying water on freshly applied watercolor to delay its drying; for applying fixatives to pastels and charcoal drawings; and for sizing grounds and underpaintings to reduce their absorbency. The introduction of fixatives and varnishes sold in cans as pressurized aerosol sprays, and of modern SPRAYERS, has diminished but not entirely eliminated the use of atomizers.

atramentum. Generic term in ancient Rome for various kinds of carbon black used in making paint and ink, and for the ink made from it. The Romans also used the term for an unknown substance employed as a glaze or varnish in painting. Scholars believe this was a solution of asphalt compounded with resin or oil so as to lighten its dark color sufficiently to impart a desirable tone to the underlying colors.

à trois crayons. A chalk drawing done in three colors, almost always red and white chalk and black chalk or charcoal. Watteau executed a great number of fine drawings in this medium, using SANGUINE as his red crayon.

attapulgite. A fibrous clay containing magnesium silicate; one of the components of MAYAN BLUE.

Augsburg Renaissance. Developments in German painting and sculpture centering in Augsburg at the beginning of the 16th century. Led by the painter Hans Burgkmair the Elder, artists in this city introduced many characteristics of the art of the Italian Renaissance into Germany. They were particularly influenced by the artists of northern Italy and Venice.

au premier coup. See ALLA PRIMA.

aureole. A depiction of radiance surrounding or emanating from the figure of a holy personage, especially in medieval and Renaissance art; also, less commonly, the radiance surrounding the head of a holy personage (see NIMBUS). Another term for an aureole is a glory. The almond-shaped aureole surrounding the figure of Christ or the Virgin Mary in medieval art is called a mandorla (Italian for almond) or vesica piscis (Latin for fish bladder).

aureolin. Another name for COBALT YELLOW.

auripigmentum. Another name for KING'S YELLOW.

aurora yellow. A variety of CADMIUM YELLOW introduced in En-

gland by Winsor & Newton in 1889, at which time it represented a considerable improvement in clarity and performance over earlier cadmiums.

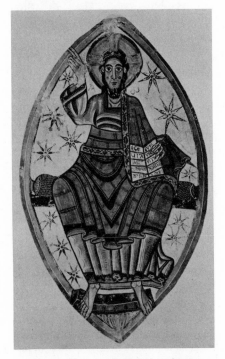

aurum musivum. A Latin term for MOSAIC GOLD.

autolithography. A term sometimes used to describe LITHOGRAPHY as a graphic art in which ORIGINAL PRINTS are made, as distinguished from commercial or industrial lithography. As the term implies, autolithography is thought by some artists to be more autographic than the other graphic arts, i.e., more immediate and truer both to the artist's concept and to the nature of his materials. The artist draws directly on the stone and makes his prints directly from that drawing. The intermediate steps of engraving or etching the design that are needed in the other graphic processes are not necessary in lithography. The texture of the stone, the graininess of the crayon, and the brushstrokes of the tusche are all reproduced exactly in the proofs. It is not even uncommon for a lithographer to use a pale tan or grayish-blue paper to duplicate in the proofs the color of the stone on which the original drawing was made.

automatism. The technique of creating a work of art without the exercise of thought or will, or any intervention on the part of the conscious mind. As a deliberate method, it has been employed by the Surrealists (see SURREALISM) and in some ACTION PAINTING. It is sometimes equated with doodling, but although the latter is rarely a deliberate action at the start, it usually becomes conscious and selective as it progresses.

avant-garde. A term describing art that departs from the existing norm in an original or experimental way. The term, French for "vanguard," may apply to an artist's technique, style, or choice of subject matter. A group of practitioners and/or advocates of a new art form may also be called avant-garde. Since avant-garde works may somewhat shock those who are used to traditional, established styles, the term is also sometimes extended to mean outlandish or extremist.

avellan cross. A cross with each arm made in a conventionalized filbert shape. It looks rather like four long, trumpet-shaped blossoms joined at the stem ends to a small circle. Avellan refers to the avellano, a filbert or hazel-

nut named for the Italian town of Avella. See CROSS for illustration.

Avignon berries. Another name for BUCKTHORN BERRIES.

avodire. An African hardwood from the tree *Turraeanthus africana*. Avodire is pale yellow and has a fine, silky texture. It comes in planks 1 or 2 inches thick, and is very widely used for decorative work.

axonometric projection. See PROJECTION.

ayous. An African wood (from the tree *Triplochiton scleroxylon*), whitish or light yellow, with a pronounced stripe. It is usually available in large logs. Ayous is lightweight but relatively strong, and is easy to work. It is also called African whitewood, obeche, or samba.

Ayr stone. A very hard, fine-grained stone used in Britain as a whetstone for sharpening sculptors' and engravers' tools and for polishing marble. Named for a river in Scotland, it is also called Scotch stone, water-of-Ayr, and snakestone.

azo colors. Bright SYNTHETIC ORGANIC PIGMENTS from which fairly permanent pigments are produced for industrial paints, printing inks, varnishes, and other products; not sufficiently permanent or reliably nonbleeding to be acceptable for artists' use, with a few exceptions.

azure blue. A hue designation for any sky-blue color; also, an 18th-century name for SMALT.

azure cobalt. A special variety of COBALT BLUE, lighter in shade than the regular type.

azurite. A clear, deep-blue, crystalline mineral, basic copper carbonate. In powdered form, azurite was used at least as early as Roman times as a permanent paint pigment, and it remained as a prominent blue for tempera and watercolor use until superseded by more readily available and cheaper blues. Smalt replaced it in the 17th century. It does not work well enough in oil to be used as an oil color. Azurite has some variation toward the green due to the presence of MALACHITE in some specimens. BREMEN BLUE is very similar to azurite in chemical composition but has a different crystalline structure. The mineral was called Armenian stone by the Romans and is also called chessylite and blue malachite. The old Italian name for the pigment was azzuro della magna, and in the 17th or 18th century it shared the name mountain blue with Bremen blue. The unstandardized term mineral blue also has been applied to azurite.

azzurro oltremarino. Italian for "blue from beyond the sea." See LAPIS LAZULI.

26

B

babul gum or **babool gum.** Obsolete name for GUM ARABIC. Babul, or babool, is the popular name of an acacia tree that is a source of the gum.

background. In the pictorial arts, that part of the composition that appears to be farthest from the viewer. The background is one of the three ZONES OF RECESSION in LINEAR PERSPECTIVE. Lointains and offscape are little-used terms for the most distant parts of a landscape.

background paper. Another name for colored SIGN PAPER in wide rolls.

back-painting. A method of transferring a print to a sheet of glass and coloring it from the rear so that the picture seems to have been done directly on the glass; also, a work so produced. Such a work was also called a glass colored print. Back-painting was popular in the late 17th and early 18th centuries. The print, usually a line engraving or a mezzotint, was given a long soaking in water to remove the sizing and soften the paper. When it had dried, it was laid face down on a sheet of glass to which a thin coating of a balsam such as Venice turpentine or Strasbourg turpentine had been applied. When the adhesive had set, the back of the print was sponged with water and the paper carefully rubbed away until only a thin, virtually transparent layer remained. The back of the print was then painted with watercolors and given a coat of pale varnish for protection. The process was revived for a time in the 19th century as a means of coloring photographs.

badger blender. A BLENDER made of badger hair, which is gray with a black

BADGER BLENDER

band. The hair of a badger blender is held by two curved pieces of quill fastened with twisted wire, to minimize the breakage of hairs.

badigeon. A stiff paste used to STOP small defects in stone. The traditional ingredients are plaster and powdered limestone.

bag wall. The wall in a down-draft KILN that separates the combustion area from the kiln proper. Baffles are constructed to channel the flame indirectly through the kiln in order to conserve heat and achieve higher temperatures. The devious flow of heat prevents its direct expulsion through the

stack. Such heat loss is the principal drawback of the older up-draft kiln.

baked enamel. Industrial, pigmented, synthetic-resin coatings designed to resist hard wear. After a coating is applied, the treated item is baked in an oven at 250° to 350° F. These coatings surpass the air-dried industrial ENAMELS in every respect. The term is sometimes erroneously applied to genuine PORCELAIN ENAMEL, which is fired in a kiln at high temperatures. Baking enamels are called stoving enamels in Britain.

balance. See EQUILIBRIUM.

balaustre. A South American wood (from trees of the genus *Centrolobium*), usually brilliant orange, although it may be yellow or red and is sometimes streaked with red or black. Also known as arariba or canarywood, it is used in shipbuilding and as a veneer for cabinetwork. Balaustre logs run from 6 to 8 inches in diameter and 8 feet or more in length.

baldachin or **baldaquin.** A canopy suspended over a throne or altar, or supported over an episcopal chair or throne carried in processions; also, a permanently constructed canopy over an altar. An example is the massive bronze baldachin by Bernini over the high altar in St. Peter's in Rome. Its name derives from baudekyn, a rare textile fabric from Baghdad (Baldacca) that was used to make such canopies. The Italian form, baldacchino, is also in general use.

ball clay. A special kind of ceramic clay of exceptionally small particle size and, consequently, very good plasticity. It is used to impart plasticity to other CLAY BODIES.

ball mill. A revolving horizontal cylinder that contains steel balls, used to disperse pigments in a paint vehicle (see PAINT). Its inner surface is made of or lined with material hard enough to resist the wear from the balls. When the vehicle and pigment are put into a ball mill, the grinding action of the tumbling balls produces a satisfactory

BALL MILL. (*Courtesy, The Craftool Company.*)

dispersion, but of a thinner, more fluid consistency than the stiff pastes that can be produced by the ROLLER MILL. An advantage of the ball mill is that it may be used when the vehicle evaporates too rapidly to be ground efficiently in an open mill. Pigmented lacquers and ethyl silicate colors must be dispersed in ball mills. Small-scale versions are sometimes improvised, using steel balls in glass or porcelain jars or tin cans riding on two revolving rollers. A mill that uses flint pebbles instead of balls is called a pebble mill. See also MULLER.

In ceramics, a ball mill is used to grind and blend glazes and the ingredients of clay bodies.

balsa. One of the lightest of woods; obtained from the tree *Ochroma lagopus*, native to South America.

Balsa is very soft and porous, and is easily carved. It is quite strong for its weight.

balsam. Any of various thick, viscous fluids, sometimes called oleoresins, exuded by cone-bearing evergreen trees and containing volatile and solid resinous ingredients. Chief among those that are specifically named balsams are CANADA BALSAM and COPAIBA BALSAM; others are VENICE TURPENTINE and STRASBOURG TURPENTINE. Balsams have been used as ingredients of varnishes and painting mediums since the earliest days of European easel painting. See also BURGUNDY TURPENTINE.

bamboo brush. A widely used misnomer for any Oriental brush, which is more frequently set into a reed than a bamboo handle. However, there is a true bamboo brush, not in very wide use; the "bristles" are the pointed end of a bamboo stalk, finely divided or shredded and shaped so that it resembles a regular pointed brush with exceptionally long bristles.

bamboo pen. A Japanese pen made from a bamboo stalk; it is cut to pen shape like a reed pen (see PEN) and used for drawing and calligraphy.

banana oil. A popular term for amyl acetate, a commonly used LACQUER SOLVENT. It has a sharp, penetrating, banana-like odor. Amyl alcohol, a lacquer DILUENT, has a similar but less penetrating odor.

banderole. A carved or painted decoration in the form of a ribbon or long scroll, sometimes bearing an inscription.

banding wheel. A small turntable used in decorating pottery with circular stripes or bands of color or gold; also called liner's wheel. The wheel, on which the piece is centered, is twirled while a brush loaded with glaze or underglaze color is held steadily against the piece.

banker. A large, sturdy workbench, sometimes with a turntable top; used for stone, wood, or clay sculpture.

banner paper. See SIGN PAPER.

Barbizon school. The name given to a group of French landscape painters active between about 1830 and 1880, who formed an informal school or art colony in the village of Barbizon, on the edge of the Forest of Fontainebleau. They were the first to paint from nature, rather than creating their landscapes in a Paris studio. In this, and in their realistic portrayal of rural scenes and characters, they foreshadowed the Impressionists. Leaders of the Barbizon school were Théodore Rousseau (1812–1867) and Charles François Daubigny (1817–1878). Associated with them more by propinquity than by similarity of style were Camille Corot (1796–1875), whose landscapes were less realistic and more suffused with light, and François Millet (1814–1875), who was less interested in the countryside than in the peasants who inhabited it. See PLEIN AIR.

bardiglio. An Italian MARBLE with dark veins on a bluish or dark-gray ground.

baren. A smooth, flat, round or oval pad, furnished with a handle so that it may be used to take an impression from a wood block by rubbing the back of paper that has been placed on the inked face of the block. The original baren, a Japanese implement, is made of layers of glued cardboard, cushioned with a coil of tough cord and covered with a sheath of bamboo. The ridges of

the bamboo help concentrate the pressure of the baren as it is drawn across the block. A modern model, sheathed with nylon instead of bamboo, is used by some printmakers. Also available are barens made of wood and of Teflon.

barite. Name for BARYTES (native barium sulfate) used in geology and mineralogy.

barium sulfate. See BARYTES; BLANC FIXE.

barium yellow. Barium chromate —a permanent pigment of a fairly opaque, pale banana-yellow with a greenish cast. Since barium yellow is much weaker or lower in saturation than strontium yellow, which has identical color properties, strontium yellow is preferable as an artists' color. First produced commercially in the first quarter of the 19th century, barium yellow was not widely used until mid-century, when chromium compounds became more available. Known in Britain as LEMON YELLOW, barium yellow has also been called by the unstandardized term PERMANENT YELLOW and by the obsolete name yellow ultramarine.

Baroque. The style dominating European art and architecture throughout the 17th century, and persisting in some places as late as 1750. It was a dynamic, theatrical style that used realism, illusionism, ornate forms, and a blending of the arts to achieve its effects.

The style is found in its purest form in the work of Gianlorenzo Bernini (1598–1680) and Francesco Borromini (1599–1667), who fused architecture and sculpture, creating an illusion of immediacy for the beholder by their use of light and space. Painting of the High Baroque in Italy often took the form of fresco, especially illusionistic ceiling decorations (see SOTTO IN SÙ) designed to merge with the elaborate moldings and carved cornices surrounding them. Among its practitioners were Pietro da Cortona (1596–1669), Giovanni Lanfranco (1582–1647), and Guercino (1591–1666).

The painter Caravaggio (1573–1610) is usually considered the first Baroque artist. In his realistic, even earthy treatment of the traditional religious subject matter and his dramatic use of chiaroscuro, he paved the way for Peter Paul Rubens (1577–1640), Rembrandt van Rijn (1606–1669), and Jan Vermeer (1632–1675). Although Rubens' paintings were usually devoted to Christian or classical themes, Rembrandt and Vermeer, along with Franz Hals (1580–1666), often chose contemporary subjects, depicting peasants and burghers in realistically domestic surroundings. Other painters of the Baroque were Anthony van Dyck (1599–1641) and Diego Velásquez (1599–1660). See also ROCOCO.

barwood. A red NATURAL DYESTUFF obtained from a tropical African hardwood of the genus *Pterocarpus*. Camwood, extracted from a very similar African dyewood, *Baphia nitida,* is generally held to be the same substance. Both have been used to dye textiles, but they resist fading poorly.

baryta. An obsolete term for barium, which survives in the term baryta water.

baryta green. An obsolete name for MANGANESE GREEN.

baryta water. A saturated solution of barium hydroxide, sometimes used in place of limewater to saturate plaster before applying SECCO colors.

baryta white. An obsolete name for BLANC FIXE.

barytes. Native barium sulfate. When ground to a fine, white powder it is used as an INERT PIGMENT and FILLER in industrial paints. The use of powdered barytes as a paint filler does not seem to antedate the late 18th century. Barytes is not used in artists' materials or the finer types of industrial paints, but precipitated barium sulfate, called BLANC FIXE, is widely used as an inert pigment. Other names for barytes are Bologna stone, heavy spar (an illusion to its high specific gravity or heaviness), and barite, a geological term. An old name is terra ponderosa.

basalt. A dense, hard volcanic rock used for carving and as a building stone by the ancient Egyptians. It is black or blackish green or brown, sometimes with glittering particles. Because of its hardness and fine grain it was sometimes employed for finely wrought vases and other delicate objects.

basalt ware or **basaltes ware.** A decorative black ceramic stoneware, developed by Josiah Wedgwood in 1768. It resembles the natural mineral basalt, and is usually decorated with Neoclassical motifs in white or in color.

base. 1. The INERT PIGMENT or colorless powder on which a dye is precipitated to form a colored pigment; also called lake base. Alumina hydrate is considered the best base for transparent results; blanc fixe is usually employed when body or opacity is sought.
2. In sculpture, the foundation or support on which a piece of sculpture rests. Besides giving physical stability to the work, it is chosen to enhance the appearance of the sculpture by means of its size, shape, color, and texture. Nearly every material has been used for a base, although wood is most frequently employed. The bottom of a smoothly finished base is usually either left rough or glued to a piece of felt to prevent it from being slippery or insecure.

basin slant. See SLANT.

bas relief. See RELIEF.

bassetaille. A technique of applying porcelain ENAMEL on metal, employed principally on flat articles of jewelry, such as brooches. The metal is fashioned in low relief (the high points being about $\frac{1}{30}$ inch below the rim) either by carving or REPOUSSÉ, and charged with translucent or transparent colored enamels. Since there are no dividers between the colors, each charge of enamel must be allowed to dry out before the next is applied. Two or three coats of color, plus a final clear coat made flush with the rim of the piece, are applied before the piece is fired.

basso-rilievo. Italian for low RELIEF.

basswood. A common softwood obtained from trees of the genus *Tilia,* especially *T. americana* (the linden), native to the U.S. and Canada. Basswood has a plain, even texture and is easily worked. It is available mostly in planks.

bat. In ceramics, a plaster or fireclay slab on which pottery is formed and dried. When made of fireclay, it may be placed in the KILN. A plaster bat may also be used to absorb excess water from the ware.

Batesville marble. A LIMESTONE from Arkansas. It may be gray or cream-colored.

Bauhaus. German school (1919–1933) of architecture and industrial arts. Founded by the architect Walter Gropius in 1919, the Bauhaus attempted to achieve a reconciliation between the aesthetics of design and the commercial demands of industrial mass production. The school did not subscribe to a particular style or aesthetic formula, but stood for a basic approach to the problem of art in an industrial world. Internationally renowned artists and architects, including Paul Klee, Lyonel Feininger, and Gropius himself made the Bauhaus enormously influential. Opened in Weimar, it was moved to Dessau, then to Berlin. Hitler closed it in 1933.

bead and reel. A convex molding with a profile that is half round or more and in which bead-shaped elements alternate singly or in groups with disks.

BEAD MOLDING (ABOVE) AND BEAD AND REEL (BELOW)

bead molding. A small convex molding, either half round or half spherical, carved in a continuous row of bead-like protuberances.

beak molding. A protruding molding, the profile of which resembles the short, downward-curving hawk's beak.

BEAK MOLDING

Beaux-Arts, Ecole des. The school of fine arts of the ACADÉMIE DES BEAUX-ARTS, located in Paris.

beaver board. See WALLBOARD.

Bedford stone. A light-colored oölitic LIMESTONE from Lawrence County, Indiana. It is one of the best American limestones for building purposes. See INDIANA LIMESTONE.

beeswax. The WAX found in honeycombs. Two grades, white refined and virgin or yellow, are sold. Melted beeswax is added to pigments in the rarely used method of wax or encaustic painting, and is the basic ingredient of etching grounds. It is used in lining adhesives and preservative coatings. It also serves as a plasticizer and stabilizer in oil colors, and as an ingredient in tempera emulsions. Beeswax is sometimes used as a flatting agent to produce a mat varnish but cannot be recommended for this purpose because it tends to become glossy when rubbed. White refined beeswax is often referred to in recipes merely as "wax."

Belgian black. A dense, hard MARBLE from Belgium, esteemed above all other black marbles for carving. Its fine, deep color and freedom from veins or streaks make it most desirable.

Belgian marble. See RANCE.

Belleek. A chinaware made in Northern Ireland since 1857. It is famous for its thinness and high ring, and has a soft, iridescent glaze.

Bell's medium. A 19th-century English proprietary oil-painting medium, originally made of blown linseed oil thinned with spike oil. It has been superseded by more modern mixtures.

belly. The widest place in the round red sable brush; also, the bulge in a single red sable hair. See BRUSH, RED SABLE; FLAG.

Bengal cutch. See CUTCH.

bent gouge; bent chisel. A wood-carving GOUGE or CHISEL, the shank of which is either curved for its entire length (a long bent) or straight for most of its length with a sharp bend near the tip (short bent or spoon). It carves a deeper cut than the straight gouge or chisel. A bent gouge or chisel is often simply called a bent. See illustration at WOOD-CARVING TOOLS.

bentonite. An extremely fine natural clay formed by the disintegration of volcanic ash; used mainly to increase the plasticity of a ceramic CLAY BODY. As a plasticizer, bentonite is about four times as effective as the most plastic ball clays. It may also be used to keep some glazes in suspension, and as an inert pigment or filler in various compounds.

benzene. See COAL-TAR SOLVENT.

benzine. A VOLATILE SOLVENT distilled from crude petroleum. Its volatility, flammability, and solvent action are about midway between those of mineral spirits and gasoline. Familiar as a dry cleaner and spot remover, it is not an ideal paint thinner. Its flash point, rapid rate of evaporation, and pungent odor make it less suitable than mineral spirits for artists' use.

benzol. See COAL-TAR SOLVENT.

benzol black. The most intense and bluish variant of CARBON BLACK. It is made by burning solvents.

Berlin blue. Another name for PRUSSIAN BLUE; most frequently used in France.

biacca. Italian for flake white, artists'-quality WHITE LEAD.

bianco sangiovanni. Calcium hydroxide plus calcium carbonate; a white pigment recommended by Cennino Cennini (*Il Libro dell' Arte*) and still used for FRESCO painting. Bianco sangiovanni is made by molding LIME PUTTY into small pieces and exposing the pieces to air in a dust-free place for several months; the hydrated lime putty becomes partially carbonated by the air, and the result is an intimate mixture of calcium hydroxide and calcium carbonate.

Bible paper. Another name for INDIA PAPER.

bice. Blue bice and green bice are names formerly used for BREMEN BLUE and Bremen green. Green bice survived as a water pigment into the 20th century.

Biedermeier. Satirical epithet applied to a phase of German arts and furniture design prevalent from the 1820's through the 1850's. It was characterized in furniture by a simplified, uninspired adaptation of the French Empire style. A self-conscious simplicity was the keynote in painting, as well, with sentimentalized views of peasants and scenes of nature. The adjective Biedermeier is also used as a noun for works of a philistine conventionality and dullness. One of the most successful centers of Biedermeier art was the DÜSSELDORF SCHOOL.

binder. The agglutinant or cementing ingredient of a paint VEHICLE. Its functions are to hold the pigment particles to each other to form a cohesive coating and to attach it securely to the ground. The term is also used for the gum or other agglutinant used in pastel crayons, drawing inks, and ceramic glazes and bodies.

biomorphic form. An abstract form whose contours are more related to plant and animal configurations than

BIOMORPHIC FORM. *Human Concretion,* cast stone (1949) after original plaster (1935), by Hans (Jean) Arp. (*Collection, The Museum of Modern Art, New York. Gift of the Advisory Committee.*)

they are to geometric shapes. The term is particularly applicable to the works of the sculptor and painter Hans Arp (1887–1966), whose forms suggest vermicular or visceral relationships.

birch. Any of the common hardwoods obtained from trees of the genus *Betula.* Birch is strong, durable, and relatively inexpensive. Birch veneers may have a curly, wavy, or other figure, although the solid wood used for carving usually has a rather plain and uninteresting grain. It is used in plywood boards that are suitable for use in panels for painting.

bird's eye. In wood or stone, a natural figure of many small nuclei or eyes surrounded by swirling and dappled patterns, as in bird's-eye maple.

bird's-eye view. A scene depicted as if observed from a point sufficiently far above it in space to include the entire spread of the subject. Any correctly drawn bird's-eye view will be in OB-LIQUE PERSPECTIVE (see illustration at LINEAR PERSPECTIVE). The HORIZON LINE is shown or imagined high in the picture or actually above it, so that most or all of the composition lies below the horizon line, causing a downward convergence of vertical lines. The raised horizon line corresponds to a high position of the POINT OF STATION. The bird's-eye view is especially suitable for panoramas, such as historical scenes in which the artist wants to show the full scope of an event. See also WORM'S-EYE VIEW.

biscuit. Ceramic ware that has been fired but not glazed; also called bisque. In any glazed porcelain the mass or body under the glaze is also known as biscuit.

biscuit mold. A MOLD made from bisque-fired clay, used in ceramics. Since the bisque is not glazed or fired to the point of vitrification, it is porous and yet is strong enough to withstand repeated use.

bishop's length. See CANVAS SIZES, PORTRAIT.

bismuth white. Bismuth nitrate. In limited use in the early 19th century as a less poisonous substitute for white lead, bismuth white soon became obsolete as a result of technical and economic improvements in zinc white production. Bougival white and PEARL WHITE are other names for bismuth white.

bisque. Biscuit; fired ceramic ware that is to be glazed. Also, hard-fired, vitreous ceramic ware that is not to be glazed. In this sense, the term is most frequently applied to unglazed but finished figurines and other small objects of extreme delicacy.

BIRD'S-EYE VIEW. *The Midnight Ride of Paul Revere* (1931), oil on Masonite, by Grant Wood. The horizon line is above the painting, and there is a downward convergence of vertical lines, particularly obvious in the defining lines of the church. (*The Metropolitan Museum of Art, Arthur H. Hearn Fund, 1950. Courtesy, Associated American Artists.*)

bisque fire. The first firing of a ceramic body, preliminary to its being glazed or fired again at a higher temperature (see GLOST FIRE).

bistre. A brown pigment derived from the tarry soot made by burning beech wood. It was widely used in watercolors and wash drawings from the 14th through the 19th centuries. Though fairly permanent in diffused light, bistre fades in bright sunlight. It is now replaced by permanent, light-proof pigments. Bistre, like sepia, was especially liked for its pleasing tonal effects in wash drawings. Compared with sepia, bistre is cooler and less reddish. Their relationship is analogous to that between raw umber and the more reddish, or less greenish, burnt umber. Sepia was more popular because of its wider range of tones. Brown lampblack and soot brown are obscure names for bistre.

bit. See BITSTONE.

biting. In ETCHING, the corrosive effect a MORDANT has upon the metal plate when the plate is placed in a bath of the acid. The composition, concentration, and temperature of the mordant and its skillful application to the plate determine the control of the process (i.e., the depth, width, and evenness of the etched lines) and the durability of the plate (i.e., its ability to stand up under the wear of printing

a reasonably large edition). Etching mordants bite in all directions and therefore tend to produce a weakened, undercut structure at the face of the plate. FERRIC CHLORIDE, either used alone or added to nitric acid, promotes a more vertical bite, thus etching lines that will better withstand the wear of printing. When for some reason the mordant bites through or undercuts the ETCHING GROUND, an undesirable phenomenon known as FOUL BITING occurs. CREVÉ, another defect that can occur on an etching plate, results from over-biting.

The extent of biting is controlled not only by the nature of the mordant but also by the length of time the plate is left in the acid bath. After the plate has been in the mordant for awhile, it may be removed, and those lines that are to be faintest may be stopped out (see STOPPING OUT) before the plate is replaced in the bath. The procedure is repeated, selectively producing successively deeper lines, until the plate is etched to the artist's satisfaction.

bitstone or **bit.** Coarse, crushed quartz (silica) spread on the bottom of a SAGGER to prevent delicate ware from sticking to it or being blemished by contact with it during firing.

bitumen. A generic term for native ASPHALT, tar, etc. ASPHALTUM is a bituminous material especially prepared for oil painting.

Bizen ware. A utilitarian Japanese ceramic ware. It has been made at Imbre in the province of Bizen since the 14th century. The body is a gray or brown stoneware. What appears to be a reddish or tea-green glaze is the result of fireflash or accidental ash.

black-and-gold marble. An Italian LIMESTONE, the best grade of which is jet-black, evenly patterned with dull golden veins. Inferior grades have a dark-grayish or brownish ground and irregular veins. Black-and-gold is also called Porto or Portor marble. It is quarried in Porto Venere and the island of Palmaria in the Gulf of Spezia.

black-boy gum. See ACCROIDES.

black chalk. A black or dark-gray native CHALK containing carbon or shale; sometimes used as a crayon. However, black pastels and chalk crayons are usually made with black pigments.

black cherry. See CHERRYWOOD.

black ebony. See EBONY.

black-figured pottery. Ancient Greek pottery decorated in black on a red or pinkish background. This style was the earlier of the two principal ways of decorating pottery. It was most prevalent in Athens during the Archaic period (the 6th century B.C.). RED-FIGURED POTTERY, produced by a more sophisticated technique, increasingly replaced it.

BLACK-FIGURED POTTERY. Attic kylix (c. 550 B.C.) with two confronted panthers on each face and the inscription "Hail and drink this wine." (*Courtesy of the Brooklyn Museum.*)

black iron oxide. A native variety of magnetic black iron oxide, the artificial counterpart of which is Mars black (see MARS PIGMENTS). It is brownish in undertone, non-greasy, and wets easily,

but is coarse and not suitable for artists' use.

black japan. See JAPAN.

black lead. An obsolete designation for GRAPHITE. The terms black lead and plumbago were used before the actual composition of graphite was known; they continued to be used until the first quarter of the 19th century.

black-letter hand; black-letter type. See GOTHIC.

black metal. See PEWTER.

black mirror. See CLAUDE LORRAIN GLASS.

black oil. Linseed oil cooked at a high temperature with as much white lead or litharge as will combine with it. Formerly used in making MEGILP, it was called "strong drying oil." Its present name came into use in the 1940's in connection with the MAROGER MEDIUM.

black oxide of cobalt. A rather coarse native black pigment, the properties of which are similar to those of BLACK IRON OXIDE; not in use as a paint pigment. Also known as cobalt black, black oxide of cobalt is used in ceramics to impart a cobalt-blue color to glazes.

black oxide of manganese. Native manganese dioxide; principally used as a raw material in the preparation of DRIERS and DRYING OILS. Used as a pigment in early civilizations, black oxide of manganese is now seldom produced in a finely ground form suitable for use in paints. An artificial variety is described under MANGANESE BLACK.

black pigments. The following black pigments are approved for use in oil

paints by the PAINT STANDARD and are generally acceptable in all other easel- and mural-painting techniques: LAMPBLACK, IVORY BLACK, and MARS BLACK.

black watercolor. Another name for Japanese ink, or sumi. See INK.

blackwood, African. See AFRICAN BLACKWOOD.

bladder. A container for artists' oil colors, known as early as the mid-17th century, and becoming widely accepted with the rise of enterprising and well organized artists' supply firms in England, France, and Germany toward the end of the 18th century and in America in the early 19th. The bladder was the first packaging for oil colors; prior to its introduction the artist or his helper had to grind colors for each painting session. The bladder was a fairly tough animal membrane, such as a thick sausage casing, filled to a globular shape with paint and securely tied with twine. The painter would puncture the bladder with an ivory tack, and, after squeezing out the color, replace the tack as a seal. Colors kept this way did not remain fresh for more than a few months. About 1835 a syringe-like container, consisting of a refillable brass tube with a plunger, appeared; but this can be classed as studio equipment rather than commercial packaging. The collapsible tin TUBE supplanted both about 1840.

bladder green. A 19th-century name for SAP GREEN.

blanc d'argent. French for flake white, artists'-quality WHITE LEAD.

blanc fixe. Precipitated barium sulfate. One of the best of the INERT PIGMENTS, blanc fixe is used as a BASE for

opaque LAKE pigments, and also used to reduce or let down their strength with a minimum effect on clarity. In water mediums blanc fixe retains much of its whiteness, and it has been used as a GOUACHE pigment under the name of constant white. Blanc fixe should not be confused with BARYTES (native barium sulfate), a coarser crystalline material used only as an extender in the cheapest of house paints. The invention of blanc fixe has been credited to F. Kuhlmann of Lille, France (c. 1835). Other names for blanc fixe are baryta white, enamel white, and PERMANENT WHITE.

blanket. In an ETCHING PRESS, a piece of heavy white felt placed between the paper on the intaglio plate and the upper roller of the press. The blanket helps to hold the paper in place on the printing surface and to distribute the pressure of the press evenly over the surface. It also prevents the edge of the plate from tearing the paper under the great pressure of the rollers in the press.

Blaue Reiter, der. "The Blue Rider," a group of German artists who created an abstract variety of EXPRESSIONISM. The group was founded in Munich in 1911 by Wassily Kandinsky (1866–1944) and Franz Marc (1880–1916), and included Paul Klee (1879–1940) and August Macke (1887–1914). The Blaue Reiter was the avant-garde art movement of its day and, together with the BRÜCKE movement which preceded it, exerted a profound influence on the development of modern art.

Blaue Vier. The "Blue Four," a group consisting of four highly individual painters—Kandinsky, Klee, Lyonel Feininger (1871–1956), and Alexei von Jawlensky (1864–1941) —who exhibited their work together

in Germany in 1922 and in the U.S. and Mexico in 1924.

bleed. 1. Of an oil color, to stain or migrate into an adjoining area of lighter color. Many synthetic organic pigments, including some of the brilliant modern pigments with good lightproof qualities, may not be used in oil painting because they bleed. White paint brushed over or painted adjacent to a bleeding color will become tinged with the color, and the stain will increase as the painting ages.

2. In the graphic arts, to be printed (as a picture or other illustration) so as to run up to one or more edges of the paper rather than being bounded by a margin. An illustration so printed is called a bleed.

blender. A type of brush, usually of badger hair, whose hairs flare out like those of a shaving brush instead of coming to a point. Blenders are used clean and dry, in a perpendicular, staccato tapping motion, to blend together two adjacent colors or tints of wet paint. If skillfully used, they can produce an imperceptible, smooth gradation or fusion of one tone into another. The BADGER BLENDER is not held together by a metal ferrule, as are most brushes, including blenders of fitch hair, which is gray with a black band, and dark squirrel, known as camel hair. The badger blender is usually considered the best, the fitch blender second. The camel-hair blender is also called a mop. Blenders are also called softeners, and were formerly known as sweeteners. The flat FAN BRUSH is also used as a blender.

blending. In painting, the gradation of color so that two hues or values merge imperceptibly. Oil colors and pastels may be blended, but tempera, gouache, casein paints, and polymer colors do not blend. The flowing of

watercolor washes may also be considered blending. Although most oil and pastel techniques emphasize individual brushstrokes, soft edges and partially fused tones frequently accompany them. Most art students are trained in bold and definite brushwork, because the habitual use of blending can lead to weak and picky work, and because its use as a major stylistic influence in paintings is outside the mainstream of art. However, blending has been an important technique ever since the beginning of oil painting. A general blend may be made by brushing two areas of wet paint into each other, but a flawless gradation is usually achieved by tapping the area of fusion with a dabber, or a clean, dry brush. The BADGER BLENDER is especially made for this purpose. Pastel blends are made on finely grained paper, by going over the colors with a STUMP or with the fingertips. Gradated effects in aqueous paints are achieved by HATCHING and cross-hatching. In the silk-screen process, blending may be produced by working adjacent charges of color with the squeegee before the printing surface is placed under the screen. In any relief printing technique, or in direct printing or painting with a brayer, smooth gradations of tone can be made by working two inks or paints together on a glass slab with the brayer.

blind printing. The technique of printing an uninked plate to produce a subtle embossed texture. This process, used for many Japanese prints, has been revived by contemporary artists to create a white-on-white image, highlighted by the shadow of the relief image on the uninked paper. Blind printing is effected by covering the uninked plate with damp paper and running the two through an etching press.

blister. In painting, a raised area indicating cleavage between the paint layer and the ground or between two layers of paint. Blistering is caused by external forces acting on a painting, such as fire, moisture, or, more rarely, a spot of foreign matter on the ground. Blisters on an oil painting may be caused by water seeping through the canvas support from the rear; even a gummed label applied to the rear of the canvas may cause a blister. Since part of the paint surface is irretrievably lost when a blister breaks, conservators must perform painstakingly the delicate operation of flattening blisters when they appear.

blister glaze. A ceramic GLAZE that produces a broken blister effect, sometimes used for decorative purposes on modern wares. It is made by combining an ordinary glaze with grains of a material that will become gaseous under the heat of firing. Calcium or magnesium carbonates, calcium sulfate, and manganese dioxide are some of the materials used to create this effect. Accidental blistering is called SPIT-OUT.

block book. A book in which the text and illustrations are entirely printed by WOOD ENGRAVINGS or WOODCUTS, made to actual reproduction size, one block to a page. In addition to copying by hand, this was a method of duplicating manuscripts before the invention of printing with movable type. Block books were especially popular in the 15th century in northern Europe, when woodcuts were used to print illustrated prayerbooks. See illustration on next page.

block-out stencil method. In SILK SCREEN and SERIGRAPHY, a technique by which the nonprinting areas of the screen are stopped out by brushing them with water-soluble glue, leaving the design open to the passage of paint

to the printing surface. This simple process is used for bold and simple freehand designs in serigraphy, but is not suitable for work of any great degree of delicacy or intricacy. Nor can it be used to print watercolors, since these would dissolve the glue. In variations of the block-out method, the nonprinting areas are stopped out with either shellac or lacquer; and a somewhat more complicated process involves spreading a glue sizing over the entire screen with a squeegee, brushing the nonprinting areas with shellac or lacquer, and finally washing out the glue in areas that are to be open and pervious to paint. In any of these processes the translucent glue may be tinted with a water-soluble color, to make it more visible on the screen. When glue is used as the stopping-out medium, the process is sometimes called the glue-cutout method.

BLOCK BOOK. Page from a facsimile of the 1477 German edition of the *Biblia Pauperum.* (*The New York Public Library, Rare Book Division.*)

block print. 1. An original print made from a single carved wooden block, i.e., a WOODCUT or a WOOD ENGRAVING. See also BLOCK BOOK.
2. A textile printed from blocks rather than from a cylinder. The term "hand blocked" designates a textile that was printed by an individual craftsman, who may also have carved the block.

block scraper. A sculptor's tool for reducing the surface of plaster blocks or molds. The usual model is a rectangular piece of thin steel 2½ by 6 or 9 inches. Sometimes one or both of its long edges are finely serrated.

blond painting. Painting done in a high key, or high values, as distinguished from that done in deep, dark, or full-toned colors. The paintings of Botticelli can be called blond, while those of Rembrandt cannot.

bloom. A whitish, cloudy, or foggy effect on the surface of a varnished oil painting. It may be caused by moisture condensation in the fresh varnish, or it may be an inherent defect of the varnish itself. Bloom is sometimes called chill.

blown oil. Linseed oil that has been bleached and thickened to the consistency of honey by blowing air through it while it is being heated in an open kettle. It is the least costly and least desirable kind of thickened or bodied oil. Because it is already partially oxidized, blown oil has poor durability and on exposure to light eventually darkens even beyond the color of the original raw oil.

blowup. An enlarged photographic copy, as of a smaller photograph or a piece of original art work, particularly graphics.

blue ashes. One of the many names for BREMEN BLUE.

blue bice. Another name for BREMEN BLUE.

blue black. A name sometimes given to IVORY BLACK.

blue frit. Another name for EGYPTIAN BLUE.

blue lake. A reduced or let-down variety of PRUSSIAN BLUE. See REDUCED PIGMENT.

blue malachite. Another name for the mineral azurite. It is not the same as malachite, a green variety of copper carbonate.

blue pigments. The following blue pigments, listed in order of their UNDERTONES, from purplish to greenish, are approved for use in oil paints by the PAINT STANDARD, and are acceptable in all other easel- and mural-painting techniques: ULTRAMARINE BLUE; COBALT BLUE; CERULEAN BLUE; MANGANESE BLUE; and PHTHALOCYANINE BLUE.

Blue Rider. See BLAUE REITER.

Blue Rose. A group of painters in Russia, active just before the 1905 revolution. They took refuge from the current oppressive environment in symbolism and fantasy, creating blue-shadowed impressionistic landscapes haunted by grotesque forms. Mistiness and nostalgia characterized their art, which cultivated a spirit of Oriental mysticism and detachment. Among the Blue Rose painters were Lancères, N. Sapanov, and Konstantin Somov.

blue verditer. An alternate name for BREMEN BLUE.

blunger. A mixing machine used to prepare clay SLIPS and glazes. One type, called a slow blunger, has a paddle that moves slowly over a long period of time. This action is more efficient for dissipating lumps than that of the fast blunger, which has high-speed propellers that may cause splattering when lumpy clay is used.

blush. Clouding or opacification of a clear lacquer; the term is equivalent to BLOOM on varnished surfaces.

board. 1. In paper terminology, one of the two basic categories of paper; the other is simply called paper. Board, further subdivided into cardboard and paperboard, is generally stiffer, thicker, and heavier than paper. Cardboard includes thinner boards than paperboard, although each of these terms is sometimes used as a synonym for board in general. Boards may be laminated or solid. Surfaced with paper, cloth, or a ground, they are sometimes used as supports for drawing and painting. See ACADEMY BOARD; CANVAS BOARD; CHIPBOARD; COQUILLE BOARD; ILLUSTRATION BOARD; BRISTOL BOARD; ROSS BOARD.
2. See PANEL.

Bocour blue; Bocour green. American trade names for PHTHALOCYANINE BLUE and PHTHALOCYANINE GREEN.

bodied linseed oil. Linseed oil that has been thickened by heat (as in the case of LITHO VARNISH, STAND OIL, and BOILED OIL), by exposure to sunlight (SUN-REFINED OIL), or by oxidation (BLOWN OIL). Each variety of bodied oil has distinctive properties.

body. 1. In oils and varnishes, a common term for viscosity. There is an optimum relationship between the thickness or viscosity of a coating material and its weight or specific gravity. An oil or varnish with high viscosity accompanied by an abnormally low specific gravity is said to have false body.
2. See CLAY BODY.

body color. Painters' term for opaque COLOR EFFECTS as distinguished from transparent or glaze painting; also, gouache as distinguished from transparent watercolor. The color effects of a pastel painting or of solidly applied oil paint are visually different from those of a transparent watercolor or of a thin, transparent layer of oil paint (glazing) over an underpainting. When the opaque properties of a specific pigment or paint are discussed, the more technical term MASS TONE is used.

body stain. In ceramics, any colorant mixed into the CLAY BODY, as distinguished from colors applied in glazes, slips, underglaze, and overglaze (see CERAMIC COLORS). The term has also been used for the pigments used in integrally colored cement.

Bohemian earth. One of the best commercial grades of GREEN EARTH.

boiled oil. Linseed oil that has been heated, usually with a liquid drier added. It is a house painters' material, not intended for artists' use. Raw oil to which driers have been added without heating is sometimes derisively called bunghole-boiled oil, as distinguished from kettle-boiled oil. Its use with oil colors is likely to lead to yellowing and other defects in the finished painting.

boîte. French for an assemblage of an artist's work to be shown to clients, a sort of artist's sample case.

bold resin. Designation for the best commercial grade of any tree resin, consisting of clean lumps of the largest size in which that particular resin is marketed. Grades that are made up of small pieces, fragments, and dust are less desirable, since they are likely to contain impurities or adulterants.

bole. A fine red earth color of velvety smoothness, composed of clay and iron oxide and resembling the native red iron oxide pigments. Also known as Armenian bole and poliment, bole is used in water gilding as a ground and a GOLD SIZE.

Bologna chalk. SLAKED PLASTER OF PARIS, an INERT PIGMENT.

Bologna stone. Another name for BARYTES.

bolting cloth. A fine silk fabric of even weave made in a number of mesh sizes. It is used for sifting powdered materials such as pigments. It is also the basic textile used in the SILK-SCREEN process, especially for serigraphy. The high tensile strength of the mesh is due to knots at each crossweave; these knots also act as miniature suction cups when paint is applied to the screen with a SQUEEGEE. The best double-weight (the so-called XX quality) Swiss bolting cloth comes in 2- to 18-gauge mesh; 12 XX is the gauge and weight of the silk most used by serigraphers.

bond paper. A strong, durable paper widely used for documents, letterhead and plain stationery, and typewriter paper. It has an immense range of quality; the best bond papers, which do not turn yellow or brittle with age, are made entirely of rag, and have excellent writing, printing, and erasing qualities. Many artists prefer the smooth finish of bond paper for sketchbooks and for pen drawing.

bone ash. The ash of calcined bones, used as a body FLUX in ceramics, especially in English and Irish BONE CHINA. Animal bones, usually obtained from slaughterhouses, are burned to obtain calcium phosphate.

42

bone black. An industrial pigment made by charring bones; a very impure form of carbon. Ordinary bone black is not recommended for use in paints or plaster, but a fine grade made for artists' use under the name IVORY BLACK is satisfactory and widely used. Animal black is an infrequently used name for bone black.

bone brown. A blackish-brown carbon pigment made like BONE BLACK; it is less completely carbonized than bone black and therefore even less desirable for use in permanent painting.

bone china. A hard, white, translucent chinaware, made with a large amount of bone ash. The formula for bone china was perfected in England by Josiah Spode about 1800, and most of this chinaware is still produced chiefly in England and Ireland.

bone folder. A thin, opaque white or ivory-colored strip of plastic shaped like a doctor's tongue-depressor, with smoothly rounded ends and edges. Originally made of bone and sold by stationers for folding paper, it is often recommended for rubbing monotypes and block prints. Any limber blade that will not mark paper, such as a stainless-steel spatula, will serve this purpose.

bone white. An obsolete INERT PIGMENT, made by burning bones to a white ash; it was formerly used on panels as a ground for drawing. Writing in the 15th century in *Il Libro dell' Arte,* Cennino Cennini said that "the best bones are from the second joints and wings of fowls or capons; the older they are, the better; put them into the fire just as you find them under the table."

book of hours. A medieval book containing prayers appointed to be said at specified hours of the day. During the Gothic period in particular, books of hours were made in monastic workshops both for churches and for the private devotions of nobles and wealthy merchants. These books were richly illuminated. Surviving ones contain some of the finest examples of miniature painting (see illustration at ILLUMINATION).

bordering wax. Another name for WALLING WAX.

boss. In metalwork, furniture, architecture, etc., a raised ornament, carved or chiseled from a protuberance left for that purpose in wood or stone or hammered out in metal by the REPOUSSÉ technique. It most frequently takes the form of a rosette but may also be of geometric or foliate design. Bosses are used as ornamental studs on doors (in which case they are usually made of metal and applied to the surface rather than carved out of it) and as decoration for hollow ware and for shields and other armor. In architecture, they are often used on ceilings, placed at the intersection of ribs in a vault or in the center of coffers. Protective and/or ornamental studs on book covers are also known as bosses.

Botany Bay gum. See ACCROIDES.

bottega. The studio-shop of an Italian artist where a master (maestro) trains his students and where apprentices or assistants contribute jointly with him to the execution of works that will bear his signature. During the height of the Renaissance there were 20 or 30 *botteghe* in Florence. Leonardo and Rubens maintained famous ones. See ATELIER.

bouchard or **boucharde.** See BUSH-HAMMER.

Bougival white. Another name for the obsolete pigment BISMUTH WHITE.

boulle-work or **boulle.** Ornamental furniture inlaid with brass, tortoise shell, and other materials; named for a French cabinetmaker, André Charles Boulle (1642–1732); sometimes spelled boule or buhl.

boxwood. A dense, hard wood (from trees of genus *Buxus*) of a pale creamy color, with a fine, uniform texture. It is extremely difficult to carve. It is used to make blocks for wood engraving, inlay, and articles that must resist wear, such as architects' scales, slide rules, modeling tools, and musical instruments. Boxwood logs and half-round logs may be 6 to 8 inches in diameter. Turkish boxwood (*Buxus balearica*) is the most desirable variety for engraving blocks. West Indian boxwood is second choice.

bozzetto. See MAQUETTE.

B.P. British Pharmacopoeia. See U.S.P.

brass. 1. An alloy of copper and zinc, usually having two parts of copper to one part zinc; sometimes small amounts of other metals are added. Brass usually has a bright golden or yellow color, and is stronger and harder than copper. It is malleable and ductile, although its properties vary widely with its composition.
2. An incised brass plate, especially one of those done during the medieval and Renaissance periods as memorials to the dead. They usually show a stylized portrait of the deceased, and are found in churches throughout Europe and in England. See also RUBBING.

brass rubbing. See RUBBING.

brass sand. See FOUNDRY SAND.

brass shim. See SHIM.

bravura. A term sometimes used to characterize brilliant, spirited brushwork.

brayer. A hand roller for inking relief blocks (see RELIEF PRINTING). The most common brayers are rollers faced with rubber of varying degrees of firmness. A soft gelatin roller is sometimes used in special processes and procedures. It will cover irregular surfaces, as in relief block printing, depositing ink on slightly depressed printing areas that the firmer rubber-faced brayer might ride over. In abstract and experimental art, brayers are sometimes used to lay paint and ink in large areas, both of solid color and of gradated tones (see BLENDING). Paint works well with a rubber brayer, but ink used in direct printing is much more effectively spread to a smooth, uniform texture with a gelatin brayer. In printing color woodcuts (see COLOR PRINT), direct printing with the roller obviates the need to cut a separate color block for an area that is to print an overall color or a solid blended tone, such as a sky. Because a gelatin brayer is highly impressionable and its shape is easily distorted if it is left lying on a surface for any length of time, it must be hung on a hook when not in use. A modern version of the soft brayer is made of synthetic material, but the original gelatin brayer is still preferred.

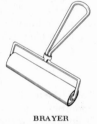

BRAYER

Brazilian rosewood. See ROSEWOOD.

Brazilian walnut. See IMBUYA.

Brazil wax. See CARNAUBA WAX.

Brazilwood lake. A LAKE pigment made from Brazilwood, a blood-red NATURAL DYESTUFF introduced into Europe from Central America in the 16th century. For centuries an article of commercial importance, Brazilwood has had some use as a pigment, and it is still employed in some trades, for which its low cost makes it preferable to better colors, despite its lack of permanence. The lake called rose pink is made from Brazilwood.

brazing. A type of WELDING using nonferrous metals that melt at lower temperatures than that of the base metal. It is usually done by applying a brass FILLER ROD made of 60% copper and 40% zinc to the joint. The brass melts and is deposited on the base metal, where it may hold two pieces of metal together. Sometimes a bronze rod is used. Brazing produces weaker joints than those produced by FUSION welding. The process may be used to cover a metal surface with metals of different color and texture, and may be varied by using alloys of different metals.

breccia. A marble or other stone in which angular fragments are embedded. The surrounding stone or matrix may or may not be of the same composition as the fragments. One kind of breccia marble is SARRANCOLIN MARBLE.

Bremen blue; Bremen green. Precipitated, hydrated copper carbonate; an azure-blue pigment and its pale-green variant, produced in a range of hues of varying degrees of greenishness. Probably originating in the 18th century, Bremen blue was widely used in the 19th, becoming of less impor-tance during the 20th century as the more satisfactory, nontoxic ultramarine blue became cheaper. The copper carbonate-hydroxide blues and greens are toxic and are not sufficiently permanent for use in creative painting. Copper blues comparable to Bremen blue were used extensively in medieval painting; in the early 19th century they began to be produced in standard grades by European manufacturers. Bremen blues and greens have been sold under many alternate names, including blue ashes, blue bice, blue verditer, copper blue, green bice, and green verditer. LIME BLUE and Neuwied blue are varieties of Bremen blue; VERNET GREEN (or Horace Vernet green) is a variety of Bremen green. Variants of Bremen blue and lime blue were also sold in the 19th century under the name MOUNTAIN BLUE. Unstandardized terms for Bremen green include mountain green, mineral green, and oil green.

brick liner. See LINERS AND STRIPERS.

bridge. An elevated handrest used to keep the artist's hands from touching the surface of a drawing or painting being done on a drawing board or a lithograph stone; it also steadies the artist's hand. A type of bridge made of a narrow strip of wood with end-pieces raising it an inch or so above the surface is commercially available; artists frequently make their own version of this type, or use an arched stave from a wooden barrel or keg.

bright. A type of brush used in oil painting, named after an Englishman who is said to have invented it. The bright, in either bristle or red sable, is a flat, thin brush with a straight, sharp end; the length of the tip is 1½ times its width. The bristle bright is popular for

45

manipulating very buttery paints. See BRUSH, BRISTLE.

brilliant scarlet. Another name for IODINE SCARLET.

brilliant yellow. Another name for NAPLES YELLOW.

bristle brush. See BRUSH, BRISTLE.

Bristol board. A stiff, durable cardboard made in thicknesses of one to four .006-inch plies, and in several smooth finishes, especially a high or plate finish. Suitable for drawing and for painting with any water paint, Bristol board may be used on both sides, and is especially popular for lettering and clear, sharp ink drawings and diagrams. The U.S. Patent Office requires that it be used for trademark and patent drawings.

Bristol glaze. In ceramics, a type of porcelain glaze containing feldspar and a rather large amount of zinc oxide. It is fired at a high temperature and used for finishes that show another color coming through in spots from below.

britannia metal. A high-quality PEWTER developed during the last half of the 18th century in England and introduced to American pewterers at the turn of the 19th century. The best grade of britannia metal is an alloy of 90% tin with 10% antimony. More commonly, however, the proportions are 94% tin, 5% antimony, and 1% copper; the addition of the copper gives the alloy a yellowish tinge, and the higher percentage of tin makes the alloy somewhat softer. Britannia metal was the only kind of pewter used to any extent after 1825. It can be electroplated with silver and was used widely in this way from the mid-19th century on. Wares made of silver-plated britannia metal are often stamped "quadruple plate."

British gum. A grade of DEXTRIN used as a paper adhesive and in the manufacture of gouache, watercolor, and other aqueous paints.

British Pharmacopoeia. See U.S.P.

British pigment standard. Popular name for the *British Standard Specification for Artists' Use,* B. S. 2876: 1957, a pamphlet issued by the British Standards Institution, listing standard terms for pigments. A few of the permanent pigment names differ from those listed in the American PAINT STANDARD. For example, French ultramarine is given instead of ultramarine blue, aureolin instead of cobalt yellow, and mineral violet instead of manganese violet. Because the British pigment standard deals only with pigments, without reference to qualitative paint standards, it includes the names of some two dozen pigments that do not appear in the more selective American list, which is confined to those approved for fine-arts purposes.

broad manner; fine manner. A classification devised in 15th-century Italy to distinguish between two widely diverse effects created in the newly invented art of line ENGRAVING. The term fine manner applies to those engravings done with fine, close lines and light cross-hatching, while the term broad manner describes those prints in which the lines are broad, coarse, and bold. The distinction is comparable to the differences between a pen-and-ink drawing done with a fine crow-quill pen and a sketch made with a blunt-nibbed pen. The same distinction naturally applies to the effects created in NIELLO work, since it was from techniques of nielloing and

CHASING that 15th-century goldsmiths derived the process of line engraving.

broken color. 1. Colors in painting applied as an OPTICAL MIXTURE instead of being thoroughly mixed on the palette.
2. A color whose brilliance has been dulled or toned down by the addition of its complementary color; also called broken tone. Broken tones tend to be muddy, but are frequently used to fit a color scheme or to remedy a raw or garish effect.

bronze. An ALLOY of copper and tin, sometimes containing small proportions of other elements such as zinc and phosphorus. It is stronger, harder, and more durable than brass, and has been, since antiquity, the metal most extensively used in cast sculpture. Bronze alloys vary in color from a silvery hue to a rich, coppery red. U.S. standard bronze is composed of 90% copper, 7% tin, and 3% zinc.

bronze blue. Another name for PRUSSIAN BLUE, especially those varieties that have a pronounced bronzy sheen.

bronze disease. A malignant corrosion of bronze that has a progressively destructive effect on the metal, as opposed to a normal PATINA, which has a self-protective effect. Bronze disease is generally attributed to the corrosive effect of chlorides on the metal; chlorides are therefore avoided in the chemical processes used to induce a patina on new bronze.

bronze doré. Gilded bronze. See ORMOLU.

bronze leaf. See DUTCH METAL.

bronze powder. Powder made from various bronze or brass alloys and used principally in lacquer or varnish vehicles, or with BRONZING LIQUID as the so-called "GOLD PAINT." This powder can be prepared to duplicate every shade of gold, from a pale or lemon color to a deep coppery hue; sometimes dyes are added to the paint mixture. Bronze powders darken or discolor after a relatively short time. Because they are not permanent and because the paint made from them has a lackluster, grainy quality, bronze powders are seldom used in the fine arts.

bronzing. 1. The painting of plaster casts to imitate the color or PATINA of bronze. VERT ANTIQUE is the finish usually applied to achieve the effect of patinated bronze.
2. See BRAZING.

bronzing liquid. A BANANA-OIL vehicle in which ALUMINUM POWDER or BRONZE POWDER is mixed to make metallic paint. Although ready-mixed metallic paints are available, it is preferable to mix bronze powders with the bronzing liquid only as the paint is needed, since the vehicle has a tendency to oxidize and therefore discolor the metal.

brown coat. In FRESCO, the second coat of plaster, which usually consists of two and a half parts sand or marble dust to one part LIME PUTTY. Before the brown coat is applied, the first (or SCRATCH COAT) must be completely set and dry, then freshly soaked with water. Sometimes the brown coat is applied in two layers. The first, called a skim coat, is diluted with water and laid thinly. Over this, a standard brown coat can be applied more thickly; it will then hold its moisture longer and is less prone to develop mechanical faults as it sets. The brown coat is also known by its Italian name, *arriccio.* See also SAND COAT; INTONACO.

47

brown lampblack. An obscure name for BISTRE.

brown ochre. A dark, dull variety of YELLOW OCHRE.

brown pigments. The following brown pigments are approved for use in oil paints by the PAINT STANDARD, and are generally acceptable in all other easel-painting techniques: RAW UMBER; BURNT UMBER; BURNT SIENNA (sometimes classed as a red); and TRANSPARENT BROWN.

brown pink. British term for DUTCH PINK.

brown sauce. A derisive term applied by early 20th-century painters to the recently past academic trend of infusing painting with an all-pervading brownness; see GALLERY TONE.

brownstone. An American SANDSTONE that contains iron. It is available in several shades, from pinkish to deep chocolate-brown. Connecticut, New Jersey, and Pennsylvania brownstones are well known.

Brücke, die. "The Bridge," a group of expressionist artists, founded in Dresden in 1905 by Erich Heckel (1883–1970), Ernst Ludwig Kirchner (1880–1938), and Karl Schmidt-Rottluff (1884–). Later adherents were Axel Gallén (1865–1931), Emil Nolde (1867–1956), Max Pechstein (1881–1955), and Otto Mueller (1873–1930). These artists practiced a representational form of EXPRESSIONISM, and were strongly influenced by Van Gogh, Gauguin, Munch, and the Fauves. A contemporary vogue for the primitive and the exotic also had its influence on them. Before the group disbanded in 1913, it had introduced modern art to Germany and contributed to a revival of interest in the graphic arts. Its representational tendencies ran counter to those of a later expressionist group, the BLAUE REITER.

Bruges school. Flemish painters working in Bruges during the 15th century. First and most outstanding of these painters were Jan and Hubert van Eyck, who have often been called the founders of the entire Flemish school. The Bruges group introduced into religious painting (partly from the art of the miniature) a loving attention to detail in the physical surroundings of their subjects. The painter Petrus Christus continued the aristocratic style of the Eycks, while the work of Hans Memling and Gheeraert David appealed more to the bourgeois patrons of Bruges. See illustration at ICONOGRAPHY.

bruising. See STUN.

Brunswick blue. A variety of PRUSSIAN BLUE containing relatively large amounts of added barytes and sometimes small amounts of ultramarine blue; not used in high-quality industrial paints or in artists' colors.

Brunswick green. A cheap variety of CHROME GREEN made from Brunswick blue and a reduced grade of chrome yellow; also known as Prussian green.

brush. A tool used to apply paint to a surface. It consists of a gather of animal hairs or bristles set in a plastic compound, held in a metal ferrule to which a wooden handle is attached. The most highly prized variety of hair (see BRUSH, HAIR) is red sable (see BRUSH, RED SABLE); differently shaped brushes are used for oil and watercolor painting. The bristle brush (see BRUSH, BRISTLE) is used for oil painting. In recent years, nylon bristles have been used to make brushes for use with

acrylic and polymer paints (see BRUSH, ACRYLIC).

Standards for the quality, design, and behavior of artists' brushes have been established over centuries of experience. Although inferior grades are common, those of top quality reflect the age-old striving for perfection, through the selection of materials from sources throughout the world and attention to manufacturing details. Today, brushes are among the few remaining mass-produced items that are the products of a handicraft industry, all significant operations being carried on by skilled workers.

When an artist's brush is made, the natural tips of the hairs or bristles (see FLAG) are always preserved. The various shapes—pointed or blunt, flat or round—are produced by cutting, trimming, and fashioning the root, or butt, ends of the hairs. A pointed brush, for example, is shaped by inserting a measured amount of hair or bristle, tips down, in a small, hollow, brass "cannon" of the size and shape desired, tapping the cannon so the hairs settle into it, and trimming them off at the root end. They are then tied and set into a metal ferrule with a thermoplastic cement, and attached to a handle of appropriate size and shape for the specialized purpose of the brush. Some fine brushes have a considerable hold of bristle or hair within the metal ferrule, in some cases to a depth equal to the length of the exposed tip; in others, the hold is very shallow. See also BLENDER; CAMEL HAIR; FITCH; LINERS AND STRIPERS; OX HAIR; SINGLE-STROKE BRUSH.

brush, acrylic. Any of variously shaped brushes made with nylon bristles and designed especially for use with acrylic and polymer artists' paints. Because these colors dry very quickly, paint-laden brushes that are shortly to be reused are kept in water.

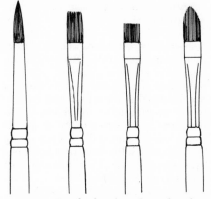

BRUSHES. Bristle brushes for oil color. Left to right, round, flat, bright, filbert.

Nylon brushes, unlike those made with hair and natural bristle, are not affected by prolonged soaking. They hold a heavy charge of paint and are easily cleaned with cold water when the paint is fresh and with hot water when the paint has hardened. Other types of brushes may, of course, be used with acrylic and polymer paints.

brush, bristle. The standard brush for oil painting, made of selected hog bristles. The most common bristle brushes, categorized by shape, are rounds, flats, brights, and filberts or ovals (see illustration, left to right). All come in sizes numbered from 0 to 12; a number of special extra-wide or extra-long brushes are usually available. The length of the bristles in a flat brush is 2½ times the width. The bristles of the best brushes are curved, and in the flats they are set so that the outer bristles curve inward; the bristles therefore retain an even width when stroked on a surface, rather than splaying outward like a broom. Brights, which are also flat in shape, are stubbier, thinner, and stiffer. Prior to about 1860, round brushes were used almost exclusively; flats and brights, which most present-day painters find more

versatile, have been popular for no more than a century.

brush, hair. Any brush made of flexible animal hair rather than stiff bristle. The finest hair brushes are made of red sable (see BRUSH, RED SABLE). Second-quality brushes may either have less red sable gripped within the ferrule or be a mixture of red sable and some less expensive hair, such as ox hair. Russian sable, which is dark gray rather than reddish but otherwise resembles red sable, is also used in second-best hair brushes. Fitch and badger hair, as well as dark squirrel (known as camel hair), are also popular, although camel hair is rather soft and floppy, so that it may be used only for certain special effects. Ox hair, on the other hand, is a little more rigid and springy than red sable and most other hairs used for artists' brushes.

brush, quill. Any artists' sable or camel hair brush, in which the hair is mounted in the tapered end of a quill instead of the customary metal ferrule. A plain wooden handle that fits snugly into the open end of the quill is supplied, but quill brushes are sometimes used without handles. Quill brushes, which have been in use since medieval times, were supplanted for general use by those made with metal ferrules and permanently attached handles about the beginning of the 19th century. They are still made, however, particularly as lettering brushes, and are preferred by some artists because quill does not break the hairs, as the edge of a metal ferrule sometimes does, and because of their lower cost. A flat piece of split quill wrapped around the hairs and fastened with twisted wire replaces the metal ferrule in the BADGER BLENDER which, because of the pouncing motion with which it is used, would be particularly susceptible to having its hairs cut by a metal ferrule.

A fine red sable watercolor brush in a quill is convenient for pocket-size watercolor boxes, in which the separated brush and handle can be carried. See also LETTERING QUILL; see illustration at LINERS AND STRIPERS.

brush, red sable. A brush made of the hair of the KOLINSKY, an animal native to Siberia. The finest brushes for watercolor, tempera, and other aqueous paints, as well as soft brushes for smooth oil painting, are red sable brushes. The hair is valued for its unexcelled combination of firmness and resiliency; for its fine points; and for its shape: each hair has a bulge or belly between its root end and its tapering point. The shape of the brush, and thus the effects that may be obtained with it, is determined by the point at which the ferrule grips the hair, i.e., above, below, or at the belly. The best round watercolor brushes are convex and tapered, with a pronounced belly about midway between the ferrule and the sharply pointed tip. Any concavity is detrimental to proper control. The single-stroke brush, for lettering and watercolor painting, is also made of red sable. Red sable oil brushes are used for smoother or more precise stroking than can be executed with the usual bristle brush. The round oil brush is tapered from ferrule to tip, without a belly. Long-handled red sable flats, brights, and longs are also made for oil painting. The finest red sable brushes are graded as "pure red sable" or "finest quality red sable." The second-quality brushes known simply as Red Sable contain some ox hair.

brush cleaners or **brush washers.** Receptacles for turpentine or other solvents used to clean paintbrushes. A typical modern washer for watercolor brushes, like that shown in the illustration, is a glass jar or metal cup with an overhead spiral holder in which the

BRUSH CLEANERS. Left, a watercolor brush cleaner; right, a two-part cleaner for oil brushes.

brush handles are clipped to keep the brushes suspended in the water. The standard oil-brush cleaner is a deep aluminum can into which is inserted a shallower can with a perforated bottom or a wire mesh upon which brushes can be lightly scrubbed. The pigment settles through the bottom of the inner can, leaving the upper portion of the solvent clear. Soldered across the opening of the inner can is a wire or thin bar upon which the brush may be scraped. Oil-brush cleaners for use with proprietary solvents are also sold. The container is a covered glass jar with a heavy scraping coil near the bottom of the jar.

bubinga. A hard, durable wood (from the tree *Guibourtia tessmanii*) from West Africa, known as African rosewood because it is striped with pink or red. It is not related to the woods of the genus *Dalbergia,* which are also known as rosewood. Bubinga is used chiefly for veneer.

bucchero ware. A black pottery made by the Etruscans before they learned about black glaze from the Greeks. It was made with an iron-rich clay that was fired in a comparatively low reduction fire.

buckeye. A term of disparagement for a class of oil painting, mostly landscapes, turned out for the mass market, and characterized by slipshod yet facile rendition, and stereotyped, flamboyant, or sentimental treatment of subject matter. The heyday of the buckeye was the second half of the 19th century, but production of such paintings has never really ceased.

buckling. 1. The appearance of waves or bulges in a canvas that has slackened on its stretcher, or in paper that is supposed to be flat.
2. The appearance of a raised wave, ridge, or bulge in a paint surface, due to cleavage between the ground and the support. A buckled area is a kind of continuous BLISTER.

buckthorn berries. The dried, half-ripe, pea-sized, greenish-brown berries obtained from various species of *Rhamnus,* a shrub grown in Europe and in Asiatic Turkey. The berries are also known as Avignon, French, Persian, and yellow berries. Buckthorn berries are boiled to make a dye that was once extensively used in making the yellow lake-pigment Dutch pink. Completely unripe berries were similarly used in making sap green.

buckthorn lake. Another name for DUTCH PINK.

buhl. See BOULLE-WORK.

building board. Another name for WALLBOARD.

bull point. See POINT.

buon fresco. True FRESCO; painting in which color is applied to freshly laid plaster, as distinguished from SECCO or other mural techniques that imitate the effects of fresco.

Burgundy pitch. See BURGUNDY TURPENTINE.

Burgundy turpentine. The oleoresin or BALSAM obtained from *Pinus maritinus,* the European pine tree that is the source of the French turpentine and rosin industry. A somewhat refined and partially solidified grade of Burgundy turpentine, known as Burgundy pitch, is frequently called for in antiquated recipes and is sometimes available in the U.S. In practical use, neither of these products has any advantage over the more easily available VENICE TURPENTINE.

Burgundy violet. Another name for MANGANESE VIOLET.

burin. See GRAVER.

burl. Wood cut from the swellings or knobs that grow on some trees. Burl planks and veneers exhibit a swirling or irregularly mottled grain of attractive appearance.

burnisher. An implement with a hard smooth rounded end or surface, used for smoothing and polishing. In GILDING, burnishers are usually small forms of polished agate mounted in wooden handles. They are available in a number of sizes and shapes and are quite expensive. The 15th-century artist-writer Cennino Cennini recommended burnishing with a dog's tooth or with hematite. A flat broad burnisher of the latter is still sometimes used for flat gilding, especially on book edges. The ceramic artist uses a burnisher of spun glass to give a bright tone to gilding on china or porcelain.

Because burnishing is a smoothing process, it can be used only for leaf that has been laid on a gesso or bole ground with WATER GILDING. Stroking the gilded surface with a burnisher smooths the gesso surface, and the malleable gold leaf, being pressed to this perfectly even surface, takes on a high, specular gloss. Gilding done

BURNISHERS. At top, two steel burnishers, used in etching and other metal-plate printmaking techniques. Below, an agate burnisher, used in gilding.

with gold ink (see GOLD POWDER) in illuminated manuscripts can also be burnished if the paper or parchment has first been prepared with a thin gesso-like wash. Burnishing gilding requires special techniques. The ground must be thoroughly dry, or the burnisher will rip the surface. The practiced gilder can determine when the work is sufficiently dry by listening to the sound made by tapping the gilded surface with the burnisher. Usually the surface is first burnished with gentle circular strokes and then gone over with firmer strokes in a uniform direction. MORDANT GILDING on sized or shellacked gesso or other nonporous surfaces cannot be burnished.

In etching and other metal-plate printmaking techniques, a smooth rounded polished steel burnisher is used to remove scratches and unwanted marks and to take down overly heavy areas to reduce the darkness of their printing (see REPOUSSAGE). A steel burnisher was also sometimes used to burnish SHEFFIELD PLATE.

burnt carmine. A deep brownish-purple or purplish-brown pigment made by carefully roasting or charring CARMINE.

burnt green earth. Another name for TRANSPARENT BROWN.

burnt gypsum. GYPSUM from which all the water of crystallization has been

driven off, as distinguished from PLASTER OF PARIS. It is used in KEENE CEMENT and other plasters where hardness and resistance to wear is required.

burnt ochre. RED OCHRE made by calcining selected grades of yellow ochre.

burnt-oil varnish. See LITHO VARNISH.

burnt sienna. An EARTH COLOR with an opaque, red-brown mass tone, displaying a bright, transparent, orangy undertone when viewed by transmitted light, and yielding salmon- or peach-colored tints when mixed with white. Made by calcining raw sienna, burnt sienna is one of the most versatile of the permanent pigments. Employed in all painting techniques, it is especially useful in mixtures of dark colors because of its clarity and freedom from chalkiness. The most desirable grades of burnt sienna have a deep, mahogany mass tone; those of paler appearance are less highly esteemed. Both raw and burnt sienna are named for the Tuscan city of Siena; the finest varieties are still imported from Italy. An old name for both raw and burnt sienna is Italian earth. Burnt sienna or alizarin crimson was formerly mixed with sepia to make Roman sepia.

burnt umber. See UMBER.

burr. In DRYPOINT and ENGRAVING, the ragged edge of the furrows cut by the needle or burin in the surface of a metal plate. In drypoint, the burr (or ridge, as it is sometimes called) is preserved to produce the soft, blurred line characteristic of that technique. In engraving, where a clean, sharp line is desired, any burrs are removed with a SCRAPER.

bushhammer. A stone-carving tool, usually with a chunky, brick-shaped head, that has two striking ends, each covered with rows of pyramidal metal teeth or points; also called by its French name, bouchard or boucharde. It comes in several sizes, and may have a long, slender head rather than a chunky one. The bushhammer is used to dress the surface of a stone by pulverizing the rock and removing it little by little. It is also used for rough shaping of sculpture in hard stone.

BUSHHAMMER

bust. In sculpture, a portrait that includes the head, neck, and part of the shoulders and breast, usually mounted on a base or column. In painting, a portrait that shows the same portion of the figure including the upper arms.

bust peg. A heavy, flat board with a vertical post in its center, on which sculpture, especially a BUST, is modeled.

butterfly. 1. In sculpture, a cross-shaped piece of wood hung within an open ARMATURE to prevent slipping or sagging of a heavy plastic mass. Small wedges of wood may be wired at intervals to the armature to perform the same function.
2. In the SILK-SCREEN apparatus, another name for the prop bar.

butternut. See WALNUT.

butt join. A join made without any overlapping of the two parts. The several sections of a large mural canvas are laid with such a join. See MAROUFLAGE.

button lac. See LAC.

butyl lactate. A VOLATILE SOLVENT or diluent used in lacquers and other industrial coating materials as a retardant, to delay setting or drying. It has an extremely low rate of evaporation, and artists have used it occasionally to delay the setting of paint for several days.

Byzantine. Pertaining to the art and civilization of the Christian empire that succeeded the Roman Empire in the East. The Byzantine period lasted from A.D. 330, when Constantinople (ancient Byzantium) became the capital of the Empire, to the mid-15th century, when the Turks conquered Constantinople. Byzantine styles in art and architecture survived for some time in the Balkans and for another two centuries in Russia.

Byzantine art was predominantly religious. Churches were decorated with mosaic, fresco, and stone carvings. The churches of Ravenna, Italy, seat of the Roman emperors from A.D. 404 and an appanage of the Byzantine Empire from 534 to 752, decorated with a monumental series of mosaics, may still be seen. During the Iconoclastic Controversy (A.D. 726–824) a richly decorative art based on plant and geometric motifs developed. Subsequently icons and other figurative work were based on a system of iconography that was strictly regulated by the Church. Human forms were stylized, subject matter was restricted to certain events in the history of Christianity, and even the positions of the various characters in a scene were prescribed. This uniformity applied not only to wall decoration but also to icons, which were painted on panels in a rudimentary tempera technique. Although relief was the only form of Byzantine monumental sculpture, carved ivory was common and attained a high degree of elaboration, as did metalwork, work in enamel, and illumination. The distinctive Byzantine style of architecture is an amalgam of Hellenistic and Oriental elements with the basic Roman styles; lavish surface enrichment takes the place of Classical boldness of form. This architecture attained a characteristic style about the middle of the 5th century in Constantinople and Italy, with later development in other lands.

Byzantium purple. Bluish shades of TYRIAN PURPLE.

C

cabinet picture. A small easel painting, usually no wider than 30 inches, meant to be viewed at close range and therefore suitable for hanging in a small room.

cabochon. A convex or dome-shaped gem; also, a convex or dome-shaped element in a design in wood or stone carving.

cachet. A monogram or cipher of original design, used in lieu of a signature. A good cachet has simplicity, treats the letter forms inventively, and sometimes cleverly takes or suggests the shape of an object or animal.

cachou. Another name for CUTCH.

cadmium green. The name used in Britain for artists' colors made of mixtures of cadmium yellow and phthalocyanine green. It is sold in the U.S. as PERMANENT GREEN.

cadmium red; cadmium yellow. Cadmium yellows are cadmium sulfide; cadmium reds are composed of cadmium sulfide and cadmium selenide in various proportions. All are dense, opaque, brilliant, and reliably permanent pigments. The principal bright yellows of the artist, cadmium yellows are available in pale and light (lemon) shades, medium and deep (golden) shades, and orange. The cadmium reds come in light (replacing the older, less reliable vermilion), medium, and deep (maroon) shades. Introduced in Germany by de Haen (1907), cadmium red came into general use by American artists in 1919. Variations in hue between different brands of tube colors offer artists a choice of several nuances of the yellows and reds.

Both cadmium reds and cadmium yellows are available in either a pure grade or a cadmium-barium type, which contains barium sulfate as an integral component of the pigment. The latter is just as permanent, but is less powerful in tinting strength than the pure cadmium. The cadmium-barium type is used in most artists' colors; the more expensive pure cadmiums are used only in some of the top-grade lines. The term cadmium-barium was adopted by the Paint Standard in 1942.

Discovered in Germany by Friedrich Strohmeyer (1817), cadmium yellow came into use slowly because of the initial scarcity of the metal. Made in England in 1846, it apparently did not appear there as an artists' color until 1851. It begins to appear in artists' supply catalogs in New York as early as 1842. Artists are known to have used cadmium yellow in Germany in 1829 and in France about 1832, perhaps obtaining the pigment from experimental sources.

Caen stone. A cream-colored French LIMESTONE; pronounced and infrequently spelled kane stone. It is soft, fine-grained, and easily carved.

caeruleum. Latin for sky-blue pigment, mainly used for EGYPTIAN BLUE. See also CERULEAN BLUE.

Calamander ebony. See EBONY.

calcimine or **kalsomine.** A cold-water paint composed of whiting, clay, glue, and water, used for rough coating of walls or ceilings. It is almost always white, not water-resistant, and not a material for permanent painting. See also DISTEMPER.

calcine. To roast at high temperatures in a furnace. The end product of this process is usually a fine powder. Calcining is done to change the hue of an earth pigment, or to alter the properties of an inorganic or mineral substance by driving off some or all of its water of crystallization. In ceramics, clays and certain glaze ingredients are sometimes heated to red heat, to drive off volatile matter and to reduce subsequent shrinkage.

calcined magnesite. One of the materials from which OXYCHLORIDE CEMENT is prepared. It is made by roasting magnesite (native magnesium

carbonate) until about 90% of it is converted to magnesium oxide. Completely calcined or "dead-burned" magnesite is all magnesia, and will not react to form oxychloride cement. Calcined magnesite is also sold under the names of magnesite, plastic magnesia, and caustic magnesite.

Caledonian brown. A native earth somewhat similar in hue to burnt sienna, but vastly inferior as a paint pigment.

Caledonian white. Lead chlorosulfite, introduced in the 19th century, and now obsolete, as a paint pigment.

calendering. The process of giving paper a smooth surface by running it between rollers under strong pressure. Super-calendering produces a polished surface.

calfskin glue. A hide glue of high quality.

California asphalt. A soft variety of ASPHALT.

calipers. A measuring device with two movable jaws. Sculptors' calipers were originally made of wood with brass fittings; the modern type is made of aluminum. They are regularly used to take the measurements of fig-

CALIPERS. Above, proportional calipers; below, sculptors' calipers.

ures in the round during the course of work, and are also useful in making copies of an original. Several sizes are available for use according to the magnitude of the work. See PROPORTIONAL CALIPERS.

calking. See CAULKING.

calligraphic. 1. Pertaining to CALLIGRAPHY.
2. Of handwriting, elaborate or ornate in design and execution.
3. In painting and drawing, free and rhythmic, with expressive brushstrokes or lines that have the variety and flexibility of beautiful handwriting; also, of design elements in the pictorial arts, resembling or reminiscent of cursive letter forms.

calligraphy. Handwriting as art; elegant penmanship that has aesthetic value apart from its textual content. It may, in fact, sacrifice legibility somewhat for the sake of decoration and design. At the present, it is practiced chiefly by commercial artists, although it has been undergoing somewhat of a revival in personal correspondence. Three important writing "hands" or "scripts," as they are also called, were evolved between the 12th and 15th centuries. All three—the GOTHIC, the ROMAN, and the ITALIC— are to some extent still used today and have also been adopted as typefaces (see TYPOGRAPHY). The chief tool of calligraphy is the LETTERING PEN, although much of the beautiful lettering in medieval manuscripts was done with reed or quill pens or with a fine brush. See also ILLUMINATION.

Calvary cross. A LATIN CROSS on a stepped platform. The three steps of the base, representing the hill of Calvary, and sometimes replaced by a conventionalized mountain, have oc-

casionally been said to symbolize the Christian virtues of faith, hope, and charity. See CROSS for illustration.

camaïeu. A painting or decoration executed in several shades of a single color; a monochrome painting. When done in various shades of gray, it may also be called GRISAILLE; when in yellow, *cirage*. Friezes and wall decorations that imitate bas relief are frequently done in camaïeu, in the manner of cameos. The term is also used for a painting in two or three tints, in which the objects represented are not rendered in their natural hues.

came or **calm.** A strip of lead used in stained-glass windows. A came is thin and flat, with grooves in both sides, into which are fitted the pieces of glass to be joined. In well-designed windows the pattern formed by the cames is an integral part of the design of the entire window.

camel hair. A fine hair used for brushes. Despite its name, it comes from the tail of a squirrel. The camel-hair brush, used for watercolor and other aqueous paints, is relatively soft and floppy. Being the cheapest kind of hair brush, it is widely used by children. See BRUSH, HAIR.

camera lucida. An optical contrivance for projecting the virtual image of an object or a scene on a surface so that it can be traced. Because it makes it possible to reproduce, enlarge, or reduce the subject accurately, the camera lucida has been extensively used, especially by commercial artists, and may be purchased from an art supply store in a variety of models, ranging from a simple inexpensive form to a finely made optical instrument for professional use. It consists essentially of a stand with an adjustable arm, at the end of which is a prism. Light from the object is deflected by the prism, and a virtual image is interposed between the eye and the drawing surface, allowing the object to be traced. By adjusting the distances between the subject, the prism, and the drawing surface, or by placing a convex or concave lens between the viewer and the prism or the prism and the surface, the user can vary the size of the projected image. The camera lucida, which in Latin literally means "light chamber," was invented about 1674 by Richard Hooke but was not widely used until after 1807, when it was redesigned and patented by William Hyde Wollaston. It largely replaced the CAMERA OBSCURA and has in turn been somewhat supplanted by the OPAQUE PROJECTOR and more elaborate optical devices.

camera obscura. An optical contrivance for projecting the image of an object or scene on a surface, from which it is traced and thus is more accurately reproduced than by being drawn freehand. It is essentially a box with a small aperture in which a double convex lens is fitted. Light is transmitted through the lens, and the image is projected, usually by a mirror, onto a surface of ground glass or translucent paper, from which it is easily traced. Virtually obsolete today, the camera obscura was often a portable box—either homemade or, in the 17th and 18th centuries, bought from an instrument maker—or a closet-like chamber in which the artist sat. An entire room has also been used as a camera obscura, into which an outdoor scene is projected by a periscope-like apparatus. (There are several of these camera-obscura rooms in the United States, chiefly in parks.)

The invention of the camera obscura, which means "dark chamber" in Latin, is variously attributed to Leone Battista Alberti (1404–1472) and to

57

Erasmus Reinhold of Wittenberg (1511–1553). It was in both principle and name the forerunner of the modern camera. For practical purposes, the portable camera obscura has long been supplanted by the CAMERA LUCIDA and by 20th-century large-screen developments (see OPAQUE PROJECTOR).

Campan marble. See GRIOTTE.

campeachy lake. A red LAKE pigment made from LOGWOOD.

campeachy wood. Another name for LOGWOOD.

camphorwood. The wood of the camphor tree (*Cinnamomum camphora*), a scented hardwood imported from Formosa and Borneo. Available in planks 4 inches thick, it may be used for carving.

camwood. See BARWOOD.

Canada balsam. The thick, resinous exudation from *Abies balsamea,* the familiar balsam fir of the eastern United States and Canada. The tree is similar to some of the firs of middle Europe that produce BALSAMS or oleoresins, such as Strasbourg turpentine and Venice turpentine, used by artists for centuries as ingredients in oil painting mediums. Canada balsam has often been proposed as a substitute for these. This has not been done, perhaps because of the high cost involved. Canada balsam has been used as an adhesive in the optical, cigar, and other industries.

canalete or **canaletta.** A hard, dense wood, suitable for carving, from the tree *Cordia gerascanthus,* native to the West Indies. It has black streaks with a metallic luster, and its heartwood is purplish lilac. When available, it usually comes in planks one inch thick.

canarywood. See BALAUSTRE.

candelilla wax. A brown vegetable wax obtained from a weed native to Texas and Mexico. It is next to carnauba wax in hardness, with a melting range of 67° to 71° C. Like carnauba wax, it is used to impart hardness to mixtures of waxes and other compounds, but its hardening effect is definitely below that of carnauba wax.

candlenut oil. See LUMBANG OIL.

cantharus or **kantharos.** 1. In ancient Greek pottery, a capacious, footed drinking cup with two handles that flare out gracefully in loops rising above the edge of the cup. See illustration at VASE SHAPES.
2. In church architecture, a stoup or basin that holds holy water.

Canton enamel. A Chinese ware of the late 19th century, consisting of metal vases and other ornamental items decorated in bright colors on white or pale-colored backgrounds of porcelain enamel.

canvas. A heavy woven fabric used as a SUPPORT for oil painting. Its surface is prepared for painting by priming with a white GROUND. The standard canvas, sold by the roll, is made of strong, specially woven LINEN, much of which is imported from Belgium and Ireland. COTTON CANVAS is a cheap substitute, inferior in every respect. For use in painting, a cut piece of canvas is stretched tightly by tacking it to a chassis or STRETCHER frame. Sometimes a painting is done on canvas and then cemented to a wall or panel; this procedure is called MAROUFLAGE. The term canvas may also refer to a stretched canvas ready for painting, or to a finished oil painting. See also ACRYLIC CANVAS; JUTE CANVAS; TWILL CANVAS; CANVAS BOARD.

canvas board. Common gray cardboard or pasteboard to which a white cotton cloth, prepared for oil painting, has been glued or pasted. Canvas boards are sold in stock sizes and in large volume; their light weight and easy portability make them suitable for outdoor sketching, and, because of their low cost, they serve as canvas substitutes for the beginning student and for the amateur painter to whom that virtue is of more importance than the quality or longevity of his paintings.

canvas carrier. A metal device for carrying two canvases face to face, consisting of a set of clamps and a handle. It is constructed so as to separate two wet canvases sufficiently for them to be transported without smudging.

canvas pin or **canvas tack.** A small metal or wood pin about ½ inch thick, with a sharp steel point protruding from each flat side. When canvas pins are pressed into the four corners of the face of a freshly painted canvas,

CANVAS PINS

another canvas of the same size can be pressed face down upon them. The pins act as separators, making it possible to protect wet paintings from smudging when transported or stored in a rack. The metal CANVAS CARRIER serves the same purpose.

canvas sizes, French. In France, stretched canvases are available in three groups according to their proportions—*paysage* (landscape), *portrait*, and *marine*. The dimensions (in centimeters) of the 19 standard sizes of each type of canvas are as follows:

No.	Portrait	Paysage	Marine
1	22 × 16	23 × 14	22 × 12
2	24 × 19	24 × 16	24 × 14
3	27 × 22	27 × 19	27 × 16
4	33 × 24	33 × 22	33 × 19
5	35 × 27	35 × 24	35 × 22
6	41 × 33	41 × 27	41 × 24
8	46 × 38	46 × 33	46 × 27
10	55 × 46	55 × 38	55 × 33
12	61 × 50	61 × 46	61 × 38
15	65 × 54	65 × 50	65 × 46
20	73 × 60	73 × 54	73 × 50
25	81 × 65	81 × 60	81 × 54
30	92 × 73	92 × 65	92 × 60
40	100 × 81	100 × 73	100 × 65
50	116 × 89	116 × 81	116 × 73
60	130 × 97	130 × 89	130 × 81
80	146 × 114	146 × 97	146 × 89
100	162 × 130	162 × 114	162 × 97
120	195 × 130	195 × 114	195 × 97

As their names indicate, the sizes and shapes of each series were traditionally considered suited to the type of painting to be done, e.g., a *marine* canvas was supposed to be of the appropriate proportions for a seascape. Artists today do not feel at all limited by the arbitrary name of the canvas in their selection of its size and shape. The system of categorizing French canvas sizes is thought by some to have been founded upon some such theory of proportion as the GOLDEN MEAN or DYNAMIC SYMMETRY. No matter why the system was devised, however, it gives painters a wide choice of canvas shapes and sizes while holding the dealer's stock to a minimum, and it also makes possible the standardization of frame sizes. See also CANVAS SIZES, LANDSCAPE; CANVAS SIZES, PORTRAIT.

canvas sizes, landscape. In England and America three standard canvas sizes were traditionally used in LANDSCAPE painting. The three traditional landscape sizes are 30 x 50 inches, 36 x

54 inches, and 40 x 60 inches. For the conventional French landscape sizes, see the table at CANVAS SIZES, FRENCH. See also CANVAS SIZES, PORTRAIT.

canvas sizes, portrait. In England and America the standard canvas sizes used by portrait painters are traditionally designated as follows (measurements in inches):

bishop's whole length	70 × 106
whole length	58 × 94
small whole length	52 × 88
bishop's half length	44 × 56
half length	40 × 50
small half length	34 × 44
kit-cat	28 × 36
three-quarter	25 × 30

Whole-length canvases are usually used for painting full-length figures. The kit-cat size, originally designed for hanging in a low-ceilinged room, was named for an 18th-century London club that met in an eating house kept by one Christopher Cat, and whose members were painted by Sir Geoffrey Kneller. For the conventional French portrait sizes see the table at CANVAS SIZES, FRENCH. See also CANVAS SIZES, LANDSCAPE.

canvas tack. See CANVAS PIN.

caposcuola. Italian for the founder or leader of a school of thought or art.

Cappagh brown. A native Irish brown earth, similar in hue to UMBER, but inferior in color and pigment properties.

capriccio. Any fantastic adornment or decoration, as in sculpture, or a composition that contains bizarre, fantastic, or grotesque subjects, as in *Los Caprichos*, a series of etchings by Goya (1746–1828). Also, an extravagantly

CAPRICCIO. "Looking for Teeth" (*A Caza de dientes*) from Goya's series of etchings *Los Caprichos*, 1803. (*The Metropolitan Museum of Art, Gift of Roger E. Sachs, 1916.*)

conceived architectural scene or VEDUTA, the elements of which are accurately depicted but anomalously combined, as in *St. Paul's, London, with the Grand Canal, Venice,* by William Marlow (1740–1813). The 18th-century *vedutisti*, Francesco Guardi (1712–1793) and Antonio Canaletto (1697–1768), painted many such capricci. A veduta with purely imaginary elements is more properly called a *veduta ideata*.

caput mortuum. An obsolete name for a fully burned, permanent red iron oxide, deeper and more bluish than Indian red.

carbon bisulfide. A VOLATILE SOLVENT with a strong, disagreeable odor and a toxic effect. It is used in the con-

servation of wooden art objects for destroying wood beetles.

carbon black. A pure carbon pigment made by collecting the soot from burning natural gas by impingement; that is, the flames impinge on metal surfaces from which the soot is scraped. Very similar pigments are made by burning other substances, such as benzol to obtain benzol black, or acetylene to produce acetylene black. Lampblack, another carbon pigment, is made by burning oil by a different method; the soot is collected from flues. Many types and grades of carbon black are used in printing and lithograph inks, in industrial black coatings, and in rubber. Although the best carbon black is a more intense jet than the other black pigments, it is not in general use as an artists' pigment because it shows in streaks when used as a tinting or mixing color. Other names for various carbon blacks are gas black and diamond black.

carbon pencil. A drawing pencil made with lampblack or another carbon pigment, instead of with graphite. It is available in various degrees of hardness, producing different intensities of line, from jet-black to charcoal gray. The carbon pencil has a fine tonal quality and a sensitivity of control and is usually used for final drawings, rather than for sketches and casual work.

carbon pigments. Black pigments composed of pure or impure carbon, such as BONE BLACK; CARBON BLACK; CHARCOAL; IVORY BLACK; LAMPBLACK; and VINE BLACK. Graphite is also a form of carbon, but it has such different properties that it is not classed with the others.

carbon tetrachloride. A VOLATILE SOLVENT with a rapid evaporation rate and excellent solvent properties, especially for waxes. It is an ingredient of the familiar spot-remover trademarked Carbona. Carbon tetrachloride, unlike most volatile solvents, is nonflammable, and has even been used as a fire extinguisher. It is highly toxic and must be used only in freely ventilated surroundings.

Carborundum. Trade name for one of the sharpest and hardest of the artificial abrasives, silicon carbide. It is available in grains of several degrees of coarseness. The finer grades are particularly useful for grinding glass.

caricature. Pictorial ridicule or satire, effected by distortion of personal physical characteristics or through exaggerated depiction of the foibles and vices of individuals, social classes, and human institutions. Caricature has been used to evoke the entire gamut of human emotional responses, from gentle laughter to fiery indignation. It has been effective as a general illustrative technique and as the vehicle for social, religious, and political commentaries. Practically all modern caricature has been executed in some form of engraving, often in a series of prints that deal with various aspects of a single subject. It has been at least a diversion for most artists throughout all art history. Among the more notable practitioners of the form are William Hogarth (1697–1764), Francisco Goya (1746–1828), Thomas Rowlandson (1756–1834), James Gillray (1757–1815), George Cruikshank (1792–1878), Charles Philipon (1800–1862), Honoré Daumier (1808–1879), Thomas Nast (1840–1902), Max Beerbohm (1872–1956), and David Low (1891–1963). See illustration on next page.

carmine. A fairly permanent red LAKE pigment made from cochineal, a

CARICATURE. *"You have the floor, explain yourself, you're free!"* a lithograph (1835) by Daumier. (*The Metropolitan Museum of Art, Gift of Mrs. Edwin De T. Bechtel, 1958.*)

dyestuff of insect origin imported from Mexico. It was an important artists' color from the mid-16th to the 19th century. The first European recipes for the manufacture of carmine appeared about 1560 in Spain; the best 17th- and 18th-century grades were made in Venice, Antwerp, and France. During the 18th century its chief competitor was the older crimson lake, a less beautiful and less permanent color. A mid-18th-century writer, bemoaning the scarcity of good domestic carmine in England, said that English ladies were responsible for the great consumption of French carmine, "almost the only substance used . . . as a red paint for living faces." During the latter part of the 19th century carmine was superseded by more permanent reds, first madder lake, then alizarin crimson.

Other names for carmine include Vienna lake, Munich lake, and (formerly) nacarat carmine. BURNT CARMINE was a brown-purple pigment made by delicately roasting carmine.

carnation. An outmoded term used in art criticism to denote the natural rosy skin coloring in a painting.

carnauba wax. The hardest of the vegetable waxes, obtained from the leaves of a Brazilian palm. Its melting range is 83° to 86° C. Different grades vary in color from a creamy, yellowish white to a deep tan. Sometimes called Brazil wax, it is used in compounds of waxes and other materials to impart hardness and durability.

Carolingian art. Frankish art from the mid-8th to the early 10th century. Under the impetus of Charlemagne's dream of reviving the civilization of Rome, the fine arts flowered both at the emperor's court at Aachen and in the monasteries. Manuscripts

CAROLINGIAN ART. Front cover, gold and jewels, of the binding of the *Lindau Gospels*, c. A.D. 870. (*The Pierpont Morgan Library.*)

such as evangeliars were richly illuminated in a style that revitalized Roman and Byzantine models with barbarian intensity. The Utrecht psalter and the Ebbo Gospels, turned out at the remarkable Reims scriptorium (manuscript workshop), and the Ada group of manuscripts are especially fine examples. Elaborate and beautiful work was also done in the Carolingian workshops in gold, silver, and gems, as in the cover of the so-called *Lindau Gospels* (c. 870).

carpenter's pencil. See FLAT SKETCHING PENCIL.

Carrara marble. The most famous of all MARBLES, quarried in the Carrara district in Apuania, Italy. It has a fine, compact grain, and ranges in color from snow-white to creamy white. It is saccharoidal, or sugary, and has a translucent appearance in the finest grades. Carrara marble was used in ancient times and again during the medieval and Renaissance periods. Much of Michelangelo's work was done in this marble. Two of the best commercially available grades for sculpture are Italian Statuary and Bianco P.

carte-de-visite. French for a calling-card; in photography, such a card (about 2½ x 3½ inches) bearing a photographic portrait, popular in the 19th century. Cards of celebrities and royalty are collectors' pieces.

cartoccio. See CARTOUCHE.

cartoon. 1. A full-sized, detailed, and usually full-color preparatory drawing or painting on heavy paper. The term is derived from *cartone*, the Italian word for the paper on which the drawing is done and, by extension, for the cartoon itself. When a cartoon is used for a mural painting, as is almost always the case with fresco, it is usually transferred to the wall by SQUARING or POUNCING. Frequently a SPOLVERO is pounced in order to keep the original cartoon intact. In mural painting the cartoon also serves as a reference, giving the artist a full-scale view of his project at any point during its execution; it may also be used as a guide for his assistants. Cartoons are used as well for tapestries, stained-glass windows, mosaics, or any other works of art the final execution of which is sufficiently divorced from the creative aspects to be entrusted to craftsmen, such as weavers in the case of tapestry. Outstanding examples of cartoons of this latter type are those

CARTOON. Left, a gouache drawing by Philippe de Lasalle for a chair back of brocaded satin, shown at right, woven in Lyons about 1770. (*The Metropolitan Museum of Art, Rogers Fund, 1938.*)

executed by Raphael for the tapestries intended for the Sistine Chapel and now in the Vatican Museum. Seven of these cartoons are in the Victoria and Albert Museum in London.

2. An often humorous or satirical drawing or series of drawings, the main interest of which is the subject matter rather than the style of execution. Cartoons are generally rendered in a simple, linear manner. They are usually entertaining but may also serve the purposes of instruction and political or social commentary.

cartouche. A painted, engraved, or sculptured ornament of irregular or fantastic form, enclosing a plain central space, usually oval or lozenge-shaped, used as a field for inscriptions. Such ornaments were much used during the 16th and 17th centuries to decorate wainscotings and the title pages of books. Also, a lozenge-shaped

outline within which an inscription can be made. The term is especially applied to Egyptian hieroglyphs on monuments, where the names of gods and royalty were enclosed in cartouches. One form of cartouche, a plate attached to a work of art and inscribed

CARTOUCHES. Left, an ornamental cartouche; right, an Egyptian cartouche, the nameplate of the ancient king Cheops (Khufu).

with such information as the title, artist's name, and date of execution, is often called by its Italian name, *cartoccio*.

cartridge paper. British term for the coarser, less expensive grades of drawing paper. The name is derived from the use of such papers for making gun cartridges and wrapping dynamite.

carver. A knife with a short, angular blade and a cord-wrapped handle, used in woodcutting. See illustration at WOOD-CARVING TOOLS.

carving. In sculpture, the act of cutting or incising wood, stone, or another material into the desired form. Among the tools used for this purpose are knives, chisels, gouges, points, adzes, and hammers. In the most common method of carving, a chisel is held in one hand and driven into the wood or stone by a mallet held in the other. Carving and MODELING are the two major sculptural techniques, although metalworking techniques such as welding have become increasingly important in the past century. A carved work may be called a carving, but the word sculpture is usually preferred for work of serious artistic and aesthetic intent. See DIRECT CARVING; POINTING.

caryatid. In architectural sculpture, a female figure that serves as a column supporting an entablature. Caryatids are graceful figures dressed in long robes. The word is Greek, and was originally used for the maidens of Caryae in Laconia who performed ritual dances at the festival of Artemis. The male counterparts of caryatids are ATLANTES or telamones (see TELAMON).

Casali's green. An early variety of VIRIDIAN.

casein. A milk protein, used as a binder in casein colors, and as an adhesive. It is produced by drying the curd of soured skim milk to form a yellowish powder. Casein is water-soluble only in the presence of an alkali such as ammonia; hence, paints with a casein binder and casein adhesives are water-resistant on drying. Casein was first introduced commercially in the 19th century. Before then, a crude form of it, sometimes called by its Latin name of *causeum*, had been made from ordinary pot cheese. Some authorities believe that casein was the binder used in some of the paints of early civilizations. Curd glue was used by the ancient Egyptians, Greeks, Romans, and Hebrews. Casein is mentioned as an adhesive in 11th-century manuscripts, but its use as a paint binder does not seem to be recorded earlier than the 18th century. It may also be used instead of glue as a binder for GESSO. Unlike glue, it can be used cold.

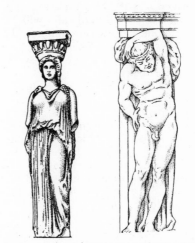

CARYATID (LEFT) AND ATLAS OR TELAMON

casein colors. Paints made by mixing artists' pigments with a solution of CASEIN, a milk protein. They are usually applied with a brush on a wall-

board panel coated with gesso, but can also be used on watercolor paper or board. Canvas cannot be used because dry casein is the most inflexible of the permanent paint binders and becomes increasingly brittle as it ages. For the same reason, the palette knife should be used with restraint, as the paint will crack if laid on too thickly; a heavy impasto should be avoided. The colors dry rapidly to a pleasing and durable mat finish, although some artists varnish their pictures to obtain a glossy finish more characteristic of oil paints. Caseins may be used to produce effects ranging from smooth areas of flat color to the robust textures of semi-impasto, for which a full bristle brush is used. Casein is also frequently used as an underpainting for oil paints and glazes.

Besides the mat quality of casein colors and their high drying speed, some artists prefer them to oils because they can be mixed with water. Although dried casein paint may be damaged if spattered with water, it is not readily water-soluble and will resist dampness. A casein painting may be sprayed with Formalin to increase its resistance to moisture. It may be cleaned with acetone.

Before World War II, American artists had built up a considerable tradition of painting with caseins, making their own colors by grinding pigments with fresh casein solution. In the late 1940's, manufacturers of artists' materials brought out complete lines of improved casein colors in tubes, and the technique became quite popular in the United States.

cashew lake. Another name for MAHOGANY LAKE.

Cassel earth. A native brown earth containing organic matter, closely similar to VAN DYKE BROWN. Cassel earth is also known as Cologne earth.

Cassel green. Another name for MANGANESE GREEN.

Cassel yellow. A variety of TURNER'S YELLOW.

cassone painting. Painting appearing on Italian household chests (cassone) of the 15th century. Frequently elaborately carved, gilded, and painted in a variety of scenes and ornamental designs, these chests were made by master craftsmen and occasionally painted by renowned artists such as Botticelli and Paolo Uccello.

cast. 1. To reproduce an object, such as a piece of sculpture, by means of a MOLD; also, a copy so produced. The original piece is usually of a less durable material than the cast.

2. A minute difference in color effect, too small to be called a TINGE; it is discernible only on close examination.

casting. See LOST-WAX PROCESS; SAND CASTING; LOST PATTERN CASTING; CENTRIFUGAL CASTING; MOLD.

casting plaster. A type of PLASTER OF PARIS especially prepared to have the properties most desirable for casting and carving; it is very fine-grained, absorbent, brilliantly white, slow setting, and capable of taking fine detail.

casting stone. See IMITATION STONE.

castor oil. The only NONDRYING OIL that is completely miscible with alcohol. It has been used as a plasticizer, to add flexibility to a coating material such as shellac or lacquer, whose strong and rapid drying action is thereby retarded and its brittleness permanently decreased.

CASSONE PAINTING. Right, a Florentine *cassone* (c. 1475) made of fruitwood, polychromed and gilt. Below, a detail showing the painting on the front panel, depicting the conquest of Trebizond. (*The Metropolitan Museum of Art, Kennedy Fund, 1913.*)

cast shadow. In a painting or drawing, the shadow of a figure or an object portrayed as it falls or is "cast" on another surface. The accurate representation of cast shadows is important in realistic depiction. The shadows as well as the objects that cast them must be drawn in perspective, and the shape, sharpness, and intensity of the shadows must correspond to the position and intensity of the source or sources of illumination in the picture. The Impressionist painters frequently used interesting effects of color in their depiction of cast shadows, but since the 1920's there has been a tendency among representational artists to eliminate or minimize cast shadows. See also CONTAINED SHADOW.

Catabond. See PHENOLIC RESINS.

catalyst. A substance that triggers or hastens a chemical reaction without itself entering into the reaction. The action of a cobalt DRIER on linseed oil is one example of catalysis. If the oil is left to dry by oxidation and polymerization, it may take several days to become dry to the touch, but the presence of a moderate amount of cobalt drier will produce the same result overnight.

catechu. Another name for CUTCH.

CAST SHADOW: CONTAINED SHADOW. Woodcut from *Underweysung der Messung* (Nuremberg, 1538) by Albrecht Dürer. (*The Metropolitan Museum of Art, Gift of Felix M. Warburg, 1918.*)

catenary curve. A curve like that made by a flexible cord of uniform thickness suspended between two points on

the same level. Catenary curves are common design elements.

cat's-eye damar. See MATA KUCHING DAMAR.

cat's gold. Another name for MOSAIC GOLD.

caulking. British term for TRACING; variants are calking, cocking, and cogging.

cauteria. Collective term by which the Romans designated the equipment and implements used to apply colors in ENCAUSTIC painting. The more important of the *cauteria* were: a copper or silver palette; a metal drum containing glowing charcoal on which the palette was placed; the portable heat source, a charcoal brazier; and the CESTRUM, or painting knife.

cavalier projection. See OBLIQUE PROJECTION.

cavetto. A concave molding with a quarter-round profile. See illustration at OVOLO.

cavityless casting. Another name for LOST PATTERN CASTING.

cavo-rilievo. Italian for hollow RELIEF.

cedar, oil of. One of the fragrant essential oils used in preference to sweet or flowery odorants to mask disagreeable odors in water-paint binders, polishes, and cleaners.

celadon. A soft ceramic GLAZE containing iron. It is made in a reduction fire, in which red iron oxide (ferric) is reduced to black (ferroso-ferric). The reduced color of the glaze may be olive green, gray-green, or gray. Celadon ware was developed and perfected during the Sung Dynasty. It was apparently valued by the Chinese for its resemblance to jade, and has always been highly esteemed in the West.

celadon green. Another name for GREEN EARTH, the coloring principle of which is celadonite, an iron silicate. Chinese celadon porcelain was named for the resemblance of its color to this willow-green shade. The name celadon comes from a character in Honoré d'Urfé's romance *L'Astrée* (1610).

celestial blue. A cheap variety of PRUSSIAN BLUE containing up to 95% BARYTES. It is not used in permanent painting.

Celite. A trade name for several grades of DIATOMACEOUS EARTH used as INERT PIGMENTS, FILLERS, and flatting agents in prepared paints.

cellophane tape. See PRESSURE-SENSITIVE TAPES.

Cellosolve. Trade name for ethylene glycol monethyl ether, a lacquer solvent.

Celluloid. Trade name for a PLASTIC which was the first commercially produced synthetic plastic. In 1876 its inventor marketed billiard balls and other "imitation ivory" products made from CELLULOSE NITRATE, plasticized with camphor. Much ingenuity was exercised in the manufacture of early plastic products. Thin sheets of opaque and translucent Celluloid were stacked alternately, laminated, and fashioned into articles that appeared to have been made of elephant ivory. Imitation tortoise shell was also a favorite. It was many years before the natural properties of plastics were exploited for their own distinctive virtues, rather than to imitate the markings (or, as it has been

said, the defects) of natural substances. Despite the tremendous rise of modern synthetic resins, nitrocellulose plastics are still in use, and camphor is still one of the best plasticizers used in their manufacture. None of the cellulose plastics, however, are sufficiently permanent for use in the fine arts.

cellulose acetate. A cellulose derivative used in the manufacture of photographic film, plastics, textile fibers, and lacquers. It is superior to CELLULOSE NITRATE in film because it is far less dangerously flammable. In lacquers it does not yellow so much in daylight as cellulose nitrate, but is inferior in hardness, durability, and other desirable lacquer properties. No cellulosic products have sufficient stability to be used in permanent painting or constructions.

cellulose cement. A viscous solution of PYROXYLIN or cellulosic material in a LACQUER SOLVENT, sold in tubes for general adhesive and repair purposes. It is especially useful when a cement that dries rapidly is required. A well known brand is Duco Cement.

cellulose nitrate or **nitrocellulose.** An industrial raw material made by nitrating cellulose fibers. It is the principal ingredient of LACQUERS and is also used to make various plastics and films. Highly nitrated grades of cellulose nitrate are known as guncotton. None of the lacquers or solid plastics based on cellulose nitrate are used in permanent painting.

Celotex. Trade name for a loose-structured board of roughly webbed texture, made of sugarcane waste. The texture of Celotex sometimes appeals to painters, but this type of board is not recommended for use as a painting support, as it becomes brittle and fri-

able on relatively short aging. See IN-SULATING BOARD.

Celtic cross. A LATIN CROSS with a ring or halo about the intersection of the arms. The circle crosses the three short arms of the cross near their ends. This cross is sometimes called the Irish cross or the cross of Iona. See CROSS for illustration.

cement. 1. Any strong adhesive used to join or repair materials; examples are tile cement, rubber cement, and cellulose cement.
2. A building material made of lime, silica, and alumina. See PORTLAND CEMENT.

central visual ray. The line of sight at the exact center of the CONE OF VISION. It is that line which makes an angle of exactly 90° with the PICTURE PLANE. The central visual ray is also known as the line of vision. See illustration at PERSPECTIVE.

centrifugal casting. A method of casting by the LOST-WAX PROCESS using a machine in which the mold revolves so that its cavity is filled with molten metal by centrifugal action and pressure. The resulting cast may be very thin and highly detailed. A high degree of finish may be obtained by this method of casting, thus reducing tedious surface treatment and finishing. It is used most commonly in the casting of small objects in precious metals such as gold, silver, and platinum, although other metals such as bronze, brass, and aluminum may also be cast centrifugally.

cera colla. A medieval term for an emulsion of glue solution and molten beeswax. A modern version would be composed of white, refined beeswax saponified with ammonia and mixed with various gum solutions and/or

casein. It is called for in various old recipes as an ingredient of aqueous paint binders.

ceramic colors. Powdered metallic oxides and other compounds used in ceramic glazes, for decorating porcelain, china, and terra-cotta, and for porcelain enameling on metals. Most ceramic colors are pale while in powder form; their full, deep color appears when the work is fired in a furnace or kiln. Ceramic colors usually contain flux and other ingredients that make them unsuitable for use in paints. They are known in Britain as porcelain colors.

ceramics. The art of making objects of clay and FIRING them in a KILN. Wares of EARTHENWARE and PORCELAIN, as well as sculpture, are made by ceramists. ENAMEL is also a ceramic technique. Ceramic wares may be decorated with SLIP, ENGOBE, or GLAZE, applied by a number of techniques, including RESIST, MISHIMA, and SANGGAM. Pots may be made by the COIL METHOD, the SLAB METHOD, or some other manual technique, or on a POTTER'S WHEEL. The making and decorating of pottery is among the most ancient of the arts. It reached a high degree of development in China and also in ancient Greece. Because ceramic practice involves the fashioning of a plastic mass, many technical terms relating to it also apply to sculpture.

ceresin. A pure white or slightly yellowish mineral wax refined from OZOKERITE. It resembles PARAFFIN but has a higher melting point in the 60°– 80° C range) which makes it a suitable substitute for beeswax as an ingredient of polishes and protective coatings for sculpture, among other uses.

cerography. 1. The art of making designs or inscriptions in wax, as on wax-coated tablets.

2. The art of ENCAUSTIC PAINTING.

3. In printing, the process of making electrotype plates from engraved sheets of wax.

cerulean blue. Cobalt stannate; a bright, deep sky-blue permanent pigment of very greenish undertone, made by roasting cobalt and tin oxides. After a few attempts by late-18th-century colormakers to produce a satisfactory cobalt-tin blue, the process was perfected by Höpfner, Germany, 1805. Cerulean blue was introduced as an artists' pigment in England by G. Rowney in 1870 under the name coeruleum (from *caeruleum*, classical Latin for sky blue pigment, such as Egyptian blue). Other names for cerulean blue are coelin, ceruleum.

ceruse. Old name for WHITE LEAD.

cestrum. Roman name for the principal tool used to apply the molten colors in ENCAUSTIC painting. *Cestra* were spatulate bronze implements, often double-ended. Their modern counterparts are limber stainless-steel PALETTE KNIVES, and painting knives in assorted shapes.

Ceylon lacquer. See LACQUER, ORIENTAL.

chalk. Native chalk (calcium carbonate) in pigment form is called WHITING; artificial calcium carbonate is known as PRECIPITATED CHALK. The term chalks is also used for chalk crayons and for drawings done with them.

chalking. The disintegration of the surface layer of a coat of paint through failure of the binding medium to hold the particles of pigment; the paint thus

becomes powdery and is easily rubbed off. Chalking is more common in house paint, which is exposed to the weather, than in artists' colors.

chalk manner. Another name for CRAYON MANNER.

chalk roll. A variant of the roulette, used in CRAYON MANNER. See illustration at ROULETTE.

chamois. An obsolete term for the pigment YELLOW OCHRE.

champlevé. A technique of enameling or an article of ENAMEL work produced by this technique. The design consists of a number of shallow depressions carved out from or ground into a metal surface, filled in with ceramic pastes, and fired. Champlevé can be readily distinguished from CLOISONNÉ by the irregular widths of the metal surrounding the colored areas. Also called *en taille d'épargne*, champlevé has been used for decorative purposes since Roman times. In medieval times it was employed for the enrichment of precious liturgical and secular objects.

charcoal. A black crayon made of charred twigs of wood, usually willow, or pieces of vine. It is available in various degrees of hardness and thickness. Charcoal is a very old and universally used drawing material. When used for itself in drawing, it is usually applied on special CHARCOAL PAPER, but it is also used for preliminary drawing on oil-painting grounds. Charcoal is also the usual black crayon used in chalk drawings. Like pastel, charcoal smudges easily, and when applied may be manipulated by the artist with his finger, a STUMP, or some other soft shading material or implement. The finished drawing must be sprayed with a FIXATIVE to be made permanently resistant to smudging.

charcoal black; charcoal gray. Pigments made by pulverizing charcoal. They have poor pigment properties and are seldom used by artists. PEACH BLACK is a variety of charcoal black; VEGETABLE BLACK is an unstandardized term applied to various grades of charcoal black and vine black.

charcoal paper. A soft paper of moderately rough grain that takes and holds charcoal well and is also adaptable to other drawing and painting mediums. It is available in pure white and a variety of tints. The best grades have a high rag content and usually a laid or watermark finish.

chasing. In metalwork and sculpture, the art of ornamenting a metal surface with indentations created by striking blunt steel chasing tools or punches with a hammer; also, the resulting engraved design. In metalwork, chasing, or directly creating intaglio designs on the obverse of an object, is distinguished from REPOUSSÉ work, in which relief designs are created on the obverse of a sheet of metal by hammering its reverse. In sculpture, chasing also refers to the process of finishing the surface of a bronze cast by chiseling and polishing it, thus removing small imperfections and seams left by the casting mold and emphasizing incised details.

chasse. French for a RELIQUARY.

chassis. 1. In painting, the wooden framework on which an artists' canvas is mounted. See STRETCHER; STRAINER.
2. In sculpture, a calibrated wooden framework, used in making an enlarged or a reduced copy of a plaster model.

chatoyant. Term used to describe the inner glow or luster of certain gems, notably cat's-eye. By extension

it is also applied to the reflection from SHELL MARBLE and similar stones.

chatter mark. In ceramics, a series of shallow vertical grooves on a pot, created by a trimming tool. It may be a defect, occurring when the potter attempts to trim a pot after the clay has dried too much, or it may be done deliberately as a kind of decoration.

chay. A red NATURAL DYESTUFF obtained from the root of an East Indian plant (*Oldenlandia umbellata*). One of the slowest-fading of the natural coloring matters, chay is used to dye textiles. There is no record of its use in paint pigments, but this may have occurred locally.

checking. 1. CRACKLE in a pattern of squares on a painting or any other surface.
2. Cracking or partial splitting in wood, along the grain, caused by shrinkage due to loss of moisture when the wood dries; it can be prevented by proper seasoning.

chef d'oeuvre. Frequently used French term for MASTERPIECE.

chemigraphy. Those printing processes in which a metal plate is incised by chemical means (i.e., BITING, as in ETCHING and AQUATINT) rather than by mechanical means (as with a burin in engraving or with a needle in drypoint).

cherry gum. A clear gum exuded by all species of wild and domestic cherry trees. When allowed to soak, it swells and absorbs water; it is then used as a binder for pigments, especially as a substitute for gum arabic in gum tempera colors. Although it is not widely used commercially, its history as a water-paint binder goes back to the 10th or 11th century in northern

Europe. Peach, plum, apricot, and almond trees also yield gum whose properties as paint binders are identical to those of cherry gum.

cherrywood. The wood of the black cherry (*Prunus serotina*), a strong, close-grained, lustrous brown or reddish wood that takes a high polish. It is used for fine carvings and is prized for cabinetwork. It has a straight, regular grain, and may have dark red growth lines. African cherry or makore (*Mimusops heckelii*), used chiefly for veneer, has similar growth lines.

cherub. See PUTTO.

chê shih. A Chinese earth pigment of a brownish terra-cotta color. It is sold with a glue binder as a prepared Chinese watercolor.

chessylite. Another name for AZURITE.

chestnut brown. A little-used name for UMBER.

chiaroscuro. In drawing, painting, and the graphic arts, the rendering of forms through a balanced contrast between pronounced light and dark areas. The technique, which was introduced in the Renaissance, is effective in creating an illusion of depth and space around the principal figures in a composition. Leonardo and Rembrandt were painters who excelled in its use. See also TENEBRISM.

chiaroscuro woodcut. A WOODCUT technique for printing single-color prints in which the effects of light and shadow (chiaroscuro) are produced by using a different wood block for each tone in the print; also, a print made by this process. The blocks are designed and cut as if for multicolor printing (see COLOR PRINT), carefully marked to

CHIAROSCURO WOODCUT. *The Death of Ananias* by Ugo da Carpi (1450–c. 1525). Above, a proof pulled from the key block; a final proof printed from the key and tint blocks. (*The Metropolitan Museum of Art, Rogers Fund, 1918.*)

print in REGISTER. A KEY BLOCK is printed in the darkest tone, usually black or dark brown. Sometimes the darkest tone, which is generally used for the outlines of the design areas, is printed with an etched or engraved copper plate, and only the tints are printed with wood blocks. After the darkest tone is printed, the tint blocks (usually one to three, although more can be used) are inked and printed with grad-uated shades of the same color or tones of a different single color. The most popular colors for chiaroscuro wood-cuts are gray, brown, green, and sepia.

The chiaroscuro woodcut was de-vised in the early 16th century as an inexpensive imitation of or substitute for the chiaroscuro wash and water-color drawings that were so popular during the Renaissance. Ugo da Carpi, who worked from drawings and copied

paintings of Raphael and Parmigianino, is said by Vasari to have discovered the process in 1516. Lucas Cranach's woodcutter, Jost de Negker, is also credited with the invention of the chiaroscuro woodcut four years earlier. Although neither man was a creative artist in his own right, both cut blocks for some of the finest prints ever made in the medium. When in the 17th century the woodcut began to be replaced by metal-plate printmaking techniques, the popularity of the chiaroscuro woodcut also began to wane on the Continent, although it continued to be used in England throughout the 18th century.

chic anglais. In the 18th century, an admiring French expression for the brilliant color effects of English painters, such as Sir Thomas Lawrence and later R. P. Bonington, who revived the use of transparent color over brilliant white grounds.

chill. A term sometimes used as a synonym for BLOOM.

China clay. A native hydrated aluminum silicate, called China clay because it is used to make chinaware. As an INERT PIGMENT in paints and pigments, China clay serves chiefly as a low-cost EXTENDER or adulterant. Kaolin is the whitest and purest variety of China clay; Devonshire clay is a variety found in England. Pipe clay is another name for China clay.

china-marking crayon. See GREASE CRAYON.

china painting. The decoration of chinaware with ceramic colors, a ladies' handicraft activity that was extremely popular during the late 19th and early 20th centuries. Special stocks of brushes, colors, and white porcelain articles were sold, and the work was sent to a professional kiln for firing and, frequently, the addition of gold decoration.

China stone. See PETUNTZE.

China wood oil. Old name for TUNG OIL, little used after about 1930.

Chinese blue. Along with steel and Milori blues, one of the three best grades of PRUSSIAN BLUE.

Chinese green. See LOKAO.

Chinese ink. See INK.

Chinese insect wax. A rather hard wax with a melting range of $79°-83°$ C., used for general purposes in China and Japan and encountered in various recipes in the arts. It is a fairly good substitute for beeswax. The insects that produce this wax swarm on a species of tree that grows in Yunan province. When their development reaches a certain stage, they are gathered and transported several hundred miles to Szechwan province, where they are placed on trees of a different species to complete their life cycle. The wax is finally gathered from the second type of tree.

Chinese lacquer. See LACQUER, ORIENTAL.

Chinese red. Another name for chrome red (see CHROME YELLOW).

Chinese vermilion. Originally, the VERMILION made in China and called chu sha; today, commonly, the English or American product. Vermilion was invented in China independently of, and earlier than, its medieval European counterpart; for hundreds of years the Chinese product was mistakenly believed superior.

Chinese white. A prepared ZINC WHITE watercolor introduced in 1834 by the English firm of Winsor & Newton.

Chinese yellow. Another name for KING'S YELLOW.

chinoiserie. Decorative work influenced by Chinese art. The vogue for chinoiserie, manifested in architecture, interior decoration, furniture, porcelain, tapestry, wallpaper, and knickknacks, as well as in the fine arts, reflected the romantic interest in China and reached its height during the 18th century. The vogue came to an end about 1795, although the Chinese style still provides standard motifs in the decorative arts. See also JAPONISM.

chipboard. An inexpensive gray or brownish cardboard made entirely from wastepaper; not recommended as a support or as a mounting or matting material for works of art.

chi-rho. Christian symbol formed of the Greek letters chi (X) and rho (P) —the first two letters of the word Christos. The chi generally intersects the upright shaft of the rho, taking the form of a Greek cross. The chi-rho, widely used in Christian art, surmounted the labarum or standard adopted by Constantine, the first Christian emperor of Rome.

CHI-RHO

chisel. Any of a number of steel tools with a cutting edge at the end of a rod or handle. It is usually held in one hand at an angle to the surface to be carved and driven by a MALLET held in the other hand. Chisels are used by

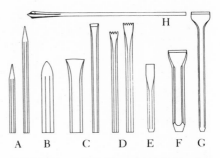

CHISELS AND POINTS. Points (A), bull point (B), flat chisels (C), tooth chisels (D), cold chisel (E), pitching chisel (F), t-chisel (G), and star drill (H), used in stone carving.

sculptors for carving or working stone, wood, metal, and other materials and by graphic artists for making woodcut blocks. The chisel used in wood carving is often simply called a "straight," to distinguish it from a bent chisel (see BENT GOUGE). See also COLD CHISEL; FISHTAIL TOOL; PITCHING CHISEL; SKEW CHISEL; T-CHISEL. See illustrations here and at WOOD-CARVING TOOLS.

chisel brush. A brush with a straight, wide working edge whose bristles or hairs are set so that its flat sides are beveled toward its tip. A chisel brush is desirable in some paint applications, especially for sign writing, in which the brush retains its original shape in use and deposits a uniform coating of paint. The chisel brush is also known as a chiseled or chisel-edge brush. See FITCH; SIGN-WRITER'S CUTTER; SLICKER.

chondrin. See GLUE.

chopped strand mat. A mat of randomly distributed glass fibers, each about 2 inches long and consisting of many filaments, bound together with a sizing which is soluble in polyester resin. These glass fibers are the most commonly used reinforcement for polyester resin. The two materials,

75

when combined in a laminate, form an extremely strong, durable casting material for sculpture. See FIBER GLASS.

Christogram. A monogram or other symbol of Jesus Christ. The most common Christogram is the CHI-RHO, formed of the first two letters of the Greek word Christos.

chroma. The hue and saturation, or degree of vividness, of a color other than black, white, or gray. It is the dimension that distinguishes the so-called chromatic colors from those in the black-white scale. Chroma is one of the three coordinates of the MUNSELL SYSTEM of color notation.

chromatic color. Any color except black, white, and the simple grays, which are called achromatic colors.

chromaticity. The chromatic or color property of a thing. Also, in scientific color measurement, the dominant wavelength of a color plus its purity. A chromaticity diagram (called also color triangle and Maxwell triangle) is a triangular or tristimulus chart that indicates the ratio or percentage of each of the three primaries in the color's makeup. These numerical elements are termed chromaticity coordinates. See also TRISTIMULUS VALUES.

chrome green. A COMPOSITE PIGMENT made with chrome yellow and Prussian blue, widely used in house paints and other industrial products. Chrome green is unsuitable for artists' colors because it has the defects of both its ingredients. Since there are many shades of chrome yellow and Prussian blue, a great variety of chrome greens can be produced. Other names for chrome green are royal green, zinnober green, and OIL GREEN. Among the many hue variants of

chrome green are leaf green, leek green, moss green, and myrtle green. Varieties of chrome green include BRUNSWICK GREEN (also called Prussian green) and NITRATE GREEN.

chrome ochre. Another name for GOLDEN OCHRE.

chrome orange. See CHROME YELLOW.

chrome red. See CHROME YELLOW.

chrome yellow; chrome orange; chrome red. Basic lead chromate. It is produced in a large range of shades, from palest primrose yellow to scarlet red, by altering the manufacturing conditions. Described in 1809 by L. N. Vauquelin, who had discovered chromium in 1797, the lead chromate pigments were first produced commercially in 1818 and have been widely used ever since for house paints and other industrial purposes. In spite of their brilliant colors and excellent pigment properties, the lead chromates are unsuitable for permanent painting: They turn brown on contact with sulfur in the atmosphere, will react with other pigments, may turn green on exposure to sunlight, and may cause lead poisoning.

The cadmium reds and yellows are perfectly suitable replacements for the lead chromates. There has really been no necessity for artists to use chrome yellow for the past 125 years nor chrome red for the past forty; nevertheless some artists have used them, almost always with unfortunate results. Turner is said to have employed chrome yellow and chrome orange, and the discoloration which some of van Gogh's sunflowers have undergone is a rather well-known example of what happens when an artist uses a material he knows is bad because he has nothing else on hand. Chrome yel-

low, for all its faults, was superior to a number of earlier pigments that it replaced and made obsolete, such as TURNER'S YELLOW, TURPETH MINERAL, and KING'S YELLOW. Chrome red is also known as Chinese red and Derby red, chrome yellow as Leipzig yellow and Paris yellow. Victoria red is one of the trade names for chrome red; Persian red is an unstandardized name for a variety of chrome red. Vienna red is also a variety.

chromium oxide green. A dense, completely opaque, pale-green pigment of medium saturation. A FURNACE PRODUCT, it is absolutely permanent for all pigment purposes and conditions, including the highest temperatures. Compared with viridian and phthalocyanine green, chromium oxide green has a rather dull color effect, is quite low in tinting strength, and is much less versatile in mixtures; hence, despite its pleasing hue, it is less frequently used by artists. Discovered in France by Vauquelin (1797), chromium oxide began to be used in the early 19th century as a ceramic color. It was first used as an artists' pigment about 1840, and became widely available by 1862. Nineteenth-century experiments in developing chromium oxide green produced varieties called Plessy's green, Dingler's green, Arnaudon's green, and Schnitzer's green. Chromium oxide used as a polishing ROUGE, particularly for platinum and stainless steel, is called green rouge.

chromo. An abbreviated designation for a chromolithograph; by extension, a term of disparagement for a cheap or gaudy picture.

chromolithograph. An outmoded term for a color lithograph, especially used to describe the product of those processes from which modern COLOR LITHOGRAPHY developed. The typical chromolithograph, or chromo, as such a print was commonly called, was poorly executed compared with color lithographs produced by later techniques. Many chromos had little or no merit. See also OLEOGRAPH.

chryselephantine. Made of, or adorned with, ivory and gold. Chryselephantine figure statues, usually with flesh of ivory and hair and garments of gold, were much prized by many ancient peoples of the Orient, the Near East, and the Mediterranean. Greek sculptors of the 5th century B.C. made chryselephantine statues of the gods to adorn their greatest temples. Among the most famous were the Olympian Zeus and the Athena Parthenos, 40-foot colossal sculptures by Phidias.

chrysocolla. A native green copper silicate. Like malachite, it was used as a green pigment in early civilizations, though it was replaced in some instances by greens made from Egyptian blue, notably in Crete.

chrysography. Lettering in gold or silver ink. The ancient Greek and Roman practice of lettering with gold on purple and rose-colored vellum was continued on natural and tinted parchment in the Middle Ages. Especially fine examples of chrysography occur in Hiberno-Saxon illuminated manuscripts of the 6th and 7th centuries. This style of lettering was widely used until the 10th century, after which chrysography declined, although it was somewhat revived during the Renaissance.

C.I.E. Official abbreviation for the COMMISSION INTERNATIONALE DE L'ECLAIRAGE, or International Commission on Illumination.

77

ciment fondu. Aluminous cement, used in casting sculpture; French for melted cement. It sets in about four hours and then hardens very rapidly. When mixed with sand, it forms a kind of concrete, whose surface and texture may be varied by the addition of different aggregates. It may be reinforced with glass fibers to make a strong, thin, light, hollow cast.

cinnabar. Native mercuric sulfide ore. It was used as a red pigment by ancient peoples prior to the invention of the much superior VERMILION (manufactured mercuric sulfide). According to Theophrastus (*History of Stones*), an outcropping of cinnabar on inaccessible cliffs on the Spanish coast was worked by shooting arrows to dislodge the ore. See also MINIUM.

cinquecento. The 16th century. The term is commonly used to designate Italian art of that period.

cinquefoil. See FOIL.

cipolin or **cipollino.** Any white MARBLE variegated with green and gray because it contains layers of mica or mica-like minerals. Its name, from the Italian word for "onion," comes from its fancied resemblance to the cross section of an onion. The stone originally named cipolin came from the Island of Euboea in the Aegean Sea.

circle cutter. See COMPASS CUTTER.

cire perdue. French term for the LOST-WAX PROCESS of metal casting.

cissing. Failure of a paint or varnish to coat a surface evenly, resulting in the formation of irregular streaks and bare spots; popularly called CRAWL or creep.

citron yellow. A hue designation for any pale yellow that tends toward the greenish, but not to the extent of being considered a greenish yellow. Examples are strontium yellow and zinc yellow.

clam. In ceramics, to seal a KILN by daubing the door with a mixture of fireclay and fine grog. It is not necessary to clam an electric kiln or a portable gas kiln, since these usually have tight-fitting, hinged doors.

Classic Acrycolor. Trade name for an American manufacturer's line of acrylic POLYMER COLORS and their adjuncts.

classical. 1. Pertaining to the art of the Greeks and the Romans. See HELLENIC ART; ROMAN ART.
2. Pertaining to the period of highest achievement and purest form of a style or technique. See also CLASSICAL PERIOD; CLASSICISM.

classical abstraction. See GEOMETRIC ABSTRACTION.

Classical period. In HELLENIC ART, the period (500–323 B.C.) of highest achievement, between the ARCHAIC PERIOD and the HELLENISTIC PERIOD. One of the early discoveries of the period was the principle of CONTRAPPOSTO, or counterpoise, whereby the weight of a standing figure was borne mainly by one leg, giving the figure a relaxed, harmonious pose. This development made possible the creation of balanced figures—and even interlocking groups of freestanding figures—in motion. While the harmonious proportions and over-perfect anatomy of the figures indicate that they were idealized portrayals of the human body rather than individual portraits, they conveyed emotion through facial expression as well as

through the expressive, kinetic pose of the body. Relief sculpture, in the form of complex narrative friezes, displayed a high degree of compositional harmony and spatial subtlety. Classical painting was probably distinguished by the evolution of techniques for giving the illusion of space, such as modeling and foreshortening, although it survives today only in examples of vase decoration, an art which had passed its peak. In architecture, the serene balance and harmony that characterized Classical art were exemplified in such buildings as the Parthenon. See illustration at CONTRAPPOSTO.

classicism. Any manifestation of the style of CLASSICAL Greek and Roman art; also, adherence to standards of simplicity, restraint, and proportion considered to characterize classical art. Since the Renaissance, classicism has had a powerful and recurrent influence on Western art and architecture, alternating in favor with periods of ROMANTICISM or impinging upon romantic styles. In its second sense, classicism may also be considered the opposite of the elaborately ornamented BAROQUE style. NEOCLASSICISM, the Adam and Empire styles of decoration, and Georgian and Palladian architecture are all derived from classicism, as are most of the architectural styles from the mid-18th to the mid-19th century. Nineteenth-century ACADEMICISM, which has been a great molder of public taste during the past 150 years, is also based on Greek and Roman ideals.

Claude Lorrain glass. A convex, black glass used as a mirror to reflect a landscape in reduced size, muted color, and merging detail. The glass is said to have been devised by the painter Claude Lorrain (Claude Gelée, 1600–1682) and to have also been used by Il Bamboccio (Pieter van Laar, 1592/5–1642) and Gaspard Poussin (Gaspard Dughet, 1613–1675). It was popular among artists of the 17th and 18th centuries, was still in common use in the 19th century, and is occasionally seen today.

clay. A native earth consisting mainly of decomposed feldspathic rock containing kaolin and other hydrous aluminous minerals. Powdered clay is used in painting as an inert pigment (see CHINA CLAY). Moist clay is the material used in CERAMICS. Potters and ceramic sculptors choose clays that are suitable for firing (see POTTER'S CLAY). Clays containing a large proportion of kaolin harden at higher temperatures than other clays. Fine porcelain is composed of relatively pure kaolin, mixed with refractory and fluxing ingredients. A sculptor who plans to cast his work uses either native clay (commonly called wet clay) or MODELING CLAY for his original model. Sculptor's clay is selected for its moisture-holding and plastic properties. It is prepared by being mixed with water. The sculptor builds up his clay model over an ARMATURE, keeping it moist overnight or between working sessions by wetting it and covering it with an impermeable cloth. The finished clay model, dried, is used in making a mold for casting the final sculpture in bronze or another durable material.

clay body. Material used for making ceramic wares. The body is a mixture of clays and other earth materials combined to meet the performance requirements for its specific purpose. The physical properties of clays, such as plasticity, texture, color, shrinkage, and thermal resistance, vary greatly. Different methods of forming a piece, such as throwing, building, casting, and pressing, require different formulas. Different body properties are also

required for different methods of firing, i.e., oxidizing or reduction firing at any of numerous possible temperatures. The ultimate body composition is therefore usually a compromise of many characteristics to achieve a certain purpose. The unadorned ceramic piece, as distinguished from the glaze or decoration that may be applied to it, is also known as the body.

cleavage. In painting, any separation between paint layers, between paint film and ground, or between ground and support. Cleavage occurs where adhesion between layers has deteriorated; it is commonly due to faulty materials or improper methods of application. It causes BLISTERS, WRINKLES, and flaking of paint.

cloison. In enameling, a cell or area enclosed by a metal border, into which colored ceramic pastes are placed. The term is French for cell. See CLOISONNÉ; ENAMEL.

cloisonné. A kind of surface decoration in porcelain ENAMEL on metal (and, rarely, on pottery), in which each color area is surrounded by a thin line of metal, flush with the enamel surface. Thin fillets of flattened wire are set on edge and attached to the base in the desired pattern. The cloisons, or cells, between the wires are filled in with ceramic color pastes. The work is then fired in a furnace, ground smooth, and polished. Cloisonné can easily be distinguished from CHAMPLEVÉ enamel by the uniform thinness of its metal lines. Beautiful examples of cloisonné were created in the Byzantine era and throughout the medieval period in Western Europe. The art has been successfully practiced in China and Japan in more modern times.

clove. See OIL OF CLOVES.

coach varnish. A fine-quality glossy varnish of the type suitable for use on carriages and automobiles. The term went out of use after the 1920's, when spray lacquer finishes replaced the older compounds, which required laborious hand-finishing.

coal-tar colors. A somewhat outmoded term for the SYNTHETIC ORGANIC PIGMENTS derived from products of coal-tar distillation, a by-product of the coal and coke industry. Coal tar yields five basic raw materials: benzene, toluene, xylene, naphthalene, and anthracene, from which numerous compounds, called intermediates, are made by a number of different chemical reactions. These intermediates are combined in various ways to produce thousands of synthetic products, including a vast range of dyestuffs. A number of these are eligible for use in permanent painting, but the greater number of them are not sufficiently lightfast or nonbleeding in oil. Because of these shortcomings, the terms coal-tar colors and ANILINE colors have acquired a pejorative meaning. Consequently, these terms are no longer in wide use, especially in referring to the better synthetic colors.

coal-tar solvent. A VOLATILE SOLVENT obtained by the distillation of coal tar; benzol, toluol, and xylol are the principal solvents so obtained. Industrial grades of these substances are widely used as solvents for rubber and many resinous materials. While each has a distinctive odor and solvent properties, the three resemble each other in these respects. Benzol is the most powerful solvent, xylol the least. The vapors of benzol are rated as dangerously toxic; toluol and xylol are much safer, and are therefore frequently used in coating materials that must be closely handled. The chemically pure grades of these solvents are

known as benzene, toluene, and xylene; they are so called in reference to chemical reactions. They are classed as aromatic hydrocarbons. In addition to their use as solvents, they are among the basic raw materials of synthetic organic chemistry and are used in the manufacture of dyes, resins, and pharmaceuticals.

A fourth coal-tar derivative called solvent naphtha has a strong naphthalene or mothball odor, contains mixed hydrocarbons, and is in general a weak solvent, useful for the superficial cleaning of coatings that would be damaged by stronger solvents.

coated paper. Paper whose surface has been coated with a thin layer of an inert pigment such as clay in an adhesive binder like glue or casein. Some coated papers have a dull or satin finish but most have a high gloss, which is produced by CALENDERING. Glossy coated paper is called enamel paper in Britain.

cobalt black. Another name for BLACK OXIDE OF COBALT.

cobalt blue. A bright, clear blue pigment, permanent for all techniques, including fresco; a FURNACE PRODUCT made by combining cobalt and aluminum oxides with phosphoric acid. The MASS TONE of cobalt blue is somewhat similar to that of ULTRAMARINE BLUE, but its undertone is more greenish than the comparatively purplish undertone of ultramarine. One of the painter's standard colors, cobalt blue was discovered by Baron L. J. Thénard in France in 1802. Introduced to artists about twenty years later, it replaced the unsatisfactory smalt and superseded several other varieties of cobalt-aluminum pigments then being developed. These included Gahn's blue, Leithner blue, and NEW BLUE. Thénard's product is sometimes called

Thénard's blue. Other early names for cobalt blue are Olympia blue and Vienna blue or Vienna ultramarine; alternate names are Leyden blue and KING'S BLUE; a rarely used term is HUNGARY BLUE. Azure cobalt signifies a light shade of one variety of cobalt blue.

cobalt drier. See DRIER.

cobalt green. A compound usually described as cobalt zincate, a FURNACE PRODUCT made by roasting cobalt and zinc oxides. The resulting cobalt green is a fairly bright, bluish-green pigment of medium saturation—fairly opaque, but with rather low tinting strength. Despite its absolute permanence, cobalt green is not widely used, since its hue can easily be matched by mixing greens and blues that are more versatile and hence more useful to the painter. Invented in Sweden about 1780 by Sven Rinman (and called Rinman's green), cobalt green began to be used as an artists' pigment in 1835. An early name for cobalt green is green smalt; alternate names are ZINC GREEN and Swedish green. Gellert green was a variety made by a somewhat different process from Rinman's.

cobalt ultramarine. A name formerly given to GAHN'S BLUE and later appropriated by manufacturers of imitation cobalt blue, a special shade of ultramarine blue.

cobalt violet. Cobalt phosphate or cobalt arsenite; a clear, semiopaque, permanent pigment made in two general types, bluish and reddish violet. Although various pinkish and purplish cobalt compounds had been tried since the early 19th century, successful cobalt violets did not come into use until about 1860, after which they were the only permanent bright violets available to artists until the 1950's. The

original cobalt violet was the poisonous cobalt arsenite. Much of the present material is nontoxic cobalt phosphate, and is so labeled. Since some of the dry pigment available may be the arsenite type, careful painters avoid it for such uses as pastel, in which its dust would be dangerous. Manganese violet is a satisfactory, less costly substitute for the bluish type of cobalt violet, but not for the reddish.

cobalt yellow. Cobalt-potassium nitrite, a permanent pigment with a brilliant golden-yellow transparency useful for glazes and for tinting. Cobalt yellow is not used in opaque layers, where it has a dull tannish hue of no particular value. Discovered in Breslau, Germany, by N. W. Fischer (1848), cobalt yellow was introduced as a paint pigment by Saint-Evre in Paris (1852), and was first sold in England and the U.S. about 1861. It was a welcome addition to the artist's palette, which had theretofore depended on unsatisfactory transparent yellow lakes of doubtful permanence. Cobalt yellow has also been known as aureolin.

cochineal. A red NATURAL DYESTUFF of insect origin, imported into Europe from Mexico as early as 1560. An important article of commerce for four centuries, cochineal was used to make CARMINE and, to some extent, to make SCARLET LAKES, until the introduction of synthetic dyes in the 19th century. One of the few surviving natural dyestuffs, cochineal is still on the market and is used for purposes where low cost is a more significant factor than permanence.

cocking. See CAULKING.

cocobolo or **cocobola.** Wood from any of several reddish South American trees of the genus *Dalbergia*, especially *D. retusa*. Cocobolo is dense, extremely hard, and difficult to carve. It may cause swelling or blisters on the skin of those allergic to its dust or splinters.

coefficient of expansion. In matter, the ratio of increase or decrease in size to increase or decrease in temperature. This physical law, when applied to clays and glazes, explains such defects as CRAZING, which occurs when the glaze does not "fit" the clay body.

coelanaglyphic sculpture. Hollow RELIEF.

coelin or **coeruleum.** Names of Latin derivation used for CERULEAN BLUE.

coffeewood. A South American hardwood obtained from the tree *Caesalpinia granadilla;* also called South American grenadilla and brown ebony. It comes in logs six feet long or longer and a foot or more in diameter.

cogging. See CAULKING.

coil method. The technique of forming a pottery vessel by building up a series of clay "ropes" or "sausages" coiled on top of one another on a flat clay base. Lengths of rolled clay are added until the wall of the vessel is the desired height, after which the piece may be shaped and smoothed by hand. Much of the pottery of primitive cultures was made by the coil method. It is a good technique for beginning potters because it is simple, requires no complicated tools, and provides experience in handling clay.

colcothar. An obsolete name for the artificial red oxides of iron, LIGHT RED and INDIAN RED.

cold chisel. A hard steel rod with a straight, flat, beveled edge at one end.

It is so called because it may be used to cut cold metals when struck with a hammer or MALLET, and to distinguish it from a wood-carving chisel. It is used by sculptors in stone carving. See illustration at CHISEL.

cold cut. See SIMPLE-SOLUTION VARNISH.

cold-pressed oil. Any vegetable oil that has been extracted from seeds or nuts by pressing them without the aid of heat. Up to the 1930's all the best oil colors were made with cold-pressed linseed oil. Since that time, specially refined, modern, steam-pressed oils have been in use, and cold-pressed linseed oil is no longer mass-produced. In the absence of conclusive data on the subject, there is some controversy as to the relative merits of artists' colors made with steam-pressed or cold-pressed oil, as regards their durability, manipulative excellence, and control over the SUEDE EFFECT.

cold-pressed paper. See WATER-COLOR PAPER.

cold-rubber mold. See RUBBER MOLD.

collage. The technique of creating a pictorial composition in two dimensions or very low relief by gluing paper, fabrics, or any natural or manufactured material to a canvas or panel; also, a work of art so produced. An entire work may be executed in collage, but the technique is also used in combination with painting in oil or with other techniques. When heavy three-dimensional objects dominate the composition the work is usually called an ASSEMBLAGE, a term used also for a freestanding construction more closely related to sculpture than to painting.

Collage evolved out of papiers collés, a 19th-century "art recreation"

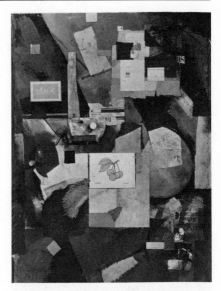

COLLAGE. Kurt Schwitters, *Cherry Picture* (1921), a collage of colored papers, fabrics, printed labels and pictures, pieces of wood, etc., on a painted cardboard background. (*Collection, The Museum of Modern Art, New York, Mr. and Mrs. A. Atwater Kent, Jr., Fund.*)

in which decorative designs were made with pasted pieces of colored paper. It was adapted to the fine arts about 1912–1913, when Picasso and Braque began to incorporate into their Cubist paintings a wide variety of prosaic materials (newspaper clippings, tickets, folded paper, pieces of wood and glass, wire, sand, etc.) selected primarily because they offered new mediums with which to represent planes and textures. Later, when the Dadaists and Surrealists began to combine such materials on the basis of their connotative and associative values, the technique was called collage. The Dadaist series of "Fatagaga" paintings (1919) by Max Ernst and Hans Arp are perhaps the most notable early works in collage. Another outstanding figure in the development of

collage as an art form was Kurt Schwitters (1887–1948).

Collages constructed with inappropriate glues or with pulp paper and materials with fugitive colors are susceptible to rapid deterioration, and the use of intricate and fragile elements sometimes precludes cleaning. Most present-day artists working in the form use the regular POLYMER MEDIUM as an adhesive and give their works a protective coating of mat polymer medium. See also COLLAGRAPH; FROTTAGE; MONTAGE.

collagraph or **intaglio print.** A contemporary INTAGLIO printmaking process in which proofs are pulled from a block similar to that used in RELIEF BLOCK PRINTING, i.e., a block on which the design or pattern is built up in the manner of a COLLAGE, whence the name collagraph. As in relief block printing, a great variety of objects may be adhered to the block, and if they are likely to be affected by the printing fluid, they are treated with a plastic spray. The surface of the collagraph block is inked, wiped to leave ink only in the depressions, and then the block is printed in an etching press. The technique has many variations for creating interesting effects of tone and texture. Sometimes etched or photoengraved plates are made an element of the composition. When constructed to a relatively level surface, with firm materials, a collagraph block may also be used to make embossed prints: Paper that has been dampened is placed over the block and the two are run through the press. Such a block may be wholly or partially inked; it creates embossed areas similar to the effects of BLIND PRINTING.

Cologne, School of. See SCHOOL OF COLOGNE.

Cologne earth. Another name for CASSEL EARTH.

Cologne spirits. See ETHYL ALCOHOL..

colonial spirits. See ETHYL ALCOHOL.

colophony. An old word for ROSIN, now obsolete in English but still encountered in French and German writings. Some say that the word is derived from the Greek for "sound glue," an allusion to its use on violin bows, but it was more likely taken from a place name, Colophon, in Ionia.

color. 1. A sensation aroused in the observer's mind as a response to the stimulus of the radiant energy of certain wavelengths acting on the eye's mechanism. White light contains all the color wavelengths, and, when it passes through a prism, separates into its component parts in the familiar rainbow SPECTRUM. A surface hit by light will reflect certain wavelengths determined by the nature of the surface, i.e., what we call its color, and absorb the rest. For example, a surface of the pigment cadmium red reflects only that portion of the light which produces a red sensation and absorbs all the rest. An alizarin pigment reflects some blue along with the red, causing the observer to see a more bluish red. White reflects all of the light and absorbs none, while black absorbs all and reflects none. All pigments and dyes reflect a certain amount of white light along with that part of the spectrum corresponding to their ostensible color.

Pigments, as well as paints, dyes, and inks, are mixed with one another to create new HUES according to the subtractive system, so called because each element of such a mixture subtracts another segment from the light absorbed. Theoretically, any chro-

84

matic hue can be a obtained by a mixture of the three primaries—red, blue, and yellow. In practice, however, many hues can only be approximated by mixing primaries, so the painter requires a multiplicity of pigments, especially when he wants bright colors and clear tones. A mixture of two or more pigments is apt to be muddy and dull in comparison with a single pigment of the same hue.

The secondary colors are made up of pairs of primaries; they are green (blue and yellow), violet (blue and red), and orange (red and yellow). Tertiary colors are mixtures of three colors. Each color has its complementary, which lies opposite to it on the COLOR CIRCLE. Red and green, blue and orange, and yellow and violet are pairs of complementaries. A given color reflects exactly those wavelengths that its complementary absorbs. A red substance, for example, reflects exactly those wavelengths that a green one absorbs. In addition, a color gives a greater degree of color contrast to its complementary than to any other color.

Colored lights, as opposed to pigments and dyes, conform to the system of additive color mixture. In colored light behavior, the primary colors are red, green, and blue. Beams of these three colors projected together will produce white light. The additive system is of more interest to color photographers than to painters. See also CHROMA; CHROMATICITY; CHROMATIC COLOR; COLOR COMPARISON; COLOR NOTATION.

2. A paint prepared expressly for artists' use. Artists' colors are customarily put into tubes, jars, or cakes and sold in a useful assortment of hues. The types of artists' colors available include OIL COLORS; WATERCOLORS; TEMPERA COLORS; GOUACHE COLORS; CASEIN COLORS; POLYMER COLORS; DESIGNERS' COLORS; and POSTER COLORS.

Colorado Yule Statuary. A fine-grained American MARBLE, suitable for sculpture. It is pure white, although some grades of Colorado Yule are clouded with gray.

color chart. A group of chromatic samples assembled to illustrate a scheme of color nomenclature or classification, to demonstrate a color theory, or to show the colors available in a manufacturer's line of goods.

color circle. A circular arrangement of the hues of the SPECTRUM in the order in which they appear in nature.

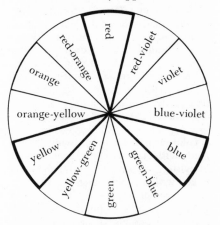

COLOR CIRCLE. Primary colors are those within the heaviest lines. Any pair of hues opposite each other are complementary colors. The three complementaries of the primary colors are called secondary colors. The remaining three pairs are intermediate colors.

The WARM COLORS lie within the half circle that contains red and yellow, the cool colors within the half that contains green and violet. COMPLEMENTARY COLORS appear opposite each other. See also COLOR WHEEL.

color comparison. Three methods are in use for evaluating color differ-

ences: visual examination, use of the SPECTROPHOTOMETER, and use of the COLORIMETER. An experienced person can evaluate color properties by observation alone with sufficient accuracy to serve many practical purposes (see RUB-OUT). The use of color charts, cards, and swatches is widespread. But because color is a subjective phenomenon, total accuracy and precise results can be obtained only by laboratory measurement. In recent years electronic circuits have been used instead of the human eye to observe the results of such measurement.

colored cement. White Portland cement or concrete to which LIME-PROOF PIGMENTS have been added. In one technique of outdoor mural decoration, such cements are troweled flat or modeled in relief. Durable cement colored with permanent pigments is a practically indestructible art and decorative medium for outdoor use.

colored pencil. A drawing pencil made with chromatic pigments instead of with graphite. The pigments are mixed with a clay binder, and the pencils are manufactured in the same way as LEAD PENCILS. A number of brands of colored pencils are sold, so that a wide spectrum of hues is available, but because few brands are labeled with the names of the pigments they contain and since the majority of these pigments are not approved for artists, colored pencils are not recommended for fine-arts purposes. Special varieties, such as those made with water-soluble dyes, are also available. They are used like ordinary colored pencils, and the result is then gone over with a wet watercolor brush to blend tones and create the effect of washes. Because they contain soluble dyes, they are never suitable for permanent work.

colored prints. See COLOR PRINTS.

colored resins. Highly colored resins sometimes used as ingredients in red, yellow, and orange colored VARNISHES. The yellow resins used for coloring varnishes are GAMBOGE and yellow ACCROIDES; for red, DRAGON'S BLOOD and red accroides are used. Transparent colored varnishes are not used in fine-arts painting because the colors are not sufficiently permanent and because they cannot be manipulated to give uniform or controlled effects. However, they are sufficiently permanent for lacquering or toning gilded frames and for other decorative purposes. In recent times, oil- or lacquer-soluble dyes have largely supplanted colored resins. When the effects of a transparent coating are needed in a painting, the artist uses a GLAZE of such permanent transparent pigments as ALIZARIN CRIMSON; COBALT YELLOW; and HANSA YELLOW.

colored sculpture. See POLYCHROME.

color effect. The total appearance of a color, including all of its color properties and physical properties, as vividness, opacity, and value. The term is frequently used in reference to the suitability of a particular color for a specific use.

colorimeter. A laboratory device for measuring or specifying color by comparison with synthetized colors. The typical colorimeter has a built-in, standard light source, three colored filters, photoelectric cells or photo-tubes, a standard reflecting surface and, in modern types, photoelectric cells and electronic circuits to replace the human eye as the receptor and thus speed up results. The results of a colorimeter examination are expressed as CHROMATICITY coordinates.

colorimetry. The science of measuring color. See COLORIMETER; SPECTRO-

86

PHOTOMETER; COLOR COMPARISON; CHROMATICITY; TRISTIMULUS VALUES.

coloring power or **staining power.** British terms for the pigment property known in the U.S. as TINTING STRENGTH.

colorist. A painter whose most outstanding quality is his successful use of color; one who has mastered color as a major means of expression.

color lithography. A multicolor lithograph is made from a series of lithograph stones, one for each basic color to be printed (see COLOR PRINTS). These so-called color stones are made from a keystone the artist first prepares and processes as though his color sketch were to be a black-and-white print (see LITHOGRAPHY). The drawing on the keystone may be complete or it may be entirely linear, with the shading to be reproduced in the proofs done later on the separate color stones. The color stones are made by pulling several proofs from the keystone on a special transfer paper. To transfer the master drawing to the color stones, the backs of these proofs are dusted with powdered red chalk or sanguine Conté crayon, which allows them to be traced onto the stone surfaces, producing nonprinting red-chalk drawings. The respective color area of each stone is then drawn in with LITHOGRAPHIC CRAYON, TUSCHE, or both, and processed as if for black-and-white lithography, except that the final printing is done with a colored printing ink. The successive impressions of the color stones are kept in REGISTER with the aid of REGISTER MARKS that were placed in the margin of the keystone and transferred to each color stone. The first major artist to exhibit a color lithograph—the only work he did in this medium—was Edouard Manet. He used seven stones for

Punchinello (1874). Slightly more than a decade later Henri de Toulouse-Lautrec discovered the medium, and it became "the passion of his brief life." Color lithography remains a very popular graphic-arts technique today. See also CHROMOLITHOGRAPH; OLEOGRAPH.

color notation. Any numerical system of classification and identification of colors according to their optical properties, as HUE, VALUE, and SATURATION. Such notation, expressed in precise, scientific terms, is invaluable for technical and scientific use, although hue designation is a more appropriate system of nomenclature for everyday use, as in reference to the products of commerce or fashion. The two most widely used systems of color notation are the MUNSELL SYSTEM and the OSTWALD SYSTEM. Other systematized color lists and charts are the Plochere Color System, the *Atlas de los Colores* (1947), and the Maerz and Paul *Dictionary of Color* (1951).

color oxides. Term used in ceramics for coloring ingredients, most of which are metallic oxides. See CERAMIC COLORS.

color prints; colored prints. The term *color prints* refers to printmaking processes in which a separate block, stone, plate, or silk-screen stencil is inked and printed for each basic color that appears in the multicolor proofs. A color print may also contain additional colors made by overprinting the basic colors used. Prints made by a single impression, with the color added by a separate process (by hand, POCHOIR, roller, or solid, uncarved wood blocks), are known as *colored prints*. Lithography (see COLOR LITHOGRAPHY) and woodcut are well suited to multicolor printing, and silk screen is seldom used for anything but color work. Intaglio plates are almost

always printed in black and white, although single-color intaglio prints (i.e., a colored ink, especially blue or brown, is used instead of black) are sometimes made. Multicolor etchings are infrequently seen. The only metal-plate techniques widely used for color printing are aquatint and mezzotint, both of which emphasize tonal masses rather than line. Although there is no limit to the number of colors that may be used in lithographs and woodcuts, artists generally limit them to two, three, or four color impressions plus secondary color effects from overprinting. The aesthetic criteria and practical considerations that impose these limitations on lithography and woodcut do not, however, apply to silk screen, whose color and textural effects are closely related to those of painting and whose range of color effects is unlimited.

In all multicolor graphic-arts processes except serigraphy (silk screen), the separate color blocks, stones, or plates from which each color impression is pulled are made from the KEY BLOCK, keystone, or key plate that the artist prepares first from his color sketch. He processes the printing surface of this "key" and pulls several black-and-white proofs from it. These proofs, which show the REGISTER MARKS that the artist has indicated on the "key," are used to transfer the master drawing to the individual color blocks, stones, or plates in such a way that all the impressions of these separate color printing surfaces will be in REGISTER. The "key" is sometimes also used itself in printing. Although no such key is used in silk screen, the artist's original drawing serves the same function in the production of separate stencils for each color to be printed. The drawing is placed in the register guides on the bed of the silk-screen apparatus; the screen is lowered upon it; and the parts of the drawing to be printed in any one color are traced onto the screen, which is then treated to make that particular color-run stencil. Serigraph stencils are also registered in this way for alignment in printing. See also CHIAROSCURO WOODCUT; PROGRESSIVE PROOFS.

color properties. A term used in describing or evaluating the color characteristics of a pigment, as distinguished from the rest of its physical, chemical, or structural qualities, which are known as pigment properties.

color scheme. The dominant colors used in a limited area, such as a picture or a decorated room, conceived as imposing a discipline on the whole. For example, the color scheme of an autumn scene might be red and gold, that of a misty scene blue and gray.

color sketch. A sketch done in color with pastel, watercolor, or oils. Color sketches are often made as preparation for a landscape painting. Such factors as changing weather and shifting light make it very difficult for a landscape artist to paint from a particular scene for more than a few hours, an insufficient period of time for most painters to execute a carefully worked-out, full-sized painting. Unless, therefore, the painter can return to the same site at the same time on successive days when the weather is the same, he needs a sketch if he wants to capture the setting's actual effects of color, light, and movement, in order to incorporate those effects in his final work. Many landscape painters, however, do not use such color sketches but get along with pencil drawings and written notes (see NOTE). Other painters can keep on painting through changes in light and weather but adhere closely to their original perceptions. See also POCHADE.

color stability. Technical term for the property of resistance to change of color (fading, darkening, or hue variation).

color triangle. See CHROMATICITY.

color wheel. A rapidly spinning vertical wheel on which colored paper disks are mounted. It is used for various experiments in the optical mixture of colors. If the entire color spectrum is put on a disk and spun rapidly, it will appear white in accordance with the additive behavior of spectral colors.

colossal. In figure sculpture, larger than twice life-size. See also HEROIC.

Columbian spirits. See METHANOL.

combed decoration. A method of decorating clay forms. A rakelike tool is used to draw parallel lines through glaze or plastic clay.

commercial artist. An artist whose work is commissioned for such uses as advertising, illustration, and the design, embellishment, or decoration of industrial products. Such art must meet the standards and requirements of its user and generally is subject to his refusal. The term is used principally to distinguish the commercial artist from the fine-art or creative artist, whose work is primarily done as an independent aesthetic, emotional, or intellectual expression. The distinction is professional or vocational rather than pejorative, for a useful art can be of high aesthetic content and accomplishment, and the line between the two in such ventures as illustration and portrait painting cannot always be sharply defined.

Commercial Standard for Artists' Oil Paints. See PAINT STANDARD.

Commission Internationale de l'Eclairage. The International Commission on Illumination. This is the authority that in 1931 established the present system for specifying color by mathematically defining each color sensation with tristimulus values obtained by spectrophotometry.

compass. A mechanical drawing instrument for describing circles and arcs, usually consisting of two hinged legs or a rod with sliding points that adjust for different diameters. A bow compass, the most common type, has two legs hinged at the top. One leg ends in a sharp steel point, the other in a holder for a ruling pen or a pencil. Both holder and point ends are replaceable. The beam compass, also frequently used by draftsmen, consists of a rod with a point fixed perpendicularly at one end as a pivot and a drawing point, ending with a pen nib, attached so that it slides along the rod and can be fixed at any point. Both types can be used as DIVIDERS. There also are several different kinds of compasses for special purposes, among them the compass cutter for cutting perfect circles from paper.

compass cutter. A device for cutting circles from paper, cardboard, etc. It is constructed like a draftsman's COMPASS, but a razor-sharp cutting edge replaces the pen or pencil.

compensating planimeter. See PLANIMETER.

complementary color. One of a pair of colors usually considered to be in extreme contrast to each other. Red and green, yellow and violet, and blue and orange are pairs of complementaries. The complementary of a PRIMARY COLOR is made by mixing the other two primaries: e.g., green (yellow and blue) is the complementary of red. The

complementaries of intermediate colors are shown on the COLOR CIRCLE.

composite pigment. Any PIGMENT that contains more than one basic ingredient, as cadmium-barium yellow, which contains both cadmium sulfide and barium sulfate coprecipitated. Also, any mixture of pigments, as PERMANENT GREEN (phthalocyanine green plus cadmium yellow), used by manufacturers of artists' materials to supply a pigment with properties or advantages that cannot be obtained from a single pigment.

composite white. An artists' color containing a mixture of white pigments, usually TITANIUM WHITE and ZINC WHITE, in proportions of 40 to 60 per cent of either. Since the 1920's, experience with white house paints has shown this combination to be superior in durability of paint film to either of its ingredients used alone. The PAINT STANDARD permits composite white oil color to be sold under a proprietary or trade name, provided that the label indicates the pigments used. Trade names include Permalba, Superba white, Mixed white, PERMANENT WHITE, and Ultra white.

composition leaf. See DUTCH METAL.

concave relief. Hollow RELIEF.

conceptual color. Color used by a painter for reasons other than reproducing the color he sees, e.g., to express a meaning, depict the effects of reflections or shadows, or conform to a theory or doctrine.

concours. French for "competition," "meet," "match," or "tournament." In an art school, an exhibition of selected students' work at the end of a semester and, in some schools, an exhibition of the results of a competitive examination. See HORS CONCOURS.

concrete. A mixture of Portland cement, sand, and crushed stone, used as a building material. Cast concrete has also been used by sculptors.

cone, ceramic. See PYROMETRIC CONE.

cone of vision. The field of vision of the observer of a work of art. The cone of vision may be thought of as an infinite number of sight lines radiating from the eye, or POINT OF STATION, in a conical pattern, although in reality the rays of light come to the eye from the subject. See illustration at PERSPECTIVE.

confluent colors. Areas of color that merge or gradate into one another.

conservation. The correct term for the reconditioning and preservation of works of art; the practitioner is called a conservator. Formerly such work was known as restoration and its technicians as restorers. But now the term restoration properly refers to only one aspect of the field, the replacement of missing parts and the filling in of missing areas in a damaged work of art. It is still correct, however, to say that a work treated by a conservator has been restored. Modern conservation is performed on a high scientific and ethical plane. Museum technicians and many private conservators enjoy the benefits of modern equipment and techniques, new advances in knowledge through research, and international cooperation. See also CRADLING; INPAINTING; LINING; PARQUETAGE; RESTRAINER; STOP; STRIP; TRANSFER.

consistency. The condition or state of a substance defined by its qualities of firmness, softness, and resistance to movement either by deformation

(PLASTICITY) or by flow (VISCOSITY, MOBILITY, or fluidity). The branch of physics that pertains to these properties of materials is called rheology. In modern artists' OIL COLORS, the standard consistency is described as *short* or buttery. Although painters always desired this quality, the current practice of using very short, paste-like paints began around 1860 when the more emphatic preference of painters (especially the Impressionists), coupled with the introduction of improved paint-grinding machinery, made this consistency standard. To employ the techniques and manipulations that require more fluid colors, a painting MEDIUM must be added to the modern tube color. The painter can thus choose between a short color to be pushed about with stiff bristle brushes or a more flowing color to use with soft ones. The more flowing color must retain enough of the short quality for the brushstrokes not to run or drip. Each pigment has its own effect on the consistency of an oil color. Some, such as raw sienna, yield smooth, buttery pastes; others, like ultramarine, tend to produce a sticky or stringy consistency. The older painter was familiar with these differences and adjusted his painting manipulations accordingly, but the modern painter has become accustomed to having all colors squeeze out of their tubes with a uniform, standard, buttery consistency. The manufacturer accomplishes this result by scientific control of GRINDING procedures and the judicious use of STABILIZERS and PLASTICIZERS.

constant white. BLANC FIXE used as a pigment in GOUACHE and designers' colors.

construction. The art of building or erecting; also, an object that is built or erected; a structure. In sculpture, a construction is a work that is put together out of different pieces, rather than cast, modeled, or carved. An ASSEMBLAGE is one type of construction.

construction paper. An inexpensive colored paper available in a large assortment of hues, used for innumerable cutout and design purposes. Its colors are not sufficiently permanent nor is the paper itself durable enough for use as a fine-arts material.

Constructivism. A nonobjective art movement that began in Russia and had far-reaching effects on modern art. It first appeared in the work of Vladimir Tatlin (1885–1953) around 1913, as a development of Cubist relief constructions, and was first called Tatlinism. Its theorists did not name it Constructivism or fully establish its principles until 1921. Constructivist work utilized materials such as iron, tin, wood, glass, and plaster in its attempt to bridge the gap between everyday life and art. An early name for it was production art, and one of its aims was to revolutionize industrial design by creating a body of artist-engineers. Tatlin came to believe that art itself was outmoded, although the brothers Antoine Pevsner (1886–1962) and Naum Gabo (1890–), who were to bring Constructivism to the West, felt that it still had a place in society. Among the principles of Constructivist art in its nonfunctional form were dynamism and an integral use of space. Gabo started making "kinetic models" and Alexander Rodchenko (1891–) made Constructivist mobiles in 1920; Tatlin's model for a proposed monument to the Third International was also created in 1920. Another important figure in the movement was El Lissitzky (1890–1941). Constructivism and SUPREMATISM were very closely related; most of their early adherents belonged to both

groups. During the four years following the Revolution of 1917, the Constructivists and other progressive, experimental artists were at first encouraged by the Soviet government to reorganize the artistic life of the country, and they set up art schools and museums. When experimental and abstract art were proscribed in 1922 (see PROLETCULT), they left Russia for France and Germany to continue the movement and contribute its principles to the mainstream of abstract art.

contained shadow. The shaded area on a depicted three-dimensional figure or object on the side that is away from the supposed light source. A contained shadow is depicted as lying within the object, whence its name, as distinguished from a cast shadow, which is thrown by an object onto another surface. See illustration at CAST SHADOW.

Conté crayons. A widely known, long-established trade name of a brand of French crayons in the form of square sticks and wood-encased pencils. Conté crayons are made of a unique compressed compound of pigments and a binder. Their composition and properties sufficiently resemble those of chalk and hard pastels for them to be frequently used in chalk and hard-pastel drawings. Conté crayons are completely grease-free, which makes them useful in lithography for drawing lines on the stone that will not appear in the proofs (as for squaring, ruling guide lines, etc.). These crayons are available in sanguine, the most popular shade, and in sepia, white, and three grades of black—soft, medium, and hard. They are named after Nicolas Jacques Conté, inventor of the modern graphite pencil.

content. The subject matter or MOTIF of a work of art and its intellectual, aesthetic, spiritual, or narrative values considered apart from the artist's formal accomplishment or the excellence of his technique. A work of art can be viewed as consisting of two elements, FORM and content.

contour. The outline or periphery of a figure or object; the line that bounds or delimits a form or an area. See also CONTOUR DRAWING.

contour drawing. A method of drawing popularized by Kimon Nicolaïdes in his book *The Natural Way to Draw* (1941), which presents it as an effective training aid or discipline. The student, fixing his eyes on the outline of the model or object, draws the contour very slowly in a steady, continuous line without lifting his pencil or looking at the paper; his eyes slowly

CONTOUR DRAWING AND OUTLINE DRAWING. Still life rendered by contour drawing (left) and in outline (right).

follow the outline of the thing that he is drawing in unison with his pencil. The student may look at his paper to place an internal feature, but once he has begun to draw it he does not glance down, but follows the same procedure as for the outline. A well-done contour drawing frequently has sufficient quality and character to be preserved as a work of art. An OUTLINE DRAWING, according to Nicolaïdes, is "a diagram or silhouette, flat and two dimensional," while a contour "has a three-dimensional quality; that is, it indicates thickness as well as the length and width of the form it surrounds. We do not think of a line as a contour un-

less it follows the sense of touch, whereas an outline may follow the eye alone."

contrapposto. In figure sculpture, a balanced but asymmetrical attitude in which the figure stands poised with most of its weight on one leg, called the engaged leg, and with the vertical axis of the body in a slight S-curve. This attitude first appeared in statues of the CLASSICAL PERIOD in Greece. It was copied and much admired by Italian sculptors of the Renaissance, who gave it its name and considered it the epitome of harmony and balance in a standing figure.

CONTRAPPOSTO. Marble torso of a Roman copy of a late fourth-century B.C. Greek statue of Eros, perhaps the Eros of Parion by Praxiteles. (*The Metropolitan Museum of Art, Fletcher Fund, 1924.*)

conversation piece. 1. In painting, a picture of a group, especially a family, in its familiar surroundings, indoors or out. John Smibert's *Bermuda*

CONVERSATION PIECE. *The Bermuda Group* (1729) by John Smibert, oil on canvas. (Yale University Art Gallery, Gift of Isaac Lothrop of Plymouth, Massachusetts.)

Group (*Bishop Berkeley and His Entourage,* 1729), Yale University Art Gallery, is a good example.
2. In general usage, a displayed *objet d'art* sufficiently unusual or attractive to evoke interest and lead to discussion.

cool colors. Those colors in which blue is dominant, including greens and violets. Bluish grays are called cool grays. The term may be used in a relative sense, so that raw umber is said to be cooler than burnt umber, although both are warm colors. All cool colors lie in the green-violet half of the COLOR CIRCLE. See also WARM COLORS.

copaiba balsam. A viscous, fluid oleoresin obtained from several species of tropical trees of the genus *Copaifera*. There are two general types of copaiba balsam: Maracaibo balsam, from Venezuela, and Pará balsam, with more volatile ingredients and fewer solids, from Brazil. Copaiba balsam is a very slow-drying material, and is no

longer used as an ingredient of painting vehicles and mediums because of its instability. It is employed in the conservation of oil paintings as a RE-STRAINER for cleaning solvents and as a conditioner or "regenerator" of aged paint films, especially in the now-discredited Pettenkoffer method. Most authorities doubt its effectiveness in treating the surface of paintings, but it is still encountered in proprietary liquids sold for that purpose. See BALSAM.

copal. A name given to several species of tree RESINS, both fossil and recent; unless preceded by a designation of the place of origin or the name of a tree, it is not a specific term. The hard fossil copals melt at high temperatures and when cooked with oil produce strong, durable SPAR VARNISHES and vehicles for deck and machinery enamels, but since the late 1930's they have been replaced for such purposes by synthetic products with superior properties, notably the PHENOLIC RESINS. Hardest among the copals is Congo copal, a clear, almost colorless fossil resin dug from the ground and the beds of streams. Next are the East African copals known collectively as animé. Sierra Leone and kauri copal are of medium hardness. A distinct and separate variety, Manila copal, is a softer resin, soluble in alcohol.

During the 19th century artists used copal varnishes both as ingredients in painting mediums and as picture varnishes. Much of the cracking and darkening of 19th-century paintings has been attributed to their use. Copal does not meet one important requirement for a PICTURE VARNISH—easy removal from paintings with mild solvents. Although it still has its proponents and is widely available in the art supply shops, hard copal varnish has been rather generally discredited by paint technologists and mu-

seum workers. The hard fossil copals require expert treatments by experienced varnish makers in order to dissolve properly in oils. These include a thermal treatment known as GUM RUNNING. The 19th-century varnish makers developed this difficult trade to a high degree.

copolymer. A polymer (see POLYMERIZATION) that contains two or more different types of monomer molecules, as, for example, a synthetic resin that contains both acrylic and vinyl groups within its chemical formula. Such a material is used in some POLYMER COLORS in place of the usual straight acrylic type.

copper. A metallic element which is malleable and ductile and has a characteristic reddish-brown color. It is used in the manufacture of such alloys as BRASS and BRONZE, which are harder and do not corrode as easily. When exposed to or combined with oxygen, copper takes on a greenish PATINA.

copper blue. One of the many names for BREMEN BLUE.

copperplate engraving. See ENGRAVING.

Coptic art. Art of the early Christians of Egypt, especially during the 4th–7th centuries, when Egypt was part of the late Roman and, later, the Byzantine Empire. Coptic wall painting was flat and highly stylized, as was BYZANTINE art in general, although the Coptic work also had roots in the realistic Fayoum portraits of the 1st–4th centuries. The Copts also produced woven tapestries employing decorative patterns of plant and bird forms in wool and linen, as well as stone and ivory carvings, illuminations, and pottery.

copy. 1. Any reproduction or facsimile of an original work of art, done in the same art form although not necessarily in the same size or with the same materials. See also FORGERY; ORIGINAL; REPLICA; REPRODUCTION.

2. Any one of a series of reproductions, especially printed reproductions, of the same original work.

3. In printing, any written or typed text or illustrative material (as a picture, photograph, or drawing) that is to be reproduced.

4. Less commonly, a model, a subject, or an original work of art considered as a PROTOTYPE.

copying press. A heavy cast-iron press that was widely used in offices before the day of typewriter carbons to make copies of letters and documents that were written in a special copying ink. It is now almost exclusively used by artists, who find many uses for this device. It may be used to press and flatten objects with a large surface area, to exert pressure on paper and boards in pasting and gluing operations, and to flatten wrinkled or buckled paper after dampening it. In the graphic arts it can function as a press on which proofs can be pulled. The copying press is made in several sizes, the largest having a bed of 20 by 24 inches. It is operated by turning a horizontal wheel at the top, which by means of a screw applies downward pressure on a broad, flat plate that in turn applies pressure to whatever is placed on the bed of the press.

COPYING PRESS

coquille board. An ILLUSTRATION BOARD whose working surface has a dotted, stippled, or otherwise embossed texture. When it is drawn upon with pencil or crayon, it produces a HALFTONE effect that makes it a useful, less expensive substitute for the halftone process plate. See also SHADING FILM.

corail. See PADOUK.

cordate. Heart-shaped.

core. In sculpture, the solid internal portion of a MOLD for casting a hollow piece of sculpture. The amount of space left between the core and the mold determines the thickness of the cast. The core is made of FOUNDRY SAND in both SAND CASTING and the LOST-WAX PROCESS.

cork black. Another name for Spanish black, a variety of VINE BLACK made by burning cork.

Cornish stone or **Cornwall stone.** A decomposed feldspathic rock found in England and used as a FLUX in clay bodies and glazes. It is very similar to PETUNTZE.

Coromandel. See EBONY.

coroplast. Literally, "doll maker." In ancient Greece, a sculptor who created figurines of clay or terra-cotta.

corporation piece. A portrait of a member or a group portrait of members of the organization that commissioned it. Perhaps the most famous is Rembrandt's *The Company of Captain Franz Banning Cocq* (1642), better known as *The Night Watch.*

correction white. A quick-drying, fluid white paint of high HIDING POWER, used in drawing to obliterate areas of ink that require alteration. It contains either a lacquer or a synthetic binder and is commonly sold with a special volatile thinner. Correction

white is designed to supplant the water-medium whites used by illustrators, designers, and others who work on paper for reproduction. It is not intended for use in permanent works of art.

corrosion. A gradual disintegration or transformation by a chemical process. The oxidation of iron, producing rust, and of bronze, producing PATINA, are forms of corrosion.

Cosmati. A school of marble workers, mosaicists, and sculptors active in Rome from the 12th to the 14th centuries. They enriched many existing churches and other buildings with their glass and marble mosaic pavements, altars, and other church furniture and decoration. The Cosmas and Cosmatus families, two of several families working in the same style, gave the group its name. The Cosmati's practice of signing their work represented a departure from the anonymity of the medieval craftsman. The term Cosmati work is often used to designate the decorative art of 13th-century Rome in general, especially mosaic work in marble with inlays of glass or colored stones.

cosmorama. Any of several 18th- and 19th-century techniques for exhibiting characteristic scenes or views of various countries. The paintings were reflected from mirrors and viewed through lenses. See also DIORAMA; PANORAMA.

costruzione legittima. See LEGITIMATE CONSTRUCTION.

cotton canvas. A low-quality CANVAS, made of cotton and widely used as an inexpensive substitute for linen canvas. It has neither the boldness of weave nor the top-quality priming that is found on linen canvas, nor is its ground so well anchored. Homemade canvas of extra-heavy cotton duck, carefully prepared, is believed by some to be adequately durable; others hold that the hygroscopic nature of cotton and its relatively poor receptivity to grounds and sizings make it inferior to linen in every respect. The appearance of the duck weave is quite different from the traditional textural effect of linen.

couch. A term for layer, underlayer, or substratum. Grounds for painting are no longer called couches in technical usage.

counterproof. A reverse impression taken from a print or drawing by passing it through an etching press with a sheet of damp paper. Some of the ink of the print or drawing is drawn off by and transferred to the damp paper, duplicating the original in mirror image. A graphic artist may make a counterproof of an engraving or etching as an aid in correcting his plate, since it allows him to see a printed duplicate of the plate, on which the drawing or design is also in reverse. The process has been used to make forgeries of valuable prints and drawings, but the weakness of the ink and the left-handed composition tend to give such copies away. A counterproof may also be made of a MONOTYPE impression by pressing a sheet of paper against the monotype print while the paint is still wet.

covering power. The surface area that a definite volume of paint or varnish will cover acceptably in one coat. In industrial coatings, covering power is expressed in square feet per gallon. The term is sometimes confused with HIDING POWER.

C.P. 1. Chemically pure. A chemical so labeled has been made as free

as possible from impurities, and is suitable for laboratory use.

2. Cold-pressed. See WATERCOLOR PAPER.

crack. In painting, any separation in the paint layer, the ground, or the support, perpendicular to the surface of the picture; not to be confused with CLEAVAGE. A crack may be hairline or wide, straight, radial, or spiral, individual or part of a network of reticulations. Cracks may be caused by accidental blows, long storage at low temperatures, sudden changes in temperature, or defects in the materials.

crackle. 1. A network of cracks in a fine, overall pattern on the surface of a painting, usually resulting from the embrittlement of the paint film as it ages. Crackle is sometimes called by its French name, craquelure.

2. Any of several reticulated patterns of cracks in ceramic glazes; they are deliberate effects, intended to enhance the appearance of the glazed surface.

cradle. 1. A brace of hardwood ribs and crosspieces attached to the back of a painted wooden panel to reinforce it and to prevent warping and cracking. See CRADLING.

2. Another name for a ROCKER.

cradling. In the conservation of paintings, a traditional technique for the reinforcement of wooden panels. After the thickness of a damaged panel has been reduced with various tools, rigid strips of hardwood are glued vertically to the rear of the panel at intervals, along the grain of the wood. There are rectangular slots at regular intervals on the undersides of these strips, through which flat strips of the same hardwood are run to form horizontal bracing. These horizontal strips are not glued, but move freely to allow for expansion and contraction of the panel and to preclude future cracking. Cradling, practiced for over 200 years, is still widely used, but some scientific conservators have abandoned it in recent years to experiment with numerous other methods of reinforcement. The term cradling is also commonly applied to the simple reinforcement of a wallboard panel by cementing or gluing it to a completely rigid framework of wooden strips.

craft. 1. Technique or skill, considered apart from the aesthetic aspect of a creation.

2. A constructive manual activity performed by artisans or craftsmen, as distinguished from the specific group of techniques known as FINE ARTS that are practiced by creative artists as aesthetic expressions or as APPLIED ARTS. See ARTS AND CRAFTS.

craquelure. French term for CRACKLE.

crater. See KRATER.

crawl. A synonym for CISSING in popular usage, especially to describe the behavior of a water paint that is repelled by a surface or does not wet it properly (see WETTING AGENT). The term is used similarly in ceramics for a faulty glaze that migrates or creeps, leaving unglazed spots.

crayon. A generic term for any drawing material made in stick form; especially, in the fine arts, a stick of CHALK or material with a chalk base, including CONTÉ CRAYONS, blackboard chalk, and hard PASTELS. The term is also applied to other drawing sticks such as CHARCOAL, GREASE CRAYONS, and LITHOGRAPHIC CRAYONS; it also commonly indicates the wax crayons used extensively by children. Crayons may be made or purchased in round or

square sticks. Some are wrapped with paper or encased in wood.

crayon manner or **chalk manner.** An ETCHING or ENGRAVING technique in which an effect that approximates the texture of crayon strokes is created by the manipulation of various multipoint tools in the etching ground or directly on the plate. The roulette, the MACE-HEAD, and two wider variants of the roulette, the chalk roll and the matting wheel (see ROULETTE), can all be used to create closely dotted lines and areas having the grainy effect of chalk lines, similar to the effect characteristic of lithography. The crayon manner can be used by itself or in conjunction with etched, engraved, or drypoint lines. As opposed to the STIPPLE ENGRAVING, which is printed as a relief plate and is, therefore, essentially a white-on-black technique, the plate in crayon manner is inked and printed as an INTAGLIO plate.

The crayon manner was in particular vogue in 18th-century France, where it was used chiefly to reproduce drawings. Extensive crayon-manner reproductions were made, for example, of Boucher's chalk drawings. Sometimes ink of a red-chalk or bistre tone was used in printing the plates for crayon manner to give the proofs a more autographic quality.

crayon sauce. Pastel in soft cake form, to be applied with a STUMP; also called sauce or stumping chalk. A prominent item in art material catalogs during the 19th century, crayon sauce is no longer in use.

crazing. An undesirable network of small cracks in a ceramic glaze or a lacquer film. In ceramics, this defect occurs when the glaze and the clay body contract at different rates as they cool after firing. Lacquer crazing is due to the inherent defects of a poorly formulated lacquer.

Cremnitz white. A high-quality variety of WHITE LEAD. It is made by a 19th-century process differing from the Dutch process used in making FLAKE WHITE in that its basic raw material is litharge instead of metallic lead. Although the differences between Cremnitz and flake whites are not great, individual artists prefer one or the other for slight variations in handling qualities. Genuine Cremnitz white has been scarce on the U.S. market for some time. It is also known as Kremnitz or Krems white.

crenellation. A continuous angular line pattern, as of a battlement or parapet, that is alternately and evenly depressed and raised. The design has been commonly used since the earliest times to decorate moldings, pottery, textile borders, etc.

creta laevis. British trade name for colored chalk pencils made in an extensive range of colors. They were especially popular in the late 19th and early 20th centuries.

crevé. In ETCHING, a defect caused by over-biting of the plate (see BITING). A crevé may be either lines that are too deeply bitten or a fusing of adjacent lines between which there were to have been spaces. Such defects can be repaired only by resurfacing the affected part of the plate (i.e., by rubbing the area with a SCRAPER, smoothing it with a BURNISHER, and re-leveling the surface by REPOUSSAGE) before re-etching it.

cribbled or **criblé.** Covered with dots or small punctures; a technique of decorating wood and metal surfaces. Also, of an engraving, flecked with white dots produced by a plate pocked

with holes, in the technique called *manière criblée* (see DOTTED MANNER).

crimson. Now a hue designation for a deep-red color rather than a pigment name. The word crimson is derived from kermes, a dyestuff of insect origin from which the obsolete pigment crimson lake was made.

crimson lake. A deep, transparent ruby-red LAKE pigment with a bluish undertone, made from kermes, a natural dyestuff of insect origin; also known as Florentine lake. Crimson lake was used by the ancient Egyptians, Greeks, and Romans; carmine, a better pigment, introduced in the 16th century, became its chief competitor. Until it was superseded in the 19th century by madder and alizarin lakes, crimson lake continued to be used by artists for transparent ruby-red and rose-pink effects.

criosphinx. See SPHINX.

crocus martis or **crocus martius.** A dark red ferric oxide, used as a colorant for ceramic glazes and, industrially, as a metal polish; also, an obsolete term for red iron oxide pigments of the most bluish shades, as Indian red, caput mortuum, and Mars violet.

croquis. A French term for a preliminary SKETCH done in pen, pencil, or crayon to get down on paper the concept of a projected work of architecture, sculpture, or painting. Because it serves to fix the impression of a scene, object, or figure that the artist has seen or to indicate the building or the subject that he imagines, the croquis has been called the stenography of painting and drawing. It utilizes broad energetic lines and strokes to capture the characteristic feeling of the thing drawn. The term is little used in English except in academies and art schools, where it serves to designate a sketch class without instruction.

cross. A figure composed essentially of two or more intersecting bars. The cross in its simpler forms has been used in art from prehistoric times, usually with a symbolic, and often a sacred, significance. The ANKH, or crux ansata, was widely used in Egyptian and Assyrian art. The LATIN CROSS is the form usually depicted in scenes of the crucifixion of Jesus, although the TAU CROSS has an older tradition of being shown for that purpose. Certain variations of the cross came to have special religious and liturgical associations in the Church. Others lent themselves to architectural use in medieval churches. The greatest proliferation of forms, however, developed in the art of heraldry at a time when noble families were eager to have crosses appear in their escutcheons, originally to indicate that their ancestors had taken part in the Crusades. For forms of individual crosses see illustration and separate entries: AVELLAN CROSS; CALVARY CROSS; CELTIC CROSS; CROSS CLECHÉE; CROSS-CROSSLET; CROSS FITCHÉ; CROSS FLEURY; CROSS FORMÉE; CROSS FOURCHÉE; CROSS GRINGOLÉE; CROSS MOLINE; CROSS POMMÉE; GREEK CROSS; MALTESE CROSS; PAPAL CROSS; PATRIARCHAL CROSS; POTENT CROSS; QUADRATE CROSS; ST. ANDREW'S CROSS; TREFLED CROSS. See also CHI-RHO. See illustration on next page.

cross ancrée. See CROSS MOLINE.

cross botonée. See TREFLED CROSS.

cross bourdonée. See CROSS POMMÉE

cross clechée. A cross with pointed arms that is "voided," i.e., drawn in outline with the interior hollowed out and the background showing through. The three points of the triangle formed

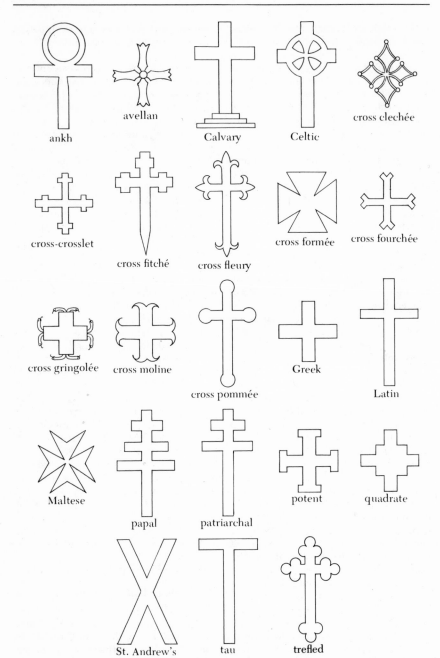

ankh

avellan

Calvary

Celtic

cross clechée

cross-crosslet

cross fitché

cross fleury

cross formée

cross fourchée

cross gringolée

cross moline

cross pommée

Greek

Latin

Maltese

papal

patriarchal

potent

quadrate

St. Andrew's

tau

trefled

by the end of each arm are often ornamented with small circles, or "pearls." The form received its name from the resemblance of the decorated arms to the handles of medieval keys. See CROSS for illustration.

cross-crosslet. A cross with short crossbars intersecting the arms near the ends. It is occasionally called the holly cross or German cross. It should not be confused with the potent cross, which has crossbars at the ends of the arms. Both forms are common in heraldry. See CROSS for illustration.

cross fitché. A cross with the upright shaft pointed at the bottom. This form of cross, so shaped to enable it to be driven easily into the ground, found its way into heraldry. The other arms of the cross may have any of the standard forms. See CROSS for illustration.

cross fleuronée. See TREFLED CROSS.

cross fleury or **cross flory; cross fleuretté.** Crosses with the arms ending in conventionalized fleurs-de-lis. In the first form the flower is represented as a part of the arm; in the second it seems to be an applied decoration at the end. See CROSS for illustration.

cross formée or **cross formy.** A cross with wedge-shaped arms of equal length meeting at their points. The sides of the wedges may form concave curves. This cross is also called the cross pattée or patty, and is often confused with the Maltese cross, which properly has V-shaped indentations at its ends. See CROSS for illustration.

cross fourchée. A cross of which the four arms are divided in half at the ends and the halves angled outward to form squat V-shapes. It differs from the cross moline and cross ancrée in that the divided ends are not curved. See CROSS for illustration.

cross gringolée. A cross similar to the cross moline, but with the recurving tongues in the form of serpents' heads. See CROSS for illustration.

cross-hatching. See HATCHING.

cross moline. A cross of which the four arms are each divided at the ends into two pointed tongues curving outward. The cross ancrée is very similar, but the tongues may be longer and more sharply curved. In the cross recercelée they are curved back in the form of ram's horns. These forms are most usually found in heraldry. See CROSS for illustration. See also CROSS GRINGOLÉE.

cross of Iona. See CELTIC CROSS.

cross pattée or **cross patty.** See CROSS FORMÉE.

cross pommée. A cross with balls or circles at the ends of the four arms. The term pommée—literally "appled"— refers to the ornamental balls. Another term for this form is cross bourdonée referring to a pilgrim's staff. See CROSS for illustration.

cross recercelée. See CROSS MOLINE.

cross section. A drawing of the inside of an object or structure, seen as though it had been cut through and the face of the cut were visible. A horizontal cross section of an orange, for example, would show the lines of its segments radiating from a central point; a vertical cross section would show its halves equally divided into segments. A cross section is conventionally indicated with SECTION LINES. See illustration on next page.

CROSS SECTION. Above, horizontal cross section of an orange; below, vertical cross section.

cross-section paper. A type of bond or ledger paper that is ruled into small squares; each square inch, consisting of from 16 to 100 squares, may be outlined with a heavier line. It is intended for use in making charts and graphs. Quadrille paper is a type of cross-section paper that lacks the heavier inch lines. Both may be ruled in either blue or green.

crow quill. The finest of steel drawing pens. The nib of the crow quill is extremely slender and firm, allowing very delicate and precise lines to be drawn. Prior to the production of steel nibs in the early 19th century, the crow-quill pen was actually made from the wing feather of a crow.

crucible. A ceramic pot used for melting metals for casting.

cruciform. In the shape of a cross. Gothic churches characteristically have a cruciform floor plan.

crushed relief. See RELIEF.

crux ansata. See ANKH.

crux commissa. See TAU CROSS.

crux decussata. See ST. ANDREW'S CROSS.

crux immissa. See LATIN CROSS.

Crylla. Trade name for an English manufacturer's line of acrylic POLYMER COLORS and their adjuncts.

cryolite. Sodium aluminum fluoride, a native crystalline mineral used as a flux and opacifier in porcelain ENAMEL.

crystalline glaze. A ceramic GLAZE in which well defined patterns of crystals are formed on firing. The most successful crystalline glaze is made of zinc silicate, but other substances are also used. The creation of such a glaze is complex and exacting.

Cubism. A revolutionary art movement (1907–1914), of which the leading figures were Georges Braque (1882–1963) and Pablo Picasso (1881–). The Cubist style had three stages of development: Facet Cubism, in which the artist started to separate objects or figures into definite, geometrical elements or facets, while placing them in a composition which still showed the influence of Cézanne; Analytical Cubism, in which objects were increasingly broken down and "analyzed" through such means as simultaneous rendition, the presentation of several aspects of an object at once; and Synthetic Cubism, in which the artist was further liberated from traditional reality, appearance, and illusion. Cubism in its early phase was encouraged by the then current Parisian interest in Cézanne, Seurat, and African sculpture. The collage or paste-up

CUBISM. Georges Braque, *Road Near L'Estaque* (1908), oil on canvas. (*Collection, The Museum of Modern Art, New York.*)

technique and the use of such materials as sand and cloth on canvas were Cubist innovations. Despite the enormous hostility with which it was greeted by the world, the Cubist movement was epochal. It was the inspiration or point of departure of many an artist in the next few decades (see ABSTRACT ART). Its innate vigor and productiveness were the result of the intensive collaboration between Picasso and Braque, who were later joined by Juan Gris (1887–1927) and Fernand Léger (1881–1955). See illustrations here and at PRIMITIVE.

cudbear. Another name for ARCHIL.

cupid. See PUTTO.

curcuma. Another name for TURMERIC.

cure. To retard the setting of concrete with wet coverings, a procedure that insures the development of maximum strength throughout its mass.

cursive. 1. A style of calligraphy and printing type imitative of running handwriting but in which the letters are not actually joined.
2. Of design, free-flowing and curvilinear, in the manner of running handwriting.

curtains. One of several terms for the irregular waves and drips that may form in varnish or thin paint that has been applied to a painting while it is in a vertical position. The descriptive names for this and similar defects also include FRILLING or sagging, TEARDROPS, and STREAMLINES.

curve. See FRENCH CURVE.

cushion, gilder's. See GILDER'S CUSHION.

cusp. In architecture and design, the intersection of two arcs, as the point made by two adjacent FOILS in TRACERY and other Gothic ornament.

cut. 1. Varnish makers' term meaning to dissolve resin in a solvent; also, the solution so produced. When preceded by a weight designation, it refers to the concentration of the solution in terms of pounds of resin to each gallon of solvent. For example, the standard damar varnish is a five pound cut.
2. In commercial printing, the block or plate with which an illustration is printed or a photograph is reproduced; also, the print made from such a block or plate.

cut-card work. A decorative technique in metalwork in which a design cut out of a sheet of metal is superimposed on the surface of an object of the same metal, usually around a pro-

tuberance such as a handle or a FINIAL. Cut-card work is used almost exclusively for silver. It was especially popular during the 18th century and is found on French, English, and American silverware of that period.

cutch. A natural dyestuff obtained from the heartwood of various species of acacia and mimosa growing in the East Indies. It is one of the most nearly permanent vegetable coloring matters, used to produce shades of brown, black, and olive. The coloring principle of cutch, a crystalline substance called catechin, can also be obtained from a few other vegetable sources. Cutch is also employed in tanning leather. Other names for cutch are catechu, Japan earth, katechu, cachou, and Bengal cutch. One variety is called gambier or gambier cutch.

cutter. See SIGN-WRITER'S CUTTER.

cutter, compass. See COMPASS CUTTER.

cuttlefish ink. The principal ink of the ancient Romans, made from the ink sacs of cuttlefish and other cephalopods. Sepia comes from the same source.

cyan. A hue designation derived from a Greek word meaning dark blue; applied to deep, saturated blues of greenish undertone (like Prussian and phthalocyanine blues), as distinguished from the relatively purplish ultramarine, and the paler or azure, blues. Cyan is the primary blue of the ADDITIVE SYSTEM of color. The term is more frequently used in color photography than in painting.

cyanine blue. A COMPOSITE PIGMENT made of Prussian and cobalt blues. Cyanine is also the name of a synthetic dyestuff.

Cycladic. Pertaining to the art and civilization of the Cyclades, islands in the Aegean Sea, between 2600 and 1100 B.C. Their art survives in numerous decorated objects, particularly pottery, and in marble figures found in

CYCLADIC ART. Marble statuettes (c. 2500 B.C.) of a woman (left) and a seated man with a harp (right). (*The Metropolitan Museum of Art. Left, Fletcher Fund, 1934; right, Rogers Fund, 1947.*)

graves, especially female idols and statuettes of musicians. The idols, which include the first examples of the life-size female nude, represented the female figure in a spare, elegant form that marked a departure from the heavy-bodied fertility goddesses of earlier times. Because the maritime activity of the Cyclades was far-flung, Cycladic art circulated throughout the Mediterranean and influenced the art of other Aegean cultures, particularly that of Crete (see MINOAN).

cylix. See KYLIX.

cyma. 1. A molding, the profile of which is formed by a continuous line in a double curve. The molding is cyma recta when the concave portion is at the top or, in a picture frame, closest to the picture; it is cyma reversa when the concave portion is at

CYMA. Left, a cyma recta molding; right, cyma reversa.

the bottom or, in a frame, farthest from the picture. Cyma is often used interchangeably with ogee.

2. In design, an S curve or inverted S curve.

Cyprian green earth. A somewhat yellowish variety of GREEN EARTH of high quality. It is mined in Cyprus.

Cyprus umber. The best quality of UMBER, mined on the island of Cyprus; also known as Turkey umber or Turkey brown.

D

dabber. 1. In the graphic arts, a pad of wadded material, usually leather or flannel, with which ink is applied to a block or plate. Dabbers were used in relief printing until the 19th century, when they were replaced by BRAYERS. In the intaglio processes of etching and line engraving a dabber is still used to force ink into the etched or incised lines and area. It is also used in etching to spread the etching ground on the face of the plate. In painting, a dabber made from a wad of absorbent cotton wrapped in cotton sheeting and tied and shaped to form a flat-bottomed bag is used, with a tapping or pouncing motion, for spreading and BLENDING oil colors. The dabber can produce smooth, flawless fields of

DABBER. Leather dabber used in the graphic arts.

color, perfect gradations, and glazes.
2. A bulky, moplike camel-hair brush used for blending in watercolor technique.

Dada. An art movement that began in Zurich during World War I, was named in 1916 by random choice from a dictionary, and spread throughout Europe and America. Its founders were the artist Hans Arp and the writers Tristan Tzara, Hugo Ball, and Richard Hülsenbeck. Its credo, "Everything the artist spits is art," provoked much controversy and outrage, as well as such unusual methods of producing art as doodling or automatic writing. Practitioners of Dada also ascribed artistic qualities to the FOUND OBJECT, the READY-MADE, the COLLAGE, and other historically unacceptable materials and techniques. The movement was antipathetic to traditional styles and materials, an at-

titude that led some critics to consider it "anti-art."

Among the important artists who participated in the Dada movement were Marcel Duchamp (1887–1968), Max Ernst (1891–), Hans Arp (1887–1966), Francis Picabia (1878–1953), Man Ray (1890–), and Kurt Schwitters (1887–1948). Among the remarkable Dada works were *The Fountain* by Marcel Duchamp, a porcelain urinal, illustrative of the Dada aim to exalt the commonplace by taking it out of its usual context; and the same artist's photograph of the Mona Lisa with a mustache, typifying the Dadaists' gleefully iconoclastic attitude toward tradition. See illustration at COLLAGE.

dagger striper. A soft brush with a short thumb-and-finger handle and long hairs that taper from a thick belly to a sharp, scimitar-shaped point. Designed for accurate straight-line striping in decorative work, it has been occasionally used by artists. See illustration at LINERS AND STRIPERS.

damar. A pale, straw-colored resin (sometimes spelled dammar in European and scientific books) gathered from forest trees of the family Dipterocarpaceae in Malaysia and Indonesia. Varieties are named for their shipping points—Batavia, Singapore, Padang, etc. Number One SINGAPORE DAMAR is considered the best for use in artists' materials. Damar is one of the few tree-resins still universally approved for use in PICTURE VARNISH and RETOUCH VARNISH and as an ingredient in painting mediums, emulsions, and encaustic colors. It dissolves in pure turpentine but not in petroleum solvents. See also MATA KUCHING DAMAR.

damascene. 1. In metalwork and sculpture, to inlay one metal with a more precious metal, creating orna-

mental patterns and sometimes even representational designs. Fine wire or thin strips of gold, silver, electrum, or copper are hammered into depressions that have been engraved in the steel, bronze, or iron ground; the inlaid metal is then smoothed and polished. This type of ornamentation is very old. It decorates daggers of the 16th century B.C. that have been found at Mycenae. Damascening was much used by the early goldsmiths of Damascus, whence its name, and is still characteristic of metalwork in the Middle East.

2. To decorate, as fabrics or metal surfaces, with a wavy or watery pattern, like that of objects made with Damascus steel. Damascus steel was specially forged with iron until the two metals were thoroughly mixed, each, however, retaining its identity. Objects made from this hard but elastic composite metal, such as the famous medieval sword blades crafted in Damascus, were lightly etched to bring out the watered pattern. The effect is comparable to the appearance of damask, a damascened fabric that also takes its name from Damascus, the original city of its manufacture.

Danube school. Painters working in various cities of the Danube valley around the beginning of the 16th century. These painters, who included the elder Lucas Cranach, Albrecht Altdorfer, and Wolf Huber, were particularly notable for their imaginative and often romantic use of landscape. A fine example is Altdorfer's *Forest with St. George.*

Davy's gray. A gray pigment made of finely powdered slate. It is no longer in general use.

daylight fluorescent colors. See FLUORESCENT PAINT.

dead coloring. The first broadly stroked application of paint on a canvas or panel. Dead coloring lacks the full intensity of color, textural qualities, and details of draftsmanship that will be supplied by overpainting. The term is rather outmoded in the U.S., where it has been replaced by underpainting or first coat.

de-air. In ceramics, to remove the air from plastic clay preparatory to use. Clay may be de-aired in a pug mill equipped with a vacuum pump or by wedging.

death mask. A facial impression or cast made after the subject's death. Since the Renaissance such masks have been made by oiling the skin of the deceased and taking a plaster cast. The ancient Egyptians made death masks of thin plates of gold. See also LIFE MASK.

decadence or **decadent period.** In the history of an art movement or style, a period of decline in creative excellence, vitality, and originality. Although the artists of such a period are usually regarded as lesser figures than those who represented the movement at its height, the so-called decadence of one style may be, in reality, the period of transition to another, as well as being inherently valuable. The period beginning in the last quarter of the 16th century, known as the Italian Decadence, included such significant figures as the Carracci, Caravaggio, Guido Reni, Domenichino, Pietro da Cortona, and Luca Giordano, whose Baroque realism influenced the French painters of the 17th century.

decadent art. A derogatory term for the works of the so-called "Aesthetic Movement" in England in the last two decades of the 19th century, when both artists and writers evinced a concern with form and beauty rather than content and morality, and were sometimes preoccupied with morbid, neurotic, and occult themes. The drawings of Aubrey Beardsley are representative of this period. See also FIN DE SIÈCLE.

decal; decalcomania. Paper on which a design has been printed in a way that permits it to be transferred to another surface. The paper is usually wetted and applied face down. The printing attaches itself to the second surface and the backing is then stripped away. Industrial or mass-produced ceramic wares are com-

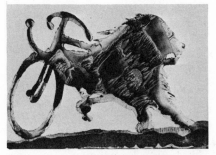

DECALCOMANIA. Oscar Dominguez, *Decalcomania* (1937), gouache. (*Collection, The Museum of Modern Art, New York.*)

monly decorated with transfers of this type. The term decalcomania also covers the process. In SURREALISM decalcomania refers to a process in which an artist spreads gouache on a sheet of paper, lays another sheet on top of it, presses the second sheet in various places, and then strips it off (see LIFTING). This technique produces effects suggesting exotic flowers, mineral deposits, or spongy growths. Max Ernst (1891–) developed this technique to a high degree in oil mediums, beginning a painting with a decalcomania base and then achieving greater definition of form through

brush effects. In recent years, particularly in PSYCHEDELIC ART, decals have been used as adjuncts to an overall artistic effect. See also MONOTYPE.

decorative art. Art serving to ornament or embellish an object that has an ulterior purpose, as distinguished from FINE ART, which exists as an end in itself. Decorative art is a class of APPLIED ART.

découpage. Decoration of a surface by covering it completely with cutout paper figures or designs; also, an object so decorated.

deep color. Any color with a high degree of SATURATION and low VALUE. Full-strength phthalocyanine blue is a dark, deep color, and strong, intense cerise or mauve hues are deeper than pink. A painting in which very little white was mixed with the colors may be called deep-toned.

deep relief. High relief (see RELIEF).

deesis or **deisis.** A depiction of Christ (usually enthroned), with the Virgin Mary and John the Baptist, either in a single painting or in separate, joined paintings. In the many-tiered iconostases that were introduced in the 14th century in Russian churches, the deesis occupied the most prominent place, above the door leading into the sanctuary.

deflocculate. To dissipate lumps or clusters in a mixture, creating a smooth, homogeneous dispersion or fluid suspension. In ceramics, to convert clay into SLIP by adding electrolytes such as sodium silicate and soda ash to produce a suspension of the particles.

degame. A Cuban hardwood obtained from the tree *Calycophyllum candidissimum*. Degame is yellowish to creamy white in color and is sometimes used for carving. It comes in logs 10 inches in diameter and 12 to 14 feet long and is also known as lemonwood. It is one of the lancewoods of commerce.

degraded color. A paint mixed with dulling or graying colors, producing a color below its normal degree of saturation or brightness.

del. An abbreviation of the Latin word *delineavit*, meaning "he drew it." *Del.*, EXC., IMP., INC., INV., PINX., and SCULP., preceded by the names of persons or firms, are sometimes inscribed in a lower corner of the margin of a print, particularly an engraving, to indicate who did what in preparing the plate and pulling the proofs. *Del.* follows the name of the artist from whose original drawing the plate was engraved or etched. *Pinx.* may appear on a print copied from an original painting. *Inv.* is more general, referring merely to the original artist, either draftsman or painter. *Inc.* and *sculp.* both refer to the person who actually engraved the plate. Thus, "Brown *del.*, Smith *sculp.*" on a print means that Mr. Smith made the engraving from an original drawing by Mr. Brown. If the inscription on an engraving reads "Brown *del.* and *sculp.*," the engraving is an ORIGINAL PRINT by Brown. "Brown *pinx.*, Smith and Jones *sculp.*" means that the engraving was copied by the firm of Smith and Jones from Brown's original painting. When a printer's name is not indicated, the engraver is assumed to have also printed the plate. When the plate is engraved by one person or firm and printed by another, the printer's name may be followed by *imp.* or *exc.* "Brown *del.* and *sculp.*, Carter *imp.* [or *exc.*]" indicates that Mr. Carter printed a plate the design of which was drawn and engraved

by Mr. Brown. *Lith.* or *litho.* means lithographed by.

delft or **delftware.** An earthenware covered with an opaque tin enamel and decorated with cobalt blue. Delft takes its name from that of the Netherlands commune where it was first produced, in the mid-17th century.

demi-relief. See RELIEF.

denatured alcohol. ETHYL ALCOHOL which has been rendered unfit for drinking, by the addition of various ingredients according to government-approved standards. The best varieties of denatured alcohol for general use as diluents and cleaners are sold in cans under various trade names. A typical recipe in wide use is S.D. No. 1, compounded by adding 5 gallons of methanol, 5 gallons of ethyl acetate, and 1 gallon of gasoline to each 100 gallons of ethyl alcohol. An anhydrous variety is also available from specialized dealers. Denatured alcohol is used because it is exempt from the heavy tax to which potable ethyl alcohol is subject. In Britain, it is called methylated spirit.

dentils. A series of rectangular, projecting blocks that form a molding. Dentil moldings are common in cornices of the Doric, Ionic, Corinthian, and Composite orders.

DENTILS

Derby red. Another name for chrome red (see CHROME YELLOW).

desco da parto. A medieval Italian basin or tray in which gifts were brought to a woman after childbirth. These were usually painted with the Nativity, and sometimes with other appropriate subjects.

design. The selection and arrangement of the formal elements in a work of art; the expression of the artist's conception in terms of a composition of these elements. Factors such as the direction, size, and shape of lines, angles, and forms and such considerations of composition and organization as spatial relationships, symmetry or asymmetry, rhythm, and dynamics are all elements of design. Among the features of visual art that are not specifically design elements are color, texture, the artist's handling of his materials, and subject matter or emotional content. Giorgio Vasari titled the technical treatise that was incorporated in the 1568 edition of his *The Lives of the Painters, Sculptors, and Architects* "The Three Arts of Design: Architecture, Painting, and Sculpture." Accordingly, these three arts have continued to be classified as the arts of design. See also DISEGNO.

designers' colors. Good quality GOUACHE tube colors with a DEXTRIN binder. Designers' colors are widely used by illustrators whose original work is infrequently preserved after being reproduced. Manufacturers' lines of designers' colors therefore include some brilliant, nonpermanent colors in addition to the standard artists' pigments.

dessus de cheminée. See OVERMANTEL.

dessus de porte. A horizontal painting designed to hang over a doorway. The use of paintings in this position was popular in the 18th century. The

dessus de porte is also called by its Italian name, supra porte.

De Stijl. See NEO-PLASTICISM.

Devonshire clay. A variety of CHINA CLAY found in England.

dextrin. A gummy material made from wheat starch and used as an adhesive, as a paint binder, in coated paper, and in textile manufacture. Designers' colors have a dextrin binder, and sometimes it is added to gum arabic in the manufacture of watercolors. Dextrin is available as a pure, white powder, and also in a yellow form (canary dextrin) which is unsuitable for use in artists' materials. It has a characteristic mild odor and taste which is familiar through its use on envelopes and postage stamps. One widely used industrial grade of dextrin is known as British gum.

diablerie. The satanic as represented or symbolized in art.

diacetone alcohol. One of the most powerful solvents used by professional conservators, especially to soften or dissolve dried linseed oil films. It has toxic effects when its vapors are breathed in large-scale operations, but can be safely handled, like most solvents used by conservators, over relatively small areas.

diaglyph. A piece of sculpture or a decoration in which all the forms lie below the level of the plane surface; an INTAGLIO. The opposite of a diaglyph is an ANAGLYPH.

diamond black. Another name for CARBON BLACK. Pure carbon black and diamonds are allotropic forms of the same element.

diaper. An all-over, repeat pattern or design on a flat surface, usually composed of clearly defined geometri-

DIAPER

cal elements. The term is most frequently applied to wall decoration. It is said to be a contraction of *linge d' Ypres*, as the use of such patterns on cloth is believed to have originated in the Flemish town of Ypres.

diatomaceous earth. A light, fluffy, absorbent clay or silica that contains the inorganic remains or skeletons of plant life, the lacy forms of which are visible under a microscope. Also known as infusorial earth and kieselguhr, diatomaceous earth is used as an INERT PIGMENT or FILLER in paints and other industrial products. Varieties of diatomaceous earth include CELITE and FULLER'S EARTH.

dichroism. The property whereby a substance exhibits two different hues or color effects when viewed under different circumstances. Cobalt yellow and alizarin crimson, for instance, are examples of oil colors whose hues show a marked difference when seen by reflected light and when spread out in a thin layer and viewed by transmitted light. Another example is the property of some oil colors to display a different visual or color effect when brushed vertically than when brushed horizontally on the same area of a can-

vas. This has been called the suede effect.

die board. See MAPLE DIE BOARD.

diffraction. The apparent deflection of light rays as they pass through very close parallel lines incised on a transparent piece of glass or plastic, or through a monomolecular or very thin layer between two different mediums. This passage produces the brilliant spectrum colors known as DIFFRACTION COLORS and the color effect of IRIDESCENCE.

diffraction color. Any brilliant rainbow or spectrum color produced by the diffraction of light rather than by pigmentation; also called prismatic color. An ever-changing play of diffraction colors is called iridescence. The iridescence of oil layers on water or of soap bubbles demonstrates the general rule that a thin layer surrounded by two mediums of different refractive index (in these cases, air and water) will usually diffract light. Diffraction colors may also be produced by use of a prism or of a diffraction grating, a piece of glass or plastic on which microscopically small, closely parallel lines have been engraved. Diffraction colors appear in nature when light passes through a surface that is either structured so that it acts as a selective diffraction grating or, like the plumage of certain birds, is equivalent to myriads of tiny lenses or prisms. Diffraction colors differ from pigment colors in their almost metallic intensity and in the fact that they are produced by the additive or light-ray process rather than the subtractive process (see COLOR).

diluent. Any liquid that is miscible with a given solution and can be used to thin or dilute it. A diluent may be, but is not necessarily, a good solvent

for the material in solution. However, some inert diluents, particularly those used in lacquers, have what is called latent solvent power, contributing to the effect of solvents already in the lacquer. See also THINNER.

dimetric projection. A projection used in mechanical drawing in which two axes or dimensions have the same degree of foreshortening in relation to their length and are therefore drawn to the same scale. The foreshortening in the third axis is different, causing the scale of that dimension to be different. In a dimetric projection of a rectangular solid, two of the three angles made where the axes meet will be equal. See illustration at PROJECTION.

diminishing glass. British term for REDUCING GLASS.

Dingler's green. One of the early varieties of CHROMIUM OXIDE GREEN.

diorama. 1. A three-dimensional representation of a scene, either full-sized or scaled, and sometimes with a painted background that merges imperceptibly with features and objects nearest it by means of aerial and linear perspective. A diorama may be constructed on a platform with or without a glass case, set in an illuminated niche, and viewed from a darkened room, or, in miniature form, boxed and viewed through a peephole. It has been used for realistic wildlife exhibits in natural history museums, exhibits of engineering and industrial projects, and advertising displays.
2. In the 18th and 19th centuries, a popular form of instructive entertainment, consisting of a painted transparency illuminated from the front and/or the rear and giving the illusion of a real scene. See also COSMORAMA; PANORAMA.

dipper, dipper cup. British terms for PALETTE CUP.

diptych. A painting or bas relief done on two panels, hinged so it can be opened and closed like a book. See also TRIPTYCH.

direct carving. Carving a piece of sculpture directly in its final form, as distinguished from casting a piece from a modeled original; also called *taille directe.* Many sculptors do make clay or wax models of a projected sculpture before cutting into a stone block. Also, sculpture executed by the artist who designed it, rather than a copy executed by artisans, by POINT-ING, or by another method.

direct metal sculpture. The fine-arts technique of shaping a piece of metal or putting together a metal construction, as opposed to casting. It employs such techniques as welding, hammer-ing, and soldering to produce a unique work of art. The work of Alexander Calder, John Chamberlain, and George Rickey consists mostly of di-rect metal sculpture.

direct painting. See ALLA PRIMA.

disegno. Design; drawing. This Ital-ian term was applied to all the visual arts, as well as to the specific elements that the word denotes. Some theorists of Mannerism include in it the *disegno interno,* the artist's ideal visualization of an object or scene as opposed to the actual appearance of the model. This concept was later involved in the arguments of the proponents of design over color in the conflict between Poussinisme and Rubénisme. See also RUBÉNISME.

dispersion. See PAINT.

disposable palette. A pad of white oil-proof paper in the shape of a rec-tangular thumbhole palette; available in several sizes. After a painting ses-

DISPOSABLE PALETTE

sion the used sheet is pulled off, expos-ing the next clean sheet. The ad-vantages of a disposable palette are obvious: cleaning of the palette is elim-inated; colors remain uncontaminated and can be transferred to a new sheet as the top one becomes fouled.

distemper. In Britain, any of several aqueous paints made with simple glue or casein binders and used for flat wall decoration and stage scenery; term not in common use in the U.S. Among the American equivalents to distemper are CALCIMINE, cold-water paints, and SCENIC COLORS. The term is usually used for bulk or wall paints rather than artists' colors. It is sometimes confused with tempera because the French word *détrempe* has both meanings.

distillation. One of the basic pro-cesses of refining, purifying, and pro-ducing liquid materials. The original substance is placed in a STILL, and heat is applied and increased until the sub-stance is vaporized. The vapor is then passed through the condenser of the still, becoming a liquid that is free of impurities. A primitive sort of distilla-tion was known to the ancient Greeks and Romans (see TURPENTINE), but

distillation in a still was first practiced by physicians and experimenters in the 3rd century in Alexandria. It did not come into established, practical use in Europe until the 15th century, when volatile solvents such as alcohol, turpentine, spike oil (and later the petroleum distillates) came into widespread use and furthered the development of oil paints and varnishes. See also ALEMBIC.

distortion. Any departure from what is generally accepted as the normal depiction of an object, figure, or scene, usually effected by a deviation from the canons of PERSPECTIVE and FORESHORTENING or from the rules of proportions for a figure (see SCHEMA). An exaggeration of size, shape, or a distortion of spatial ordering subordinates order and precision to emotion, giving emphasis to the artist's feelings about his subject matter and, perhaps, evoking the same feelings in the viewer. Furthermore, some objects and scenes appear purer in design when distorted than when realistically depicted. Thus in Mannerist art, which widely employed distortion, human anatomical proportions might be stretched not only to evoke an emotional response in the viewer but also to express what the artist conceives of as an intrinsic harmony of size and shape. Even academic realism often distorts details to produce an overall effect of correct proportions. When, as in some Chinese paintings, the viewer is informed about a side of an object that would not be seen in normal perspective, another type of distortion results; this may be called informative distortion. Distortion has been consciously used by artists throughout history, notably in Gothic sculpture, in Mannerist painting (most obviously by El Greco), and in the work of many Cubist, Surrealist, and expressionist painters, e.g., Picasso, Dali, and Modigliani. Distortion is also found, however, in works from more classical, reserved periods of art. Some of the 15th- and 16th-century sculptures of Donatello and Michelangelo display distortions not unlike those characteristic of certain Hellenistic Greek sculptures.

dividers. A draftsman's instrument used to transfer measurements and to divide lines. It has the same design as a bow COMPASS, but both legs terminate in steel points. Most compasses, both bow and beam types, can be converted to dividers by substituting a steel point for the pencil or pen fitting.

dividing brass. British term for brass SHIM.

divisionism. The principle of OPTICAL MIXTURE applied to painting; POINTILLISM. Seurat and the other practitioners of the technique preferred this term to pointillism.

doctor or **doctor blade.** A straightedge used for scraping off fresh paint or other pasty materials. It may be made of metal, rubber, or plastic. An example is the steel bar that removes the oil colors from the roller of a mill.

dolomite; dolomitic limestone. Any LIMESTONE that contains 45% or more of magnesium carbonate, as well as calcium carbonate, is called dolomite. Limestones containing as little as 10% of magnesium carbonate are called dolomitic limestones. Many varieties of marble are metamorphic forms of dolomite.

dominant color. The prevailing color or tonal character of a painting or other multicolored object.

dossal. A painted or decorative cloth hung behind an altar.

113

DOUBLE IMAGE. *Tree into Hand and Foot,* watercolor and ink study (1939) by Pavel Tchelitchew for his *Hide-and-Seek.* (*Collection, The Museum of Modern Art, New York, Mrs. Simon Guggenheim Fund.*)

dotted manner; dotted print. A 15th-century method for creating a CRIBBLED, or dotted, area—chiefly for backgrounds and textural details—by stamping dots in a metal plate with a PUNCH. The dotted print, which is usually a combination of dotted-manner engraving and line ENGRAVING, is printed as a relief plate; the stamped dots and engraved lines show as whites in the proof (see RELIEF PRINTING). The dotted-manner process, which was not widely used after the early Renaissance, was to some extent revived toward the end of the 18th century. The French term *manière criblée* was used in the 15th century to describe the effects created by this process.

double-end tool. See MODELING TOOLS.

double image. In painting and drawing, a figure or object that can be identified as two separate images, e.g., a cloud that is also a human head, or a series of hills that is also a reclining figure. Many examples of the double image may be found in the work of Pavel Tchelitchew (1898–1957).

Dowicide. Trade name for a synthetic organic preservative and fungicide used as a component of water paints. Dowicide A, chemically, sodium orthophenylphenate, is used with casein and other glue binders. Dowicide B, sodium trichlorphenate, is used with gums. See also PRESERVATIVE.

drafting. See MECHANICAL DRAWING.

drafting machine. A device that combines all the functions of a STRAIGHTEDGE, a T SQUARE, and an ADJUSTABLE TRIANGLE with a protractor and SCALES for precise calibration. One arm of the machine is attached to the drawing board, anchoring the apparatus so that it can be entirely controlled with one hand by the draftsman, leaving the other hand free for drawing. Used by draftsmen, designers, architects, and engineers, the drafting machine is available in several precision-engineered professional

DRAFTING MACHINE. Paragon drafting machine. (*Courtesy, Keuffel and Esser Co.*)

models and in a compact, portable model of lightweight aluminum.

drafting paper. A high-quality DRAWING PAPER with a relatively high finish, hard surface, and excellent water resistance and erasing qualities. It may be used for both ink and pencil work.

drafting tape. See PRESSURE-SENSITIVE TAPES.

draftsman or **draughtsman.** 1. In art, one who is adept at DRAWING; traditionally, draftsmanship is one of the criteria of excellence in a work of art.
2. In architectural or MECHANICAL DRAWING, one who renders an architect's or an engineer's drawings proficiently and in accordance with professional standards.

dragging. Another name for retroussage (see WIPING).

dragging stroke or **scruffing.** A technique of stroking oil color lightly over a rough surface so that it covers the high spots and leaves the depressions untouched, thus creating a broken area of color with irregular spots of the undercolor showing through. See DRY-BRUSH PAINTING.

dragon's blood. A transparent, ruby-red, resinous exudation of the fruits of several rattan palms of genera *Daemonorops* and the genus *Calamus*, native to Asia. Dragon's blood was traded into Italy as early as the Roman period. Although it is not a true pigment, it was used as a color by medieval manuscript illuminators. It has long since been replaced by more permanent pigments. It has been most commonly used to color varnishes, especially ormolu varnish, and has also been used as a resist in a special etching technique. It is readily soluble in alcohol, benzol, and a few other sol-vents, but practically insoluble in mineral spirits and turpentine.

Pliny the Elder (first century A.D.) propagated the myth that dragon's blood is actually the commingled blood of those legendary enemies, the dragon and the elephant, spilled during their mortal combat. For his remark about the use of dragon's blood in Roman painting, see INDIGO.

draperie mouillée. In figure sculpture, thin, clinging drapery that reveals the form beneath; French for wet drapery.

drawing. 1. The delineation on a surface of shapes and forms. It may be further elaborated with applications of color, highlights, and shading with HATCHING or washes to produce the effect of light and shadow. Drawing is a major fine-art technique in itself, but it also serves as the basis of all pictorial representation and as a preliminary step in most painting, sculpture, and architecture. Although it is an integral part of most painting, drawing per se is distinguished from painting (in which mass, defined in areas of color, dominates line) by the predominance of the linear element.

The techniques of drawing vary widely according to the effect desired by the artist and the purpose that the drawing will serve, that is, whether it is an end in itself or a preliminary to some other medium or form. A sharp PENCIL line or PEN stroke on a smooth ground will produce a more LINEAR drawing with relatively clear contours. A more PAINTERLY effect is created, especially on rough paper, with thicker or more pliant media such as soft pencil, CRAYON (WAX; CHALK; PASTEL; or CHARCOAL), and ink or watercolor washes. In WASH DRAWINGS, as works executed in the last two named media are called, gradated areas replace hatching.

Drawings may be separated into

two categories according to their function as art. Some drawings are independent and finished works of art. Others, although distinct from the final product, also have intrinsic artistic value. This category includes general stylistic exercises (e.g., CONTOUR DRAWING; LIFE DRAWING; DRAWING FROM THE ANTIQUE OR FROM CAST; DRAWING FROM THE FLAT), as well as separate SKETCHES (e.g., CROQUIS; ESQUISSE; NOTE) and STUDIES. CARTOONS, which are worked out in greater detail than sketches and are more immediately related to the finished work than studies are, also fall into this category. A third category could also be defined: drawings preliminary to other works of art that are actually incorporated into those works and thus deprived of independent artistic value. An example is the underdrawing in fresco and panel painting (such as SINOPIA and ABBOZZO).

Because drawing implies spontaneity, it has been highly appreciated since the Italian Renaissance, when it was revered as the embodiment of the artist's ideas. This spontaneous quality has always been used to particular advantage in CARICATURE and ILLUSTRATION. The invention of printmaking techniques in the 15th century made the duplication and dissemination of drawings possible, further establishing drawing as a definitive art form. See also MECHANICAL DRAWING.

2. In ceramics, removing ware from a kiln after firing.

drawing board. 1. An ILLUSTRATION BOARD.

2. A squared panel used as a base for drawing paper. A typical drawing board is a rectangle of softwood about ¾ inch thick, with a perfectly plane, smooth surface. To give the board perfectly parallel, smooth edges and to prevent warping, it is reinforced on each of its shorter sides either with a strip of wood mortised to it or with a metal cleat running the length of the edge. An accurate horizontal base against which triangles may be placed is made by holding the head of a T square against the true mortised wood or metal edges of the board. A lightweight drawing board made of balsa wood can also be obtained, although for outdoor sketching and watercolor painting artists often improvise easily portable boards from such materials as wallboard and corrugated board. In the studio, a DRAWING TABLE may be used either to support a drawing board or actually to replace it.

drawing curve. See FRENCH CURVE.

drawing from nature. Drawing a landscape or an object or element from nature. Sketched outdoors, such a drawing may be finished in the studio, but it differs from a STILL LIFE in that even an inanimate object is shown in its natural setting. Drawing from nature and other stylistic exercises such as LIFE DRAWING, DRAWING FROM THE ANTIQUE OR FROM CAST, and DRAWING FROM THE FLAT are often part of an artist's academic training. In addition to being a finished work of art, a drawing from nature can serve as a note or a study for further work in the studio.

drawing from the antique; drawing from cast. Drawing classical sculptures or their parts or fragments precisely and accurately, showing every nuance of shading. The sculpture drawn may be either in the round or in relief, either an original work (the antique) or a white plaster copy (a cast). Although the term drawing from the antique denotes the copying of classical sculpture, more recent works are sometimes used, notably the sculpture of Michelangelo, Donatello, Bernini, and Rodin. Drawing from cast is a traditional academic art course, the satisfactory com-

pletion of which is requisite for entry into a class in LIFE DRAWING. Many independent art schools, however, no longer include drawing from the antique or from cast in their required curriculum. See also DRAWING FROM NATURE; DRAWING FROM THE FLAT.

drawing from the flat. Drawing a copy of a painting, a print, or another drawing. The artist may use this technique, along with LIFE DRAWING, DRAWING FROM NATURE, and DRAWING FROM THE ANTIQUE OR FROM CAST, as a tool in the development of his own style. Rubens' copy of Leonardo da Vinci's cartoon for *The Battle of Anghiari* is one of the most brilliant works of this kind.

drawing paper. A close-textured, hard-surfaced paper with a dull finish, good erasability, and good water resistance. There are many specialized varieties of drawing paper, such as CHARCOAL PAPER and DRAFTING PAPER.

drawing pen. See RULING PEN.

drawing pin. British term for THUMBTACK.

drawing table. A table whose top may be adjusted to any degree of slant to suit the artist's or draftsman's needs or preferences. Some drawing tables are adjustable in height as well. Two styles are available for general use. One has cross-legs at either end, the slant of the top being controlled by metal quadrants and screw knobs. It has a smooth wood top that can function either as a DRAWING BOARD itself or as a support for a drawing board. Tables of this type are available in a number of drawing-surface sizes, from about 20 by 30 inches to about 40 by 60 inches. The other standard type of drawing table is a varnished oak board with a flange at its bottom edge to hold

DRAWING TABLE. (*Courtesy of Anco Wood Specialties, Inc.*)

a drawing board. It is supported by a central cast-iron column that has a ratchetted clamp to hold the board at any tilt from horizontal to nearly vertical; the column can be raised, lowered, and revolved. This so-called pedestal stand of cast iron can also be purchased separately as a support for an artist's own drawing board. Both the cross-leg and tripod types of drawing-board are available in lightweight, folding models for easy storage.

draw-out. A sample of two transparent pigments on a pad of paper, made for purposes of comparison and quality testing. It is made by placing two dabs of oil color rather close to one another on the edge of a sharp, clean wallscraper, spreading them thickly on the paper over an area of an inch or so to show their mass tones, then bearing down heavily so as to bend the scraper's flexible blade and scrape the color down so that it makes a wide, transparent stain on the paper. Minute differences in color, undertone, and tinting strength can be discerned by holding the transparent draw-out to the light. This technique is especially useful in comparing printing inks; since they are a form of oil color usually applied

as a thin stain on paper rather than as a massive paint layer, evaluations of their transparent color are usually more significant than comparisons of mass tone.

Dresden liner. See LINERS AND STRIPERS.

dress. In finishing stone, to impart a smooth or other desirable texture with chisels, hammers, or other tools.

drier. A compound of any of several metals, notably lead, iron, manganese, and cobalt, which has a siccative (drying) effect when cooked at a high temperature with linseed oil. When a small amount of such a linoleate is added to an oil paint or oil varnish, it will greatly accelerate the speed (called the speed of dry) with which the coating becomes dry to the touch. Modern liquid driers are more apt to be napthenates than linoleates. Cobalt drier is by far the best of the driers; it is the only kind now used in artists' materials and is also preferred in industry. The action of driers is generally held to be catalytic: that is, it triggers the polymerization and accelerates the oxidation of the oil. A substance producing a reverse, or antoxidant, effect on oil, slowing its speed of dry, is called a retardant. In modern practice, adding a liquid drier to varnish or paint is generally preferred to the older procedure of cooking the metallic oxide directly in the oil. A prepared liquid drier is sometimes called a siccative. Pigments also affect the rate of drying of oil colors, some accelerating and some retarding it.

drollery. A comic picture or one characterized by humor, especially one depicting animals dressed as humans or engaged in human pursuits; in French, *drôlerie.*

drop black. An industrial grade of VINE BLACK originally sold in the form of small, molded lumps or drops; also known as Frankfort black and German black. Many DROP PIGMENTS were sold during the 19th century.

dropout. In PHOTOENGRAVING, a HALFTONE area in which the dots are in part painted out on the film with opaquing fluid or etched away on the plate in order to create a highlight; also, a print or area of a print containing such a highlight. Halftones with dropped-out areas are also known as highlight halftones.

drop pigments. Formerly, and especially in Germany, pigments marketed in the shape of molded drops or cones an inch or less in length. Of a soft consistency, these drops could be crushed or ground into paint as easily as powder. Cleaner and more dust-free than powdered pigments, drop pigments were a boon to the user of simple open equipment because they greatly reduced the health hazard of breathing in dust during handling. Pigments were also made in cylindrical and in flat, corrugated shapes, to suit the preferences of various trades. At the end of the 19th century the expansion of the paint industry, along with improvements in mills, mixers, and paint-factory techniques in general, made drops obsolete; they are seldom encountered today.

dry-brush painting. The technique of creating a broken or mottled effect, revealing traces of the paper or underpainting, with water paint or ink. It is done by holding the brush at such an angle that its side lies almost flat against the paper, or by drawing it rapidly across the surface. In oil painting, a similar broken effect is usually called a DRAGGING STROKE or scruffing.

THE COLOR EFFECTS OF PIGMENTS IN PAINT. At top, approximations of variations in the color effects of a pigment that are related to the difference between the index of refraction of the pigment and that of its surrounding medium. The closer these indexes are, the more light is absorbed, the less reflected, and the darker the pigment appears. Conversely, the farther apart the indexes, the lighter the pigment. At left, cobalt blue pigment (refractive index 1.75) in a film of linseed oil (1.48) is quite dark and intense. At far right, dry cobalt blue (i.e., seen only through air, which has a refractive index of 1.00) is a rather pale blue. The same pigment in a dry gouache film (center) is darkened by the binder of the paint. A cobalt blue gouache when wet is nearly as deep-toned as the oil paint film, because of the presence of water (1.33).

At bottom, representations of the three color effects of burnt sienna: left, its mahogany mass tone in a full-strength, opaque paint film; center, its orangy undertone in a thin, transparent film of the same paint; right, its pinkish undertone in the same paint tinted white to about the same value as the transparent layer.

LINEAR AND PAINTERLY. Left, *A Lady of the Sassetti Family*, by Domenico Ghirlandaio (1449–1494), an example of painting in a linear style. (*The Metropolitan Museum of Art, The Michael Friedsam Collection, 1931.*) Right, a more painterly portrait, *Flora* (c. 1650), by Rembrandt. The artist first painted his subject's hat with a much broader brim at the front; his original intention has become known through the appearance of the dark oval area through the lighter, overpainted background. This phenomenon is called pentimento. (*The Metropolitan Museum of Art, Gift of Archer M. Huntington, in memory of his father, Collis Potter Huntington, 1926.*)

dry color. The term commonly used in the industrial paint field for powdered pigment.

dryfoot. To clean the bottom rim of a piece of glaze-coated pottery before firing so that it remains unglazed. Such a rim is called a dry foot.

drying oil. Any vegetable oil that will solidify to a tough, leathery film when spread out in thin layers, either alone or with the assistance of a metallic salt known as a drier. This property makes drying oils valuable for use in paints and varnishes. They do not dry by evaporation, as do other liquids, but react with the oxygen of the air to become converted into a new compound, a solid with different properties from those of the original oil, to which it cannot be reconverted by any means. Among the drying oils, LINSEED OIL; WALNUT OIL; POPPYSEED OIL; and SAFFLOWER OIL have been used in artists' colors. Others include HEMPSEED OIL; LUMBANG OIL; PERILLA OIL; and TOBACCO-SEED OIL. See also SEMIDRYING OIL; NONDRYING OIL.

drying time or **speed of dry.** The measured interval between the application of a paint or other coating material and the point at which the entire film, or the surface of the film, may be considered dry. A film of oil paint or varnish is completely dry when it has reached its ultimate state of solidity and strength, but according to the requirements of the user, the film may have a functional degree of dryness at any of several intermediate states, as: dry dust-free; dry to the touch; dry resistant to the application of overpainting; dry resistant to the imprint of a heavy, grinding pressure of the thumb. Among the factors that influence drying time are the thickness of the film, the inherent accelerating or retarding action of its various constituents (as

the presence of a DRIER or a DRYING OIL), and temperature and humidity.

An acceptable drying rate is one of the general requirements an artists' oil color must meet in order to be approved by the PAINT STANDARD. The *Standard's* prescribed test for the drying rate of a paint film and its surface is made with measured amounts of the paint on glass test panels that are kept in a constant atmosphere of 76° F. and 55% relative humidity. Surface drying is tested with a simple apparatus that pours sand on the sample: the paint passes this test if 72 hours after application the sand neither sticks to the film nor leaves a visible mark on it. The solidity of the film is tested with a device that applies controlled pressure. The paint passes this test if at the end of 21 days a sharp-edged ring under a 200-gram weight leaves no visible mark on the film.

dry mounting. A method of attaching a drawing, print, photograph, or other work of art done on paper to a cardboard backing. Instead of paste or another moist adhesive, a thin sheet of DRY-MOUNTING TISSUE is sandwiched between the paper and the mount, and a smooth, secure bond is obtained by first tacking the three layers together with a TACKING IRON and then applying heat and pressure in a special dry-mounting press or with a HAND-MOUNTING IRON. Some dry-mounting tissues are designed to adhere permanently; others are removable. Dry mounting is extensively used in commercial work but not generally approved for use in the fine arts.

dry-mounting tissue. A thin sheet of rubberlike, thermosetting resin used as the adhesive in DRY MOUNTING.

dry painting. See LINEAR.

drypoint. An INTAGLIO printing process in which a copper or zinc plate is inscribed directly with a pointed needle of steel or, more rarely, with a JEWEL POINT; also, a print made by this process. The incising process leaves an almost imperceptibly ragged edge, or BURR, which when printed produces the softness of line that is a distinguishing characteristic of the drypoint. The first proofs pulled will be of the highest quality. Because, however, the burr soon gets worn down, broken, or pressed into the furrows in the etching press (where a drypoint is printed like a regular etching or copperplate engraving), few good proofs—thirty at the very most—can be made from a drypoint plate. The proof number (see PROOF) is therefore much more significant in drypoint than in other printing techniques. A drypoint edition may be enlarged by giving the plate a STEEL FACING.

A good drypoint is esteemed not only for its subtlety and pleasing tonalities but for the effect of spontaneity produced by the direct nature of the process. Etching is a comparatively indirect process, requiring many steps to translate the artist's conception into the finished etched drawing on the plate. Even line engraving, in which the plate is incised directly with a graver, is a necessarily deliberate process that results in a rather strict linear quality. On the other hand, the drypoint needle can be used on a metal plate with almost as much ease and flexibility as a pencil on paper; the artist's execution of the design on the plate can keep pace with his inspiration. Since the time of Rembrandt artists have used drypoint not only by itself but also in combination with other printing techniques to enhance etchings and engravings. See illustration at STATE.

dry rot. A kind of decay to which wood is subject; it occurs in the absence of moisture. The wood becomes very weak and powdery. Dry rot in picture frames can be prevented by avoiding a hermetic seal at the rear of pictures, so that air has access to panels and stretchers.

Duco. Trade name for a line of top-quality industrial and household paint products. Duco automobile lacquers have been used by artists who have more regard for a high rate of production of paintings than for the ultimate permanence of their work.

ductile. In metal, having the property of being pliant, easily shaped, and capable of being drawn out into wire. Gold and silver, for example, are ductile metals. They may be drawn out or hammered permanently, but remain malleable.

duecento. The 13th century. The term is commonly used to designate Italian art of that period.

Dumont blue. Another name for SMALT.

dunt. In ceramics, to crack because of over-rapid cooling in the kiln after firing.

Dunville stone. An easily worked, fine-grained SANDSTONE from Wisconsin. Dunville, also called Dunn County stone, is buff to cream-colored. Like much sandstone, it is soft when first quarried, but gradually hardens upon exposure as its moisture (see QUARRY WATER) evaporates.

Düsseldorf school. An academy of art founded in Düsseldorf, Germany, in 1767. The school is best known for the works it produced in the 1830's and 1840's, which infused genre landscapes with emotion in a manner derived from the Romantic painters of the Nazarene school. These works may

be classed as BIEDERMEIER art, but the painters received rigorous training. Their influence spread even as far as America, as seen in the work of the romantic landscapist Albert Bierstadt and others.

dust box. A wooden box in which an AQUATINT plate is coated with finely powdered rosin. (Lump rosin is easily powdered by wrapping it in strong cloth and pounding it with a hammer.) A number of contrivances have been designed for this purpose. The simplest is an airtight plywood box about 3 feet high and 18 to 20 inches square. A 2-inch slit near the bottom of one side is covered with a hinged flap. The box, containing about 4 ounces of powdered rosin, is shaken vigorously and set down with a light thump. After about two minutes, when all but the most minute particles of rosin have settled, the metal plate is inserted into the slit, face-up on a plywood tray that sits on runners along two inside walls of the box. The finest particles of rosin gradually cover the plate with a uniform coat. The length of dusting time and the amount of powder used are determined by trials made to ensure the desired graining of the plate and are also related to the strength of the mordant that is to be used and to the duration of biting.

dusting brush. A flat brush with long, coarse bristles set in a wooden handle. The dusting brush is used by artists and draftsmen to sweep away eraser crumbs from work being done on a drawing board.

Dutch Caravaggism. A movement in Dutch painting in the first half of the 17th century. The most fervent imitators of the Italian painter Caravaggio's highly dramatic lighting effects gathered in Utrecht. Their most gifted painter, Hendrik Terbrugghen, assimilated Caravaggio's distinctive style successfully, but most of his fellow artists imitated only its most striking effects of lighting. Rembrandt, who did not belong to this group, was the one Dutch painter to use Caravaggio's techniques to evoke profound emotional responses.

Dutch metal. Brass with a low zinc content that is made into leaf for use in gilding as an imitation of GOLD LEAF. It is also called metal leaf, composition leaf, and bronze leaf. Dutch metal must be lacquered, shellacked, or varnished to prevent it from tarnishing rapidly. It is used primarily to gild inexpensive frames and to decorate furniture. Because the color of Dutch metal is inferior to that of gold and because its natural metallic luster is impaired when it is coated to prevent tarnish, it is not a satisfactory substitute for gold in a fine work of art.

Dutch mordant. A carefully compounded solution of potassium chlorate and hydrochloric acid that is used as a MORDANT in ETCHING, particularly when very fine lines are to be produced. Dutch mordant, which was not used for etching until the 19th century, acts efficiently on copper plates but is less violent than nitric acid and thus less likely to make the sharp lines in the ground ragged. Smillie's bath, a mordant used in aquatint, has essentially the same composition as Dutch mordant but is much more concentrated.

Dutch pink. A transparent, golden-yellow LAKE pigment made from dried, half-ripe BUCKTHORN BERRIES. Although not sufficiently lightfast for use as an artists' pigment, Dutch pink has been popular since the 16th century as a decorators' color, and has survived to some small extent into the 20th century. Other names for Dutch pink are brown pink, buckthorn lake, English

pink, stil-de-grain (French), and Italian pink.

Dutch-process white lead. Another name for WHITE LEAD made by corroding metallic lead with vinegar or acetic acid, a process that goes back at least to the ancient Greeks. The method described by Theophrastus (*History of Stones*) and Pliny (*Natural History*) is substantially the same as that used today.

Dutch white. An unstandardized term that has been applied variously to a species of clay, to pure WHITE LEAD, and to a special white lead cheapened by reduction with blanc fixe or barytes.

dyes; dyestuffs. Soluble coloring matters that impart their colors to textiles, INERT PIGMENTS, or other substances by staining or being imbibed by them. Dyes differ from pigments, which are insoluble materials that impart color by being spread over a surface, as in painting, or by being mixed in as an ingredient, as in coloring plastics, rubber, or paper. The painter has little concern with soluble dyes as such, though some of his colors (LAKE pigments) are made from them. NATURAL DYESTUFFS are coloring matters extracted from plant and animal sources, as distinguished from the synthetic dyestuffs manufactured from coal-tar derivatives and other raw materials by modern chemical processes. The latter have largely replaced natural dyestuffs in modern times.

dynamic symmetry. A theory of proportion believed to have been practiced in ancient art and architecture, especially in Egyptian art and in Greek art of the 5th century B.C. The existence of such a system, which is not now widely credited, was first postulated by artist-writer Jay Hambidge (1867–1924), who, in his treatise *Dynamic Symmetry* (1917) and in his extensive subsequent writings on the subject, became its most articulate exponent. Briefly stated, the concept proposes that the determining factor in imposing a sense of symmetry on a particular form is the relationship between various areas around its center of balance rather than the relative length of its lines. Thus, although there might be a measurable inequality in corresponding lines on opposite sides of an object, an overall sense of symmetry around the center of mass might still be felt as the result of the relationship of mathematically symmetrical sub-areas within the complete structural pattern. Dynamic symmetry is so called because it is said to correspond closely to the organic, kinetic symmetry of living things, as opposed to the "static" symmetry of inanimate forms. Hambidge related dynamic symmetry to the mathematical ratios he observed in plant life, especially in the spiral forms of sunflower heads and pine cones and in the orderly distribution of leaves in plants. See also GOLDEN MEAN.

E

earth colors. Paint pigments made by refining naturally colored clays, rocks, and earths; also, the pure iron-oxide reds (Indian red, light red, and Mars red), which, although artificial counterparts, are still classified with the native red earths. Earth colors are also classified as MINERAL PIGMENTS, along with manufactured inorganic pigments.

earthenware. Any opaque ceramic ware fired under 2,000° F., as distinguished from porcelain, fired at higher temperatures. Earthenware has a relatively coarse, highly absorbent body and is commonly of a reddish color. When it is glazed, soft or semi-hard glazes are used.

easel. A freestanding structure designed to hold an artist's CANVAS or PANEL during painting. The studio easel usually has a square or rectangular base made of four sturdy wooden bars mounted on casters, and two sturdy uprights with crossbars at the top and middle braced by a diagonal strut at the rear. A vertically adjustable sliding tray, held at intervals by a spring catch that grips the notches in a vertical metal strip, holds the painting; a sliding clamp secures it at the top. The sketching easel, made of wood or aluminum, is small, lightweight and

EASELS. Left, studio easel; right, sketching easel. (*Courtesy of Anco Wood Specialties, Inc.*)

portable, the parts folding to a compact bundle; its design is a compromise between rigidity and portability. The most common type has three legs, of which two stand forward, holding a rest for the paintings, and the third may be slanted back to adjust the angle of the board or canvas. The school or art-class easel is sturdier than a sketching easel and lighter than a studio easel. Most easels may be folded for easy storage. See also TABLE EASEL.

easel painting. Creative or fine-arts PAINTING done on a portable support in

one of the standard techniques, such as oils, watercolor, or tempera, as distinguished from other kinds of painting, as mural painting, decorative work, illustration, and commercial art.

East African copal. See COPAL.

East Indian rosewood. See ROSEWOOD.

eau de Javelle. See JAVELLE WATER.

eau de Labarraque. See JAVELLE WATER.

ébauche. In oil painting, the first underpainting. Also, a rough sketch in oils, particularly for a proposed portrait.

ebony. Any of various black, dense, smooth-grained hardwoods obtained from trees of the genus *Diospyros*. Ebony is extremely durable, but is difficult to carve because of its toughness. Among the finest and most intensely black ebonies are black or Gaboon ebony (*D. dendo*) from Africa and *D. ebenum* from Ceylon and India. Other ebonies are usually considered inferior, as they have golden-brown or purple streaks rather than being a uniform jet-black, and are coarser in texture. However, they are fine woods in their own right, and are highly valued for their decorative effects. Other Asian ebonies include Calamander ebony (*D. quaesita*), and Macassar ebony (*D. melanoxylon*), also called Coromandel. Several black or deep-hued woods from trees not related to *Diospyros* are also popularly known as ebony; these include green ebony, brown ebony (see COFFEEWOOD), blue ebony, and Mozambique ebony (see AFRICAN BLACKWOOD).

echoppe. A NEEDLE whose point is beveled to an oval facet, used in ETCHING and line ENGRAVING. It is used in etching to draw lines of varying widths in the ground. In engraving, the echoppe is used to enlarge or slightly widen lines that have already been engraved with a burin. It is especially useful for varying part of a line, e.g., making a line that has been cut in the plate swell or taper at some point along its length.

eclecticism. In art, the practice of borrowing and combining stylistic features from other art movements or from the works of other artists. In theory, by taking what is best from various schools or masters, the eclectic artist produces a work that surpasses any of them. In practice, the reverse is more likely to be the case. Elements of eclecticism have existed in all phases of the world's art, although the term is rarely used when the borrowed elements are harmoniously fused into a creative new style. This is not to say that the eclectic point of view may not result in works of some artistic value. The most notable historical example of eclecticism is the Academy of the Carracci in late 16th-century Bologna, although some authorities deny that their work is any more influenced by previous art than that of most artists, or that they worked according to deliberately eclectic principles. Elements of eclecticism are also found in Etruscan, Hellenistic, late Roman, Byzantine, Romanesque, and Mannerist works, among others.

écorché. A drawing or statue of a flayed human or animal figure, used in the study of musculature.

ectype. A replica of an original, as a lithograph proof from the artist's drawing on stone. Also any copy of an original, as a reproduction of an artist's picture or a painting that is copied from another. See also PROTOTYPE.

ÉCORCHÉ. Woodcut, after John of Calcar, from *De Humani Corpore Fabrica* (Basel, 1555) by Andrea Vesalius. (*The Metropolitan Museum of Art, Gift of Dr. Alfred E. Cohn, 1953,*) *in honor of William M. Ivins, Jr.*)

efflorescence. A white, powdery crust formed from the salt residue of moisture that seeps through concrete walls, mortar, and cement, evaporates, and adheres to their outer surfaces. Some pigments used to color cement or the mortar joints in a wall are subject to efflorescence—for example, lampblack or ivory black. Others, such as Mars black, are free from it.

egg, use in painting. Egg yolk is the traditional medium for TEMPERA colors. When mixed with water and pigments, and exposed to air and sunlight, it forms a tough, leathery adherent layer which has proved over the centuries to be the most durable of all paint

films. Although Cennino Cennini, writing in the 15th century, advised using only pale-colored yolks, the coloring matter in egg yolk, carotin, is extremely fugitive and thus does not affect the colors in the dried painting. Egg white is carefully excluded from egg tempera, although egg-and-oil tempera is made with whole egg. The white of egg was probably used as a binder in manuscript illumination and has been employed as a size in gilding (see GLAIR); but in comparison with the yolk, it has little use in painting.

egg and dart. A continuous banded design of alternate, engaged ovoids and arrowheads carved in high relief. This motif was a familiar feature of capitals and entablatures of the Ionic order of ancient Greek architecture, and has been adopted as a conventional molding in decorative woodwork.

EGG-AND-DART MOLDING

eggshell finish. A semimat finish with a dull, diffuse sheen. See MAT.

egg tempera. The traditional form of TEMPERA paint consisting of pigments ground with pure egg yolk.

Egyptian art. The art of ancient Egypt, from about 3200 B.C. to the conquest of Egypt by Alexander the Great in 332 B.C. Funerary statues and decorated tombs were the primary forms of Egyptian art. The pyramids of the Pharaohs and smaller tombs of the lesser nobility were found in extensive funerary districts. Every tomb housed

sculpture, wall paintings, and household implements intended for the use of the spirit of the deceased. The paintings—narrative scenes of everyday activity or ritual—were done in aqueous paints on various grounds. Many that have survived for millenniums in the perfectly dry air could be removed with the swipe of a damp cloth. The pigments the Egyptians used are well known. The exact nature of the binders, however, has never been determined, although it is certain that milk, plant juices, and gums were all used. Sometimes resin color was used to fill in incised lines. Reliefs sculptured on the tomb walls were also painted.

Massive portrait statues of the dead were the chief form of sculptural expression. Carved in stone, usually in a standard erect or seated position, they were painted for realistic effect; the faces, unlike the bodies, were usually individual likenesses. The Egyptians also attained a high level of craftsmanship in working with gold, ivory, glazed terra-cotta, and semiprecious stones.

Egyptian blue. A mixture of copper silicates; the celebrated ancient Egyptian frit or pottery glaze, processed into pigment form. One of the earliest known artificial pigments, Egyptian blue was used as a water-paint pigment for blues and greens in ancient Egyptian wall paintings. It was imported into Mesopotamia, Crete, and other Mediterranean lands, and later manufactured in Italy under the name of POMPEIAN BLUE. According to Vitruvius (1st century B.C.) the process for Egyptian blue was brought from Alexandria to Pozzuoli (Puteoli), Italy, where its production was established by Vestorian (Pozzuoli blue). Genuine Egyptian blue is extremely difficult to make in soft pigment form, though it was available in the early 20th century from a Parisian firm; in recent years there has been little demand for it. Since so many mixtures of modern pigments can substitute for real Egyptian blue, interest in it is mainly antiquarian. Unless specifically identified as genuine, any modern pigment offered as Egyptian or Pompeian blue would be a synthetic lake-color of doubtful permanence. Other names for Egyptian blue are Alexandria or Alexandrian blue, blue frit, Pozzuoli blue, Vestorian blue, ITALIAN BLUE, Venetian blue, and caeruleum (Latin for sky-blue color). Greenish shades are called Egyptian green, but most of the Egyptian and Mediterranean greens used in ancient painting were palette mixtures of the blue with yellow ochre.

Egyptian brown. Another name for MUMMY.

Egyptian cross. See ANKH.

Egyptian green. See EGYPTIAN BLUE.

Egyptian paste. A self-glazing ceramic ware, first produced in ancient Egypt. The earliest glazed ware, it is sometimes anachronistically called Egyptian Faience. It probably consisted of clays, some soda ash or other sodium salts, and pulverized copper ore. Egyptian paste tiles and figures, as well as simple pottery, were produced by the First Dynasty (3200–2980 B.C.). Oscar, the tiny turquoise hippopotamus in the Metropolitan Museum of Art, New York, and the tiles from the step-pyramid of King Zoser displayed in the Brooklyn Museum are well-known examples. Egyptian paste is easy to reproduce and is therefore popular with modern hobbyists.

Eight, The. A group of American painters and illustrators of the early 20th century, led by Robert Henri

(1865–1929) and John Sloan (1871–1951), and including George Luks (1867–1933), William Glackens (1870–1938), Everett Shinn (1867–1953), Maurice Prendergast (1859–1924), Arthur B. Davies (1862–1928), and Ernest Lawson (1873–1939). These artists were also called, derisively, the "Ashcan school," because their work depicted such prosaic subjects as the streets and inhabitants of big cities (chiefly New York) with a vigorous realism that many of their contemporaries found offensive. The epithet was subsequently extended to other artists of the first two decades of the century, notably George Bellows (1882–1925), another champion of the commonplace in art.

electroplating. An electrochemical process for coating a surface or object with a layer of metal. In its simplest terms, an electrical current set up in a bath of salt solution decomposes a metal and deposits it on either another metal or on a nonmetal that has previously been mechanically coated with a metal or graphite. In metalworking and sculpture, gold and silver are often electroplated onto a base metal, frequently brass, copper, or britannia metal. The process, which was discovered in the 19th century, has also been used by sculptors to metallize objects of wax, plaster, and wood (providing that they have first been given a metal or graphite coating) to make them resemble metal sculpture.

electrum. A natural alloy of gold and silver, pale gold in color. It is used for jewelry and other precious metalwork.

elemi. A soft RESIN obtained from several tropical trees of the family Burseraceae. Elemi was much used during the 19th century to impart flexibility and toughness to varnishes made from hard, brittle resins. It is soluble in alcohol, benzol, and the strong lacquer solvents but does not dissolve satisfactorily in turpentine or mineral spirits. The best grade, called Manila elemi, is obtained from trees on the island of Luzon. Less valuable grades come from Mexico and Brazil. Manila elemi is white, opaque, soft, and granular, and tends to darken and harden as it ages. It was formerly employed in industrial finishes and in some artists' varnishes and mediums, but its use diminished during the early 20th century with the introduction of resins such as damar and the synthetic resins that do not require its softening effect. Modern opinion does not rate its durability and color stability sufficiently highly to qualify it for use in materials for permanent painting.

elephant's ear. A soft, naturally flat sponge found in the eastern Mediterranean; used by potters for finishing clay.

Eleusinian marble. A fine black MARBLE from Attica, prized in ancient Greece, especially for friezes and interior decoration.

elevation. An architect's drawing or plan of a project seen from a given angle and drawn on a vertical plane to a given scale. An elevation usually shows a particular side of a building, as a front elevation, or those faces of a structure that are oriented to a particular point of the compass, as a south elevation. Such drawings ignore perspective, showing the plan in two dimensions only.

ellipse guide. A TEMPLATE with elliptical cutouts, used in drafting and the commercial arts for drawing ovals and for ruling curves. Ellipse guides are available in two varieties. Some templates have cut-out ellipses of the

same projection degree (e.g., 45°) but with major axes of different length. Other templates have a number of ellipses in a range of projection degrees, usually ten projections, in 5-degree increments, from 15° to 60°. See also FRENCH CURVE.

Elsner green. A COMPOSITE PIGMENT made with Bremen blue and a fustic lake. It is not used for permanent painting.

embossing. The technique of creating raised figures or designs in relief on a surface. Embossing on leather, paper, metal, or cloth, as for book covers and various kinds of ornamental work, is usually effected by stamping the surface in a press with a pair of matched dies, a relief die striking from the underside into an intaglio die on the obverse. The process of creating relief designs on coins is known as striking rather than embossing. An old method of embossing on wood is driving a blunt tool such as a chisel into the wood along the lines of the desired pattern, planing the surface down to the level of the sunken design, and then wetting the entire surface. The moisture causes the compressed areas forming the design to rise to their original height and thus to project from the planed surface. In sheet-metal work, the process of executing designs in relief by hand, rather than by mechanical means, is called REPOUSSÉ.

embrittlement. Loss of flexibility or elasticity. In a paint film, ground, or support, it is a common cause or contributory element in the deterioration of pictures on long aging. Of all types of paint, oil and polymer colors retain their elasticity best, making it possible to use them on flexible supports. Of all natural textiles which might be used as supports for painting, linen canvas has the greatest and longest-lasting degree of resistance to embrittlement. See also PHOTOCHEMICAL EMBRITTLEMENT.

embu. French term for a sunken-in area in an oil painting. See SINKING IN.

embuya. See IMBUYA.

emerald chromium oxide. A confusing name for VIRIDIAN; not a term for emerald green. The name is no longer in use.

emerald green. Copper aceto-arsenite; an extremely brilliant pigment unequaled in clarity and vividness by any green in the artist's permanent palette. Although emerald green was used by painters during the 19th century, it has since been rejected for several reasons: It is dangerously poisonous; it reacts with other pigments, causing some mixtures to become dark or brownish and some varieties to fade. The closest approximations of emerald green are mixtures of phthalocyanine green and Hansa yellow. Emerald green is known in Europe as Schweinfurt green, after the German town where it was invented by F. W. Russ and Wilhelm Sattler in 1814 and marketed in 1816. Before the adoption of our standardized system of nomenclature (see PAINT STANDARD and BRITISH PIGMENT STANDARD), viridian was sold in America under its French name, vert émeraude, and confused with emerald green; this confusion has been kept alive in the 1960's by translators of French and Italian books who are not conversant with English usage. Early varieties of emerald green include MITTIS GREEN (also known as Vienna green) and IMPERIAL GREEN; other names are English green, vert cendre (French) and verde ceniza (Spanish). Emerald green used as an insecticide is known as Paris green.

emeraude green. An incorrect and confusing name for VIRIDIAN; not a term for emerald green.

emery. An abrasive used in finely powdered form for polishing, in coarser form for smoothing rough surfaces. Emery is natural black corundum or aluminum oxide, the hardest existing mineral after the diamond.

empathy. Emotional identification of the viewer with a work of art. The term, a translation of the German *einfühlung*, became widely known through its use by Wilhelm Worringer in his *Abstraktion und Einfühlung* (*Abstraction and Empathy*, 1908).

empyrematic. Having the odor of an oil, wood tar, or other organic substance that has been burned or smoked.

emulsion. A suspension of one liquid in another with which it is immiscible, as a dispersal in water of microscopic droplets of oil. To form a stable emulsion, a third ingredient must be present—a substance (called an emulsifier or emulsifying agent) that forms adsorbed films about the tiny globules of the dispersed fluid and keeps them from coalescing. The droplets of the dispersed fluid are known as the inner phase of the emulsion, the surrounding liquid as the external phase. An emulsion is usually made by dripping or slowly pouring one of the ingredients into the other while stirring vigorously.

A familiar emulsion that occurs naturally is whole milk, the inner phase of which consists of globules of butterfat; the external phase is a watery solution of casein, sugar, and other substances. Another natural emulsion is egg yolk—the vehicle used in the "classic" tempera process—which consists of egg oil in an aqueous solution that contains, among other things, albumen and lecithin. The latter is a lipoid (fatlike) substance that is one of nature's most efficient emulsifying agents. Albumen, too, is a good emulsifier.

Milk and egg yolk are oil-in-water emulsions. There is also a second type, the water-in-oil emulsion, in which the phases are reversed. An example is butter, which has aqueous constituents dispersed in tiny globules throughout the butterfat. Water-in-oil emulsions are not frequently encountered among artists' materials, although an oil tempera has been used experimentally. Most manufactured emulsions are made by combining the OILY INGREDIENT with colloidal solutions, as of casein or albumen, which are not only good emulsifiers but also confer desirable properties when the emulsion is used as a paint binder. Like all emulsions, those used in painting are milky or opaque because of the refraction and dispersion of light by the minute droplets, but when dry they become transparent, or nearly so.

emulsion ground. A GROUND made by combining, or emulsifying, GESSO and oil. Emulsion grounds tend to be soft and spongy when fresh, unlike pure gesso grounds, but become brittle when they age. They lack the complete absorbency of gesso grounds and the flexibility of oil grounds, and combine to some extent the disadvantages of each. Emulsion grounds are sensitive to moisture and are generally considered less durable than oil grounds on canvas or gesso on panel.

enamel. 1. A vitreous porcelain or ceramic glaze applied as a surface decoration to pottery or metal and fused in a furnace or kiln to produce a hard, durable finish, usually smooth and lustrous; also, an object so decorated. The opacity of enamels and

their use on metal distinguish them from other glazes used on ceramics. Enameling techniques include CLOISONNÉ; CHAMPLEVÉ; BASSETAILLE; and PLIQUE-À-JOUR. These are delicate techniques, appropriate for jewelry and *objets d'art;* ceramic or porcelain glaze applied to metal panels on a larger scale is known simply as porcelain enamel or vitreous enamel. Genuine porcelain enamels are inorganic, and are fired at temperatures of 1,500° F. or more.

2. A fluid paint that dries to a hard, glossy, smooth finish suggesting that of vitreous enamel. The vehicle of enamel is a resinous varnish. The two types are air-drying enamel and baking enamel. The latter achieves a tough, resistant character after it has been baked in an oven at 250° to 450° F.

3. A translucent glaze made of ground glass and colored with metallic oxides for use in painting on glass. The development of this form of vitreous enamel in the 16th century revolutionized the art of STAINED GLASS by enormously increasing the range of colors that could be used on a single piece of glass. Hitherto, only a limited number of color effects had been possible with GRISAILLE, SILVER STAIN, and JEAN COUSIN. The wide use of enamels finally converted the art of stained glass from a form of mosaic to a form of painting.

enamel paper. A British term for glossy COATED PAPER.

enamel white. Another name for BLANC FIXE.

encaustic or **encaustic painting.** The art or technique of painting with hot wax colors that are fused after application into a homogeneous layer and fixed to a support with heat; also, a painting so executed. The technique,

ENCAUSTIC. Mummy portrait on wood (A.D. 120–130) from the Egyptian Fayoum. (*Courtesy of The Brooklyn Museum.*)

invented by the ancient Greeks, takes its name from the Greek *enkaustikos,* or "burning-in," the term now used for the last step in the process. Any wax technique that omits this final thermal treatment is not, properly speaking, encaustic.

Encaustic colors are made by mixing pigments with molten beeswax and a little resin; they are kept fluid on a

hot palette and painting is done on any permanent support with brushes or spatulate instruments. When all the colors have been laid the panel or canvas is set face-up on a table and the heat element is passed above it at a fixed distance until the colors are hot enough to fuse into a uniform film (but not so hot that they flow or run into one another). As the paint cools, the resin helps harden the film. In the encaustic technique the heaviest impastos may be used with safety; the paintings are permanent, and when polished with a soft cloth they have a pleasing dull sheen.

The burning-in (or "inustion" as it was formerly called) is done with any radiant heat source, such as a therapeutic heat lamp or a reflector light bulb. While the painter is at work he may hold a heating device in his free hand, warming the colors to a plastic consistency so they can be manipulated and blended. Without such surface heating the colors will congeal quickly into crisp, separate, brushstrokes.

Encaustic palettes with built-in heating elements and depressions for the paints are on the market, but equipment may easily be improvised by setting a metallic tray on a box heated with light bulbs or on a stand over an electric hot plate. The best working temperature for most purposes is about 200° F.

The ancient Greeks heated their wax colors on a copper or silver palette set over a metal drum filled with glowing charcoal, and for burning-in they used a brazier filled with charcoal. They applied colors to the painting with a bronze spatulate instrument. The Romans called this tool a *cestrum*, and all of the instruments used in encaustic, collectively, *cauteria*. The wax used in ancient times was called "Punic wax" by Pliny the Elder, but because of differing interpretations of his description of its preparation, the exact nature of this material was long in dispute. It is now generally held to have been the equivalent of modern white refined beeswax.

No Hellenic encaustic painting has survived, but the use of the technique by both the Greeks and Romans is rather thoroughly documented in Roman writings and in relics. It was employed not only in artistic works but also, in some cruder form, as a protective coating, as on ships. Of the extant ancient encaustics the most notable are mummy portraits from the Fayoum district of Upper Egypt, which date from the 2nd to the 4th centuries.

As is true of fresco and other techniques that originated in antiquity, encaustic is basically a simple process, but the modus operandi made its execution a cumbersome task. It was abandoned at some time during the Roman era, and the evidence concerning easel and mural painting from that time to the Renaissance indicates the use only of aqueous media and the early use of oils. During the 17th century alla prima oil painting began to come into use, and for the first time since the age of the encaustic painters, artists again had the means of creating direct, impasto, painterly works.

During the 18th century and again in the mid-19th, a number of experimenters studied the old methods with the aim of reviving encaustic for murals that could withstand harsh climatic conditions. They had little success, however, because like other surface coatings, encaustic is susceptible to damage from moisture seeping in from behind, and because no substantial improvements had yet been made in the awkward heating arrangements.

The technique was successfully revived for easel painting during the first quarter of the 20th century, when the

availability of electric heating appliances made the process easy to manage. It has maintained its appeal for many artists even after the introduction of polymer colors, which can approximate to some extent the effects of wax colors and their full, rich impasto.

engaged. In sculpture, attached, embedded in, or otherwise connected to another element; not freestanding. A figure that is carved with no open space between the arms and torso or between the legs has engaged limbs. Much ARCHITECTURAL SCULPTURE is engaged rather than freestanding.

English green. Another name for EMERALD GREEN.

English pink. Another name for DUTCH PINK.

English red. Formerly the American term for LIGHT RED; in general usage until 1942, when it was replaced in the Paint Standard by the more universally used light red.

English sycamore. See HAREWOOD.

English vermilion. VERMILION made in England.

English white. Another name for WHITING, much of which is mined from the chalk cliffs of England.

engobe. A variety of SLIP used for decorating pottery. Engobe contains COLOR OXIDES as well as clay, feldspar, and silica. Usually of heavier consistency than the typical slip, it is applied to leather-hard or dry bodies.

engraving. The process of incising a design, inscription, etc., on a hard surface, usually metal or wood, with a sharp tool, especially a GRAVER, either as ornamentation or as preparation of a printing surface; also, the resultant incised design or the print made from it. In metalwork and sculpture, engraving is used for the surface decoration of objects in silver, gold, or other materials; sometimes it is a step in another decorative technique, such as niello. In the graphic arts, engraving is that process whereby the graver or other sharp tool is used to create an INTAGLIO or RELIEF PRINTING surface on a metal plate or a wood block, as in line, or copperplate, engraving (see below), STIPPLE ENGRAVING, and WOOD ENGRAVING. Plates for prints done in the CRAYON MANNER can be either engraved or etched. Although the WOODCUT and the LINOCUT employ the principles of engraving, they are really knife-and-chisel carving processes and are not classified as engraving. The plates made for PHOTOENGRAVING are actually etched (see ETCHING) rather than engraved.

Until rather late in the 19th century, engraving was used as a generic term for all graphic-arts processes; the terms line engraving and copperplate engraving were adopted to designate both the specific intaglio printmaking process of incising a metal plate in lines, rather than tonal areas, and an ORIGINAL PRINT made by this process. Today the term engraving is almost always used as a shorter designation for line engraving. In this process, the engraver first transfers his design in reverse to the plate, which is usually copper but may be steel, and then incises the polished metal with a graver, or burin. The thickness of the furrows cut by the burin can be varied either by carefully manipulating the tool (the graver should not be used at too great an angle, however, or the resulting cut will be too slanted to one side to hold ink); by changing tools to get cutting surfaces of different sizes; or by using an ECHOPPE. The depth of the furrow is

increased not by forcing the tool but rather by retracing shallow lines with the burin until the desired depth is achieved (as in etching, the deeper the incised line, the darker it will print). Hatching and cross-hatching are used to indicate form and space, light and shadow. As the burin digs into the plate, it throws up small shavings of the metal, leaving behind a minute ridge, or BURR, on each side of the furrow. This must be removed with a SCRAPER in order that the printed lines not be blurred. TRIAL PROOFS are repeatedly pulled throughout the execution of any metal-plate engraving so that the engraver may see as his work progresses which furrows need deepening or widening, whether hatching needs to be denser, etc. Each set of trial proofs is called a STATE. The artist prints the regular editions of his plate in an ETCHING PRESS.

Line engraving, like etching, developed from metalworking techniques. The earliest engravers were goldsmiths. The early link between metalworking and printing is evidenced by the application of the terms BROAD MANNER and fine manner to both the art of engraving and the art of NIELLO, from which decorative technique engraving may have been derived. It is not known who executed the first line engraving. The technique developed simultaneously in Germany, the Netherlands, and Italy during the 15th century. The foremost early German engraver was Martin Schongauer (c. 1450–1491), the son of a goldsmith, whose 115 copper engravings influenced artists throughout Europe—not the least of whom were Albrecht Dürer (1471–1528) and Lucas Cranach the Elder (1472–1553). In Italy during this period, both Sandro Botticelli (c. 1445–1510) and Andrea Mantegna (c. 1431–1506) were influential in the development of the art of line engraving. The 16th century, which produced such masters as Dürer, Cranach, Lucas van Leyden (c. 1494–1533), and Marcantonio Raimondi (c. 1480–c. 1534), was the heyday of engraving. During the 17th century graphic artists began to be lured away from engraving by the freer and more expressive technique of etching, and engraving declined to the status of a reproductive technique. Some of the 17th-century engraved portraits and copies of drawings are very fine, however.

enlarging. The process of increasing the size of a work of art without changing the scale of the elements contained. The various methods of enlarging—both by hand, such as by SQUARING, and by the use of such devices as the PANTOGRAPH and the slide projector—are used especially for increasing the size of an artist's preparatory sketch or a photograph to fit the larger surface on which the finished work of art is to be executed. A small preliminary drawing for a mural, for example, may first be enlarged by one of these methods to a CARTOON that is then transferred to the wall surface by POUNCING, or it may be directly enlarged on the wall itself. The same principles, many of the same techniques, and much of the same equipment are used to reduce the size of an original work of art, although this is less frequently required.

en taille d'epargne. See CHAMPLEVÉ.

entrelac. A linear motif of intertwined lines and whiplash curves, often found in art nouveau designs.

environment. An art form related to assemblage and usually employing large elements designed to be moved among or through, rather than merely viewed. These elements often include

found objects, as well as painted or sculptured pieces. The environment is regarded as an extension of collage to the point that the work no longer has the illusory space of a two-dimensional painting but occupies real space, which it shares with the viewer. Forerunners of the environment, in the form of paintings with the dimensions of rooms, were produced in Munich in the late 1930's. A group of young New York painters in 1952 and the Gutai group in Japan in 1955 gave a new impetus to the concept of environmental art, which, now widespread, has been further extended by the use of action to include the HAPPENING. Among the leading creators of environments are Walter Gaudnek, Allan Kaprow, James Dine, Claes Oldenburg, and Salvador Dali.

epigone or **epigon.** An imitator or follower of a great artist to whom he is inferior or of a school or art period to which his own school is inferior; from the Greek *epigonos,* one born after.

epigraphy. The deciphering and interpretation of ancient inscriptions incised on stone, clay, metal, or another hard surface. In this study everything from noble sentiments chiseled on the marble of a temple to random scratchings on a wall (see GRAFFITO) is of interest and value. Much of the archaeologist's knowledge of the past comes from it. The word is sometimes also applied to the study of more recent inscriptions, to the practice of carving inscriptions, or to a collection of incised inscriptions.

epoxy resins. A group of synthetic thermosetting resins, developed during the late 1940's and early 1950's, widely used in industrial molded products and in baking enamels, and becoming increasingly popular with experimental sculptors. The epoxies

require a catalyst or hardening agent that is added at the time of use. They are well adapted to molding because of the accuracy of the reproduction, there being practically no shrinkage or loss of volatile ingredients. All sorts of fillers—chopped fiber glass, fiber-glass mats or fabrics—and pigments are used with the resins. Baked coatings made of epoxy resins have excellent resistance to chemical attack and they protect surfaces from corrosion. The resins are perhaps best known as adhesives, for which purpose they are sold in sets of two tubes, the resin and the hardener, to be mixed in equal volumes just prior to use. Epoxy cement has the advantages of forming a secure join without the necessity of using clamps or pressure while it sets, and of creating a permanent bond of very great strength.

Epoxies must be handled with careful safeguards against the highly toxic effects of their solvents and the skin irritation caused by their hardeners.

equilibrium. A balance of elements in a composition. A work that lacks equilibrium may be unpleasantly one-sided and/or without coherence. A composition in which most of the prominent shapes and masses are on one side, for example, would seem to be lopsided unless the other side had interest—spatial, linear, or color—to balance it. Directional lines at different angles, balanced distribution and intensity of color, and proportionate areas allotted to the significant and the secondary parts of the composition all contribute to balance.

eschel. A mixture of smalt and ZAFFER, considered a grade of SMALT.

esparto. A coarse grass used in the production of paper, especially in England; grown in Spain and North Africa.

esquisse. A preliminary sketch for a drawing, painting, or sculpture. The artist uses the esquisse to experiment with and work out the composition, the proportions, and the schemes of perspective and color that he will want to incorporate in the ultimate work of art. The *esquisse en sculpture* is a small model in clay or wax that roughly indicates the thoughts and forms that the sculptor will later articulate explicitly in the final work. The French term esquisse and the Italian word schizzo are derived from the same root and may be used interchangeably, but both words are considered somewhat of an affectation when used in English.

essential oil or **essence.** A fragrant liquid that is extracted or distilled from any of numerous flowers, leaves, woods, and other vegetable sources as well as from some animal sources. An essential oil is not really an oil in the same sense as linseed or petroleum oil. OIL OF CLOVES; OIL OF LAVENDER; SPIKE OIL; and oil of rosemary (see ROSE-MARY) have some uses in oil painting, and certain other essences are used as odorants in such products as water paints, polishes, and cleaners (see CEDAR, OIL OF).

ester. The chemical designation of any of a wide group of organic compounds that is made up of an acid and an alcohol (or a phenol) and that during HYDROLYSIS breaks down to these component parts; it can also be more simply regarded as a salt of an organic acid. An ester may be specified by either constituent: for example, ethyl silicate can be called the silicon ester of ethyl alcohol or the ethyl ester of silicic acid.

ester gum. ROSIN that has been hardened, bleached, and had its acid neutralized by chemical and mechani-

cal treatments. Its properties are improved so greatly as to make it suitable for use in good-quality industrial products but it is not used in artists' paints or varnishes. It has found some use in the wax-resin adhesives used in LINING. Its name is an instance of the varnish maker's use of the term gum interchangeably for resin.

etch, lithographic. See LITHO-GRAPHIC ETCH.

etching. BITING; or the process whereby a surface is partially eaten away by a MORDANT in order to create a design, either as decoration, as on glass, or as an INTAGLIO or RELIEF PRINTING surface on a metal plate. In the latter capacity, etching is the process used to prepare the printing surface of the metal plates used in ANASTATIC PRINTING, PHOTOENGRAVING (both line and HALFTONE), and PHOTO GRAVURE, as well as the plates made for the specific fine-arts printmaking technique that is known as etching (see below). Etching is a chemical process and differs, therefore, from the mechanical methods of creating a raised or lowered design on a surface, as in ENGRAVING.

The intaglio printmaking process that is known as etching is, traditionally, the preeminent graphic-arts technique. An original print made by this process is also known as an etching. The drawing is made with a steel etching NEEDLE through a thin coat of an acid-resistant ETCHING GROUND, blackened, if needed, by SMOKING, on a highly polished metal plate, usually copper. The actual engraving agent in etching is the mordant; the lines drawn with the etching needle merely expose areas of the metal plate—the point touching but not digging into the surface of the metal. When the design has been drawn on the plate, the back and the edges of the plate are protected

with an asphalt-varnish RESIST, and the plate is subjected to biting by immersion in a mordant bath. After a measured period of time, the plate is removed, rinsed and dried, and the lines that the etcher wants to be faintest are protected with STOPPING-OUT varnish (the deeper a line is etched, the darker it will print). The plate is then placed for a second time in the ACID BATH to deepen the etch of those lines not stopped-out. This procedure of stopping-out and re-biting may be repeated several times to create progressively deeper lines on the plate. When the plate is bitten to the etcher's satisfaction, it is cleaned and polished and then inked with a dabber and wiped to leave the ink in the etched lines only (see WIPING). The PROOFS are printed, or pulled, by running the inked plate and sheets of damp paper through an ETCHING PRESS. The print is a reversed copy of the drawing on the plate. Most etchers make LIMITED EDITIONS of twenty to fifty proofs; collectors generally seek low-numbered proofs that are pulled before the plate begins to show signs of wear. When a large edition of an intaglio print is needed, as for a book illustration, the plate is given a STEEL FACING, a process that prolongs its printing life.

There are wide variations in materials and procedures in almost every step of the etching process. Sometimes the less expensive but less sensitive zinc plate is used instead of a copper plate. Because of the variety of techniques and materials available to the etcher and because etching can be very successfully used in combination with other techniques such as DRYPOINT and AQUATINT, etching permits a multiplicity of effects and allows for a completely individual artistic expression.

The etching of metal plates as a printmaking process developed from the common medieval practice of etch-ing designs on armor with acid. It was, in fact, an etcher of armor, Daniel Hopfer (1493–1536), who is thought to have first inked and printed an etched iron plate. The first dated etching, however, was executed by Urs Graf, a Swiss artist, in 1513. Although copper plates were always used for etching in the Netherlands and in Italy, iron plates were used elsewhere until the 17th century. Iron plates required the most skillful handling in order to obtain acceptable results from that coarsely grained metal. Perhaps the fact that Albrecht Dürer used iron for the five etchings he executed between 1515 and 1518 explains the small success he had with the medium. During the 17th century, particularly in the hands of two virtuoso etchers, Hercules Seghers (1589/90–?1638) and Rembrandt (1606–1669), etching so progressed in versatility of technique and subtlety of effect that it surpassed engraving as the most popular graphic art. Seghers was the first graphic artist to use the process of *vernis mou*, or SOFT-GROUND ETCHING, and Rembrandt used drypoint extensively in his etchings to achieve the directness that is characteristic of his work. With simple line etching and drypoint, Rembrandt achieved effects that have never been topped, not even by artists using more modern methods and exploiting more sophisticated variations in technique. Anton van Dyck, a contemporary of Rembrandt, was also a master etcher and is especially well known as a graphic artist for his *Iconography*, a superb series of more than 100 etched portraits of contemporary artists and writers, only about 18 plates of which, however, were completely prepared by van Dyck himself. Etching innovations in the 18th century, such as CRAYON MANNER and aquatint, were taken up in Spain by Goya (1746–1828)—certainly one of the greatest masters of the technique

of etching, as his *Los Caprichos, The Disasters of War,* and *Los Proverbios* series well demonstrate (see illustration at CAPRICCIO). The great 19th-century painter-etchers, among them James McNeill Whistler and Joseph Pennell, obtained new effects with etching. Picasso, Rouault, and Chagall are among the significant 20th-century painter-etchers.

etching ground. In ETCHING and AQUATINT, the thin resist, or acid-resistant coating, that is applied to the face of the copper plate and through which the drawing is incised with a needle in etching and the plate is grained in aquatint. A good etching ground must resist the MORDANT for the duration of BITING. It must be of the proper consistency—soft enough and not too adhesive—to be penetrated easily by the needle, but it must also be hard enough to withstand a certain amount of handling. Various combinations and proportions of beeswax and resins are used, but the wax is usually slightly less than double the quantity of the other ingredients. Many etching grounds contain a highly acid-resistant, soft asphalt such as manjak or Trinidad. A few basic types of ground may be either made up by the etcher (see REMBRANDT'S GROUND) or bought ready-made. The ground is applied by rubbing a lump of it on a heated plate and spreading it with a DABBER. Since most grounds are transparent (even those containing asphalt have only a light-brown tinge when spread thinly and evenly on the plate), etchers usually blacken the surface of the plate by SMOKING the applied ground. The addition of an equal quantity of tallow to a regular etching ground produces a suitable resist for SOFT-GROUND ETCHING. This soft ground, or *vernis mou,* does not require blackening by smoking. See also STOPPING OUT.

etching press. A printing press used in INTAGLIO printing (etching, engraving, drypoint, aquatint, etc.), consisting of a large upper roller, a lower roller about half the diameter of the upper one, and a flat steel bed or iron plate that moves on gears through the rollers as the SPIDER WHEEL is turned.

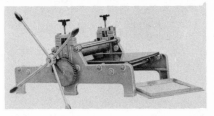

ETCHING PRESS. (*Courtesy, The Craftool Co.*)

The inked and wiped (see WIPING) intaglio plate is printed by placing it, printing surface face-up, on the bed plate of the press; covering it with a piece of damp paper, which is in turn covered with a felt etching BLANKET; and running the whole "sandwich" of bed, plate, paper, and blanket through the rollers. Sensitive proofs can be printed only if the artist has complete control of the press. An etching press can also be used for printing a metal-plate MONOTYPE and for creating a SAND-GRAIN GROUND on an aquatint plate.

ethanol. See ETHYL ALCOHOL.

ether. A colorless, volatile, highly inflammable liquid made principally by the distillation of alcohol and sulfuric acid and used chiefly as a solvent and anesthetic; called also ethyl ether and diethyl ether. Ethyl ether is called for in some antiquated recipes for etching grounds, but because it is dangerously explosive and toxic it has long been replaced by less hazardous solvents such as acetone.

ethiop. Amorphous black mercuric sulfide; an intermediate stage in one method of making VERMILION.

ethyl acetate. A VOLATILE SOLVENT that has a mild, fruity odor and is not dangerously toxic if properly handled; extensively used as a LACQUER SOLVENT. It is also known as acetic ether.

ethyl alcohol. A VOLATILE SOLVENT widely used in industry but of relatively minor importance to artists. It is the solvent for shellac and a few other resins, a diluent for some of the fixatives, and a mildly active wetting agent. Pure ethyl alcohol is the basis for alcoholic beverages and is therefore subject to a heavy tax. For this reason, DENATURED ALCOHOL is far more readily available for artists' use. Those who require pure alcohol for technical purposes can usually get a permit to obtain it in small quantities. ABSOLUTE ALCOHOL, which is free of water, is also available from chemical supply sources. The vapor of pure ethyl alcohol is less harmful to the health than that of most solvents. Other names for ethyl alcohol include grain alcohol, ethanol, Cologne spirits, and colonial spirits.

ethyl silicate. A LIQUID SILICATE used as a vehicle in mural painting. It is a clear, thin liquid which superficially resembles a volatile solvent. When carefully formulated with alcohol and a small amount of water, it will hydrolize into a pure silica binder, after going through a viscous, adhesive, intermediate stage while drying. Painted on any absorbent or porous surface, ethyl silicate colors produce effects comparable to those of fresco; in their durability and resistance to adverse conditions and the brilliance of their colors, they surpass fresco. The colors must be freshly prepared each day, because once water has been added the HYDROLYSIS cannot be halted. Ethyl silicate is the best and most readily available of several SILICON ESTERS. It was first introduced as a paint vehicle by George King in England in 1931, and was introduced in the U.S. by Ralph Mayer in 1937.

Etruscan art. The art of the people of ancient Etruria, now Tuscany, in the western part of Central Italy, who ruled in Rome itself during the 6th century B.C. but were under Roman political domination by the end of the 3rd century B.C. The Etruscans may have come from Asia Minor or the Middle East, or have been at least partly indigenous to Italy. They were thoroughly established in Etruria by 700 B.C. and their civilization reached its peak in the 7th and 6th centuries. Their art shows MINOAN, MYCENAEAN, HELLENIC, and EGYPTIAN influences, but also contains some original elements, which in turn affected the development of Roman art.

The elaborate stone tombs of the

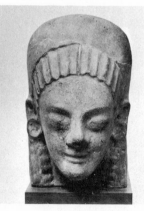

ETRUSCAN ART. Archaistic female head with earrings; terra-cotta antefix (6th–5th centuries B.C.), said to be from a temple at Caere. (*The Metropolitan Museum of Art, purchased by subscription, 1896.*)

Etruscans, in a huge necropolis or city of the dead at their ancient capital of Tarquinii (near modern Tarquinia), were decorated with lively wall paintings depicting scenes of activity and pleasure from daily life. Some of these murals were done in true fresco, others in a sort of tempera—both on white plaster grounds. Terra-cotta statues, of life size or larger, on the sarcophagi of the dead, differed from their Egyptian counterparts in that the deceased were shown happy, and vigorous as in life, rather than solemn as in death. In the 6th century such figures had the "Archaic smile" of Hellenic sculpture of the period (see ARCHAIC PERIOD), although later statues were more solemn, possibly in response to a similar change in Hellenic work. Pottery, painted vases, ivory objects, gold jewelry, and bronze statuettes were also made by Etruscan craftsmen. In the 3rd century superb bronze portrait heads of living individuals began to appear. Roman writers tell us that the Etruscans were also master architects and city planners, but of their temples and homes, built in wood on stone foundations, almost nothing remains.

étude. French for STUDY.

euchrome. An archaic name for burnt UMBER.

Euville stone. See LIMESTONE.

evangeliar or **Gospel Book.** Medieval book containing the four gospels; in Latin, *evangelarium.* Evangeliars were often richly ornamented and are among the finest examples of the art of illumination. The best known of the surviving evangeliars is the famous 8th-century *Book of Kells,* produced in Ireland, but a number of other Irish examples, as well as various German, Frankish, and English manuscripts also show a high degree of artistry.

even-sided. Designating paper or board that has the same surface on both sides and thus may be used for drawing, painting, or printing on either side.

exc. An abbreviation for the Latin word *excudit,* meaning "he executed it." A synonym for *imp.* (*impressit,* "he printed it"), *exc.* is sometimes inscribed in a lower corner of the margin of a print following the name of the printer and identifying him as such. For an explanation of other terms used for marking prints, see DEL.

exploded view. In mechanical drawing and commercial illustration, a rendering of a complex object in which each of its components is shown separately but in the same scale as the other parts. The parts are in correct relative position (except for the distance between them), as if they were ready to be pushed into reassembly.

expressionism. A concept of painting in which traditional adherence to canons of realism and proportion is overridden by the intensity of the artist's emotions, resulting in distortions of line, shape, and color. Whereas the Impressionists were concerned with rendering nature in a new and more valid way, such painters as the Fauves and Van Gogh, by considering their emotions as important as their subject matter, became the forerunners of expressionism. It was brought to the status of a full and vigorous movement by artists in Germany during the first quarter of the 20th century, especially by the BRÜCKE, BLAUE REITER, and NEUE SACHLICHKEIT groups. Among the prominent early expressionists were Edvard Munch (1863–1944), Max Beckmann (1884–1950), James Ensor (1860–1949), Oskar Kokoschka (1886–), Emil Nolde (1867–1956), Georges Rouault (1871–

1958), and Chaim Soutine (1894–1943). Like much of modern art, expressionism owes a great deal to the impact of African sculpture on Europe in the decade preceding World War I.

The artistic tendency to distort forms for emotional emphasis and impact can be traced back to such individual masters of fantasy and feeling as Hieronymus Bosch (active 1488–1516) and Matthias Grünewald (c. 1475–1528) in the late Gothic period. See also NEO-EXPRESSIONIST; ABSTRACT EXPRESSIONISM.

extender. Any substance, such as an INERT PIGMENT, that is added to a material in order to increase its bulk. It is classified as a FILLER if its function is to cheapen or downgrade the material. Extenders may serve necessary or desirable functions, such as controlling the excessive tinting strength of a pigment like phthalocyanine blue. A printing-ink extender of semi-paste consistency enhances the working qualities of the ink and improves its transparency. The transparent base used in silk-screen paints is also known as extender.

ex-voto. An object presented at a shrine as a votive offering. Pictures and other art objects have often been commissioned for this purpose.

F

f. or **fec.** Abbreviations for FECIT.

fabric. In ceramics, the whole nature of a body of work done in a given period, including its workmanship, materials, technique, and general style.

Fade Ometer. Trade name for a laboratory accelerated testing device in which samples of colored materials or coatings are exposed to a carbon arc to determine their degree of resistance to fading. The arc emits an intense actinic light which has, in a few hours, the destructive effect of many days of ordinary daylight. Although it does not duplicate exactly the effect of long exposure to sunlight, it serves as a very efficient indicator of what degree of light fastness can be expected of a material, and of the comparative resistance to fading of a number of samples. See also ACCELERATED TEST.

fading of colors. The gradual loss of color of pigments and dyes that are chemically unstable. Entering into chemical reactions on exposure to the ultraviolet rays in daylight, and to the oxygen and moisture of the atmosphere, they form colorless or less highly colored compounds. Dyes and pigments subject to such reactions are called FUGITIVE COLORS. The technologists' term for the property of color

permanence is color stability or fade resistance. There is no way of preventing the fading of unstable colors. A protective coating such as polymer medium will preserve fragile materials from damage but will not block out light; the acrylic and vinyl resins have the highest transmission of ultraviolet light of all materials.

faience. Earthenware with a colorful, opaque glaze, such as MAJOLICA. Faience is the French name for the Italian town of Faenza, famous for such pottery since the 16th century.

fake; fakery. See FALSIFICATION; FORGERY.

falciform. Having the shape of a scythe or sickle.

false biting. See FOUL BITING.

false body. See BODY.

falsification. In the fine arts, a broad term for any form of misrepresentation about the authenticity of a work. FORGERY, the creation of a fake, is a form of falsification, but the latter term is specifically used for the circulation of a copy or an imitation (that is, a work not originally made as a deliberate deception) as something genuine. Such are four bas-relief heads in Pentelic marble that were declared spurious in 1954. They were apparently made without dishonest intention in the mid-19th century as facsimiles of carvings from the Parthenon, but subsequently were sold and traded as true antique works.

fan brush. A sparsely bristled fan-shaped brush set in a flat metal ferrule at the end of a long handle; also available in red sable and badger hair. It is used dry for subtle or delicate blending of wet paint and for special manipulations in representing hair, foliage, and other fine, soft details. See also BLENDER.

FAN BRUSH

fast colors. In textile dyeing and other industrial processes, colors that will satisfactorily resist fading for the effective life of the product in which they are used; in artists' paint pigments, nonfading over long exposure to daylight. Lightfast and sunfast are variations of the term.

fat. In ceramics, a term describing a clay that has great plasticity. A fat clay such as BALL CLAY or BENTONITE may be added to a SHORT clay to make it more workable. Sometimes GROG or a less plastic clay must be added to an extremely fat clay to make the body more porous and allow it to dry uniformly.

fat over lean. The practice of applying layers of color rich in oil over an underpainting that contains less oil and is therefore less flexible. It is the recommended way to apply oil colors, as painting the "lean" over the "fat" would make the resulting work likely to crack after aging: the more brittle overpainting would be unable to adjust to the underpainting's expansions and contractions due to temperature and atmospheric changes.

fatty acid. Any of the organic acids combined with glycerin to produce fats and oils. Fatty acids are sometimes

separated from and used instead of the whole oil in alkyd resins and varnishes.

Fauves, les. A group of revolutionary painters whose work, especially during the first decade of the 20th century, was influenced by such Postimpressionist masters as Van Gogh, Gauguin, and Cézanne, while it rejected the formal aspects of earlier Impressionism. The term "fauves," meaning "wild beasts" and first used by a contemporary critic, referred to the violent liberties the artists took with color and, to a lesser degree, with form. Rejecting the Impressionist technique of breaking color up, they painted an object in the colors—often brilliant and explosive —that they thought best expressed its inner qualities, rather than as it appeared in nature. Although they were never a coherent group, the Fauve artists were linked by their intense use of color and their liberation from the restrictions of earlier art, as well as by personal friendship. Among them were Henri Matisse (1869–1954), André Derain (1880–1954), Maurice de Vlaminck (1876–1958), Albert Marquet (1875–1947), Raoul Dufy (1877–1953), and Georges Rouault (1871–1958).

fawn brown. Another name for VEL-VET BROWN.

fecit. A Latin word meaning "he made it" that is sometimes inscribed on a painting, print, sculpture, or building after the artist's name or initials. It is sometimes abbreviated to *fec.* or *f.*

feldspar. A crystalline mineral used as a FLUX in porcelain and glazes or frits. It contains aluminum silicates together with other compounds in varying compositions.

felt-tip pens and markers. Pens that are widely available in a great variety of pointed and blunt felt or nylon tips. Because they make possible a great flexibility of line and an ease of control in drawing, felt-tip pens, which are also known as fountain brushes, are especially popular for sketching. The ink reservoir is in the shaft of the marker. These pens come in a wide range of colors, none of which is sufficiently permanent for use in the fine arts, since the inks contain soluble dyes. However, a special refillable pen that also has interchangeable felt tips may be filled with a special ink made with a carbon-black pigment.

fence. In casting, a thin wall of either clay or sheet metal (usually brass) set on or into a model to create a separation in a waste mold or piece mold made of plaster.

ferric chloride. An iron salt used in ETCHING as a MORDANT or as an additive to another mordant in order to obtain more vertical biting and to lessen undercutting at the edges of lines. It tends to deposit salts rapidly on the walls of the etch, thus protecting them from further corrosive action, while the bottom of the etched furrow, where the mordant collects, clogs up less rapidly.

Ferrite; Ferrox. Trade names for Mars yellow, one of the MARS PIGMENTS.

festoon. Any decorative design of gracefully curved lines caught up in loops, as of cords or fabrics; specifically, a decorative carving or painting of a garland of leaves, flowers, and fruit arranged in a hanging loop between two points from which depend wavy ribbons or vine-like extensions of the foliage and flowers. A festoon is also called a swag.

FESTOON

fettle. In ceramics and sculpture, to trim away unwanted material, such as mold marks and coarse edges, from cast and plastic substances with a knife or other implement. A fettling knife, also called a POTTER'S KNIFE, is often used.

fiberboard. See WALLBOARD.

fiber glass. Glass that has been drawn into filaments made up of very fine, hairlike particles. It is nonflammable, light, and strong. In sculpture, it is used to reinforce polymer and polyester resins, since its tensile strength is very great. Fiber glass is available as CHOPPED STRAND MAT, glass fiber scrim, fiber cloth, tissue, and surface mat. Glass cloth is sold under the trade name Fiberglas.

fig milk. Trade name for a German ready-made tempera EMULSION (Feigenmilch) of undisclosed composition.

fig-tree juice. The milky juice of the fig tree, recommended in the 15th century by Cennino Cennini as an additive to egg TEMPERA. Cennini suggested beating or whipping the egg yolk with fresh, young fig-tree shoots. There have been various explanations for this practice. It may have been used as a preservative, or to give additional toughness and flexibility to the paint film, or as a plasticizer to improve brushability. Since fig-tree juice

closely resembles LATEX, the latter has been proposed as a modern substitute for it. However, practically no tempera painters of succeeding periods have followed Cennino's advice, feeling either that the twigs provided too small an amount of juice to be effective, or that Cennino meant to recommend them merely as conveniently available whisks to beat the egg to a light consistency.

figure. 1. In the pictorial and sculptural arts, a representation of the human body.
2. In design, any given pattern or repeated decorative motif, as in a figured textile.

figurine. A small statue, especially one a few inches in height and not over 10 inches.

filbert brush. A bristle brush, used in oil painting, which is flat and oval in shape; also known as an oval brush. While the flat and the bright brushes have straight edges, the filbert tapers to a blunt point, resembling a flat whose edges have been rounded by wear. See BRUSH, BRISTLE.

filigree. Fine wire, usually gold, silver, or SILVER-GILT, worked into delicate, intricate designs, either as openwork or as surface decoration for a gold or silver ground to which it is soldered. The wire, which may be curled, twisted, or braided, is often varied with beads or grains of the metal. If the filigree is to stand alone it is usually set within a framework of either heavier wire or strips of the metal, or bands may be actually intermixed with the wrought wire. The use of filigree for jewelry and other ornamental work is both old and extensive. Ancient Greek tombs have yielded fine examples, as have Anglo-Saxon and Celtic treasures. The art of making filigree

reached its peak in 17th-century Italy, where some of the finest filigree is still produced today.

filler. An INERT PIGMENT added to a paint or pigment to cheapen or adulterate it. An inert pigment used to impart desirable properties to or to enhance the performance of a pigment is classified as an EXTENDER.

filler rod. A thin stick of bronze, brass, or another metallic alloy, used for BRAZING or welding a metal with a higher melting point. An acetylene torch is used to melt the rod, which is then deposited on the base metal as a means of joining pieces together or of covering the surface.

fillet. A very narrow, flat plain molding, sometimes called reglet or quadra, which may be used as a border or as the raised part of a design in any of a number of patterns; also, a narrow, flat band that separates two moldings or other elements of a decorative design.

film. In painting, a continuous layer of paint. A dried paint coating is referred to as a paint film in discussions of its composition, structure, and behavior.

film-former. The fluid ingredient in a paint, varnish, or other coating material that enables it, on application to a surface, to form a continuous adherent layer; also, the nonvolatile components of a vehicle or medium, as distinguished from its volatile thinners. Various drying oils and solutions of resins, gums, waxes, and casein are the more common film-formers used in artists' materials. The effectiveness of an oil as a film-former is indicated by its IODINE VALUE.

film integrity. Term used in reference to the flawless continuity—without breaks or pinholes—of a paint or varnish film.

film-stencil method. A SILK-SCREEN technique in which the stencils are cut from a paper-backed stopping-out film. This transparent sheet is composed of a thin film of colored lacquer (the color makes the design visible on the screen) laminated to a sheet of glassine backing paper. The design to be printed is traced onto the film and then cut out with a stencil cutter, through the lacquer layer only. These cut-out printing areas are then stripped from the backing paper, and the film is attached to the underside of the screen with an adhering thinner. Before the stencil is printed, the paper backing is removed from the film, leaving the design areas open and pervious to the paint that is applied with a SQUEEGEE. Nonprinting areas of the screen outside the stencil are also blocked out, either with paper (for short runs) or lacquer (for larger editions). NuFilm and Profilm are well-known trade names for the lacquer stencil film used in the process. It is sold in 30 x 40 inch sheets and in rolls. The film-stencil method of silk screening is especially suited to commercial work requiring precision in printing and is also used in SERIGRAPHY for geometrical designs and simple drawings.

film-thickness gauge. A laboratory device especially designed to measure the thickness of wet or dry films of paint or other coating materials. Several different types of mechanical and electrical instruments are used in the preparation of test samples.

filter press. A machine for filtering solids from liquids. It consists of a series of square frames held in position between solid plates, with a square of filter cloth attached to each frame. The fluid is pumped into the press under

strong pressure until the areas between the plates are filled with solid cakes of paste or pulp material. This may be given a final rinse by pumping water through the press. The filter press is essential equipment in pigment manufacture, where the filter cake is dried and pulverized, and in ceramics, where it is used to concentrate, or remove water from, clay SLIP.

fin de siècle. "End of the century"; characteristic of the arts and mores of the last two decades of the 19th century. The period was notable for its artistic and literary spirit of jaded sophistication and world-weary aestheticism. See also ART NOUVEAU; DECADENT ART.

fine art. Art created primarily as an aesthetic expression, to be contemplated or enjoyed for its own sake. Unlike APPLIED ART, it is not used as an instrument for some other activity. Examples of fine art include painting, drawing, sculpture, print making, and architecture. The distinctions between fine and applied art are, however, arbitrary at best. For instance, a Greek vase or a medieval manuscript illumination that may have been functional at the time of its creation is enjoyed today as a purely aesthetic object. See also MINOR ARTS.

fine manner. See BROAD MANNER.

finger painting. The application of colors to a surface with the fingertips. With the expansion of organized art activities for children in the 1930's, special materials were developed for their use. Finger paints, available in jars, are nontoxic, easily worked, and easily washed away. Some serious artists have experimented with finger painting, using both water-miscible and oil paints. Chinese artists of various periods have also practiced finger

painting, both alone and in conjunction with brushwork.

finial. In architecture, furniture, metalwork, and ceramics, an ornament that serves as the crowning detail, as at the apex of a roof or gable or on the lid of a tankard or covered bowl. The finial serves chiefly as decoration. It may be functional as well when it is used as a knob to grasp or when it locks elements together, as on a lampshade. In ceramics and metalware this protuberance usually takes the shape of a flower bud, a bunch of foliage, an acorn, etc.; a flame, a steeple, or an urn—the traditional finials in a broken pediment—are more common in furniture and architecture.

finish. 1. The surface appearance of a work of art, such as a painting or sculpture, or another object, such as a sheet of paper or a piece of furniture: e.g., a glossy finish, a rough finish, a smooth finish, a mat finish. Industrial coating materials are sometimes called finishes. See also PATINA.

2. In art criticism, a work that shows careful attention to perfection of line, form, and detail, as distinquished from a rough, spontaneous, or casual treatment, is said to have finish, or to be a highly finished work.

finishing trowel. A flat-faced tool used to produce a smooth, level surface on plaster or concrete work.

FINISHING TROWEL

firebrick. Bricks made from infusible material such as FIRECLAY, used for constructing or lining furnaces, kilns, and chimneys, which are to be subjected to extreme heat.

fireclay. A highly refractory clay, i.e., one that fuses at higher temperatures than those used in firing pottery,

glazes, and enamels. It may thus be used for making a MUFFLE, FIREBRICK, and KILN linings. Fire clay commonly contains a considerable proportion of alumina.

fire gilding. A chemical process for applying a coat of gold to another metal by coating the surface with an amalgam of gold and mercury and vaporizing the mercury with heat. The thin coat of gold that remains is then treated with GILDER's WAX and a paste of salts in water or weak ammonia to heighten its color. This process is also called amalgam gilding and, rarely, wash gilding (it should not be confused with the mechanical process known as WATER GILDING, in which leaf is laid on a gesso or bole surface that has been moistened with water). Fire gilding, which is probably the oldest technique for gilding metals, was used particularly to decorate arms and armor. The process is seldom used today and is, in fact, forbidden by law in most places, since the fumes of the volatilized mercury can be toxic. It has been largely replaced by METALLIZING processes.

fire marble. See SHELL MARBLE.

fire red. An industrial or printing-ink pigment of a hue associated with fire engines; usually made from TOLUIDINE RED. Fire red is not sufficiently permanent or non-bleeding for artists' use.

firing. In ceramics, the process of exposing a clay body, glaze, or enamel to intense heat, usually in a KILN. Firing hardens clay permanently by changing it both physically and chemically. Glazes and enamels are vitrified during the firing process. See MATURATION; REDUCTION FIRE; GLOST FIRE; BISQUE FIRE.

fish glue. Glue made from fish bones or skin. It is sold in liquid form for use as an adhesive on wood and other materials. Although it is a much weaker adhesive than hide glue, it is adequate for many purposes.

fishtail tool. A wood-carving chisel or gouge that flares out widely at its cutting end. See illustration at WOOD-CARVING TOOLS.

fissure. A crack in the paint film which leaves the ground or underpainting visible. Such a crack is called a TRACTION FISSURE when caused by contraction of the paint.

fit. In ceramics, the mechanical suitability of a glaze to a clay body. If the glaze and the body have similar coefficients of expansion, certain glaze defects such as CRAZING will be minimized.

fitch. 1. The hair of the fitch or polecat, used in making brushes; also, a brush made of fitch hair.

2. More commonly, a CHISEL BRUSH made of bristle or camel hair, with a ferrule that tapers toward the handle and straight bristles

FITCH BRUSH

that flare out slightly. Fitches are employed primarily for sign writing and decoration, using the side edges of the brush, but a good one can also be used on its flat sides like a SINGLE-STROKE BRUSH.

fixative. A thin liquid consisting of a resinous or glutinous binder and a volatile solvent, sprayed over pastels and drawings, especially CHARCOAL DRAWINGS, to protect them from smudging. Fixatives for charcoal and pencil drawings usually contain a small proportion of resin dissolved in a large amount of alcohol or other rapidly evaporating solvent. Their ac-

tion binds the particles securely so that the work will not rub or smudge when given a normally careful handling. To remain invisible, a fixative cannot be used excessively or it will build up to a continuous layer, like a varnish film. The artist applies fixative with a sprayer, a mouth blower, or an atomizer, and he may also buy it packed in a pressure spray can. The term workable fixative means that the drawing may be worked on even after fixing. (The resinous deposit of some fixatives repels water and so precludes further work.)

Pastel fixatives differ from the common variety in that they are not intended to supply full protection, but only to render the surface less fragile so that the particles will not dust away of their own accord; the work is then framed under glass with a mat sufficiently thick to prevent contact with the glass. During the two centuries in which pastel has been popular as a fine-arts medium much effort has been directed toward the invention of a protective fixative that would neither alter the colors nor destroy the characteristic soft pastel quality. But this is optically impossible, for when a pigment is surrounded by a medium, both its color effect and its opacity are altered so that its appearance differs from that displayed when it is surrounded by air. Some binders produce less color change in relation to their binding power than others. An alcoholic solution of casein is one of the best in this respect.

fixed oil. A rather outmoded term for the nonvolatile component or film-forming oil in a paint vehicle or varnish, as distinguished from the volatile solvents which were formerly called volatile oils.

flag. In bristle used to make a brush, the end opposite the root, or butt, end;

called also the split end. Flag ends are always set as the free end of a brush. See also BELLY; HEEL.

flake white. Artists'-quality WHITE LEAD oil color. The same precautions should be taken in using this color as with other lead-based pigments.

Flamboyant style. See GOTHIC.

flame black. An inferior carbon pigment made by burning waste coal tar and mineral oils. It tends to be brownish and to contain oily impurities. Flame black can be considered an impure LAMPBLACK.

flashing. A method of coloring glass by dipping clear glass, while still pliant, into a bath of molten glass of a deep color, or by fusing a thin sheet of dark glass to a thicker one of clear glass. Flashing has been practiced at least since the 12th century in the making of STAINED GLASS and in other glassmaking techniques. It is necessary because the darker shades of glass, in the thickness required for use in windows, would be nearly opaque. See SGRAFFITO.

flat. Term used to describe a mat, or lusterless, surface finish.

flat color. A uniform, unbroken, unshaded area of color.

flat sketching pencil. A broad, flat-pointed LEAD PENCIL, useful for sketching and lettering, especially for drawing in wide lines and shading large areas. It is available in several degrees of softness, from 2B to 6B. The common carpenter's pencil is comparable in composition, size, and use. Although it is sold in one degree only (approximately 4B) and is not made to the same standard of quality as a flat sketching pencil, artists nevertheless

use carpenter's pencils for many of the same purposes.

flatware. Utensils or receptacles that are relatively flat. Although the term can be applied to ceramic, glass, and metal objects, in common usage flatware refers almost exclusively to pieces made of metal, especially silver. See also HOLLOW WARE.

flavine lake. A fugitive LAKE pigment formerly prepared from the natural dyestuff quercitron (see QUERCITRON LAKE). It was made in a number of shades, including greenish yellow, dull yellow, bright orange, olive, and greenish black. The name flavine is also associated with a series of synthetic dyes.

flax. A plant (genus *Linum*) that grows in all temperate and cold countries. The linen for artists' canvas is made from flax fiber, and linseed oil is pressed from its seeds.

Flemish white. An obsolete name for WHITE LEAD, used in England during the 19th century.

flesh color. The paint used to depict the skin color of white people. Typically, it is a mixture of white and yellow ochre or raw sienna tinted with very small amounts of red or a trace of black, green, or another color for subtle variations. Oil colors and pastels labeled flesh color are ready-made mixtures of no standard composition, but they can usually be depended on to be permanent.

flesh ochre. A special YELLOW OCHRE modified by admixture of other pigments; useful in creating FLESH-COLOR effects.

flint. A form of quartz used as a source of silica in ceramic glazes and in clay bodies. The terms flint, silica, and quartz are frequently used interchangeably in ceramic terminology.

flitch. A log or section of a log that has been specially selected and prepared for cutting veneer. Some woods used extensively for veneer and not available in blocks for carving may be obtained in this form.

float. A flat-faced tool for finishing plaster, cement, and similar materials. In plastering for fresco painting a float with a roughish wooden surface is usually preferred; it may be made by fastening an angled handle to a cedar shingle. In other kinds of plastering, floats covered with cork, carpet, felt, or glass may be used.

floating signature. An artist's signature applied to a painting on top of the coating of varnish. A floating signature is obviously not an integral part of the painting, since if the painting were cleaned and the varnish removed, the signature would come away with it. Although an artist might conceivably sign his work after varnishing it, the discovery by test that a signature is floating is usually accepted as evidence that the signature is fraudulent.

flocking. Strewing pulverized cloth over a surface coated with PASTE or other adhesive to create a felt or velour effect. One kind of PASTEL PAPER is made in this way, and there are a great many industrial uses of the process, especially in the decoration of surfaces such as wallpaper by stenciling or printing the designs with adhesive. The process is not sufficiently durable to be used in works of art. In commercial flocking, a flock gun, similar to the SPRAY GUN used for liquids, is employed to apply the flock.

flong. A material made of layers of tissue paper held together with wet paste, used in PAPIER MÂCHÉ and other molded paper techniques.

Florence zinc oxide. An American trade name for FRENCH-PROCESS ZINC OXIDES.

Florentine brown. A name given to brown shades of VAN DYKE RED.

Florentine lake. Another name for CRIMSON LAKE.

floriated. Decorated with realistic or stylized representations of flowers.

fluidity. See MOBILITY.

fluorescence. 1. The property whereby certain substances become luminous, or emit light, when viewed under ultraviolet light or another source of electromagnetic radiation. 2. The property whereby a number of synthetic organic dyestuffs and some transparent solids exhibit a two-toned color effect. Examples are fluorescin (uranine), solutions of which are transparent yellow with a strong green fluorescence, and rhodamine, which is pink with a greenish-yellow fluorescence. See FLUORESCENT PAINT; URANIUM YELLOW.

fluorescent paint or **daylight fluorescent colors.** Any of a group of paints derived from a series of SYNTHETIC ORGANIC PIGMENTS, the colors of which have great intensity and which, in daylight, create a glowing or luminescent effect. They can also be activated by ultraviolet (black) light to glow in the dark. A familiar trade name of fluorescent paints is Day-Glo Colors, available in brilliant red, orange, yellow, blue, and green. Although nontoxic and sufficiently permanent to serve the decorative and industrial purposes for

which they are intended, fluorescent paints do not possess a sufficient degree of lightfastness for use in fine-arts painting. Originally the term fluorescent paint applied only to paints containing materials that even in daylight require excitation by ultraviolet light; now, however, the term applies almost exclusively to paints that are luminescent in daylight. See also LUMINOUS PAINT.

fluorite or **fluorspar.** Native calcium fluoride, used in ceramic or porcelain glazes as a FLUX.

fluting. Closely spaced parallel or nearly parallel grooves, used to embellish moldings and other surfaces. Flut-

FLUTING (LEFT) AND REEDING.

ing is commonly used in architecture for the decoration of columns and pilasters. The raised area between two adjacent flutes, as the grooves are called, is known as a stria or an arris. See also REEDING.

flux or **fluxing ingredient.** A substance that promotes fusion or vitrification by lowering the melting point of a substance or compound to which it is added. In ceramics, the fluxes used in various glazes and enamels include feldspar, white lead, red lead, and borax. Clay bodies usually contain sufficient fluxing ingredients to complete their vitrification at the temperature used, but sometimes they require an added flux such as feldspar or a clay that functions at a lower heat. A RE-

FRACTORY substance may also be present to balance the effect of the flux. In metalwork, fluxes are used in soldering, welding, and brazing to promote fusion by removing impurities on the surface of the metals to be joined.

foamed plastics. Plastics throughout which air- or gas-filled cells, or bubbles, have been distributed during manufacture. These expanded plastics are strong, lightweight, and usually buoyant and water-resistant. They may be hard or soft, rigid or flexible. In sculpture, they are used for solid forms and in making molds for casting, especially in the recently developed method called LOST PATTERN casting. The foamed plastic most commonly used by sculptors is polystyrene or Styrofoam, although foamed urethanes, methanes, and vinyls are also used.

foil. 1. One of several small arcs, which when joined together make points, or CUSPS, and create a decorative effect that was especially popular in Gothic architecture and design. Thus, trefoil refers to a three-lobed decoration in a stylized trifoliolate leaf pattern (tre-three; foil-leaf), most often clover-shaped. By extension, the terms quatrefoil and cinquefoil apply to four-lobed and five-lobed designs, respectively. Trefoil, quatrefoil, and cinquefoil designs are the most common shapes used in TRACERY.
2. A very thin sheet of metal, the thinnest variety of which is nevertheless heavier than LEAF. A sheet of paper to which foil has been laminated is also known simply as foil.

foliated. 1. In design, decorated with foliage designs or leaf shapes; also, ornamented with FOILS, as in TRACERY.

2. Of a material, built up of or separable into thin layers, as mica.

folium. A medieval term for mulberry-colored pigments made from various vegetable dyestuffs.

folk art. Art, handicrafts, and decorative ornament produced by people who have had no formal art training but have an established tradition of styles and craftsmanship. A country or region may have a characteristic folk art.

FOIL. Typical Gothic tracery. The center circle encloses a quatrefoil and various forms of the trefoil occur in pairs around it. The point formed where arcs meet is called a cusp.

Fontainebleau school. Italian and French painters working at Fontainebleau in the mid-16th century. The flowering of this group of painters began with the arrival of Il Rosso (Giovanni Battista de'Rossi) in 1530. He was followed to Fontainebleau in the next few years by other Italian Mannerist painters, including Niccolo dell'Abate and Primaticcio, and by Benvenuto Cellini. Somewhat later in the century the group, dominated by French artists, developed MANNERISM into a nearly international style.

foots. Technical term for the cloudy,

MANNERISM. El Greco's *Laocoön* (1608). (*The National Gallery of Art, Washington, D.C., Samuel H. Kress Collection.*)

TENEBRISM. *St. Sebastian Nursed by St. Irene* (c. 1631–1633) by the Workshop of Georges de La Tour. (*The Detroit Institute of Arts, Ralph H. Booth Bequest Fund.*)

OPTICAL MIXTURE. Study (1884) for *A Sunday Afternoon on the Island of La Grande Jatte*, by Georges Seurat, oil on canvas. (*The Metropolitan Museum of Art, Bequest of Samuel A. Lewisohn, 1951.*)

mucilaginous sediment that falls out of some vegetable oils on storage.

fore-edge painting. A watercolor painting on the surface formed by the long edges of the pages of a closed book. Fore-edge painting is found in conjunction with fine bindings of the 18th and 19th centuries. It is scarcely ever practiced today, but constitutes a recognized specialty for book collectors.

foreground. In the pictorial arts, that part of the composition that appears to be closest to the viewer. The foreground is one of the three ZONES OF RECESSION in LINEAR PERSPECTIVE.

foreshortening. The diminishing of certain dimensions of an object or figure in order to depict it in a correct spatial relationship. In realistic depiction, foreshortening is necessary because although lines and planes that are perpendicular to the observer's line of vision (CENTRAL VISUAL RAY), and the extremities of which are equidistant from the eye, will be seen at their full size, when they are revolved away from the observer they will seem increasingly shorter. Thus, for example, a figure's arm outstretched toward the observer must be foreshortened—the dimensions of lines, contours, and angles adjusted—in order that it not appear hugely out of proportion. The term foreshortening is applied to the depiction of a single object, figure, or part of an object or figure, whereas the term perspective refers to the depiction of an entire scene.

forest marble or **landscape marble.** A pale-colored MARBLE whose surface, when polished, displays dark markings that suggest the profile of woodlands or fields and streams. See also FORTIFICATION MARBLE; PAGODA STONE; RIVER MARBLE; GRAPHIC GRANITE.

forgery. In the fine arts, the creation of a spurious work with the intention of deceiving and/or defrauding; also, the spurious work itself. A forgery is rarely a copy of an original. Sometimes it is created as an anonymous work of a previous age or of an artist heretofore unknown; more commonly it is offered as a newly discovered work of a re-

FORESHORTENING. In the photograph (left) of a reclining man, the camera records distortion like that which the eyes actually see, but for which the mind makes appropriate adjustments. The artist compensates for such distortion through the use of foreshortening and perspective, as in the woodcut at right, a detail from *The Groom Bewitched* by Hans Baldung (called Grün, 1475–1545). (*New Haven, Yale University Art Gallery, Maitland F. Griggs, B.A. 1896, Fund.*)

nowned artist. Since it is almost impossible to avoid some anachronistic element of style, technical method, material, or subject matter, the fraud is usually ascribed to an obscure period, to one of great experimentation, or to a little-documented "transitional" period of an artist's life. The forger may use materials (e.g., obsolete pigments or a support stripped of a painting of little value) contemporary with the purported date of the forgery, or he may use old and/or new materials and age the work artificially. If convincing documentation cannot safely be forged, the work is represented as having been "dug up"—literally or figuratively.

To detect or confirm such frauds, the modern art expert has at his command, in addition to the esthetic and critical criteria first brought to bear, a wide array of scientific aids. These include standard chemical analyses; dating (of organic materials) by measuring the residual radioactivity of carbon 14; and examinations made with the use of optical instruments, X rays, and infrared and ultraviolet light. In 1967 a gamma-ray shadowgraph confirmed suspicions about a bronze horse in the Metropolitan Museum of Art in New York—a figure that until then was acclaimed as a magnificent 2,400-year-old example of Greek art. The museum's test proved that the piece had not been made by the ancient *cire-perdue* process, but was a fake, made by a sand-core technique not used before the 14th century. See also FALSIFICATION.

form. 1. The manner in which the artist presents his subject matter or CONTENT in creating a work of art. Form is the product of his organization, design, composition, and manipulation of materials.

2. In the more common meaning of the word, the individual masses, shapes, or groupings in an art work are its forms.

Formalin. Trade name for a 40% solution of formaldehyde with a small amount of methanol. A dilute solution, made by adding 9 parts of water, is sprayed on coatings of glue or casein in order to toughen them and render them more resistant to moisture.

formalism. In the arts, rigid observance of established rules, methods, or traditions. In the Soviet Union, however, art critics attach the term to work that departs from ACADEMIC depiction of subject matter and so is not in accordance with SOCIALIST REALISM. In this sense, formalism is taken to mean emphasis on form rather than content.

Formica. Trade name for sheets of laminated PHENOLIC RESIN, sold in many opaque colors.

fortification marble. A name sometimes given to any stone whose markings suggest towers and battlements. See also FOREST MARBLE.

fossil resin. See RESIN.

foul biting or **false biting.** In ETCHING, a plate defect that produces unintended spots of ink in the prints. Foul biting is usually caused either by a faulty RESIST or by too violent action of the MORDANT, causing BITING in areas that are supposed to be blank.

found object. An object which is found, selected, and exhibited by an artist, usually without being altered in any way. The display of such objects is a 20th-century art form, practiced by the Dadaists and Surrealists. Called *objet trouvé* in French, the found object may be natural, e.g., a shell, a

stone, or a piece of driftwood, or it may be manufactured, e.g., a household item, a piece of clothing, or a piece of machinery; a manufactured object is also called a READY-MADE. It may be given new aesthetic qualities by inventive methods of mounting and display. The artist's role in its presentation is creative only in that it points out aesthetic values that the object already possesses but that were not deliberately considered in its construction. When a found object is altered in any way it is sometimes called a "found object interpreted." The concept of the found object is in accordance with a Surrealist doctrine which holds that anything with aesthetic value, even inadvertently so, is a work of art and worthy of being exhibited as such. See illustrations here and at ASSEMBLAGE.

foundry sand. A special kind of sand used in SAND CASTING. It is composed of silica, alumina, and clay that is refractory, i.e., capable of resisting great heat. It is also called brass sand and French sand. It may be used as a CORE in other methods of casting.

fountain brush. A brush used for painting or drawing that has a reservoir in its handle for paint or ink. The term is also used to designate the FELT-TIP PENS AND MARKERS that have supplanted this type of brush.

foxing. Yellowish or brown spots and splotches which appear on paper in a scattered pattern; caused by a species of MOLD which is encouraged by dampness. Skilled conservators can use bleaching processes to remove these stains from paints, drawings, and other works of art on paper.

fractional rendering. In the pictorial arts, the practice of rendering the ele-

FOUND OBJECT. Robert Rauschenberg, *First Landing Jump* (1961), a "combine painting" of found objects (cloth, metal, rubber, leather, wood) and oil paint on composition board. (*Promised Gift and Extended Loan from Philip Johnson to The Museum of Modern Art, New York.*)

ments of a composition individually rather than as an organized and unified whole. Since the individual elements of a fractional rendering are more significant than the work as an integrated whole, isolated forms are often meticulously depicted. Fractional rendering is characteristic of the art of primitive cultures and early civilizations, notably Egyptian painting, and is also apparent in much of the work of modern primitive and naïve painters. Unity has always been a precept of composition in all sophisticated schools of art, and the absence of this quality is one of the reasons for the low esteem in which primitive art was held prior to the 20th century, when it came to be appreciated for its virtues.

fractur or **fraktur.** 1. An illuminated style of writing used by the

FRACTUR. Eighteenth-century birth and baptismal certificate from Lancaster County, Pennsylvania, printed and painted in watercolor. (*The Metropolitan Museum of Art, Gift of Mrs. Robert W. de Forest, 1933.*)

Pennsylvania Dutch; a form of German Gothic calligraphy ornamented in color with flowers, birds, and other motifs. It is employed in framed household mottoes and especially in documents such as wedding and baptismal certificates, outstanding examples of which are valued as folk art. Called also fractur (fraktur) painting.

2. German black-letter text type (see GOTHIC).

frame sizes. See PICTURE FRAMES, AMERICAN STOCK SIZES.

Frankfort black. Another name for DROP BLACK.

free-form shapes. Any amorphous, curvilinear, asymmetrical shape, not bounded by geometrical lines, but shaped in accordance with biomorphic or visceral conformations. Such forms are widely employed in contemporary interior decoration. They are characteristic of the work of the sculptor and painter Hans Arp (1887–1966), and are also to be found in the Chinese "oil spot" technique of the Sung Dynasty. See also BIOMORPHIC FORM.

freehand drawing. Drawing executed without the aid of mechanical devices.

freestone. Any stone that can be carved freely in any direction without fear of its splitting or flaking. Limestones and most sandstones are freestones.

French berries. Another name for BUCKTHORN BERRIES.

French blue. A name for ULTRAMARINE BLUE originating in the first half of the 19th century, when the pigment was first imported from France.

French chalk. Another name for TALC.

French curve. A thin, rigid piece of clear plastic or some other material, cut in a continuously curved or scroll shape so that it can be used as a guide for ruling curves through a series of points that are not on the arc of a circle. French curves, which are also

FREE-FORM SHAPES. Hans (Jean) Arp's *Relief* (1938–39, after a relief of 1934–35), wood. (*Collection, The Museum of Modern Art, New York, Gift of the Advisory Committee, by exchange.*)

called irregular curves and drawing curves, are available in a great many shapes and sizes; some have names that relate to the special function for which they were designed, such as the aircraft curve used extensively for de-

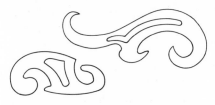

FRENCH CURVES

signing airfoils and the ship curve used in nautical design. French curves, which are sold individually and in sets, are widely used by commercial artists and draftsmen. See also ADJUSTABLE CURVE RULER; ELLIPSE GUIDE; SPLINE.

French polish. The traditional finish for fine furniture, achieved by applying oil and a very dilute solution of shellac. It was formerly used in preference to varnishing because of its flawless depth and luster, but has been superseded by modern synthetic finishes of superior resistance to wear and less tendency to spotting. The application of French polish demands much skill and patience, as it includes multiple wet-into-wet rubbings with oil and dilute shellac.

French-process zinc oxide. Pure ZINC OXIDE made by burning the zinc vapor from molten metallic zinc and collecting the fumes. The artists' term for zinc oxide made by the French process is ZINC WHITE. The best grades of zinc oxide are sold under the American trade name Florence zinc oxide. The three top grades are red seal, white seal, and green seal, each with somewhat different physical properties that suit various uses. Green seal is best for artists' pigment use, but the distinction is small enough to permit using the others when green seal is not available. Chemically pure 100% or U.S.P. zinc oxide is distinctly inferior in pigment properties to the French-process pigments. Because the latter are produced by the fume process they have been referred to as "white lampblack."

French purple. A lake made from ARCHIL; also known as pourpre français.

French sand. See FOUNDRY SAND.

French ultramarine. A name for ULTRAMARINE BLUE surviving from the late 1820's and 1830's, when the pigment was first imported from France.

French Veronese green. An obsolete name for VIRIDIAN. Colors labeled simply Veronese green are likely to contain almost anything, as the name is unstandardized.

French white. An unstandardized term that has been used for both FLAKE WHITE and ZINC WHITE.

fresco. The preeminent mural-painting technique, in which permanent limeproof pigments, dispersed in water, are painted on freshly laid LIME PLASTER; also, a mural so painted. Fresco (Italian for "fresh") is sometimes referred to as buon fresco or true fresco to distinguish it from techniques such as SECCO or MEZZO FRESCO that approximate its effects.

In fresco, the pigments are absorbed into the wet wall by capillary action and become an integral part of the wall's surface. Indoors, on a properly prepared support, fresco is one of the most permanent painting techniques. Its colors are stable not because they are protected by a calcareous film or

FRESCO. *Crucifixion with St. Bernard,* fresco (left) and its sinopia (c. 1500, school of Perugino), from the Church of Santa Maria Maddalena dei Pazzi, Florence. Besides the changes in detail between sinopia and fresco, evidence of the extent of each day's work (*giornata*) is to be seen in the finished work. One indication is clear in the photograph: the abrupt change in the color of the sky at the arms of the cross. Secco retouching must have once blended the two areas. (*Courtesy, Soprintendenza alle Gallerie, Florence.*)

"limeskin"—as formerly believed—but because they are made with chemically inert pigments. Fresco is not adaptable to exterior murals; its chief enemies are polluted air and abrasion by windborne particles.

Fresco meets all the requirements for an ideal mural painting: it has a perfectly mat surface; its color effect is brilliant; it lends itself especially to monumental styles; and it ages nobly.

The fresco wall must be constructed according to an exacting procedure, in several layers of lime plaster. Typically (there are many variations) the support consists of: a rough layer called the SCRATCH COAT (*trullisatio* in Italian), a BROWN COAT (*arriccio*), a SAND COAT (*arenato*), and finally the paint-ing coat, or intonaco. Usually, when the next-to-last coat is dry, a CARTOON of the entire composition is pounced on it (see POUNCING) and its lines are strengthened with dark watercolor. (During the Renaissance the preliminary sketch was often executed directly on the *arenato* with paint pigmented with SINOPIA, and that name came to be applied to the underdrawing itself.) The intonaco is laid over the drawing in sections (called *giornate*) as large as the artist expects to finish painting at one time, and the appropriate portion of the cartoon is then re-pounced on the wet plaster. The artist paints on the intonaco to the end of the day or until the wall becomes too dry to imbibe the colors.

Areas of the plaster that remain unpainted must be cut away and relaid just before the next session of painting. The plaster joins are carefully planned to follow the contour lines of the composition and to avoid crossing an area of flat color, except in murals on high walls, where a newly plastered area, called a *pontata*, must be a horizontal strip determined by the height of the scaffolding, which is gradually lowered.

Fresco was used in most of the early Mediterranean civilizations, notably the Minoan in Crete, and throughout the entire history of art in Europe. A remarkable series of frescoes painted between 200 B.C. and A.D. 600 in cave temples at Ajanta, India, have puzzled scholars because they were executed without the plaster joins normal to the process.

The Renaissance Italian masters brought fresco painting to its highest stage of development. Among the most magnificent of the celebrated Italian frescoes are those by Giotto (1267?–1337) in the Arena Chapel at Padua and the church of San Francesco at Assisi; Piero della Francesca (c. 1420–1492) in the church of San Francesco at Arezzo and the Palazzo Communale at San Sepolcro; Michelangelo (1475–1564) in the Vatican's Sistine Chapel; and Raphael (1483–1520) in the Stanza della Segnatura and the Logge of the Vatican.

After the 17th century the use of true fresco declined considerably. It had its greatest modern revival in Mexico, in the works of José Clement Orozco (1883–1949) and Diego Rivera (1886–1957). In the United States, the Federal Art Project (1935–1943) commissioned frescoes for many public buildings.

The painting of a large-scale fresco, an expensive and time-consuming undertaking, has in modern times become an event and an adventure. Because the artist requires the help of a crew of plasterers and other assistants, and because their work would interfere with the use of a room or delay the opening of a new building, fresco is often passed over in favor of more expeditious techniques. Indoor murals are now done primarily in oil colors, but also in casein colors, polymer colors, secco, and tempera. Most contemporary fresco work is confined to single panels in small rooms.

For methods of transferring frescoes see STACCO and STRAPPO.

fresco liner. See LINERS AND STRIPERS.

fresco secco. See SECCO.

fret. 1. A piece of interlaced or perforated ornamental work, as in pierced woodwork.

FRET OR MEANDER

2. An angular, continuous band design, which in several variations was much employed in ancient Greek and Roman decoration and is still a traditional motif for moldings and borders; also called meander, Greek fret, Greek key, Roman key, gather, and wall of Troy pattern.

fretwork. Openwork patterns cut in wood with a fretsaw; commonly used in interior decoration of the late 19th and early 20th centuries.

frilling or **sagging.** The appearance of irregularly scalloped horizontal waves in picture varnish or thin paint that has been applied while the painting is in a vertical position. Other defects similar in nature to frilling in-

clude CURTAINS; STREAMLINES; and TEARDROPS.

frisket. A stencil cut from tracing paper and attached to a drawing or painting with rubber cement to protect part of the work or to maintain blank areas while further application of color is made; it is subsequently peeled away. Friskets are primarily employed by commercial artists for AIRBRUSH work, but watercolor painters have also used them, especially to protect areas from overall washes. Ready-made frisket paper, coated on one side with a pressure-sensitive adhesive, is available and in common use, as is a liquid frisket, which is more easily controlled than paper coated with ordinary rubber cement, the protective covering being easily rippled away when the work is completed.

frit. A ceramic glaze material containing a FLUX, silica or another refractory, and coloring ingredients, melted together and pulverized; also, to melt and pulverize these ingredients to produce a frit. Many materials must be fritted for specific reasons. For example, lead glazes must be fritted because lead is extremely toxic while the lead silicate produced by fritting is not. Borax and soda ash are fluxes that are fritted to make them insoluble in water. A glaze that has not been fritted and contains no fritted ingredients is called a raw glaze. Some paint pigments are identified as frits, notably Egyptian blue, cobalt blue, and smalt.

frontal depiction. The head-on representation of a figure, object, or scene. The so-called convention of frontality is the strict use of frontal alignment (i.e., PARALLEL PERSPECTIVE) in representation. Frontality was a guiding principle of composition in Egyptian art. Portrait statues of standing and seated dignitaries were conceived

front-on and often have nearly perfect bilateral symmetry.

frottage. The technique of making an impression of the texture of wood, stone, fabric, etc., or of the configurations of a subject such as a twisted mat of string, by placing paper over the ob-

FROTTAGE. Max Ernst's *The Origin of the Pendulum*, from *Histoire Naturelle* (1926), a portfolio of phototypes, after frottages, printed in black. (*Collection, The Museum of Modern Art, New York, Gift of James Thrall Soby.*)

ject and rubbing the paper with a crayon or pencil; also, the impression itself. Frottage is an adaptation by the Surrealists of the traditional method of making a RUBBING. Painters in that movement, especially Max Ernst (1891–), who first introduced them in his works, often used such rubbings as part of a collage, or com-

bined frottage with painting techniques.

frottis. French term for a thin wash of paint, especially a transparent or translucent one; also, a GLAZE, a SCUMBLE, or the thin color left after wet oil paint has been rubbed away.

fruitwood. A general term applied commercially to the woods of various fruit trees, especially apple, pear, and plum. Imported apple and pear woods are often used for carving, while plum wood is used more rarely. All these woods are rather soft, but have great stability and permanence, and are smooth and uniform in grain and texture. They range in color from golden yellow to yellowish red.

fuchsine. Another name for MAGENTA dye.

fugitive colors. Pigments and dyes that fade, especially those which lose color rapidly on exposure to daylight. Although still in general use, the term is rather old-fashioned, wrongly implying that FADING is an evanescence or flying away of the color rather than the result of an actual chemical change.

fuller's earth. An absorbent variety of DIATOMACEOUS EARTH used in refining oils and sometimes as an INERT PIGMENT.

full length. Designating a portrait in which the entire figure of the subject is shown. The term "whole length" is sometimes used in its place.

full mold casting. Another name for LOST PATTERN CASTING.

fumigation. In art conservation, the process of exposing a work of art, especially a print, to the vapor of a volatile crystalline substance within a closed cabinet, in order to destroy mold. Thymol is the substance most commonly used, although paradichlorobenzene has the same effect. A few crystals of the fumigant are sometimes placed inside a closed exhibit case or glass frame to prevent further infestation.

fundamental colors. A name sometimes used for the basic hues of the spectrum: red, orange, yellow, green, blue, and violet.

furnace products. Inorganic pigments whose manufacturing processes include roasting in furnaces at various temperatures from dull-red to bright-white heat. Pigments that have undergone this treatment are of the highest degree of permanence. Among them, only ultramarine blue has a limitation: though completely permanent in easel painting techniques, it cannot be used in fresco. Viridian, which is roasted to a dull-red heat, would convert to chromium-oxide green if it were subjected to white heat. The various iron-oxide pigments—Indian red, light red, and Mars colors—vary in hue according to the temperature and duration of their roasting and their chemical treatment in the intermediate or wet stage.

furring. In wall plastering, the creation of an insulating space of a few inches between an exterior wall of a building and the lath of the plaster wall; also, the material (thin strips of wood or metal) used in this process. Such insulation is necessary for mural paintings on the plaster of exterior walls, to protect the plaster and its paint from moisture and rapid changes in temperature.

fusion. The melting together under heat of two objects or substances; especially, the joining of metals in this

way. The technique of WELDING is one of fusion.

fustet. Another name for YOUNG FUSTIC.

fustic. A yellow NATURAL DYESTUFF made from the wood of *Morus tinctoria,* a tree native to the Americas; a rather weak dye of poor lightfastness. Fustic is also known as old fustic; another yellow dyestuff called YOUNG FUSTIC (or fustet) is a different substance.

Futurism. A revolutionary movement in the arts, beginning in Italy in 1909 with the publication of a manifesto by the poet Marinetti, and followed a year later by the Manifesto of Futuristic Painters, signed by Carlo Carrà (1881–), Umberto Boccioni (1882–1916), Luigi Rossolo (1885–1947), Giacomo Balla (1871–

1958), and Gino Severini (b. 1883). The futurist movement abandoned most of the traditional concepts of art. All previous art, including the Cubism of the day, was held to be static and outmoded, although Futurist paintings actually had much in common with Cubist work. Futurism was aggressively dynamic, expressing movement and encompassing time as well as space; it was particularly concerned with mechanization and speed. Objects were reassembled in terms of "lines of force"; animals in motion were given a multiplicity of legs; colors were rich and vibrant. Although the organized movement did not survive World War I, it was an important force in the development of 20th-century art: Dada, Surrealism, Vorticism, and Cubism itself owed something to its influence.

fylfot. See GAMMADION.

G

Gaboon ebony. See EBONY.

gadroon. In metalwork, a decorative edging or border of vertical, slanted, or spiraled REEDING, usually done by REPOUSSÉ. Gadrooning was commonly used on 17th- and 18th-century silverware and is still widely found in traditionally styled wares. It is used chiefly on the edges of trays and the rims and bases of hollow ware. When the term is applied to woodworking, it refers to

any carved or notched design on a rounded molding.

Gahn's blue. A forerunner or inferior earlier version of COBALT BLUE, made by a process invented in Germany in 1777. Gahn's blue has also been known as cobalt ultramarine, a name later appropriated by manufacturers of imitation cobalt blue, a special shade of ultramarine blue.

gaine. In sculpture, the quadrangular, tapered pillar of a TERM or HERM; also, the lower part of any figure sculpture in which the head or bust alone is detailed or realistic, the remainder being either roughhewn or carved in the general form of a tight sheath tapering downward, as in many Egyptian and Archaic Greek examples.

galipot. The thick, resinous exudation from a pine (*Pinus pinaster*) of southern Europe, especially France.

gallery tone. A 19th-century euphemism for the lowering of tone in old oil paintings caused by the darkening of the varnish and the accumulation of dirt and grime. During the 19th century and the early part of the 20th, such golden-brown discoloration was admired and even imitated (see BROWN SAUCE); today's taste, however, requires that the colors in a painting appear as the artist first created them, and modern conservation standards demand the removal and replacement of discolored varnish.

gallipot. 1. A miniature porcelain container used in laboratories and by painters to hold their oils and mediums.
2. A variant spelling of GALIPOT.

gall nut or **nutgall.** A small, round, nutlike swelling formed on an oak tree by the sting of an insect, and used in the preparation of writing INK.

gallstone. An obsolete yellow LAKE pigment, similar to DUTCH PINK. It was said to have been made from oxgall, although it came more often from vegetable sources such as quercitron (see QUERCITRON LAKE).

galvanized metal. Metal, usually iron or steel, that has an electroplated zinc coating making it resistant to weather and rust. It is used in welded sculpture.

gambier. A variety of cutch made from a species of *Uncaria,* a Malayan vine. It is also called Bengal cutch.

Gambier-Parry spirit fresco. See SPIRIT FRESCO.

gamboge. A bright, transparent, golden-yellow gum resin produced by trees of the genus *Garcinia,* native to southeast Asia, especially Thailand. It has been used in the arts since the medieval era. Formerly it was used in powdered form as a paint pigment, because it was one of the most satisfactory available transparent yellows for glaze and watercolor techniques, but it has long since been replaced for these purposes by cobalt yellow. It fades slowly in oil paints; in watercolor it fades rapidly in sunlight, less rapidly in diffused light. Since it is a resin, it does not meet all the requirements for a desirable paint pigment; nevertheless it finds a few uses in the arts, one of which is the coloring of varnishes. It is soluble in alcohol.

gammadion. A design or device formed by the junction of four gammas (of the Greek alphabet). Examples are

GAMMADION. Left, a swastika or fylfot; right, a voided Greek cross.

the swastika and the voided Greek cross. A swastika is also called a fylfot, from the old English word for the pattern used to fill the foot or lower part of a painted window.

ganosis. The process, employed by the ancient Greeks, of applying a non-glare wax polish on plain or painted marble sculpture. The surface of the marble was warmed, rubbed with sticks of wax, and then polished with cloths. The same treatment was used on plaster walls, to protect the vermilion or other colors with which they were frequently decorated, and to create a finish with a uniform sheen.

garance. French for the madder plant (*Rubia tinctorum*), source of MADDER LAKE.

garnet lac. See LAC.

garnet paper. An abrasive paper; apart from its pink color, it resembles sandpaper, but is coated with fine fragments of garnet, which are much sharper than sand. The finest grades, 4/0, 5/0, and 6/0, are excellent for smoothing gesso and for other artists' purposes.

garzone. Italian for a studio boy, or artist's apprentice.

gas black. Another name for CARBON BLACK.

gate. In casting, any of several small channels or ducts through which molten metal is carried from the main channel, or SPRUE, to the hollow part of the MOLD. The waste piece of material formed by such a duct is also called a gate. A gate is sometimes called a runner.

gather. See FRET.

gaude yellow. Another name for WELD.

gauffrage. See GOFFER.

gauge. In plaster work, to mix plaster, plaster of Paris, or casting plaster with the exact amount of water necessary to obtain the desired consistency. When the usual medium consistency is desired the water is placed in a mixing bowl and plaster lightly scattered over its surface in small handfuls until it settles just below the surface of the water; when there is no longer any movement in the water, it is stirred to a uniform smoothness. For a thicker consistency, plaster is added until it lies somewhat above the water level.

gelatin. A protein material, made by prolonged boiling of animal tissues; a highly refined GLUE. The best grades of gelatin are colorless, odorless, and tasteless. When dry, it is hard and flexible. It is used in various photocopying processes, in dyeing, and in the preparation of sizes and cements. Because of its purity it is sometimes recommended as a binder for gesso, but its extremely high glutin content makes it a weaker adhesive and a more poorly balanced binder than hide glue. In sculpture, the negative containing MOLD for casting may be made of flexible gelatin.

gel-coat. In casting with polymer resins, the first application of resin to the mold. The gel-coat is the outer layer of the finished sculpture. It may be colored with pigments, or may contain fillers for economy as well as visual effect.

Gellert green. A variety of COBALT GREEN made by a somewhat different process than Rinman's. It is not ordinarily available.

gel medium. A prepared painting medium of gelatinous consistency. It is added to oil colors and aqueous paints to impart a smooth, fluid, facile quality

without reducing viscosity so that brushstrokes stay in place, and also to add transparency to the paint. The first gel medium, MEGILP, was abandoned by painters during the 19th century. Gel mediums were reintroduced by manufacturers of artists' materials in the U.S. and England in the mid-20th century. Their handling properties are attractive, and, unlike megilp, they are made of non-yellowing, permanent ingredients. A modern gel medium for oil painting is made either by dispersing a colloidal inert pigment such as Celite in an oil or synthetic resin solution, or by mixing an oil or synthetic resin with another synthetic resin that is not entirely compatible with it, so that it forms a gel instead of a clear solution. So far, no data based on either experience or scientific tests indicates that gel mediums are not permanent. Yet it is suggested that the use of any gel medium, however excellent the properties of its components may be, will produce a weak and underpigmented paint film, likely to wrinkle and eventually to crack. This may happen only in the case of oil colors, since gel mediums for watercolor and polymer colors are usually made of materials whose properties are identical to or closely resemble those of their vehicles, and whose films need not be reinforced by closely packed pigment particles.

genre painting. Painting representing some phase of everyday life, such as a domestic interior or a rural or village scene.

geometric abstraction. Abstract painting whose shapes are those of simple geometry, e.g., the straight line, the circle, the square, the rectangle. This style includes neither free-form elements nor the blended areas, freehand brushstrokes, and textural qualities that characterize most representa-

tional paintings. Sometimes referred to as classical abstraction, it is frequently contrasted to ABSTRACT EXPRESSION-ISM. The pioneers in geometric abstraction were Malevich, who propounded the theory of SUPREMATISM in 1915, and Mondrian, whose work during the early 1920's was incorporated in the doctrine of NEO-PLASTICISM.

Geometric period. The second phase of HELLENIC ART (900–700 B.C.). Surviving examples are mainly of painted vases decorated with colored circles, parallel lines, frets, spirals, and other basic linear and geometric elements. Toward the end of the period human and animal figures were in-

GEOMETRIC PERIOD. Athenian terra-cotta jug (9th–8th century B.C.) ornamented with birds and linear patterns. (*The Metropolitan Museum of Art, Fletcher Fund, 1941.*)

cluded, or even formed elaborate scenes within the design, which was still dominated by abstract shapes. Geometric sculpture consisted of small ceramic and bronze figures of birds, animals, and occasionally human figures.

Georgia White. A fine American MARBLE, excellent for sculpture. It is saccharoidal, or sugary, in texture and is capable of taking a high polish.

geranium red or **geranium lake.** One of the most intense and brilliant of the red synthetic organic pigments; a bright red geranium-petal hue. It is used only by illustrators and others whose work is done for reproduction, as it fades after relatively short exposure to daylight.

German black. Another name for DROP BLACK.

German cross. See CROSS-CROSSLET.

gesso. A white fluid or plastic coating material made by mixing chalk or whiting with a glue solution (or occasionally casein). It is used as a GROUND on wood or hardboard supports in painting, gilding, and other decorative processes. The concentration of the glue solution must be carefully controlled to obtain the desired degree of hardness. When applied to flat panels or to carved moldings, frames, or furniture, gesso is normally sandpapered to a flawlessly smooth, ivory-like surface. It is fully absorbent and is thus an ideal ground for tempera painting and water gilding. For oil and casein painting and oil gilding, a gesso surface requires sizing. A gesso ground is too brittle to be used on canvas.

Gesso has been used in Europe since medieval times. The early gesso was made from parchment glue and slaked plaster of Paris; modern gesso utilizes rabbitskin glue and precipitated chalk or whiting. In Renaissance practice, two grades of gesso were applied to wood panels for painting: an undercoat of *gesso grosso* (coarse gesso) and several coats of *gesso sotile* (fine gesso). Modern workers almost universally omit the coarse layer (presumably plain plaster of Paris), which our pre-smoothed panels and moldings seem to render unnecessary.

The Italian word *gesso* comes from gypsum, from which plaster of Paris is made, and has been used for the specific substance described above for centuries. However, American manufacturers have, in recent years, applied the term to polymer primers, which are entirely different from gesso in composition and cannot be used as a substitute for it.

gesso duro. Plaster of Paris hardened by the addition of glue solution. This mixture is much more durable than plain plaster and is therefore suitable for decorative molding or modeling.

giallolino or **giallorino.** Obsolete and rather obscure Italian terms for an opaque yellow containing lead. The one mentioned by Cennino Cennini in his 15th-century treatise was probably Naples yellow; other writers refer to MASSICOT as giallolino, giallorino, and giallolino di Fiandra (Flemish yellow).

gilded or **gilt.** Covered with gold or a golden finish, whether by gilding with gold leaf, by electroplating or metal spraying, or by applying gold paint. See also PARCEL-GILT; SILVER-GILT.

gilder's cushion. In GILDING, a pad upon which the leaf is flattened and cut. The cushion consists of a thin wooden board about 6 × 12 inches in surface, covered with a thin layer of cotton batting over which a piece of suede is stretched and tacked. Two

GILDER'S CUSHION. At top, the underside of the cushion, showing the leather thumb grip and the sheath with knife in place. At right below, a top view of the cushion, showing the stiff paper that prevents drafts from disturbing the fragile leaf. The gilder's tip is at lower left.

loops of soft leather are attached to the underside of the board, one in an appropriate spot to act as a thumb grip for holding the board as a palette and another tacked flatly at one edge of the board to serve as a sheath for the GILDER'S KNIFE. A stiff piece of kraft paper about 8 inches high is sometimes fastened to the rear edges, running around three sides to enclose about one-third of the board; this acts as a windshield to protect the fragile leaves from air currents. In gilding with Dutch metal, a gilder's cushion is not used; the leaf is simply pressed from the book. See also GILDER'S TIP.

gilder's knife. In GILDING, a knife used to cut metal leaf into the size and shape desired for application to the ground. About the size of a table knife, the gilder's knife has a slightly flexible blade of steel with an oblique end. It must be sharp enough to cut the leaf with a single back-and-forth stroke but not so sharp that it will cut the leather of the GILDER'S CUSHION. See also GILDER'S TIP.

gilder's tip. An implement used in GILDING to pick up the sensitive and

fragile leaves of metal and transfer them to the area to be gilded. The tip is a sort of brush, a row of camel hair mounted between and protruding from two cards about four inches wide; the density of the hold of hairs varies. Tips may be bought in varying hair lengths: a tip of long hairs is used to pick up whole leaves; a short-hair tip is used to pick up cut pieces of leaf. The gilder holds the GILDER'S CUSHION in his left hand and makes the tip slightly oily by running it over his hair. This causes the leaf to cling to the tip until the leaf is touched to the wet size on or in the ground, which holds it securely. A tip is not usually needed for metal leaves that are heavier and easier to handle than gold, but one may be necessary for silver leaf, in which case a special tip with a double thickness of hairs is used. Considering the antiquity of gilding, the tip, which apparently dates from the 18th century, can be called a modern improvement. The old methods of lifting and handling leaf, such as those described in the 15th century by Cennino Cennini in his treatise *Il libro dell'arte*, would be too crude for modern thin gold leaf. See also GILDER'S KNIFE.

gilder's wax. A preparation used to heighten the color of gold that has been applied to another metal by FIRE GILDING. Gilder's wax is a combination of beeswax with verdigris or some other copper salt and an acidic substance, such as alum, borax, or vitriol. The wax is applied to the surface to be treated, which is then exposed to fire until the wax has been burned off. The gilded surface is cleaned both by the acid in the preparation and by the firing process, which serves to drive off any mercury that may remain in the gold after fire gilding. The pigment in the wax imparts a warm tone to the gold surface.

gilding. The art of adhering thin metal LEAF to a surface to approximate the effect of solid or inlaid metal. The laying of leaf is the traditional method for creating a metallic effect in a work of art, and the use of such other materials as metallic powders dispersed in a liquid medium produces a vastly inferior effect. Although the term gilding is derived from a word for gold, it also designates the application of other metal leaf to a surface. GOLD LEAF, SILVER LEAF, and PALLADIUM LEAF may be used in painting, sculpture, and fine decorative work. DUTCH METAL and ALUMINUM LEAF are cheap imitations of precious-metal leaf that yield inferior results and are not sufficiently permanent for fine-arts use. On the other hand, they are definitely superior in both effect and permanency to the so-called GOLD PAINT made with BRONZE POWDER and to the silvery paints made with ALUMINUM POWDER.

There are two currently used techniques for the application of leaf to a surface. MORDANT GILDING, the simpler process, may be used with any kind of leaf on any properly treated surface. In WATER GILDING, the older method, the leaf is laid on a gesso or bole ground, producing a bright metallic sheen which may then, if desired, be brought to a brilliant specular finish by rubbing the gilded surface with a BURNISHER. Leaf laid with mordant gilding cannot be burnished. Mordant gilding and unburnished water gilding are known as mat gilding. A third method, FIRE GILDING, is a chemical process. Although it is the oldest method for gilding metals, it is no longer practiced and has been replaced by ELECTROPLATING and METAL SPRAYING. Precious-metal leaf is beaten so thin that it is economically feasible to use in works of art; GOLD POWDER is a great deal more expensive to use and is practical only when it is made into watercolor or ink and used with a pointed brush or a pen to apply fine lines to a surface.

Gilding is a very old practice. It was used by the ancient Egyptians and Chinese, and it is mentioned in the Old Testament and by Homer. Gilding developed to a high degree of craftsmanship during the Middle Ages, when it was used in manuscript illumination and in panel painting, not only for figures and lettering but also for the frequently used solid gold background (*fondo d'oro*) that is especially notable in Sienese tempera panels. The craft reached a high point during the 19th century and the first quarter of the 20th century when gilded objects and ornaments were the Victorian fashion (see ORMOLU) and when gold-leaf frames were almost compulsory for an artist exhibiting his work. Although fine gold-leaf work is still produced by professional gilders, there are fewer gilders' shops today.

Gilsonite. A trade name for uintaite, a hard ASPHALT.

gilt. See GILDED.

giornata. Literally, a day's work; applied to FRESCO painting. Since the paint had to be applied to wet plaster, only as much of the INTONACO, or final plaster coat, could be laid as the artist could paint before it dried. The seams between adjacent *giornate* are clearly visible in some old frescoes. On high walls requiring scaffolding, the plaster was laid in horizontal sections, called *pontate*, corresponding to the level of the scaffold, which was gradually lowered.

Giotteschi. Painters of the mid-14th century whose work appears to have been strongly influenced by that of Giotto di Bondone (1267?–1337). Few of their names are known.

gisant. A sculptured, recumbent, effigy of a deceased person, usually part of a monumental tomb. Late Gothic sepulchral monuments often included both a lifelike statue of the deceased and a gisant that was a decaying corpse; the transient nature of the flesh was occasionally emphasized even more gruesomely by showing the corpse crawling with vermin. Renaissance monuments characteristically reflect the classical attitude toward death: the gisant may be an idealized portrait and the entire monument is conceived as a poignant commemoration of the dead person rather than a memento mori.

glair. 1. In GILDING, a GOLD SIZE made of beaten egg white mixed with a little water and allowed to stand overnight. It may be used to lay leaf the morning after it is prepared, but if left longer still, it becomes stickier and even better for sizing. Glair has long been used as a size, but most modern gilders prefer a weak solution of hide glue or gelatin because unless a fresh batch of glair is made fairly frequently, the egg white develops a putrid odor that is unpleasant in the draft-free conditions preferred by gilders.
2. In painting, a little-used medium, with relatively weak binding and film-forming qualities. Glair was sometimes used in manuscript illumination to bind very pale or reactive colors for which an egg-yolk medium was unsuitable. The chief use of egg white today is in the whole-egg composition that is used in egg-oil TEMPERA emulsions. See also EGG, USE IN PAINTING.

glance. Outmoded word for GLOSS.

glass colored print. See BACKPAINTING.

glassine paper. A smooth, glossy, transparent or translucent paper. Familiar through its use in packaging and envelope windows, it is used by art conservators as a facing in lining an oil painting by the wax-adhesive method; since wax does not adhere strongly to glassine, the paper can be peeled away after any ironing or pressing treatment.

glass painting. Painting with ceramic colors on pieces of glass which are fired in a kiln and used as segments of a stained-glass window or transparency; also, painting with oil or gouache colors on sheets of clear glass, to be viewed from the unpainted side of the glass.

glaze. 1. In oil painting, a thin film of transparent color laid over a dried underpainting. The technique of applying such a film is called glaze or glazing. The total color effect of glaze painting has a luminous quality which differs from that of solid, opaque painting. Light impinging on an opaque surface is reflected back directly; on a glazed surface it penetrates or is transmitted through the transparent layer and reflected from the underlayer back through the glaze, so that the color effect is a mixture of the colors used in the two layers. Glazing is best done by mixing oil color with an oil-resin glaze medium, applying it evenly with a brush, and stippling or pouncing the wet surface with clean, dry brushes or dabbers until the color coat is sufficiently thin for the desired effect.
2. In ceramics, a thin, vitreous coating that is fused to a ceramic body by firing in a kiln. A glaze may be applied by dipping, pouring, spraying, or brushing before the ware is fired; or glazing may be accomplished in a firing atmosphere containing alkali vapor, as in salt glazing. The function of glaze on a ware may be to water-

proof the body, to change its color or texture, or generally to enhance the appearance of the ware. See ALKALINE GLAZE; ASH GLAZE; CELADON; MAT GLAZE; PEACH BLOOM; SANG DE BOEUF; SALT GLAZE; BLISTER GLAZE; BRISTOL GLAZE; CRYSTALLINE GLAZE.

glory. See AUREOLE.

gloss. Specular, or mirrorlike, reflection from a surface. Gloss is measured by the sharpness or definiteness of the image it reflects. Any brilliant, highly reflective surface is said to have high gloss or to be glossy. The average oil paint or waxed surface has a dull gloss. A low sheen or satiny finish is called semigloss. In the 19th century paintings that had a high-gloss finish were admired; today a low or dull gloss is preferred. A finish without gloss or luster is called a MAT finish.

glost. Glazed ceramic ware.

glost fire. The second firing of ceramic ware, done to vitrify a glaze applied to biscuit ware, i.e., ware that has already been bisque-fired (fired once to harden the clay body). See BISQUE FIRE.

glue. 1. Any viscous material used as an adhesive to join surfaces, or, in weak dilution with water, as a size.
2. Any adhesive made from the bones or hides of animals; the best glues are made from hides. Glue contains two groups of proteins: chondrin, which accounts for its adhesive strength, and glutin, which contributes jelling strength. The best hide glues are well balanced between the two. The standard top-quality glue, with the best balance of adhesive strength and jelling strength, is rabbitskin glue. Made in the U.S. and in France, it is sold in solid form in sheets or granules, and is dissolved by soaking overnight in water. For full-strength adhesive use, the water is drained off and the glue melted in a glue pot or double boiler. For use as a size or binder, the water is carefully measured and allowed to remain in the pot while the glue is heated. If glue is boiled, its properties alter and the strength of the solution changes erratically.

The finest glue used in medieval times was homemade from parchment clippings; the modern rabbitskin and calfskin glues give comparable results with the advantage of greater uniformity. Glues made from animal hides are used to make gesso and to manufacture low-cost water paints such as scenic colors and show-card colors. GELATIN may be considered a highly refined glue.

glue-cutout method. See BLOCK-CUT STENCIL METHOD.

glutin. See GLUE.

glycerin. A clean, pure nontoxic heavy liquid; also called glycerol. It has some oily properties, but is miscible with water and alcohol. Glycerin is an ingredient in watercolor and gouache paints, where it serves to delay initial drying so that brush manipulations can be carried on before drying begins.

glyphic art. Carving, especially in vertical grooves; also, certain symbolic or conventionalized forms in Mayan sculpture.

glyptic art. The art of incising or carving designs and ornaments on gems and semiprecious stones; also, carved sculpture as distinguished from modeled sculpture.

Gmelin's blue. A name given to ULTRAMARINE BLUE after Christian

Gmelin, who published his process for its manufacture in Germany in 1828.

goffer or **gauffer.** To decorate a surface by indenting or embossing it, as in the stamping of linen book bindings or gold leaf surfaces; also, the tool used in this work. Goffered work is also known as gauffrage.

golden mean or **golden section.** A canon of proportion in painting, sculpture, and architecture. It is based on the ratio between two unequal parts of a whole when the proportion of the smaller to the larger is equal to that of the larger to the whole. As applied to a SCHEMA of figure drawing, the golden mean would dictate that the distance from the foot to the knee be half the length of the whole leg and, correspondingly, that the length of the leg be half the height of the whole body. The "ideal" proportions of a rectangle are determined by the golden section; in such a figure, the longer side is equal in length to the diagonal of a square whose side is equal to the shorter side of the rectangle. This ratio works out numerically to .618 to 1, or approximately 5 to 8. In a rectangle drawn or constructed according to the golden section, therefore, the width should be .618 of the length. Based on a Euclidean theory, the golden mean was worked out in the 1st century B.C. by Vitruvius, who used it in his treatise *De architectura* to establish architec-

GOLDEN MEAN. *Pastoral Landscape,* oil on canvas, by an unknown Italian artist of the late 17th century, formerly attributed to Claude Lorrain. The focal point of the painting, where the horizon line meets the vertical tree trunk just to the left of center, is five-eighths of the distance from right to left and from top to bottom. (*Collection, Art Gallery of Ontario, Gift of Reuben Wells Leonard Estate, 1937.*)

tural standards for the proportions of columns, rooms, and whole buildings, with the understanding that individual variations were expected of the architect. During the Renaissance, *De divina proportione* (1509), written by Luca Pacioli and illustrated by Leonardo da Vinci, defined the golden section as the "divine proportion" that is the subject of the treatise and thus perpetuated the canon. The French term *Section d'Or* was adopted by a group of Cubists, without reference to the principle, as a name for both an exhibition that they held and the magazine that they published. Perhaps the most familiar geometrical proportion system to be advanced in recent years is DYNAMIC SYMMETRY.

golden ochre. An American term for a house paint or industrial pigment made by brightening yellow ochre with the addition of chrome yellow; not to be confused with the permanent artists' pigment transparent gold ochre. Golden ochre is also known as chrome ochre.

golden section. See GOLDEN MEAN.

gold leaf. Gold beaten into leaf for use in GILDING. Gold is the most malleable of metals. It may be drawn out to a cobweb filament and beaten so thin that the resulting gold leaf will transmit light and display a characteristic greenish color when held up to a light source. Since gold is also one of the most inert metals, it does not tarnish or become dull. Because of these properties, its occurrence in pure form in nature, and its intrinsic value, early civilizations learned how to use gold decoratively as leaf, an art that developed over the centuries into a highly refined craft.

Gold leaf is sold in books of 25 three-inch-square leaves, packed between tissue papers dusted with bole to keep the leaves from sticking. It is also sold in ribbon form in tissue paper rolls of various widths and lengths. The standard leaf is 23½ carat; leaf of this so-called rich gold is about ⅟₃₀₀,₀₀₀ of an inch thick, and about 2,000 leaves weigh an ounce. Two other types of leaf also available are lemon gold (18½ carat) and pale gold (16 carat). Since these are alloyed with the less malleable silver, they are somewhat thicker and thus easier to handle than pure gold. Rich gold is also available as patent gold, for "gilding in the wind," with each leaf pressed onto a piece of tissue paper. Patent-gold leaf, which is known in Britain as transferred gold, is applied like a transfer, making its handling easier for outdoor MORDANT GILDING, but creating a finish of inferior quality in work that is seen closely. Available on special order is a double-thick leaf that is believed to be the equivalent of a pre-19th-century leaf, judging by old writings and handling instructions, which indicate a less fragile and more easily manipulated material than the modern product.

Gold leaf has been used in various times and ways to gild sculpture, domes and doors of buildings, household furnishings and decorations (see ORMOLU), frames, etc. Prior to the advent of oil painting, gold leaf played an important part in tempera painting, fresco, and manuscript illumination, where it was used for large initial letters, backgrounds, haloes, and other details. It is still used for some of these purposes but not nearly as much as formerly.

gold paint. Chiefly, a misnomer for BRONZE POWDER mixed with BRONZING LIQUID to make metallic paint. (Similarly, paint made with ALUMINUM POWDER is sold commercially under the misnomer "silver paint.") This so-called gold paint, which is sold in paint, hardware, and art-supply stores,

produces a relatively coarse and lack-luster coating and is not sufficiently permanent for use on fine works of art. Large amounts of bronze-powder gold paint are used for commercial decoration and industrial products. Real GOLD POWDER mixed in a watercolor vehicle to make gold ink was used in the Middle Ages for the writing and illumination of manuscripts and in the Renaissance, by such artists as Andrea Mantegna and Giovanni Bellini, for details and highlights in panel paintings. It is used occasionally today for gilding details in fine works of art but to a much smaller extent than is gold leaf. See also SHELL GOLD.

gold powder. Pulverized gold. Gold powder dispersed in an aqueous binder has been used to highlight tempera paintings and was used to illuminate medieval manuscripts. As gold powder is more difficult to obtain and considerably more expensive to use than gold leaf, gilding with leaf has always been much more common in works of art. Probably the chief use of gold powder today is in the preparation known as Liquid Bright Gold used to decorate ceramics. This solution (pulverized gold mixed with a small amount of oxide of bismuth, gum water, and a flux, usually borax) is applied with a brush to the ceramic surface, which has previously been fired and glazed. The piece is then refired in a kiln, and the applied gold is cleaned and burnished. A federal regulation prohibits the sale of powdered gold in the United States, but a tiny cake of imported gold watercolor, not unlike 19th-century SHELL GOLD, can be bought in an art-supply store. Artists can obtain actual gold powder by the medieval method of grinding gold leaf with honey and water in a glass mortar and then rinsing out the honey by repeated washings and settlings with hot water, but electrolytic and reduction methods for powdering gold commercially have chiefly replaced the older mechanical means. Gold cannot be powdered dry because of its ductility; friction would cause the particles to lump together.

gold size. In GILDING, the adhesive that holds the metal leaf to the ground. In WATER GILDING, the glue or gelatin already contained in the gesso or bole supplies the adhesive; it is activated by brushing the ground with water containing a bit of glue just prior to laying the leaf. GLAIR was formerly used instead of glue. The commercial red "gold size" sold in glass jars is simply bole made up to paste consistency with water, which the gilder prepares for use by thinning with a solution of glue in water. In MORDANT GILDING, the size must be applied to a nonabsorbent ground; a porous surface must first be shellacked and sanded to a smooth finish. Two types of mordant size, oil and varnish, may be used. *Oil, or slow-drying, size* is a cooked-oil varnish that takes forty-eight hours to become completely dry; applied in the evening, this varnish retains the tackiness necessary to hold the leaf through the following day. This size usually contains golden chrome-yellow pigment so that when applied it clearly marks the areas that are to receive the leaf. *Varnish, or quick-drying, size* is usually based on synthetic resins. Thinly applied, it reaches the correct stage of tackiness in thirty to forty-five minutes but remains in this state for only twenty to thirty minutes, although the period can be lengthened somewhat by adding oil color or oil size to the varnish size. POLYMER MEDIUM serves as an easy-to-use gold size of this type; the leaf may be pressed on the wet size immediately after its application without waiting for it to reach a critical stage of tackiness.

Gospel book. See EVANGELIAR.

Gothic. 1. Pertaining to European art between the mid-12th and mid-15th centuries. The first Gothic cathedral was begun in France in 1137, and the style spread to other countries from about 1200 on. The High Gothic period spanned the 13th and 14th centuries, although the Late or Flamboyant style was not fully developed until the early 15th century. In painting and sculpture, a fairly homogeneous International Style existed about 1400–1420, after which the Renaissance style gradually replaced it, beginning in Italy.

Gothic architecture, especially in the great cathedrals, was characterized by pointed arches, cross-ribbed vaults, and flying buttresses, which made possible thin stone walls and an airy interior space. The vertical orientation of the space was symbolic of a striving toward heaven. In the Flamboyant period carved ornamentation became extremely lacy and profuse.

Monumental sculpture in the round was revived for the first time since antiquity during the Gothic period. It had a graceful, sinuous elegance and great emotional appeal, although the International Style showed a renewed concern for weight and volume, as well as for realistic observation.

In painting, manuscript illumination reached its peak during the Gothic era, although panel painting and fresco became increasingly important, especially in 14th-century Italy with the Sienese school and Giotto. The International Style was notable for subtle modeling, acutely observed realistic details, and the beginnings of the use of light as an independent element. During the first half of the 13th century, the great age of cathedral construction, stained-glass work also reached its high point.

In England the early, middle, and late styles of Gothic architecture are known as Early English, Decorated, and Perpendicular, respectively. Until the last of these developed in the early 14th century, English structures lacked the verticality that characterized the European cathedrals.

2. In calligraphy, a hand that was developed during the 12th century, when this art was practiced chiefly in monasteries, which were the literary and artistic enclaves of the Middle Ages, and in the universities, which were the legal centers. Gothic is a highly stylized hand, with thick downstrokes and thin upstrokes bent back at the ends. It has a decidedly vertical character and is a very compact hand, giving the impression of almost covering the page with ink, whence its other name, black-letter hand. Apart from regional variations, it took three main forms during the Middle Ages according to its use. The formal Gothic book hand was used for liturgical texts, inscriptions, and seals. More graceful, cursive forms were used for legal documents, the most notable of which were the Italian chancery hand and the French bastard (*bâtarde*) hand. An informal Gothic cursive was developed for personal use. The Humanist movement of the 15th century brought about a reform in handwriting, and the Gothic was largely replaced by the ROMAN and ITALIC hands. It continued, however, to be used for some time in England and Germany and is still employed to a certain extent in Germany. Although the Gothic hand was copied in type by such early printers as Gutenberg and William Caxton, it did not have the good fortune—as did the roman and italic hands—to be extensively used for printing and thereby standardized. It survives only in several so-called black-letter typefaces that are used for announcements of and invitations to formal occasions and for display purposes and special effects. Wedding Text, Engraver's Old English, and Cloister Black are three

typefaces that were derived from the Gothic hand. The modern sans-serif typefaces, such as Futura, Vogue, and Franklin Gothic, are known also as gothic type, usually spelled with a lower-case "g." They bear no resemblance, however, to the calligraphic hand from which they take their name. Indeed, gothic fonts tend to be almost starkly simple, characterized by the absence of SERIFS and by a relative uniformity in the thickness of the strokes or lines. See illustration at TYPOGRAPHY.

gouache. The technique of applying opaque watercolor to paper; also, a work of art so produced. The usual gouache painting displays a light-reflecting brilliance quite different from the luminosity of transparent watercolors. Gouache colors, sold in tubes, contain the same ingredients as transparent watercolors, but chalk is added to some of the duller pigments to brighten them. Other opaque, water-miscible paints, such as designers' colors, Chinese white watercolor, and casein colors, may be used as well as the special gouache colors in what is called a gouache painting. Gouache, watercolor, pastel, and India ink are frequently combined in the same painting.

Gouache was occasionally used in medieval manuscript illumination, and for miniature painting in the 16th–18th centuries, although toward the end of this period its use was confined to emphasizing highlights. In the 18th century, it was popular with Italian, French, and Swiss watercolorists. Nineteenth-century painters, like the later miniaturists, used it for special effects in transparent watercolor paintings. But because of its potentially dulling effect, it is more difficult to add gouache touches to watercolor successfully than it is to add transparent watercolor to a painting done predominantly in gouache.

gouge. A curved chisel with a keen cutting edge, used in wood carving. When the blade is a deep, pronounced scoop shape, the tool is known as a U-gouge; when the blade is V-shaped, the tool is called a V-gouge, V-tool, or PARTING TOOL. Very small gouges, both U-shaped and V-shaped, are used in making woodcuts. See also BENT GOUGE; see illustration at WOOD-CARVING TOOLS.

gradation. 1. A series or progression of shades, tints, or values, as a sequence of grays from light to dark.
2. The smooth, imperceptible fusion of adjacent colors or tones (see BLENDING).

Graeco-Roman. See GRECO-ROMAN.

graffito. In archeology, a casual scribble or pictograph on an ancient wall, stone, or other surface. In recent years the term (almost always in the plural, graffiti) has been applied to humorous, satiric, or obscene writings and drawings executed anonymously on fences, walls, and, especially, in public restrooms. In the past, the word graffito was also used for the technique of decoration now commonly referred to as SGRAFFITO. Graffito is an Italian word, from *graffiare,* to scratch.

grain. An alternate name for KERMES.

grain alcohol. See ETHYL ALCOHOL.

graining. 1. The art of imitating the characteristic markings of attractive and popular hardwoods by the skillful application of colors with special brushes, sponges, or combs.
2. The preparation of a LITHOGRAPH STONE for use in making prints.
3. The granulation of metals. For

example, aluminum in noticeably coarse particles is called grained aluminum rather than aluminum powder.

grain lac. Another name for seed LAC.

granite. A hard, compact igneous rock, composed mostly of silica and silicates. Granite is more difficult to carve than marble and is esteemed for its durability and permanence of polish. There are many grayish, reddish, and variegated kinds of granite. See GRAPHIC GRANITE.

grape black. Another name for VINE BLACK.

graphic arts or **graphics.** In the fine arts, the various multiple-replica processes by which ORIGINAL PRINTS are created. The principal graphic-arts processes are AQUATINT; CRAYON MANNER; DRYPOINT; ETCHING; line ENGRAVING; LITHOGRAPHY; MEZZOTINT; MONOTYPE; SERIGRAPHY; SOFT-GROUND ETCHING; STIPPLE ENGRAVING; WOODCUT; WOOD ENGRAVING; and mixed-media methods in which several of the above techniques are combined. A number of simplified printmaking methods, among them linoleum cutting (see LINOCUT), potato printing, and the making and printing of simple cardboard relief prints, are less accepted for serious creative work and are more accurately classified as arts and crafts. A trend of the late 1960's is to shorten the term graphic arts to graphics, which refers not only to the techniques but also to the individual prints, or proofs, as they are called.

In the commercial arts, the term graphic arts has a more comprehensive meaning: it includes not only the noncommercial processes but all the processes used in the entire field of commercial printing and lithography, for the reproduction of both text and art work.

graphic granite. A GRANITE whose polished face displays markings that give the effect of being inscribed with Hebrew or cuneiform writings; also called HEBREW GRANITE. See also FOREST MARBLE.

graphics. See GRAPHIC ARTS.

graphite. An allotrope of carbon that is grayish-black, semicrystalline, flaky, and greasy. These qualities limit its usefulness as an artist's pigment but favor its use for PENCILS, special industrial paints, and lubricants. Graphite was first mined in Barrowdale, England, in 1664 and used for writing purposes in small lumps mounted on a stick. It was not until the 18th century, however, that its true composition was determined and the material was given the name graphite. It had previously been called plumbago or black lead. The latter misnomer has persisted in the designation of the modern graphite pencil as a LEAD PENCIL. The mixture of graphite and clay now used to make lead pencils was discovered simultaneously in 1795 by Nicolas Jacques Conté in France and Joseph Hardmuth in Austria. Graphite, also made artificially by passing an electric current through granular anthracite, is also used to make the stirring rods and crucibles used in sculpture for casting molten metal. Because graphite is extremely stable at high temperatures, it does not contaminate the molten metal or conduct its heat.

graphite paper. A thin transfer paper coated on one side with graphite. The lines transferred are as erasable as ordinary pencil lines, making graphite paper superior to carbon paper for artists' use.

grater. See RASP.

graticulation. See SQUARING.

graver or **burin.** Any of a class of rod-shaped steel ENGRAVING tools with variously shaped points and a wooden handle that is generally rounded to fit against the palm. The graver is either

A B C D E

GRAVERS. At top, typical straight- and bent-shanked gravers. At bottom, common cutting points: lozenge (A); flat (B); round (C); point for multiple lines (D); elliptical (E).

elliptical-lozenge-shaped in section, ending in an oblique point, or rectangular in section, with an oblique face that comes to a blunt, rounded, or sharp point. The point and width of the cutting face vary according to the depth and width of the lines to be engraved. Gravers are sold in a wide range of sizes and shapes. Both bent- and straight-shanked models are available. See also TINT TOOL.

gravure. A generic term for any or all INTAGLIO printing processes; specifically, PHOTOGRAVURE.

grease crayon or **grease pencil.** A black or colored crayon, usually in the form of a pencil with a peel-off paper casing. It is used to write on glass, china, and other surfaces to which other pencils and crayons will not adhere and is, therefore, often called a china-marking crayon. Artists frequently use black grease pencils for drawing on paper, but the pigments suspended in the greasy base of colored grease pencils are not always permanent. LITHOGRAPHIC CRAYONS, which are considered a type of grease pencil because of their comparable composition and their use on stone and metal, are often preferred by artists for use on paper as well. Their range of hardness (five degrees in pencil form and seven degrees in stick form) and their more uniform quality make them superior to other grease pencils for drawing.

Grecian purple. Another name for TYRIAN PURPLE.

Greco-Roman. In art history, pertaining to the period (late 2nd and 1st centuries B.C.) when HELLENIC ART was assimilated and imitated by ROMAN ART. The major types of Greek sculpture were reproduced, as were individual works by such renowned Greek sculptors as Polyclitus and Praxiteles; it is to these copies that we owe most of our knowledge of the most famous Hellenic works. Although we have no surviving examples of Hellenic painting on which to base an idea of its style, the Fayoum mummy-case portraits of the 1st–4th centuries A.D., naturalistic paintings done in a province of Egypt governed by Rome and settled largely by Greeks, are generally known as Greco-Roman work.

Greek art. See HELLENIC ART.

Greek cross. A cross with four arms of equal length that intersect at their middles, as in the plus sign. This symbol is found widely among pre-Christian cultures. It is often inscribed with a circle. See CROSS for illustration.

Greek key or **Greek fret.** See FRET.

Greek pitch. An obsolete name for ROSIN.

Greek pottery. Ceramics was one of the important activities of the ancient Greeks. Their vases, painted with decorative motifs, figures, mythological scenes, and the events of daily life, are highly valued by museums and collectors not only as works of art but also as documents of the times and as indications of what Hellenic painting was like, in the absence of any surviving mural or easel paintings. The most outstanding examples of painted vases are from Athens; it is believed that the major successive developments of the art (see GEOMETRIC PERIOD; ORIENTALIZING PERIOD; ARCHAIC PERIOD) began there. Corinth was the second most important site. See VASE SHAPES.

green bice. Another name for Bremen green, the greenish variant of BREMEN BLUE. It has also been used for GREEN EARTH. See BICE.

green earth. A native clay containing iron silicate; a permanent pigment occurring in a limited range of clean, medium-pale willow or celadon shades. Green earth comes from various parts of the world; the best commercial grades, found in small deposits in central Europe and Cyprus, are called Tyrolean and Verona (relatively bluish), Bohemian (clear middle-green), and Cyprian (relatively yellowish). Green earth has been a favorite pigment for watercolor and other aqueous media since the time of By-zantine and early Italian tempera painting. Although green earth is available as an oil color, its chief attraction is its low cost, since it becomes dark and muddy in oil, with very little hiding power or tinting strength. Other names for green earth are CELADON GREEN, green bice, holly green, stone green, verdeterra (Italian), and the old Italian term, verdetta.

green marble. See SERPENTINE.

green pigments. The following are approved for use in oil paints by the PAINT STANDARD and are generally acceptable in all other easel- and mural-painting techniques: VIRIDIAN, PHTHALOCYANINE GREEN; CHROMIUM OXIDE GREEN; GREEN EARTH; COBALT GREEN. See PIGMENTS.

green rouge. See CHROMIUM OXIDE GREEN.

green smalt. An early name for COBALT GREEN.

greenstone. Any of various compact green rocks suitable for building or carving; also, an alternate name for nephrite (see JADE).

green verditer. An alternate name for Bremen green, the greenish variant of BREMEN BLUE.

greenware. Pottery that has been formed and allowed to dry, but has not yet been fired.

grenadilla. See AFRICAN BLACKWOOD.

grenadilla, South American. See COFFEEWOOD.

grinding of paints. See PAINT.

griotte. A purplish red MARBLE, occasionally spotted with white, from the Pyrenees; also called Campan marble and French Red. It is esteemed as one of the finest red marbles.

grisaille. 1. Monochrome painting executed in shades of gray, as its French name implies; a camaïeu done in grays. Grisaille is often used as an imitation of bas-relief and as such is especially suited to architectural subjects. Not having the techniques of chiaroscuro at their disposal for the representation of relief, the ancient Greek painters relied heavily on grisaille for gradation and modeling. Some Gothic miniatures were illuminated in grisaille. It was also used later as underpainting, especially by Northern Renaissance artists. Thus, some extant paintings in grisaille are merely unfinished works, although the medium has been used also for separate sketches and studies, such as Ingres' study *en grisaille* for his famous full-color *Odalisque* (see illustration at ODALISQUE).

2. A mixture of crushed glass with iron or copper oxides, cobalt, or other mineral pigments in a liquid medium such as wine. Resins were often added to increase the adhesive properties of the mixture. Grisaille was used, beginning in the 9th century, to alter the colors of single pieces of STAINED GLASS, to which it was fused by firing. Prior to its invention, forms could be shown in stained glass only through the juxtaposition of separate pieces of glass. The use of grisaille, made in tones of black, brown, and green, made it possible to shade and delineate detail in figures, such as facial features and drapery; to achieve a three-dimensional effect through modeling of figures; to darken areas bordering the leaden strips (see CAME) in order to enhance their structural function in the picture; and to tone down the brightness of pieces of glass that contrasted too strongly with adjacent pieces. Detail was often drawn by scratching through areas of grisaille with stiff brushes or pointed tools to reveal lines of clear glass. Modeling and shading were often achieved through the use of hatching.

3. A decorative glazing or enameling technique used on pottery, glass, or metal in which an opaque or semiopaque color is applied to the surface in varying degrees of thickness, the design or decorative effect being created by the dark undercolor showing through the thinner areas of enamel.

grog. Ground, previously-fired ceramic material, such as pulverized pottery, brick, or fired earth clay. It is mixed with plaster to impart strength to a casting formula and with fresh, unfired clay to thicken its consistency while wet, to reduce shrinkage and increase its hardness when fired, and to create interesting surface textures. Grog is also used in the manufacture of crucibles and other products that must resist extreme heat.

grotesco. Italian for a work of art in the GROTESQUE style. The plural is *groteschi.*

grotesque. A style of decorative painting, engraving, sculpture, and ornamental work in which fantastic human and animal figures are combined with leaf and flower forms interlaced in ornate curvilinear ARABESQUES; also, a work of art or one of the figures or designs in a work of art done in this style. The word "grotesque" comes from the Italian *grotte* (grottoes), the name given to underground chambers created by the excavation of ancient Roman buildings, in which much decoration of this kind was found. Raphael is generally credited with the revival of grotesque

forms, which have continued to be important motifs to the present day.

ground. 1. A surface to which paint is applied; also, a coating material used to prepare a surface for painting. An oil ground, consisting of oil and white pigment, is used on canvas; either an oil ground or GESSO is used on boards or panels. The SUPPORT is coated with one or more layers to provide uniform texture and absorbency for painting. Special grounds are used for certain types of painting: polymer colors, for example, are used on supports prepared with a special POLYMER PRIMER. Some painting surfaces, such as watercolor paper and parchment, serve as ground and support in one. See EMULSION GROUND; MULTIPURPOSE GROUND.
2. In relief sculpture, the flat surface from which figures project.
3. See ETCHING GROUND.

group. The term "group" used as a historical classification of a number of artists does not always imply a closely-knit association of artists working under a program of aesthetic doctrines. Different groups have banded together for different reasons: for example, for economic or political advantage, for companionship with artists of similar aesthetic philosophies, to foster art locally, or to unite artists of divergent tendencies in opposing established authority.

grout. 1. Wet mortar or any soft cement used to fill joints between the tesserae in mosaic; also used for setting tiles, decorative stones, or other small objects in a wall.
2. In building construction, a wet cement or concrete that can be poured into cavities or around the bases of steel columns.

guide, printmaker's. See REGISTER MARK.

Guignet's green. One of the various older names for VIRIDIAN. It distinguishes the standard product from those made by other processes.

guilloche. An ornamental design or a band molding formed of interlaced curved lines.

GUILLOCHE

gum. A hardened sap or exudation from any of various trees and shrubs. Some are soluble in water; the rest will absorb water and swell enormously when soaked in it. Gums are used in vehicles or binders for aqueous colors, in tempera emulsions, and as adhesives, sizes, and stiffeners. Typical examples are GUM ARABIC and GUM TRAGACANTH. In the varnish industry RESINS are invariably called gums (gum damar, gum copal, etc.), but this confusing usage does not extend to artistic or scientific discussion, where the precise terms are always used. Gums are insoluble in the volatile solvents (alcohol, turpentine, etc.) in which resins may be dissolved. Starches and similar water-miscible adhesives are generally classed with the gums because of their similar behavior and uses. For example, one grade of dextrin, called British gum, can be used as an adhesive backing for so-called gummed paper.

gum accroides. See ACCROIDES.

gum arabic. A GUM obtained from various trees of the genus *Acacia*, growing in Africa, Asia, and Australia. The best varieties have always come from North Africa. Gum arabic is soluble in hot water. It is used in solution

as the medium in watercolors and gum tempera, and as a binder in ceramics, to help the glaze adhere to the clay body. It is widely used in pharmaceuticals, confectionery, and various industrial products. When a solution of gum arabic is heated to the boiling point its character changes: It becomes dark, acquires a pronounced odor, and will not function properly in the recipes calling for a hot water solution; however, it may be used as a paper adhesive. Common mucilage is cooked gum arabic. The best grades of gum arabic come from the *Acacia senegal;* they are sometimes identified as Senegal gum or Kordofan gum. Gum arabic may be obtained in lump or powder form. Its pharmaceutical name is acacia.

gum eraser. A firm yet soft and crumbly rubber eraser made in tan blocks. It is used on paper to eradicate pencil lines and smudges without tearing the paper or harming its surface.

gum hog. See GUM KARAYA.

gum karaya. A vegetable gum that swells enormously in water, used as an inexpensive substitute for GUM TRAGACANTH. It is usually preferred to gum tragacanth for use as the gel base in marbling paper. It is colloquially known as gum hog.

gummigut. German for GAMBOGE.

gumming up. In LITHOGRAPHY, brushing a solution of gum arabic and water over the stone to seal off and "desensitize" the nonprinting areas and margins of the surface so that when wet with water they will repel ink. This process is the final treatment given to the stone after the lithographic etch and before ROLLING UP. After the gum-arabic solution has been applied, the stone is dried with a fan or

an electric blower, and then the surplus gum is washed away. The gum is dried in order to have the highest possible concentration of gum in contact with the stone; this occurs just before the gum is completely dry, creating the greatest adsorption of gum onto the stone.

gum resin. A small class of gums with resinous ingredients obtained from various shrubs and trees. The typical gum resin has the appearance of a resin, and is insoluble or incompletely soluble in water but dissolves freely in alcohol. Little or no use is made of gum resins in artists' materials.

gum running. A preliminary thermal treatment that some RESINS, notably the COPALS, require when they are used in the manufacture of cooked oil-and-resin VARNISHES. During the process, the resin is improved by the loss of some of its constituents through distillation. Gum running is one of the skills of the experienced varnish maker. The use of the term GUM for what should properly be called resin is one of the peculiarities of the varnish industry and the resin trade.

gum spirits of turpentine. See TURPENTINE.

gum tempera. Artists' colors consisting of pigments ground in an EMULSION medium in which the oily ingredient is linseed oil, STAND OIL, or, most often, a mixture of stand oil and DAMAR varnish, emulsified by shaking it together with a gum arabic solution plus a small amount of glycerin; also, the technique of painting with such colors. Gum tempera colors are brilliant and have working qualities that appeal to many painters. Their resistance to accidental damage by water is low, and so works of art in which they are used

are usually framed under glass. Gum tempera is one of the accepted permanent painting techniques. See also TEMPERA.

gum thus. The oleoresin or balsam from pine trees of the southern United States. It is the exudation from which TURPENTINE and ROSIN are obtained.

gum tragacanth. A GUM obtained from various species of a shrub (genus *Astragalus*) native to Asia Minor. It is commercially available in hard, thick flakes of a dull grayish-white to yellowish color, and in powder form. When soaked in water overnight, it swells to a translucent, gelatinous mass which is used in various dilutions as a binder for pastel crayons, and industrially as a thickener and stiffener in many substances, including foods and pharmaceutical products. In ceramics, it is sometimes used to help a glaze adhere to a clay body.

gypsum. Native calcium sulfate; used in the manufacture of PLASTER OF PARIS, wall plasters, and to some extent as a FILLER. It has been argued that the SLAKED PLASTER OF PARIS recommended by Cennino Cennini (*Il Libro dell' Arte*) for use in GESSO is an ideal material because of the felting property of the long, needle-shaped crystals contained in precipitated or chemically manufactured calcium sulfate; however, few, if any, of the varieties of native gypsum have this monoclinic structure. Other names for gypsum are mineral white and terra alba. The type of alabaster in most common use is a variety of gypsum. See BURNT GYPSUM.

gypsum plaster. Any of the common wall plasters in general use, all of which contain various amounts of gypsum, as distinguished from the pure lime plaster used in fresco. It is inferior to lime plaster in that it tends to effloresce (see EFFLORESCENCE) because of its slight solubility in water.

H

Haarlem blue. Another name for ANTWERP BLUE.

Haarlem school. Late 15th-century Dutch painters, working mainly in Haarlem. This was the earliest Dutch school to produce paintings quite distinct in style from the already established Flemish tradition. Geertgen tot Sint Jan was the most distinguished of the Haarlem painters, many of whom are unknown by name. The city became, about 1600, the site of the earliest Dutch art school, which trained students in the classical style, opposed to the Mannerism that had prevailed in the Low Countries throughout the 1500's.

hachure. HATCHING, especially in cartography as a system for indicating relief.

hafner ware. A well known German salt-glazed stoneware. The term was first applied to ceramics made in 14th-century Germany by the Rineland stovemakers, who became famous for their lead-glazed tiles; later they made container forms.

half-chalk ground. Misnomer for EMULSION GROUND, which is called *halbkreide,* literally meaning half-chalk in German but better translated as semi-gesso.

half length. See CANVAS SIZES, PORTRAIT.

half-relief. See RELIEF.

halftone. 1. A shade of gray or a chromatic color whose value is intermediate between the darkest and the lightest tone of that color.
2. In printing, an area of ink either black or colored, that has been broken up into dots. The dots vary in size and density according to the value of the halftone. The more white space between black ink dots, for example, the lighter gray the area will appear (see also DROPOUT). There is a procedure for making halftones in all three categories of printmaking techniques —intaglio, planographic, and relief. Halftones are also produced by commercial printing methods. The terms halftone cut and halftone engraving usually refer to the products of photoengraving and photogravure, made by photographing the original through a screen.

half uncial. A smaller, more cursive adaptation of the UNCIAL hand. It was used as a book hand in Latin codices from the 5th to the 9th centuries. A modified half-uncial hand with both minuscule and majuscule forms was developed in England and Ireland from the sacred texts brought there from the Continent. This Insular half uncial was used in Hiberno-Saxon manuscripts until the 11th century.

hallmark. An identifying series of marks stamped on a British silver or gold object in some inconspicuous place, usually on the REVERSE of the object. The term hallmark is derived from Goldsmith's Hall in London, home of the Goldsmith's Company; gold and silver articles assayed there were stamped to indicate their purity and quality.
British wares generally have five marks: the maker's initials or registry; a mark representing the town in which the article was made; an assayer's mark indicating quality; a tax-paid or official mark; and the year of manufacture, which is indicated by a letter of the alphabet through *u,* the font being changed every twenty years. Other European silverware usually has two marks, the maker's initials and the town mark; the latter sometimes indicates quality, as well, and usually incorporates the date. American silver was generally stamped with one mark only, the maker's name or initials, until the mid-19th century; later the word STERLING was added as a statement of the metal's purity. No official standards or regulations for marking metal wares were ever established in the U.S. Town names and other marks were used occasionally as trademarks, and some silversmiths used pseudo marks that resemble English hallmarks but have little or no significance. 17th-century pewterers and 18th-century makers of SHEFFIELD PLATE sometimes also used imitations of silver hallmarks on their wares. More commonly, however, a special mark known as a TOUCH appears on PEWTER.

halo. See NIMBUS.

hand coloring or **hand illustration.** Other names for POCHOIR.

hand-mounting iron. An electrically heated iron used in DRY MOUNTING. It is lightweight, flat, and rectangular and is used when a dry-mounting press is not available.

handrest. See BRIDGE.

hand vise. A clamp with a handle used by the artist to hold a small object in one hand while he works on it with

HAND VISE

the other. The hand vise is often used for holding an object against a grinding or buffing wheel or over a flame. The illustration shows the type of hand vise used to hold an ETCHING plate while blackening, or SMOKING, its surface.

hand-wiped. See WIPING.

Hansa yellow. A brilliant, transparent, light-yellow pigment made from a series of synthetic dyestuffs called pigment yellow, which were developed in Germany in the 20th century. Hansa yellow is one of the relatively few modern organic pigments qualified by color stability and pigment properties for use in permanent painting. Originally a German trade name, Hansa yellow has won general acceptance as a designation for the pigment itself. This pigment, mixed with phthalocyanine blue, produces greens that may substitute for emerald green and other fugitive greens. Used alone, it gives brilliant effects, but it does not replace the golden tone of cobalt yellow in glazes. Monolite yellow is another trade name for Hansa yellow.

happening. An extension of the art form called the ENVIRONMENT to include action. In Europe happenings have been called "manifestations" or "realizations." The term "happening" was invented in the mid-1950's by Allan Kaprow, one of the leading creators in the form. Happenings are often brief dramas juxtaposing symbolic, often vaguely disturbing, bits of action, such as a live Santa Claus struggling to escape from a wrapping of cellophane. The viewers may be seated like audiences at a play, but the art elements and even the action often invade the viewing areas. Principal exponents of the happening in the United States have included, in addition to those already known for their environments, Robert Whitman, Jr., George Brecht, and Red Grooms.

hardboard. Any firm, dense, rigid WALLBOARD.

hard-edge painting. A painting technique in which shapes are clearly and sharply defined, often in a simple, austere design. The term is of recent origin, and is more frequently applied to GEOMETRIC ABSTRACTION than to representational work.

hardening on. A process by which ceramic ware is heated to 600° F. in order to burn off organic material that may be present in the colors used in underglaze decorations. Hardening on is necessary to prevent such defects as crawling and blistering.

hard paste; hard-paste porcelain. A hard, high-fired PORCELAIN; a "true" porcelain, as distinct from the somewhat softer and lower-fired porcelains called SOFT PASTE. The term hard paste also designates the clay mixture used to make a high-fired porcelain. It usually contains feldspar as a flux and

flint as a refractory ingredient, and is fired at 2,420° F. or under.

hard solder. A SOLDER that requires red heat for fusion. See also SOFT SOLDER.

hardwood. The wood of most deciduous trees, including walnut, maple, and birch. It is dense and rather hard, unlike the wood of conifers such as the pines and firs and of a few deciduous trees such as poplar. The latter, called softwoods, are less resistant to mechanical forces.

hare's fur. In ceramics, another name for TEMMOKU, a slip glaze.

harewood. A variety of MAPLE (*Acer pseudo-platanus*); a light-colored wood with a delicate, figured grain. Harewood is available "weathered" and in pink and silver-gray—all artificially colored. It comes in planks 1 to 2 inches thick, and is also known as English sycamore.

Harrison red. A bright cherry-red of the PARA RED or LITHOL RED type. In the early 20th century this pigment was such a great improvement over the earlier synthetic organic reds that it was prematurely adopted for artists' use. Its shortcomings soon became evident, as it began to show signs of bleeding and fading on aging for a year or two.

Hatchett's brown. A name given to brown shades of VAN DYKE RED.

hatching. Shading or modeling with fine, closely set parallel lines. When a second series of lines crisscrosses the first set, the technique is called crosshatching. By varying the size and closeness of the lines, an artist is able to indicate tones and suggest light and shadow in drawing, linear painting, engraving, and etching. Hatching is also used for shading and modeling in tempera and other aqueous media where tones cannot be made to fuse by blending as they do in oil painting. A similar technique is used for highlighting and shading in tapestry, where hatched lines are produced by weaving in contrasting threads.

hawk or **mortarboard.** A plasterer's implement formed of a sheet of aluminum with a wooden handle, usually cushioned with a large circle of sponge rubber on the underside of the board about the handle. A hawk may be a square foot or larger in size. The plasterer's working supply of mortar is placed on the hawk, from which he takes it up with his trowel much as a painter takes a load of color from his palette.

HAWK

H. C. Abbreviation for HORS CONCOURS.

heartwood. The wood at the center of a tree. It consists of dead cells, unlike the SAPWOOD which surrounds it, and is harder and more resistant to decay. It is often a darker or more vivid color than the sapwood, and is usually the part of a tree that is commonly known and commercially valuable as wood.

heavy spar. Another name for BARYTES.

Hebrew granite. See GRAPHIC GRANITE.

heel. The point at which the bristles of a flat or round brush bend when its point is applied to the painting surface. A high-grade bristle brush is both sup-

ple and resilient. Its heel occurs about ¼ of its length from the ferrule. A brush whose bristles are too limp or too firm will not possess this desirable feature.

heelball. A prepared mixture of beeswax and lampblack or chromatic pigments, used to make a RUBBING. Cobbler's wax may be used in place of heelball.

heighten. In painting, to complete the rendition of forms by raising the VALUE of appropriate areas with white or pale color.

Helladic. Pertaining to the bronze age on the Greek mainland. Helladic civilization is divided into early (2600–2000 B.C.), middle (2000–1580 B.C.), and late (1580–1100 B.C.) periods. See MYCENAEAN.

Hellenic art. The art of Greece and the lands under Greek influence, from about 1100 B.C. to 100 B.C. Hellenic art may be divided chronologically into six stylistic periods: PROTOGEOMETRIC PERIOD, 1100–900 B.C.; GEOMETRIC PERIOD, 900–700 B.C.; ORIENTALIZING PERIOD, 700–600 B.C.; ARCHAIC PERIOD, 600–500 B.C.; CLASSICAL PERIOD, 500–323 B.C.; and HELLENISTIC PERIOD, 323–100 B.C. During the second and first centuries B.C., as Roman political influence grew, Rome absorbed Hellenic art and so modified it as to make it her own. See GRECO-ROMAN; ROMAN ART.

Hellenistic period. The final phase of HELLENIC ART (323–100 B.C.), considered to have begun with the death of Alexander the Great. Thanks to his conquests, Hellenic art in this period was produced far beyond the borders of Greece, and was therefore subject to cosmopolitan influence. The harmony resulting from the concept of ideal beauty gave way to a dynamism and individuality verging at times on melodrama. Realistic portraits, of the aged and suffering as well as of the young and vigorous, were produced. Private emotions and psychological states were portrayed for the first time. Great rulers were depicted with a stature heretofore reserved for the gods. Draperies acquired a sensuous life of their own. Architectural and landscape backgrounds were introduced in figure compositions. In addition to monumental sculpture, artists produced small statuettes, in bronze for example, whose subject matter was even more mundane and whose treatment was even more realistic and personal than was common in the larger works.

hematite. A native red iron oxide; the chief ore used for smelting iron. Used in powder form as a red pigment, hematite is mentioned by Cennino Cennini (*Il Libro dell' Arte*) and other Italian writers of the 14th to the 16th century. In the arts, however, the term hematite usually refers to a type found in dense stones of extreme hardness, which is used to make the broad, flat burnishers used in some kinds of gilding.

hemp. A strong fiber used for making ropes and textiles. Hemp fabric has been used as a support for paintings, especially in India, and is believed to be as satisfactory as linen for that purpose.

hempseed oil. A vegetable drying oil expressed from the seeds of the hemp plant (*Cannabis sativa*) that has been used as a substitute for linseed oil, especially in India. Its properties, which resemble those of POPPYSEED OIL, are less suitable than those of linseed oil for use in oil colors.

herm or **herma.** A statue or monument in which the head is fully carved and the rest of the figure, in proportion, is a plain quadrangular column tapering downward. Herms are named for the Greek god Hermes, the subject of many such statues which were placed along the thoroughfares in ancient Athens. The herm is very similar to the TERM or terminal figure.

heroic. In figure sculpture, larger than life-size without being COLOSSAL; usually, a foot or two higher than life-size.

hide glue. See GLUE.

hiding power. The degree of opacity of a coating material; its ability to obliterate anything over which it is spread. Hiding power is a direct function of the refractive index (see REFRACTION) of the coating, and is also influenced by fluidity. See also COVERING POWER.

hieracosphinx. See SPHINX.

Higgin's vegetable glue. A proprietary water paste sold in cans. It is used to make paper or cloth adhere to various surfaces, such as wooden drawing boards, glass, metal, and leather.

highlight. The spot or one of the spots of highest VALUE in a picture (see LIGHT); also, a depiction of the high point of a form to give final emphasis to a convexity.

highlight halftone. See DROPOUT.

Hispano-Moresque ware. A lusterware originally made by Moorish craftsmen at Manises, a potters' community near Valencia in Spain. It was later made by Spanish potters, who adapted the Islamic inscriptions to purely decorative purposes.

Hogarth's line. The so-called line of beauty, a term introduced by the English painter William Hogarth (1697–1764) in his book *The Analysis of Beauty* (1753). It is a graceful S curve, which he presented as the basis of all successful artistic design.

HOGARTH'S LINE

hold-down. A homemade clamp that holds objects on a workbench while they are being tooled, but permits them to be readily turned. The object to be sawed, or carved, is placed under one end of a plank. A long loop of rope

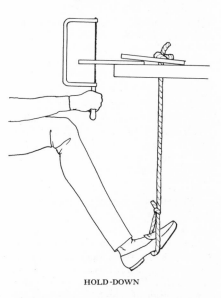

HOLD-DOWN

or leather is passed through a hole drilled beyond the midpoint of the plank and through a corresponding hole in the workbench so that the lower end of the loop forms a stirrup dangling near the floor. The rope is held at the top by a knot too large to slip through the hole. The user's foot in the stirrup pulls down the plank

firmly on the object, but can release it readily when it is necessary to turn it.

hollow ware. In metalwork, ceramics, and glassware, vessels or bowls; technically, any such pieces that are either hollow or deeply concave, as opposed to FLATWARE.

holly. An almost white wood with an unobtrusive grain. A well-made, sturdy plywood faced with a holly veneer and given a colorless sizing makes an attractive ground for mural panels.

holly cross. See CROSS-CROSSLET.

holly green. Another name for GREEN EARTH.

Honduras rosewood. See ROSEWOOD.

hone. To finish the sharpening process on an edged tool, usually by rubbing it on an OILSTONE or SLIP, after preliminary sharpening on a whetstone or grindstone. Knives, chisels, and gouges used for wood carving should be honed.

honeysuckle ornament. See ANTHEMION.

Hooker's green. A bright olive-green sold in two shades, yellowish and bluish; a COMPOSITE PIGMENT made with Prussian blue and gamboge, neither of which is approved for permanent painting. However, a modern replacement for Hooker's green is permanent if it bears on its label the names of such permanent components as phthalocyanine green and either Hansa or cobalt yellow.

Horace Vernet green. Another name for Vernet green, a variety of Bremen green. See BREMEN BLUE.

horizon line. A line, either shown (as in a landscape) or theoretical (as when the horizon in a landscape is concealed by objects, when the line exists outside the PICTURE PLANE, or when, as in interior scenes, there is no actual horizon), on which are located all the VANISHING POINTS of all sets of horizontal lines. (The vanishing point of any set of receding parallel *vertical* lines in a drawing of an object in OBLIQUE PERSPECTIVE is not on the horizon line.) Since nature's horizon always appears at the observer's eye level, in any picture in which the CENTRAL VISUAL RAY intersects the picture plane at its center, the horizon line will divide that plane horizontally in its center. In a conventional view, then, the horizon line usually crosses the picture plane near its center. In a view from above, however, the horizon line is high in the picture plane or may even be above it; in a view from below, it is low in the composition or even below the picture plane. Depending upon the angles of the axes in a given composition and the corresponding angles of receding lines, the horizon line may extend beyond the sides of the picture. See illustrations at LINEAR PERSPECTIVE; PERSPECTIVE.

hors concours. Ineligible to compete for prizes in an exhibition. This is usually the case because an artist has won a prize at a previous exhibition of the same organization or because he is a member of the jury. The term is sometimes abbreviated to H.C. Its literal meaning in French is "out of competition."

hot-pressed paper. See WATERCOLOR PAPER.

hot table. In the conservation of paintings, a specially constructed, electrically heated table used as the working surface in the LINING of a canvas. The warmth of the table's bed is

regulated for the optimum working temperature of the lining adhesive. A cover of rubber sheeting is stretched over the table, and a pump mounted below causes the formation of a vacuum, which flattens the rubber membrane over the canvas and causes its impregnation with the adhesive. The hot table was developed by museum technicians in the 1950's.

Hudson River school. A group of American romantic painters in the 19th century who drew their inspiration from the American landscape. Although they ranged the continent, many of them painted scenes of the Hudson River valley and Catskill Mountains. This area was accessible to artists from New York City, where the group frequently gathered. Among the early Hudson River painters were Thomas Cole (1801–1848), Asher B. Durand (1796–1886), and Thomas Doughty (1793–1856); later artists included Frederick Edwin Church (1826–1900), John Kensett (1818–1872), and Albert Bierstadt (1830–1902). See illustration at TOPO-GRAPHIC LANDSCAPE.

hue. The actual color of anything, identified by a common name such as red or greenish yellow. In describing the direction toward which a hue tends, as in color comparison, the standard procedure is to use the following pairs of terms: A blue is described as either greenish or purplish; a red as either bluish or yellowish; a green as bluish or yellowish; a yellow as greenish or orangy; a violet or purple as bluish or reddish; an orange as yellowish or reddish; a gray as cool (bluish) or warm (toward the red or yellow); a brown as cool (greenish) or warm (reddish). Grays and browns can also be described as neutral, i.e., neither markedly cool nor markedly warm, but a neutral hue is cooler than a warm one. Oils, varnishes, and similar trans-

parent liquids are said to range in hue from pale yellowish to dark brown, in degrees that include straw, amber, golden, golden amber, brown, and blackish brown. An artists' color is often designated according to its resemblance to some hue in nature, without reference to its chemical composition or origin. Examples are primrose yellow, sea green, sky blue, and rose pink. Hue designations may also be made by reference to a familiar object, as in brick red and battleship gray. A paint that is given such a designation rather than a standard pigment name often contains impermanent ingredients.

Hungarian green. Another name for MALACHITE.

Hungary blue. A rarely used term for COBALT BLUE; perhaps first used for SMALT in the 16th and 17th centuries.

hydrated lime. Calcium hydroxide or slaked lime, also called slack lime. See LIME.

hydraulic. Pertaining to any action or movement effected by means of water; in cements or concrete mixtures, having the property of setting while submerged in water.

hydria. An ancient Greek water jug. It usually had rounded shoulders, with horizontally attached handles, and a vertical handle at the neck for use in pouring. See VASE SHAPES for illustration.

hydrofuge. A means of removing moisture from a substance; a material (as SILICA GEL or calcium chloride) or an apparatus (as a FILTER PRESS) so used.

hydrolysis. Any chemical reaction that is caused by the action between water and a salt, resulting in the chem-

ical decomposition of the salt and the formation of a new substance. An example is the conversion of silicon ester to silica in ETHYL SILICATE painting.

hydromel. A mixture of honey and water, usually of equal proportions. It is used as a PLASTICIZER in watercolor paints. The term is no longer in common use.

hydrophile. A material that attracts or has an affinity for water. Ordinary, clean watercolor paper is a hydrophile, as is the adsorbed coating of gum arabic on the nonprinting portion of a lithograph stone.

hydrophobe. A water-repellent material or surface. The crayon and tusche used in drawing on a lithograph stone are hydrophobes.

Hyplar. Trade name for an American manufacturer's line of acrylic POLYMER COLORS and their adjuncts.

I

I.C.I. International Commission on Illumination. Since 1951 its official abbreviation has been C.I.E.

icon. In churches of the Eastern rites, a venerated representation of Christ, the Virgin Mary, or another religious subject, done in the Byzantine manner in painting, mosaic, niello or another art form in two dimensions or very low relief. The typical icon is a small tempera painting on a wooden panel, sometimes embellished with an elaborate repoussé cover of silver or other metal, cut out to reveal the central part of the picture.

iconography. 1. A set of images or symbols conventionally associated with a subject, e.g., the iconography of Christianity; also, the imagery used in a work of art, by a painter or artistic school, or in the art devoted to a par-

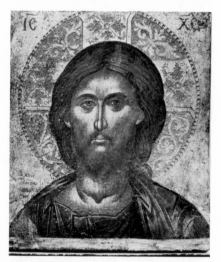

ICON. Head of Christ, tempera on wood, by Emmanuel Tzanès (1639–1699), Greco-Italian artist. (*The Metropolitan Museum of Art, Gift of Mrs. Henry Morgenthau, 1933.*)

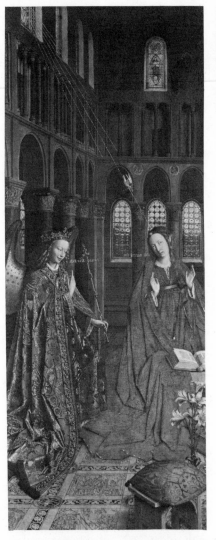

ICONOGRAPHY. *The Annunciation,* by Jan van Eyck (1385–1441), is replete with conventional symbols as well as architectural analogs, the latter a recurring feature in the artist's paintings. At the moment of conception the Holy Spirit, in the form of a dove, descends from a typically Romanesque clerestory, here equated with the Old Testament and Judaism. The single high window depicts the Lord of Hosts of the Israelites; it is flanked by mural paintings (not discernible here) of the finding of Moses and the giving of the Ten Commandments, events that presage the acceptance of Christ by the community of the faithful and the giving of the New Covenant. The transition to Christianity is symbolized by the downward progression to Gothic elements and to three windows representing the persons of the Trinity, a concept developed in the New Testament. The continuity of the old and new dispensations is reflected in the subjects of the floor panels (shown in the detail), which include the death of Samson (prefiguring the Crucifixion) and David slaying Goliath (prefiguring the triumph of Christ over Satan). At the corners of these panels are zodiacal signs, a common device for proclaiming God's dominion over both the physical and spiritual universe. The lilies attest to the purity of the Virgin, and the footstool, together with the single high window, may refer to Isaiah 66:1: "The heaven is my throne, and the earth is my footstool." Mary's response to the angel's greeting is written upside down, so it may be read by God. (*The National Gallery of Art, Andrew Mellon Collection, 1937.*)

ticular subject, e.g. the iconography of western religious art.

2. The meaning assigned to a set of images or symbols according to a particular convention.

3. A collection of pictures constituting a complete visual record of a specific subject, such as a person, a locality, or an activity; especially, a collection of portraits.

iconostasis. In an Eastern church, the screen or partition that separates the sanctuary from the nave and to which icons are attached.

idiom. The style or techniques peculiar to an individual artist or characteristic of a period, movement, or medium. One might say of an architect that his buildings were designed in the idiom of Palladio or of a painter that he works in the surrealistic idiom.

igneous rock. See ROCK.

I.I.C. Standard abbreviation for the INTERNATIONAL INSTITUTE FOR THE CONSERVATION OF HISTORIC AND ARTISTIC WORKS.

illumination. The art of decorating manuscripts with designs and pictures in color and using elaborate calligraphy. The oldest known illuminations are on Egyptian papyrus rolls, including the *Book of the Dead*. The art was practiced in classical Greece and Rome, but of these only a few Roman specimens of the 3rd to 6th century survive. Byzantine religious manuscripts contain many dramatic miniature paintings, and 14th-century Persian editions of the Koran have marvelously delicate designs and calligraphy. In Europe throughout the Middle Ages, manuscripts were produced almost exclusively by monks, who became skilled at illuminating parchment or vellum Bibles and EVANGELIARS, antiphonaries, and devotional works such as the type of prayer book called BOOK OF HOURS. During the Renaissance a great variety of secular works, notably chronicles and romances, were also illuminated.

Early medieval manuscripts were executed in red lead and cinnabar (vermilion). Ornamentation at first reflected the training of scribes: it consisted of enlarged, intricately drawn

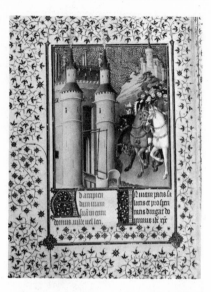

ILLUMINATION. A miniature painting from the *Belles Heures du Duc de Berry* (c. 1410–13) by the Limbourg Brothers, depicting the Duke on a journey. (*The Metropolitan Museum of Art, The Cloisters Collection, Purchase, 1954.*)

initial letters and decoration also essentially calligraphic. Gradually the decorative elements became more important. Elaborate initial letters sometimes framed very small pictures; the letters and paintings often filled entire pages. Pictures were painted on gold grounds or surrounded with Gothic architectural tracery, in imitation of stained glass; pages were given elegant borders of linear elements combined with plant and animal motifs. The illuminations were done almost entirely with aqueous paints: gray monochrome (GRISAILLE); outline drawings tinted with pale water washes; brilliant tempera colors, often with burnished gold. Some medieval manuscripts were partly or wholly lettered in gold or, less commonly, in silver, often on tinted parchment or vellum.

This technique is known as CHRYSOG-RAPHY.

The art of illumination began a slow decline in the 15th century, with the advent of printing. Many of the earliest printed books, however, resemble illuminated manuscripts, for initial letters and other colored embellishments were often added by hand to texts set with movable type.

illusionism. The use of pictorial and perspective techniques to create in a work of art the illusion of reality. Illusionism was the guiding principle of Roman wall painting and relief sculpture. In the wall paintings at Pompeii, for example, light and shadow were manipulated to create an illusion of realism and depth. Since no geometric system of perspective had yet been formulated, Roman artists used what are essentially the techniques of AERIAL PERSPECTIVE to achieve an illusion of recession in their paintings. Later, Renaissance and Baroque artists utilized detailed and accurate systems of perspective and color to create in painting an illusion of reality. This technique was known as TROMPE L'OEIL.

illustration. A picture especially executed to accompany a printed text, such as a book or an advertisement, in order to reinforce the meaning or enhance the effect of the text. A work of art originally created for another purpose may also be used as an illustration if it is appropriate to the content of a text. Art that appears in conjunction with a text but is not specifically related to it is decoration rather than illustration.

illustration board. A sheet of cardboard to which paper has been pasted on one or both sides. The paper used may be anything from an inexpensive drawing paper to the finest pure rag watercolor paper, in a limited variety of surface textures. Boards with paper on both sides are more resistant to warping than those mounted on one side only. Illustration boards are used by illustrators, draftsmen, and others whose work is to be reproduced and is therefore much handled. They are not suitable for permanent fine-arts use because of the undesirable properties of wood-pulp cardboard. See COQUILLE BOARD.

ilmenite. A black, lustrous titanium ore, containing iron, from which titanium white pigments are made. It has also become popular with studio potters, who use it in milled form as a coloring agent for glazes and in granular form as an agent for producing speckled effects in glazes and ceramic bodies. See also RUTILE.

imagiers. Stone carvers and sculptors who carved the figures and decorations of the Gothic churches and cathedrals under the supervision of the clergy. Their work is admired for its vigor, imagination, and humor.

imagines à vestir. Doll-like, clothed effigies of saints, displayed in Italian churches. The heads and extremities of such figures are delicately carved and tinted; the bodies are usually roughly constructed and covered with lavish garments, sometimes bearing precious jewels.

imbrication. Any decorative pattern composed of overlapping elements arranged like shingles or roof tiles. See illustration on next page.

imbuya or **embuya.** Any of several brown woods with figured grain from Central and South American trees of the genera *Nectandra* and *Phoebe*. Excellent for carving, it comes in logs of various sizes and in

planks 1 to 2 inches thick. Imbuya is also known as Brazilian walnut because of its color.

IMBRICATION

imitation stone. Any of various mixtures of cements or plasters, aggregates, and pigments which, when made up to a plastic consistency with water or a chemical solution, harden to a rocklike cohesiveness, appearance, and durability. One such material is OXYCHLORIDE CEMENT mixed with aggregate and pigments; others are sold ready-mixed in supply shops as casting stone or under various trade names. Some of the latter use epoxy resin as a substitute for cement. Imitation stone is used for casting by sculptors, who may try to duplicate the color and texture of various carving stones, or utilize it to achieve new and different effects.

imitation vermilion. Another name for AMERICAN VERMILION.

imp. An abbreviation of the Latin word *impressit*, meaning "he printed it." Sometimes it follows the printer's name in engraving proofs that have been printed by someone other than the engraver. *Imp.* is synonymous with *exc.*, an abbreviation for the Latin *excudit* ("he executed it"). In lithography, the name of the printer is followed by the word lith. or litho. For explanation of other terms used in marking proofs, see DEL.

impasto. Paint applied in outstandingly heavy layers or strokes; also, any thickness or roughness of paint or deep brushmarks, as distinguished from a flat, smooth paint surface.

imperial green. A reduced or letdown grade of EMERALD GREEN.

Impressionism. The first great modern art movement. The Impressionists broke away from the traditional technique of continuous brush strokes, from the representation of clearly outlined objects, and from preconceived notions of the color that things have in nature. They sought instead to break light up into its component parts and to render its ephemeral play on various surfaces. To achieve their effects, they worked in a succession of discontinuous strokes of color, which were to be combined by the eye (see OPTICAL MIXTURE). Although Impressionist paintings did not conform to traditional ideas of how things should be depicted, they were in fact attempts to observe nature as it really is and transmit it to canvas. Bright colors in a high key were characteristic of Impressionist work.

The first Impressionist exhibition was held in Paris in 1874; seven more were held between 1876 and 1886. They were received with hostility and contempt. It was not until the group had disbanded, each artist continuing his own artistic development, that the Impressionists achieved solid recognition. The leader of the movement was Claude Monet (1840–1926), whose paintings of haystacks and other subjects at different times of day perfectly exemplify the Impressionists' concern with the effects of light. Although the group was not formally

bound together by doctrines or principles, Camille Pissarro (1831–1903) and Alfred Sisley (1839–1899) were close to Monet both artistically and personally. Other important painters who accepted Impressionist concepts were Pierre Auguste Renoir (1841–1919), Edgar Degas (1834–1917), and Paul Cézanne (1839–1906), who was to have a great influence on succeeding generations of artists. Younger men associated with the movement, such as Gauguin and Van Gogh, were rather practitioners of POSTIMPRESSIONIST PAINTING. See also POINTILLISM.

The term impressionism has been used in the 20th century to characterize discontinuous brushwork or an analytical approach to light in many works of the past. It has been applied to the work of ancient Roman mural painters, Hals, Velásquez, Turner, and Constable, among others. The Impressionism of Monet and his group, however, is generally held to have been almost entirely free of such historical influences. See colorplate facing page 151.

imprimatura. In oil painting, a thin, transparent GLAZE of color applied over a drawing on a white ground as a preliminary color coat. The English equivalent, VEIL, is more frequently used. See also TONED GROUND.

inc. An abbreviation of the Latin word *incidit,* meaning "he cut it." It sometimes follows the engraver's name in a lower corner of the margin of a print, where it has the same meaning as *sculp.,* an abbreviation for the Latin *sculpsit,* "he carved it." For an explanation of other terms used for marking proofs, see DEL.

incised relief. Hollow RELIEF.

incunabula. A Latin term whose literal meaning is cradle, birthplace, or beginning. It is used to designate works created during the earliest stages in the development of an art form or technique or at the beginning of any new period of artistic productivity. The word is most frequently used as a specific term for books printed before 1501.

India ink. Name commonly used in the U.S. for black liquid drawing INK.

Indiana limestone. The limestone most widely used by American sculptors. It is oölitic, relatively soft, and easy to carve, especially when it is freshly quarried. Indiana Buff Statuary is especially fine-grained and attractive. BEDFORD STONE is another Indiana limestone.

Indian blue. An old name for INDIGO.

Indian lake. An obsolete red lake color made from lac dye (see LAC).

Indian madder. An orange-red NATURAL DYESTUFF made from the East Indian plant *Rubia cordifolia;* one of the slowest-fading of the natural coloring matters, used extensively for dyeing textiles in the Orient. Indian madder is also known as munjeet.

Indian purple. A label for various mixtures of blue and red pigments. The most satisfactory of these MIXED PIGMENTS is composed of ultramarine blue and alizarin crimson.

Indian red. Pure iron (ferric) oxide; a furnace product, usually made from steel-mill wastes. One of the artist's basic pigments, Indian red is dense, opaque, permanent, and of a relatively deep brick hue with a bluish undertone, as compared to the bright, scarlet

top tone of light red, the other pure iron oxide pigment. Originally a native earth imported from the East, Indian red was first manufactured in the early 18th century. For a time afterward, the native earth pigment was called "true" or real Indian red to distinguish it from the furnace product; since the 19th century, Indian red has been applied specifically to the latter. The term's usage antedates its reported introduction to England by the American painter Benjamin West (1738–1820), who used it in reference to the red earth-color employed by the American Indians. Both Indian and light reds are called red oxide, and have also been known by the obsolete name colcothar. See also POMPEIAN RED.

Indian yellow. An obsolete yellow LAKE formerly made in India from the urine of cows fed on mango leaves; less fugitive than most other yellow lakes. From the early 19th century, Indian yellow was widely used by Europeans, but its process of manufacture was kept hidden from them until the 1880's. Indian yellow was exported in a crude lump form called piuri (variously spelled pioury, puree, and pwree), which had to be purified and powdered for pigment use. In 1908 its production was prohibited on humane grounds, since mango leaves were harmful to the cattle. A modern color labeled Indian yellow might contain any one of a number of yellow synthetic dyestuff or lake pigmemts.

India paper. The thinnest paper that is sufficiently strong and opaque for book and print use; also called Bible paper.

India rubber. Obsolete term for rubber or rubber eraser.

indigo. A deep-blue pigment originally made from a NATURAL DYESTUFF obtained from plants of the genus *Indigofera*, cultivated in India; now made synthetically from coal tar. Exported to Europe since Roman times, indigo is not a very lightfast color. Writing in the 1st century A.D., Pliny says that the Greeks, with their simple mineral palettes, produced works superior to those of his own day, even though the Romans possessed such new resources as "the slime of India's rivers [indigo] and the blood of her dragons and elephants [dragon's blood]." Indian blue is an old name for indigo; intense blue is a deep variety of indigo lake.

inert pigments. A class of white or nearly white inorganic powders that become colorless or nearly colorless when ground in oil. Inert pigments can be used as FILLERS or weakeners of paint pigments, but their presence does not always indicate adulteration. Certain inert pigments, especially ALUMINA HYDRATE and BLANC FIXE, are necessary ingredients of LAKES and certain other colored pigments; some are used as EXTENDERS to control various attributes of oil colors, such as CONSISTENCY, TINTING STRENGTH, and bulk; others are added to create textures and to reinforce the paint layer. CHALK (or WHITING) is used to make GESSO and PASTEL CRAYONS. Other common inert pigments are clay, precipitated chalk, and gypsum.

infusorial earth. Another name for DIATOMACEOUS EARTH.

inherent vice. In art conservation, any condition in the materials of a work of art that may cause defects to develop, as opposed to extraneous causes of decay or damage. The term is used in scientific and technical discussion as well as in questions of insurance.

ink. A fluid, semifluid, or paste material containing coloring matter and used for pen and brush drawing, writing, and printing. Inks for these purposes differ from one another in their composition and physical properties. Black *writing ink* is a thin fluid consisting of a solution of tannic and gallic acids extracted from gall nuts, combined with copperas or another iron salt, dilute hydrochloric acid, a preservative such as phenol, and a black or blue dye. On exposure to atmospheric oxygen, the tannin in the gall nut extract reacts with the iron to form an intense black stain on the paper. The added dye is needed to make the writing visible at once, since the chemical reaction involved takes a day or two for completion. Iron-gallotannate inks have been used since medieval days, but the fact that a surface treated with copperas could be blackened by an infusion of gall nuts was known in the first century. Writing ink will remain legible for centuries, especially when kept away from light. But the fading and color changes that occur would be disastrous in a drawing, so writing ink is not used for permanent works of art. Colored writing inks, as well as special writing fluids for ballpoint and felt-tipped pens, are made of soluble dyes and so are never sufficiently lightfast to be used in works of art. *Drawing ink*, usually called India ink in the U.S., is especially made for use in permanent works of art, such as pen drawings and wash drawings, and in mechanical drawing. It consists of particles of a carbon pigment, usually lampblack, finely dispersed in an aqueous binder, with a wetting agent and a preservative added. Ordinary drawing ink dries water-resistant so that it may be gone over with a wash or watercolor; its traditional binder is a solution of shellac and borax. A soluble drawing ink, the dried layer of which may be washed away with water, is also available; it is sometimes preferred to water-resistant ink for fine lines and delicate manipulations. The Romans used an ink comparable to India ink, *atramentum,* which they made with lampblack obtained by burning rosin in a special furnace, for both writing and artistic purposes; their principal ink, however, was CUTTLEFISH INK. *Chinese ink* is similar to India ink, although various minor ingredients are added to enhance its brilliancy, working qualities, and range of tone. After the ink is made it is dried and molded into little sticks or cakes, which the artist puts into solution by rubbing their ends on an inkstone with a little water. *Japanese ink,* also called sumi or black watercolor, is made in sticks that resemble their Chinese counterparts. Distinguished by numerous subtleties of quality and grade, the sticks are made and used according to ancient traditions and, in Japan, with a connoisseurship that virtually amounts to a cult. Most colored drawing inks make few claims to permanence; those that are made with permanent pigments are labeled with pigment names rather than hue designations. PRINTING INK is more closely related to oil colors than to the pen and brush inks.

inlay. To create a design or picture on a surface by inserting thin pieces of a material such as wood, metal, tile, stone, shell, or ivory precisely in a series of shallow depressions or on a depressed ground; also, a piece of work so produced. See DAMASCENE; INTARSIA; MARQUETRY; MOSAIC; PIETRA DURA. See illustration on next page.

inpainting. In the conservation of paintings, coloring or painting an area that has been damaged or obliterated so that it blends with the surrounding colors, without covering any of the original paint which still remains. Al-

INLAY. "Farnese Table" (c. 1565–1573) designed by Jacopo Barozzi da Vignola; inlay of marbles and semiprecious stones. (*The Metropolitan Museum of Art, Purchase, 1958, Dick Fund.*)

though these restored areas are called repaints, repainting is not an accurate term for the procedure.

insect wax. See CHINESE INSECT WAX.

in situ. Term used to describe the creation of a work of art or the construction of an edifice entirely on the site for which it is intended; literally, in place. It also describes the repair or other treatment of a painting while it is hanging on the wall, and the examination of an artifact without removing it from the site where it was found.

inspissated oil. An obsolete term for oil that has been thickened or rendered viscous by any means.

insulating board. A weak, porous variety of WALLBOARD made for insulation and soundproofing. Since insulating boards are necessarily of loose, cellular construction, they have neither the durability nor the structural strength of the denser hardboards, and so are unsuitable for use as supports for permanent painting. Celotex and Masonite Insulation Board are trade names for two insulating boards.

intaglio. 1. Any sculpture in which the areas or lines that form the design, inscription, etc., are incised and lie below the surface, as distinguished from RELIEF sculpture.

2. In the graphic arts, one of the three major categories of printmaking techniques (the others being RELIEF PRINTING and PLANOGRAPHIC PRINTING). It includes all metal-plate engraving and etching processes in which the printing areas are recessed, i.e., line ENGRAVING; ETCHING; DRYPOINT; SOFT-GROUND ETCHING; AQUATINT; CRAYON MANNER; and PHOTOGRAVURE. COLLAGRAPH blocks are also printed as intaglio surfaces. Intaglio plates are printed by inking the plate and then WIPING the plane surface clean, leaving the ink only in the etched or engraved depressions. The ink is then transferred to damp paper by running the plate and the paper through an ETCHING PRESS. Gravure processes are an exception: the proofs are pulled on dry paper, and in rotogravure the plate is wrapped around a cylinder, itself forming part of the gravure press. Intaglio prints are distinguished from those made by a relief printing process, in which the areas of the block or plate that are left

standing in relief are inked with a roller. Although the plate used to make a line or halftone PHOTOENGRAVING resembles the plates used in intaglio processes, the photoengraving plate is printed as a relief block, the etched areas producing the whites in the proof.

intaglio print. See COLLAGRAPH.

intaglio rilevato. Italian for hollow RELIEF.

intarsia. A decorative technique in which small pieces of wood veneer are inlaid in a wood surface; in Italian, *tarsia*. Woods of contrasting colors and grains are used to obtain striking effects. The art of intarsia, a form of MARQUETRY, reached a peak of development during the Renaissance in Italy, when it was used to depict figures and elaborate scenes in deep perspective on paneled walls. See INLAY.

intense blue. A deep variety of INDIGO lake; more recently, an American trade name for PHTHALOCYANINE BLUE.

intense white; intense black. See OPAQUE WHITE.

intermediate. Term used in synthetic organic chemistry for compounds derived from the raw materials of coal-tar distillation and used in various combinations to produce a vast number of synthetic materials for various fields, including pigments, resins, and drugs.

intermediate color. Any of the six colors that are located between the primary and secondary colors in the spectrum as shown on the COLOR CIRCLE.

intermediate varnish. An unspecific term for any varnish or sizing that is applied between two layers of paint. It has been used to denote retouch varnish, ISOLATING VARNISH, and the thin sizing varnishes used between a tempera or casein underpainting and an oil glaze or overpainting to prevent the glaze from being absorbed.

International Institute for the Conservation of Historic and Artistic Works. A society whose members include museum technicians and conservators. It fosters scientific methods of conservation and publishes research data on all areas of its field.

International Style. See GOTHIC.

intimism. A branch of Postimpressionism, characteristically dealing with small domestic subjects such as interiors and garden scenes, treated in such a self-contained way as almost to deny the existence of an outside world. The term is associated with a group of artists called the Nabis, and its principal practitioners were Edouard Vuillard (1868–1940) and Pierre Bonnard (1867–1947).

intonaco. In FRESCO, the final or painting coat of plaster. Typically, the intonaco is composed of five parts of lime putty and seven of sand or MARBLE DUST; it is vigorously troweled and finished with a float. Of the four traditional Italian terms for coats of plaster, intonaco is the only one commonly used in English. The intonaco is laid in sections, called *giornate*, that are small enough to be painted before they dry. See also BROWN COAT; SAND COAT; SCRATCH COAT.

inustion. Obsolete term for the "burning-in" operation in ENCAUSTIC PAINTING.

inv. or **invent.** Abbreviations of the Latin word *invenit,* meaning "he designed it." They are sometimes inscribed in a lower corner of the margin of a print following the name of the artist who did the original drawing or painting from which the print was made. When used in this way, *inv.* and *invent.* are synonymous with either *del.,* the abbreviation of *delineavit* ("he drew it"), or *pinx.,* the abbreviation of *pinxit* ("he painted it"). For explanation of other terms used in marking proofs, see DEL.

invest. In metal casting, to coat or surround with refractory material, as in the LOST-WAX PROCESS, which is sometimes called investment casting.

investment. A containing negative MOLD, used in sculpture for casting metals. In the LOST-WAX PROCESS it consists either of earth clay and sand or of plaster of Paris mixed with such materials as clay, calcined clay, pulverized calcined plaster, pulverized quartz or silex, asbestos fibers, and glue size.

iodine scarlet. Mercuric iodide; a dangerously poisonous inorganic pigment of the most brilliant scarlet hue. It is useless as a paint pigment because it fades to a pale yellow after short exposure to light. Iodine scarlet is also known as brilliant scarlet, pure scarlet, and ROYAL SCARLET, a name shared by a SYNTHETIC ORGANIC PIGMENT.

iodine value or **iodine number.** A laboratory measurement of the unsaturated state of an oil or fat based upon the amount of iodine it can absorb. A proportion is set up of the number of centigrams of iodine absorbed by one gram of the substance being measured. The magnitude of the resultant iodine number, in the case of an oil, is an indication of the oil's excellence as a

FILM-FORMER, i.e., of its ability to form a tough, durable coating. A list of all the vegetable DRYING OILS arranged according to their iodine values shows that linseed oil leads poppyseed, safflower, and walnut oils by a definite margin and is second only to perilla oil, which is unsuitable for permanent painting because of its tendency to darken.

iridescence. A color effect caused by the DIFFRACTION of light rather than by pigmentation; a play of variegated, brilliant, rainbow or spectrum colors, called DIFFRACTION COLORS. Iridescence occurs when light is diffracted from a thin layer that lies between two mediums of different refractive index (e.g., air and water), as in a soap bubble or a thin film of oil on water.

iris green. Another name for SAP GREEN; also, an obsolete color made from the juice of iris flowers.

Irish cross. See CELTIC CROSS.

iron. A metallic element, silver-white in color, which is readily oxidized, or rusted, in damp air. Iron is malleable and ductile, and may be cast or wrought for sculptural purposes. It has a high melting point, as well as low fluidity when in a molten state. Because of this, and because it contracts as it cools, it is more often wrought by sculptors than cast.

iron black. Precipitated metallic antimony; no longer in use as a pigment.

iron blue. Another name for PRUSSIAN BLUE.

iron brown. Another name for PRUSSIAN BROWN.

iron pigments. A general term for the pigments that contain iron. Those in approved use are the iron oxides: Indian red and light red, raw and burnt sienna, ochre, and the Mars colors. Prussian blue, which contains iron, is called iron blue in the pigment trade.

irons. In sculpture, mild steel reinforcements for molds or casts. They are usually wrapped in strips of burlap or jute and saturated with plaster. They are frequently embedded in the final coating of plaster in a negative MOLD in order to strengthen the mold mass and prevent it from breaking as the clay model is removed.

iron yellow. Another name for Mars yellow, one of the MARS PIGMENTS.

irregular curve. See FRENCH CURVE.

isabella. A hue designation for a light brown or drab color. The term is sometimes used disparagingly of any dull or depressing color or color scheme. It is not a specific pigment name.

isinglass. 1. A clean, colorless kind of fish glue made from the sounds (swimming bladders) of fish. The best grade, Russian isinglass, comes from the sturgeon. Isinglass is no longer used to any great extent, having been superseded by gelatin and synthetic materials.
2. Thin, transparent sheets of MICA.

isocephaly. In reliefs, friezes, and other decorative works, the practice of modifying natural proportions in the interest of symmetry, and having the heads of the principal figures (whether mounted or on foot, standing or seated) carved at the same, or nearly the same, level. This practice, universal in Hellenic friezes, is illustrated in the frieze of the Panathenaic procession, from the Parthenon.

isolating varnish. A dilute varnish for spray application in a very thin layer over dry oil paintings in order to prevent the paint from being disturbed or picked up by the solvent action of another coat of paint. A recently dried painting protected by a coat of isolating varnish can be worked over freely and false strokes can be rubbed away continually, because the varnish is made of resins which are insoluble in the oil, turpentine, or mineral spirit used in the overpainting. An isolating varnish containing a vinyl resin that is soluble in alcohol and lacquer solvents is sold with straight acrylic colors.

isomeric colors. Colors that appear identical but have different chemical or physical properties. For example, burnt umber and a mixture of burnt sienna, black, and a touch of green create an exact imitation of the mass tone of burnt umber. See also METAMERISM.

isomers. In chemistry, two or more compounds with molecules identical in kind and number, but which differ in molecular structure and, consequently, in properties.

isometric projection. A projection used in mechanical drawing that avoids the use of foreshortening, since foreshortening necessarily varies the scale of the dimensions of the object drawn. The height, width, and depth of the object are drawn on the same scale at equal angles of 120° with one another. This projection produces an appearance of distortion that is increased as the scale of the drawing is increased, but it is very useful to the craftsman or engineer who needs to see things in their proper proportions. See illustration at PROJECTION.

Istrian marble. A large-grained, buff MARBLE quarried in Istria on the Adriatic Sea and on some of the Dalmatian islands.

Italian blue. Another name for EGYPTIAN BLUE; also known as Venetian blue. Since the term Italian blue is unstandardized, a modern pigment so labeled is likely to be a blue lake or Bremen blue.

Italian earth. An old name for SIENNA.

Italianizers. See ROMANISTS.

Italian ochre. Yellow ochre produced in Italy; also called ROMAN OCHRE.

Italian pink. A name given to various shades of DUTCH PINK.

italic. In calligraphy, a hand that, like the *antiqua* or ROMAN hand, was developed in the 15th century as a result of the Humanist reaction against the medieval GOTHIC hand. It was a cursive script that was adopted at the end of that century as a style of type and was thus standardized. Most type fonts have an italic alphabet in addition to a roman one. Italics slant to the right and are often used in conjunction with a roman alphabet to give emphasis to a word or group of words. See also OBLIQUE. See illustration at TYPOGRAPHY.

ivory. A hard, calcareous substance of which teeth are composed; especially, the tusks of the elephant and certain other large mammals. Ivory is fine-grained, opaque, and a striated creamy white in color. When aged, it may become yellow or brown. Used as a medium for carving since ancient times, ivory is less brittle than bone and takes a high polish. It is easily sawed or filed, but must be carved with very sharp steel tools because of its grain. Its disadvantages are its expense, scarcity, unavailability in large-sized pieces, and tendency to warp. Elephant ivory is especially valued by sculptors for its beauty and homogeneity, and for the size of the tusks, although they have occasionally used the tusks of the walrus, hippopotamus, and narwhal. Modern substitutes are inexpensive, easily-worked plastics made to resemble ivory. See CHRYS-ELEPHANTINE; SCRIMSHAW.

ivory black. A carbon pigment originally made by burning real ivory; now high-grade BONE BLACK. Ivory black, which has good properties for use in oil, is perhaps the most widely used black pigment in the artist's palette. It is sometimes called blue black. Paris black is an inferior grade.

J

jacaranda. A name used to identify a number of unrelated woods, including Brazilian ROSEWOOD and so-called blue ebony.

jacaranta brown. A little-used name for UMBER.

jade. An extremely hard stone, ranging in color from white to deep green. There are two distinct mineral forms of jade—nephrite (or greenstone) and jadeite. It is difficult to carve, but is used, especially in the Orient, for intricate and delicate work.

japan. 1. A type of clear varnish that is mixed with paints and oil colors to impart gloss and hasten drying. Such varnishes are used in decorative work, as on painted tinware, but they are too brittle for use in creative painting.
2. An inexpensive decorative enamel, which almost always contains asphalt and therefore is usually black or transparent, brownish black; called also japan black or black japan. Both air-drying and baked forms of this enamel were once widely used for black japanned tinware and ironware.
3. A type of paint, also called japan color, composed of pigment ground in an oil-free resin varnish, which dries quickly to a mat or lusterless finish. Japan colors are used in sign painting

and decorative work and are usually protected with a coat of durable varnish.
4. Japan drier a liquid solution of a strong drier, usually with resin, used in sign painting and industrial coatings. None of these products are intended to be used in permanent painting.

Japan earth. Another name for CUTCH.

Japanese lacquer. See LACQUER, ORIENTAL.

Japan wax. A wax obtained from a species of sumac tree as a by-product of lacquer manufacture in India and China. It is a soft, yellowish wax with adhesive properties. It has a melting range of 50–52° C. but, when recently solidified, is likely to have an erratically lower melting point for some time. It is used in the manufacture of pharmaceuticals and cosmetics such as lipstick, among other industrial purposes, and is used in the arts as an ingredient in wax compounds to impart adhesive properties to the mixture. Japan wax is sometimes called vegetable wax, Japan tallow, or sumac wax.

Japonism or Japanism. The influence of Japanese art on Western art and decoration following the opening

of Japan to the western world by Commodore Perry in 1854, and extending into the early 20th century. Japonaiserie (work done in the Japanese manner) superseded CHINOISERIE as a motif in furniture and the decorative arts. In the major arts of painting and graphics, the Impressionists and Postimpressionists owed something to its influence.

jasper. A compact, opaque type of impure quartz. It may be yellow, brown, or dark green, and occasionally black or blue.

jasper ware. A ceramic ware developed in England in 1774 by Josiah Wedgwood that became popular for bas reliefs and cameos. Most jasper ware is ornamented in the Neoclassical style in white relief on a colored ground, especially blue and sage green, but also olive green, black, yellow, pink, and lilac. It is also made in pure white. Wedgwood's masterpiece in jasper ware is his reproduction of the Portland Vase, a cameo glass vase with figures from classical myths in white on a blue ground. The original was Roman, and is believed to date from about the 1st century A.D.

jaune brillant. An unstandardized French term for several pigments, including NAPLES YELLOW and cadmium yellow (see CADMIUM RED).

Javelle water. A dilute bleaching solution that was once widely used. It was made from either sodium hypochlorite or potassium hypochlorite. The solution of sodium hypochlorite was also known as *eau de Labarraque,* while Javelle water was often called by its French name, *eau de Javelle.* Nowadays ordinary bleaching powder (calcium hypochlorite) or the strong solution, Clorox, is universally used by conservators for bleaching prints.

Jean Cousin. A red ceramic color (trioxide of iron) used in the 15th and early 16th centuries to color STAINED GLASS in local areas. Together with the older GRISAILLE and SILVER STAIN, it was the only material used to alter the color of parts of single pieces of glass until the invention of vitreous ENAMELS for this purpose in the 16th century.

jequitiba. See MAHOGANY.

Jerusalem cross. See POTENT CROSS.

jet. In painting, a hue designation for an intense black, named after the highly polished mineral of that name.

jewel point. A diamond or ruby point mounted in a handle, used in DRYPOINT to incise the plate. Curved lines can be drawn with greater facility with a jewel point than with a steel NEEDLE. A jewel point also functions as a glass cutter.

jomon ware. The earliest Japanese pottery, dating from 7000 B.C. The wares were formed by the COIL METHOD and baked in open fires.

journeyman. A skilled worker who has served his apprenticeship in an art or manual craft and is qualified to work under a master artist or master craftsman.

Judas hair. Bright-colored or pronounced red hair in paintings. So called because early painters conventionally gave this color hair to representations of Judas.

Jugendstil. German term for ART NOUVEAU, from the magazine *Die Jugend,* meaning "youth."

Jura turpentine. An oleoresin or BALSAM obtained from the red pine of

the Vosges mountains in France. It is not available in the United States.

jute canvas. A canvas or burlap with a coarse, square weave that makes it attractive to painters. But jute, an East Indian fiber, turns dark and becomes weak and extremely brittle with age, and is therefore unsuitable for use as a support for permanent painting.

juxtaposition of colors. See OPTICAL MIXTURE.

K

kalsomine. See CALCIMINE.

kane stone. Infrequently used alternate spelling of CAEN STONE.

kantharos. See CANTHARUS.

kaolin. The whitest and purest variety of CHINA CLAY; originally found in Kao-ling, Kiangsi province, China.

karaya. See GUM KARAYA.

Kassler yellow. Another name for TURNER'S YELLOW.

katechu. Another name for CUTCH.

kauri. A resin, either fossil or recent, produced by Australian trees of the genus *Agathis*, especially *A. australis.* Kauri is dark brown and has a pleasant odor. It was widely used in the early 20th century to make top-quality, hard-wearing floor and furniture varnishes of brilliant finish, but it has been replaced by the synthetic resins. The fossil deposits were depleted and the growing trees became scarce before 1930, so that the resin is no longer readily available in large amounts. It has also been known as kauri copal, but this is a misnomer, for its properties are distinctly different from those of the copals.

Keene cement or **Keene's cement.** A very hard plaster used for patching walls and other surfaces that are exposed to much wear. It consists of dead-burnt gypsum with additives of alum and other salts, and was invented by Richard W. Keene in England during the 19th century. It is used in fresco and by sculptors for modeling and repair.

kelebe. See KRATER.

kermes. A red NATURAL DYESTUFF obtained from an insect found on the kermes oak (*Quercus coccifera*), which grows in the Mediterranean area. Generally held to be the first natural coloring matter for which a standard production technique was developed, kermes was in ancient times the most important red for dyeing fabrics and

for making lakes. In the medieval period kermes was surpassed in Europe by lac from India, in the 16th century by materials from the New World like cochineal and Brazil wood, and in later times by madder. Although kermes and cochineal have the same chemical components, CRIMSON LAKE made from kermes is much inferior to carmine, the lake made from cochineal. The name kermes is Persian, and the English word crimson derives from it; the old English name for kermes is grain, from the Latin *grana*.

kernel black. A variety of VINE BLACK made by burning peach kernels or similar material.

kerosene. The least volatile and expensive of the solvents distilled from petroleum. It is intended primarily as a fuel, and makes an ineffective paint thinner, drying with extreme slowness and leaving a lingering odor and an oily residue.

kettle-boiled oil. See BOILED OIL.

key. 1. In painting, the prevailing range of color VALUES and tonal quality. A painting in a high key is dominated by light, bright, or pale colors, while one in a low key is dark or subdued.

2. A thin, triangular wooden wedge hammered into the slot at an inner corner of a STRETCHER in order to tighten the canvas by expanding the stretcher.

3. One of the protuberances that act as registers on some molds, by fitting into corresponding holes in the other half of the mold; a similar projection employed in carpentry on wood joints. See also NATCH.

4. Roughness or interstices in a surface, whose function is to strengthen the bond or anchorage of a material laid over it. Brick and stone walls may be hacked or scored before plaster is applied to them; the spaces between laths serve the same purpose; and in some jewelry techniques, metal is scored with a graver to receive enamel.

key block; key plate; keystone. In multicolor woodcuts (key block), aquatints and mezzotints (key plate), and lithographs (keystone), the "template" block, plate, or stone from which is made each separate printing surface for each color run (see COLOR PRINT). The key block, plate, or stone contains the complete drawing, incised, etched, or drawn with tusche or lithocrayon as though made for a final black-and-white print but sometimes done in outline rather than complete detail. From this key drawing each partial drawing for each basic color to be printed is copied on a separate plate, block, or stone. REGISTER MARKS on the master block, plate, or stone are duplicated on the separate-color printing surfaces so that when all the blocks, plates, or stones are printed on a single sheet their impressions will be in REGISTER. See illustration at CHIAROSCURO WOODCUT.

kiathos. A teacup-shaped ancient Greek vessel for pouring. See VASE SHAPES for illustration.

kickwheel. A POTTER'S WHEEL operated by a pedal or by simply kicking at a weighted wheel at the bottom of a vertical shaft.

kidney. In ceramics, a rubber tool shaped like the profile of that organ. It is used for smoothing plastic clay surfaces. Sometimes it is made of spring steel and can be used for scraping clay.

kieselguhr. Another name for DIATOMACEOUS EARTH.

KICKWHEEL. (*Courtesy of Paul Soldner, Aspen, Colo.*)

killed plaster. CASTING PLASTER used to STOP holes and to smooth irregularities on fresh plaster casts. It is made by stirring the gauged mix until it is on the verge of setting, and is then applied with the fingers. It dries to the same hardness, absorbency, and white color as the plaster body.

kiln. A furnace used for FIRING ceramic wares and sculpture and for fusing enamels onto metal surfaces. Kilns are lined with brick or stone, come in a large variety of sizes depending on the use for which they are intended, and may run on gas, oil, or electricity. It is easier to regulate the temperature of an electric kiln than of a gas or oil kiln, but some potters and sculptors feel that an electric kiln heats up too quickly. Heat inside a kiln is measured by means of a PYROMETER or by PYROMETRIC CONES observed through a peephole. See SAGGER; MUFFLE.

kiln-dried wood. Wood that has been artificially seasoned by being heated in a kiln or oven. Wood for carving should be well dried and seasoned if it is not to split and crack as it dries and shrinks. Since natural seasoning is extremely time-consuming, hot-air or kiln seasoning is used commercially and by sculptors to dry and stabilize the wood. Kiln-dried wood is inferior to naturally seasoned wood in that it tends to re-absorb moisture from the atmosphere.

kinetic art. A general term for all artistic constructions that include moving elements, whether actuated by motor, by hand crank, or by natural forces as in MOBILES.

king's blue. A name formerly given to the obsolete pigment SMALT; now sometimes applied to COBALT BLUE.

King's yellow. A fine grade of ORPIMENT formerly prepared for artists' use.

kingwood. A hardwood (from a South American tree, *Dalbergia cearensis*), of a dark violet-brown color, sometimes almost black, streaked with golden and light-yellow markings. It may be polished to a bright luster. Available in logs 6 to 8 inches in diameter, it is used principally for veneer. Kingwood is related to the rosewoods, which are also of the genus *Dalbergia*.

kit cat. See CANVAS SIZES, PORTRAIT.

kitsch. A blatantly sentimental, slick, or pretentious artistic production or design. Kitsch, usually of low quality and sometimes mass produced, is intended to appeal to popular tastes.

knife, gilder's. See GILDER'S KNIFE.

knife-file. A thin, tapered file, wedge-shaped in cross-section, whose thin side resembles a knife edge.

knop. In metalware, glassware, and ceramics, a small decorative knob or protuberance that may also aid in grasping a utensil, as a knob in the stem of a goblet or chalice or on the shaft of a candlestick; also, a FINIAL.

koa. A very light but durable hardwood suitable for carving, obtained from the Hawaiian tree *Acacia koa*. It may be red or brown in color, depending on the age of the tree.

kolinsky. The red Tartar marten or Siberian mink, native to Siberia and Manchuria. Brushes made from kolinsky hair are called red sable brushes (see BRUSH, RED SABLE).

Kordofan gum. See GUM ARABIC.

krater or **crater.** A rather large, wide-mouthed ancient Greek jug in which wine was mixed with water. Kraters were made in a great variety of shapes. The calyx and bell kraters are named for the respective shapes of their bowls; other types vary from a simple bowl to a rather tall jug with a single tubular foot. A usually ovoid krater with handles joining the shoulders to extensions of the lip is known as a kelebe. Kraters of several shapes often have columnar or volute handles; on others the handles are horizontal. See VASE SHAPES for illustrations of some characteristic forms.

Kremnitz white or **Krems white.** Other names for CREMNITZ WHITE.

kylix or **cylix.** In ancient Greek pottery, a drinking cup with a broad shallow bowl and two short handles affixed horizontally near the edge of the cup. Early examples have a low, round foot or base, while the later ones have a high, stemlike foot. To modern eyes the kylix seems a footed bowl rather than a cup; it has long been a popular model for such pieces as footed fruit bowls and shallow compote dishes. See illustration at VASE SHAPES.

L

labarum. See CHI-RHO.

lac. A resin of insect origin, collected in India from twigs of several species of tree of the acacia family. Lac is secreted as a kind of protective scale about the bodies of the insects (*Coccus lacca*), which attach themselves to the twigs to feed on sap and to complete their life cycle. The crude resin, called stick lac, consists of twigs encrusted with the excretion and the insects' remains; it is processed in several steps to produce SHELLAC. The first step produces a granulated substance called seed lac or grain lac. This is melted to form thin sheets of garnet lac, which are broken into pieces. Further refinement produces button-shaped pieces known as button lac and an elongated form called tongue lac. The most refined form, shellac or orange shellac, is in flakes; it is free of impurities and has lost the greater part of its original ruby color. Orange shellac may be further refined by a chemi-

cal bleaching process to produce the grade called bleached white shellac, in small pieces that look like molasses candy. Alcohol solutions of both orange shellac and bleached white shellac are widely used as varnishes.

The blood-red dye obtained from lac was formerly the most valuable product of the refining process. It has been used as a dyestuff since very ancient times and was the dye used in the pigment Indian lake. The word "lac" (as well as the color term "lake") is derived from the Sanskrit *laksa* (Hindi *lakh*), "a hundred thousand"; one of the host trees is referred to in Sanskrit writings as "Lakshatarn, the tree which nourishes a hundred thousand insects."

lacewood or **silky oak.** A wood with a distinctive, lacy figure, from the Australian and European tree *Cardwellia sublimis.* Lacewood is pink with a silver sheen, and is used for veneer. It comes in huge logs up to 40 inches in diameter and is also available in planks.

lacquer. 1. A natural resin, the exudation of trees grown in several countries of the Far East; see LACQUER, ORIENTAL.

2. Any of various clear or pigmented industrial coatings that are constituted principally of a cellulose derivative (such as CELLULOSE NITRATE) and that dry quickly by evaporation of their volatile solvents. Lacquer films are glossy, hard, and resistant to wear and weathering. Pigmented lacquers are sometimes called lacquer enamels. Because of their ease of application (most are designed for use in sprays), rapid rate of drying, and their tough films, lacquers are used as finishes for a great number of assembly-line products, especially automobiles. The most prominent trade name in industrial lacquers is Duco. In the

1930's, after the introduction of modern lacquers, made more durable by the use of alkyd resins (and, later, acrylics), several prominent and many lesser artists began painting with car lacquers. Their use in the fine arts, however, is condemned by all specialists in artists' materials. All lacquers are diluted with powerful LACQUER SOLVENTS, which emit toxic fumes, and their films start to disintegrate after 12 to 15 years' exposure to the ultraviolet in daylight.

lacquer, Oriental. The term lacquer, now applied to modern cellulosic coating materials, originally referred to a resinous product obtained from a tree (*Rhus vernicifera*) native to China, cultivated in Japan as far back as the 6th century and used in China, Japan, Ceylon, Burma, and other southeast Asian lands. None of the Oriental lacquers are exported, but are used locally to make clear and pigmented coatings for use on furniture, bowls, dishes, and other small articles. Lacquer is also built up into solidified forms through the application of a series of thick coatings around a base material, then carved into artistic works known simply as lacquers. The films of Oriental lacquers are hard, tough, and permanent. The fluid material has toxic and irritant properties similar to those of poison ivy.

lacquer solvent. Any volatile solvent which can be used to dissolve or dilute cellulose lacquer. Most lacquer solvents have a very high rate of evaporation and many have toxic or obnoxious fumes or residual odors. The milder ones, however, are occasionally used by artists as paint removers and for other special purposes. A liquid commercially labeled "lacquer solvent" is a blend of several of these fluids, which include ACETONE; ETHYL ACETATE; BANANA OIL.

lacuna. An area of a painting, manuscript, or other work of art that is missing completely as a result of any form of damage to the work. The word lacuna is Latin for gap; the plural, lacunae, is frequently used.

lagynos. A type of ancient Greek jar that is wide in its lower half, narrow in its upper half. See VASE SHAPES for illustration.

laid paper. Any paper that has a type of WATERMARK which covers the whole sheet and consists of closely spaced parallel lines in one direction and heavier, more widely spaced lines perpendicular to them; these are the wire-marks of the screen from the roll or mold on which the paper is made. Paper that is not laid is called wove; a wove finish is produced on a screen so tightly meshed that the wire-marks are not visible.

laitance. A gelatinous material that sometimes exudes from a Portland cement wall; it must be removed by hacking or with a wire brush in preparing the wall for painting or plastering.

lake. A pigment made by precipitating or developing a dyestuff on an inert pigment with the assistance of chemicals and other manufacturing aids, by a process comparable to the dyeing of textiles. All of the older pigments made by this method are still called lakes, but few of the SYNTHETIC ORGANIC PIGMENTS developed in the last forty years use the name, even though some fit the above definition. The inert pigment in a lake is called its base; alumina hydrate is the standard base for transparent lakes, blanc fixe for those in which opacity is desired. Clay, chalk, gypsum, white earth, green earth, and various chromatic pigments have all been used as lake bases at one time or another. The permanence or color stability of a lake is a function of the permanence of the dye used. All lakes made from natural dyestuffs (except madder lake) are insufficiently permanent for artists' paints. Similarly, most of the early lakes made from synthetic organic dyes are not sufficiently nonbleeding for use in oil colors, even though the lightfastness of some of them has been increased in recent decades by the molybdic and phosphotungstic processing methods. Most modern synthetic organic pigments of good permanence—such as alizarin crimson, Hansa yellow, phthalocyanine blue, phthalocyanine green, and quinacridone red—are not lakes; they are insoluble compounds usable directly as pigments.

The word lake may come from the Italian "lacca," a term used by medieval Italian dyers for the scum that they removed from their dye vats and sold to painters, frequently with the addition of a little inert powder to increase the yield. The Italian term is related to "lac," which derives through Persian from the Sanskrit "lākṣā." Lake making goes back to the ancient Egyptians and Greeks; Roman recipes still survive for making paint pigments from such natural dyestuffs as kermes and Tyrian purple. 17th- and 18th-century writers frequently used the term "lake" to mean transparent red lake, without specifying whether CRIMSON LAKE, CARMINE lake, or LAC lake was meant.

lake base. The BASE, or inert pigment, used in making lakes.

lamination. The process of building up a material in layers, usually for increased thickness and strength. Laminated materials in general are much more sturdy for their weight than solid pieces of the same material. Plywood is a commonly used laminate. Trade names for laminated phenolic resin

sheets are Formica and Micarta. In sculpture, polymer resins are used in lamination; a layer of neat resin is followed by two or more layers of FIBER GLASS impregnated with more resin.

lampblack. A pure CARBON PIGMENT made by burning oils and collecting the soot from flues. An extremely light, fluffy powder, it is used in all techniques of permanent painting. One of the oldest manufactured pigments, lampblack was used in the earliest civilizations. Oil black is a seldom-used name. FLAME BLACK is an impure variety.

lancewood. Any of several elastic woods used in making bows, fishing rods, tool handles, and other objects of similar shape and function, and sometimes used for carving. Among the woods known by this name are the wood of *Oxandra lanceolata,* DEGAME, and beefwood (from trees of the genus *Mimusops*), which is also known as red lancewood.

land plaster. An old name for GYPSUM.

landscape. A painting, drawing, or other depiction of natural scenery. Although figures and man-made objects may be included in a landscape, they are of secondary importance to the composition and incidental to the content. Prior to the 17th century few artists painted or drew a landscape for its own sake; natural scenes were depicted merely as adjuncts to or backgrounds for figures and events. Landscape's first full flowering as a separate genre occurs in the works of such 17th-century Dutch painters as Ruysdael and Hobbema. 18th- and 19th-century England enjoyed another heyday of landscape under such painters as Gainsborough, Turner, and Constable. It continues to be a popular genre

today. The French word for landscape, *paysage,* also designates a series of French canvas sizes (see CANVAS SIZES, FRENCH). See also CANVAS SIZES, LANDSCAPE.

landscape marble. See FOREST MARBLE.

Languedoc marble. A bright-red MARBLE with white blotches, quarried in the French Pyrenees. It is sometimes called French Red, as is GRIOTTE, which it resembles.

lapis lazuli. A semiprecious blue stone used for jewelry and small carvings; the raw material from which the original ULTRAMARINE BLUE pigment was prepared. Lapis occurs in Chile and various other parts of the world; a very fine quality has been imported to Europe from Afghanistan since medieval times.

lard stone. See STEATITE.

latex. 1. A viscous, milky-white fluid composed of RESINS or waxes in the form of tiny globules in aqueous suspension, and occurring in rubber trees, milkweed, and other plants; specifically, rubber latex.

2. Any milk-white water dispersion or emulsion of a synthetic resin obtained by polymerization, such as polymer medium, so-called for its resemblance to rubber latex. The term is used to designate house paints made with such vehicles.

Latin cross. Cross in which the arms intersect the upright shaft above the middle. This cross, the crux immissa of the Romans, is traditionally shown in art as the cross used in the crucifixion of Jesus, although the tau cross occasionally appears in crucifixion scenes. The Romans also used the St. Andrew's and tau crosses in executions.

The Latin cross on a three-stepped platform is known as the Calvary cross. See CROSS for illustration.

laurel. 1. A dark reddish-brown East Indian wood with a wavy grain, strong and elastic. It comes in logs as large as 30 inches in diameter and up to 17 feet in length.

2. California laurel or baytree (*Umbellularia californica*), from the west coast of the U.S., which produces a hard, strong wood used for veneer; it is golden brown and yellowish green, sometimes with dark purple blotches.

3. A tropical American wood from the tree *Cordia alliodora;* also called tepesuchil, palmwood, or bonyon. Used in cabinetwork, it resembles American walnut in color and density, and has a uniform texture.

lavender, oil of. See OIL OF LAVENDER.

lawn. A fine sieve used for screening ceramic glazes; also, to strain through such a sieve. Originally made of fine cloth, the lawn may also be of brass or copper mesh. Lawns are made in several degrees of coarseness.

lay figure. A manikin of average human proportions, jointed so that it can be made to assume any desired pose and serves as a substitute for a live model. The best lay figures are carefully made of wood with all joints articulated, even the knuckles, although cheaper and simpler models are more generally available. They range from life size to less than a foot in height; animal fig-

LAY FIGURE

ures, especially horses, have also been made. The artist may drape a lay figure by dipping a piece of muslin or other thin cloth in a glue or weak shellac solution and molding it into the desired shape while wet; such drapery will hold its folds through any number of sittings.

lazuline blue. An old name for genuine ULTRAMARINE BLUE made from lapis lazuli.

lead. A very heavy, soft metallic element. It is bluish in color, but tarnishes to a dull gray. Lead is malleable, ductile, and easily fused; it melts at 620° F. In the fine arts, it is used for making pigments, e.g., WHITE LEAD, LITHARGE, and ORANGE MINERAL; as a valuable constituent of alloys; and as a component of pottery glazes. It has been used as a casting material—Greek statuettes were occasionally made from lead—but its use has declined over the centuries, although it is still common in architectural and garden sculpture. Cast lead tends to shrink as it cools, a characteristic which is less noticeable in small casts, which cool and solidify quickly. Lead may also be wrought, or hammered into form.

lead, white. See WHITE LEAD.

lead pencil. A writing or drawing tool of GRAPHITE, China clay, and a binder, molded or extruded into thin rods and encased either in lacquered red cedar or in a mechanical pencil holder. The lead pencil was given its name because the prevalent 19th-century name for graphite was black lead. Drawing with rods of real lead would be called lead point (see SILVER POINT). Since the introduction of the modern lead pencil in 1795, methods of production and the quality and uniformity of the materials used, not the least important of which is the wood,

have been refined to produce a superior product.

Drawing pencils are normally available in 17 grades of hardness, depending upon the proportions of pure graphite, clay, and binder used. 9H contains the most clay and is the hardest, and 6B, which contains practically no clay, is the softest; between H and B are two medium grades, HB and the slightly softer F. Some manufacturers are now making drawing pencils in an even wider range of degrees of hardness. Standard writing pencils are usually graded numerically, from soft to hard, by the degrees 1, 2, 2½, 3, and 4. The diameter of harder leads is comparatively smaller than the softer leads, since hard leads are stronger and require less bulk. The diameter of the leads in the softer degrees (usually HB to 6B) increases progressively. The very soft, fat leads are particularly suited for sketching. The size of leads made for mechanical pencil holders usually varies somewhat less throughout the range of degrees so that all the degrees may be used in the same adjustable holder. Both adjustable (or adaptable) lead holders and holders specialized for certain diameters of lead are available.

leaf. Metal beaten or rolled out to extreme thinness for use in GILDING. The kinds of leaf commercially available are GOLD LEAF, SILVER LEAF, and PALLADIUM LEAF; ALUMINUM LEAF and DUTCH METAL are also used, but for less exacting purposes. Gilding with precious-metal leaf usually requires three special pieces of equipment, a GILDER'S CUSHION, a GILDER'S KNIFE, and a GILDER'S TIP.

leaf green. A term applied to various shades, usually middle shades, of CHROME GREEN.

lean. In oil painting, a term describing a paint with a relatively low oil content, or a ground such as GESSO that contains little or no oil. See FAT OVER LEAN.

leather-hard. In ceramics, a term describing clay that has dried to the limit of its shrinkage but still has enough moisture to retain its original wet color. At this stage the clay body can be handled, trimmed, and carved without becoming misshapen, for it is no longer in the plastic state.

lecithin. A lipoid, or fatlike, substance that is found in egg yolk and other animal and vegetable matter. It has been called nature's emulsifier, as it is one of the most effective materials assisting in the formation and stabilization of emulsions.

lecythus or **lekythos.** In ancient Greek pottery, a slender, cylindrical jug, tapering to a disk foot. It has a narrow, rather long neck with a flaring spout; its handle springs from its shoulder and curves in to the neck. Later forms were squatter. The lecythus was used for oils and perfumes and often included among grave offerings. See illustration at VASE SHAPES.

ledger paper. A strong, durable, smooth, and rather heavy writing and drawing paper, now made in many grades. It was originally used for handwritten records and documents. Provided it is of rag composition, it is suitable for pen-and-wash drawings and other work where a pronounced texture is not desired.

leek green. A hue designation for a rather yellowish medium-green; also, the name of a CHROME-GREEN pigment of that shade.

legitimate construction. The strict application of the rules of LINEAR PERSPECTIVE. The composition is arranged

as far as possible so that objects depicted will appear parallel to the PICTURE PLANE (see PARALLEL PERSPECTIVE), and the apportionment of the picture's area among the three ZONES OF RECESSION is determined mathematically rather than by free choice. This strict delineation of the zones of recession and the predominantly parallel ordering of the composition tend to break it up into planes. Thus, although the system of legitimate construction was devised to portray recession accurately and naturally, the end effect of this system, when rigidly adhered to, is more stilted than the freer schemes of recession subsequently practiced. This can be readily seen in the work of Rembrandt, a "borderline" artist between the Renaissance and Baroque styles. His earlier paintings, which adhere fairly closely to the conventions of legitimate construction, are more stilted in their representation of perspective than his later works, which depart somewhat from the rules. Perhaps the most frequent liberty taken by an artist whose work otherwise closely follows linear perspective is a shortening of the foreground.

The term legitimate construction is a translation of the Italian *costruzione legittima,* used by Renaissance writers to describe the rigid system of geometrical perspective developed notably in the writings of Filippo Brunelleschi (1377–1446) and in Leone Battista Alberti's treatise *Della Pittura* (1432). The Italian word *legittima* carries with it some of the meaning of the Latin root *lex, legis* that is lost in the English word legitimate; the original term implies construction according to the laws or rules.

Leipzig yellow. Another name for CHROME YELLOW.

Leithner blue. An early variety of COBALT BLUE. First made by Joseph Leithner in Vienna (1795), it was superseded by Thénard's blue.

lekythos. See LECYTHUS.

Lemnian ruddle. A variety of RUDDLE mined on the Aegean island of Lemnos.

lemonwood. See DEGAME.

lemon yellow. Another name for BARIUM YELLOW; also a general hue designation for any pale lemon-yellow pigment, as distinguished from medium or deep (golden) yellows. Like primrose yellow, lemon yellow is a "fancy" name that contributed to confusion in pigment nomenclature but has now been controlled by the PAINT STANDARD, which permits it to accompany the pigment's true name. In Britain lemon yellow is the standard term for barium yellow.

Lepanto marble. Trade name for a SHELL MARBLE, gray with white and pink markings caused by embedded fossils. It is quarried near Plattsburg, New York.

let-down pigments. Another name for REDUCED pigments. In the field of ILLUSTRATION, the term let-down is sometimes used to mean undertone.

lettering brush or **show card brush.** A long, flat brush with a wide, straight-cut edge, and made either of red sable or camel hair set in a metal ferrule or in

LETTERING BRUSH

a quill (see QUILL BRUSHES; LETTERING QUILLS). Such a brush is used to make clean, precise lines and for lettering. A lettering brush half the width of any of the standard sizes is called a RIGGER.

Other brushes that may serve the same purposes as lettering brushes are CHISEL BRUSHES; LINERS AND STRIPERS; SINGLE STROKE BRUSHES; and SIGN WRITER'S CUTTERS.

lettering pen. A pen holder, usually made of a lightweight wood, into which specially shaped metal points can be fitted. These interchangeable nibs are available in a great number of styles, from extremely broad and flat to

LETTERING PENS. An assortment of Speedball nibs.

very narrow and pointed. Some are shaped particularly for facility in writing special calligraphic hands or for making serifs and flourishes on letters. All lettering pens must be dipped, and most are constructed to take up and hold a small supply of ink either between the two layers of those pen points that have a kind of double blade construction or in the well that is made by an S-shaped piece of metal fitted into the nib.

lettering quill. A brush of CAMEL HAIR, long and with a straight, square edge and bound with wire in a natural quill. Lettering quills are made in many sizes and are used for lettering and decorating on glass, metal, and other smooth surfaces with oils, japans, enamels, and gold size.

letterpress. Commercial RELIEF PRINTING with movable type and with line and halftone cuts made by PHOTO-ENGRAVING. Practically all newspapers and most books and magazines are printed by letterpress. In Great Britain the term letterpress is also used to indicate text, as opposed to illustrations.

letterwood. See SNAKEWOOD.

leveling. The property whereby fluid coating materials flow out to form a smooth surface and dry free from brushmarks. STAND OIL is notable for its leveling property, which it imparts to oil paints, mediums, and varnishes made with it. A smooth surface is desirable in some oil painting styles, but the textural effects of brushstrokes are more frequently preferred.

levigation. 1. The process of grinding a material in a wet state, as in the preparation of paint pigments or the processing of clay for use in ceramics; also, the separation by sedimentation of fine particles from a coarse material suspended in a liquid. In purifying and grading bulk materials such as clay or whiting, the wet material is run or pumped with added water into settling tanks, where the heavier, coarser particles settle much more rapidly than the finer particles and are separated out. The term levigation is sometimes used for the entire process of grinding, settling, and separation into grades of fineness, as in the production of WHITING and SLIP CLAY.
2. The wet grinding of a surface to make it smooth or to produce on it a desired texture, as in the graining of a LITHOGRAPH STONE.

levigator. A hand tool for grinding a flat surface with powdered abrasive and water, such as the heavy steel disk used in graining a LITHOGRAPH STONE. See illustration on next page.

LEVIGATOR. Cast-iron levigator used in grinding a lithograph stone. (*Courtesy, Rembrandt Graphic Arts Co.*)

This disk has an off-center handle by means of which it can be revolved on the stone, grinding the surface with an abrasive (such as Carborundum) and water. It may also have wells, with openings at the bottom, by means of which the abrasive and water are fed onto the surface of the stone.

Leyden blue. An early name for CO-BALT BLUE.

library paste. A ready-for-use white paste, sold in jars. Usually made from dextrin, it does not stain paper, and is generally accepted as a product of good quality for permanent application.

life drawing. Drawing the human figure from a living model. Life drawing and other stylistic exercises such as DRAWING FROM NATURE and DRAWING FROM THE ANTIQUE OR FROM CAST were in the past always part of an artist's academic training. See also ACADEMY FIGURE.

life mask or **life cast.** An impression of the face of a living person. The technique for making a life mask was probably developed during medieval times and practiced during the Renaissance. Cennino Cennini, writing in the 15th century, gives detailed directions for greasing the subject's face, inserting a double-stemmed breathing tube in his nostrils, and applying plaster to form a mold from which a cast may be made. He also gives directions for casting the whole nude body by building a wooden form around the subject. Life casts are seldom attempted today, although some experiments with modern synthetic resins and plastics have been reported. See also DEATH MASK.

life-size. In figure sculpture, of the same size as the actual model. Life-size statues are smaller than HEROIC and COLOSSAL figures.

lifting. In painting, the technique of creating a special textural effect resembling that of the DRAGGING STROKE. A sheet of cloth or paper is laid on the surface of wet paint, rubbed lightly, and lifted away, taking splotches of paint with it and thus altering the surface. The MONOTYPE necessarily has much of this lifted quality. See also DECALCOMANIA.

light. In painting, drawing, and the graphic arts, an area or point of high VALUE in a picture as distinguished from the low and middle values that ordinarily comprise most of its area. See HIGHLIGHT.

lightfastness. COLOR STABILITY or the ability of a substance to withstand exposure to daylight without fading or changing color. Truly lightfast pigments are not affected by daylight un-

der the indoor conditions in which a work of art is normally exposed. The label "lightfast" on industrial paint and printing-ink pigments, however, merely indicates that these have a degree of color stability sufficient for the purposes for which they were designed.

lightness. See VALUE.

light red. This permanent pigment composed of 99% iron (ferric) oxide is a FURNACE PRODUCT made from steel-mill wastes. Light red has a bright, scarlet top tone, and when mixed with whites yields salmon pinks, as distinguished from the bluish mass tone and rose pinks of Indian red, the other type of pure iron oxide pigment. However, compared with brilliant red pigments like the cadmium reds and alizarin crimson, all the iron oxides would be referred to as brick reds. Light red and Indian red, which are solidly opaque and have great tinting strength and hiding power, have entirely replaced their native-earth counterparts on the artist's palette. In the U.S. light red was formerly called English red. Other names no longer in use are Prussian red, colcothar, morelle salt, and the unstandardized Persian red. Light red is also known as Antwerp red; both light red and Indian red are also called red oxides.

lignum vitae. The heaviest, hardest, and most dense of the commercially available woods. Although it is difficult to carve, some sculptors value it for the rugged, stone-like effects that can be created with it. Its color varies from a light olive-green to a blackish brown. Its grain is uniform and fine, and it rubs up to a high natural polish. Its logs run from 3 to 24 inches in diameter and from 2 to 10 feet in length. The tree (*Guaiacum officinale*)

is native to the West Indies, Central America, and northern South America.

lime. Calcium oxide, made by calcining or roasting native calcium carbonate with wood in a simple brick kiln. Calcium carbonate occurs plentifully in the form of limestone, marble, chalk, oyster shells, etc. Lime is an active, caustic alkali; when it is mixed with water, there is a violent reaction, generating much heat and forming calcium hydroxide or slaked lime. Slaked lime, mixed with just enough water to make a soft paste (lime putty), is mixed with sand to form MORTAR, which is used by plasterers to make walls and stucco, as well as by bricklayers. When the mortar dries, the particles of lime adhere very strongly to each other; the sand in the mortar stabilizes it by creating a constant volume below which the drying lime cannot shrink. When all the water has evaporated, the calcium hydroxide or slaked lime begins to be converted to calcium carbonate by reacting with carbon dioxide in the atmosphere. Eventually it becomes solid calcium carbonate, chemically the same as the original limestone or marble. Carbonation below the surface proceeds very slowly; it may take years to be complete. A solution of lime is called limewater; it is invariably a dilute solution, as lime is one of those rare substances that dissolve better in cold than in hot water. Lime in lump or powder form is sometimes called quicklime, to distinguish it from slaked lime.

lime blue. A variety of BREMEN BLUE in which slaked lime replaces salt in the manufacturing process. Used as a limeproof color during the 19th century, lime blue has since been almost entirely replaced by synthetic organic pigments. Neuwied blue is lime blue sold in DROP PIGMENT form. Variants of lime blue were also sold in the 19th

century under the name MOUNTAIN BLUE.

limeproof pigments. Pigments that maintain their color stability in contact with alkaline substances. Limeproof pigments are suitable for use in FRESCO painting and in colored-cement work.

lime putty. Lime that has been slaked with water and aged; a soft, plastic paste that is mixed with sand or marble dust to make the several types of mortar used in the plaster support of a painting in FRESCO. The lime used in fresco plastering must be pure or RICH LIME, and the putty must be aged for at least six months. Seemingly there is no limit to the improvement in plasticity and freedom from defects (such as POPPING) that is afforded by prolonged aging. Since the Renaissance, Italian painters have aged their slaked lime in casks stored in pits dug below the frost line; such hoards are said to have been handed down through several generations. Aged lime putty is carried in stock by some building-supply firms, chiefly for use in ornamental plasters, but it is becoming increasingly more scarce as the calls for plastering of high craftsmanship decrease.

limestone. A crystalline stone, usually granular in appearance, composed chiefly of calcium carbonate. It is of the same composition and sedimentary origin as MARBLE, which is actually a metamorphic form of limestone. Limestone is softer, more easily worked, and less compact than marble. When polished, it takes on a mat finish rather than the glossy surface that is characteristic of marble. Some of the more closely grained, highly colored, or intricately patterned varieties of limestone sometimes go by the name marble; examples are BATESVILLE

MARBLE and BLACK-AND-GOLD MARBLE. Most of the limestones used in sculpture are cream-colored or gray. Certain so-called oölitic limestones, such as INDIANA LIMESTONE and CAEN STONE, are composed of tiny, rounded granules of calcium carbonate bound together compactly and resembling fish roe in miniature.

French limestones enjoy a high reputation among sculptors for their excellent working and aesthetic qualities. Some of the more celebrated of these cream-colored stones are Caen stone, Euville, Lotharinga, Normandeaux, and Peuron. Among the best-liked American limestones are Indiana Buff Statuary, Batesville marble, NAPOLEON GRAY, and TEXAS LIMESTONE. Another limestone is TUFA, occasionally used by the ancients for sculpture. Solnhofen stone and other gray Bavarian limestones are the preferred stones for lithography (see LITHOGRAPH STONE).

limewash painting. See SECCO.

limewater. A solution of lime, used to saturate plaster before applying secco colors. Since lime is only partially soluble in cold water and still less soluble in hot water, limewater is always quite weak.

limited edition. A set number of replicas of a work of art, of which the plate, mold, or die is destroyed or mutilated after the determined number of copies has been made. The practice of limiting editions and numbering PROOFS originated with ETCHING and DRYPOINT, in which the quality of the proofs declines as the copper plate begins to show evidence of wear. By thus limiting his edition to first-rate examples of his work, the artist protects both his artistic integrity and the value of the work to the collector. There is no technical reason for limit-

ing or numbering editions of works of art that are made by processes capable of turning out an indefinite number of uniformly good copies, such as lithography, serigraphy, and casting methods that employ durable molds. Editions are frequently limited, however, for purely economic reasons; by ensuring the relative rarity of his work, the artist increases its value. See also ORIGINAL PRINT; RESTRIKE.

limited palette. See RESTRICTED PALETTE.

limner. 1. In the 17th–19th centuries, a painter of MINIATURES or, sometimes, watercolors.

2. In America up to the early 19th century, an itinerant and often self-taught painter, especially of portraits; also, any painter.

3. An illuminator of medieval manuscripts.

Limoges enamel. A type of fine ENAMEL, in which the design, frequently a realistic picture, is painted with ceramic colors on porcelain or on metal that has already been given a smooth coat of white enamel and fired. It is distinguished from other kinds of decorative enameling by the absence of metal separators or cloisons. It takes its name from the town of Limoges in France, where an excellent grade of kaolin, or fine porcelain clay, is found, and where fine porcelain has been made since the 18th century.

linear. A term applied to the dominance of line rather than mass as a means of defining form in painting, sculpture, and architecture. It was first used in this sense by Heinrich Wölfflin in his *Principles of Art History* (1915), along with its opposite, "PAINTERLY" (*malerisch*). Linear drawing or painting, for example, is draftsmanlike, with modeling depicted primarily in

LINEAR AND PAINTERLY. Above, a 12th-century Byzantine ivory panel, *Sorrowing Adam*, carved in a linear style. (*The Walters Art Gallery.*) Below, a painterly sculpture, *The Thinker*, a bronze statuette by Auguste Rodin, 1840–1917. (*The Metropolitan Museum of Art, Gift of Thomas F. Ryan, 1910.*)

terms of line and the forms clearly delimited. This sharp outlining of forms restricts the movements of the viewer's eye or directs it along a definite course; and tends to make the

work appear more static. Painterly work, on the other hand, deemphasizes the edges of forms, leaving the eye able to wander more freely.

Italian painters from Giotto to Botticelli used a linear style, as did Durer and most of the early Flemish painters. Tempera, their medium, is essentially a linear technique. In the work of later painters, oil painting was adopted to meet the preference for techniques that permit softer edges for forms, and the *malerisch* style of painting became dominant. Dry painting is a pejorative term sometimes used for linear painting. See also RUBÉNISME. See illustration on previous page and color-plate facing page 119.

linear perspective. The standard system of geometric PERSPECTIVE. It is based on the actual or imagined construction on the PICTURE PLANE of a perpendicular grille of parallel lines that converge on the HORIZON LINE at VANISHING POINTS. The picture plane is divided horizontally into ZONES OF RE-

CESSION. There are three systems with which a rectangular solid may be depicted in linear perspective: PARALLEL PERSPECTIVE; ANGULAR PERSPECTIVE; and OBLIQUE PERSPECTIVE. Linear perspective, which was clearly formulated and competently practiced during the Renaissance, is distinguished from the color-based system of AERIAL PERSPECTIVE and from special systems, like SOTTO IN SÙ, which is used to solve special perspective problems. When the rules of linear perspective are strictly applied, the system is known as LEGITIMATE CONSTRUCTION. However, most treatises and instructional handbooks written since the 18th century on the use of perspective admonish the artist not to apply the rules of perspective too mechanically.

linear quinacridone. See QUINACRIDONE RED.

line drawing. A drawing in which forms are depicted exclusively by lines, as in OUTLINE DRAWING and CON-

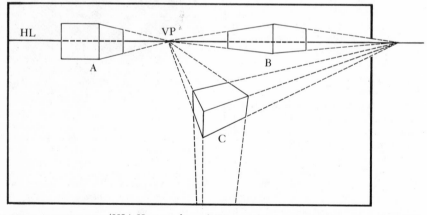

LINEAR PERSPECTIVE. (HL) Horizon line; (VP) vanishing points; (A) rectangular solid shown in parallel, or one-point, perspective; (B) solid in angular, or two-point, perspective; (C) solid in oblique, or three-point, perspective. Note, in oblique perspective, the convergence of a third set of lines to a third vanishing point not on the horizon line. Here, in a bird's-eye view, the convergence is downward. If the page is viewed upside down, figure C is seen in a worm's-eye view, with an upward convergence of its vertical lines.

TOUR DRAWING. Also, a drawing done in lines or masses with pen, pencil, crayon, or drybrush that is used as an original for ENGRAVING, especially a drawing that can be reproduced with a linecut, i.e., without the use of HALF-TONES.

line engraving. See ENGRAVING.

linen. The fabric from which artists' canvas is made. Linen is made from fibers of the flax plant. Although virtually every textile fabric has been used to prepare canvas for oil painting at some time or place, linen remains the first choice because it excels in durability, strength, stability, receptiveness to grounds, and the ability to retain the bold texture of its weave, fine or coarse, after the application of a ground. The strong, unbleached linen woven especially for artists' canvas is not produced in the U.S.; most of it comes from Belgium and Ireland. Close-woven fabrics are most desirable; heavy linen is preferable to lightweight; and a square weave, with warp and weft of equal threads, is considered best. Twill weaves were popular in the 18th and early 19th centuries.

linenfold. A decorative relief design or motif, representing a flatly folded cloth; also known as linen pattern and linen scroll. This traditional relief pattern first came into use in Gothic

LINENFOLD

woodwork of the late 16th century.

line of beauty. See HOGARTH'S LINE.

line of vision. See CENTRAL VISUAL RAY.

liners and stripers. Brushes originally designed for coach painters, decorators, and sign writers, for painting fine, straight lines and sharp edges, and for which artists sometimes find uses in painting. Individual liners vary for specialized use. Some are made of long CAMEL HAIR, with wide, straight

LINERS AND STRIPERS. From top to bottom, angular liner, dagger striper, long-haired liner, sword liner.

ends. Others, called angular liners, have the hairs set so that the end is diagonal; some of these, made of bristle and also called fresco liners, are used on their edges or corners rather than their flat sides. Dagger stripers look like miniature daggers, with sharp points and short handles; one side of the brush is straight, the other curved. In the sword liner, both sides curve inwardly to a point. Other specialty brushes are the brick liner for representing the mortar lines in a brick wall and the Dresden liner used in CHINA PAINTING.

liner's wheel. Another name for BANDING WHEEL.

lining. In the conservation of oil paintings, the process of cementing a piece of fresh linen to the back of an old canvas which has become too weak to withstand further aging or whose deterioration is too severe or extensive

to be rectified by local treatments such as patching. Most paintings are now lined with the use of a thermoplastic adhesive such as a wax-resin compound; the support of the painting is impregnated with the adhesive, thus preserving the picture from further decay. The technique is carried out under vacuum on a HOT TABLE. Formerly, lining was done with animal glue, hot, heavy irons, and powerful clamps, all of which were potentially hazardous to the painting. The term relining is a common misnomer for the first application of the lining process to a painting.

linocut or **linoleum cut.** A popular type of relief print (see RELIEF PRINT-ING), made by a process similar to woodcutting (see WOODCUT), that employs a block constructed of a layer of thick battleship linoleum glued to a block of wood, the whole made TYPE-HIGH so that it may be used in a printing press. The soft linoleum surface is very easily carved in relief with the same tools that are used in woodcutting (see WOODCUT TOOLS); special linoleum-cutting tools with light-weight, replaceable blades are also available. The block is inked with a brayer and printed like a woodcut, either by hand or in a press. It is quite durable and holds up well through many printings. Linoleum cuts are less expressive than woodcuts but are admirably suited to broad work and simple posterlike designs. The process can be easily mastered. Although the challenge of overcoming the resistance of an intractable material is virtually absent, some artists, such as Matisse and Picasso, have liked the medium and have used it to good advantage.

linoxyn. The tough, solid material formed when linseed oil is converted to a solid, as in the drying of oil paint or the manufacture of linoleum. See DRYING OIL.

linseed oil. The principal DRYING OIL used in paints. It is expressed from the seeds of the flax plant, which is grown in all cold and temperate countries of the world. Quality is governed by the variety of seed, the absence of impurities (mostly foreign or weed seeds), and the degree to which the oil has been chemically or physically refined. The best quality linseed oil is superior to all other drying oils in resistance to embrittlement combined with color retention or resistance to yellowing.

lipoid. A substance whose superficial properties resemble those of a fat or oil.

lipophile. A substance that is attracted to or easily combined with a fatty or oily material.

liquid drier. A DRIER prepared in liquid form for use as an additive to paint, as distinguished from a solid or powdered material that is cooked into an oil or varnish.

liquid silicate. Any of various fluid silicon compounds, including sodium silicate or water glass, a thick, viscous fluid with alkaline properties, and potassium silicate, as well as the SILICON ESTERS. Silica, which occurs in nature in the form of sand or quartz and as the sinter in several types of rock, is one of the most inert and durable of materials, as are some of the rocks composed of various silicates. A paint with a silica binder could therefore be expected to survive the most severe atmospheric conditions. From the early years of the 19th century, when water glass became available, artists and chemists made innumerable efforts to employ it as a vehicle in paints for mural painting, but none of these

efforts were successful. The most nearly so was a complex and impractical process called MINERAL PAINTING. The problem was solved in the 1930's when the silicon esters became available. Paints with an ETHYL SILICATE vehicle have a pure silica binder, and may be expected to withstand many of the adverse conditions which would destroy fresco and other traditional paints.

Liquitex. Trade name for an American manufacturer's line of acrylic POLYMER COLORS and their adjuncts.

literary. Depicting a story. The word is applied to storytelling painting, sculpture, drawing, or graphic works. Used pejoratively, it implies that the aesthetic value of the work has been sacrificed to some degree. The adjective "narrative" may be applied to storytelling elements that do not diminish a work as art.

lith. or **litho.** See IMP.

litharge. Lead monoxide; a heavy, yellowish powder which, when cooked with linseed oil, acts as a powerful DRIER. It is also used (less commonly in the United States than in Europe) as a low-fired flux in ceramics. In the past it was occasionally used as a base for lake pigments. Litharge was known to the Greeks as lithargyron and to the Romans as plumbum ustum. MASSICOT is a lead oxide similar to litharge, but somewhat deeper or reddish in hue.

lithochromy. The technique of painting on stone.

lithographic crayon or **litho crayon.** An oily crayon with which the drawing is applied to the stone, plate, or transfer paper (see TRANSFER LITHOGRA-

PHY) in LITHOGRAPHY. It is made of varying proportions of wax, soap, and lampblack—to which may be added spermaceti, shellac, tallow, or a combination of these—and it is sold commercially in a peel-off paper casing, like an ordinary grease pencil, or in square crayon-stick form. Lithographic crayons in stick form are available in seven degrees, from #00 (extra soft) to #5 (containing copal for extra hardness), while the pencil form is sold in five degrees. When printing ink is applied to the lithograph stone or plate, it adheres to only those areas that have been drawn on with the crayon but not to the unmarked, dampened areas. TUSCHE, a black liquid that contains the same ingredients as the litho crayon, is applied to the stone or plate with a pen or brush. Lithographic crayons are also often used for drawing on paper.

lithographic etch. In LITHOGRAPHY, the first step in creating the nonprinting areas on the stone, i.e., "desensitizing" the stone so that areas not drawn upon will, when wet, repel lithographic ink; also, a solution used in this process. After the drawing has been completed with LITHOGRAPHIC CRAYON or TUSCHE, the stone is sponged or brushed with a solution of gum arabic, water, and a small amount of nitric acid. The solution is absorbed on all exposed areas of the stone, however miniscule, but the greasy printing areas are not affected by it. The etch is fanned dry to get its full, concentrated effect, and then the surface gum is sponged away with water. The adsorbed layer that remains is strengthened and made more durable in the subsequent process, GUMMING UP. Although there is no actual "etching" or biting below the plane surface in a lithographic etch, the process has always been so called.

lithographic points. Steel points or needles of various degrees of sharpness, used in a screw-grip holder for scratching crayon areas on a LITHO-GRAPH STONE to create white-line effects.

lithograph ink. The ink used in printing lithographs, similar in composition to other PRINTING INKS but somewhat less tacky than the ink used in letterpress printing. Lithograph ink, which is available in all colors in tubes and tins, is strongly pigmented and fairly opaque; a prepared extender is used to reduce a color or make it more transparent. The consistency and behavior of ready-made lithograph ink can be altered by the addition of a LITHO VARNISH. Lithographic TUSCHE, the black, greasy fluid used for brush-drawing on the lithograph stone in place of or in addition to lithographic crayon, should never be referred to as ink. Lithograph ink and tusche differ in composition, purpose, and performance.

lithograph stone. A thick, heavy, flat slab of limestone used in LITHOGRAPHY. The face of the stone is ground to a lightly grained surface to prepare it for being drawn on with LITHOGRAPHIC CRAYON or TUSCHE. The blue-gray Bavarian limestone that is mined at Solnhofen, Germany—on which the technique of lithography was discovered and perfected—is still preferred by most artists, even though similar limestones are also used. A somewhat softer yellowish-tan variety can also be used for lithography, but it does not take as satisfactory a grain or hold up as well when a large edition is printed. Some lithographers, sticklers for maintaining the last degree of the autographic quality of the technique, pull their proofs on paper that matches the blue-gray or tan color of the stone used.

Lithograph stones are too cumbersome to be handled freely, for they are hard but brittle and must be relatively thick to survive the stress of printing. The greater their surface area, the thicker they must be: a stone measuring 10 x 12 inches is more than 2 inches thick and weighs about 30 pounds; one 18 x 22 inches is about three inches thick and weighs about 100 pounds. The stone must be grained each time it is used. (A stone may be cleaned, refinished, and reused as soon as the complete edition of the previous drawing has been pulled.) Graining, which serves to make the surface of the stone perfectly level and free from tool marks, gives the surface a fine texture that, reproduced in the proofs, is characteristic of the lithograph. This texture on the stone permits better adhesion of the litho crayon or tusche to its surface. Graining is achieved by placing two stones face-to-face, with water and a fine abrasive such as carborundum or sand between them, and rotating the top stone by hand. This process gives a grain to both stones simultaneously. A single stone may be ground with a LEVIGATOR or with an abrasive block made commercially for such purposes.

lithography. A PLANOGRAPHIC PRINTING process in which proofs are pulled on a special LITHO-PRESS from a flat surface that has been sensitized by chemical means so that the ink takes on the design areas only and is repelled by the blank areas. Lithography was invented in 1798 in Solnhofen, Germany, by Alois Senefelder, who discovered that when a smooth-grained local limestone was drawn upon with a greasy crayon, and then wetted with water and inked with a ROLLER (see ROLLING UP), the oily printing ink would adhere only to the greasy drawing, making it possible to pull prints from the inked stone. The actual litho-

graphic process, although based on the simple principle of the attraction of an oily ink by an oily surface and its repulsion by water, is somewhat more complicated. Several operations are necessary to create an adsorbed water-attractive, grease-repellent condition on the blank parts of the stone (see GUMMING UP) and to give the areas that have been drawn on with the crayon an adsorbed fatty-acid layer that will take the ink with precision (see LITHOGRAPHIC ETCH). After its discovery lithography rapidly became an important commercial reproduction process and a popular artists' medium. It has been refined and improved through the years, so that in both black-on-white and color printmaking, it has held its own with intaglio and relief processes. It is a versatile printmaking technique. In addition to LITHOGRAPHIC CRAYON, TUSCHE—a water-miscible black liquid that contains the greasy ingredients of the crayon—can also be applied to the stone with a pen or brush. Crayon areas may be scratched with LITHOGRAPHIC POINTS. Although the LITHOGRAPH STONE gives softer and usually more expressive prints with finer nuances of line, an aluminum plate with an oxidized surface layer, or a zinc plate grained to imitate a stone surface, are also used in lithography; these have the advantage of being lightweight and portable. In TRANSFER LITHOGRAPHY the drawing is first done with litho crayon on paper and then transferred to the stone. When a lithograph is printed by the OFFSET method, it is not reversed. The process is known as offset lithography. The most important commercial application of lithography is photo-offset printing, in which the type and artwork to be printed are transferred to the plate by a special photographic process. Lithography is very well adapted to color printing (see COLOR LITHOGRAPHY). In the relatively short time since the invention of the process, artists have been continually attracted to lithography by the variety of effects it permits and by its autographic qualities (see AUTOLITHOGRAPHY).

The early history of lithography is dominated by such great French artists as Daumier, Géricault, and Delacroix, although the process was always popular in its native Germany and was also taken up in Spain by Goya. Although lithography suffered a slight decline in popularity during the last four decades of the 19th century, it underwent a great fin-de-siècle revival in the hands of Degas, Bonnard, Munch, and especially Toulouse-Lautrec, who executed 370 lithographs in the last ten years of his life. Throughout the 20th century lithography has been extensively used by many great artists, including Picasso, Bracque, and Miró.

lithol red. A bright, cherry-red, synthetic organic pigment of fair permanence. Lithol red is used in printing inks and industrial paints, but it has been rejected for artists' use, since it is not sufficiently lightproof and most varieties bleed in oil.

lithopone. Zinc sulfide coprecipitated with barium sulfate; a dense white pigment used in house paints and industrial coatings. Because it is inferior to the widely accepted FLAKE WHITE, ZINC WHITE, and TITANIUM WHITE, lithopone is not recommended for artists' colors; however, it is suitable for use in GROUNDS. The first English patent (Orr's white) for the manufacture of lithopone was issued in 1874 to John Orr, presumably also its inventor. Another early name for lithopone is oleum white.

litho-press. The printing press on which proofs are pulled from a LITHO-

GRAPH STONE or plate (see LITHOGRAPHY). The stone is placed drawing-side-up on the bed of the press, inked, and covered with a sheet of damp paper, which is in turn covered with a piece of dry paper and a tympan. The tympan, a sheet of strong fiberboard,

LITHO-PRESS. (*Courtesy of Charles Brand Machinery, Inc.*)

protects the paper as the stone is run through the press and evenly distributes the pressure of the scraper. The scraper, a leather-covered wooden bar under which the stone passes as the bed is cranked through the press, presses on the tympan, the top side of which is greased to facilitate its passage under the scraper. The pressure of the scraper effects a transfer of ink from the stone to the damp paper that covers it. An OFFSET press, employed for most commercial lithography, may also be used by artists.

litho varnish. A heat-BODIED LINSEED OIL that is the vehicle in LITHOGRAPH INK and, usually, in other PRINTING INKS. Depending upon the duration of heating, litho varnishes acquire varying degrees of viscosity and are sold in light, medium, and heavy grades. At the end of heating, the linseed oil is set afire and allowed to burn for a limited time. Litho varnish is therefore also known, especially in

Great Britain, as burnt-oil varnish. Like stand oils, which they resemble, litho varnishes are polymerized and, depending upon their degree of polymerization, acquire distinctive properties. For this reason more than one type of litho varnish is often called for in formulas for altering the degree of oiliness or tackiness of ready-made printing inks. Another British term for litho varnish is plate oil.

litmus. A NATURAL DYESTUFF obtained from several lichens. Used by chemists as an indicator, litmus that is red turns blue on contact with alkali; when blue, it turns red on contact with acid. Two other natural coloring matters, archil and turnsole, behave similarly. Litmus is not sufficiently stable for use as an artists' color.

livering. Solidification of tubed oil color into a firm, rubbery mass, rendering it useless. Livering is caused by the reaction of impurities in the pigments, especially free sulfur, with the oil. It does not occur in colors made of high-quality, well-washed artists' pigments that have been skillfully ground in the best oils.

liver of sulfur. Common name for potassium sulfide, used in recipes for staining or coloring bronze and other metals.

loaded. In painting, fully charged. Loaded lights are the palest areas painted thickly, accompanied by darks of average or less than average thickness. A loaded brush is one that is charged with paint to its full capacity.

local color. The true color of an object in ordinary daylight, as distinguished from its apparent color when influenced by unusual lighting, abnormal atmospheric conditions, reflected color, and the like. Also, the normal

color of a thing, as distinguished from its rendition in an anomalous coloration that is merely the predilection of the artist.

logwood. A blood-red NATURAL DYE-STUFF obtained from *Haematoxylon campechianum*, a tree indigenous to Central America, Mexico, and the West Indies. It produces blue, black, and violet colors by chemical treatment. Brought to Europe soon after the discovery of America, logwood was one of the most important of the natural coloring matters until the 19th century, when it was superseded by synthetic dyestuffs of superior brilliance. Logwood was formerly used to make a black ink; it is still in use for dyeing textiles black. Lake pigments made from logwood (also known as campeachy wood) are campeachy lake, a dark reddish-purple, and vegetable violet.

lointains. The most distant part of a landscape. The term, little used in English, refers especially to those elements on or near the HORIZON LINE. It is French for background.

lokao. A green NATURAL DYESTUFF of Chinese origin, prepared from the leaves, roots, bark, and twigs of *Rhamnus utilis*, *R. chlorophorus*, and other buckthorns by treating an aqueous extract with lime. Among the more permanent of the natural dyestuffs, lokao is also one of the few green ones. It is also known as Chinese green.

London white. An obsolete name for WHITE LEAD, used in England during the 19th century.

long-oil varnish. See OIL LENGTH.

lost pattern casting. A relatively new method of casting metals; also called full mold, vaporization, and cavityless casting. The original is made of FOAMED PLASTIC, usually expanded polystyrene. This positive is packed in FOUNDRY SAND, which forms the MOLD or negative. When molten metal is poured into the mold (i.e., over the polystyrene), the plastic is vaporized or "lost," leaving the sand negative filled with metal. This method of casting, developed for sculptural use, is currently being adapted to industrial purposes.

lost-wax process. A method of casting metal in a mold, the cavity of which is formed with wax that is then heated and drained; also called investment casting and, in French, *cire perdue*. The process is used especially for hollow bronze statues, but has also been adapted to the multiple production of small, solid objects such as statuettes and jewelry (see CENTRIFUGAL CASTING). First a plaster cast is made of the original. Then a negative (hollow) gelatin PIECE MOLD is made of the plaster cast. The piece mold is assembled, and the inside coated with molten wax, to form a hollow wax model. This in turn is packed with a CORE of FOUNDRY SAND, at which point it may be corrected and reworked by the sculptor. Rods of wax are attached to the wax model, and the entire figure is encased, or invested, in heat-resistant plaster or clay. Metal PINS are inserted to keep the core in place. Next, the whole structure is placed in an oven and baked until the plaster mold has become dry and the hot wax has run away through vents created by the melting of the wax rods. The mold is then packed in sand, well supported by bricks, and molten bronze is poured through the vents into the space vacated by the melted or "lost" wax. After cooling, the inner sand is shaken out and the cast is cleaned and finished. Most cast metal sculpture is

made by the lost-wax process; SAND CASTING, the other principal method of casting metal, is more commonly used in industry.

Lost-wax casting is a time-honored technique. Greek craftsmen were using the method expertly by the fifth century A.D., and it was known also by the ancient Egyptians, who cast over a core of ash.

Lotharinga stone. See LIMESTONE.

loutrophoros. A tall ancient Greek ceremonial vase with double handles. It was used to carry holy water for a bride's ritual bath and became a customary symbol on grave markers for girls who had died unwed. See VASE SHAPES for illustration.

Louvain school. A group of 15th-century Flemish artists. Louvain became a leading center of humanistic culture after the founding of the university there in 1425. The most influential of the Louvain painters was Dirk Bouts the Elder, whose strong realism was kept within the bounds of a refined style.

low color. Color of low intensity; weak or faint color.

low key. See KEY.

low relief. See RELIEF.

luce di sotto. See LUMINOUS.

Lucite. See ACRYLIC RESIN.

lumachelle. See SHELL MARBLE.

lumbang oil. A DRYING OIL from the Philippines that has been used in industry as a substitute for linseed oil, to which it is inferior; also called candlenut oil. There is no record of its use in artists' materials.

lumbayao. Philippine mahogany. See MAHOGANY.

luminism. Depiction of the play of light, of clear, brilliant lighting effects, or of glowing light, as a major characteristic of a painter's work; also, any school or method of painting, especially those of the latter half of the 19th century in France (as IMPRESSIONISM and POINTILLISM), the principal concern of which is the technique of expressing the effects of light.

luminous. Appearing to give off a diffuse glow from within. For example, a clear oil or varnish GLAZE over a tempera painting on a brilliant white gesso ground has a luminous quality that an opaque gouache painting lacks. The Italian term *luce di sotto* (light from beneath) refers to this quality.

luminous paint. Paint that glows in the dark; a coating that contains a pigment called a phosphor (usually a form of zinc or calcium sulfide) that stores light when exposed to it for a length of time, emitting it as a greenish or bluish glow when the light source is removed. Luminous paint differs from fluorescent (daylight fluorescent) paint, which glows normally in daylight but must be specially activated with ultraviolet light to glow in the dark. Because luminous paint glows for a relatively short time, signs and other markings made with it serve best in situations where the light is renewed after a few hours or where its period of use is not prolonged, as in theatrical effects. Sometimes a trace of radioactive material is added, thus producing a continuous excitation, rather than a gradually decaying one. This process is used in marking watch, clock, and instrument dials with luminous paint. It cannot be employed in general painting because of the dangerously toxic

nature of the radioactivity. See also FLUORESCENT PAINT.

lunette. In painting, a semicircular panel, often over a window or doorway.

luster. Surface GLOSS. Types of luster include satiny or dull, vitreous (a hard, porcelain effect), nacreous (pearly), and metallic. See also SHEEN.

lusterware. Porcelain or earthenware decorated with a metallic, iridescent glaze.

lute. To seal an opening or leak in any vessel or tube with a compound of putty-like or semi-paste consistency. In ceramics, to stop an opening or crevice in a wet clay body, or to join sections of a piece of pottery, especially using SLIP as an adhesive.

luteolin. The yellow coloring principle of WELD.

Lutschism. The Russian word for a native 20th-century movement in painting known in the West as RAYONNISM.

lye. A powerfully active or caustic alkaline substance. Its corrosive or destructive action is effective in such processes as the removal of incrustations from metals. Ordinary lye is sodium hydroxide (caustic soda).

Lysippian proportions. A canon of proportions for the human figure developed by Lysippus, a sculptor who worked at the court of Alexander the Great in the 4th century B.C. Lysippus' ideal of the human figure differed radically from that of his predecessor Polyclitus (see POLYCLITAN SCHOOL), who had also laid down laws of proportion, and even from the more graceful figures of Praxiteles. Lysippus' bodies were more slender and had rather small heads. He made great advances in conceiving the figure in three-dimensional terms, which made it possible to view sculptures with equal pleasure from several viewpoints.

M

Macassar ebony. See EBONY.

macchia. 1. An Italian term meaning sketch or outline. Literally the word means spot or stain, and it was in this sense that *macchie*, the plural, was used by a group of late 19th-century Florentine realists to describe their landscapes, painted in patches, or spots, of color in order to emphasize the effects of chiaroscuro. These painters were subsequently given the name *Macchiaioli*, a term that was later extended to all late 19th- and

early 20th-century Tuscan painters whose tendencies toward realism had a strong foundation in the color theories of Impressionism. Hence the term *macchia* is sometimes used to mean an impressionistic painting or sketch.

2. By extension of the meaning "spot" or "mark," *macchia* is also sometimes used to describe the first underpainting in an oil painting, in which masses of light and shade are blocked out.

mace-head, matter, or **mattoir.** A tool used in CRAYON MANNER and MEZZOTINT, consisting of an irregularly spiked, rounded knob at the end of a handle of wood or metal. The wood-

MACE-HEAD

handled tool is most often used in crayon manner; in this technique it is manipulated on the plate to create lines and areas that will print with a chalk-like graininess. The metal-handled mace-head is used in mezzotint to go over those areas of the plate where the engraver wants a heavier burr than that produced by the rocker.

McGuilp. Variant spelling of MEGILP; purportedly the name of its inventor.

madder brown. A brown alizarin lake, formerly made from madder. See RUBENS MADDER.

madder lake. A transparent ruby-red LAKE pigment made from the natural dyestuff madder, obtained from the root of the madder plant, or garance (*Rubia tinctorum*); known to artists as rose madder. Madder was used in ancient Egypt, Greece, and Rome for dyeing textiles and, to some extent, for making pigments. It was said to have been introduced into Italy by the Crusaders. By the 13th century madder was being cultivated on a fairly large scale in Europe, but there is no evidence of its use in medieval or Renaissance painting. Madder lake was most widely used in the 18th and 19th centuries, though never so extensively as were the ruby-red lakes made from kermes, cochineal, brazilwood, and lac.

In 1826 two French chemists, Robiquet and Colin, isolated the coloring principles of madder—alizarin and purpurin—by treating the root with sulfuric acid. The resulting extract, known as garancine, was used to make madder lakes, rose madder, and madder carmine. Prior to this improvement madder lake had been so costly that its use was confined to miniature painting. For fifty years afterward no other ruby-red or rose-pink coloring matter gave better or more permanent results.

Synthetic alizarin was first made in 1868. In the following years madder lake was superseded by ALIZARIN CRIMSON, a pigment superior to it in every respect. Synthetic alizarin did not replace natural madder immediately. The French government attempted to protect its madder-growing industry by making it mandatory to use madder in dyeing trousers for the army. Since many 19th-century painters believed that alizarin did not have the delicacy or subtlety of rose madder, the latter continued to be available into the 20th century. Today most painters prefer alizarin, but a few artists' colors made from rose madder can still be found among the European brands. The dry pigment, which is difficult to obtain, is still available in small quantities from Holland. In typical pigment form, rose madder or madder lake is a very pale pink powder; in oil and watercolor it seems like

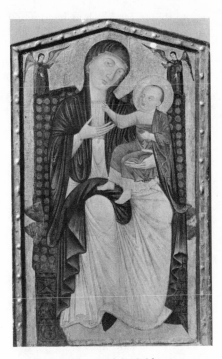

magenta. A brilliant synthetic dye of poor stability; also known as fuchsine. Magenta is widely used as a hue designation for a deep, dark, purplish red or bluish maroon.

magic realism. In the 20th century, a type of painting in which objects are painted with a precise kind of REAL-ISM, but which paradoxically projects an effect of the fantastic resulting from the disparate juxtaposition of time-space elements, e.g., an illuminated street light at high noon. Chirico and other painters of the *scuola metafisica* in Rome, French and Dutch painters of the 1920's, and some American social painters of the 1930's all practiced magic realism. In the 1950's and 1960's magic realism has consisted of infusing ordinary subject matter with an air of mystery or strangeness by the use of flat color without cast

MAESTÀ. *Madonna and Child,* tempera on wood with a gold ground, by an unknown Tuscan painter, second half of the 13th century. (*The Metropolitan Museum of Art, Gift of George Blumenthal, 1941.*)

MAGIC REALISM. *The Sacred Fish* (1919), oil on canvas, by Giorgio de Chirico. (*Collection, The Museum of Modern Art, New York, acquired through the Lillie P. Bliss Bequest.*)

alizarin crimson enormously reduced with alumina hydrate. When viewed by transmitted light, paint films of madder lake have a pronounced bluish undertone.

maestà. In medieval and Renaissance religious art, a painting of the Virgin and Child enthroned, surrounded by angels and other symbols of glory; in English, majesty. The most famous example is Duccio's altarpiece for the Siena Cathedral, completed in 1311. Less commonly, a painting of Christ enthroned in majesty was also called a *maestà.*

Magen David. See SOLOMON'S SEAL.

shadows in a kind of simplified or selective *trompe l'oeil* technique.

magilp. See MEGILP.

Magna. Trade name for a manufacturer's line of artists' straight ACRYLIC COLORS, and their isolating varnish.

magnesia white. An unstandardized term used for magnesium carbonate, magnesium oxide, and native magnesite.

magnesite. Native magnesium carbonate, calcined for use in OXYCHLORIDE CEMENT, and occasionally used in powdered form as a FILLER or INERT PIGMENT. It is sometimes called by the unstandardized name magnesia white.

magnesium carbonate. Probably the whitest of all pigments. It has the same general properties as PRECIPITATED CHALK. Magnesium carbonate is manufactured in two forms: a very fluffy, lightweight powder, not recommended for artists' use, and a heavy or dense variety that is suitable for use as an INERT PIGMENT. It is sometimes substituted for chalk in gesso by enthusiasts who want to use the very whitest material in existence, but the practical advantage is nil. Magnesium carbonate is sometimes known by the unstandardized name magnesia white.

magnesium oxychloride cement. See OXYCHLORIDE CEMENT.

magnetic black iron oxide. A term applied either to the native BLACK IRON OXIDE or to its synthetic counterpart, MARS black (see MARS PIGMENTS), both of which are strongly magnetic.

mahlstick. A light, inflexible wooden rod, three or four feet long, which the painter uses as a support or rest to steady his brush or hand while executing particularly detailed and exacting work. The typical mahlstick is ball-shaped at one end; the ball is sometimes covered with a piece of soft

MAHLSTICK

leather to minimize possible damage to the canvas. Some mahlsticks are joined in sections like fishing rods so they will fit into a sketchbox; some are made of aluminum with screw joints and rubber-ball ends. The conventional mahlstick is frequently replaced by a yardstick or other improvised prop. Sometimes spelled maulstick, it is called an *appuie-main* in French. See also BRIDGE.

mahogany. Any of several species of close-grained hardwood from trees of the genus *Swietenia;* sometimes called acajou. Although it is strong and hard enough to be extremely durable, it is still easy to saw, plane, and carve. It has less tendency than many other hardwoods to shrink, swell, or warp. Its only disadvantage as a wood for construction or cabinetwork is its weakness under lateral strain. In color, it may be anywhere from light brown to dark or reddish brown.

Varieties of true mahogany grow in Mexico, the West Indies, and Central and South America. The most desirable varieties come from Mexico, Cuba, and the Dominican Republic. The latter, called San Domingo mahogany, is particularly esteemed. Mahogany is available in large logs and blocks cut for carving.

Jequitiba (genus *Cariniana*) is also known as Brazilian or Colombian mahogany. Philippine mahogany is the popular name for two distinct woods: lumbayao (*Tarrietia javanica*), which has a purplish color lacking in true mahogany; and seraya (genus *Shorea*),

a wood from the Malay Peninsula that ranges from pink to purple-brown in color. African mahogany, or red khaya (*Khaya senegalensis*) may be anywhere from pink to red. Both Philippine and African mahogany have splintery and softwood characteristics that make them difficult to carve; they are commonly used for veneer and paneling.

Mahogany was first used for building in the Cathedral of Santo Domingo, completed in 1540. In 1595 Sir Walter Raleigh is said to have repaired his ships with it in the West Indies. In the late 1700's, it became popular as a cabinet wood for such great furniture makers as Chippendale, Hepplewhite, and the Adam brothers. Mahogany panels for painting were first used in 17th-century Holland and England, and remained universally popular throughout the 19th century.

mahogany lake. A red or brown LAKE made with various dyes on a burnt sienna base. It is not a permanent pigment. It has also been called cashew lake.

mahogany stain. A wood STAIN made of linseed oil and thinners mixed with a lake color or—for permanent results—with burnt sienna.

majesty. See MAESTÀ.

majolica or **maiolica.** An EARTHENWARE or FAIENCE of brownish-red body, decorated with heavily embossed, richly colored, glossy, opaque glazes. The high reputation of majolica as a ware of outstanding design and quality was gained in Renaissance Italy from the 15th to the 17th century. Nineteenth-century examples of the ware made in American, English, French, and German potteries are sought after as collectors' items. Its name comes from the Spanish island of

Majorca, where pottery of this type has been made since the 12th century.

makore. The African cherry; see CHERRYWOOD.

malachite. Native green crystalline copper carbonate, pulverized and used as a pigment from Roman times until the introduction early in the 19th century of more powerful, permanent greens. The greenish shades of Bremen blue have the same chemical composition as malachite, but not the same crystalline structure. Malachite has the same general pigment properties and history as AZURITE, the blue variety of native crystalline copper carbonate. Other names for malachite are Hungarian green, mountain green, and the unstandardized MINERAL GREEN.

Malay damar. Another name for SINGAPORE DAMAR.

malerisch. See PAINTERLY.

malleable. In a metal, capable of being beaten or rolled in all directions without breaking or cracking under the stress. A malleable metal must have a certain structural plasticity, since the molecules adhere to each other when the metal is hammered. The most malleable of all metals is gold, which can be beaten to a foil only $1/300,000$ inch thick. Other metals used by sculptors, in descending order of malleability, are silver, aluminum, copper, tin, platinum, lead, zinc (when hot), and soft steel. Cast iron and hard steel are not malleable. Alloys, such as brass and bronze, are usually less malleable than the metals of which they are made.

mallet. A wooden hammer. A sculptor's mallet is shaped something like an old-fashioned churn, with a truncated conical head and a handle that extends

from the center of the smaller end. It is made of hardwood, usually boxwood, hickory, or lignum vitae, in one piece, and may weigh from ¾ to 2¼ pounds. It

MALLET

is used for striking chisels and gouges in wood carving. A one-pound mallet of similar shape, made of zinc, is used in stone carving, as are BUSHHAMMERS and soft-iron hammers with brick-shaped heads and inserted wooden handles, weighing from 1 to 2½ pounds.

Maltese cross. Specifically, a cross with wedge-shaped arms meeting at the points and with V-shaped indentations at the outer ends. These indentations make it a cross of eight points, as it is sometimes called, especially in heraldry. The cross derives its name from its adoption during the Middle Ages as the emblem of the Knights of the Order of Malta. The cross pattée or formée, similar in shape but with unindented ends, is often called the Maltese cross. See CROSS for illustration.

mandala or **mandara.** In Hindu and Buddhist art, a pictorial schema of mystical symbols of the universe, usually in the form of a circle surrounding a square, frequently shown with a symmetrical representation of a PANTHEON.

mandorla. See AUREOLE.

manganese black or **manganese brown.** Artificially made manganese dioxide. A powerful drier in oil, it has also been used as a permanent brownish-black pigment. Manganese black (brown), which was patented in England by Rowan in 1871, is not in common use. The native variety is described under BLACK OXIDE OF MANGANESE.

manganese blue. Barium manganate; a brilliant, clear, transparent, azure or sky-blue permanent pigment with a very greenish undertone. It was introduced to artists about 1935. Manganese green is a green variety of manganese blue.

manganese green. A green form of barium manganate (MANGANESE BLUE); also known as Cassel green, Rosenstiehl's green, and BARYTA GREEN. Manganese green has been known as a permanent pigment since the 19th century, though little used; it has not been available in the 20th century.

manganese violet. Manganese ammonium phosphate; a permanent bluish-violet pigment with the same general color properties as the bluish shade of cobalt violet. Introduced in Germany in 1868, manganese violet was not produced commercially in America until the 1930's. Lower in cost than cobalt violet, manganese violet is becoming more and more widely used. Formerly known as mineral violet, it has also been called Burgundy violet, permanent violet, and Nuernberg violet.

manière criblée. See DOTTED MANNER.

manifestation. See HAPPENING.

manifesto. In art, a public declaration or exposition in print of the theories and directions of a movement. The manifestos issued by various individual artists, or groups, in the first half

of the 20th century served to reveal their motivations and raisons d'être and stimulated support for or reactions against them.

manikin. See LAY FIGURE; ÉCORCHÉ.

Manila copal. An alcohol-soluble resin tapped in the Philippines from trees of the genus *Agathis*. It has few properties in common with the other resins properly called COPALS. Manila copal occurs in many old recipes, especially for fixatives. It is, on the whole, a rather inferior resin; some of the synthetic polyvinyl and acrylic resins are improved substitutes for it.

Manila elemi. See ELEMI.

manjak. A medium-soft asphalt from Barbados. It is used in some recipes for ETCHING GROUNDS and as a constituent of various acid-proof and other protective coatings.

Mannerism. An artistic style prevalent especially in Italy between 1525 and 1600. It developed in reaction to the classical balance and austere harmony of the High Renaissance, and was characterized by a subjective, sometimes highly emotional portrayal of its subject matter through elongated or otherwise distorted forms, exaggerated perspective, and relatively harsh, vivid colors. Its major exponents were El Greco (1541–1614) and Tintoretto (1518–1594); some of the late work of Michelangelo is also considered by some authorities to fall into the Mannerist category. Others working in this style included the painters Rosso Fiorentino (1494–1540), Parmigianino (1503–1540), Pontormo (1494–1557), and Agnolo Bronzino (1503–1572), and the sculptor and goldsmith Benvenuto Cellini (1500–1571). See also DISTORTION. See color-plate facing page 150.

Mapico pigments. Trade name for a series of MARS PIGMENTS deve')ped by Fireman in Alexandria, Virginia, about 1900.

maple. One of the most widely used hardwoods (from trees of the genus *Acer*). About two dozen different species are found in the United States alone. They are subdivided into hard and soft maple. The most important hard variety is sugar maple (from *Acer saccharum*), used for dance floors and bowling alleys, among other things. Soft maple is less expensive and has a less interesting figure; it is used for carving rather than for veneers. The red maple (*Acer rubrum*) is a common species of soft maple. It is often used for wood-engraving blocks. See also HAREWOOD.

maple die board. An all-maple, 5-ply plywood board, sold in several thicknesses from ½ to ¾ inches and in sizes of from 2 x 3 feet to 3 x 4 feet. It is intended for use in machine work, as the backing against which dies are used. Since it is stronger and sturdier than other plywoods, being made of plies of equal thickness, it is popular with painters for use as a support.

maquette. In sculpture, a small model in wax or clay, made as a preliminary sketch, presented to a client for his approval of the proposed work, or entered in competition for a prize or a scholarship. The Italian equivalent of the term is bozzetto, meaning small sketch.

Maracaibo balsam. See COPAIBA BALSAM.

marble. A hard, crystalline form of calcium carbonate, fine-grained, dense, and capable of taking a smooth, high polish; the traditional stone used by sculptors. Marble is a metamorphic

form of LIMESTONE, which is similar in chemical composition although not in structure or appearance. Some varieties of marble are metamorphic dolomites, containing magnesium carbonate as well as calcium carbonate. Because calcium carbonate is susceptible to the destructive action of acids or acidic impurities in the atmosphere, marble is not the most durable stone for outdoor use in sculpture.

Numerous varieties of marble, differing greatly in coloring and surface appearance, are or have been quarried in all parts of the world. From Greece come PARIAN MARBLE; PENTELIC MARBLE; ROSSO ANTICO; and ELEUSINIAN MARBLE—all used by the sculptors and architects of antiquity. The ancients also used PAVONAZZETTO NERO ANTICO. Italy's most famous stone, CARRARA MARBLE, was used for many great works of the Renaissance. Other Italian marbles are BARDIGLIO; CIPOLIN; and PARMAZO MARBLE. Belgium produces RANCE; BELGIAN BLACK; and SAINT ANNE MARBLE. Among the many French varieties are LANGUEDOC MARBLE; GRIOTTE; and SARRANCOLIN MARBLE. SUSSEX MARBLE is an English variety. In the U.S., the three most highly rated marbles for carving are VERMONT WHITE STATUARY; GEORGIA WHITE; and COLORADO YULE STATUARY; additional marbles prized by sculptors are ALABAMA CREAM, TENNESSEE PINK, and ROCKINGHAM ROYAL BLACK. Marbles of unusual appearance or composition include SHELL MARBLE; BRECCIA; and FOREST MARBLE.

marble dust. Crushed marble, the finest grade of which is used as an inert pigment, the coarser form as an aggregate. Marble dust mixed into plaster used as the support for a fresco is in the form of small cubical or pyramidal grits. When the painting surface, the INTONACO, is troweled, some of the flat facets of the marble dust are exposed.

The fresco colors are not absorbed at these spots, which remain bright and add sparkle and brilliance to the work.

marbling. 1. The imitation of marble patterns on wood or other solid surfaces.

2. The art of producing variegated and usually multicolor designs on paper in free, swirling patterns; used on endpapers for books, on book edges, and for other decorative purposes. The process consists of filling a shallow pan or trough with a gum solution of soft gel consistency, on which are floated fluid colors made by grinding pigments in a special gum vehicle. The colors are dispersed by adding a wetting agent. The flowing, curved patterns are controlled by dragging the surface with a steel comb that has widely spaced teeth. The design is then transferred to the paper surface by laying the paper against the fluid surface. Marbling was popular in Europe during the 17th and 18th centuries and in the U.S. as well in the 19th century, but its commercial use has declined during the present century. There has been some revival of marbling as a craft activity.

marc black. Another name for VINE BLACK.

marine. 1. A pictorial representation of a nautical scene; a seascape.

2. French for a series of canvases sold in France, in sizes at one time considered appropriate to marine painting. See table at CANVAS SIZES, FRENCH.

Marinite. Trade name for an ASBESTOS BOARD.

marmolite. A thin, laminated SERPENTINE, usually pale green.

Maroger medium. A MEGILP or GEL MEDIUM for oil painting. It was intro-

duced in the U.S. in the 1940's by Jacques Maroger, a painter and conservator, who presented it as a recreation of the highly effective medium of the Renaissance painters, supposed to have been lost to the world since the 17th century. Although the theory has followers among artists, it has been disputed by most technical specialists in the fine arts, on the grounds that Maroger's evidence is not historically valid and that the materials he recommends are not technically sound. The best consensus is that megilp and heavily leaded oils were more probably derived from the practices of 18th-century trade painters and decorators. The Maroger book, *The Secret Mediums and Techniques of the Masters* (1948), also attributes several other mediums to various schools and masters. These attributions, too, have been adversely treated by specialists. Maroger's book contains few technical points that are not to be found in J. F. L. Mérimée, *Art of Oil Painting*, published at the beginning of the 19th century and typical of the technology of the late 18th century, which was a sort of "dark ages" of painting techniques.

marouflage. The process of cementing a painted canvas to a wall. Traditionally, the adhesive used in marouflage is commercial WHITE LEAD IN OIL, spread evenly on both the plaster and the back of the canvas with a wide brush, a spatula, or a wall scraper. The canvas is flattened wrinkle-free with the palm of the hand; a rubber-surfaced roller, used cautiously, can assist. Sometimes a little damar varnish is added to the white lead paste to create immediate tackiness. Aqueous adhesives and some of the newer synthetics also have been used satisfactorily, but white lead in oil remains the standard cementing material. Some architects recommend a delay of two

years before painting a mural or attaching it to the wall in a new building, since the plaster may develop cracks as the structure settles.

When a large mural is to be laid in several sections, the separate pieces are cemented with a butt join, i.e., without overlapping edges. Usually, one or both of the canvases to be joined are painted an inch or so beyond what is needed, with duplicate detail on the edges that are to meet. The canvases are then laid with an overlap, the matching detail in perfect alignment. While the adhesive is still fresh, the surplus canvas is cut away in a straight line with a razor-sharp blade held vertically to the wall surface.

marquetry. A method of decoration in which small pieces of wood veneer, mother of pearl, metal, or ivory are in-

MARQUETRY. Top of an 18th-century French dressing table of oak, tulip-wood, purple-wood, kingwood, etc. (*The Metropolitan Museum of Art, Gift of the Mary Ann Payne Foundation, 1963.*)

laid in a floral or other ornamental pattern in a wood veneer or other surface, for use on furniture and paneling; also, a decorative surface so produced. Marquetry was an important art form during the Renaissance. See INTARSIA.

Mars pigments. Originally a trade name, now the accepted artists' name for a group of iron oxide pigments made by a special furnace process.

They include Mars yellow, Mars brown, Mars red, Mars violet, and Mars black. The Mars pigments are ferric oxides except for the yellow, which contains ferric hydroxide, and the black, which is ferroso-ferric oxide. While Mars yellow closely approximates the hue of yellow ochre, it is clearer, more brilliant, and has greater tinting strength. Mars brown is produced in a medium chocolate shade, and Mars red in shades ranging from scarlet to maroon, but these are less frequently used in artists' colors, perhaps because of the satisfactory performances of light red, Indian red, and the umbers. Mars violet, which may appear dull compared with the brilliant cobalt and manganese violets, is quite useful for producing lavender and orchid tints in paintings of low key. Mars black, which is dense and heavy, is widely used as an alternate to ivory black and lampblack, which are lightweight, fluffy pigments of high oil absorbancy. Mars black produces oil films of greater stability and also works well in water media. Unlike the carbon blacks, Mars black does not effloresce when used to color mortar or cement. Like its native counterpart, black iron oxide, Mars black is attracted by a magnet. One trade name for Mars colors is Mapico pigments. Other names for Mars yellow are iron yellow, yellow oxide of iron, and the trade names Ferrite and Ferrox. Mars red has also been known as totem; Mars black, as magnetic black iron oxide.

mascaron. A face or mask, often grotesque, used as a decorative device in carving, metalwork, and ceramics; from the Italian word, *mascherone*. Familiar examples would be the tragic and comic masks.

mascherone. Italian for MASCARON.

masking tape. See PRESSURE-SENSITIVE TAPES.

Masonite. Trade name for a line of hard WALLBOARD, made by exploding wood fibers with steam, and reuniting them under great pressure. In this type of dense board, which is the most widely used support for panel painting, the fibers are bound by the natural components of the wood, without the addition of other binders. The variety most recommended for use by artists is called Standard Masonite Presdwood, a dark brown board that is perfectly smooth on one side, and bears the impression of wire screening on the other. Another type, called Tempered Presdwood, contains additional ingredients to strengthen it and increase its durability. But Standard Masonite Presdwood surpasses it in the ability to hold a ground (especially gesso) permanently—a property far more essential to its success as a permanent support.

mass. In painting and design, any area of sufficient size or importance to be a significant element in the design, e.g., a building or a group of trees against the sky.

mass color. See MASS TONE.

massicot. An oxide of lead similar to LITHARGE, but deeper or more reddish in hue. Also known as plumbic ochre, it is occasionally referred to as GIALLOLINO, giallorino, and giallolino di Fiandra (Flemish yellow). Massicot was used as an artists' pigment from the 15th century to the end of the 18th or the early 19th century.

massier. French term for the monitor or student in charge of an art class.

mass tone. The surface color effect of a pigment when viewed by reflected

light, as distinguished from its UNDER-TONE; also called top tone, mass color. See colorplate facing page 118.

master. 1. An artist of high achievement, especially one of the leaders of a school or period.

2. Originally, the status or standing of one who was an artist or craftsman qualified to execute commissions by himself or with a hired JOURNEYMAN.

masterpiece. One of an artist's works that represents his top level of accomplishment; any work of art that ranks among the best of its kind. A frequently encountered French equivalent is chef d'oeuvre.

mastic. 1. A RESIN obtained from a tree (*Pistachia lentiscus*) that grows in the countries bordering the Mediterranean. It comes on the market in pale amber-colored drops or tears the size of small peas. Mastic is soluble in both alcohol and turpentine; a turpentine solution was popular as a PICTURE VARNISH during the 19th century, when a smooth, high-gloss finish for oil paintings was admired. It was superseded in the first half of the 20th century by DAMAR, which does not have the defects of yellowing, clouding (bloom), or cracking with age that are characteristic of mastic, and which does not produce such a glassy finish. Nevertheless, mastic, the best grade of which is known as Chios mastic, makes a better picture varnish than any of the other tree resins. Mastic was also used as an ingredient of MEGILP. Its name derives from the local use of mastic as a chewing gum.

2. Any of several adhesive, resinous cements of plastic consistency used in building construction to fill gaps in masonry, to insulate or waterproof, and also to set tiles and the tesserae of mosaics. The term includes cements of various compositions, most

of them black in color and resistant to weathering. An oil-based mastic was in use as early as the 16th century as an improvement on plaster for setting mosaics. During the recent past, ASPHALT and coal tar were largely used, but the most successful present-day mastics for mosaic setting and other uses are trade products made with synthetic resins.

mat. 1. Lusterless; having a dead, flat surface appearance; sometimes spelled matt and, in Britain, matte. Mat effects are due to a microscopic roughness or irregularity of surface, which causes light to be reflected in a diffused manner, in contrast to the specular or mirrorlike reflection of a glossy surface. Water paints usually dry to a mat finish, although sometimes they have a satiny sheen called semimat or eggshell. Oil colors are naturally glossy when dry and may receive added luster if a glossy picture varnish is applied to them. Polymer colors dry with a gloss unless the mat medium is mixed with them to create a mat or semimat finish. See also GLOSS.

2. A stiff material, such as cardboard, cut out in the center so that it forms a border between the outer edges of a picture and the inner edge of its frame. MAT BOARD is specifically designed for this purpose, but other types of paperboard have been used. A mat is occasionally used as the sole frame of a picture and, with glass and a backing, in the method of framing called PASSEPARTOUT.

Mata Kuching damar. Traditionally, a DAMAR resin of superlative quality—a selected grade of Singapore damar that has been absent from the market for decades. Mata Kuching means "cat's eye," and the damar is also known by that name.

mat board. A stiff cardboard with a thin facing of paper on one side, used to make mats for pictures, especially those done on paper. Mat board, unlike illustration board, which has a base layer of gray cardboard, has a white or whitish base, to make a pleasing beveled edge. Its surface may be smooth or pebbled, dull or glossy; the typical mat board has a fine, pebbled texture and a dull finish. Mat board comes in a wide variety of colors, although the most common are various shades of white, cream, and gray; special finishes and textures, including linen, metallic, and wood-grain effects, are available. Mat board is usually made of wood pulp. A pure rag board is best used for matting permanent works of art, since paper may become discolored from prolonged contact with a wood-pulp board.

mat cutter. A device used to make neat, accurate cuts, either straight or beveled, in MAT BOARD. Of the several types made, one is built like a T-square, with a blade holder that slides along the long arm. Another is a heavy steel implement, its back shaped to fit the hand and with a perfectly smooth face meant to slide along the edge of a ruler. The face has a recess in which the

DEXTER MAT CUTTER

blade is held. On all types, the blade may be adjusted for both the angle and the depth of the cut.

mat gilding. MORDANT GILDING or unburnished WATER GILDING, producing an unpolished surface. Gilding on glass automatically has a specular finish, as though it had been burnished. In order to obtain a mat finish on glass, therefore, the areas to be mat must be coated with damar or mastic varnish before the leaf is laid. Burnished metal appears darker than an unburnished surface, and mat and burnished gilding may be used in combination to give a striking effect of reflected light and contrasting tones; lettering and designs on glass frequently have mat centers.

mat glaze. In ceramics, an opaque glaze with a dull, nonreflective surface. A mat effect can be induced by adding barium or alumina (clay) to raise the maturation point of the glaze.

mat knife. A knife with a short, thick handle and a razor-sharp blade. Two types are in use, one designed to hold a

MAT KNIVES. Above, a heavy-duty knife with a short, replaceable blade. Below, a knife with a long, adjustable blade that is lengthened as it is worn through sharpening.

short, replaceable blade, the other with a long blade, most of which fits into the handle and which may be repeatedly sharpened and reset to the proper length as it wears away.

mat medium or **mat polymer medium.** See POLYMER MEDIUM.

matrix. 1. A natural mineral substance in which another material, such as a metal, crystal, or fossil, is embedded.

2. By extension, any concave form that surrounds or encases a solid form, such as a mold used in casting, a recessed die used to strike or stamp a relief pattern, or a foundation for inlaid damascene work.

3. The binder used to cement the particles in a composition or conglomerate material such as concrete or imitation stone.

matter. Another name for a MACE-HEAD, used in CRAYON MANNER and MEZZOTINT.

matting wheel. A variant of the roulette, used in CRAYON MANNER. See illustration at ROULETTE.

mattoir. Another name for a MACE-HEAD, used in CRAYON MANNER and MEZZOTINT.

maturation. In ceramics, the hardening of a ware as a result of firing. The clay matures only when given sufficient time and heat. Overfiring causes deformation of the ware.

mat varnish. Any varnish intended to give a flat, non-glossy effect when applied. There are no completely successful non-yellowing mat varnishes for permanent, fine-art paintings. One mat varnish made by adding white refined beeswax to damar varnish gives fairly good semi-mat or satin finish results, but, like all wax coatings, polishes when it is rubbed, so that the mat effect is not reliably permanent. Special proprietary mat varnishes are used in MAT GILDING. Industrial mat varnishes are available and can be used by decorators and others to whom eventual yellowing and darkening are not as critical as they are to the artist.

maulstick. Variant of MAHLSTICK.

mauve. A SYNTHETIC ORGANIC PIGMENT of medium saturation and a pale violet-purple hue, more intense than lavender. It resists fading poorly. Discovered by W. H. Perkin in 1856, mauve or PERKIN'S VIOLET was the first synthetic dyestuff produced from coal tar. Pink mauve is a reddish variety of mauve.

Maxwell triangle. See CHROMATICITY.

Mayan blue. A greenish-blue pigment found in Mayan artifacts and, to a lesser extent, in those of other pre-Columbian civilizations. The chemical identity of Mayan blue was unknown and sought for over three decades. According to extensive studies made in Belgium and published in 1967, it is now considered to consist of INDIGO and ATTAPULGITE.

meander. See FRET.

mechanical drawing. A type of drawing used by architects and engineers to convey specific information in graphic form. Its chief objective is to make it possible for someone to construct what someone else has designed. Also known as drafting and precision drawing, mechanical drawing takes its name from the fact that the draftsman uses mechanical devices to achieve his end. SCALES and detailed, accurate systems of PROJECTION and proportion, as well as such tools as the FRENCH CURVE, the T SQUARE, and the compass, are used to indicate the exact size and shape of the thing drawn and the relationship of the parts to each other and to the whole. The RULING PEN is a common drawing implement. Whereas in freehand drawing the creative artist defines his ideas, in mechanical drawing the draftsman communicates those

ideas in a universal, unequivocal language. When the draftsman sketches without the use of instruments but still adheres to the conventions of mechanical drawing, the practice is known as technical sketching. See also ELEVATION; EXPLODED VIEW; RENDERING.

medieval art. Art of the Middle Ages in Europe, from the decline of Roman civilization about A.D. 500 to the 14th century, when it was supplanted by the Renaissance style and spirit. See BYZANTINE; ROMANESQUE; GOTHIC.

medium. 1. A liquid that may be added to a paint to increase its manipulability without decreasing its adhesive, binding, or film-forming properties. A highly recommended oil painting medium contains a small percentage of a non-yellowing resin such as damar, an equal or somewhat larger amount of a non-yellowing, heavy-bodied drying oil such as stand oil or sun-refined oil, a rather large percentage of turpentine, and, usually, a small amount of cobalt drier. A non-yellowing, oil-modified alkyd resin is also recommended. The use of acrylic resin solution as an oil painting medium or ingredient is not recommended because of its imperfect miscibility with oils. The liquid in which pigments are dispersed or ground to make a paint is called a VEHICLE rather than a medium. *Pl.*, mediums.
2. The specific tool and material used by an artist, e.g., brush and oil paint, chisel and stone. *Pl.*, media.
3. The mode of expression employed by an artist, e.g., painting, sculpture, the graphic arts. *Pl.*, media.

megilp. A gel painting medium, sometimes spelled magilp or McGuilp. Megilp is made by mixing mastic varnish and linseed oil supersaturated with white lead. It was popular during the 18th and 19th centuries because of the facile and versatile manipulative qualities it gives to oil colors. But as early as 1826 chemists advised against its use by artists, and by 1900 it had been completely discredited as a medium on the grounds that it was a major cause of embrittlement, cracking, and yellowing of oil paintings. It is generally believed that megilp was originated by decorators and trade painters of the 18th century, although it has been attributed, without much substantial proof, to artists of the Renaissance. See also MAROGER MEDIUM.

MEK. See METHYL ETHYL KETONE.

memento mori. A motif used in art and elsewhere as a reminder of death; from the Latin words meaning, "Remember that you must die." A skull is

MEMENTO MORI. *Vanitas* (1623) by Pieter Claesz, oil on wood. (*The Metropolitan Museum of Art, Rogers Fund, 1949.*)

a common memento mori. During the Renaissance a small ornament in the shape of a skull was often carried; it was usually of fine craftsmanship and might be set with gems. In art, a typical memento mori is the skull in Dürer's engraving, *St. Jerome in His Study* (1514). An entire painting might also be called a memento mori.

mending tape. See PRESSURE-SENSITIVE TAPES.

mercury yellow. Another name for TURPETH MINERAL.

metal leaf. See DUTCH METAL.

metallizing. Coating a surface with a metal by ELECTROPLATING, METAL SPRAYING, or a modern vacuum process.

metal spraying. Depositing a thin layer of metal on a surface or object with a spray gun. The spray gun is loaded with a coil of thin wire (gold, silver, bronze, etc.) and contains a heating element to liquefy the wire. The liquid metal can be deposited with the gun on any surface, however flammable, in a smooth, even coating. This process is used by metal sculptors for "gilding" works executed in base metals.

metamerism. The undesirable tendency of two colored surfaces that appear alike when viewed under one kind of light (daylight, fluorescent tube, tungsten bulb, etc.) to differ from each other when viewed under another. Such colors are called metamers or metameric pairs. Gloss, surface texture, transparency, and ratio of pigment to binder may contribute to metamerism in colors. But its main cause is difference in the composition of the two colors used. Painters may avoid its occurrence when repainting or adding new touches to a picture by using identical pigments instead of a mixture of other materials to match a color.

metamorphic rock. See ROCK.

methacrylate resin. See ACRYLIC RESIN.

methanol or **methyl alcohol.** A VOLATILE SOLVENT with solvent properties at least as good as ethyl alcohol. Both the liquid and its vapors are dangerously toxic and have a notably destructive effect on the optic nerve. It is also called wood alcohol and, formerly, Columbian spirits. The chemical name methanol has long been preferred because of the dangerous confusion between methyl and ethyl alcohol.

methyl acetone. Impure ACETONE, containing varying amounts of methanol and methyl acetate. Its solvent action is weaker and its vapors more toxic than those of pure acetone.

methyl alcohol. See METHANOL.

methylated spirit. British term for DENATURED ALCOHOL.

methyl cellulose. A cellulose product that resembles fluffy white cotton. Methyl cellulose is related to the cellulosic compounds used in LACQUER, but it is soluble in cold water rather than in volatile solvents. It has found a few uses in artists' materials, principally as a binder in pastels and other crayons.

methyl ethyl ketone. A LACQUER SOLVENT used in industrial processes; usually abbreviated MEK. Its properties are similar to those of acetone except that it is a more efficient solvent for some resins and is dangerously toxic. Its presence in epoxy and polyester resin materials makes those materials hazardous to use except under carefully controlled conditions.

methyl silicate. See SILICON ESTER.

métier. In art, the specialty that an artist is best qualified in, most successful at, or most at home in.

Mexican onyx. See ONYX MARBLE.

mezzo fresco. A term used to distinguish a FRESCO technique of the latter half of the 16th century from that of "buon fresco." In mezzo fresco, painting was done on partially dry intonaco. Because the colors sank only slightly into the firm plaster, lime was added to them to enhance their adherence. The drawing was incised on the half-firm intonaco by tracing on a cartoon with a stylus.

mezzo-rilievo. Italian for middle or half-RELIEF.

mezzotint. A RELIEF PRINTING process, that is a kind of reverse ENGRAVING procedure, in which the entire surface of a copper or steel plate is heavily abraded with a special tool called a ROCKER, or cradle. The over-all burr thus created prints as a dark, velvety black. The areas to be white in the print are painstakingly rubbed with a BURNISHER and an engraver's SCRAPER, which smooth and depress those areas so that they do not take the ink in relief printing. Thus, the whites are extracted from the blacks, whereas the usual procedure in line engraving is to engrave the blacks and print the plate as an intaglio surface. For HALF-TONES (from which the process gets its Italian name, mezzo = half + tinta = tone), the burr is only partially removed with the scraper or burnisher, leaving areas of variously concentrated dots. A GRAVER, MACE-HEAD, ROULETTE, or drypoint NEEDLE may be used to increase the burr of the printing areas, making them even darker in the proofs. Other abrasives and methods (e.g., sand, pumice, and nitric acid) have been used to roughen the surface of a mezzotint plate, but none is as effective as the rocker.

Because mezzotint produces form in tonal areas rather than in line, it is particularly suited to color printmaking. It was widely used in the 18th and 19th centuries to reproduce portraits and other paintings, but became obsolete for this purpose with the introduction of photoengraving and photogravure. Although some artists still use the mezzotint technique to get an extra textural effect on a plate done primarily in another medium, the laborious preparation of the mezzotint plate is a deterrent to its wide use in the fine arts.

mica. A native complex silicate that occurs in laminated, colorless, plate form. Pulverized, it is used as an INERT PIGMENT in industrial products, such as white CASEIN wall paint, to which it adds sparkle and brilliance, and in which its plate structure retards settling of the heavier pigments. Mica is not highly rated as an ingredient of permanent paints because it is apt to split up into additional laminations. Micronized mica, an extremely fine variety used in ETHYL SILICATE paints, is held to be more suitable for permanent uses than the ordinary pulverized grades.

Micarta. Trade name for laminated plastic sheets of a PHENOLIC RESIN, sold in many opaque colors.

microcrystalline wax. A white wax produced in the refining of petroleum oils. Like other paraffin waxes, it is chemically inert. It came into wide use in the arts in the mid-20th century as an additive to or replacement for white refined beeswax in a number of operations, notably for modeling and lost wax casting in sculpture and as an ingredient of lining adhesive in the conservation of paintings. It is available in various degrees of hardness and melting ranges to suit specific preferences. The harder varieties can be softened by adding up to 20% of mineral oil or

petroleum jelly, or by adding softer waxes.

middle distance. In the pictorial arts, that part of the composition between the foreground and the background. The middle distance is one of the three ZONES OF RECESSION in LINEAR PERSPECTIVE.

mildew. See MOLD.

mild steel. Malleable steel with a low carbon content; also called soft steel. Hard steel is not malleable and therefore cannot be worked. Mild steel will work well when heated to redness, although it is more difficult to shape than wrought iron.

milk of lime. Water containing a small amount of slaked lime (calcium hydroxide) in suspension, and used in SECCO painting.

Milori blue. PRUSSIAN BLUE. Along with Chinese and steel blues, one of its three best grades.

mineral blue. An unstandardized name applied to ANTWERP BLUE and AZURITE.

mineral gray. An old name for ULTRAMARINE ASH.

mineral green. An unstandardized term applied both to MALACHITE and the green variety of BREMEN BLUE.

mineral lake. Tin (stannic) chromate, an obsolete yellow pigment. Also, POTTER'S PINK.

mineral oil. Any of several grades of oil refined from crude petroleum. These products have similar viscous qualities and the same lubricity or unctuousness as the vegetable oils. They are chemically inert, and are seldom used in artists' materials. A refined, white, medicinal grade of mineral oil has been recommended for removing or preventing BLOOM in varnished oil paintings. A drop or two on a tissue is rubbed sparingly over the surface of a painting that has aged for some time; it is not used on fresh varnish, which it might injure.

mineral painting. A method of mural painting with pigments ground in potassium silicate (potash water glass); called also stereochromy and water-glass painting. The technique, known since about 1825, was perfected and standardized by Adolf Keim of Munich in the 1880's. It was so complicated that artists had small success with it, and it was abandoned before the end of the century. See also LIQUID SILICATES.

mineral pigments. Inorganic pigments of mineral origin and those made from inorganic chemicals or raw materials not in themselves coloring matters.

mineral spirits. A paint thinner, used as a substitute for turpentine and sold under the trade names of the various oil companies, e.g., Varnolene, Texaco spirits; also called petroleum spirits or petroleum solvent. It may be odorless or smell faintly like benzine. It has a low flash point; its fumes are nontoxic. It is refined especially for use as a thinner for varnishes and oil paints, and is preferred to turpentine by some artists because it costs less, is not sticky, and is free of turpentine's residual odor. Mineral spirits is known in Britain as white spirit.

mineral turbith. Another name for TURPETH MINERAL.

mineral violet. Another name for ULTRAMARINE VIOLET; formerly, a name for MANGANESE VIOLET.

mineral white. Another name for GYPSUM.

mineral yellow. Another name for TURNER'S YELLOW.

minette. An old name for YELLOW OCHRE.

miniature. 1. A very small portrait, painted on ivory, card, or occasionally another surface such as chicken skin. Miniatures were done in water paints; transparent watercolors were used almost exclusively from the 18th century on, although before that time tempera and other mediums were commonly used. The round, oval, or occasionally rectangular miniatures were often framed in narrow gold or gilt frames and protected by flat or convex glass. They had their greatest

MINIATURE. Pendant, watercolor on ivory, by Richard Cosway (1742–1821). Left, *Portrait of a Lady;* right, landscape with mother-of-pearl altar. (*The Metropolitan Museum of Art, Bequest of Mary Clark Thompson, 1924.*)

vogue in the 17th and 18th centuries, and were still popular in the 19th. The invention of photography caused the popularity of miniature portrait paint-

ing to wane. Samuel Cooper (1609–1672) and Richard Cosway (1742–1821) are considered among the greatest of many English miniaturists; Nicholas Hillyard (c. 1547–1619) was the earliest notable figure. Among American miniaturists, Robert Field (1749–1819) and Edward Green Malbone (1777–1807) are outstanding. Well known painters who occasionally worked in miniature include Holbein, Fragonard, Goya, and Rosalba Carriera. A miniaturist was often called a limner.

2. An ILLUMINATION. The portrait miniatures of the 17th–19th centuries developed out of medieval illuminations. The word miniature comes from the Latin verb *miniare,* "to color with minium (red lead)." Minium, with cinnabar, was the principal pigment used on early medieval illuminations.

3. Any very small picture in any medium.

minimal art. A name adopted in the late 1960's for a movement in which three-dimensional structures of basic or simplified form and flat color are created, suggesting the lines, planes, and solids of geometry; also called primary structure and ABC art. The individuality traditionally associated with creativity is minimized to such an extent that the artist is frequently able to have his work executed by a process of craftsmanship, such as cabinetmaking or tinsmithing, or of modern technology, such as the forming of plastics or fluorescent tubes. His own role in its creation is that of originator, designer, and technical supervisor. Perhaps the major source of this development has been the rise of basic design courses in art schools, where pure geometric forms are studied intensively both for their own sake and for their application to industrial design. Most of the activities of the minimal art movement

have centered around New York and Los Angeles.

minium. In writings of the classical period, minium means CINNABAR (native mercuric sulfide); at some time during the Middle Ages it came to mean RED LEAD. In English, the use of the term minium continued into the 19th century. Through the word "miniate," meaning to paint with minium, it gave rise to the word MINIATURE.

Minoan. Pertaining to the art and civilization of ancient Crete, which achieved a high level of artistic and technical development. Minoan civilization has been divided by scholars into early (3400–2400 B.C.), middle (2400–1580 B.C.), and late (1580–

MINOAN ART. Statuette of a snake goddess (16th century B.C.), ivory and gold. (*Courtesy, Museum of Fine Arts, Boston. Gift of Mrs. W. Scott Fitz.*)

1100 B.C.) periods. It reached its peak about 1500 B.C. Minoan pottery, fresco painting, and architecture are all noteworthy. Pottery was decorated with simple linear and abstract designs during the early and early-middle periods, and with a variety of plant, human, animal, and other naturalistic forms in the later phases. Frescoes on the walls of the great palace of Minos at Knossos, discovered in 1912 and restored partially since then, give us some idea of Minoan social and religious life. While these frescoes are similar to the stylized wall paintings of ancient Egypt, with which the Minoans traded, they are far more naturalistic, sensuous, and individualistic. Minoan architecture is best represented by the palaces of the middle to late periods, at Knossos, Phaistos, and Malia—each of which was built on the site of an earlier palace. Besides having elaborate wall decoration, these later palaces were remarkable for their sophisticated drainage systems.

minor arts. All art forms other than architecture, painting, sculpture, drawing, and printmaking (which are ordinarily called FINE ARTS). Although the term is a standard classification, it tends to be misleading. Daniel F. Thompson, in his *Materials of Medieval Painting* (1936), points out that precisely those artistic creations that touched the lives of other ages most closely—such as Greek pottery making, medieval book painting, Far Eastern ceramics, and Persian rug making—fall into the arbitrary category of "minor" art. However, like APPLIED ART, the term is useful for making pragmatic distinctions, even if it will not bear intense philosophical scrutiny.

Miracle clay. Trade name for a SELF-HARDENING CLAY.

Mir Iskusstva. See WORLD OF ART.

mishima. A method of decorating ceramic ware that originated in Korea. Depressions are pressed or stamped into plastic clay and filled with an engobe of a contrasting color. Sometimes added glazes are brushed on the surface of the ware.

Mittis green. A somewhat less clear and deep variety of EMERALD GREEN; also known as Vienna green. Some believe that its invention by Baron Ignatz Von Mitis in Vienna antedated the discovery of emerald green in Schweinfurt (1814).

Mittler's green. VIRIDIAN made by a method that was abandoned in favor of Guignet's process.

mixed technique. In painting, the technique of combining tempera colors with paints in an oleoresinous medium to produce various effects that cannot readily be duplicated by other means; in German, *mischentechnik.* The application of tempera colors with a fine, pointed sable brush on the wet glaze of an oil painting produces fine, crisp lines and touches; loose, free areas or opaque dragging strokes in tempera on darker areas of transparent glazes can yield a glowing effect. Some investigators have held that such techniques were used by painters of the transitional period between the era of tempera painting and the development of oils. Use of a stand oil-damar glaze and an egg-and-oil tempera is believed to increase the permanence of the technique. Mixed technique first became known in the U.S. and Britain in 1934 with the publication in English of Max Doerner's *The Materials of the Artist and Their Use in Painting.* See WET-INTO-WET.

Mixed white. Trade name for a COMPOSITE WHITE artists' oil color.

mixing bowl. In sculpture, a round bowl of rubber or thin, flexible brass used for mixing and containing wet plaster. Hardened remnants of plaster adhering to the bowl after use are easily turned out because of the bowl's flexibility.

mixing varnish. Any VARNISH that may be mixed with oil paints and other coating materials. For example, damar varnish, when used as an ingredient of an artist's painting medium, confers such properties as hardness, quick setting, and desirable manipulative qualities.

mobile. In sculpture, a delicately balanced arrangement of thin rods or stiff wires and objects suspended from them. The entire construction hangs from a thin filament and is moved by slight air currents. The mobile was named by its inventor, the American sculptor Alexander Calder (b. 1898), who made use of flat plates in bold colors and abstract, curvilinear shapes, usually hanging in rows like leaves on a branch. The form has been widely adopted by artists and decorators, who include in their mobiles a great variety of natural and abstract objects, materials, and shapes. The stabile, also invented and named by Calder, resembles the mobile but is rigid and stationary rather than flexible and suspended.

mobility. The ease with which a material flows—the opposite of VISCOSITY. The word fluidity has the same meaning as mobility except that it is generally applied to thin, free-flowing liquids, while mobility refers to the flow of thicker or slow-moving oils, varnishes, and paints. See CONSISTENCY.

mock gold. Another name for MOSAIC GOLD.

modeling. 1. In sculpture, the technique of manipulating a plastic substance such as clay; especially, the technique of building up a form in clay by an additive process of shaping and enlarging, as distinguished from CARV- ING, or cutting away.

2. In drawing, painting, and other two-dimensional media, the depiction of solid or three-dimensional form. It is usually achieved through the representation of light and shadow.

3. Posing for an artist.

modeling board. A sturdy board that the sculptor may place on his work table or MODELING STAND as a base for the clay or other modeling material on which he is working.

modeling clay. 1. A composite plastic substance used for MODELING. It

is non-hardening and cannot be used for permanent work, but is useful for making models for casting, or for use by students, as it can be reused many times if kept clean. The original material, made in Italy, consists of tallow, sulfur, and a high-quality clay. Inferior imitations are made of clay, an inert filler, and various petroleum greases and oils; coloring matter is added, usually to produce a gray-green color. Modeling clay is sold under various trade names, such as Plasticine and Plastilina. It is also called modeling wax and plasteline.

2. Any natural CLAY used for modeling by sculptors; more commonly called wet clay.

modeling paste. A stiff white paste sold with the various brands of POLY- MER COLORS as a modeling material. It

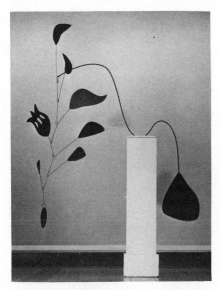

MOBILE. Alexander Calder, *Pomegranate* (1949), sheet aluminum, steel, steel wire and rods. Height 72 inches; diameter 68 inches. (*Collection, Whitney Museum of American Art, New York; Geoffrey Clements, photographer.*)

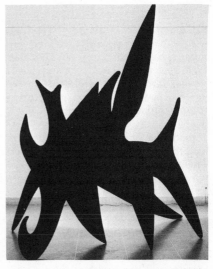

STABILE. Alexander Calder, *The Cock's Comb* (1960), sheet iron, 119¼ x 145¾ x 98½ inches. (*Collection, Whitney Museum of American Art, New York; Gift of the Friends of the Whitney Museum of American Art; Geoffrey Clements, photographer.*)

has many uses, such as making textured effects in polymer painting, sculpture, and collagraphs. It is essentially a stiffer, less fluid form of POLYMER PRIMER.

modeling stand. A 3- or 4-legged revolving stand on which sculptor's CLAY is modeled; also called a turntable. Made of wood or steel, a typical

MODELING STAND

modeling stand is about 3 feet high with a 16-inch-square revolving top that can be elevated to about 20 inches higher. Another type of stand has a smaller circular top, and some heavy models have a central supporting column and a circular base.

modeling tools. Implements used in modeling or shaping clay and plaster. There are three basic types: the wooden tool, usually of boxwood, in a great variety of pointed, spatulate, serrated, and rounded shapes; the wire-end tool, with one end flaring out to form a wooden tool and the other consisting of a loop of strong steel wire set in a brass ferrule, on a rounded wooden handle; and the double-end wire tool, which has a loop on each end of a wooden handle. The loops, used to carve or shave away the clay, come in a wide variety of rounded and angular shapes. Boxwood tools, shaped differently at each end, are usually 6 to 8

inches long. Wire-end and double-end tools of similar lengths are available, although very small, thin-line versions of these tools exist for modeling on faces and other delicate work, as do large, so-called "professional" tools up to 13 inches long with maple handles and brass wire loops.

modeling wax. See MODELING CLAY.

modello. In Italian, a model. Thus, a smaller version of a proposed work of art, sometimes sketchy and sometimes highly finished (see SKETCH). A modello of a projected work is often executed for discussion with a patron or teacher or for the approval of a client. A small model for a work of sculpture is also called a MAQUETTE.

model stand. In an art class or a portrait-painter's studio, a low platform on which the model poses. It is sometimes made in the form of a wooden box on rollers, which, when not in use, may be upended to save studio space. Its hollow interior may be used for storage.

MODELING TOOLS. (A) Boxwood tools; (B) wire-end tools; (C) double-end wire tool.

Mogen David. See SOLOMON'S SEAL.

moiré effect. The optical illusion observed when curved parallel or periodic lines are superimposed, forming a pattern which does not in fact exist. Watered silk exhibits the moiré effect, which has been used by such mid-20th-century practitioners of OP ART as J. R. Soto and Gerald Oster.

moisture trap. A device attached to the air compressor of a SPRAY GUN or AIRBRUSH to prevent condensed moisture from entering the spray line.

mold. 1. A hollow, or negative, container that gives its form to a substance placed within it and allowed to harden, in the process of casting. A typical mold is made by coating an original piece of sculpture with plaster of Paris and removing it when the plaster sets. A plaster cast that is a duplicate of the original may then be made by pouring liquid plaster into the cavity of the plaster mold and allowing it in turn to harden. A one-piece mold that must be destroyed to get the cast out is called a waste mold. A mold consisting of two or more separable pieces is called a piece mold. Removal of the mold without damage to the cast is aided by shellacking the inside surface and using a PARTING COMPOUND. The rubber mold, a 20th-century development, is also in wide use for casting plaster; other materials used for molds are glue, gelatin, and latex. Metal casting is done by SAND CASTING, in which both the negative containing mold and a positive CORE, allowing the final cast to be hollow, are made of foundry sand; or by the LOST-WAX PROCESS, in which a complex mold is made of gelatin, plaster, sand, and wax.

2. A kind of fungus which grows on various surfaces; it is implanted by spores, which are microscopic "seeds" that float in the air. Mold growth begins as a white downy mass, known as hypha and popularly called mildew. Later on it becomes either green, black, gray, or yellow depending on its species. The more common types, some of which have several variants, are *Penicillium* (green), *Aspergillus niger* (black), *Rhizopus nigrocans* (brown or black), and *Aspergillus flavus* (yellow and orange).

Mold on oil paintings is usually best removed by professional CONSERVATION methods such as fumigation and bleaching. Mold commonly occurs on prints in the form of FOXING, i.e., brown spots and splotches; if the infestation is not too severe it can usually be removed entirely by a hypochlorite bleach process. On the more fragile watercolor and pastel, the removal of mold is very difficult, when not impossible. Mold growth on works of art is encouraged by confined storage in a dark, warm, moist atmosphere, e.g., the hold of a ship. Water paints and pastel crayons can easily be protected from it by including a tiny amount of a modern fungicide or mold preventive in their composition. Mold should not be confused with bacteria, which are invisible micro-organisms. Whitish areas on an oil painting cannot always be identified as mold without a microscopic examination, for opacified or whitened varnish or an incrustation of foreign material can be mistaken for it. See also PRESERVATIVE, SILICA GEL.

molding or **moulding.** A narrow strip used for framing pictures and for finishing or decorating walls, furniture, and other structures. It may be applied, as an ornamental strip of wood or metal edging, or it may be actually carved or shaped from the material of the structure it decorates. Picture-frame molding is distinguished by the fact that it has a rabbet cut along one edge. Molding may be flat or round, simple or highly ornamented in con-

tour. Part of its decorative value lies in the shadows cast by its forms, which contribute an element of contrasting light and shade.

Monastral blue; Monastral green. British trade names for PHTHALOCY-ANINE BLUE and PHTHALOCYANINE GREEN; also, several dyestuff pigments of entirely different composition made by the same firm.

monochrome. Painted or decorated in light and dark shades of a single color, i.e., one pigment plus white. See CAMAÏEU; GRISAILLE.

Monolite yellow. A trade name for HANSA YELLOW.

monolith. A massive bulk of uniform composition, a sculpture (usually huge) carved from or cast in one solid piece. The term originally and literally meant carved from a "single stone."

monotype. A one-of-a-kind print made by painting on a sheet or slab of glass and transferring the still-wet painting to a sheet of paper held firmly on the glass by rubbing the back of the paper with a smooth implement, such as a large hardwood spoon. The painting may also be done on a polished metal plate, in which case it may be either printed by hand or transferred to paper by running the plate and paper through an etching press. Any paint that does not dry too quickly can be used. Enough of the original paint remains on the glass or plate after the transfer so that the same or different colors may be reapplied if subsequent prints of the same design are to be made. No two prints will be exactly alike, however, since variations in the repainting and transferring processes are unavoidable. Since each print is unique and executed separately by hand, monotype printing is not strictly

a multiple-replica process. Because monotypes are prints on paper, however, they are generally classed and exhibited as graphics.

montage. A picture made up of portions of various existing pictures, such as photographs or prints, arranged so that they join, overlap, or blend with one another. See also ASSEMBLAGE; DÉCOUPAGE; COLLAGE.

montan wax. A mineral wax refined from lignite coal. It is used in industrial paints, waterproofing, adhesives, leather finishes, and sometimes as a substitute for beeswax and carnauba wax. It is rather hard and brittle. The average grade of montan wax melts at about 80° C.

Monthier blue. A variety of PRUSSIAN BLUE.

Montpellier green. Another name for VERDIGRIS.

Montpellier yellow. Another name for TURNER'S YELLOW.

monumental. On a grand scale. In art criticism the term is often applied to a work of art that is usually, though not necessarily, large in size; elevated in idea; and gives an impression of grandeur of form, nobility or simplicity of conception, enduring significance, or ARCHITECTONIC quality. This effect, is, for example, striven for in many murals of Puvis de Chavannes (1824–1898) and in the monument to Balzac (1897), by Auguste Rodin.

mop. A round camel-hair brush of very large size, used in watercolor for blending and other manipulations.

morbidezza. An Italian word meaning softness or mellowness, used to de-

scribe the soft blending of tones and the rounding off or hazing of edges in pictorial and sculptural representations. *Morbidezza* was a much-used term in 18th-century art criticism, often applied to the painting of Correggio.

mordant. 1. In all printing processes in which a plate is produced by ETCHING and in the decorative etching of glass, steel, etc., the acid or acid mixture in a bath of which the object to be etched is immersed. The acid etches or eats away those lines, dots, and/or areas of design that are unprotected by a resist or ETCHING GROUND.

The mordants most commonly used in printing are dilute solutions of nitric acid (aquafortis) and hydrochloric acid (see DUTCH MORDANT; SMILLE'S BATH). FERRIC CHLORIDE, which is also sometimes used, hydrolyzes to form hydrochloric acid. A mordant must be of the correct concentration to act efficiently without also eating away the resist that protects the nonprinting areas. The term comes from the French *mordant* meaning "biting" (Latin, *mordere*), and indeed BITING is the descriptive term used in the graphic arts for the etching or eating-away effect that the mordant has upon the metal plate.

Glass is usually etched with a mordant solution of hydrofluoric acid. When a mat or "frosted" etch is desired on glass, ammonium fluoride is added to the hydrofluoric-acid mordant. Sulfuric acid is sometimes also used as a mordant for etching glass.

2. In dyeing, a chemical additive that sets or precipitates the dye and assists in attaching it permanently to the textile fibers or other substance being dyed.

3. In MORDANT GILDING, an oil or varnish GOLD SIZE.

mordant gilding. Metal leaf laid with an oil or varnish GOLD SIZE rather than with water, as in WATER GILDING. As the technique of mordant gilding does not permit burnishing, a mat finish is produced. The size must dry to the correct degree of tackiness in order to perform properly and must maintain that consistency for the duration of the work at hand. The surface of the ground must be sufficiently nonabsorbent to prevent the size from sinking in; if the surface is porous, like gesso, it must first be shellacked. (The shellacking of a gesso ground prevents it from being smoothed by a burnisher, so that even on gesso, mordant gilding must be mat.) Mordant gilding is used to lay leaf in oil painting.

morelle salt. Artificial red iron oxide; also an old name for LIGHT RED.

morinda. A yellow NATURAL DYESTUFF obtained from several East Indian mulberry trees and shrubs of the genus *Morinda*. Unlike most natural coloring matters, morinda has rather good resistance to fading.

mortar. 1. In fresco plastering, a mixture of aged LIME PUTTY and sand or marble dust.

2. The common cement used in bricklaying, stone setting, and repairing masonry. It is made by mixing lime plaster or gypsum plaster, sand, and Portland cement with enough water to obtain the desired plasticity.

3. See also MORTAR AND PESTLE.

mortar and pestle. The mortar is a sturdy bowl made of metal, stoneware, or heavy glass, in which dry materials are crushed or pulverized with the pestle, a short rod with a bulbous working end, made of the same material as the mortar. Sometimes the mortar is used for wet grinding, but for paints, the MULLER is more efficient.

mortarboard. See HAWK.

mosaic. The art or technique of creating pictures or designs with TESSERAE set in a MASTIC or a plaster GROUT; also, a work so made. Mosaic is one of the oldest decorative and pictorial arts and certainly one of the most durable. It has been executed on walls, ceilings, floors, pavements, portable icons, and occasionally on furniture and (with exceedingly tiny units) on jewelry. The tesserae may be small pieces of colored glass, stones, marble, wood, pottery, or any other hard, imperishable material. Mural mosaics are commonly made of opaque glass broken into small cubes. They are set with their fractured sides exposed, to reflect light and give the entire surface a sparkling brilliance. The same spar-kle may be achieved by setting flat-surfaced glass tesserae at slight angles or at varying depths. Floor and pavement mosaics are usually laid with flat tesserae or tiles in a perfectly even surface.

Up to and throughout the Middle Ages, mural mosaics were almost always set piece by piece directly into a bed of plaster. Since that time they have usually been assembled in sections in a studio or a shop. In the most commonly used method, known to the Italians as *mosaico a rivoltura,* a small portion of the mosaic is set into dry sand on a tray. Paper or cloth is pasted over the face of the assembly to hold it together, and it is then set as a unit into a surface prepared with grout or mastic. The paper is scrubbed away after the work has set. Sometimes the tesserae are glued face-down on a

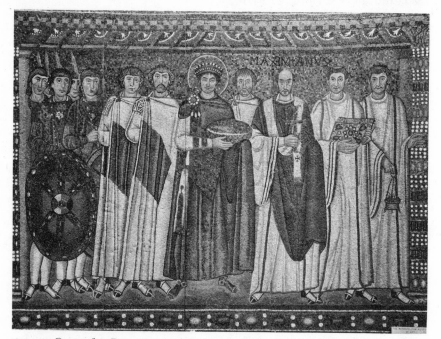

MOSAIC. Copy of a Byzantine mosaic (A.D. 536–547) in the Church of San Vitale, Ravenna, showing the Emperor Justinian and members of his court. (*The Metropolitan Museum of Art, Fletcher Fund, 1925.*)

paper cartoon, then transferred to the wall.

Mosaic was extensively used in Greek, Roman, and other ancient civilizations. The earliest known works that might be classified as mosaic are Sumerian surface decorations, clay cones with plain or colored heads driven into wet walls, that date from the third millennium B.C. Greek and Roman pictorial mosaic appears to have evolved out of nonfigural decoration with stones and shells set in cement, a technique in use in the 5th century B.C. in Greece, and several centuries earlier in Crete and Asia Minor. Polychrome pebble mosaics were being made by the 4th century B.C. Two notable groups of this age discovered at Olynthos and Pella in Macedonia, are elaborate works that typically contain a central mythological scene, a pictorial frieze, and an intricate border. Stone tesserae with beveled edges came into use during the 1st century B.C., at first merely to delineate fine detail (such as facial features) in pebble mosaics, then as the sole element of composition.

One of the most notable extant pictorial mosaics of the Hellenistic period is that from the floor of the House of the Faun in Pompeii (c. 100 B.C.), now in the National Museum at Naples, which depicts a battle between Alexander and Darius. Perhaps the finest mosaics of Imperial Rome are those decorating Hadrian's Villa near Tivoli, including a battle scene of centaurs and wild animals that was probably copied in the first half of the 2nd century from a Greek painting. Until about the 1st century A.D. pictorial mosaic was done almost exclusively on floors and pavements; mural mosaic did not become common until the early Christian era.

The potentialities of pictorial mosaic using opaque glass tesserae were most fully realized in Byzantium and in the West in medieval works influenced by the Byzantine style, as evidenced by the sumptuous examples in churches at Constantinople, Ravenna, Venice, and Rome. In Byzantium mosaic was the predominant representational art form, and it was usually integrated with the architectural composition of a church. This integration is well exemplified in the mural mosaics of the 11th-century Catholicon at Daphne, Greece. The mosaics include hierarchical arrangements of the figures of Christ, the Virgin, saints, and prophets—a common feature of Byzantine art. Dominating all is the resplendent *Christ Pantocrator* in the cupola, one of the glories of Byzantine mosaic.

During the Renaissance skilled mosaicists, or families of them, began to execute works designed by painters. Raphael, for example, supplied cartoons for mosaics done about 1516 in the dome of the Chigi Chapel of S. Maria del Popolo in Rome, and several mosaics for the Basilica of St. Mark in Venice were done between 1535 and 1545 from cartoons by Titian.

The attempt to duplicate in mosaic the effects of the paintbrush, and the delegation of its execution to craftsmen—concomitant developments of the 15th century—mark the beginning of the decline of mosaic art. Although it has been in eclipse for several centuries it has never been completely abandoned. A taste for color and decoration in architecture and the need for a durable medium that could withstand outdoor exposure brought about a considerable revival of the technique in the mid-20th century. One of the more striking modern mosaic works is that executed on the walls of the library of the University of Mexico in the 1950's from designs by Juan O'Gorman.

mosaic gold. Tin bisulfide; a fairly permanent pigment with a strong metallic luster. Used as a cheap substitute for gold leaf and powdered gold as

early as the 13th century, mosaic gold was replaced by BRONZE POWDERS by the mid-19th century. Other names for mosaic gold are aurum mussivum, cat's gold, mock gold, porporino, and purpurino.

moss green. One of the many hue variants of CHROME GREEN.

mother mold. An outer case or container for a negative MOLD made of gelatin, rubber, or another weak, flexible substance. The mother mold is made of a rigid material.

motif. A thematic or visual element in a work of art, usually recurrent. In design, a repeated form or pattern—geometrical, naturalistic, or stylized.

moulage. The technique of taking an impression or making a cast from a ready-made or natural object. Plaster of Paris is often used for this purpose, but a specially prepared moulage plaster, available in sculptors' supply shops, may be used on delicate or valuable materials such as art objects in museums and human skin and hair. See LIFE MASK; DEATH MASK.

mountain blue; mountain green. Medieval and Renaissance names for AZURITE and MALACHITE respectively; in modern times, applied to BREMEN BLUE and its greenish variant, Bremen green. In the 19th century several variants of Bremen blue and LIME BLUE were sold under the name of mountain blue in an unsuccessful effort to produce a substitute for the scarce and costly azurite.

mountain soap. Saponite, a soft, blackish mineral with a soapy or greasy feel; used as a FILLER or INERT PIGMENT in crayons. It is also known as rock soap.

mouth blower. See SPRAYER.

moyen-âge. Of, pertaining to, or reminiscent of the Middle Ages.

Mozambique ebony. See AFRICAN BLACKWOOD.

mucilage. A liquid adhesive made by boiling gum arabic solution with a small amount of a preservative and odorant. It is used principally as a paper adhesive. The terms mucilage and mucilaginous are also commonly used as generic terms describing gummy or gluey water-miscible substances.

muffle; muffle furnace or **muffle kiln.** A furnace with a compartment or a separate fireclay container called a muffle is sometimes used in firing ceramic wares, and in the calcination of inorganic pigments. The material or objects to be fired are placed in the muffle to protect them from the direct flames of the fire.

muller. An implement used for grinding paints by hand; it has a flat bottom and glides across a hard slab or tabletop. As far back as ancient Egypt and until the 18th century, both the muller and the slab were made of porphyry or another hard stone, and the muller was an irregular cone large enough to be held with two hands. Almost every old woodcut of an artist's studio shows a boy grinding away in a corner. Since the 19th century, the muller has been

MULLER

formed of solid glass, and the slab has been a sheet of plate glass or a marble tabletop. A large early 19th-century American muller was 11 inches high, weighed 22 pounds, and had a 6-

inch grinding face. Such mullers were used in the commercial production of artists' colors until about 1860, when mechanical paint mills were introduced. A modern muller of conveniently efficient size has a 4-inch face and weighs 3 pounds, but many are smaller. The curved edge at its base is an important part of its design, as it furnishes a wedgelike entrance for stiff paste colors. Mechanical devices for grinding paints include the BALL MILL and the ROLLER MILL.

multiliner tool. A wooden-handled metal SCRATCHBOARD tool with a broad, flat end that is serrated into several sharp points so that it can be used

MULTILINER TOOL

to scratch several lines with one stroke. This lightweight version of the MULTIPLE GRAVER is used not only for drawing closely parallel lines on scratchboard but also for scratching the ground on an etching plate and the crayon on a lithograph stone. The multiliner tool is available in six widths having three to ten points.

multiple graver. A graver whose cutting end is divided into two or more evenly spaced points, making it possible to incise several closely parallel lines with a single stroke. The multiple graver is used in line ENGRAVING and WOOD ENGRAVING, where it serves the same purpose as the MULTILINER TOOL does in etching and scratchboard. The multiple graver is known in Great Britain as a multiple-tint tool or a threading tool. See illustration at GRAVER.

multiple-tint tool. British term for MULTIPLE GRAVER.

multipurpose ground. A prepared canvas or panel designed for use with many media, such as oil, polymer, and watercolor. Since each painting medium has its own ideal requirements for a ground and since many of them are mutually exclusive, no multipurpose canvas or panel can equal the excellence of one prepared for a specific purpose, with the exception of the traditional gesso panel, which may be used or adapted for use with all artists' paints.

mummy. ASPHALTUM recovered from ancient Egyptian tombs, where it was used for embalming. Supposedly superior to ordinary asphalt, mummy was extensively used in the 19th century despite its grisly origin. It is also known as Egyptian brown.

Munich lake. Another name for CARMINE.

munjeet. Another name for INDIAN MADDER.

Munsell system. A system of color notation based on three responses of the human eye to color: the perception of HUE, VALUE, and CHROMA. Each color is identified with reference to these three characteristics. The system has been widely used and generally approved since its introduction by Albert F. Munsell in 1915, and in recent years certain faults in the spacing of colors have been observed and work has been done toward correcting them and improving the system. This method of color notation is explained in *The Munsell Book of Color* (1929) and in *A Practical Description of the Munsell System* (1937) by T. M. Cleland.

mural. A painting executed directly on a wall or ceiling; done on canvas and cemented to a wall (see MAROU-

FLAGE); or done on a panel that is made an integral part of a wall. Mural painting has, in addition to the technical requirements it shares with easel painting, a set of its own requirements, which make it a distinct branch of painting. A successful mural is not merely superimposed embellishment: it must be appropriate to and partake of its architectural setting. Unlike easel paintings, most of which are intended for viewing at or near eye level, the elevation of all or part of a mural, as well as its great expanse, often present rather formidable problems of perspective. Ideally, a mural painting's surface should be mat and textureless, so that it may be viewed without glare from any point. It must also be permanent for the expected life of the building and it must be able to withstand periodic cleanings.

Fresco, the traditional and ideal technique for interior murals, is not widely employed at the present time; it is a complex, laborious, and expensive process. Most modern indoor murals are done in OIL COLORS and, to a lesser extent, in SECCO, TEMPERA, CASEIN COLORS, and POLYMER COLORS. Murals on exterior walls must resist conditions much more adverse than those under which paintings are preserved indoors. Hence they are best executed with imperishable materials such as mosaic tesserae of stone, glass, or ceramics; glazed terra-cotta tiles; colored cement; porcelain enamel on iron; and relief stone carving painted with flat color that can be replaced periodically. No surface paints for exteriors have yet been devised that meet the fine-arts definition of permanence, for none can long withstand the continual bombardment of ultraviolet rays, airborne dust particles, chemical pollutants, rain and snow, and precipitous changes in temperature and humidity. Although fresco has been used outdoors in the dryer climates of southern Europe, on walls protected from direct exposure (as those of porticos and cloisters), it has always failed on exteriors in moist climates. The SILICON ESTER paints offer good possibilities for the development of a long-lasting surface paint for partially sheltered outdoor murals.

murex purple. Another name for TYRIAN PURPLE.

murrey. An old name for a mulberry hue, not used after the 18th century.

mutual solvent. A VOLATILE SOLVENT that is miscible with more than one class of liquids. ACETONE, for example, mixes with water as well as with oil, alcohol, or ethereal fluids. Such a material is also known as a coupling agent, because it can cause two ordinarily immiscible liquids to combine with each other to form a clear solution.

Mycenaean. Pertaining to the art and civilization of Mycenae and other cities on the Greek mainland during the late HELLADIC period (c. 1600–

MYCENAEAN ART. Late Helladic cup decorated with octopus motif, 1400–1100 B.C. (*The Metropolitan Museum of Art, Rogers Fund, 1906.*)

1100 B.C.). In elaborate tombs comparable to those of ancient Egypt, the Mycenaeans buried their dead, wrapping and sometimes preserving them, and covering their faces with golden masks. Jewelry, decorative cups, and weapons, often in gold, show Minoan as well as Near Eastern influence. Ornamental stone carving and ivory sculpture have also been found. The Homeric account of the Trojan War was first confirmed by the excavations at Mycenae, Tiryns, and Troy, discovered by Heinrich Schliemann beginning in 1870.

Mylar. Trade name of a polyester plastic available in the form of sheeting and used as a facing to prevent materials from sticking to a surface in operations that require any degree of pressure. The sheeting, which does not adhere permanently to waxes and many plastics in the unhardened state, is readily peeled away after the operation has been completed. It is used in the LINING of paintings and in laminating with polyester and other plastics.

myrtle green. One of the many hue variants of CHROME GREEN.

N

N. A. National Academician. Members of the NATIONAL ACADEMY OF DESIGN are entitled to append these letters to their names.

nacarat carmine. An obsolete term for the highest grade of CARMINE.

naphtha. A term applied to several VOLATILE SOLVENTS, including solvent naphtha, a COAL-TAR SOLVENT; VM & P naphtha, a petroleum solvent similar to MINERAL SPIRITS; and petroleum naphtha, a general term which covers petroleum solvents of various degrees of volatility. From ancient times to the 19th century, naphtha meant any highly volatile and flammable liquid. In the late 19th and the early years of the 20th century it was most commonly applied to all volatile petroleum solvents of greater volatility than kerosene, including gasoline and benzine.

Naples yellow. A permanent but rather pale yellow pigment made by calcining lead and antimony oxides. It has long been a favorite among painters because of its agreeable manipulative qualities in oil. Said to have been found in Babylonian tiles, it was used by European artists as early as the 14th century. Naples yellow was supposed by older writers, including Cennino Cennini, to be a native earth from Vesuvius. The dry pigment is manufactured on a small scale, and not at all in the U.S., since it is used only for artists' oil colors. Not all American brands of Naples-yellow oil color contain the genuine pigment; the label on the tube should indicate the composition.

Naples yellow is also used in ceramics as a stain to impart a yellow or ivory color. Because of its lead content the same precautions that are recommended for WHITE LEAD apply to it. Other names are antimony yellow, brilliant yellow, and jaune brillant.

Napoleon gray. A dark American LIMESTONE.

narrative. Depicting a story or idea. The term can be used as a nonpejorative synonym for LITERARY.

natch. In ceramic casting, a protuberance on one of the halves of a mold that fits into a depression in the other half to prevent the halves from getting out of alignment.

National Academy of Design. The principal ACADEMY of art in the U.S., founded in New York in 1826. Its first president was Samuel Finley Breese Morse (1791–1872). The Academy and its school for the training of artists served as a powerful influence on the American art world until the rise of modern or revolutionary movements in the 20th century. It has, however, continued to flourish as the leading society and showcase of conservative or traditional painters, sculptors, and architects. A member is entitled to place the letters N.A. (National Academician) after his name. The standard procedure is to admit a new member as an Associate (A.N.A.). He may be elected to full membership after a period of time.

natural dyestuffs. Coloring matters extracted and processed from plant and animal sources, as distinguished from the dyestuffs manufactured from coal-tar derivatives by modern chemical processes (see SYNTHETIC ORGANIC PIGMENTS). The use of natural dyes for making paint pigments and dyeing textiles has been traced back to the earliest primitive peoples. Other dyestuffs were developed in the ancient civilizations of Greece, Rome, and the Orient; still others, in medieval and Renaissance times. Insofar as their use in creative painting is concerned, all the natural dyestuffs can be considered obsolete. However, some are still used for specialized purposes or for reasons of economy; despite their lack of permanence and relative dullness, their low cost makes them preferable to more durable materials in coloring cheap products such as wrapping papers, scratch pads, and handbills.

The LAKE pigments made from natural dyestuffs were superseded during the 19th century by synthetic pigments of greater brilliance, which have been followed in turn by newer products of superior color stability. All the natural-dyestuff pigments will fade at varying rates on exposure to light. On fading, most of them also undergo a change in hue: for example, all the yellows except weld become reddish or brownish; some of the reds become more bluish, and a few will darken before fading. Many of the natural dyestuffs are still employed for coloring foods and cosmetics.

Some traditional natural dyestuffs are:

alkanet	litmus
annato	logwood
archil	lokao
barwood	madder
brazilwood	morinda
buckthorn berries	quercitron
chay	safflower
cochineal	saffron
cutch	turmeric
dragon's blood	turnsole
flavine	Tyrian purple
fustic	ventilago
kermes	weld
Indian madder	woad
indigo	

258

Synonyms or alternate names for these dyestuffs are listed and cross-referenced to the above main headings.

naturalism. See REALISM.

naval stores. The U.S. Government's designation for supplies of TURPENTINE and ROSIN, products of the distillation of pine BALSAMS. This usage was established by the Naval Stores Act of 1924 and is now in general use in the U.S.

naviform. Boat-shaped.

Nazarenes. Derisive name given to the Lukasbrüder (Order of St. Luke), a group of artists and writers. Founded in Vienna in 1809 by Johann Friedrich Overbeck (1789–1869) for the elevation of German art, its aim was to revive the spirit of the Middle Ages and to encourage the concept of art as a servant of religion. Its works displayed a heroic, or at least romantic, quality regarded as suitable to inspirational subject matter. Among its members were Peter von Cornelius (1783–1867), Karl Begas (1794–1854), Franz Pforr (1788–1812), and Julius Schnorr (1795–1872). Although the group was short-lived, it influenced certain painters of similar ideas in England and France, notably the PRE-RAPHAELITES and Ingres. Some of its characteristics were carried into the works of the DÜSSELDORF SCHOOL by its director, Wilhelm von Schadow.

needle or **point.** In ETCHING and DRYPOINT, a fine-pointed instrument for drawing on the plate. In drypoint the needle is used to incise the metal surface; in etching it merely cuts through the ETCHING GROUND. Etching needles are available in a wide variety of styles but can also be homemade. The traditional kind, made in one

ETCHING NEEDLES

piece, is a well-balanced, double-pointed steel rod about 4 inches long; sometimes the center of its shaft is twisted, corrugated, or squared for a good grip. A type of needle more widely used in etching is a pencil-sized holder of wood or cork into which is inserted a single point; some handles have a screw grip or chuck that allows points of different sizes and shapes to be interchanged and worn or broken points to be replaced. A sharp point is adapted to certain kinds of drawing, but a needle with a slightly rounded point, like that of a steel phonograph needle, is the standard, preferred needle for general use; it is more easily manipulated and is less likely than a sharp point to dig in to a sudden stop. Lines that have already been inscribed with a graver can be made to taper or swell by using an oval-faceted needle called an ECHOPPE; in etching, the echoppe can widen these lines without necessarily causing deeper biting into the plate. The sharpness of a point can be increased by whetting it on an Arkansas stone (see OILSTONE), or the point can be dulled slightly, to prevent it from digging into the plate, by drawing it across glass or cardboard. A blunted point creates coarser or somewhat wider lines. In drypoint, JEWEL POINTS are also sometimes used, facilitating the drawing of curved lines.

needle-point pen. See STYLOGRAPH.

negative mold. See MOLD.

neoclassical art. Any art which revives, or is influenced by, that of ancient Greece or Rome.

Neoclassicism. A style of the late 18th and early 19th centuries, particularly in France. The painter Jacques Louis David (1748–1825) was not

NEOCLASSICISM. Jacques Louis David (1748–1825), *Portrait of Madame de Servan*, oil on canvas. (*The Springfield Museum of Fine Arts, Springfield, Mass.*)

only influenced stylistically by classical art, but took classical themes for his subject matter. Other artists working in this style were Joseph Vien (1716–1809), J.A.D. Ingres (1780–1867), Anton Raphael Mengs (1728–1779), and the sculptor Antonio Canova (1757–1822).

neo-expressionist. In art, a term sometimes used to characterize all schools of abstract art whose forms are basically determined by emotional, impulsive, or accidental forces, as distinguished from geometric abstraction or any other meticulously planned work. ABSTRACT EXPRESSIONISM can be classified as a neo-expressionist movement. Neo-expressionist art stems from

Kandinsky, its antithesis from Mondrian.

Neo-Plasticism or **De Stijl.** An art movement adhering to principles of abstraction and simplicity; form was reduced to the rectangle, and color to the primary red, blue, and yellow, in Neo-Plasticist paintings. The group of Dutch artists working in this style published an influential magazine called *De Stijl* between 1917 and 1928; *Neo-Plasticism* was the title of a manifesto published in 1920, and the term preferred for the principles of the movement by its leading figure, Piet Mondrian (1872–1944). Others active in the group were the painters Theo van Doesburg (1883–1931) and George

NEO-PLASTICISM. *Color Planes in Oval* (1914?), oil on canvas, by Piet Mondrian. (*Collection, The Museum of Modern Art, New York.*)

Vantongerloo (b. 1886), and the architects J.J.P. Oud (1890–1963) and Gerrit Thomas Rietveld (b. 1888).

Their interest in minimal elements greatly influenced graphics, industrial design, and the cinema, as well as painting and architecture.

nepheline syenite. A feldspathic rock used as a FLUX in ceramics. It fuses at a lower temperature than most potash feldspars, thus permitting significant saving of fuel.

nephrite. See JADE.

nero antico. A black MARBLE with occasional white spots or lines. Used by ancient Greek and Roman sculptors, it is said to have been quarried on the promontory of Taenarum in Greece.

nest saucers. A set of small, flat, porcelain dishes used for diluting and mixing inks, watercolors, or other aqueous paints, so called because their flanged bottoms allow them to be stacked up to occupy a small space, while preserving the washes and keeping them clean.

Neue Sachlichkeit or New Objectivity. A form of expressionist art, practiced in Germany just after World War I by such artists as Otto Dix (1891–1969) and George Grosz (1893–1959). It insisted on using representational detail in a clear and precise technique carried beyond the point of normal observation. A phrase often used to describe it is "clinically exact." Unlike

NEUE SACHLICHKEIT. *Street Scene*, a lithograph from the portfolio *Im Schatten* (1921) by George Grosz. (*Collection, The Museum of Modern Art, New York.*)

other forms of EXPRESSIONISM, it was often concerned with social and political criticism and satire as well as with the artist's emotions.

neutral color. A color that is neither warm nor cool, i.e., not dominated by red or blue. Medium grays and browns are usually considered to be neutral.

neutral orange. A prepared artists' color made of MIXED PIGMENTS. The best grades would contain cadmium orange or deep cadmium yellow and light red.

neutral tint. A prepared watercolor of a grayish-violet hue; a COMPOSITE PIGMENT usually composed of India ink, phthalocyanine blue, and a small amount of alizarin crimson.

Neuwied blue. LIME BLUE sold in DROP PIGMENT form.

new blue. An unstandardized name originally given to a variety of COBALT BLUE containing chromium; also, perhaps more frequently, applied to special shades of ULTRAMARINE BLUE.

New Masters. Trade name for an American manufacturer's line of COPOLYMER (acrylic-vinyl) POLYMER COLORS and their adjuncts.

newsprint. The type of paper on which newspapers are usually printed; it is a very cheap paper, made of wood pulp. Newsprint is available in pads up to 18 x 24 inches in size, in single sheets up to 24 x 36 inches, and in rolls 42 inches wide. It takes charcoal, soft lead pencil, and litho crayon well, and is therefore a popular sketching support in art school classes and for preliminary drawings. But since it turns brown and becomes brittle on relatively short aging, it cannot be used for permanent work.

New York school. The group of painters, working principally in New York City, who gained worldwide prominence in the decade after the end of World War II as the creators of ABSTRACT EXPRESSIONISM.

niello. A black metallic compound of sulfur alloyed with an amalgam of silver, lead, and copper, used to decorate gold, silver, and other metals by filling in incised designs; also, the decorative metalwork so created. The incised metal surface is covered with pulverized niello mixed with borax, which acts as a flux, and heated until the niello becomes a solid mass. After cooling, the surface is scraped, leaving the black, enamel-like metal in the incised lines, and then burnished. The metal surface is then sometimes gilded. This technique, which is particularly adapted to very small, delicate work, dates from antiquity. Rather complete details of the process were given by Theophilus Presbyter in the 11th century and by Benvenuto Cellini (1500–1571), who claimed in his writings to have revived it from a forgotten art. Niello is used to decorate both jewelry and larger surfaces; Russian TULA work is a notable example. See also BROAD MANNER; FINE MANNER.

nigged. In stone carving, dressed, or finished, with a pick rather than a chisel.

nimbus or **halo.** A radiance depicted about the head of a sacred personage as a symbol of glory or veneration; also, a representation or stylization of such a radiance in a work of art. The nimbus appears on representations of Christian saints, Old Testament figures, angels, imperial personages, ancient Greek and Roman deities, and venerated figures in Buddhist and other Asian art. The nimbus is usually circular, although it is sometimes hexagonal or

lozenge-shaped, and may be rayed. A living person is sometimes shown with a colored square nimbus, as a sign of reverence. After the 5th century, Christ was commonly depicted with a nimbus containing a cross.

The nimbus is occasionally called an aureole, although this term is usually reserved for the radiance surrounding the entire body, rather than the head, of the venerated figure. See illustration at AUREOLE.

nitrate green. A variety of CHROME GREEN, usually of cool or bluish undertone.

nitrocellulose. See CELLULOSE NITRATE.

noir belge. See BELGIAN BLACK.

non-creep or **non-crawl.** Painter's term for a solution of WETTING AGENT; non-crawl solution is available in dropper bottles in art supply shops.

nondrying oil. A vegetable oil that does not form a solid film on exposure to air, even over a long period of time, and does not dry even when a drier is added to it. CASTOR OIL is a nondrying oil.

nonobjective. In art, not representing any object, figure, or element in nature, in any way; nonrepresentational. Nonobjectivism was also another term for SUPREMATISM, used by

Alexander Rodchenko. See ABSTRACT ART.

normal butanol. A volatile organic liquid used as a diluent or thinner for lacquers.

Normandeaux stone. See LIMESTONE.

note. A SKETCH, either in black and white or in color, from life or nature, subsequently used as a reference for a work to be done in the studio. A note is frequently of a detail and is sometimes done to capture an ephemeral effect. It may be accompanied by written descriptions of colors, shapes, lighting, and atmospheric effects, which serve to refresh the artist's memory when he refers to the note for his final work.

Nottingham white. An obsolete name for WHITE LEAD, used in England during the 19th century.

nouveau. French term for a beginner or inexperienced student in an art class.

Nuernberg violet. Another name for MANGANESE VIOLET; said to have been invented by E. Leykauf, who gave it this name.

NuFilm. See FILM-STENCIL METHOD.

nutgall. See GALL NUT.

nylon brush. See BRUSH, ACRYLIC.

O

oak tag. A strong, tough cardboard, capable of standing much wear and tear. It is used for such purposes as making stencils and lightweight mounts, but is not durable enough for use in permanent works of art.

obeche. See AYOUS.

objective art. Art whose subject matter consists of recognizable objects. The term came into use with the introduction of NONOBJECTIVE or ABSTRACT ART, and is used to designate REPRESENTATIONAL ART of all schools and periods, from cave paintings to the works of the expressionists.

objet d'art. A French term used to designate a work of art that has intrinsic material worth over and above its aesthetic qualities. It is applied to all sorts of decorative and precious articles but ordinarily denotes relatively small objects such as porcelains, metalwork, bibelots, and curios owned privately, rather than museum pieces.

objet trouvé. See FOUND OBJECT.

oblique. A style of type that slants to the left, as opposed to ITALIC type, which slants to the right. Obliques are seldom used in printing except for special effects. Sometimes the term is erroneously used as a synonym for italic.

oblique perspective. Linear perspective in which a rectangular solid is oriented so that three of its faces are shown, none parallel to the PICTURE PLANE. Thus, all three of the sides shown recede from the picture plane at angles (the same or different for each surface, depending upon the angle at which the object is inclined to the picture plane and the object's position relative to the HORIZON LINE). The defining lines of all three surface dimensions converge at a separate VANISHING POINT for each set of parallel lines. Because there will be three vanishing points in the depiction of an object in oblique perspective, such a depiction is also said to be in three-point perspective. See also PARALLEL PERSPECTIVE; ANGULAR PERSPECTIVE. See illustration at LINEAR PERSPECTIVE.

oblique projection. A projection used in mechanical drawing in which an object is represented with two of its axes parallel to the picture plane, causing the face of a rectangular solid, for example, to be shown unaltered, that is, with four 90° angles. The third axis is drawn at an arbitrary angle and foreshortened an arbitrary amount. When the third axis is inclined to the plane of projection at an angle of 45° and shown in the same scale as the other dimensions, the projection is called cavalier. See illustration at PROJECTION.

obverse. 1. In a two-sided object, such as a coin, a medal, a seal, or a panel with a painting on each side, the face that has the principal design. The other side is known as the reverse.

2. An adjective describing the shape of an object or figure the top or apex of which is broader than its base or point of attachment, such as a lightbulb. The term obverse might be used, e.g., to describe any piece of flaring hollow ware, such as a goblet, but it is more often applied to the shape and orientation of a design element, as in an abstract painting.

ochre. A general term for clays used to make the earth colors YELLOW OCHRE and RED OCHRE. These clays may also be used as colorants in ceramic slips and glazes. In pigment terminology, the word ochre is very often used as a synonym for yellow ochre.

odalisque. A female slave in the harems of the East, especially in that of the Sultan of Turkey. A favorite subject of 19th-century artists, the odalisque was depicted as a reclining nude or semi-nude in typically Turkish surroundings. Ingres and Matisse each painted several odalisques.

ODALISQUE. Jean Auguste Dominique Ingres (1780–1867), *Odalisque in Grisaille,* oil on canvas. (*The Metropolitan Museum of Art, Wolfe Fund, 1938.*)

odorant. A fragrant ESSENTIAL OIL added to a water paint or other compound to mask the unpleasant odors of some materials, or to maintain uniformity of odor in a mass-produced product. Traditionally, a "clean" or "simple" odorant such as sassafras, cedar, or lemon is deemed more appropriate for this purpose than a sweet, flowery perfume.

oenochoe or **oinochoe.** An ancient Greek wine jug with a handle at the neck. Another type of jug, the olpe, is similar in shape, but is less tapered at the bottom. Both were used for pouring wine into kraters for mixing. See VASE SHAPES for illustration.

offscape; offskip. Outmoded terms for the distant part of a landscape. See LOINTAINS.

offset. In printing, the transfer of the inked impression on a block, plate, or stone to another surface from which the actual proofs are pulled. In offset LITHOGRAPHY, for example, a rubber roller of large diameter passes over the inked stone, picks up the impression, and deposits it on the paper. The offset printing process obviates the need for drawing on the stone or plate in reverse. The "positive" original drawing is reversed on the offset cylinder and righted again when it is transferred to the paper. The offset method is most widely used in commercial lithography. When an offset press is available to an artist, however, he may use it to pull proofs from his original stone without affecting their status as ORIGINAL PRINTS.

ogee. A CYMA molding.

oil. See BODIED LINSEED OIL; COLD-PRESSED OIL; DRYING OIL; ESSENTIAL OIL; MINERAL OIL; NONDRYING OIL; SEMIDRYING OIL; VEGETABLE OIL.

oil black. A seldom-used name for LAMPBLACK.

oil colors. Artists' colors made by dispersing pigments in LINSEED OIL or another vegetable DRYING OIL to a smooth paste consistency. Other ingredients include a DRIER, when the pigment used has a natural retarding effect on the drying rate of the oil, and a STABILIZER and PLASTICIZER such as wax or a waxy material like aluminum stearate, to give each color the same buttery CONSISTENCY. A painter in oils may increase the manipulative control of his colors by adding a MEDIUM; and he almost invariably uses a THINNER such as turpentine. Oil colors may be applied with a BRUSH or a PALETTE KNIFE, most frequently on a CANVAS support.

Oil colors are no longer made with the highly effective cold-pressed linseed oil, but with this possible exception the modern colors, especially those that comply with the PAINT STANDARD, are of higher quality in every way than those made in the past. Artists may still grind their own oil colors with a MULLER and SLAB, as they did before the end of the 18th century, but the modern power mill can do a consistently better job. Oil colors are universally available in collapsible TUBES.

For five centuries oil painting has been the standard, principal easel painting technique. Oils remain the most popular painting medium for many reasons: the great versatility of the technique; the absence of color change when the paint dries (there is a great difference in color between wet and dry aqueous paints); its ease of manipulation within a wide range of color and tonal effects; freedom to combine opacity and transparency or linear and tonal areas in the same painting; the light weight of canvas, permitting large-scale work; and the universal availability of supplies. The defects of oil colors, such as cracking, yellowing, and darkening, can be eliminated by correct handling and proper choice of materials. See OIL PAINTING, DEVELOPMENT OF; see also PROCESS OIL COLORS.

oil green. An unstandardized term for certain industrial, rather than artists', pigments; it has been applied to CHROME GREEN and to the green varieties of BREMEN BLUE.

oiling out. The practice of rubbing an oil painting with a coat of linseed oil to obtain a pleasing dull sheen, as an alternative to the glossy finish produced by varnishing. After the oil is brushed on, the surplus is removed and the surface polished with a soft, absorbent cloth. Oiling out is now condemned as a substitute for varnishing because it has been found to cause yellowish brown streaks to appear over the paler portions of the painting, through darkening or YELLOWING of the oil, after a moderate aging period.

oil length. The proportion of oil to resin in an OIL VARNISH. Long-oil industrial varnishes, such as spar varnish, contain 25 or more gallons of oil to each 100 pounds of resin; medium-oil varnishes, such as the typical varnish used on interiors, contain 10 to 29 gallons per 100 pounds; short-oil varnishes, such as furniture finishes, contain 10 gallons or less per 100 pounds. If an oil-modified ALKYD RESIN is used in the formulation of a painting medium, its oil length must be known so that the formula may be balanced as to the proportion of total oils to total resins.

oil of cloves. An ESSENTIAL OIL, the standard RETARDANT recommended for delaying the drying of oil paints. It has also been used as a combination pre-

servative and odorant in water paints. While not so efficient as more modern concentrated preservatives, it is a mild disinfectant, and it masks the unpleasant odors characteristic of some water binders.

oil of lavender. An ESSENTIAL OIL (*Oleum lavandulae*) used in perfumery and sometimes recommended as a RETARDANT in oil painting. This fragrant oil is sometimes confused with the product of another species of lavender, SPIKE OIL or oil of spike lavender, formerly used as a thinner for oil colors.

oil of turpentine. An obsolete term for turpentine or spirits of turpentine. It is current in French as *huile de térébenthine*. In German, *Terpentinöl* is still encountered in publications, but in more recent German texts *Turpentingeist* (spirit of turpentine) is usually used.

oil painting, development of. Oil painting was not an invention or sudden discovery, but was gradually developed over a period of 100 years during the 15th and 16th centuries by artists who strove to cope with the problems created by changing times and styles. The technical and stylistic requirements for 14th-century European easel painting were eminently served by the egg-tempera technique, but its dry and linear quality was ill-suited to meet the new demands imposed by the development of new ideas and aspirations, the broadening of art forms, and the inclusion of other motifs than the devotional. Fifteenth-century painters turned to materials more amenable to the fluent depiction of flowing and billowing shapes and blended tones, utilizing oils and resins that had been employed for more than two centuries in strictly functional rather than creative painting. Oily ingredients were incorporated into tempera paints to create the intermediate tempera technique seen in some works of Piero della Francesca (c. 1420–1492), Filippo Lippi (c. 1406–1469), and Vittore Carpaccio (c. 1470–1523). In these paintings were effects that could not be obtained with the pure egg technique. Other painters, such as Antonello da Messina (1430–1479), and 15th-century Flemish masters, such as Jan van Eyck (1385–1441), applied oil and varnish glazes over tempera underpaintings. Although these works lean definitely toward oil-painting effects, they are really tempera paintings in the modern sense of the term. Thanks to an anecdote by Vasari, however, van Eyck was credited for centuries with the single-handed invention of oil painting, although this claim was disproved as early as 1781. The Venetian painters used more and more oily ingredients, until by the time of Titian and Tintoretto oils were used throughout the painting, although the guiding principles of tempera were still in evidence. Velásquez is generally cited as the first of the great masters who used oils exclusively on a canvas or who could have painted his pictures out of a modern paint box. The whole development of the medium can be traced in the long life of one painter, Giovanni Bellini (1430–1516). His early work was pure or "primitive" egg tempera (*Madonna Adoring the Sleeping Child*, Metropolitan Museum, New York); later he used a meticulous, jewel-like glazed tempera (*Madonna and Child in a Landscape*, National Gallery, Washington); and finally he began to use oil colors in strokes rather than glazes. His later portraits and allegorical pictures have always been classed as oil paintings. It is not possible to chart the transition from tempera to oil chronologically, because different painters evolved their techniques at different

times; some returned to former methods; some, such as Sandro Botticelli (c. 1445–1510), never abandoned egg tempera, or, if they tried the newer materials, did not alter their styles to utilize the new effects.

oil size. See GOLD SIZE.

oil-soluble dyes. A group of synthetic organic dyes that are soluble in oil and insoluble in water. They are used for coloring varnishes, lacquers, and such oily materials as petroleum products, candles, etc. The modern ones are unsulfonated azo dyestuffs, which are more permanent than the older resinate type made by precipitating brilliant water-soluble dyes with a rosin or resin soap. Available in a rather full range of colors, none of the oil-soluble dyes is sufficiently permanent for fine-arts use.

oilstone. A fine-grained, hard WHETSTONE on which a very small amount of machine oil is placed. The oil reduces friction and carries away the tiny particles of metal that are ground off the edge or point of the tool being sharpened, thus keeping the grinding surface clean and always in contact with the metal. White Arkansas stones are commonly used and are available in many shapes and sizes to suit various purposes. See also SLIP.

oil tempera. A paint in which the vehicle is made with a water-in-oil EMULSION instead of the more usual oil-in-water emulsion. Such a vehicle is thinned with turpentine rather than water, and is therefore not really TEMPERA as the term is generally understood. It has been experimented with, but is not a usual type of artist's color.

oil varnish. A term sometimes used to denote a VARNISH made by cooking together linseed oil or other drying oil, resins, and driers, as distinguished from SIMPLE-SOLUTION VARNISH, which contains only resin and a volatile solvent. See OIL LENGTH.

oily ingredient. In TEMPERA paint, the ingredient which, with water, forms an EMULSION; it may be oil, wax, or resin. In lithography, the ingredient of the LITHOGRAPHIC CRAYON or TUSCHE creates in the surface of the stone the greasy areas that will accept ink; the areas untouched by a crayon containing this ingredient remain blank when ink is applied to the entire surface of the stone.

oinochoe. See OENOCHOE.

oiticica oil. A Brazilian DRYING OIL that has been used in industrial coatings as a substitute for TUNG OIL; not suitable for use in artists' materials.

old fustic. Another name for FUSTIC.

old master. Popular epithet for any of the great artists of the Renaissance period, especially those of Italy, Holland, and Belgium; also, any of their works.

oleograph. A CHROMOLITHOGRAPH printed with a kind of oil-color ink on cloth or textured board so as to be an inexpensive imitation of an oil painting. The oleograph was extremely widespread and popular during the second half of the 19th century.

oleoresin. A BALSAM or exudation from trees, especially the conifers. Since the term implies that the material contains a resinous substance plus an oil, it is a misnomer, for few if any of the balsams contain an oil in the modern sense. Their fluid constituents are essences (ESSENTIAL OILS) and other volatile materials.

oleum white. An early name for LITHOPONE.

olio d'Abezzo. See STRASBOURG TURPENTINE.

olive green. A hue designation for any of several dull, warm greens; not a specific pigment name.

olpe. In ancient Greek pottery, a short-necked jug tapering to a foot. See illustration at VASE SHAPES. The word also denoted a leather flask used for carrying liquids. See also OENOCHOE.

oltremontani. A Venetian Renaissance epithet for the Flemish painters; literally, "those who dwell beyond the mountains."

Olympia blue. An early name for COBALT BLUE.

oneiric. In painting, pertaining to a dreamlike quality. Much surrealist work contains oneiric forms or scenes.

one-point perspective. See PARALLEL PERSPECTIVE.

one-stroke brush. See SINGLE-STROKE BRUSH.

on-glaze. British for OVERGLAZE.

onyx. A fibrous type of quartz with parallel striped markings, usually black and white or brown and white, used especially for cameos.

onyx marble. The "alabaster" of the ancients; a pure white calcite, a precipitated form of calcium carbonate. Onyx marble is also called Oriental alabaster. It is often found in caves in the form of stalactites and stalagmites. Onyx marble from Mexico, called Mexican onyx and tecali, has been successfully used for sculpture.

oölitic rock. Rock consisting of small rounded granules that are bound together by a lime or silicate SINTER. Sandstone and certain limestones are oölitic in structure.

opacifier. In ceramics, an additive used to render glazes opaque. The best and most expensive is tin oxide. Lower priced opacifiers are made from zirconium oxides. Two well known commercial opacifiers are Zircopax and Opax.

opacity; transparency. These terms refer to the ability of a substance to transmit light. An opaque paint is one that transmits no light and can readily be made to cover or hide what is under it. A semiopaque paint transmits very little light, but is incapable of concealing dark colors and strong markings under it unless an unusually heavy coat is applied. A transparent material transmits light freely; when a transparent glaze of oil color, for example, is placed over another color, it produces a clean mixture of the two hues without much loss of clarity. A semitransparent paint transmits much light, but is not clear; a semitransparent glaze, when placed over another color, will produce a pale or cloudy effect because of the reflection of light from the surface. Semitransparency and semiopacity are also known as translucency. Pigments are classed as opaque, semiopaque, and transparent.

In painting techniques, opaque and transparent pigments produce color effects in two different ways: Watercolor employs transparent color, relying on the brilliant white paper to create white and pale colors; casein, gouache, and pastel are completely opaque, using white pigment to obtain whites and pale colors; tempera is semiopaque, combining the effects of both systems; and oil painting is capable of utilizing opaque, translucent,

and transparent effects, sometimes all in the same painting.

opalescence. A cloudy IRIDESCENCE that resembles the play of colors in an opal; a translucent milkiness with a fiery red undertone.

opaline paper. A glossy variety of PARCHMENT PAPER.

opaque projector. A lantern that throws an enlarged image of a small drawing, painting, print, or photograph on a blank surface, where it can be traced. Artists use this device to enlarge a small work of art and to transfer a drawing to a canvas, panel, or wall. Some of the more elaborate models can be mounted on a wall so that the image is projected down onto the top of a drawing table; others, used in commercial art studios, have a built-in drawing board and a hood or curtains to screen the working area from room lighting.

opaque white; opaque black. Aqueous colors with great hiding power, especially prepared for use in retouching, correcting, or heightening photographs, illustrations, and drawings that are to be reproduced. These colors have excellent hiding power. They are also known as intense white and intense black. Opaque white must be distinguished from CORRECTION WHITE, which does not have a water medium.

op art or **optical illusion art.** A term, first used in New York in 1963, for a current style of art in which sharp-edged abstract patterns stimulate a reaction on the retina of the eye, producing an illusion of dazzle or movement. When colors other than black and white are used, the dazzle effect is enhanced by the juxtaposition of complementary colors (see MOIRÉ EF-

OP ART. Benjamin Frazier Cunningham, *Equivocation* (1964), synthetic polymer paint on gesso panel. (*Collection, The Museum of Modern Art, New York, Larry Aldrich Foundation.*)

FECT). Victor de Vasarley (b. 1908) and Yaacow Gipstein Agam (b. 1928) are among the artists who are now working in the op style. Op art motifs have been adapted to textile design and other forms of decorative art.

Opax. Trade name for an OPACIFIER used in ceramic glazes.

open. In ceramics, to render a CLAY BODY more porous by adding GROG. Opening the body expedites drying, thus permitting thicker cross-sections for heavy pottery and sculptural pieces.

opening. A private showing of an exhibition of works of art, usually held on the day prior to its opening to the public. It was formerly called VARNISHING DAY.

ophite. A general term for any of several mottled rocks, usually green, whose surface appearance resembles the skin of a snake; SERPENTINE is an

example. The name is derived from the Greek word for serpent.

optical mixture. In painting, the close placement of small strokes or dots of separate colors on a painting surface, so that when the picture is viewed from beyond a certain distance they create the effect of mixed colors of considerable brilliance. For example, numerous dots of blue and red appear as violet to the observer when viewed from a distance, according to the principle of optical mixture. This painting technique was fully explored by the practitioners of IMPRESSIONISM and POINTILLISM. See colorplate facing page 151.

orange mineral. A lead oxide similar to RED LEAD, but more yellowish and less intense; not sufficiently permanent for artists' use. Orange mineral has better pigment properties than red lead and is more desirable as a pigment in some industrial coatings.

orange-peel effect. A surface texture that some coating materials exhibit when they dry, resembling, in miniature, the irregular surface of an orange. Although this is a normal, acceptable condition of some coatings, notably shellac, it is considered an aberration or defect in coatings such as varnishes, that are intended to dry to a perfectly smooth surface.

orange pigments. CADMIUM ORANGE is the only pigment of this hue approved for use in oil paints by the PAINT STANDARD and generally acceptable in all other easel-painting techniques. Formerly in use were ANTIMONY ORANGE and REALGAR. ORANGE MINERAL, ORANGE VERMILION and PERSIAN ORANGE are not used by artists.

orange vermilion. A term sometimes applied to the more yellowish kinds of VERMILION.

orant. In ancient Greek art, a figure in a praying posture. In Christian art, a standing figure with arms raised in prayer.

orchil. Another name for ARCHIL.

organic pigments. Originally, pigments of vegetable or animal origin, as distinguished from the inorganic pigments of mineral origin; more recently, pigments containing the element carbon in their composition. The modern organic pigments are those made synthetically from coal-tar derivatives, such as phthalocyanine blue, alizarin crimson, and the LAKES made from synthetic dyes.

Oriental alabaster. See ONYX MARBLE.

Orientalizing period. In HELLENIC ART, the transitional period (700–600 B.C.) between the GEOMETRIC PERIOD and the ARCHAIC PERIOD, during which the influence of such eastern civilizations as Syria, Egypt, and Phoenicia enlarged the scope and transformed the goals of art in Greece. Vase decoration, which was the most important form of art during the Orientalizing period, took on a narrative form; human and animal figures became more important and were portrayed with descriptive rather than geometric precision; new motifs, such as battle scenes, fighting animals, and winged monsters, were introduced. Perhaps the most significant innovation of the period was the idea of using stone for permanent architecture and sculpture, a concept to which we owe a large part of our knowledge of Hellenic art, as well as the full measure of its greatness.

orient yellow. A variety of deep CADMIUM YELLOW.

original. 1. An artist's independent creation.

2. A work of art considered as a PROTOTYPE, as that from which copies and reproductions have been made. See also COPY; ORIGINAL PRINT; REPLICA; REPRODUCTION.

3. The person or an object that is represented in an artist's work.

original print. Any print made by a recognized graphic-arts process in which the artist has created the master image on the plate, block, stone, screen, or transfer paper and has printed it himself. In the case of a technically involved process such as lithography, a professional printer may assist the artist in pulling the proofs. The term original print, which has been adopted by the Print Council of America, distinguishes such proofs from mechanical or photographic reproductions that are executed neither by the artist nor under his supervision. Since the early 20th century original prints have been signed in pencil on the lower right-hand margin of the print, close to the bottom of the impression. In limited editions, the artist also records in the margin the size of the edition and the number of the PROOF.

In accordance with the standards of originality in the graphic arts adopted by the Print Council the artist is expected to identify clearly a second edition, both by altering it in some way (as by a change in color) and by marking it "2nd Ed." If the artist makes any significant change in the printing surface while pulling an edition, proofs of the reworked surface should be marked "2nd st." (second state). When the artist decides that he will make no additional prints from a plate, stone, or stencil, the Council suggests he either obliterate the image (as, for example, by cleaning the lithographic stone), or "cancel" the printing surface. A cancellation is any form of alteration (as by rounding off square corners) or defacement (as by incising a line through a printing area) which insures that further proofs cannot be confused with those of the limited edition.

orlean. Another name for ANNATTO.

ormolu. 1. Gilded bronze or brass used as pure or functional decoration. Although the word is of French derivation (literally, "ground gold"), it is not used in that language but is instead the English equivalent of the French *bronze doré.* Ormolu is used chiefly for mounts and ornaments on furniture, clockcases, candlesticks, chandeliers, and jewelry. Authentic ormolu is cast and chiseled by hand, and its finish is gold leaf or, formerly, FIRE GILDING. Ornaments made this way should be distinguished from those that, although often cast from the same molds, are not gilded but are merely coated with a golden lacquer. The art of making ormolu reached its peak in France at the beginning of the 19th century, when it figured strongly in the empire style of furniture, and the finest ormolu cost almost as much as similar objects in precious metal. It continues to be produced today, mostly in France.

2. A transparent reddish-orange varnish used to give luster and a warm tone to surfaces gilded with gold leaf or Dutch metal and to make silvered surfaces look like gold.

Orphism. A style of painting that employed overlapping planes of brilliant, contrasting colors. Related to Cubism, it was more abstract, as well as more concerned with color. The term was first used by the French poet Apollinaire in 1913. The chief expo-

nent of the style, Robert Delaunay (1885–1941), preferred the name Simultaneism. Stanton MacDonald Wright (1890–) and Morgan Russell (1886–1953), Americans who exhibited works in a similar style in Paris in 1913, called it Synchromism. The Czech artist Frank Kupka (1871–1957) was also associated with this style.

orpiment. Native arsenic trisulfide. A pigment ranging from bright golden-yellow to orange that was used in many early civilizations. It occurs in early Egyptian, Syrian, and Persian art. It has appeared in Chinese cave paintings and is found extensively in illuminated manuscripts but has seldom been used in the West by oil painters. Originally it was made by coarsely grinding arsenic trisulfide into a pigment that worked well in oil but was not reliably permanent, especially in mixtures with other pigments. In the 18th century arsenic trisulfide began to be produced artificially by precipitating or sublimating the native mineral. The artificial product was both purer and cheaper than the native variety it replaced, but because it was extremely poisonous it was later abandoned for large-scale use. However, a fine grade known as king's yellow continued to be prepared for and used by artists until it was replaced by CADMIUM YELLOW. Sunflower yellow is a variety of orpiment found in Chinese painting. Red orpiment is a name for REALGAR. Other names for orpiment are arsenic yellow, auripigmentum, and Chinese yellow.

Orr's white. A name given to LITHOPONE after John Orr, holder of the first English patent (1874) for its manufacture.

ostrum. A Latin name for TYRIAN PURPLE.

Ostwald system. A system of COLOR NOTATION introduced by the German scientist Wilhelm Ostwald in 1931. The system covers a comprehensive range of chromaticity variations, arranged in the form of a "color solid," and gradates its 24 "foundation hues" with both white and black. It has had wide acceptance, especially in the arts, but in the U.S. it has lagged behind the MUNSELL SYSTEM in general popularity. However, in recent years, interest in it has revived and is increasing. Its most complete and recent exposition appears in the *Color Harmony Manual* (1949) by Carl E. Foss and Egbert Jacobson.

Ottonian art. German art between the early 10th and early 11th centuries. In this period, named for Otto the Great of Saxony, elements of Carolingian, Roman, and Byzantine styles rather quickly developed into an unmistakably German style notable for

OTTONIAN ART. Ivory carving of the second half of the 10th century, depicting the emperor Otto I offering a model of Magdeburg Cathedral to Christ in majesty. (*The Metropolitan Museum of Art, Gift of George Blumenthal, 1941.*)

an intense expressiveness. Outstanding work was done in sculpture in wood, ivory, gold, and silver, especially at Reichenau. The art of manuscript illumination also reached a high point at Hildesheim, Regensburg, and Cologne, as well as at Reichenau.

outline drawing. A drawing in which an object or model is depicted by its outline alone. The lines are of equal width and strength throughout. No shading is employed, and no internal features are drawn (as distinguished from contour drawing, in which some internal details may be included). See also SILHOUETTE. See illustration at CONTOUR DRAWING.

oval brush. See FILBERT BRUSH.

overglaze. In ceramics, color that is applied on top of the GLAZE; called on-glaze in Britain. In addition to the colorant, an overglaze contains a flux and a fluid binder to control brushwork. Most overglazes are fired at relatively low temperatures, thereby allowing the use of certain colors that a porcelain firing would destroy.

overmantel. A painting or carving of relatively elongated horizontal shape, suitable for hanging over a mantelpiece; also, any decoration so located. In French, *dessus de cheminée.*

overpainting. The finishing coat of color applied to a painting after the preliminary layer, or UNDERPAINTING, has dried. This method of applying color in two stages is practiced in many types of painting, including oil and tempera. The underpainting may be used to establish the forms and design, so that in applying the overpainting the artist can concentrate on the details of technique. The multiple applications of color may create a desirable color or textural effect that can not be achieved with one coat of paint.

Overpainting is also useful when many touches or brushstrokes are required for a complex effect, and when a thick layer of paint is desired. Thin, transparent or translucent overpainting is called either GLAZE or SCUMBLE, depending on its nature. Broken overpainting, through which the underpainting is revealed in spots, is called DRAGGING STROKE or scuffing.

overpigmentation. The condition of a tube color that has insufficient oil to supply the proper soft consistency for normal manipulation. This condition may be the result of the manufacturer's overzealousness in avoiding an excessive amount of oil. Some well-made oil colors may be considered to contain too great a proportion of pigment to oil by painters who have become accustomed to very oily colors. The defect of becoming a rubbery, insoluble mass is called LIVERING.

ovolo. A convex, quarter-round molding with narrow horizontal bands

OVOLO MOLDING (LEFT) AND CAVETTO (RIGHT)

top and bottom. The lower part of its curve and the lower band recede deeply. A concave quarter-round molding is called a cavetto molding.

Oxford ochre. A fine grade of YELLOW OCHRE produced in England and used there in artists' colors; also called stone ochre and stone yellow.

oxgall. A powdered material prepared from bile taken from the gallbladders of cattle. It has been used as a WETTING AGENT in water paints, but modern synthetic products have largely replaced it.

ox hair. A fine hair obtained from the ears of cattle, and used in artists' brushes. It is firmer and more resilient than red sable, and is therefore not so suitable for use in the best watercolor brushes. Second-grade watercolor brushes are usually blends of red sable with ox hair. However, the properties of ox hair make it desirable for use in larger brushes, such as the architect's rendering brush, and some painters also prefer a large second-grade SINGLE-STROKE BRUSH, containing some ox hair, to the pure red sable variety.

oxide. 1. Any compound of oxygen and another element, either artificial or natural. Rust, PATINA, and other corrosive surface effects are sometimes oxides.
2. In ceramics, the color ingredients are almost always called oxides, regardless of their composition.

oxidizing fire. In ceramics, the normal kiln firing, during which an ample supply of oxygen is maintained in the atmosphere of the kiln. Firing in an atmosphere deficient in oxygen, called REDUCTION FIRING, produces color changes in the color oxides of the glaze and clay body.

oxyacetylene welding. The process of WELDING with a torch in which the fuel is acetylene mixed with oxygen. Separate tanks of each gas under pressure are connected with a nozzle through which a mixture of the two is emitted, when ignited, as a concentrated jet of blue flame. Oxyacetylene welding is done at 6300° F., a temperature sufficient to melt most metallic substances. It is used in direct metal sculpture.

oxychloride cement. A hard, durable, stonelike composition made of CALCINED MAGNESITE mixed with a strong solution of magnesium chloride to a plastic consistency. Like Portland cement, it is used to bind together a mass of inert material, as in stucco or imitation stone. Another name for this substance is Sorel cement.

oyster white. A hue designation for any gray-tinted off-white of a neutral shade, i.e., neither bluish nor brownish, obtained by tinting a white paint with controlled small amounts of raw umber and black.

ozokerite. A mineral wax occurring in the vicinity of petroleum deposits. It is the crude, dark-colored wax from which CERESIN is refined.

P

paddle. In ceramics, to form a hollow cylindrical shape from a slab of moist clay by pressing or beating it against a round wooden form with a flat paddle.

padouk. A deep-red or bright-red hardwood from trees of the genus *Pterocarpus,* found principally on the west coast of Africa and in the Andaman Islands. It comes in large logs up

to 30 inches in diameter, and is usually available in 1- and 2-inch planks. It is also known as vermilion or corail.

pagoda stone. A Chinese marble whose markings, when the stone is cut sectionally, resemble the shape of a pagoda. The markings are due to fossil content. See also FOREST MARBLE.

pagodite. See AGALMATOLITE.

paint. A fluid or pasty coating material made by grinding a PIGMENT in a liquid VEHICLE to form a dispersion. It is used for coloring and protecting surfaces by close adhesion. The process of grinding the pigment with strong friction is necessary to disperse the particles, i.e., to distribute them evenly throughout the liquid vehicle, so that no dry or lumpy portions remain. The mill does not reduce the size of the pigment particles; its action is one of squeezing, not pulverizing. Pasty paints, such as artists' oil colors, are made in a steel ROLLER MILL, while paints of a more fluid consistency may made in a BALL MILL. Small batches of color may be handmade with a MULLER and slab.

painterly. 1. Having the quality of expertly brushed workmanship; technically excellent in terms of control of the brush and the medium of painting; also, pleasing in terms of the handling of color effect. The term may be used of painting in which every element, including content, is handled in accordance with high technical and aesthetic standards.

2. A term applied to the dominance of tonal masses over line as a means of defining form in painting, sculpture, and architecture. It was first used in this sense by Heinrich Wölfflin in his *Principles of Art History* (1915), along with its opposite, "LINEAR." Because the word "painterly" has other senses, Wölfflin's original German term,

malerisch, is more precise. *Malerisch* painting, for example, relies less on draftsmanship to depict modeling than on the juxtaposition of areas of color, or of dark and light. Because the outlines of forms are relatively indistinct, the viewer's eye wanders rather freely over the whole painting, which gives it a greater illusion of movement. Wölfflin regarded Rembrandt's paintings as the epitome of this approach. The oil-painting medium, developed in the 15th and 16th centuries, lent itself to the *malerisch* style, since soft-edged forms could be more easily depicted than they could be in the tempera medium. See also RUBÉNISME. See illustration at LINEAR and color-plate facing page 119.

painter's etching. A term, no longer current, for an ORIGINAL PRINT.

painting. In art, the creation of a work of aesthetic import by the skilled application of paint to a surface or ground. The principal accepted fine-arts techniques for permanent easel and mural painting are oil, tempera, watercolor, gouache, pastel, polymer, encaustic, and fresco painting. The artist chooses his technique, materials, and working methods from among these, according to the effects he wishes to obtain, their appropriateness to the work in hand, and his personal preference. He needs to acquire a thorough knowledge of his craft in order to insure his control of effects and the permanence and appropriateness of his work. He paints to express himself aesthetically, to depict persons, objects, or scenes, or to commemorate an event. Painting may be used in association with other arts, as in mural painting and decoration (architecture) and illustration (literature). It may also be used in applied art, in such areas as industrial design and advertising. Applied or commer-

cial artwork is almost always done for reproduction, and because the original is seldom preserved the designer or commercial artist can disregard the technical rules for permanence and employ any means he pleases to secure his effects, including the use of super-brilliant, fugitive colors.

painting knife. A very thin and flexible blade of tempered steel, sometimes with a rounded end but more generally elongated and triangular, and usually with a long offset or angular tang, used for so-called palette-knife painting; the ordinary PALETTE

PAINTING KNIVES

KNIFE is less suited to accurate deposition of color. The painting knife is a delicate implement made especially for this work. Artists who specialize in palette-knife painting are most particular about their equipment and soon become collectors of well balanced, finely tempered knives of various sizes and shapes. Although various spatulas, palette knives, and slices have been in use since primitive days, the delicate painting knife did not appear before the latter half of the 19th century.

painting medium. See MEDIUM.

paint mill. See BALL MILL; ROLLER MILL; PAINT.

paint quality. In reference to an oil painting, beauty of surface. The term implies skillful handling and fully realized use of the medium. Although it can be used for any type of painting, it is usually applied to oil painting. It is related to such PAINTERLY effects as a full, substantial paint layer and a pleas-

ing combination of color and brush-stroking. The term paint quality refers solely to the artist's proficiency, and not to the quality of the materials used.

paint remover. A fluid or paste compound sold in paint and hardware stores and used for removing old, hardened paint from furniture, walls, and other surfaces. A coat of remover is brushed on the surface and allowed to remain until its active ingredients soften or dissolve the old coating. It is then scraped away with a broad, flat blade such as a putty knife or wall scraper. Paint removers are compounded of several powerfully active solvents and a wax or other ingredient of pasty consistency which keeps the active solvents in contact with the old coating and reduces flowing on vertical surfaces. Since most paint removers contain ingredients that may attack the skin, they should be handled with care; since all of them contain solvents that emit toxic fumes, they must be used in a well ventilated place, preferably outdoors. The uncontrolled strength of paint removers and the fact that they deposit waxy materials which are difficult to remove make them unsuitable for use on artists' paintings.

Paint Standard. A popular name for the Commercial Standard for Artists' Oil Paints CS 98-62. This is a set of standard specifications defining the minimum quality required for top-grade artists' oil colors. It is issued by the U.S. Department of Commerce. The Standard was established and is maintained by voluntary agreement among manufacturers, representatives of artists' organizations, and the National Bureau of Standards. It was first promulgated in 1942 and was revised in 1950, 1951, and 1962. A standing committee keeps it up to date. Firms that comply with all its provisions may print its number with a guarantee to

that effect on the tube labels. The Paint Standard has established a rational system of pigment nomenclature in the U.S. Each approved pigment is now known by one specific name, so that colors labeled with vague or pretentious names are known to be substandard. Before the Standard was established, pigment nomenclature was in a chaotic state: Some pigments had as many as six names; sometimes as many as three different pigments went by the same name; and new proprietary names were brought out every year. Copies of the Standard may be ordered under its full name from the Superintendent of Documents, Washington, D.C. See also BRITISH PIGMENT STANDARD.

palette. 1. A thin oval or oblong board or tablet with a thumb hole and finger grip at one end, on which the painter arranges his colors. Palettes are traditionally of lightweight wood, although some are now made of aluminum or plastic; some painters use a palette of a dark wood color, others prefer a lacquered white or pale neutral color. Sometimes a glass or marble-topped table is preferred to a hand-held palette. See also ARM PALETTE; DISPOSABLE PALETTE.

2. The complete set of colors suitable or available for use in a technique, method, or medium of painting.

3. The selected group of colors an artist has chosen to use in a particular picture.

4. See POTTER'S PALETTE.

palette, limited or **palette, restricted.** See RESTRICTED PALETTE.

palette cup. A small cylindrical vessel, usually tin, soldered singly or in pairs to a bent strip. The strip is

DOUBLE PALETTE CUP

clamped to the edge of a PALETTE so the painter has a handy supply of turpentine or medium in which to dip his brush while working. The palette cup is known as a dipper or dipper cup in Britain.

palette knife. A limber, spatulate blade of tempered steel with a rounded end, securely set in a strong hardwood handle. Straight and tapered palette knives are made in numerous sizes. Those commonly used by artists have blades from 3 to 4 inches long. Some are set straight in their handles; others

PALETTE KNIVES

have angular tangs that help keep the artist's knuckles from touching the paint. Palette knives serve a number of purposes: they are used for handling paint on the palette, for scraping, for mixing pigments with oil or other vehicles, and for spreading paint on the canvas. This last operation, however, is better served by the PAINTING KNIFE. Larger knives or spatulas (6- to 8-inch blades) for heavy-duty mixing of pigment and vehicle are called paint knives. After considerable use, the edges of a palette knife are apt to become dangerously sharp; it should then be discarded.

palette-knife painting. The painting technique whereby oil colors are applied with spatulate blades instead of with brushes. The most useful implement for palette-knife painting is the PAINTING KNIFE, especially made for this purpose. The ordinary PALETTE KNIFE, designed for heavy-duty use in mixing colors on the palette, is not so well adapted for use in painting. A

blade was occasionally used to spread on or smooth out oil paint on canvas at least as far back as the 17th century, but palette-knife painting appeared as a separate technique after the standardization of the plastic consistency of commercial tube colors in the mid-19th century.

palimpsest. Originally, a PARCH-MENT that had been used more than once. The original writing on a piece of parchment could be eradicated by washing, bleaching, abrasion, or a combination of methods, so that the parchment might be reused for another manuscript. The use of palimpsests for letters, documents, and literature was common in ancient Greece and Rome and increased throughout the middle ages as parchment became scarcer. Although the practice of reusing parchment was forbidden during the Renaissance, it was only with the advent of printing that it altogether ceased.

In modern usage the word palimpsest has been extended to mean any canvas, panel, or paper that has been reused. Thus a second painting done over an earlier one or on the back of a canvas, one side of which has already been used, may be called a palimpsest. The term is also applied to a memorial brass that has inscriptions on both sides, the side not exposed being the older and often, though not necessarily, the more important.

palisander. Another name for Brazilian ROSEWOOD.

Palissy ware. A glazed ceramic ware made in France in the 16th century and named for the potter Bernard Palissy (c. 1510–1589). It is decorated with colored natural shapes, such as flowers and seashells, in high relief.

palladium leaf. A thin, beaten leaf used in gilding for a silvery effect. Pal-

ladium is a precious metal belonging to the platinum group of elements. Although it is somewhat duller than silver and has a slight leaden quality, it does not tarnish at normal temperatures and is therefore frequently preferred to silver when a permanent result is desired.

palmette. The conventionalized palm leaf ornament; a radiating cluster of petals. The palmette was widely used in classical architecture and occurs often as an element of an ANTHEMION.

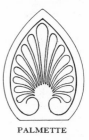

PALMETTE

panel. Any rigid, flat support for painting, such as wood or wallboard, prepared with a ground. GESSO panels, made primarily for tempera painting, can also be used for oil; more often, an oil ground is used for oil painting. Although panels may be textured, most of those artists who prefer them to canvas do so for their flat smoothness, as well as their rigidity. A wooden panel is sturdier than a canvas and so would be expected to be more durable, but museum conservators observe that both show the effects of time to about the same degree.

Pannetier's green. An obsolete name given to VIRIDIAN after its inventor.

panorama. 1. A broad, all-inclusive view of a wide landscape.

2. An 18th- and 19th-century display or exhibition technique, popular for its entertainment and educational value, consisting of a continuous landscape, sometimes depicting a long journey, painted on a long roll of canvas that could be stretched around the walls of a room. In the mid-19th cen-

tury the panorama became a traveling entertainment in America: the long roll was wound on two cylinders to be slowly unrolled behind a frame, accompanied by a lecture and sometimes music. It may be considered a crude forerunner of the stereopticon slide and the motion picture. Generally painted in a broad, simple style with few aesthetic pretensions, the panorama had the great advantage of portability over such displays as the COSMORAMA and the DIORAMA.

pantheon. In classical architecture, a temple dedicated to all the gods; also, a representation of all or several of the gods of a given religion. See also MANDALA.

pantograph. A device used to copy, enlarge, or reduce a work of art. It operates on essentially the same principle as lazy tongs. Four strips of wood or some other material are hinged together in a square so that they overlap

PANTOGRAPH

and can be adjusted according to the scale of the copy to be made; the end of one of the strips is anchored to the drawing board. The four sides move in unison so that as the lines of the original are followed by a tracing point, they are repeated, in the same or a different scale, by a pencil point on the surface on which the original is to be copied. The pantograph is available in a number of grades, from professional models of great precision to inexpensive, rather inaccurate toys.

Paolo Veronese green. Another name for VERONESE GREEN.

papal cross. A Latin cross with two additional crossbars above the main crossbar, each shorter than the bar below it. It is carried before the Pope in processions. See CROSS for illustration.

paper. A felted or weblike mass of interlaced plant fibers in sheet form, used as a combination ground and support in drawing, watercolor and pastel painting, and the various graphic art techniques. Fine-arts papers are made of pulped linen and cotton rags; lower quality, impermanent papers are made of wood pulp or of a combination of wood pulp and rag. See DRAWING PAPER; PASTEL PAPER; WATERCOLOR PAPER. The best watercolor paper is handmade, and comes in a number of standard sizes; see PAPER DIMENSIONS. The forerunners of European paper were papyrus in ancient Egypt, and PARCHMENT from Roman times through the Middle Ages. Paper mills were widely established and paper was often used as a support for works of art by the 15th century, when the printed book and the artist's engraving came into being.

paper dimensions. Watercolor and drawing papers come in a number of standard sizes with distinctive names. Because the best of these papers are handmade, the dimensions in inches, given below, are only approximate. Some traditional paper sizes are: Demy, 15 x 20; Medium, 17 x 22; Royal, 19 x 24; Super-Royal, 19 x 27; Imperial, 22 x 30; Elephant, 23 x 28; Double Elephant, 27 x 40; and Antiquarian, 31 x 53. See also WATERCOLOR PAPER.

paper-stencil method. A SILKSCREEN technique in which the stencil

design is made from cutouts in paper. The original design is covered with a special transparent stencil paper and the printing areas of the design are trace-cut with a STENCIL CUTTER. The screen is then lowered on the stencil and squeegeed with thick paint, which causes the stencil, with its design areas still intact, to adhere to the bottom of the screen. The design areas are then stripped from the stencil, leaving them open to the passage of paint. If multi-color prints are to be made, a separate stencil must be cut for each color.

The paper used may be either a special transparent stencil paper or any thin, white bond paper that lies perfectly flat and is somewhat absorbent, so it will soak up enough paint to adhere to the screen. Ordinary tracing paper is not absorbent enough to be used in silk screen. If need be, the stencil paper or the bond paper can be made more transparent by rubbing it with turpentine or kerosene.

The paper-stencil method is used to make large silk-screen prints of simple designs, such as posters. The method is particularly suited to a kind of impasto work, since paint can be applied more thickly with a paper stencil than with any other kind. Paper cutouts cannot be used, however, with water-based paints, since these would quickly wrinkle the paper and make it impossible to print clean-cut impressions.

papier mâché. A molding material made of paper torn into strips or pulped and soaked in a binder of starch or flour paste or dextrin. It is easily made, and is widely used to make decorative and functional objects which are usually painted and varnished. The term is French for "chewed paper." See also FLONG.

papiers collés. Literally, pasted paper. See COLLAGE.

Pará balsam. See COPAIBA BALSAM.

paraffin. A semitransparent white wax, one of the products of refining petroleum. It is quite inert chemically and has the characteristics of petroleum or MINERAL OIL rather than of the vegetable and animal waxes. It is sold in several grades whose melting points range from 50° C to 60° C. Ordinary paraffin wax has few uses in the fine arts, but special refined grades, such as MICROCRYSTALLINE WAX and CERESIN, are employed in wax compounds and adhesives.

parallel perspective. Linear perspective in which a rectangular solid is oriented so that one of its surfaces is parallel to the PICTURE PLANE, i.e., seen full face. Thus, the lines defining two of the dimensions of the object will be parallel to the picture plane and therefore parallel or at right angles to each other. These lines do not recede to a VANISHING POINT, but the lines defining the other visible face or faces of the object do recede away from the picture plane at some angle (depending upon the position of the object relative to the HORIZON LINE), converging on the horizon line at a single vanishing point. Because there will be only one vanishing point in the depiction of an object in parallel perspective, such a depiction is also said to be in one-point perspective. See also ANGULAR PERSPECTIVE; OBLIQUE PERSPECTIVE. See illustration at LINEAR PERSPECTIVE.

parallel rule. A device used in mechanical drawing to expedite the drawing of many parallel lines. It consists of two flat rulers hinged together near both ends by two metal strips, on which the rulers swing parallel to each other. Another model is comprised of a single ruler that slides in a frame.

para red. A lake or toner of a bright, opaque, cherry-red color with a rather bluish undertone. It is made from paranitraniline, a coal-tar derivative. Para red is fairly permanent for many industrial uses, but not sufficiently so for artists' colors, since it not only fades but also bleeds badly in oil. SIGNAL RED is a variety of para red.

parcel-gilt. Partially gilt; used to describe an object, usually silver, that is gilded on only one surface, as the inside of goblets and bowls, or that is decorated with gilded designs.

parchment. The skin of an animal, often a sheep or goat, processed so that it has a smooth, pale surface suitable for writing on with ink or painting on with aqueous colors. VELLUM is parchment made from calfskin, although the term is also used today for any fine-grained parchment.

Parchment was first used in the 2nd century B.C. in Rome and the Near East. Pliny attributes its introduction to Eumenes II (197–158 B.C.), king of Pergamum in western Turkey, of whose fine library the Ptolemies were so jealous that they prohibited the export of papyrus on which writing had previously been done (see PALIMP-SEST). Because of its excellent surface and durability, parchment immediately became popular for significant writings and records. During medieval times it was very widely employed in sheets, books, and scrolls for religious and secular writings and music, often lavishly decorated with gilded ILLU-MINATION and painting. It continued to be used to a limited extent by artists, especially in portrait painting, up to the 17th century.

parchment glue. See GLUE.

parchment paper. Any of several types of paper that resemble PARCH-MENT. Vegetable parchment is paper that has been treated with sulfuric acid to make it resistant to oil and grease. Parchment deed is a tough, durable bond with a parchment-like finish. Imitation parchment is a wrapping paper with some of the characteristics of vegetable parchment.

parergon. 1. A work of art created as an activity apart from or subsidiary to one's profession or principal employment. A doctor's painting is a parergon. The term is derived from the Greek *para*, meaning "beside," plus *ergon*, or "work."
2. An accessory or subordinate part of a work of art, as a background scene in a portrait or room details in a painted scene, e.g., the still lifes in the foreground of many of Vermeer's paintings.

Parian marble. A pure white saccharoidal MARBLE of coarse, sparkling texture, used by the ancient Greeks for fine sculpture as well as for building. It is quarried on the island of Paros in the Cyclades.

Parian ware. A fine, unglazed white porcelain or biscuit ware whose surface appearance resembles that of Parian marble. It was first made in England about 1840 and was popular during the rest of the 19th century. Decorative pieces are valued as Victorian antiques.

Paris, School of. See SCHOOL OF PARIS.

Paris black. An inferior grade of IVORY BLACK.

Paris blue. Another name for PRUS-SIAN BLUE.

Paris green. EMERALD GREEN used as an insecticide.

Paris white. A superfine grade of WHITING.

Paris yellow. Another name for CHROME YELLOW.

parmazo marble. An Italian MARBLE with a white or grayish ground and black or blue veins. It comes from the Miseglia, Pescina, and Bocca del Probli quarries in the Apuan Alps.

parquetage. The gluing of thin wood strips to the back of a wooden panel, formerly practiced in the conservation of panel paintings to repair cracks, correct warping, and safeguard against deterioration. Strips laid flat against the panel are called *parquetage à plat,* while other thin strips, glued on edge, are called *parquetage de champ).* Both of these methods of reinforcement have been abandoned, as has CRADLING to some extent, because they frequently lead to further damage to the panel.

parting compound. A paste or liquid material used in casting to coat the interior of a mold in order to prevent the plaster cast from adhering to it. Such a material is called a parting agent, or release agent, in Britain. Soft soap or tincture of green soap is frequently used as a parting agent.

parting tool. A GOUGE used in wood carving, with a steel blade that is a sharply angled V-shape rather than curved or scoop-shaped; also called a V-gouge or V-tool. Smaller versions are used for woodcut. See illustration at WOOD-CARVING TOOLS.

passe-partout. A method of framing, in which a picture on paper, a mat, and a cardboard backing are bound together with an adhesive paper, cloth, or plastic tape all around the edges.

paste. 1. An adhesive substance with a starch base. Common paste, made by cooking wheat flour or cornstarch with water, is the standard adhesive used by artists for mounting and joining paper; it is also used in facing paintings for relining. Prepared, ready-to-use pastes sold in containers are made of various ingredients such as dextrin and synthetic agglutinants. They also contain a mold preventive and an odorant.
2. In ceramics, clay prepared for potters' use. The word is used in such terms as SOFT PASTE and HARD PASTE.

paste blue. Another name for PRUSSIAN BLUE.

pastel. A colored crayon that consists of pigment mixed with just enough of an aqueous binder such as GUM TRAGACANTH to hold it together; a work of art produced with pastel crayons; the technique itself. Pastels vary according to the volume of chalk they contain; the deepest in tone are pure pigment. Pastel is the simplest and purest method of painting, since pure color is used without a fluid medium and the crayons are applied directly to the PASTEL PAPER.

Pastels are called paintings rather than drawings, for although no paint is used the colors are applied in masses rather than in lines. Soft pastels are used for this purpose; the artist may build up his colors without touching them once they are applied, or he may blend them by rubbing them in with his fingers or a STUMP. Although soft pastels are the basic tools of the medium, some artists have used the harder grades of crayon, sharply pointed, to obtain effects similar to those achieved by drawing.

Pastel paintings are among the most fragile works of art, as the color remains on the surface in a powdery form. When properly cared for, how-

ever, they can survive indefinitely. They must be framed and sealed under glass with a thick mat to keep the glass from touching the surface of the painting. A thin spray of fixative is applied to the surface to reduce its fragility, but if used heavily it will alter color effects, color relationships, and characteristic soft quality of the pastel.

Artists have used soft chalks and other dry lumps of colored material since the earliest days of art. One could even claim the method goes back to the prehistoric cave painters. But pastel painting as it is known today was first made popular in Paris in the 1720's by the Venetian painter Rosalba Carriera (1675–1757). Among the great 18th-century pastellists were Maurice Quentin de La Tour (1704–1788), J. B. S. Chardin (1699–1779), and Jean Etienne Liotard (1702–1789); in the 19th century, Edgar Degas (1834–1917) produced outstanding pastel work.

pastel paper. 1. Any paper with a fibrous structure that will take and hold pastel colors. Pastels will adhere to a variety of ordinary rag drawing papers, which may be hard or soft, rough or smooth, for various effects. Many pastel papers are gray, blue, or another permanent color that may contribute to the total effect of the painting, although white is also used. 2. A paper made especially for use in pastel painting. One variety has a surface coated with an abrasive such as finely ground pumice; it is generally preferred for precise, realistic work and for smooth blends. Marble paper, coated with marble dust, also has a granular texture. Another type of coated pastel paper has a flock or velour finish. Muslin pasted on rigid boards has also been used for pastel painting when an especially large surface area was desired. In general, fibrous drawing paper and coarse-grained pastel paper are best for broad, free work, fine-grained pastel paper for smoothly blended effects.

pastel shades. A term commonly used to denote any pale, delicate color of high KEY. But pastel paintings can be, and often are, done with full-toned, deep colors.

pastiche or **pasticcio.** A work of art done in diverse styles borrowed from other works.

pastiglia. The technique of duplicating the effects of carving, low relief, or repoussé on a surface by building up a rather thick layer of GESSO, which is then modeled or tooled and enriched with paint or gilt. In the Middle Ages and the Renaissance craftsmen used

PASTIGLIA. Italian casetta (casket) of the latter half of the 15th century, ornamented in pastiglia relief. (*The Metropolitan Museum of Art, Rogers Fund, 1910.*)

the process to embellish chests, moldings, and other wood surfaces, and painters built up elements such as jewels and halos with gesso before applying tempera colors or gilt. Occasionally entire compositions were executed in painted relief. Modern artists have sometimes used gesso under a paint film of normal thickness to achieve very heavy textures. The process is durable only on rigid supports such as panels; any gesso layer is too inflexible for use on canvas.

pastose. Thickly painted. See IM-PASTO.

pâte or **patte.** In ceramics, the paste or clay mixture of which pottery is formed.

patent yellow. Another name for TURNER'S YELLOW.

patera. A circular or oval ornament with a rayed geometrical or leaf pattern, used in furniture or wall decoration. It is named for a Roman saucer or shallow bowl used as a drinking vessel.

PATERA

pâte sur pâte. In ceramics, surface decoration in low relief, created by brushing thin layers of SLIP on the body.

patina. 1. A film or incrustation, usually green, that forms on copper and bronze after a certain amount of weathering and as the result of the oxidation of the copper. Such a deposit on metal is also known as aerugo and verdigris; an ancient name for it was aes ustum. A fine patina enhances the aesthetic value of antique bronze sculpture and is sometimes induced on new bronze casts by special treatments that duplicate the green copper carbonates and hydrated oxides of natural bronze patinas. The rarer bluish and reddish patinas that are sometimes found on bronze may also be duplicated. A patina is normally a kind of protection, tending to retard further corrosion considerably. Occasionally, however, a malignant kind of corrosion known as BRONZE DISEASE occurs. The process whereby a patina is either naturally acquired or artificially induced is known as patination. In a quite different practice known as bronzing, a

VERT ANTIQUE or other finish is applied to casts of plaster and materials other than bronze to imitate the patina of real bronze.

2. By extension, a mellowing of tone or texture in paintings, prints, stone sculpture, furniture, and other woodwork as the result of age and use.

patriarchal cross. A Latin cross with a second and shorter crossbar intersecting the upright shaft above the main crossbar. The effect is often that of a Greek cross standing on a tau cross. This cross, especially when the lower crossbar intersects the shaft well below the middle, is also known as the cross of Lorraine, because of its use as the emblem of the dukes of that French province. It is also called at times the archiepiscopal or archbishop's cross. See CROSS for illustration.

pattern. 1. The overall composition or layout of a work of art.

2. A decorative design, usually of a repeated figure or motif.

3. A model or MOLD from which something is copied or made; especially the final positive model, usually of plaster, from which a negative mold of foundry sand (see SAND CASTING) or gelatin (see LOST-WAX PROCESS) is made in BRONZE CASTING. When the piece being cast is of such a complex shape that the removal of the pattern in one piece would break the mold, the pattern may be made in two or more pieces and doweled together.

pavonazzetto or **pavonazzo.** A white to drab yellow MARBLE with purplish veins; also, a similarly colored marble found on ancient Roman buildings and said to have been much favored by the emperor Hadrian. The ancient marble has also been known as Phrygian marble, because it is be-

lieved to have come from Phrygia in Asia Minor. *Pavonazzo* is Italian for peacock blue, violet, or purple.

Payne's gray. A COMPOSITE PIGMENT composed of blue, red, black, and white permanent pigments. It is especially useful for watercolors. Although ready-mixed pigments are generally considered undesirable additions to the artist's palette, the continuing popularity of Payne's gray has proved it to be an exception.

paysage. 1. French for landscape. 2. A series of French canvases, in sizes at one time considered appropriate to landscape painting. See table at CANVAS SIZES, FRENCH.

peach black. A variety of CHARCOAL BLACK made from peach pits. It is deeper and more intense than ordinary charcoal. Peach black is no longer in general use.

peach bloom or **peachblow.** In ceramics, a peach blossom-pink Chinese glaze with a mat finish. It is obtained by firing an alkaline glaze with copper as the colorant and cooling it slowly to achieve a devitrification of the surface.

peach gum. See CHERRY GUM.

peacock blue. A rich greenish-blue LAKE pigment made from any of several synthetic organic dyes. Unless labeled with the name of a permanent blue pigment, it can be taken to be a nonpermanent synthetic lake pigment.

pearl white. A name given to two obsolete pigments, BISMUTH WHITE and pulverized mother-of-pearl waste. The latter was used in the 19th century as a delicate watercolor white, but has since been abandoned as overprecious and superfluous.

pear wood. See FRUITWOOD.

pebble mill. See BALL MILL.

pellicular. A term used to describe the binding action of a paint vehicle in which the particles of pigment are completely contained in a film, as in oil paint and polymer colors. In watercolor, on the other hand, the binding action is a simple gluing together of particles without an enveloping film, and is described as cementitious.

pen. An instrument for drawing and writing with ink or a similar fluid. Until the 19th century, most writing and drawing with ink on papyrus, parchment, and paper was done with pens made from the stalks of marsh reeds or, more commonly in the Western world, with the shafts of the wing feathers, or quills, of various birds. The metal pen is also a very old instrument, dating from ancient Roman times if not earlier, but it was never widely used until practical methods for the mass production of steel nibs were developed in England in the 19th century, after which metal pens soon supplanted quill and reed pens. Bamboo pens are still frequently used, however, by Chinese and Japanese artists, and reeds and goose quills are occasionally employed in calligraphy. The name CROW QUILL still survives to designate the smallest steel drawing pen.

Most pens have a similar construction. The tubular material, be it metal, quill, or reed, is cut to a point, which may be sharp or blunt, fine or wide, according to the artist's needs. The nib is usually split a short distance up the middle to give the point greater flexibility, and an S-shaped piece of metal is fitted into the hollow of the point to act as an ink reservoir. The nib may be permanently fitted into a holder or may be removable so that a single holder can be used with a variety of

interchangeable points, as is the case with LETTERING PENS. Certain specialized drawing pens such as the STYLO-GRAPH, the FELT-TIP PEN, and the RULING PEN used by draftsmen do not have a nib.

pen-and-wash drawing. See WASH DRAWING.

pencil. Until the advent of the so-called LEAD PENCIL at the turn of the 19th century, the word pencil referred exclusively to a small, pointed brush, such as those used for watercolor, that was usually made of squirrel or sable hair. Penciling was the painter's draftsmanship. The name pencil is now more commonly applied to a writing or drawing utensil made of a hard, pigmented stick or rod in a case or holder. Most pencils can, if desired, be brought to a fine point. The lead pencil is the most extensively used of all the implements that are called pencils, but there are many other types for drawing and writing, such as COLORED PENCILS, CARBON PENCILS, FLAT SKETCHING PENCILS, charcoal pencils, and graphite pencils with extra-soft, extra-thick leads. Wood-encased pencil forms of virtually all the chalks, colored crayons, and litho crayons that are usually made in stick form are also available.

penetrant. A fluid which when added to a coating material will increase its penetration into the surface. This is a useful property in, for example, a wood stain. All of the volatile solvents have this property to some degree.

pentacle. A five-pointed star, usually including the pentagon formed by extending the sides inward. This figure has had a long history as a magical symbol and amulet. Some of its magical attributes may have arisen from the fact that so complex a figure can easily be drawn with a continuous line, as can SOLOMON'S SEAL.

Pentelic marble. A famed Greek MARBLE quarried at Mt. Pentelicon near Athens; it ranges from white to grayish in color. It was used as early as the 6th century B.C. and remained the favorite Athenian stone for building and sculpture. The Parthenon is made of Pentelic marble.

pentimento. The reappearance on the surface of an oil painting of paint or drawing that the artist had covered by overpainting, as a result of the increasing transparency of the overpainting on aging; from the Italian word for repentance. Examples of pentimento can be found in most museums, especially among the thinly painted panels of 17th-century Dutch artists like De Hooch, in which checkerboard marble floors were painted before the figures were put in, so that the black tiles eventually showed through women's dresses and furniture. Sometimes there is the ghost of one of the children or small dogs that so often inhabit these scenes. More modern paintings may also exhibit such unintentional effects after some years of aging, and they are sometimes blemished by evidences of brushstrokes running in a different direction from those of the overpainting. If the modern painter has profited from the example of older painters, he will take steps to preclude the eventual disclosure of his "repentances." He may, for example, remove lines or colors that are darker than the new paint with a knife or scraper, and smooth out any thick impasto in the first layer of paint before overpainting. See color-plate facing page 119.

peperino. A volcanic rock found near Rome. It is named for its black specks, which resemble peppercorns.

Peperino, also known as Albani stone, has been used extensively in architecture since classical times and was occasionally employed in the 16th century as a support for painting in oils.

perforating wheel. A finely spiked or serrated wheel mounted at the end of a handle, used to perforate paper along the lines of a drawing in order to transfer it to another surface by POUNCING. This implement, also known as a tracing wheel, is available both in a straight model, with the wheel fixed in one position so that it turns essentially on a straight line, and in a swivel model, in which the wheel swings freely on a rotating axle. Although the swivel wheel was designed to follow the curves in a drawing more easily, the straight model can also be used to trace curved lines.

PERFORATING
WHEEL

Pergamene school. One of the Hellenistic schools of sculpture of the 3rd century B.C., in the ancient city of Pergamum (Pergamon) in Asia Minor. The works of this school were remarkable for their extraordinary vigor and power. The human body was usually shown in positions of extreme muscular tension. One of the best known major works of the Pergamene school was the elaborate altarpiece of the great altar of the temple of Zeus at Pergamum. Parchment (Latin, *pergamena*) derives its name from Pergamum.

perilla oil. A DRYING OIL obtained from the seeds of the plant *Perilla ocimoides*, grown in southeast Asia. It has excellent film-forming properties and is highly recommended for use in house paints and other industrial coatings, but cannot be used in artists' colors because of its strong tendency to turn yellow and spotted with age.

Perkin's violet. The first SYNTHETIC ORGANIC PIGMENT, discovered in England by W. H. Perkin (1856) and widely known as MAUVE. Aniline violet is a variant.

Permalba. Trade name for a COMPOSITE WHITE artists' oil color, introduced in 1920 by F. Weber of Philadelphia.

permanent blue. A name given in the mid-19th century to ULTRAMARINE BLUE. Since that time the term has been applied to so many products, including synthetic organic pigments, that it is not a reliable pigment designation, unless the name of its color ingredient is also printed on the maker's label.

permanent green. A bright, opaque, yellowish-green artists' tube color, sold in Britain as cadmium green; a COMPOSITE PIGMENT usually composed of cadmium yellow and phthalocyanine green. Before the invention of the latter, viridian was used. Permanent green is not a standard pigment name, so its reliability is assured only if its ingredients are stated on the label. Although it is not one of the artist's essential pigments, many painters like the convenience of its ready-mixed hue.

permanent violet. Another name for MANGANESE VIOLET.

permanent white. Another name for BLANC FIXE; also the trade name for a COMPOSITE WHITE artists' oil color.

permanent yellow. An unstandardized term applied variously to BARIUM

YELLOW and to some of the permanent yellow synthetic organic pigments.

peroba. A pink hardwood obtained from the Brazilian tree *Aspidosperma peroba* and used for furniture and flooring. Peroba is also useful for carving, as it has a firm, close grain and an even texture.

Perpendicular style. See GOTHIC.

Persian berries. Another name for BUCKTHORN BERRIES.

Persian Gulf oxide. A native RED IRON OXIDE. The brightest and best of the native red earth-colors, it has been superseded for artists' use by LIGHT RED.

Persian orange. An opaque lake made from various dyestuffs precipitated on a barytes or blanc fixe base; not used in permanent painting.

Persian red. An unstandardized name applied to LIGHT RED, PERSIAN GULF OXIDE, and a variety of chrome red (see CHROME YELLOW).

perspective. A system of representing three-dimensional objects on a two-dimensional surface so that the effect is the same as if the actual scene were viewed from a given point, the objects appearing three-dimensional and receding in depth with the same space relationships. Perspective is a basic element in representational art of the Western world and, traditionally, one of the criteria of its excellence. The use of perspective in the depiction of an individual form is ordinarily called FORE-SHORTENING, the term perspective usually being reserved for the depiction of entire scenes and structures.

There are a number of different methods, both geometric and illusion-

ary, for indicating perspective. An artist often uses several of them in conjunction to achieve the effect of spatial ordering and depth that he desires. The principal geometric system used by artists is called LINEAR PERSPECTIVE. Objects are made to recede in space by being drawn progressively smaller and closer together toward the horizon and are projected on the PICTURE PLANE by means of a system of guide lines ruled to a point or points on the HORIZON LINE called VANISHING POINTS. Structures, roads, and areas of

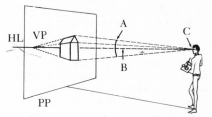

PERSPECTIVE (HL) Horizon line; (VP) vanishing point; (PP) picture plane; (A) cone of vision; (B) central visual ray; (C) point of station.

terrain are placed in perspective, for example, by having their parallel vertical lines, when theoretically extended, converge on one or more points. Depending upon the orientation of an object, its depiction will involve one or more vanishing points, and depending upon their number, the object is said to be drawn in PARALLEL PERSPECTIVE (one-point perspective), ANGULAR PERSPECTIVE (two-point perspective), or OBLIQUE PERSPECTIVE (three-point perspective).

There is a procedure to cover any problem in perspective, but it is seldom desirable in creative work to adhere rigidly to the last degree of LEGITIMATE CONSTRUCTION, as geometrically correct linear perspective is called. Departures within small tolerances have always been made in spirited

work to avoid a mechanical or stilted effect. In 20th-century representational work, some of the rules of legitimate construction have been greatly relaxed, particularly those that govern the proportions of the three ZONES OF RECESSION in a composition. In addition to linear perspective, AERIAL PERSPECTIVE, which makes use of such illusionary devices as ADVANCING AND RETREATING COLORS, may be employed to depict recession and space.

The earliest writer on perspective, according to Vitruvius (1st century B.C.), was the painter Agatharchus of Athens. His description in the 5th century B.C. of his stage setting for a new tragedy by Aeschylus led Anaxagoras and Democritus to write further about the depiction of receding and advancing objects on a flat surface and about the CONE OF VISION, the pattern of sight lines from the "observer's eye" at the POINT OF STATION to the picture plane. Roman wall paintings reveal an understanding of such principles and show a well-organized parallel perspective. The rules of linear perspective were developed and codified by painters and architects of the 15th century. Notable studies were made by Leone Battista Alberti (1404–1472), Piero della Francesca (c. 1420–1492), Paolo Uccello (1396/7–1475), Albrecht Dürer (1471–1528), Leonardo da Vinci (1452–1519), and others. See also PROJECTION; SOTTO IN SÙ.

pétard. French term (literally, fireworks) for an outrageously wild or extravagantly colored painting designed to attract attention. Twentieth-century developments in painting have made this term obsolete.

petite nature. A painting in which the figures are between life-size and half-size.

petrolatum. Petroleum jelly, sold under the trade name of Vaseline. It occurs in the arts as an ingredient in lubricating and moisture-protective substances.

petroleum ether. The most highly volatile liquid obtained from the distillation of petroleum oil; it evaporates instantaneously. It is also called casinghead gasoline and is dangerously flammable and explosive.

petroleum solvent. See MINERAL SPIRITS.

petroleum spirits. See MINERAL SPIRITS.

Pettenkofer process. A method of giving a new gloss to dull or whitened varnish on an old oil painting by treating the surface with copaiba balsam and exposing it to alcohol fumes. The process, introduced by Max von Pettenkofer in Germany around the middle of the 19th century, has been discarded as unsound.

petuntze or **petuntse.** A partially decomposed feldspathic granite found in China and used with clay to make oriental porcelain; also called China stone. Petuntze has a finer grain and a more complicated formula than the feldspars of Europe and the U.S. China's supply of this mineral accounts in part for her very early development of porcelain. CORNISH STONE is sufficiently similar in composition to petuntze to be considered its equivalent.

Petworth marble. See SUSSEX MARBLE.

Peuron stone. See LIMESTONE.

pewter. An alloy of tin with some other metal or metals in varying pro-

portions. Pewter is used for tableware, hollow ware, both domestic and liturgical, and applied decorations, usually functional, such as door latches. The additional metal, usually copper, antimony, or both, is added to harden the malleable tin and to give it strength; but even with these additives, pewter is easily bent and melted. The quality of the pewter depends upon the amount of tin it contains and the metals with which the tin is alloyed. The highest grade of pewter contains a large proportion of tin and a small amount of copper; the low-grade pewter that is sometimes called black metal is almost half lead.

Until the 19th century, pewter was made by casting the molten metal in a brass mold, turning it on a lathe to smooth it, and sometimes hammering it to give it strength. Many old pieces of pewter have faint hammer marks left by this last process. During the 19th century SPINNING replaced the older methods of shaping metal wares. This process eliminated the need for hammering, so that most post-19th-century pieces have no hammer marks. About the same time as the invention of the spinning technique, an especially high quality pewter known as BRITANNIA METAL began to be extensively used.

Pewter wares that date from the Roman period have been found in England, but the alloy may have been used even earlier. Although it has been thought of as "poor man's silver," pewter has aesthetic qualities of its own and is now highly prized for itself. Most pewter wares are similar in design to simply designed silver. Some continental pewter is engraved, but the soft alloy is not suited to such decorative techniques as repoussé and chasing. Fine pieces produced during the 18th and 19th centuries were marked by the artisans who crafted them with a TOUCH.

phenol. Carbolic acid; a disinfectant and mold preventive. The full-strength acid is a dangerously toxic material to handle. A .1% solution may be added to water paints as a PRESERVATIVE. Since phenol is volatile and does not remain fully effective after the paint has dried, it has been replaced in some products by the more modern permanent preservatives. An ODORANT is sometimes added to a paint containing phenol to mask its aroma.

phenolic resin. A class or family of thermosetting resins, the most prominent of which, sold under the trade names of Bakelite and Catalin, is used for making hard, tough, and durable varnishes. The phenolics have replaced the older spar varnishes and copal varnishes but are not employed in permanent artists' materials because of their tendency to darken with age. Flat sheets of laminated phenolic resin, sold under such names as Formica and Micarta, have great durability and can withstand severe abuse. Artists have employed them in various constructions, such as murals executed by shaping and inlaying pieces of various colors. Catabond, a member of the Catalin group of phenolic resins used in industrial casting, is available in opaquely colored, heavy solutions that can be used in the studio for slush molding and solid casting through an easily mastered series of manipulations.

Philippine mahogany. See MAHOGANY.

phosphor. See LUMINOUS PAINT.

phosphotungstic pigments. Brilliant, powerful pigments of many hues made from some earlier synthetic dyes by a process that gives them greater color stability than such colors produced by older methods. These

pigments were developed in Germany during the first quarter of the 20th century. Apart from their brilliance and improved lightfastness, they are not as good as the newer SYNTHETIC ORGANIC PIGMENTS in approved use, and they may possess the fault of bleeding. None of the phosphotungstic pigments has been adopted by impartial authorities as suitable for permanent painting.

photochemical embrittlement. Loss of flexibility or elasticity of a paint or varnish film through long exposure to the ultraviolet content of daylight. See EMBRITTLEMENT.

photoengraving. A commercial RELIEF PRINTING process in which a photographic negative of the original to be reproduced, either linecut or halftone, is printed on a metal plate sensitized with a coating containing a bichromate. After the plate is processed, it is coated with powdered DRAGON'S BLOOD, which adheres to the photographic image only. When the plate is heated, the dragon's-blood dust fuses, forming an acid RESIST on the design areas of the plate. The plate is then etched (see ETCHING) as in an INTAGLIO process, but because the design areas remain in relief, the plate is inked and printed as a relief plate, differing in this way from photogravure, which is entirely an intaglio technique.

photographic stencil method. A SILK-SCREEN technique in which the stencil is prepared from a specially sensitized photo film. This method, which is rather more complicated than the other methods by which silk-screen stencils can be made, is essentially a reproductive technique, since no creation is actually done on the screen. Any original work of art done in any medium on any surface can be photographically transferred to the film from which the stencil is made. Every detail of the original is reproduced, including delicate halftones. This process is used chiefly for commercial work. An artist who is so inclined may make photographic-film stencils with only a few supplies in addition to those of standard silk screening, but for such work he usually avails himself of the services of a commercial silk-screen specialist.

photogravure. The most important commercial INTAGLIO printing process, noted for its high-quality reproduction of HALFTONES and color artwork. The printing surface is either a flat copper plate (sheet-fed gravure) or a copper-covered cylinder (rotogravure). The original to be reproduced is photographed through a finely cross-ruled screen onto a sensitized copper plate, breaking up the photographic image into evenly sized cells. The margins and nonprinting areas of the plate are then covered with an acid RESIST, and the plate is etched (see ETCHING), producing wells in the surface. All of these "ink cups" are of uniform size, varying only in depth, so that when the plate is inked the small amount of ink contained in the shallowest cups barely stains the surface of the paper, printing pale areas, whereas the deeper cups take proportionately larger charges of ink and print deeper gradations of tone. The process differs from PHOTOENGRAVING, which is a RELIEF PRINTING process in which halftones are produced by raised dots that vary in size and density. In both sheet-fed gravure and rotogravure, the inking and printing processes are essentially those employed for printing an etching.

photo mural. A photographic blow-up enlarged to the dimensions of a wall space and attached to it with wallpaper paste or other adhesive; an art form of the mid-20th century.

Phrygian marble. See PAVONAZ-ZETTO.

phthalocyanine blue. Copper phthalocyanine; a deep, intense, CYAN-blue pigment, with a very greenish undertone and very high tinting strength. It is permanent for all paint uses, and replaces the older and less reliable Prussian blue, which is identical in physical and color properties. Both pigments, in dry powder form, exhibit a coppery bronze sheen when rubbed. Phthalocyanine blue was discovered accidentally in a British dyestuff plant, when a dark color was observed in a kettle in which an intermediate (phthalamide) was being made. Curiously, Prussian blue and ultramarine blue were discovered through similar accidental observations. The PAINT STANDARD permits the labeling of phthalocyanine blue and phthalocyanine green with proprietary names, provided the pigments are identified in small print. This exception to the rule was condoned because of the wide acceptance of such names during the period prior to 1942, when the new pigments were being developed. Among American trade names in use for phthalocyanine blue and green are intense blue and green, Thalo blue and green, and Bocour blue and green. Winsor blue and green and MONASTRAL BLUE and green are British trade names; Rembrandt blue and green are Dutch. Phthalocyanine blue was put on the market in Britain in 1935 and in America in 1936.

phthalocyanine green. Chlorinated copper phthalocyanine; a brilliant, cool, transparent emerald-green pigment, with the same pigment properties and permanence as PHTHALO-CYANINE BLUE. Phthalocyanine green can be used in place of viridian, although many painters still prefer viridian's less vivid effects. For some trade names, see PHTHALOCYANINE BLUE.

phyllomorphic. Resembling a leaf. The term is applied to painting, drawing, engraving, or carving that has leaflike details.

physionotrace. A device for tracing the profile of a sitter, used in the late 18th and early 19th centuries, the heyday of the SILHOUETTE.

picture frame. A structure, usually of wood, in which an easel painting, print, or drawing is enclosed to improve or enhance its appearance, to isolate it from a wall, or to link it to a decor, as well as to support and protect it. Prints, watercolors, and pastels should be matted and framed under glass with a dustproof seal at the back. A canvas on the usual lightweight stretcher should be braced in a frame of substantial construction before it is hung on a wall, to prevent warping. The mid-20th-century vogue for hanging unframed canvases calls for a more solid and substantial stretcher than the ordinary lightweight variety. Stripping (see STRIP) also fails to support and protect a canvas, and should not be considered a permanent means of framing a painting on an ordinary lightweight stretcher. The floating frame, in which there is a space between the canvas and the wood, will not give a painting the necessary reinforcement either, unless it is strengthened at the rear. Traditionally an unframed painting was considered incomplete. Until the second quarter of the 20th century, the great majority of picture frames were gilded; since then, painted and raw wood frames have also come into wide use.

picture frames, American stock sizes. Ready-made picture frames in various styles and widths are carried in

stock in the following sizes (measurements in inches):

Relatively broad, sometimes ornate frames for paintings:

8 × 10	18 × 24
11 × 14	20 × 24
12 × 16	24 × 30
16 × 20	24 × 36

Simple, narrow frames with glass for prints and drawings:

5 × 7	11 × 14
8 × 10	12 × 16
8½ × 11	14 × 18
9 × 12	16 × 20

picture plane. In perspective, the plane occupied by the surface of the picture. It is conceived of theoretically as a transparent plane through which pass all the lines of sight between the eye of the viewer and the apparent positions of the subjects depicted in the picture. The painter draws these subjects on his canvas as if it were a pane of glass held up in front of a scene. He indicates their supposed distance beyond the picture plane by variations in size and by other means, with attention to laws of perspective. The picture plane is conceived of as perpendicular to the CENTRAL VISUAL RAY, the viewer's most direct line of sight. See illustration at PERSPECTIVE.

picture putty. A cement used by conservators for stopping or filling in holes in paintings. It is made with stand oil and chalk or another inert pigment, plus cobalt drier and, if desired, tinting pigments. Ordinary window putty, a mixture of linseed oil and whiting, is not stiff enough to be used as picture putty.

picture varnish. A VARNISH used as a final coating over a thoroughly dried oil painting to protect and preserve it and to create a uniform gloss. Casein paintings are sometimes varnished to imitate the depth of color in oil painting. The two modern varnishes that come closest to meeting an ideal set of requirements are DAMAR, which dries to a bright gloss finish, and clear acrylic (methacrylate) varnish, which dries quickly to a dull or satiny gloss. An oil painting accumulates adhesive grime and must be cleaned periodically. Unless the picture is varnished, its colors are likely to be injured in cleaning. A good picture varnish must be readily soluble in mineral spirits or other mild solvent so that dirty varnish can be removed by safe, routine conservation methods. MASTIC varnish was popular in the 19th century when a smooth, glassy finish was admired; damar has replaced it because it has a duller gloss, may be used in thinner coats, does not turn yellow, and is not so susceptible to BLOOM. Copal varnish does not qualify for this use because such powerful solvents are needed for its removal that the colors of the painting would be damaged.

piece mold. A rigid mold made in sections, for casting forms that are too complex to be handled in one piece and for making multiple replicas of a model. The face of each piece has two or more small protuberances that fit closely into corresponding depressions on the other piece, keeping them aligned during use. Since a piece mold can be taken apart without breaking it to remove the cast inside, it is reusable, unlike a WASTE MOLD.

piercing. A decorative technique in metalwork in which areas of the metal are cut out, leaving pierced designs. It is used chiefly on handles of trays, porringers, etc. A fretsaw is usually used for piercing silver, but a special tool is needed to pierce SHEFFIELD PLATE so

that the copper does not show in the cut-out edges. See also À JOUR.

pietà. A painting or sculpture showing the Virgin Mary holding the body of the dead Christ; called *Vesperbild* in German, *Vierge de Pitié* in French. It is a prominent motive in devotional art.

pietra dura. Inlaid work in which pieces of hard, polished stone are set into marble or another hard surface; also, stone suitable for such work. The term is Italian for hard stone.

pigment. A finely powdered coloring material used in making paint, printing ink, and a number of industrial products. A pigment is insoluble in the liquid vehicle with which it is mixed, imparting its color effect by being spread over a surface. Soluble colors that impart their hues to substances by staining or being imbibed by them are called DYES. A pigment made by precipitating a dye on a colorless, or inert, BASE (see INERT PIGMENTS), thus rendering the dye insoluble, is called a LAKE. A synthetic organic compound that is insoluble and can be used directly as a pigment is called a TONER. In general, toners require reduction with inert pigments to be used in artists' colors.

A pigment is usually classified according to its origin: Those made by processing colored earths are called EARTH COLORS; those made by chemical means from inorganic raw materials that are not in themselves coloring matters are known as artificial inorganic pigments. Earth colors are mined and processed the world over, but the finest grades occur in specific localities: For example, French yellow ochre, Italian raw and burnt sienna, and Cyprian umber are traditionally preferred. Among the earliest pigments used in the arts were native earths such as the RED IRON OXIDES and yellow ochre, and manufactured pigments such as crimson lake, lampblack, and white lead. While a very few of the permanent, artificial inorganic pigments are produced in small amounts almost exclusively for artists' use, the great majority are massproduced for industrial purposes. The highest grades of artificial pigments produced in the U.S. are equal in quality to those made elsewhere and are manufactured under scientific control to meet standards no less exacting than those of the artist. In addition, large quantities of cheaper, inferior grades are also made.

To be acceptable for use in artists' materials, a pigment must be fine enough to pass through a screen of 325 meshes to the inch; must meet very exacting standards of brilliance, clarity, and TINTING STRENGTH; and must possess the degree of opacity or transparency and the general color properties characteristic of its type. In addition, a pigment must be chemically inert, so that it will not react harmfully with other pigments or liquids with which it may be mixed, and it must be lightfast, so that it will not fade or darken on exposure to normal indoor conditions (i.e., indirect sunlight, artificial light of average intensity, and controlled temperature and humidity variations). All pigments approved for artists' use will survive indefinitely under the aforementioned conditions, although some of them may undergo loss of color if exposed to direct sunlight. In painting outdoor murals, the artist must limit his palette to pigments that are absolutely permanent under all conditions of exposure, such as cobalt blue, cerulean blue, manganese blue, Indian red, light red, Mars red, viridian, chromium oxide green, and yellow ochre. In fresco painting, the palette is even more restricted, since a fresco pigment must also be limeproof and re-

sistant to acid impurities in the atmosphere. Many brilliant colors used in house paints, printing inks, etc., are labeled permanent, but the industrial connotation of permanence is limited: A pigment that lasts long enough to serve its purpose is called "permanent," and fading during the required period is called "premature failure."

The pigments approved by the Paint Standard for use in oil paints and those acceptable for other easel-painting techniques are listed here under the following headings: BLACK PIGMENTS; WHITE PIGMENTS; BROWN PIGMENTS; YELLOW PIGMENTS; RED PIGMENTS; BLUE PIGMENTS; GREEN PIGMENTS; ORANGE PIGMENTS; and VIOLET PIGMENTS. See also SYNTHETIC ORGANIC PIGMENTS

pigment nomenclature. For centuries the nomenclature of artists' pigments was in a chaotic state. When the PAINT STANDARD was first promulgated in 1942, the names of all permanent pigments became standardized in American usage. A similar BRITISH PIGMENT STANDARD was established in 1957. With minor exceptions, the makers of the best American, British, and European artists' colors now adhere to correct nomenclature. Colors labeled with unstandardized names can be considered substandard materials.

pigment properties. A term used in describing or evaluating a pigment, referring to all characteristics other than its COLOR PROPERTIES, such as fineness of grain, behavior in paints, and chemical stability.

pigment yellow. An azo dyestuff used to make a number of yellow pigments of fair to excellent permanence, including HANSA YELLOW, one of the SYNTHETIC ORGANIC PIGMENTS accepted for permanent painting.

pine oil. One of the products of the steam distillation of pine wood in the manufacture of WOOD TURPENTINE. Although not a common or standard ingredient of artists' materials, it has been used because of its very slow rate of evaporation as a retardant for oil paints that dry too rapidly during the painting process, and as a preservative. It has an agreeable terpene odor which resembles that of some of the perfume oils.

pine-soot black. Chinese name for LAMPBLACK made by burning pitch pine.

pink. A pale red. The term was also used in the past for several yellow lakes of vegetable origin, such as Dutch pink.

pink color. A pale reddish pigment made by roasting chromium and zinc oxides in a furnace; similar to POTTER'S PINK. Although pink color is useful as a ceramic color, its low saturation and high cost preclude its use as a paint pigment. Pink color was made as early as 1836 in Germany, where it was known by its English name.

pink mauve. A reddish variety of MAUVE.

pins. In the casting of metals, nails used to maintain the space between the MOLD and the CORE. They are often made of iron, although bronze pins are used in casting bronze, so that no spots of alien matter will appear on the finished piece.

pinx. An abbreviation of the Latin word *pinxit,* meaning "he painted it," formerly inscribed on a painting after the artist's signature but rarely used this way today. *Pinxit* or *pinx.* is still sometimes inscribed, however, in a lower corner of the margin of a print,

where it may have the same meaning as *inv.* or *invent.*, abbreviations of the Latin *invenit*, "he designed it." For an explanation of other terms used in marking prints, see DEL.

pipe clay. Another name for CHINA CLAY.

pisciform. Fish-shaped.

pitchers. In ceramics, pulverized shards of unglazed pottery used as GROG. Faulty glazed ware cannot be used for this purpose since the glaze would change the chemistry and reduce the porosity of any clay body in which it was used.

pitching chisel. A short, sturdy, one-piece steel chisel with a relatively broad tip, used to create an edge on the flat surface of a stone. See illustration at CHISEL.

pithos. An ancient Greek storage urn. Pithoi, some of which were very large, were often half buried in the earth. They were used for storing both grains and liquids, such as wines and olive oil. See VASE SHAPES for illustration.

piuri or **pioury.** INDIAN YELLOW in crude lump form; also spelled puree and pwree.

plafond painting. A painting on a ceiling, usually of ornate or elaborate design.

planimeter. A draftsman's instrument that determines the area of a surface on maps, plans, and diagrams drawn to scale by tracing the perimeter of the area to be calculated. The planimeter automatically compensates for the irregularities in non-geometric forms, allowing the area of any shape to be measured in this way. For this reason, it is sometimes also called a compensating planimeter.

planographic printing. In the graphic arts, one of the three major categories of printmaking techniques (the others are INTAGLIO and RELIEF PRINTING). The term was devised to categorize LITHOGRAPHY, in which proofs are pulled from a flat surface (hence the name planography, "flat writing") rather than from indented or relief areas of a plate. In lithography, both the printing and the nonprinting areas lie in the surface of the lithographic stone or metal plate. The two areas are differentiated only by their respective attraction and repulsion of printing ink when it is applied to the dampened surface of the stone or plate.

plasteline. See MODELING CLAY.

plaster. A fine, white powder which, when mixed with water to paste or cream consistency, sets to a hard, cohesive mass. Three kinds in common use are lime plaster, used in mortar for fresco, wall, and ornamental plastering and fine stucco; GYPSUM PLASTER, used in ordinary wall plastering and made either from gypsum or gypsum and lime; and PLASTER OF PARIS, used by sculptors.

plasterboard. See WALLBOARD.

plaster of Paris. A soft white powder consisting of gypsum that has been calcined or roasted until three-fourths of its water of crystallization is driven off. When mixed with water to a cream or paste consistency, the plaster soon sets to a firm, hard mass without shrinkage or loss of volume, because it sets before all the water can evaporate. Its speed of setting may be retarded by the addition of a glue solution, or accelerated with a small amount of alum. Plaster of Paris is widely used as a

CASTING PLASTER, for modeling and carving, for molds used in sculpture and ceramics, and as an ingredient of other cements and plasters for special purposes. See also SLAKED PLASTER OF PARIS.

plaster primer. An industrial white paint made specifically to be applied as a first coat to a plaster surface. Its vehicle is oil or oil and resin; it penetrates well and dries to a mat finish. If made by one of the manufacturers of the highest quality house paint, it is a good base or PRIMER for mural painting in oil. Plaster primers are often simply called wall primers.

plaster tools. Sculptors' implements made of forged and tempered steel;

PLASTER TOOLS

used for cutting, shaping, and incising hardened plaster. They may be pointed, square, rounded, or hooked, with straight or tapered ends and smooth-edged or serrated blades.

plastic. 1. Capable of being readily molded. Common putty and moist clay are plastic materials.
2. Any of a large group of synthetic organic POLYMERS that can be molded to any desired shape and are capable of retaining the new shape. The industrial plastics, made from synthetic RESINS, are formed (shaped) by molding, casting, or extruding. Several of the synthetic resins have been used in plastic sculpture for work that cannot be accomplished by using tra-

ditional sculptors' materials, and some of them have been adapted to printmaking techniques. See VINYL RESIN; ACRYLIC RESIN; POLYESTER RESIN.

plastic art. 1. Three-dimensional art, such as sculpture, as distinguished from drawing and painting; also, art in which three-dimensional effects are created, such as realistic painting.
2. One of the creative visual arts, including sculpture, architecture, painting, drawing, and the graphic arts, as distinguished from poetry, music, drama, and literature; usually used in the plural.

plastic gesso. Stiff GESSO, used for modeling and filling in. To minimize shrinkage, it is made with only as much water as will make it plastic.

plasticity. The property of a solid material that permits it to be molded and to retain its new shape. Modeling clay, for example, has good plasticity. So have artists' oil colors, which can readily be brushed onto a surface but then "stay put" instead of flowing. This latter quality is the opposite of fluidity and the LEVELING tendency of some paints. The plasticity of a material is measured by the degree to which it resists deformation when a certain finite force (the stroke of a brush, a palette knife, a modeling tool) is applied to overcome its internal friction and make it assume another shape. Various materials become plastic only when heated, and set rigidly after cooling. Some familiar examples are glass and the synthetic resin products of the thermoplastic type, which permanently retain new shapes after being subjected to heat and molded.

plasticizer. An ingredient which is added to a paint, lacquer, or varnish to impart a necessary property or to overcome an undesirable one. Ordinarily a

plasticizer is used to impart flexibility and overcome a tendency to brittleness, or to improve brushing qualities and effect the smooth compatibility of pigment and vehicle. Beeswax has been used as a plasticizer for oil colors, sugar for watercolors, and castor oil for shellacs and lacquers.

plastic magnesia. See CALCINED MAGNESITE.

plate-finished paper. A flawlessly smooth, stiff paper or card, widely used for drawing with India ink.

plate mark. In all intaglio PROOFS except photoengravings, a rectangular impression made on the paper by the embossing action of the ETCHING PRESS along the beveled edges of the plate. (The edges of the plate are usually beveled to keep them from cutting the paper in the press.) The plate mark, which forms a kind of frame around the print, is a distinctive characteristic of an original INTAGLIO print, although artificial plate marks are sometimes embossed on photographic reproductions of prints. An ETCHING or ENGRAVING that does not have a plate mark has had its margin trimmed and is not considered a choice collector's item.

plate oil. British term for LITHO VARNISH.

plein air. French term meaning, literally, open air. The expression *en plein air* was used during the second half of the 19th century to describe painting done outdoors. Prior to that time even landscape painting was done wholly in the studio. The *plein air* painters, by working directly in the ambience of light and atmosphere, were able to develop new techniques to achieve new effects in their paintings. The new practice led to a realist philosophy that challenged the prevailing Romantic doctrine and strongly influenced the development of later art movements. The mid-century BARBIZON SCHOOL comprised the first painters to work outdoors almost exclusively, but the artists specifically called *pleinairistes* were a group of Impressionists of the 1880's and 1890's, notably Camille Pissaro (1830–1903), Claude Monet (1840–1926), Alfred Sisley (1839–1899), and Pierre Auguste Renoir (1841–1919). See also IMPRESSIONISM.

Plessy's green. An early variety of CHROMIUM OXIDE GREEN made by a special process; named after its inventor.

plexiform. Resembling plaiting, braiding, or weaving.

Plexiglas. See ACRYLIC RESIN.

plinth. A block which is sometimes placed between a statue and its pedestal; also, in architecture, the block on which a column rests.

plique-à-jour. An ENAMEL technique in which the spaces in a delicate wire framework, filigree, or fretwork are filled with transparent or nearly transparent enamels, for a jewel or stained-glass effect. This technique is used for jewelry and precious decorative objects.

plumbago. An obsolete designation for GRAPHITE.

plumbate ware. A pre-Columbian ceramic ware from Central America. Its lustered slip, containing iron and aluminum, was heat-treated in a poorly controlled reducing fire. Technically and in appearance plumbate ware resembles Etruscan BUCCHERO WARE.

plumbic ochre. An archaic name for MASSICOT.

plum gum. See CHERRY GUM.

plum wood. See FRUITWOOD.

plywood. Wood laminated in layers called plies or veneers, which are glued together under pressure with the grain of each layer running perpendicular to that of the adjacent layer. Artists' panels for painting may be made of thick 5-ply maple or birch. The common fir and other softwood plywoods are not acceptable as supports for permanent painting. See MAPLE DIE BOARD.

pochade. A rapidly executed COLOR SKETCH in oils. This term often refers to a small, rough landscape sketch done outdoors, to be used later in the studio as a reference for the final painting.

pochade box. See SKETCH BOX.

pochoir. A stencil and stencil-brush process for making multicolor prints, for tinting black-and-white prints, and for coloring reproductions and book illustrations, especially fine and limited editions. Pochoir, which is the French word for stencil, is sometimes called hand coloring or hand illustration. Pochoir, as distinguished from ordinary stencil work, is a highly refined technique, skillfully executed in a specialized workshop.

point. 1. A sturdy, hardened-steel rod, usually hexagonal and from 4 to 8 inches in length, with one pointed end. It is used for carving stone and is struck with a mallet. A bull point is a thick, stubby version. See illustration at CHISEL.
2. Another name for the NEEDLE used in etching and drypoint.

pointillism, pointillisme, or **divisionism.** A branch of French IMPRESSIONISM in which the principle of OPTICAL MIXTURE or broken color was carried to the extreme of applying colors in tiny dots or small, isolated strokes. Forms are visible in a pointillist painting only from a distance, when the viewer's eye blends the points of color to create visual masses and outlines. The inventor and chief exponent of pointillism was Georges Seurat (1859–1891). Its other leading figure was Paul Signac (1863–1935). See colorplate facing page 151.

pointing. 1. In sculpture and stone carving, a technique of reproducing a clay or plaster model or of copying a finished work through measurements. From many points on a series of planes about the model, measurements are made to the precise depths of the model's form. At corresponding points on the block of stone (or other medium), holes are drilled to the correct depths and the surrounding stone is then cut away. Pointing may be done in stages; the first step, with relatively few measurements, produces a very rough form of the model in stone; at each succeeding step the measurements become more numerous, the carving more precise. Primitive pointing devices were used by the ancient Greeks; in the 19th century an adjustable pointing machine was developed that greatly facilitated the transfer of measurements. The technique is now considered a craft rather than an art; most modern sculptors prefer DIRECT CARVING.
2. In construction, filling the spaces between stones or bricks with mortar or cement.

pointing trowel. A small tool with a flat, finely tapered blade, used by masons and plasterers. The pointing trowel is used in filling the spaces be-

tween stones and bricks with mortar (i.e., "pointing"), in stopping small irregularities, and for work in corners and other difficult spots. In fresco plastering it is used to cut away the excess plaster of the intonaco and to create the joins between areas of the intonaco.

point of station. In perspective, the point in space that represents the eye of the observer. In any perspective projection, the observer is thought of as having only one eye, which is on a level with the horizon depicted or implied on the PICTURE PLANE. Sometimes, as in a BIRD'S-EYE VIEW or WORM'S-EYE VIEW, the HORIZON LINE is located above or below the picture plane, respectively. See illustration at PERSPECTIVE.

poliment. Another name for BOLE.

polishing rouge. See ROUGE.

Politec. Trade name for a Mexican manufacturer's line of acrylic POLYMER COLORS and their adjuncts.

polychrome or **polychromatic.** Decorated in several colors; multicolored. In art, the term is most frequently used to refer to the decoration of wood and stone carving in full color and gold. Much Egyptian, Greek, and other ancient sculpture was originally polychrome, as were such ancient buildings as the Parthenon. Polychrome decoration was extensively practiced in medieval and Renaissance art.

Polyclitan school. An ancient Greek school of sculpture. It was named for the sculptor Polyclitus (Polykleitos) of Argos or Sicyon, who worked from 450 to 420 B.C. and who, next to Phidias, was the most admired sculptor of his era. He worked out a system of proportions for the human figure that were

illustrated in his famous statue of an athlete called the *Doryphorus*, which was called "the canon" for this reason. Unfortunately, the statue is known only in somewhat stilted Roman copies.

polyester resin. Any of a series of synthetic resins of the glyceryl phthalate group. Polyester resin is used industrially in the manufacture of paints and synthetic fiber (Dacron), and it has been used as a molding material for sculpture, for which it is well suited. It is THERMOSETTING, but before heat is applied the resin must be mixed with chemical additives, a catalyst, and an accelerator. The transparent or translucent plastic is made opaque by the addition of fillers, such as inert pigments or metallic powders, and is given color by the addition of permanent pigments. Like all synthetic resins, polyester is produced as a raw material for industrial use. Although it is entirely possible for sculptors to prepare and cast it, most works are cast from the sculptor's original model in an industrial shop, where safeguards are maintained against the dangerously toxic effects of its solvents (notably methyl ethyl ketone) and other ingredients. Severe disabilities have resulted from the haphazard use of polyester resin by artists. It may, however, be handled safely by employing forced ventilation and by wearing compressed air masks and protective gloves and clothing. The polyesters belong to the same group as the ALKYD RESINS, the difference being that the oil-modified alkyds are fluid coating materials soluble in artists' safe solvents.

polymer. A synthetic or natural substance whose structural unit is a number of identical molecules linked together. The polymer form of a particular type of molecule has a higher

molecular weight and a different set of physical properties than the monomer, which is composed of single molecules. An example of a polymer is polyvinyl acetate, which is made from the monomer vinyl acetate by subjecting it to POLYMERIZATION. Another polymer, linseed oil, contains triglycerides, i.e., molecules of glycerides of linolenic acid linked together in threes. Virtually every film-former is a polymer.

polymer colors. Water-miscible artists' colors in which the pigment is dispersed in an acrylic polymer resin or acrylic-vinyl copolymer vehicle. The resin is present in the form of myriads of tiny globules dispersed in the water, forming a milky-white, viscous fluid or LATEX. The mixture dries very rapidly and the particles of resin coalesce, producing a continuous, adherent film. The color then becomes impervious to water; it can only be removed with a strong solvent, and the brushes must be kept in water while they are in use. Polymer paints have a high degree of toughness, resistance to aging, and more brilliance of color and greater flexibility than oil colors. They are remarkably versatile and may be used to create effects that range from an approximation of the water media to an effect like that of heavy, impasto oil paint. They are, however, better suited for a broad style and FLAT COLOR than for the kinds of painting that require delicacy of control and BLENDING. Polymer colors should not be used on an oil-primed canvas or as an underpainting for oil colors; because the polymer colors retain elasticity longer than oil paints, it is doubtful that the two types of paint will adhere to each other permanently. Easel painting with polymer colors should be done on the ACRYLIC CANVAS specially primed for this purpose. About a dozen brands of polymer colors are on the market. Although their handling is substan-

tially the same and their basic resins are identical, each one is sufficiently different from the others to be preferred by its users. This is due to the maker's choice of PLASTICIZER, WETTING AGENT, thickener, or method of compounding. For this reason not all brands can be mixed with others; some such mixtures may curdle. Each brand is accompanied by several adjunct products such as POLYMER PRIMER (polymer "gesso"); MODELING PASTE; POLYMER MEDIUM; and a RETARDANT medium for slowing the drying of the colors in outdoor use.

Following the success of polymer paints in the industrial paint field, they were introduced in the United States in the mid-20th century to serve those contemporary art movements and trends in which high brilliance, application to a wide range of textural effects, and, above all, the rapid completion of a painting of full-bodied PAINT QUALITY, outweigh the superior manipulative properties offered by oil colors. Although polymer colors are necessarily unproven by the test of time and little or no data have been accumulated on optimum painting rules for enhancing longevity, the technicians can foresee no faults. The new colors offer excellent promise to the experimentally-minded painter. Special brushes (see BRUSH, ACRYLIC) have also been developed for use with the polymer colors.

polymerization. A chemical change in which the molecules of a compound (the monomer) are rearranged to produce a new compound (the polymer) with a higher molecular weight, more complex structure, and new physical and chemical properties. Polymerization is employed in the manufacture of synthetic resins and stand oil, and plays a part, along with oxidation, in the solidification of DRYING OILS.

polymerized oil. See STAND OIL.

polymer medium. A milky liquid, or LATEX, sold with POLYMER COLORS and ordinarily employed as a DILUENT. It is the same material as the polymer-color vehicle in which the pigments are dispersed. A mat medium (the regular medium containing a flatting agent, usually a colloidal inert pigment) is also available in most brands of acrylic polymer products. Polymer mediums are also used as adhesives in collage techniques, as GOLD SIZES, as protective varnishes for polymer paintings, and as mat varnishes for paper collages and works on paper.

polymer primer. A white paste composed of titanium white and other white or inert pigments ground in POLYMER MEDIUM, and used to prepare grounds for painting with POLYMER COLORS. It is sold in flat, round cans with replaceable caps. Although most brands are labeled "gesso," polymer primer has no significant properties in common with real GESSO and cannot be used as its substitute.

Polymer Tempera. Trade name for the original POLYMER COLORS available to artists; developed by Alfred Duca of Boston in the late 1940's, and based on POLYVINYL ACETATE. These colors were superseded in the 1950's by paints based on ACRYLIC RESIN polymers and acrylic-vinyl COPOLYMERS, which have superior characteristics.

polymethyl methacrylate. See ACRYLIC RESIN.

polyptych. A set of paintings or bas reliefs on hinged panels, more than three, but usually five. See also TRIPTYCH; PREDELLA.

polyvinyl acetate. A VINYL RESIN, one of the clear, water-white, thermoplastic synthetic resins widely used in industrial coating materials. Polyvinyl acetate, often abbreviated PVA, has been used since 1935 by museum conservators, who have employed it to coat and impregnate various artifacts for their preservation. Like the majority of the resins used in the coating materials industries, it can only be put into solution by powerful volatile solvents. It is completely insoluble in the mild and slowly evaporating liquids (turpentine and mineral spirits) that are required for use in artists' paints. However, this same property makes it valuable as an isolating varnish. In experimental sculpture, PVA has been used in a hot-melt molding compound, and it is an excellent parting compound for polyester resin.

polyvinyl chloride. A colorless VINYL RESIN; sometimes abbreviated PVC. It has been used as a component of industrial paints and as a base for silk-screen inks, but it is not stable enough for use in artists' colors. It is produced as a powder for molding, in solution, in flexible and rigid sheets, and in solid blocks. In the last-named form it has been used to carve relief or intaglio printing blocks.

Pompeian blue. Another name for EGYPTIAN BLUE; also, a label for certain impermanent synthetic lakes that resemble the genuine Egyptian blue in hue. The real pigment is extremely scarce and would be unmistakably identified on its container.

Pompeian painting. Paintings uncovered in the ruined city of Pompeii, on the slopes of Mount Vesuvius. The city had been buried in an eruption of the volcano in A.D. 79. Although the paintings depart from the Greek two-dimensional painting without back-

grounds and strive toward illusionism and atmospheric effects, they still shed much light on the Greek painting techniques from which Roman techniques were developed, and of which virtually no examples have survived.

Pompeian red. A variant of TUSCAN RED.

pompier. French for pump maker or fireman; a term used to describe a work of art that is pretentious or garish, usually in a trite, stereotyped way.

poncif. French term for a drawing made by POUNCING. By extension, any work that is dull and spiritless.

pontata. See GIORNATA.

pop art. A style (known also as new realism and neo dada) derived in the main from commercial art forms and characterized by outsized replicas of items of mass culture such as comic-strip panels, popular foods, and brand-name packages. Pop art developed in New York in the late 1950s concurrently with the last major accomplishments in abstract expressionism, which it reacted against and, in the mid-1960s, superseded as the dominant avant garde form in the U.S. Late in the decade pop art began to lose ground to MINIMAL ART and HARD-EDGE PAINTING. Among its leading exponents are Jasper Johns (1930–), Robert Rauschenberg (1925–), Andy Warhol (1931–), Larry Rivers (1923–), Claes Oldenburg (1929–), Roy Lichtenstein (1923–), George Segal (1924–), and Robert Indiana (1928–).

popping. The appearance in set plaster of small, conical holes, called pops. This defect, caused by particles of active or improperly slaked lime, may occur from three months to a year after setting. See LIME PUTTY.

poppyseed oil or **poppy oil.** A DRYING OIL extracted from seeds of the opium poppy. It is odorless and very pale, and it gives oil colors an excellent buttery consistency. But in every other respect it is inferior to linseed oil: it yellows more with age and its dry film is weaker and more prone to cracking. Poppy oil has been used to some extent in hand-ground colors but it is now little used except as an additive to some linseed-oil colors, to improve their consistency.

porcelain. The finest ceramic ware, usually made of clay, feldspar, and flint, fired at high temperatures. True porcelain, called *shing yao* by the Chinese, was first produced during the T'ang Dynasty. It is characterized by a white or very light gray, translucent body that rings when struck. It was first made in Europe in the early 18th century. Because of its durability and resistance to attack, porcelain is also used for heavy-duty utilitarian products such as laboratory ware, electrical insulators, and doorknobs. The term porcelain is currently used for all translucent wares, as distinguished from EARTHENWARE and STONEWARE.

The early Oriental porcelain owed its distinctive qualities to kaolin and petuntze. European potters, in their attempts to duplicate this hard porcelain, first achieved serviceable, but somewhat softer, imitations of it with mixtures of clay and previously fired materials such as ground glass. Porcelain of this type, which is fired at lower temperatures than true porcelain, is now called SOFT PASTE, soft-paste porcelain, or artificial porcelain. "True" porcelain is called HARD PASTE or hard-paste porcelain. Johann Friedrich Böttger discovered the secret of its manufacture in 1709.

porcelain colors. See CERAMIC COLORS.

porcelain enamel or **vitreous enamel.** An opaque or glassy coating, as of powdered frit, fused to a metal panel (usually iron or steel; occasionally aluminum, copper, or some other metal) by firing at about 1,500° F. Porcelain enameling, the standard industrial process used for such items as stoves, outdoor signs, and panels for building fronts, has been adapted to artists' use for mural painting and decoration in exposed locations where weathering and environmental conditions are more severe than any paints can withstand. American artists have often painted successfully on porcelain enamel, using white enameled iron sheets or panels secured from a porcelain enamel works, painting on them with CERAMIC COLORS ground in a suitable vehicle, and returning them to the factory for firing. In 1937 a group of thirty painters launched a project to decorate part of the New York subway system with such murals. They explored the medium thoroughly, established a working method, and held an exhibition at the Museum of Modern Art in February 1938, but circumstances prevented them from putting the plan of subway decoration into effect.

porphyry. One of the hardest of rocks, traditionally the best material for the MULLER and slab used for grinding artists' colors. First quarried in ancient Egypt, porphyry is a dark purplish-red igneous rock, capable of taking a high polish. It is valued as a durable sculptor's material.

porporino. Another name for MOSAIC GOLD.

portcrayon or **porte-crayon.** A handle for holding chalk, crayons, or charcoal. It is a split metal tube, usually double-ended, in which the

PORTCRAYON

crayon is secured by a ring that slides over the split end.

portfolio. 1. A carrier or storage container for drawings or prints; made of two pieces of strong cardboard hinged together, it is held closed by a pair of tapes at the middle of each free edge. The conventional portfolio is covered with black paper embossed in a leather grain.

2. The artist's stock or collection of works on paper offered for exhibition and/or sale. Also, especially in commercial art, an assemblage of an artist's work to be shown to clients as a representative sample, usually for the purpose of securing a commission.

Portland cement. A popular building material, made by calcining or roasting limestone and clay in a kiln or furnace. Its main chemical ingredients are lime, silica, and alumina. It is named for its resemblance to Portland stone, an English building stone of a pale, drab color. Portland cement has hydraulic properties: i.e., it will set under water, and it sets most strongly in the presence of moisture. The process of covering a concrete surface or object with wet cloths while it is setting is known as curing. A white variety of Portland cement can be used as a ground for murals, or colored with pigments and used in works of art— such as creative or decorative reliefs and castings—that are exposed to severe outdoor conditions. Portland cement is an important ingredient in concrete, mortar, and other building materials.

Porto marble or **Portor marble.** See BLACK-AND-GOLD MARBLE.

portrait. 1. A painting, sculpture, drawing, photograph, or other representation, especially of the face, of a real person, living or dead; a likeness. Portraiture, the art of executing portraits, is part of most artists' training. Many painters execute self-portraits and portraits of families and friends as a discipline rather than as commissions. A portrait may be full length, head and torso, or head only. A sitter may be drawn or painted face-on (see FRONTAL DEPICTION) but is more frequently portrayed in half profile, less frequently in full profile, or, rarely, in PROFIL PERDU. The SILHOUETTE is also a kind of portrait. In sculpture, a portrait takes the form of a BUST or a HERM, a seated figure (such as the portraits of Egyptian pharaohs and gods), an equestrian figure, a freestanding one, or a reclining effigy intended for a tomb. Some portraits have been executed in relief or intaglio, as well, most notably busts on coins and medals and full-length memorial-brass images. Many sculptured portraits are life-size or larger. Painted portraits range from life-size or somewhat larger to the tiny MINIATURES that were especially popular in the 17th and 18th centuries.

The portraitist's technique varies widely, depending to a great extent upon his attitude toward his subject and his art, i.e., whether he reveres truth or beauty more. The key factor in a review of the history of portraiture is that artists have always worked for patrons who wished to perpetuate their own memories. Most early portraits of rulers and dignitaries are completely idealized. This was especially true in Classical Greece, where carved portraits represented ideal beauty at the expense of individual characteristics, and in ancient Egypt, where portraits were executed as a monument to the sitter's greatness rather than as a commemoration of his physical appearance. On the other hand, Etruscan and Republican Roman portraiture was by and large very realistic; it included every detail of the sitter's physiognomy and figure, beautiful or ugly. Many portraits were made from DEATH MASKS. Portraiture became a lost art during the Middle Ages, when artists took divine rather than human figures as their subjects. It was revived and it flourished during the Renaissance, when man became more than ever the chief subject of art. Portraiture even entered somewhat into Renaissance religious art, with the donor portraits found on many altarpieces and devotional paintings. Many of the portraits of the 17th and 18th centuries flatter their subjects by depicting them as mythological figures or by placing them in allegorical settings. Rubens' cycle of paintings in the Luxembourg Palace chronicles the life of Marie de' Medici with allegorical imagery; François Boucher painted his patroness Mme. de Pompadour in mythological garb; Antonio Canova sculptured Pauline Borghese as Venus. Van Dyck, who was perhaps above all a portraitist, captured his sitter's likeness while at the same time flattering him. Notable examples are his portraits of Charles I, whom he usually painted on horseback or in a landscape with a low horizon line, in order to make the short English king, who was very sensitive about his height, appear taller and more stately.

Some portraits appear almost to be genre paintings. This is true of Frans Hals' rosy-cheeked young men and Chardin's honest bourgeois women. It is true also of Goya's portraits, in some of which are elements of caricature. Several of the Romantic painters, most of the Impressionists, and all of the expressionists sought in their portraits to give sensitive insight into the character of their sitters rather than to express only their physical ap-

pearance. Delacroix's portrait of Chopin and Rodin's monumental sculpture of Balzac are prime examples of this.

2. French for a series of canvases sold in France, in sizes at one time considered appropriate to portrait and figure painting. See table at CANVAS SIZES, FRENCH; see also CANVAS SIZES, PORTRAIT.

poster colors. Inexpensive opaque colors made with a simple water-soluble binder such as gum or glue-size, sold in jars and intended for work in which no sensitive manipulations or delicate effects are required, such as posters, flat designs, and children's work; called also show card colors. The pigments in poster colors are not selected to conform to the standards for permanent painting.

postiche. In art, a fake, a spurious addition; a French word, from the Spanish *postizo,* short for *apostizo,* "false," "imitation."

Postimpressionist painting. General term for the trends in modern art, from the mid-1880's to the early 1900's, in reaction to IMPRESSIONISM. Where the Impressionists had presented an objective, analytical portrayal of nature in terms of light, the Postimpressionists Paul Gauguin (1848–1903) and Vincent van Gogh (1853–1890) were concerned with the subjective or emotional content of what they observed, as well as the formal qualities. Paul Cézanne (1839–1906), who had exhibited with the Impressionists, worked with new ways of controlling form and space, and Seurat (see POINTILLISM) created severely formal compositions while further refining the Impressionist breakdown of light. The paintings of this period were received with hostility and derision by press and public.

potassium silicate or **potassium water glass.** See LIQUID SILICATE.

potboiler. A work with artistic pretensions turned out primarily for monetary gain. Its second-rate character is usually obvious, especially when the artist is known for finer efforts.

pot-cheese paint. See CASEIN.

potent cross. A cross with short crossbars at the ends of the four arms, each arm forming the letter "T." The potent cross, which is sometimes called the Jerusalem cross, is similar to the cross-crosslet, but the latter has crossbars near, not at, the ends of the arms. Both forms are common in heraldry. The term "potent" derives from an old French word for crutch. See CROSS for illustration.

POSTIMPRESSIONIST PAINTING. *Hospital Corridor at Saint Rémy* (1889–1890), gouache and watercolor by Vincent van Gogh. (*Collection, The Museum of Modern Art, New York, Bequest of Abby Aldrich Rockefeller.*)

potstone. An inferior grade of SOAP-STONE, used in China since ancient times for making hollow vessels because of the ease with which it may be carved.

potter's clay. Native CLAY selected for its fineness, plasticity, absorbency, and other qualities that suit it to various ceramic uses. Clay is seldom used alone but is mixed with other minerals and chemicals to obtain required performance properties. The principal types of ceramic clay are pure clay, earthenware clay, BALL CLAY, FIRE-CLAY, Bentonite slip clay, and stoneware clay. See CLAY BODY.

potter's knife. A kind of spatula with a narrow blade that tapers from the handle; a fettling knife. See FETTLE.

potter's palette. Any of several thin, flat, flexible steel tools, used to scrape, smooth, finish, or decorate plaster or

POTTER'S PALETTES

clay forms. A potter's palette may be an oval, a rectangle, or a parabola with a flat side, and measures about 2 by 4 inches. It has either smooth or serrated working edges.

potter's pink. A pure, not very intense pink pigment made by roasting chromium and tin oxides in a furnace; similar to PINK COLOR. Used in ceramics, Potter's pink is said to have been discovered c. 1790–1800 by an unknown Staffordshire potter. Despite its permanence, it has found little acceptance among painters because of its weak color and high cost. Potter's pink

has been recommended as an addition to the limited fresco palette, but it is not always available. It is also known as MINERAL LAKE.

potter's wheel. A turntable on which clay pots and other vessels are thrown, or shaped. The simplest form of wheel is the kickwheel. To operate it, the potter kicks at some form of disk or crank with a steady motion of his foot, in order to keep the turntable rotating. Power-driven wheels, whose speed can be regulated by the potter as he works, are usually used. The potter's wheel has been in existence from the times of the ancient Egyptians and Chinese up to the present day. It is no longer used in commercial ceramic manufacture, except for making large stoneware jars, but is part of the basic equipment of the artist-potter. See illustration at KICKWHEEL.

pottery. 1. Ceramic ware, but more specifically, coarse vessels fired at relatively low temperatures, classified as EARTHENWARE as opposed to porcelain.
2. A shop in which ceramic ware is made.

pottery, Greek. See GREEK POTTERY; VASE SHAPES.

pounce. 1. A fine powder of charcoal, chalk, or pipe clay used in POUNCING to transfer a drawing to another surface. If chalk or clay is used, it is usually mixed with a pigment in order to make the transferred lines more visible; a pigment such as umber is sometimes used alone as pounce.
2. A fine resinous powder, usually a mixture of sandarac and pumice or cuttlefish bone, with which parchment or unsized paper is dusted to prepare it for drawing or writing with ink. Similarly, pounce may be sprinkled over an erasure to keep reapplied ink from

spreading. It was formerly used instead of a blotter to dry ink after writing and was kept in a pounce box, a special container with a perforated lid for sprinkling the powder.

pouncing. A process for transferring a drawing or design to paper, a wall, a canvas, or other surface. The lines of the original drawing or CARTOON are pricked with a needle or a PERFORATING WHEEL, and then a pounce bag, a square of wide-mesh cloth in which a quantity of POUNCE has been wrapped and tied, is gently tapped along the perforations. The powder passes through these tiny punctures, duplicating their pattern on the surface to receive the drawing. When the original work must be preserved intact, as is usually the case with a cartoon for fresco, it is traced onto a sheet of tracing paper that is pounced instead of the original. Both the pounce powder and the auxiliary cartoon are designated by the Italian word *spolvero*.

pourpre français. Another name for French purple, a lake made from ARCHIL.

Poussinisme. See RUBÉNISME.

Pozzolana. A volcanic clay used with lime as an aggregate in stucco, or combined with Portland cement to form Puzzolan cement. Its name comes from a deposit of the substance in Pozzuoli, where it was used in ancient times by the Romans.

Pozzuoli blue. Another name for EGYPTIAN BLUE.

Pozzuoli red. A native red earth-pigment mined at Pozzuoli, Italy. The traditional fresco red used by painters since the Italian Renaissance, it is esteemed for its bright, rosy hue and its unique property of setting like cement.

précieux. Overrefined, extremely precious in treatment, to the detriment of the work as a whole.

precipitated chalk. Pure artificial calcium carbonate, frequently a by-product of drug and chemical manufacturing. One of the whitest powders, it is used industrially as an INERT PIGMENT (and in many other products), and is employed by artists in making GESSO grounds and pastel crayons. Native calcium carbonate, or WHITING, serves similar purposes, but is neither so white nor so uniformly fine in texture.

precision drawing. See MECHANICAL DRAWING.

pre-Columbian art. Art of the early civilizations on the American continents prior to their discovery by Columbus.

predella. A platform upon which an altar is set, or a steplike platform at the back of an altar top upon which candlesticks, flowers, or an altarpiece may be set; also, a painting or relief carving decorating the faces of either of these. The term may also refer to a long, narrow panel running horizontally along the lower edge of the altarpiece itself. In Renaissance altarpieces, particularly those in the form of triptychs or polyptychs, the predella is often an integral part of the structure and its face usually contains a series of small paintings or carvings (*predelle*) related in subject matter to that of the main panels (see illustration at TRIPTYCH). Many altarpieces have been disassembled and their parts scattered. Among the extant works with *predelle* are Fra Angelico's *Annunciation* at Cortona and Gentile da Fabriano's *Adoration of the Magi*, in the Uffizi Gallery.

prehistoric art. Art that antedates recorded history. Notable among surviving examples are the cave paintings of Altamira, in Spain, and Lascaux, in southern France.

Presdwood. See MASONITE.

preservative. Any substance added to paints made with water binders to prevent fermentation and MOLD infestation; a disinfectant preservative (such as phenol) or a mold preventive (such as sodium orthophenylphenate) is added to the vehicle during manufacture. Such chemicals are effective in very small amounts, so that the paint is in no way harmed. Nonvolatile mold preventives give permanent protection, but the volatile preservatives act only on the material in its wet stage.

pressure-sensitive tapes. Strips of paper, cloth, or plastic coated on one side with an adhesive which operates when pressure is applied. Cellophane tape, well known by the trade name of Scotch tape, is made of transparent plastic. It has a pressure-sensitive adhesive on one side and is shiny on the other side; it appears yellowish in the solid roll. Ordinary cellophane tape must not be used on paper that is to be permanently preserved because it turns brown and sticky after a relatively short period of time. The acetate type, or transparent mending tape, which has a mat surface and appears colorless in the roll, has a much higher degree of permanence and does not change color. It is therefore suitable for most general mending and splicing of paper, although museum conservation specialists do not recommend any plastic tape for mounting or repairing works of art, but rely on simple flour or starch paste for most paper repairs.

Masking tape is a strong brown-paper tape of crinkly texture, made in rolls of various widths. Its pressure-sensitive adhesive holds the tape firmly to any dry, hard, nonfibrous surface, and it may be peeled away easily. It is widely used in decorative painting, especially when spray coatings are to be applied, to mask or protect areas that are to be left blank or have already been painted, and to control sharp edges or stripes. A variety known as drafting tape has a smooth texture and an adhesive that will peel away from paper without damaging the fibers as ordinary masking tape may do; this variety may be used to attach paper to a drawing board.

Cloth pressure-sensitive tapes in an assortment of widths and colors are useful for the temporary binding of a canvas that is exhibited without a frame, but are not permanent and should be removed after the occasion for their use is over. Pressure-sensitive tapes in general are not considered sufficiently durable to be used as permanent elements of works of art, mats, mounts, or frames.

press view. A preview of an art exhibition to which newspaper and magazine critics are invited.

pricking. 1. In POUNCING, puncturing the cartoon or *spolvero* with a needle rather than with a PERFORATING WHEEL.

2. A test of the age of an old painting. When an impasto area, or thick spot, of an old oil painting is pricked with a needle, the old paint will resist the needle's penetration. On the other hand, the relatively newly applied paint of a recent copy of an old work will be penetrated by the needle, and the softer consistency of the paint will be divulged. This is not in itself a test of authenticity, since an old copy will not be penetrated by a needle either, and, in fact, forgers have been known to bake their copies to harden the paint and sometimes to crack the

paint surface in order to give the painting the appearance of age. Nevertheless, pricking has been widely used as one of a series of tests to confirm the date and authenticity of paintings.

primary color. One of the three chromatic colors from which all other hues, tones, and shades may theoretically be obtained by mixture, with the assistance of black and white; also called primary. Red, yellow, and blue are the three paint primaries. In practice, it is necessary to use secondary and intermediate colors such as green and violet as well as red, yellow, and blue pigments of various shades to duplicate many hues, because an artist's pigment is not "pure color": The wavelengths of its minor components differ from the dominant wavelength, affecting the color produced. For the same reason, a mixture of the three primaries will produce blackish tones rather than pure black. Red, blue, and green are the three beam-of-light primaries. When mixed together according to the additive system (by projecting all three transparencies on the same spot on a white screen) they produce white light. See COLOR.

primary structure. See MINIMAL ART.

prima vera or **primavera.** A pale yellowish wood from the tree *Cybistax donnellsmithii*, found throughout the tropical regions of the Western Hemisphere. Prima vera is used for veneer, which may be striped or mottled, depending on the grain of the wood. It is also called white mahogany.

primer. A white GROUND or coating that is applied over a coat of size to a surface before painting. It provides a base that is a brilliant white and gives uniformity of texture, absorbency, and structural stability. A coat of white lead in oil or a mixture of zinc white and titanium white in oil are the usual primers for oil painting. Prepared canvases are sold either "single primed" or "double primed"; the former is a relatively supple canvas, the latter more rigid. Although the process just described may be referred to as priming, and the prepared canvas is said to be primed, the material used in oil painting as a primer is invariably called a GROUND. Metals requiring a primer are usually roughened with an abrasive and covered with two coats of white lead in oil. Plaster walls, prior to receiving paint, are covered with a ready-made plaster primer, which adheres well without excessive penetration. It dries to a mat finish and provides a good surface for receiving and holding the final painted coat.

primitive. 1. In art, naive or self-taught, i.e., not subject to the influence of previous or contemporary work. The best known French primitive painter was Henri Rousseau (1844–1910). Among the notable American primitives were Edward Hicks (1780–1849) and "Grandma" Moses (1860–1961).

2. Pertaining to the art of peoples who adhere to a traditional pattern of life, without evolving socially or artistically over the generations. Most primitive art—in wood, stone, metal, or clay—is created for some religious or practical purpose. African masks and statues had a substantial influence on such 20th-century European artists as Derain and Picasso. Fine work has also been found in such places as New Guinea and other parts of Oceania, in Alaska, and in the southwestern United States, among such peoples as the Navaho.

See illustrations on next page.

primitives, Italian. An outmoded term for the Italian tempera painters of the 13th and 14th centuries, as distin-

PRIMITIVE ART. Above, an example of naïve painting, Henri Rousseau's *The Repast of the Lion* (c. 1907), oil on canvas. (*The Metropolitan Museum of Art, Bequest of Samuel A. Lewisohn, 1951.*) Far left, a wooden mask from the Itumba region of Africa. (*Collection, The Museum of Modern Art, New York, Abby Aldrich Rockefeller Purchase Fund.*) Near left, a detail from Picasso's *Les Demoiselles d'Avignon* (oil on canvas, 1907), in which the strong influence of African primitive art is evident. (*Collection, The Museum of Modern Art, New York, Acquired through the Lillie P. Bliss Bequest.*)

guished from the later artists of the REN-AISSANCE. By gradually breaking away from the conventions of BYZAN-TINE art, they ushered in the Renaissance. Among them were Cimabue (1240–1301) and Giotto (1267?–1337) in Florence, and Duccio and the Lorenzetti brothers in Siena (see SIENESE SCHOOL). Later painters such as Fra Angelico (1387–1455), Paolo

Uccello (c. 1396–1475), Piero della Francesca (c. 1420–1492), and Sandro Botticelli (c. 1445–1510), working when tempera technique had become a more controlled and expressive medium, were still considered primitives by the Victorians.

primrose yellow. An unstandardized term applied in industry to the lightest shade of chrome yellow; also a hue designation (palest yellow) rather than the name of a specific artists' pigment. Like lemon yellow, primrose yellow is a "fancy" name that contributed to confusion in pigment nomenclature until it was controlled by the PAINT STANDARD. Such hue words may now be used descriptively, provided that the accepted pigment name accompanies it.

print. Any one of multiple impressions made on paper from the same plate, block, stone, screen, transfer paper, or film negative. In the fine arts, the various processes by which ORIGINAL PRINTS are made are called GRAPHIC ARTS, and the individual prints are called PROOFS.

printing ink. Any ink used in printing. Printing inks are made by dispersing a pigment in a drying-oil vehicle in a roller mill. Thus they resemble artists' oil colors more than they do writing and drawing inks. The composition of an ink varies according to whether it is to be used for letterpress (relief), lithographic (planographic), or gravure (intaglio) printing. Lampblack is the pigment usually used for black inks in letterpress and lithography. In these two processes most colored inks are thinly deposited for a transparent effect, so that most of the pigments used are chosen for clarity and brilliance. Transparency is sometimes increased by addition of an extender such as aluminum hydrate.

Heavy or opaquely pigmented inks are used chiefly for special purposes, especially on dark colored paper. In gravure, the ink is deposited on a plate in depressions of varying depth rather than being thinly spread on an even surface, so that different properties are required. Ivory black or Frankfort black are usually used instead of lampblack, and sometimes the tone of a black ink for etching is warmed by adding burnt umber. The usual vehicle in a printing ink is a specially prepared linseed oil known as a LITHO VARNISH.

prismatic color. Another name for DIFFRACTION COLOR.

problem picture. A painting of obscure meaning which depicts people involved in a situation or event of a mysterious or anomalous nature.

process oil colors; process tempera colors. Commercial silk-screen colors, called "process" to indicate that they are specially formulated with ingredients that give the paint the proper consistency, flexibility, and drying time for silk-screen use. These colors contain unidentified vehicles and only a few have the names of artists' permanent pigments. While the process colors are widely used by serigraphers, the printmaker who is concerned with the permanence of his works will use standard artists' oil colors, which, like the process colors, may be mixed with a clear TRANSPARENT BASE.

profile. 1. An outline, especially the contour of a face viewed from the side. See also PROFIL PERDU; SILHOUETTE.
2. In ceramics, a tool with which clay is shaped on a revolving potter's wheel. The profile is a metallic plate, the working edge of which is the negative of the exterior contour of the object to be shaped.

Profilm. See FILM-STENCIL METHOD.

profil perdu. A profile (in French, literally "lost profile") that is seen not directly side-on but more from the back of the head; thus, a turned-away face, showing chiefly the contour of the cheek and the jaw. The *profil perdu* was used especially by the Impressionist painters. Also, the view of any object when turned so that its front is barely visible.

progressive proofs; successive proofs. Sets of PROOFS of all the stages in the creation of a COLOR PRINT, compiled by the artist as a record or for demonstration purposes. The progressive-proof set contains a proof held out from each color run, showing the multicolor print at each stage. A set of successive proofs is made up of a proof of each single color impression.

projection. A kind of construction used in mechanical drawing; a system of perspective that is non-linear, i.e., that has no VANISHING POINTS. Like linear perspective, however, projections are used to represent three-dimensional objects on two-dimensional surfaces. Unlike linear perspective, which aims chiefly to create the illusion of actuality, systems of projection are used, particularly in mechanical drawing, to communicate more specific dimensional and geometric information. In order to do this, a projection of an object may distort its appearance to some extent. The principal types of projection are either axonometric or oblique. ISOMETRIC PROJECTION, DIMETRIC PROJECTION, and TRIMETRIC PROJECTION are considered axonometric; that is, they differ with respect to the angles formed by the three axes and, more significantly, according to the corresponding amount of FORESHORTENING of each axis. In oblique projection, an object is represented with two of its axes parallel to those of the PICTURE PLANE, causing the face of a cube, for example, to be shown unaltered, i.e., with four 90° angles. Depending upon the angle at which the third axis is drawn and the corresponding amount of foreshortening, the construction is called either simply an OBLIQUE PROJECTION or a cavalier projection.

Proletcult. In Russia, the Organization for Proletarian Culture, founded in 1906, although it did not become active until after the Revolution of 1917. Its aim was to create a proletarian art and culture, working with industry in order to unite industry and art. Its leaders believed that Proletcult should be autonomous, not a branch of Party or government. Its chance came in 1922, when Lenin's New Economic Policy forced the government to relinquish its exclusive patronage of the arts. The Constructivists and other progressive artists (see CONSTRUCTIVISM; SUPREMATISM), who had had great power in directing the country's artistic life since the Revolution, either allied themselves with Proletcult, which supported them economically, or left the U.S.S.R. for exile in Paris, Munich, or Berlin. Under Proletcult, artists became artist-engineers, creat-

PROJECTION. At top, left to right, axonometric projections: isometric, dimetric, and trimetric. At bottom, oblique projections: left, oblique; right, cavalier.

ing strictly functional industrial design, for the rest of the 1920's. In 1932 the Party once more took over the supervision of Soviet art (see SOCIALIST REALISM).

proof. In the graphic arts, any print. In commercial printing, a trial impression, taken at some stage in the printing process in order that it may be examined and, if necessary, corrected. Trial proofs are also pulled in graphics so that the printing surface from which they are made may be examined and corrected. An impression taken by the artist before the plate is completed or its inking routine is perfected is called a STATE or stage. (The special series of color-print proofs known as PROGRESSIVE PROOFS and successive proofs are comparable in a way to a set of black-and-white prints compiled by taking one proof from each succeeding state.) In engraving, the final proof of state, which is without the artist's signature, a title, the publisher's mark, etc., is called an unlettered proof or a "proof before letter." When these inscriptions and marks have been added, the impression is called a "proof after letter." When the artist has added his signature and perhaps a title to the block or plate, he begins to print the regular edition, marking each proof in pencil in its lower left margin with a fraction that indicates the size of the edition and the number of each impression in the order of printing; the third proof of an edition of twenty-five would be marked $\frac{3}{25}$. The practice of numbering proofs in this way is a relatively modern one. Because the copper plate in ETCHING and DRYPOINT tends to wear down rather rapidly, the low-number proofs of an edition are considered more desirable than the higher-number proofs. Etchings and drypoints are often printed in LIMITED EDITIONS. In other printmaking techniques, the number of the proof has no significance in an edition of reasonable size.

Proofs, especially engravings, that are pulled by someone other than the creator of the original design may be inscribed with the names of all the people or firms involved in their production, each of whom is identified with a standard abbreviation as artist, engraver, printer, or publisher (see DEL). See also COUNTERPROOF; ORIGINAL PRINTS; RESTRIKE.

proof after letter; proof before letter. See PROOF.

proportion. In any composition, the mathematical relationship of the parts to each other and to the whole (see also ASYMMETRY; DYNAMIC SYMMETRY). Specifically, the term refers to the

PROPORTION. Plate from Dürer's *De Symmetria Partium Humanorum Corporum*, Nuremberg, 1532. (*The Metropolitan Museum of Art, Gift of Felix M. Warburg, 1918.*)

mathematical and geometric relationships of the parts of the human body and the ratio of each part or unit of parts to the whole mass and form. The average human body is actually be-between 7 and 7½ times as tall as the height of its head, and the arm spread is approximately equal the height of a human figure. A SCHEMA for drawing the ideal body, however, often divides the body into an evenly divisible number of parts (e.g., the total height equals 8 heads). One theory of proportion, the GOLDEN MEAN, provides for a continuous halving of the body and of the fragments of the body resulting from each prior division.

What the proportions of the human figure are and/or what they should be have been debated throughout the history of art. The outstanding early treatise on the subject is Vitruvius' late-1st-century B.C. *De Architectura*. Other important studies were made during the Renaissance, notably by Leonardo da Vinci (1452–1519) and Albrecht Dürer (1471–1528).

proportional calipers. Sculptors' large calipers that have a pair of jaws at either end, one pair large and one small. A sliding set-screw permits adjustment so that proportional measurements can be made for enlarging or reducing an original work when making a copy. See illustration at CALIPERS.

Protogeometric period. The earliest phase of HELLENIC ART (1100–900 B.C.). The principal art form during this period was pottery decorated with painted geometric designs. It was followed by the GEOMETRIC PERIOD.

proto-porcelain. Primitive Chinese pottery made before the perfection of the porcelain process.

prototype. A term used in art to designate an original creation as opposed to works that stem from it or are reproduced or copied from it. A copy or replica of an original model is called an ECTYPE.

Prussian blue. Ferric ferrocyanide; a deep cyan-blue pigment with a very greenish undertone and a full-strength, dark mass tone that has a bronzy sheen. Few other pigments equal it in tinting strength. Discovered in 1704, Prussian blue is the earliest synthetic pigment of established date. It is also the first of three blue pigments (including ultramarine and phthalocyanine blue) discovered under similar accidental conditions. Diesbach, a Berlin colormaker, stumbled on Prussian blue when he was given the wrong material during an experiment with a shade of red. His inadvertent use of a partially refined animal product rather than a pure chemical, together with the highly complex nature of the resulting reaction, almost certainly precludes the possibility that Prussian blue could have been invented independently elsewhere. Diesbach's method of production was kept secret until 1724, when it was published in England by John Woodward. First used by artists about 1770, Prussian blue won wide acceptance for 165 years, although its behavior in oil and watercolor tends to be erratic; it will hold up well in full strength and fade in weaker tints, or the reverse, depending on its manufacture. Prussian blue and a COMPOSITE PIGMENT product, CHROME GREEN, are used in large quantities for industrial purposes. For permanent painting, Prussian blue was replaced in 1936 by the completely reliable PHTHALOCY-ANINE BLUE, which has identical color and pigment properties.

Other names for Prussian blue are Berlin blue, BRONZE BLUE, iron blue, Paris blue, and paste blue. Among the

many names for varieties of Prussian blue are ANTWERP BLUE (also known as Haarlem blue); BLUE LAKE; BRUNSWICK BLUE; CELESTIAL BLUE; Monthier blue; and SOLUBLE BLUE. Highest quality Prussian blues are known as Chinese blue, Milori blue, and steel blue. TURNBULL'S BLUE, produced as an intermediate stage in one process for the manufacture of Prussian blue, is not used as a pigment.

Prussian brown. Precipitated iron (ferric) hydroxide. It is used as a drier in the manufacture of cooked oil varnishes. Its name derives from an obsolete method of preparation, which involved the calcining of rejected grades of Prussian blue. Occasionally used as a pigment during the 19th century, Prussian brown is no longer considered a useful addition to the permanent brown pigments because of its dull color effect and indifferent pigment properties. Another name for Prussian brown is iron brown.

Prussian green. Another name for BRUNSWICK GREEN.

Prussian red. An old name for LIGHT RED.

psychedelic art. Decorative and abstract art inspired by the stimulus colors and shapes said to be experienced by persons under hallucinatory drugs, especially LSD. It was introduced as a new style in the U.S. in 1966. Among the typical psychedelic designs are hard-edge areas of flat color in swirls and swelling curves that closely resemble those of ART NOUVEAU; patterns resembling those of iridescent oil films on water; profuse melanges of rectangular and pointed shapes; and sometimes splotches of fireworks. The color is typically soft and high in key with mauves and pale greens predominating, but sometimes brilliant and in-

tense. The special calligraphy that accompanies such designs is in a swelling, curvilinear style evolved from art nouveau.

psykter. A type of ancient Greek jar narrow at top and bottom, but with bulging shoulders. The shape was designed to keep liquids cool. See VASE SHAPES for illustration.

puddle. In WELDING, the pool of molten metal that forms when the welding torch is used. A good weld is made by forming a small puddle at some point on a seam of metal, then distributing an equal amount along the seam, forming another puddle, and so on in a regular sequence. The puddle is made by melting a FILLER ROD and/or the edges of the metal to be joined.

pug. In ceramics, to prepare clay for use by ridding it of air bubbles in a specially designed mixing machine called a pug mill. See also WEDGE.

pulling. A term used in the graphic arts and the printing trade for making prints. One speaks of *pulling* a PROOF rather than printing or making it.

pulling pliers. British term for STRETCHING PLIERS.

pumice or **pumice stone.** A lightweight pale gray substance of volcanic origin, used in powdered form as a mild abrasive in several degrees of fineness; also available in lump form. In painting, powdered pumice is used to make grained-surface pastel paper; it may be added to a ground to give tooth to the painting surface and is sometimes mixed with paints to coarsen their textures.

pumping. Another name for retroussage (see WIPING).

punch. A tool used in decorative work to stamp designs or elements of designs on such surfaces as gilded gesso panels and leather articles. The usual punch is a slender, tapering 3-inch rod of steel or brass with a design cut into its point; the design is stamped into the surface by holding the point against it while the butt end is struck or tapped with a light mallet.

punch'ong. A Korean method of decorating ceramics. The entire ware is covered with an ENGOBE whose color contrasts with that of the CLAY BODY. The engobe is worked on by SGRAF-FITO or loosely applied iron or cooper oxides.

Punic wax. A term used by Pliny and others for the treated or processed beeswax used in ancient ENCAUSTIC PAINTING. Neither Greek nor Roman sources identify this material with certainty, and scholars have presented varying opinions about the nature of its composition. The modern consensus is that Punic wax was not markedly different from white refined beeswax.

pure color. A color or hue that is un-mixed with other hues. Beam-of-light or spectrum colors are pure colors, but no paint or pigment color is free from some elements of another hue. In painting, pure color may also mean unmixed color straight from the tube, lightened only with white and deep-ened only with more of the same paint when necessary, without the use of other pigments. *Purity of color* has a somewhat different meaning, referring to the clarity of a color according to its type. For example, alizarin has a clear, clean undertone, while it is natural for Indian red to be comparatively muddy in undertone. *Purity of pigment* means freedom from adulteration or impurities.

puree. A variant spelling of PIURI.

pure scarlet. Another name for IO-DINE SCARLET.

Purism. An art movement that be-gan with the publication of a mani-festo, *After Cubism,* by the painter Amédée Ozenfant (1886–) and the architect Le Corbusier (Charles Edouard Jeanneret; 1888–1962), in 1918. The Purists felt that Cubism had become too decorative and fan-tastic; they wished to retain some of the Cubist principles but to return to simplicity and pure function. They sometimes used the machine as the symbol of these desirable qualities. Their subjects were mainly still lifes, painted in pure colors with sharply delineated, geometrically simplified forms. The sculptor Constantin Bran-cusi (1876–1957) was also associated with Purism.

purpleheart. See AMARANTH.

purple of Cassius. A permanent pig-ment made by precipitating gold and tin chlorides; discovered by Andreas Cassius in Germany (mid-17th cen-tury). Since purple of Cassius resists high temperatures, it has been used in ceramics and in coloring ruby glass. Artists have used it in enameling, painting on porcelain, and miniature painting; it has also been suggested as a fresco pigment. Purple of Cassius was replaced by cobalt violet in the mid-19th century.

purple of the ancients. Another name for TYRIAN PURPLE.

purple pigments. See VIOLET PIG-MENTS.

purpurin. Along with alizarin, one of the coloring principles of the mad-der root. Synthetic purpurin became

available in the 1920's and provided a purple lake (alizarin violet) that was expected to surpass alizarin crimson in color stability by dint of an additional hydroxy group in its formula. However, it proved insufficiently permanent for artists' use.

purpurino. Another name for MOSAIC GOLD.

purpurissum. Latin name for the pigment made from TYRIAN PURPLE dye.

putto. A chubby nude infant, often depicted in art from the 15th century on, especially in Italy; pl. *putti.* Another name for such a figure is *amorino.* When a child angel is represented, it may also be called a cherub; a cupid is a similar figure representing the pagan god of love.

putty. See PICTURE PUTTY.

Puzzolan cement. POZZOLANA combined with PORTLAND CEMENT.

PVA. Abbreviation for POLYVINYL ACETATE.

PVC. Abbreviation for POLYVINYL CHLORIDE.

pwree. A variant spelling of PIURI.

pyrometer. A device for measuring temperatures above the range of a mercury thermometer, as in a furnace or kiln. The standard pyrometer operates by measuring the electrical resistance in a thermocouple, of which one end (the hot junction) is inside the kiln while the other (the cold junction) is connected to a dial that records the temperature. Another type is the optical pyrometer, which is focused on the heated area from a convenient distance and angle, and which measures the intensity of the light emitted. A third

type, also focused from a distance, is the radiation pyrometer. The automatic, built-in pyrometer in an electric kiln may be set at a desired temperature. Like its standard, non-automatic counterpart, it measures heat by means of changes in electrical resistance.

pyrometric cone. A clay cone used to determine the approximate temperature of an oven or KILN that does not

PYROMETRIC CONES. From left to right, the cones before firing, at the desired temperature, and at excessive heat. The cones are set at slight angles; the maturing temperature is indicated when the cone for that temperature (here, the one at left) is half down. The other cone (several may be used) melts at a lower heat, and serves as a warning.

have a PYROMETER. Each numbered cone has a known melting point, and arches over when this temperature is reached. Several cones with successively higher melting points may be used at once, to indicate the rising temperature in the kiln as it heats up.

pyroxylin. A general term for all cellulosic plastics and solutions such as lacquers made from CELLULOSE NITRATE, CELLULOSE ACETATE, or photographic film scrap. The term pyroxylin is now less frequently used than it was in the past.

pyxis. A small box used by the ancient Greeks for storing ointments. It was generally cylindrical and the lid had a knob or finial in its center. The anglicized term "pyx" is used today in the church for a box for holding a carrying the sacrament. See VASE SHAPES for illustration.

Q

quadra. 1. A square frame or border, such as that enclosing a bas-relief.

2. A FILLET.

quadrate cross. A cross with a square superimposed over the intersection of the arms so that its corners project from the angles between the arms. See CROSS for illustration.

quadrille paper. Paper faintly ruled with small squares. Also, paper so patterned with a watermark or a plate finish. See CROSS-SECTION PAPER.

quarry water. Moisture held within certain limestones and sandstones when freshly quarried. Such stones are soft at first but become hard on aging, as the moisture disappears. DUNVILLE STONE, among others, contains quarry water.

quarter round. Any convex strip or molding, the profile or projected profile of which is a quarter circle.

quartz. The crystalline mineral silicon dioxide; in powdered form, the inert pigment SILICA.

quartz inversion. In ceramics, the series of changes in the crystalline structure of clay that occur during firing. This phenomenon helps account for the necessity of firing and cooling ceramic ware at a slow rate.

quatrefoil. See FOIL.

quattrocento. The 15th century. The term is commonly used to designate Italian art of that period.

queensware. A creamy white earthenware first produced in 1763 by Josiah Wedgwood and named for Charlotte, wife of George III. The name queensware is now applied to any cream-colored English earthenware.

quenching. The process of plunging a hot metal into liquid, usually water, in order to cool or harden it. It may be part of the processes of ANNEALING and tempering (see TEMPER).

quercitron lake. An obsolete yellow LAKE pigment made from quercitron, a NATURAL DYESTUFF obtained from the powdered bark of the black quercitron oak. Many old lakes were made from quercitron, including flavine lake and gallstone.

quick-drying size. See GOLD SIZE.

quicklime. See LIME.

quill. See BRUSH, QUILL; PEN.

quinacridone red. A brilliant bluish or rose-red SYNTHETIC ORGANIC PIGMENT considered in 1962 for future adoption by the Paint Standard and recommended as the most promising of the pigments derived from recently developed dyestuffs. Besides this relatively yellowish or scarlet shade, bluish, magenta, and violet shades are also made from the same dyestuff (linear quinacridone) that yields quinacridone red. Two trade names for the "scarlet" shade of quinacridone red are Acra red and Thalo Red Rose.

R

R.A. Royal Academician. Members of the ROYAL ACADEMY OF ARTS are entitled to use this abbreviation after their names.

rabbitskin glue. See GLUE.

raffia. A strong fiber obtained from leafstalks of the raffia palm (*Raphia rufia*) native to Madagascar. Raffia, dyed in bright colors, is available in one-pound hanks and is a popular material for weaving, basketry, and other craft work.

rag-wiped. See WIPING.

raku ware. An earthenware developed by Japanese potters in the 16th century. It is usually thick, resistant to thermal shock, and quite irregular in form and colors. Raku ware is often used in the traditional tea ceremony.

ramiform. Having a branched structure, or a twiglike linear pattern.

rance. A dull-red MARBLE with blue and red streaks and veins; also called Belgian marble.

Rapidograph. A well known trade name for a STYLOGRAPH.

rasp. Any of a number of file-like steel tools with sharp raised points rather than the ridges found on the surface of the usual file. Rasps are used in sculpture and ceramics for rough-shaping, abrading, and striating stone, wood, plaster, and clay. Double-ended, all-purpose rasps are sold in a variety of lengths and blade shapes. Rifflers, used for working in depressions, are small double-ended tools with fine, thin blades, variously curved or shaped. A special rasp made specifically for use on plaster (sometimes called a grater) is also double-ended, with rectangular abrading surfaces like those on a kitchen grater. Single-ended rasps especially made for use in wood carving are available in several sizes and with either a fine or a coarse tooth.

RASPS. (A) Plaster rasp; (B) all-purpose rasps; (C) riffler; (D) common wood-carving rasp; (E) double-sided wood-carving rasp with fine and coarse teeth.

Also sold is an open, double-sided wood-carving rasp with one side fine, the other coarse.

raw glaze. A glaze containing no fritted ingredients (see FRIT).

raw sienna. A brownish-yellow EARTH COLOR obtained from a natural clay containing iron and manganese. It is one of the basic permanent artists' pigments. Since raw sienna is semi-opaque and has more subtlety of color than yellow ochre in tints with white, it is usually preferred to yellow ochre for creating flesh tones. As an oil color, raw sienna requires little or no stabilizer in its manufacture, since it tends to have a short consistency that handles well under the brush. Raw sienna was originally found near the Tuscan city of Siena, as its Italian name, terra di Siena, indicates; the best grades are still imported from Italy. It is called raw to distinguish it from BURNT SIENNA. Italian earth is an old name for both raw and burnt sienna.

raw umber. See UMBER.

Rayonnism. A theory and technique of painting devised by the Russian painter Michel Larianov (1881–1964) and also practiced by Natalia Goncharova (1881–1962). Larianov's manifesto on the subject, published in 1913, dealt with the dispersion of color as light rays emanating from objects, as demonstrated in his work with parallel or intersecting beams of light. Rayonnism, called Lutschism in Russia, was based on Impressionist ideas, and was probably influenced by the contemporary Cubist and Futurist movements as well. It was only one of the styles in which Larianov and Goncharova were painting between 1911 and 1914. Other of their works are considered by some to be among the earliest examples of nonobjective painting.

ready-made. A man-made object, usually mass-produced, that was not made with any artistic consideration in mind but is mounted or displayed as an aesthetically significant structure; a form of FOUND OBJECT. Among the earliest ready-mades was a porcelain urinal exhibited in New York in 1917 by Marcel Duchamp, a founder of the Dada movement.

realgar. Native arsenic disulfide; a poisonous, bright reddish-orange pigment. Although realgar does not fade, it is likely to react with other pigments. Used in most early civilizations, it was replaced in the late 19th century by cadmium orange. In the late 18th and early 19th centuries an artificial variety of realgar, similar to King's yellow, was made, but only in insignificant amounts, since it was far costlier than the native product. Other names for realgar are red orpiment and arsenic orange; ancient names are rose-aker and SANDARACA.

realism. 1. In general, the depiction of human figures, real objects, or

READY-MADE. A replica (1945) of Marcel Duchamp's wood-and-metal snow shovel, entitled *In Advance of the Broken Arm*, 1915. (*Yale University Art Gallery, Collection of the Sociéte Anonyme, bequest of Katherine S. Dreier.*)

scenes as they appear in nature, without distortion or stylization. The term is sometimes also used to mean representational or objective painting as distinguished from abstract painting, although it is less confusing to use the word reality than realism in this case. In MAGIC REALISM and TROMPE L'OEIL painting, additional elements are involved. The word "naturalism" is sometimes used as a synonym for realism.

2. An art movement in France from about 1850 to 1875. The first Realist exhibition was organized in 1855 by Gustave Courbet (1819–1877)

in protest against the rejection of his works by the Academy. Nineteenth-century Realism sought to counter the idealized subject matter of Romantic and Neoclassical painting with a frank or even harsh picture of everyday life.

3. See SOCIALIST REALISM.

realization. See HAPPENING.

rectified turpentine. Turpentine that has been purified, especially through distillation. Since all turpentine is distilled or double-distilled, the term has no significance as an indicator of quality.

red chalk. See SANGUINE.

reddle. Another name for RUDDLE.

red-figured pottery. Ancient Greek pottery decorated in red on a black background. Made as early as the last quarter of the 6th century B.C. in Athens, this type of pottery superseded the earlier and less highly developed BLACK-FIGURED POTTERY toward the middle of the 5th century. White backgrounds and occasional supplementary colors also came into limited use during the late 5th and the 4th century B.C.

red indigo. Another name for ARCHIL.

red iron oxides. Native red earths that contain various amounts of iron oxide and occur the world over. They are known by the names of their places of origin, e.g., PERSIAN GULF OXIDE; VENETIAN RED; SPANISH RED. They were the basic reds of the palette from the time of the prehistoric cave painters to the mid-19th century, but gradually they were almost entirely replaced by their artificial counterparts (INDIAN RED; LIGHT RED; and MARS

RED)—pure iron oxides that are finer, brighter, more uniform in texture, and of higher tinting strength. In 1942 the PAINT STANDARD eliminated the native red earths from its list. The old Latin name for red-earth pigment is SINOPIA. See also ROUGE.

red lead. Lead monoxide and lead peroxide; a heavy, opaque, orange-red pigment. Red lead is no longer used as an artists' color, since it has poor brushing qualities and will darken on exposure to light. One of the early artificial or man-made pigments, red lead was used by the ancient Greeks and by the Romans. Pliny called red lead *secondarium minium.* When he and other writers of the classical era wrote of "minium," they meant cinnabar (native mercuric sulfide), but by the Middle Ages, the name minium came to be applied exclusively to red lead. It was then rather extensively employed in illuminated manuscripts, and its use, through the Latin verb *miniare* ("to color with red lead"), gave rise to the word MINIATURE. Today red lead is chiefly used in industry as a primer for structural steel. Another of its obsolete names is saturnine red.

red ochre. An earth color made from red earth or clay; less intense in color and weaker in tinting strength than the red oxides. Red ochre is also made by calcining selected grades of yellow ochre; this type is sometimes called burnt ochre.

red oil. Crude oleic acid called for in some of the older recipes, especially as an ingredient of metal cleaners and polishes.

red orpiment. Another name for REALGAR.

red oxides. See RED IRON OXIDES.

red pigments. Among red pigments, the following are approved for use in oil paints by the PAINT STANDARD, and are generally acceptable in all other easel-painting techniques: LIGHT RED; INDIAN RED; CADMIUM REDS (light, medium, and maroon); QUINACRIDONE RED; and ALIZARIN CRIMSON. BURNT SIENNA, classified in this book as a brown, is sometimes grouped among the reds.

red sable. See BRUSH, RED SABLE.

reduced pigments. Dry pigments that are combined with INERT PIGMENTS in order to reduce their tinting strength; also called let-down pigments. Sometimes reduction improves the performance of a pigment, as in the case of phthalocyanine blue, which is usually too powerful at full strength. In many cases, however, the aim is adulteration. Although reduced colors are unchanged in general hue, they are inclined to be less clear or a degree muddier than full-strength C.P. pigments.

reducing. See ENLARGING.

reducing glass. A small hand glass with a double concave lens (the reverse of a magnifying glass). It is used for viewing work that is intended to be reproduced smaller than the original, so that the artist can get an idea of how effective his work will be in the smaller size. The reducing glass is known in Great Britain as a diminishing glass.

reduction fire. A FIRING during which, by limiting its entry, a scarcity of oxygen is maintained in the atmosphere of the KILN. Reduction firing enables the ceramist to produce special effects, such as the celadons from iron glazes or purples and oxblood reds (sang de boeuf) from copper glazes. Since it is difficult to achieve consist-

ent results with a reduction fire, commercial potters favor an oxidizing fire. The same variability, however, makes reduction firing popular with artist-potters.

reeding. Closely spaced parallel or nearly parallel convex ribs forming a molding or embellishing a surface. Reeding is widely used to decorate the legs of furniture and the rims and bases of hollow ware (see GADROON). It is distinguished from fluting, in which the pattern of raised and lowered areas is essentially reversed. See illustration at FLUTING.

reed pen. See PEN.

reflected color. Light that is reflected from a colored surface and is tinged with that color. On striking an object it alters the color of the object. In planning or selecting a studio, artists try to avoid the effect of light reflected through windows from trees, brick buildings, or other colored areas.

reflected light. That portion of light that is deflected from a surface, as distinguished from transmitted or absorbed light. White light, when reflected from a colored surface, is tinged with the color of that surface.

refraction; refractive index. Refraction of light is the bending or deflection of a ray of light from a straight course as it passes obliquely from one medium to another (e.g., from air to a transparent pigment). The amount of deflection is related to the speed of light in the two mediums, and the refractive index (RI) or index of refraction of any substance, stated in the simplest terms, is the ratio between the speed of light in air and its speed in the substance. The refractive index of a pigment and its vehicle is an important factor in both the color value and the hiding power of a paint. The greater the difference between the refractive index of a substance and that of its surrounding medium, the more light will be reflected and the less absorbed; the smaller the difference, the less light will be reflected and the more absorbed. Hence when dry cobalt blue (RI 1.75) is surrounded by air (RI 1.00), much light is reflected, and the dry pigment has a rather pale hue. When the same pigment is ground in linseed oil (RI 1.484), less light is reflected, more is absorbed, and the pigment appears as a deep navy blue. The change in the color of pastels when they are sprayed with fixative, and the differences between a varnished and an unvarnished picture, may be explained in the same way. See colorplate facing page 118.

refractory. In ceramics, having a point of fusion higher than the temperatures used in firing pottery and porcelain; also, one of a class of mineral substances that are infusible at these temperatures. Firebrick and kiln linings are made of refractory material. A refractory such as flint is sometimes added to ceramic clays, slips, and glazes, so that its properties balance those of the flux.

register. In multicolor printmaking, the precise alignment (usually by means of register marks) of the blocks, stones, plates, or silk-screen stencils for all the color runs needed to pull a single multicolor proof (each major color requires a separate printing surface), so that the separate impression created on the paper by each successive color will be perfectly coordinated with all other colors in the final print (see COLOR PRINTS). When the printing surfaces and the impressions made from them are aligned, they are said to be in register. The paper must always be kept in the same position throughout

the series of color runs required to pull the composite multicolor proof. This is accomplished with the use of register guides.

register mark; register guide. In multicolor printmaking, *register marks* are small dots, circles, crosses, or other characters placed on the edge or margin of the KEY BLOCK, key plate, or keystone and traced on precisely the same point of each block, plate, or stone that is made from the key. These marks are made to enable the printer to align the printing surfaces, so that each color impression will be in register with all the other impressions. Such marks are also often placed on silk-screen stencils to register them for multicolor printing. *Register guides* are small contrivances set on the bed of the press to guide or hold the paper in position so that each impression will be in exact alignment with the others. In lithography, color registration is achieved through the use of cross marks on the paper and on the stone or plate for each color impressions. A proof is positioned through the use of needles that pierce the paper at the center of each cross mark and are set into slight indentations made at the centers of the cross marks on the stone.

reglet. See FILLET.

reinforced concrete. In construction, concrete that has metal bars running through its mass to increase its tensile strength and strengthen its resistance to damage by external forces.

release agent. See PARTING COMPOUND.

relief. In sculpture, any work in which the figures project from a background. Reliefs are classified by the degree of projection. In high relief (deep relief; alto-rilievo) the figures project at least half of their natural circumference from the background. In low relief (bas-relief; *basso-rilievo*) the figures project only sightly and no part is entirely detached from the background (as in medals and coins, in which the chief effect is produced by the play of light and shadow). Between these two types is middle relief (demi-relief; half-relief; *mezzo-rilievo*). The lowest degree of relief, in which the projection scarcely exceeds the thickness of a sheet of paper, is called crushed relief (*rilievo stiacciato* or *rilievo schiacciato*). There is also a relief in reverse, called hollow relief, in which all the carving lies within a hollowed-out area below the surface plane, and which, through an illusion of depth and roundness, looks like raised relief. Hollow relief, also called sunk or concave relief (*cavo-rilievo*), incised relief (*intaglio rilevato*), and coelanaglyphic sculpture, is the kind of carving done on gems by the Greeks and Romans. Relief sculpture must be distinguished from SCULPTURE IN THE ROUND. See REPOUSSÉ; INTAGLIO.

relief block printing. A general term for any contemporary relief printmaking method (see RELIEF PRINTING) in which shaped or textured printing elements—natural, manufactured, molded, built-up, or carved—are adhered to a board, inked, and then handprinted in the manner of a WOODCUT. Sometimes the printing surface is coated with a plastic spray, to make substances such as cloth, cardboard, or gesso impervious to the printing fluid, or to permit cleaning of the block after printing.

The term relief block printing is also used to designate direct printing from a textured surface such as a wirebrushed wood block or a small portion of a weathered log. A print made from a built-up relief block, but inked and

printed as an intaglio surface, is known as a COLLAGRAPH.

Such printing methods, however ingenious, are not very highly rated by traditional standards. Nevertheless, because they can be used to create interesting effects with tonal areas and textures, the relief block and the collagraph have been rather widely used for serious works by present-day printmakers.

relief printing. In the graphic arts, one of the three major categories of printmaking techniques (the others being INTAGLIO and PLANOGRAPHIC PRINTING). It includes all those printing processes in which all nonprinting areas of the block or plate are carved, engraved, or etched away, leaving on the original plane surface only the lines and areas to be printed. A relief block or plate is inked with a BRAYER or a DABBER, and the impression is made by these relief areas as the ink is transferred to paper, either by hand or in a press. WOODCUT, WOOD ENGRAVING, line and halftone PHOTOENGRAVING, MEZZOTINT, ANASTATIC PRINTING, STIPPLE ENGRAVING, and LINOCUT are the most common relief printing processes. The intaglio plates used for ETCHINGS and ENGRAVINGS are also sometimes inked and printed as relief plates, in which case the engraved or etched lines and areas appear in the proofs as whites on a solid-ink ground (see WHITE-LINE CUT). See also RELIEF BLOCK PRINTING.

relining. In the conservation of paintings, the process of reinforcing a damaged or decayed canvas by cementing it to a new piece of linen. The preferred term for this operation, however, is LINING.

reliquary. A casket, chest, shrine, or other repository for keeping or displaying sacred relics, especially in churches. During the medieval era, in accordance with the veneration in which relics were held, reliquaries were made with the utmost skill and

RELIQUARY. French reliquary, 15th century, silver plaques on wood. (*The Metropolitan Museum of Art, Gift of J. Pierpont Morgan, 1917.*)

artistry, and were often adorned with gold, precious jewels, exquisite painting, enameling, or carving. Many were in the form of miniature buildings. Some were made of precious metals in the shape of the relic they contained, usually the remains (e.g., an arm or a finger) of a saint or martyr.

remarque; remarque proof. In ETCHING, a small sketch in the margin of the proof. A print with a remarque is

known as a remarque proof. The artist makes remarques on an edge of the plate while etching the large drawing, either to aid in making corrections in the large etching from one STATE to the next or to test the degree of BITING of the mordant before immersing the

REMARQUE PROOF. Felix Buhot (1847–1898), *Une Jetée en Engleterre*, etching. (*The Metropolitan Museum of Art, Rogers Fund, 1917.*)

entire plate in the acid bath. Although such remarques are supposed to be removed with a scraper and burnisher before the final edition of the plate is printed, they are often seen on proofs of advanced states and are sometimes even left in the final edition. During the 19th century remarques of small details related to the subject of the large etching were often intentionally etched and left on the plate, especially in prints of landscapes and seascapes. A seascape might, for example, have

an elegant little sketch of a beached boat in a lower corner.

Rembrandt blue; Rembrandt green. Dutch trade names for PHTHALOCY-ANINE BLUE and PHTHALOCYANINE GREEN.

Rembrandt's ground. An ETCHING GROUND composed of beeswax and one or more resins (usually pitch, mastic, and/or asphaltum) in various proportions. Several recipes for Rembrandt's ground have been published. There is actually no evidence concerning the origin of these grounds: Rembrandt left no records of any kind. In fact, the grounds known as Rembrandt's ground were probably not used before the 18th century. Recipes for Rembrandt's ground are still used today by those etchers who prepare their own grounds.

Renaissance. A comparatively brief but tremendously important period in Western European history and culture that followed the medieval era and produced the beginnings of modern thought. The term Renaissance, French for "rebirth," does not imply that art was dead during the centuries that preceded it, but that the period was marked by a revival of the spirit of Greece and Rome. The renewal of the ancients' concern with man, embodied in the philosophy called humanism, meant an increasing preoccupation with the importance of the individual and with secular life.

Although scholars, including art historians, disagree on the dates of the Renaissance period, the Italian Renaissance in art may be considered to have begun in Florence around 1400, and to have continued until the death of Michelangelo Buonarroti (1475–1564) or, in Venice, until the death of Tintoretto (Jacopo Robusti, 1518–1594). Sometimes, however, the pe-

riod is said to have begun with Giotto di Bondone (1267?–1337). The years from about 1500 to about 1530, when painting especially reached a peak of technical mastery and artistic perfection, are often called the High Renaissance.

In Northern Europe medieval traditions in painting persisted longer. In Flanders and Holland the Renaissance may be said to have started with the brothers Jan (1385–1441) and Hubert van Eyck (1370?–?1426) and ended with Peter Bruegel the Elder (1525–1569), but 15th-century Low Countries painting has also been called "the flowering of the Middle Ages." The Renaissance in Germany began with Albrecht Dürer (1471–1528) and continued, especially in architecture, until the middle of the 17th century. The influence of Renaissance painting was carried to England by the German painter Hans Holbein the Younger (1498–1543), but an English Renaissance style of architecture did not develop until about 1600, and its influence continued into the 18th century.

The Renaissance produced great technical advances in painting and a number of innovations in the other arts, as well as the advances in the mechanical arts, manufacturing, and international trade and communications that led to a new availability of materials and processes. In Italy linear perspective was invented and developed by a number of painters and architects, beginning with Filippo Brunelleschi (c. 1377–1446) and including Leone Battista Alberti (1404–1472), Paolo Uccello (1396/7–1475), and Piero della Francesca (c. 1420–1492). A turning point in the history of painting techniques came in the 15th century when oil painting was perfected in Venice (see OIL PAINTING, DEVELOPMENT OF). Leonardo da Vinci (1452–1519) first employed the tech-

nique of chiaroscuro. Among the many other outstanding painters of the period were Sandro Botticelli (c. 1445–1510) and Raphael Sanzio (1483–1520). Other developments in painting included secular portraiture, unknown since Roman times, and landscape painting. Printmaking, in the form of woodcuts, engraving, and etching, began as a major art form with the increased availability of paper in the early 1400's.

In sculpture, the revival of the classical attitude toward human physical beauty led to remarkable achievements, starting with the work of Donatello (c. 1386–1466), which had a profound influence on his contemporaries, and culminating in the monumental marble statues of Michelangelo.

rendering. An architect's accurate, detailed drawing, usually made to present his plans for a building or other project to his client. The architect executes the rendering in an attractive manner by using watercolor washes and by drawing the building or buildings in an attractively landscaped setting.

repaint. An area of a damaged painting that has been restored by INPAINTING.

repeat glass. A square frame in which four rectangular lenses are set closely together. When a design is viewed through the glass, it is seen as a quadruple image. It is used by designers of textiles and other products to visualize repeat patterns. The usual model is about 7 x 7 inches.

replica. In the fine arts, an exact copy or duplicate of a work, done in the same size and in the same medium, and done by the artist who created the original (or, sometimes, done under the

artist's direct supervision). A replica is considered in all important respects to be the equal of the original and of other replicas of the same work. The word is sometimes loosely used for any copy of a work done in the same medium by someone other than the creator of the original. See also COPY; ORIGINAL; REPRODUCTION.

repoussage. A technique by which the surface of a copper plate used in etching or engraving is smoothed out and made level after it has been altered or repaired. (When a plate is corrected or repaired by rubbing the surface with a scraper or a burnisher, a depressed spot is usually left that would smudge if printed.) In repoussage, the plate is laid face-down on a hard flat surface, and the back of the spot to be leveled is tapped with a broad, flat-headed hammer. The term repoussage comes from the French verb *repousser,* meaning to push or pound back.

repoussé. In metalwork, a technique for decorating a surface by hammering the REVERSE of the object, sometimes into a mold of wood that has been carved in intaglio, to create designs in relief. Repoussé work is often refined by CHASING the decorated surface. Repoussé is used widely to ornament fine metal wares, especially silver hollow ware. It is also used by sculptors to create relief panels and plaques from sheet metal, especially copper.

representational art. Art in which recognizable objects, figures, or elements in nature are depicted, as distinguished from NONOBJECTIVE or ABSTRACT ART.

reproduction. A general term for any copy, likeness, or counterpart of an original work of art or of a photograph, done in the same medium as the original or in another, and done by someone

other than the creator of the original. See also COPY; ORIGINAL; ORIGINAL PRINT; REPLICA.

reredos. See ALTARPIECE.

reserve. 1. In the decorative arts, an area that retains the original color of the surface or ground. When color glazes are applied to a piece of pottery, for example, those areas that are left undecorated, thus retaining the natural color of the clay, are called the reserve.
2. A line that circumscribes a monogram, a cachet, a cipher, or initials. See also CARTOUCHE.

resin. An amorphous, transparent, or translucent solid organic material, soluble in a VOLATILE SOLVENT either cold or when melted by heating. The resultant solution is used in varnishes and other coating materials. Resins may also be added to solid compounds by fusion. The various resins differ widely in such properties as color, odor, solubility, and hardness. Resins may be classified according to origin as natural, synthetic, or artificial.

Natural resins are the hardened exudations of certain trees. Those obtained from living trees are called recent resins; those dug from the ground (or from the beds of streams), where they have been deposited by the vegetation of former times, are called fossil resins. The more familiar natural resins are ACCROIDES; AMBER; COPAL; DAMAR; ELEMI; ESTER GUM; KAURI; MANILA COPAL; MASTIC; ROSIN; SANDARAC; and SHELLAC (an insect resin).

Synthetic resins are the products of modern chemistry. They are synthetic organic compounds with resinous properties; that is, they resemble the tree resins in appearance and performance characteristics. They are, how-

ever, more uniform and have greater clarity, durability, flexibility, and resistance to chemical attack. Although they have replaced the natural resins very successfully in industrial products, only a few are suitable for use in artists' materials. Most of them are insoluble in the mild solvents that artists must use; they require strong solvents that evaporate too rapidly and give off obnoxious or toxic vapors. Among the groups or "families" of synthetic resins from which materials for painting and sculpture have been made are methacrylate or ACRYLIC RESIN; ALKYD RESIN; POLYESTER RESIN; VINYL RESIN; melanine resin; PHENOLIC RESIN; polystyrene; and urea-formaldehyde resin. When a synthetic resin is used in its solid state to mold or fashion various articles, it is known as a PLASTIC. Synthetic resins, according as they react to heat and pressure, are broadly classified as either THERMOPLASTIC or THERMOSETTING. Although the cellulose polymers, cellulose acetate, cellulose nitrate, and ethyl cellulose, are processed from a natural material and so do not conform to the definition of a synthetic resin, they are always classified and studied with the synthetic resins.

An artificial resin is a product that does not have individually unique properties but is made or compounded of various substances to imitate the properties of another resin. It may contain natural or synthetic resins and various chemical substances. An example is a mixture of Manila copal, carnauba wax, and castor oil, which in an alcohol solution is a cheap varnish used as a substitute for shellac.

In the varnish industry the word gum is frequently used for the more correct term resin. A true gum is water soluble, and when ignited chars to a black mass as sugar does. A resin is insoluble in water and burns with a smoky flame.

resist. Any substance that is used to block out or mask temporarily a surface area, in order to prevent or impede an action (as of a chemical) on the masked area. In any process in which lines or surface areas are to be incised with acid—as in glass etching and the metal-plate printing techniques of etching, aquatint, photoengraving, and gravure—a resist (sometimes called acid resist) is used to mask areas that are not to be bitten by the mordant and to protect the back and edges of the plate. In the graphic-arts processes of etching and aquatint, a resist known as stopping-out varnish is used in the STOPPING-OUT process, and the ETCHING GROUND itself is a form of resist. In ceramics, a resist is applied to portions of a ceramic ware to prevent a glaze, engobe, or coloring oxide from taking on those portions. This may be a ready-made wax emulsion that is applied to the ceramic surface cold, or it may be a homemade resist of a resin in molten beeswax. A resist is used in dryfoot firing and for decorative purposes. In electroplating, the deposition of a metal on a selected area is blocked with the use of a nonconducting resist. Resists used in fabric dyeing may be either mechanical shields or chemicals that prevent the fixing of a color. In industrial textile printing, a pastelike resist is printed on the cloth with engraved metal rollers before the fabric is dyed; in batik printing, this resist is molten beeswax. A liquid FRISKET or rubber cement used with watercolor mediums may also be called a resist.

restoration. The repair or reconditioning of works of art by the replacement of missing parts and the filling in of missing areas. See also CONSERVATION.

restorer. See CONSERVATION.

restrainer. A fluid used along with a solvent such as alcohol in cleaning or stripping oil paintings to reduce the strength and slow down the activity of the solvent and thereby lessen the danger of skinning (see SKIN). The restrainer may be either mixed with the solvent before use or applied alternately with the solvent so that it acts as a sudden, intermittent brake on the solvent action. Turpentine is the substance most frequently used as a restrainer.

restricted palette or **limited palette.** A selected, relatively small number of artists' colors, sometimes including the primaries and sometimes from a limited part of the spectrum. An artist may be said to use a restricted palette in a single painting or as a regular practice. He may do so for several reasons: for convenience in a small, portable outdoor sketching outfit; as a point of discipline, in the case of a student; to conform to some aesthetic belief or preference (see BROWN SAUCE); or because a wider range of colors is available. A palette of less than a dozen pigments may be called restricted; from 12 to 15, complete; and over 15, elaborate.

restrike. An impression made from a plate, block, lithograph stone, silk-screen stencil, mold, or die of any multiple-replica process after the original edition has been exhausted; especially an impression made after the first edition has been out of circulation for an appreciable length of time. See also ORIGINAL PRINT.

rest-stick. See MAHLSTICK.

retable. See ALTARPIECE.

retardant. An ANTOXIDANT fluid added to paints in order to delay their initial setting or drying. It is used especially by the portraitist or other artist who works on an oil painting two or more days in succession. The most highly recommended retardant is OIL OF CLOVES, which is quite effective when a few drops are mixed into the colors. Other retardants are oil of rosemary, oil of lavender, and pine oil. Butyl lactate, which has a very slow rate of evaporation, is used to retard the drying of industrial lacquers.

reticulation. A network of cracks. See CRACKLE; CRAZING.

retouch or **retouch varnish.** A very thin solution of damar or other non-yellowing resin that the artist sprays or brushes over a dry, unfinished oil painting before the resumption of painting with fresh colors. The retouch temporarily brings dry or sunken-in areas up to the depth and intensity of wet paint, so they can be accurately matched with the new paint. Retouch is meant to be used sparingly and very thinly to avoid complicating the paint structure with an additional varnish film.

retouching. Making changes on a finished picture by going over it with fresh paint. The term is usually confined to work done on a picture by the artist who originally painted it. See also INPAINTING.

retreating colors. See ADVANCING AND RETREATING COLORS.

retroussage. See WIPING.

Reubens madder. Another spelling for RUBENS MADDER, also known as madder brown.

reverse. In a two-sided object, such as a coin, a medal, a seal, or a panel with a painting on each side, the face

of lesser significance. The more significant side is known as the obverse.

Rhenish school. German artists of the late Romanesque period working in and around Cologne. The outstanding figure of this group was Nicholas of Verdun, whose goldwork was at once more monumental and more expressive than most sculpture of the period. His greatest work is the *Three Kings' Shrine* (c. 1200) in Cologne cathedral. The Rhenish school also did remarkable work in enamel notably the *Victor Shrine* in Xanten (1129).

rhyton. A type of painted vase made by the ancient Greeks for use as a drinking vessel. A development of the ancient drinking horn, it was made to resemble the head of a ram, donkey, goat, griffin, deer, or other animal. Frequently Dionysiac or erotic subject matter was employed in its decoration. The rhyton came to Greece from the east in the 5th century B.C. See illustration at VASE SHAPES.

rib. In ceramics, a tool, usually of hardwood, used in throwing pots. The ancient potters used the rib of an animal.

rice paper. Any of several soft, tissue-thin artists' papers made in the Far East from the pith or fibers of various trees.

rich lime. LIME of the highest quality, containing no gypsum and a minimum of impurities. It is the grade required for fresco plastering.

ridge. Another term for the BURR on the plate in DRYPOINT.

riffler. See RASP.

rigger. A LETTERING BRUSH, half the width of the standard lettering brush of the same numbered size, and made with short, medium, and long hairs. The term rigger originated with a pointed brush used in the days when sailing vessels with their rigging accurately depicted were popular subjects for painters.

rilievo stiacciato or **rilievo schiacciato.** See RELIEF.

Rinman's green. A name given to COBALT GREEN after its Swedish inventor, Sven Rinman.

Ripolin. European trade or brand name for household ENAMELS. The name was widely publicized because the product was used by Picasso.

riser. See VENT.

ritoccata. Italian term for a retouched area on a painting.

river marble. A kind of LIMESTONE whose surface, when polished, has markings that resemble winding rivers. See also FOREST MARBLE.

Roberson's medium. A proprietary painting medium made by the English firm of that name during the 19th century, and probably consisting of copal varnish, poppy oil, and white wax.

rocaille. An ornamental style using forms based on those of shells and water-worn rocks, and characterized by elaborate scrolls. It was popular in 18th-century France, especially during the reign of Louis XV. The term rococo was probably derived from *rocaille.*

rock. Concreted earthy material. Igneous rock, such as granite and basalt, is formed by the cooling of molten masses deep in the earth and their subsequent hardening as geolog-

ical changes bring them closer to the surface. Sedimentary rock, such as limestone and sandstone, occurs where water has flowed, depositing layers of sediment that are slowly mixed with organic and other particles by erosion. Metamorphic rock is igneous or sedimentary rock that has been radically changed by natural forces such as pressure, heat, and chemical reaction. Marble is a metamorphic form of limestone. Cut rock is called STONE.

rocker. A special steel tool with a slightly curved, serrated front edge, used in MEZZOTINT to prepare the surface of the plate. The name rocker and its alternate name, cradle, come from the undulating motion with which it is moved across the plate. Six movements of the rocker (up, down, side-to-side, and across at angles) constitute a single stroke, and many such strokes are needed to abrade the surface of a mezzotint plate completely.

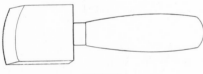

ROCKER

Rockingham Royal Black. A Virginia MARBLE, considered the best American black marble. It is jet black and is veined irregularly with white lines.

rock soap. Another name for MOUNTAIN SOAP.

rococo. A style of art and interior decoration in the 18th century, especially in France during the reign of Louis XV. It was a gay, delicate refinement of the elaborate, curvilinear forms of the High Baroque in Italy, reduced to a smaller scale. Rococo rep-

resented a reaction against the heavy, ornate classicism of the arts under Louis XIV as exemplified in the palace

ROCOCO. *The Toilet of Venus,* oil on canvas, by François Boucher, 1703–1770. (*The Metropolitan Museum of Art, Bequest of William K. Vanderbilt, 1920.*)

of Versailles. Rococo painting was devoted to light, intimate scenes of the more frivolous aspects of courtly life, sometimes in a pastoral setting. It was characterized by charm and artificiality. Its chief exponents included Jean Antoine Watteau (1684–1721), François Boucher (1703–1770), and Jean Honoré Fragonard (1732–1806). Sculpture tended to be delicate and small in scale; the work of Clodion (1738–1814) is typical. The work of Giovanni Battista Tiepolo (1696–1770), which was vast and airy, flamboyant and theatrical, is considered the greatest manifestation of the rococo style in Italy.

rod. See FILLER ROD.

334

roller. 1. In relief printing, a BRAYER.

2. In lithography, a cylinder like a rolling pin, about 4 inches in diameter, with a hand grip at either end, used for ROLLING UP the lithograph stone. It is made of a single piece of hardwood, covered with felt, over which a soft, fine calfskin cover has been sewn. A new roller or an old one that has been put away for a while cannot be used until it has been conditioned by impregnating it thoroughly with LITHO VARNISH.

roller mill. A machine that disperses pigments in a vehicle for artists' oil colors. The most modern type of roller mill has five steel rollers mounted vertically. Water runs through each roller to cool it. The first roller revolves the most slowly; each successive roller moves more rapidly than the one preceding it. Pigment that has been mixed with oil to a dry paste consistency is run between the first and second rollers, then between the second and third, and so forth, until it is removed from the fifth roller by an attached scraper or doctor blade. The most common mill in use, however, is a horizontal three-roller mill. Another type of mill for grinding fluid colors is the BALL MILL. Colors may be ground manually with a MULLER.

rolling up. In LITHOGRAPHY, the process by which the stone is inked. After the LITHOGRAPHIC ETCH, GUMMING UP, and washing away the surplus gum, the drawing on the stone is washed away with turpentine. Although the drawing seems to disappear, the adsorbed fatty acid layer remains in the surface of the stone and will attract the ink when it is applied. Then the stone is dampened with a sponge and water, and printing ink is carefully applied with a ROLLER (whence the expression "rolling up").

The wet, desensitized areas repel the ink, while the areas that were drawn on receive it. The pressure of the roller enhances the adsorption by the stone of the ink's fatty acids (pressure is one of the ways in which adsorption of a material by a surface is induced), assuring the precise retention of ink in subsequent inkings.

roman. In calligraphy, a hand that developed during the 15th century as a result of the Humanist reaction against the medieval GOTHIC hand. Originally the roman hand was called the *antiqua,* a name reflecting the fact that it was modeled on the neat Carolingian minuscule of the 9th century, which had in turn been developed from Latin cursive scripts. The *antiqua* was a very legible, rounded hand that was used for books. It was extremely well suited to printing and, with the advent of the printing press at the end of the 15th century, it was adopted as type and thus standardized (see below). The most common style of ordinary lettering used today (which school children learn when they are taught to "print") is also called roman. It is a style founded on the classic Roman alphabet, the ideal model of which is the inscription on the Column of Trajan (A.D. 106–113) in Rome.

In typography, those fonts that are known generically as roman type are serif typefaces; that is, they are characterized by serifs and a noticeable contrast between thick and thin lines within each letter. Among roman typefaces a distinction is made between old style and modern. Old-style roman type, such as Caslon and Garamond, is modeled after the type of early printers; modern roman typefaces, such as Bodoni, are more stylized, with flattened serifs and a greater contrast between thick and thin lines. The wide use of roman fonts in printing has fixed that script, rather than Gothic, in

handwriting as well. The term roman is also used in printing to designate an upright alphabet of any typeface, sans serif as well as serif, as distinguished from an ITALIC or slanting alphabet. See illustration at TYPOGRAPHY.

Roman art. The art of Rome and of its colonies from the late 2nd century B.C. to the close of the 4th century A.D. Like Roman civilization as a whole, Roman art was heterogeneous in its origins, owing much to the Greeks, the Etruscans, and the Egyptians. While much of it was influenced by or merely imitative of HELLENIC ART, a distinctive Roman style existed, especially in portrait and relief sculpture. Portrait busts and figures were highly individual, realistic, and expressive, although with the establishment of the Empire in the late 1st century B.C., the concept of the divine

ROMAN ART. Bronze portrait bust of a young man from the first half of the 1st century A.D. (*The Metropolitan Museum of Art, Bequest of Benjamin Altman, 1913.*)

ruler led to a certain idealization and stylization in the portrayal of various emperors. Roman relief sculpture was innovative in its depiction of specific historical events; narrative reliefs appeared on triumphal arches, columns, and monumental altars. These reliefs displayed a high degree of spatial contrast in the various figures; on the other hand, certain relief panels were treated pictorially, with a realistic landscape or other background as carefully detailed as the foreground. Roman wall painting evolved from a rather flat style to one in which architectural perspectives and forms were used to create an illusion of depth (see ILLUSIONISM). Light was also used to create this illusion, but it does not seem to have been studied or used systematically, even in a single painting. Panel paintings also existed. Like much of Roman sculpture, many of the Roman paintings may have been copies of Greek works.

Romanesque. Pertaining to European art of the period immediately preceding the development of the Gothic style. Some authorities give the designation Romanesque to art produced as early as the 7th century, although others give the 11th century as the starting point. The Romanesque style was superseded by the Gothic about A.D. 1200. Romanesque art was primarily of and for the Church, and it existed in a variety of regional styles.

Painting, which survives today mainly in illuminated manuscripts, had a decorative linear quality and showed some Byzantine influence. Fresco and mosaic work were also popular.

The period was marked by the revival of monumental stone sculpture, which was created in great profusion as architectural ornament and relief, although large figures were seldom

found outside niches. Freestanding statues were usually small products of the metalworker's art.

The Romanesque church was characterized by rounded arches and vaults, piers rather than columns, and an abundance of arcades. The ribbed groined vault, developed during this period, was to be extremely important in Gothic architecture.

Romanists. Non-Italian artists who were attracted to the arts and antiquities of Rome. This term and the synonymous "Italianizers" were applied particularly to Flemish artists of the early 16th century who visited Rome and later influenced the art of their homeland by painting in the manner of the Italian Renaissance. Notable among the Romanists were Jan Gos-

saert (also called Mabuse), Frans Floris de Vriendt, and Bartholomaeus Spranger. The term Romanists is also applied, more loosely, to the many artists who have expressed their admiration for the city of Rome by painting pictures of it, particularly of its ruined monuments of classical times.

Roman linen. Term sometimes used for 17th- and 18th-century handwoven Italian linen.

Roman ochre. A variety of YELLOW OCHRE with a relatively warm or golden tone; also, an ochre produced in Italy (Italian ochre) or the ochre used in ancient Rome.

Roman sepia. SEPIA blended with burnt sienna or alizarin crimson to

ROMANTICISM. *The Lion Hunt* (1858) by Eugène Delacroix. (*Courtesy, Museum of Fine Arts, Boston, S. A. Denio Collection.*)

337

produce a warmer or more reddish tone.

romanticism. An approach to art that emphasizes the personal, the emotional, and the dramatic, which it often expresses through the use of exotic, literary, or historically remote subject matter. In the 19th century, the Romantic movement arose as a reaction to the austerity of Neoclassicism and as an expression of the spirit of revolution that characterized the age. In painting, Eugène Delacroix (1798–1863) and Theodore Géricault (1791–1824) in France and J. M. W. Turner (1775–1851) in England were leading Romantics. In sculpture, François Rude (1784–1855) and Antoine-Louis Barye (1795–1875) are notable. Art historians use the words classicism and romanticism in a general sense for basic and opposing attitudes in art and architecture. Both classical and romantic influences are sometimes seen in the work of a single artist or school. See illustration on preceding page.

Roman white. An obsolete name for WHITE LEAD.

rondel or **rondelle.** 1. Any circular work of art or other object or circular element of such a work.
2. Specifically, a disc of glass in stained-glass work.

roseaker. An ancient name for REALGAR.

rose carthame. A French name for SAFFLOWER PIGMENT.

rose famille. A class of Chinese porcelain decorated with multicolored flower patterns in which reds and pinks dominate.

rose madder. Artists' name for MADDER LAKE.

rosemary, oil of. An ESSENTIAL OIL sometimes recommended as a RETARDANT in oil painting.

Rosenstiehl's green. Another name for MANGANESE GREEN.

rose pink. A reduced grade of BRAZILWOOD LAKE, weak and fugitive.

rosewood. Any of several woods obtained from trees of the genus *Dalbergia*, and valued for their rich red color, fine grain, smooth texture, and ability to take a high polish. Rosewood is named for the roselike fragrance it emits when sawed. It is used in cabinetwork and for veneer.

Brazilian rosewood (from *Dalbergia nigra*), or palisander, is one of several unrelated woods sometimes called JACARANDA. A hard, close-textured wood of purple or red to tawny color, it is the finest of the rosewoods. Honduras rosewood is paler. East Indian rosewood (from *Dalbergia latifolia*) has a striped grain and considerable variation in color, from yellow to red or deep purple.

AFRICAN BLACKWOOD is related to the rosewoods, although African rosewood (see BUBINGA) belongs to a different genus, as does Australian rosewood (*Dysoxylum fraseranum*). See also KINGWOOD.

rosin. A resin obtained from several species of pine trees, especially the longleaf pine (*Pinus palustris*), the Cuban pine (*Pinus caribaea*), and the loblolly pine (*Pinus taeda*), which are crop grown in the southeastern United States, and from similar pines in various parts of the world. The trees are tapped, and the exudation, a thick, viscous material (known as GUM THUS), is distilled. The volatile distillate is turpentine; the solid resin that remains is called rosin. Rosin is also produced by distilling the tree stumps and wood

scraps. Rosin has too many undesirable properties to be used as an ingredient of varnishes and paints for any purpose, but because it is one of the cheapest of raw materials, it has been used in them as an adulterant. However, it has many other uses in the arts for various adhesive, sealing, and other mechanical purposes. Rosin was once known also as COLOPHONY and Greek pitch.

Ross board. Trade name for a large and varied line of textured boards that are similar to COQUILLE BOARDS.

rosso antico. 1. A deep, brick-red MARBLE, sometimes purplish, with thin black veins and white splotches, from Cape Matapan in Greece. Rosso antico (Italian for antique red) was popular with ancient Greek, Roman, and Etruscan sculptors. The Romans called it *marmor Taenarium*.
2. A red quartz and feldspar rock used by ancient Egyptian and Roman sculptors.
3. A red ceramic ware with a mat finish.

rouge. Any of the smooth, finely powdered grades of RED IRON OXIDE pigments used for polishing metals. It is also called polishing rouge. Cosmetic rouge is made from the more brilliant and varied dyestuffs. Green rouge, a similar polishing agent, is CHROMIUM OXIDE GREEN.

rouge flambé. 1. A hue designation for a deep mottled red of a pronounced bluish shade.
2. A class of old Chinese porcelain of this color, more commonly called SANG DE BOEUF.

rouge végétal. A French name for SAFFLOWER PIGMENT.

roughcast. 1. Coarsely textured or pebbled stucco or plaster; thrown or unsmoothed plasterwork.
2. In ceramics, pottery that has been given a rough surface texture prior to firing.
3. In sculpture, to fashion roughly, without finish or correction.

roughhew. In sculpture, to carve or shape roughly all over either as a first stage prior to further refinement or as a complete technique.

roulette. An instrument with a small, sharply ridged, revolving cylinder at the end of its handle, used in INTAGLIO printmaking for making dotted lines and areas on a copper plate. It was in general use in the days when MEZZOTINTS and ENGRAVINGS were widely used for the reproduction

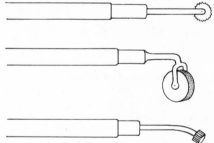

ROULETTE. Top to bottom, a roulette, a chalk roll, and a matting wheel.

of portraits and other pictures in which HALFTONES were desired. The roulette may be used in DRYPOINT, AQUATINT, and other techniques, but while some graphic artists have achieved interesting effects with it, most dislike the measured, mechanical quality of the dotted patterns it produces on the plate.

The roulette and two variants, the chalk roll and the matting wheel, are used in CRAYON MANNER to create

densely dotted lines and areas on the plate. The cylinders of the chalk roll and the matting wheel are thicker than the wheel of the roulette and have several rows of teeth.

Royal Academy of Arts. A society founded in 1768 to advance the fine arts in England. For a century it was the only British art school. Members are entitled to append the letters R.A. to their names.

royal blue. A hue designation rather than a specific pigment. It has also been used as an unstandardized name for smalt, ultramarine blue, and various synthetic organic pigments.

royal green. One of many synonyms for the industrial pigment CHROME GREEN.

royal red. A pigment made from eosin dye. This SYNTHETIC ORGANIC PIGMENT fades rapidly on exposure to daylight.

royal scarlet. A brilliant, but fugitive red lake pigment made from a synthetic dye. The name has also been used for IODINE SCARLET.

rubber cement. A thick, viscous solution of gum rubber in benzol and other solvents. It is very useful as an adhesive, but only for temporary purposes, since it soon turns dark brown and loses adhesion. Rubber cement serves as the adhesive base for a FRISKET and is also widely employed as a RESIST in engraving, watercolor painting, fabric printing, etc., to mask areas the artist wishes to leave untouched. It is easily applied, produces little or no wrinkling, curling, or shrinking of the paper, and can be quickly and safely removed by rippling it away with a finger.

rubber mold. A widely used substitute for, and often an improvement on, the plaster MOLD for casting sculpture in plaster, composition, imitation stone, plastics, and low-temperature metals. Modern rubber molds are made of cold rubber, a special compound based on synthetic rubber, which may be painted or sprayed on the model. Its advantage over plaster is its flexibility, which permits it to be used on complex and UNDERCUT models from which it can be pulled away and reused indefinitely.

rubbing. A handmade replica of an incised or carved surface, taken by holding a piece of paper tautly on the work and rubbing the paper with a black or colored material. The traditional materials for rubbing are rice paper and a lump of black material called HEELBALL. Powdered graphite

RUBBING. Contemporary rubbing of a 15th-century monumental brass from Derbyshire, depicting Robert and Joanna Eyre. The crouching lion, indistinctly seen at the knight's feet, indicates he died in battle.

mixed with oil to a stiff, dryish consistency and applied to the paper with a dabber is sometimes preferred to heelball, especially to rub fine or weak lines. Rubbings have been made of relief work of all kinds and from every cultural epoch: of designs incised on stone, especially of ancient Chinese and other Asiatic cultures; of memorial brasses in medieval churches and cathedrals; of tombstones of the colonial period in the United States; even of fish, in Japan. Artists have also used the rubbing technique as a creative process, using colors and making additions to, and variations of, the lines of the original. See also FROTTAGE.

rubbing block or **rubbing brick.** A brick-shaped block of coarsely textured stone or a composite abrasive material, used in smoothing marble.

Rubénisme. A French art movement of the late 17th century which propounded the supremacy in painting of color over design. It was in conflict—sometimes violently—with the Poussinistes, who insisted that design was the principal element in painting and color was mere decoration. This argument antedated not only Rubénisme and Poussinisme but also the two artists whose names were attached to it after their deaths by their followers. The leading painter in the Rubéniste style was Watteau. See also PAINTERLY; LINEAR; DISEGNO.

Rubens brown. A variety of VAN DYKE BROWN.

Rubens madder. A permanent, transparent lake with a brownish-orange undertone; more commonly known as madder brown and sometimes spelled Reubens madder. Rubens madder is now made from synthetic alizarin, but some lots are known to have been off-shade, faulty batches of alizarin crimson and of MADDER LAKE.

rub-out. A test by which the color and quality of pigments are compared. It is made by using a muller to rub the dry pigments to a stiff paste with a little linseed oil, and placing a dab of each side by side on a piece of thin, clear glass or a microscope slide with a palette knife. When the glass is turned over and the rub-outs examined in a good light, minute differences in color quality may be discerned, especially at the point where the two dabs touch each other, or line of demarcation. In the laboratory, precise methods are used for making rub-outs: the pigment is weighed on an accurate balance, the same number of drops of oil is added to each regardless of consistency, and each is given the same number of rubs with a muller to spread it on the slide.

ruddle. Any red earth-pigment, as red ochre or red iron oxide, used in its native state, i.e., without processing; also known as reddle. The ruddleman or reddleman was a miner of or dealer in ruddle, who went about covered with red dust, marketing his wares from town to town. Lemnian ruddle is a red earth mined on Lemnos.

ruling pen. A basic drafting implement used to inscribe lines of uniform thickness and usually guided by a straight edge, French curve, template, etc. The standard ruling pen has a

RULING PEN

short, slender handle and a point made of two parallel blades between which a drop of ink is placed with a dropper; the ink supply is limited to control the flow. The gap between the blades can be widened or narrowed with a screw

to produce thicker or thinner lines. The pen comes in a variety of sizes. A special type of ruling pen has one curved blade and is used for drawing curved lines; it may be attached to the marking arm of a compass for the drawing of arcs and circles. The ruling pen is sometimes classed as a drawing pen.

runner. 1. Any device that has a grinding surface, as a muller for grinding oil colors, or the revolving part of a mill.
2. In casting, another name for a GATE.

runs. General term for the unintentional effects of applying wet paint to a surface held in a vertical position so that the paint flows down toward the bottom of the support. Other terms for this and similar defects are CURTAINS; FRILLING; STREAMLINES; TEARDROPS.

Russian sable. Hair from the tail of the Russian fitch, occasionally used for artists' brushes. Russian sable is somewhat inferior in quality to red sable.

rust. 1. Hydrated ferric oxide; a brittle, porous, reddish-brown coating formed on the surface of iron or steel when it is exposed to moisture or otherwise chemically attacked. Rust has traditionally been considered undesirable corrosion; however, a type of steel called weathering steel that forms a handsome, self-protecting surface of rust has been developed and is often used in sculpture and architecture. The term rust is sometimes used for corrosion on metals other than iron and steel.
2. A hue designation for a reddish-brown color typical of iron rust.

rutile. One of the two titanium ores suitable for making the pigment titanium white; the other is ILMENITE. Rutile is also used as a yellow or ivory colorant in ceramic glazes.

R.W.S. Standard abbreviation used after their names by members of the Royal Society of Painters in Water Colours.

S

sable brush. See BRUSH, RED SABLE.

saccharoidal. Characterized by a crystalline or granular texture resembling that of a lump of sugar. Certain stones, including sculptural marbles, are described as saccharoidal.

sacra conversazione. A painting of the Madonna and Child with saints, in which the characters are depicted in realistic association with one another; the term is Italian for "holy conversation." Prior to the mid-15th century each sacred personage was painted on a separate panel of a polyptich.

SACRA CONVERSAZIONE. *Madonna and Child with Saints Peter, Margaret, Lucy, and John the Baptist*, tempera and oil on wood, by Giovanni Bellini, 1430–1516. (*The Metropolitan Museum of Art, The Jules S. Bache Collection, 1949.*)

safflor. Another name for SAF-FLOWER PIGMENT.

safflower oil. A pale, non-yellowing DRYING OIL of good film-forming properties and excellent color retention. Used for many years in India, it has been cultivated and used industrially in the United States on a large scale during the 20th century. Safflower oil has been used as a substitute for linseed oil in artists' oil colors to some extent; however, there has as yet been little published on its efficacy from either a scientific or a practical viewpoint.

safflower pigment. An obsolete, fugitive, red LAKE made from safflower dye; a natural dyestuff made from the dried petals of the safflower plant, *Carthamus tinctorius*. Safflower was used even in ancient times for making pigments and for dyeing textiles. Saf-

flower pigment is also called safflor and, in French, *rose carthame* and *rouge végétal*. Safflower is also an English and American distortion of the term ZAFFER.

saffron. A fugitive yellow NATURAL DYESTUFF prepared from the dried flowers of *Crocus sativus*. It was used in Roman and medieval times, but has long been obsolete as a pigment color.

sagger or **saggar.** In ceramics, a thin-walled box made of FIRECLAY. It is used in a simple kiln as a container for delicate articles, protecting them against direct contact with the flame. Some saggers have provisions for holding pins to support the ware and prevent pieces from touching each other. BITSTONE is spread over the bottom of a sagger to support the ware.

sagging. See FRILLING.

343

St. Andrew's cross. A cross in the form of the letter "X." This form, the crux decussata, was one of several types of crosses used by the Romans in crucifixions. It is also called a saltire, particularly in heraldry. See CROSS for illustration.

Saint Anne marble. A deep, blue-black MARBLE with short, white veins, from Saint Anne, Belgium.

St. Anthony's cross. See TAU CROSS.

St. Lazarus' cross. See TREFLED CROSS.

Salian art. A style of German art that flourished between the early 11th and early 12th centuries. The Salian style seems to have been a reaction against the expressiveness and sometimes extreme intensity of Ottonian art and a return to the static and symmetrical canons of Byzantine models. The principal centers of this style in sculpture and painting were Regensburg and Salzburg.

Salon des Indépendants. An annual art exhibition in Paris. It was first held in 1884 by a group of painters, including Seurat and Redon, whose work had been rejected by the official salon (see ACADÉMIE DES BEAUX-ARTS).

Salon des Refusés. An art exhibition held in Paris in 1863, considered a landmark in the history of modern painting. It was set up by Emperor Napoleon III, at the instigation of the artists involved, as a showcase for paintings that had been refused for the official annual salon of the Academy (see ACADÉMIE DES BEAUX-ARTS). The show's major sensation was Manet's *Déjeuner sur l'Herbe*, which caused a scandal by portraying nude and clothed figures together in a scene of everyday life. Other exhibitors were Monet, Pissarro, and Whistler.

salt glaze. A transparent ceramic glaze applied by adding common salt to the flame of a kiln while it is at its top heat. The salt vaporizes and combines with the surface of the body, forming a glassy film of sodium silicate. The surface of salt-glazed pottery has a pleasing semigloss finish of a pebbled or orange-peel texture, which is particularly effective on modeled or raised designs and on underglaze decorations, as the cobalt blue designs of 19th-century American stoneware crocks and jugs. Salt glazing was first employed in Germany and Holland as early as the 12th century. With the development of English pottery in the 18th century, very fine salt-glazed wares were produced; these are now sought by collectors.

saltire. See ST. ANDREW'S CROSS.

samba. See AYOUS.

Samian pottery. See TERRA SIGILLATA.

sandarac. A North African resin obtained from the alerce tree (*Calitris quadrivalis*) in the form of yellowish, opaque tears and broken cylindrical pieces. It can be dissolved in alcohol to make spirit varnishes and also in oil to make cooked varnishes. Sandarac was known to the Romans and to medieval painters and was employed in the early days of oil painting. Some investigators believe it may have been the "amber" of old varnish recipes. Its most outstanding property is hardness, and it was once widely used, with softer resins, to make spirit and oil varnishes with balanced properties. It is little used now, DAMAR having replaced it in artists' varnishes, the synthetic resins in industrial varnishes.

sandaraca. A word used by the Romans for the red pigment REALGAR; in medieval times, the name for SANDARAC resin. In some ancient writings the precise meaning of the term sandaraca must be deduced from the context. It is probable that some Latin writers considered its meaning to be red pigment, for the term was variously applied to red earths, a reddish-yellow lead oxide, and cinnabar.

sand box. A box containing sand, which serves as a cushion for sheet metal being shaped by hammering. It is also used in the repair of china and glassware to assist in holding the broken pieces in place while the cement sets.

sand casting. The process of casting metal sculpture, especially hollow bronzes, in a mold made of FOUNDRY SAND. The sand is packed carefully around a plaster cast of the original piece of sculpture in easily separated units to form a sand PIECE MOLD that is a negative of the original. The pieces are held together by a surrounding steel frame called a flask until it is time to remove the finished bronze cast. When the sand mold is enclosed in the flask, the plaster model is removed, and a CORE made of sand on an armature is fitted into part of the empty space. After the sand mold has been dried out in an oven, molten metal is poured into the space left between the core and the inside of the negative. The sand is permeable enough to allow gases and steam to escape. When the bronze has cooled and hardened, it must be smoothed and finished, as must metal cast by the alternative LOST-WAX PROCESS. Sculptors almost always send their work to a foundry to be cast in metal, although they may either finish the completed cast themselves or supervise the expert workmen who do.

sand coat or **sand finish.** In fresco, the third coat of plaster, which typically consists of one part lime putty and two-and-a-half to three parts sand or marble dust. Finely crushed pottery is sometimes used to replace as much as a third of the sand. The sand coat is laid when the BROWN COAT is firmly set but still moist; it is applied and smoothed with a FLOAT. The traditional Italian name for the sand coat is *arenato.* See also SCRATCH COAT; INTONACO.

sanders blue. An old name (or misnomer) for *bleu cendres,* the French term for ULTRAMARINE ASH. It was sometimes spelled saunders blue.

sand-grain ground. An AQUATINT ground prepared by placing a sheet of sandpaper face down on a plate that has been completely coated with a resist and running the plate-ground-sandpaper "sandwich" through an etching press to produce fine, uniformly spaced pits in the ground, through which the MORDANT will bite. The American artist Joseph Pennell (1857–1926) was a master of sand-grain aquatint.

sandstone. A porous stone made up of fine grains of sand bound together with silica or another substance such as iron oxide, clay, or calcite. The varieties of sandstone differ greatly in their durability, hardness, ease of carving, and ability to take a polish. Much sandstone is most easily worked when it has just been quarried. Newly cut stone often contains quarry water that carries dissolved minerals. Upon exposure of the stone to air, the moisture gradually evaporates, and the remaining minerals harden the stone. Some American sandstones used by sculptors are BROWNSTONE; AMHERST SANDSTONE; and DUNVILLE STONE.

sang de boeuf. A dark, mottled, ox-blood red porcelain of the most exquisite quality, made in China during the Ming Dynasty (1368–1644). The color is obtained by reduction firing of a copper glaze. An alternate term for *sang de boeuf* is *rouge flambé*.

sanggam. A Korean method of decorating pottery. It resembles MISHIMA, except that depressions are incised into the clay, rather than pressed or stamped, before being filled with a contrasting engobe.

sanguine. A hue designation for a red that is close to BURNT SIENNA; also a pencil or crayon of that color made with clay or chalk containing red iron oxide. Sanguine is the principal color in which CONTÉ CRAYONS are manufactured and is the usual red in drawings done Á TROIS CRAYONS. The common designation "red chalk" usually refers to a chalk of this color. A drawing done with sanguine crayon is also sometimes called a sanguine.

sans serif. See SERIF; GOTHIC.

santa conversazione. A CONVERSATION PIECE of a devout character.

sap green. An outmoded LAKE pigment of a rather dark yellowish green, made from unripe BUCKTHORN BERRIES. The original sap green faded quite rapidly on exposure to daylight. Some modern pigments of this name are more permanent, but the term sap green is unstandardized and has become unreliable. Other names for sap green are BLADDER GREEN, IRIS GREEN, and verd vessie.

saponify. To make into soap. An oil, fat, or wax can be saponified by boiling it with an alkali. An example is the saponified wax paste made by adding ammonia to molten beeswax and used in wax-tempera EMULSIONS.

saponin. Powdered bark of the soapbark tree. Saponin has a foamy, soaplike character when mixed with water. Used for cleaning delicate materials which would be injured by real soap, it has been recommended as a mild detergent in picture cleaning.

sapwood. The wood beneath the bark of a tree and surrounding the HEARTWOOD. It is softer than the heartwood and, in some trees, differs from it in color, grain, or texture.

sarcocolla. A GUM obtained from a plant native to Iran; it is frequently encountered in recipes from very early times up to the 19th century, but has been little used in modern times. GUM ARABIC is usually used in its place, although the two gums differ in composition.

Sarrancolin marble. A variegated French breccia marble, usually with gray, red, or yellow predominating, quarried near Sarrancolin in the Pyrenees. See MARBLE; BRECCIA.

satinwood. Any of several golden-toned hardwoods of mottled grain and excellent working qualities. Satinwood has long been valued as a furniture wood and for inlays in mahogany and rosewood. East Indian or Ceylon satinwood (from *Chloroxylon swietenia*), a pale-gold wood, is generally considered the true satinwood, although West Indian satinwood (from *Zanthoxylum flavum*), which is bright gold, is equally popular. Brazilian satinwood (from *Euxylophora paraensis*) is also used, chiefly for veneer.

saturation. In color terminology, vividness or intensity of color; degree

of freedom from white or dulling elements.

saturnine red. An old name for RED LEAD.

sauce. See CRAYON SAUCE.

saunders blue. An alternate term for SANDERS BLUE.

Saxon blue. Another name for SMALT.

scagliola. Plaster of Paris or cement mixed with pigments, marble dust, and other inert fragments, and sometimes glue. It is applied to surfaces to simulate the decorative effect of variegated marble and other stones.

scale. 1. A ratio of the proportions or dimensions of a drawn object or scene to those of the original. When, for example, a drawing of a building is in the scale of one inch to ten feet, one inch in the drawing stands for ten feet of the actual size of the building. See SCALE DRAWING.
2. A ruler used in mechanical drawing. See SCALES, ARCHITECTS' AND ENGINEERS'.
3. The relative size or extent of a work of art, as in a painting that is executed "on a grand scale."

scale drawing. A representational drawing, plan, map, or chart whose dimensions or distances are in the same ratio to each other as are those of the actual thing drawn.

scales, architects'; scales, engineers'. An architects' scale is a ruler with two or more faces, marked off in various scales proportional to a foot, and subdivided into inches. It is used by architects in making scale drawings. Common scales are $1'' = 1'$, $\frac{1}{2}'' = 1$, $\frac{1}{4}'' = 1'$, $\frac{1}{8}'' = 1'$, $\frac{3}{8}'' = 1'$,

$1\frac{1}{2}'' = 1'$, $3'' = 1'$, $\frac{3}{32}'' = 1'$, and $\frac{3}{16}''$ $= 1'$. Thus, where $\frac{3}{8}'' = 1'$, for example, each $\frac{3}{8}''$ will be subdivided into twelfths, representing inches. Architects' scales are often made of boxwood but come in a variety of woods, sometimes with plastic facing, or may be made entirely of plastic or aluminum. Both edges of a face are used, and each edge may have a scale reading in

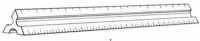

ARCHITECTS' SCALE

either direction, so that there may be four different scales to a face. Multiple-faced scales may be triangular or trefoil shape in cross-section, or any of a variety of other shapes. A common variety has 6 faces bearing a foot rule and 11 scales.

An engineers' scale differs from an architects' scale in that it is based on the decimal system rather than inches, so that a scale foot is divided into tenths instead of twelfths. Common scales range from $1'' = 10'$ to $1'' = 60'$. Engineers' scales are read in only one direction, so that there may be only two scales to a face, or a total of 6 in the trefoil model. Many artists find both architects' and engineers' scales useful for such purposes as enlarging and reducing sketches and drawings.

scarlet lake. Formerly a semitransparent LAKE pigment made from cochineal, sometimes with the addition of vermilion; since the late 19th century, bright scarlet colors made from synthetic dyestuffs. Scarlet lake is no longer used as an artists' pigment, since it is impermanent and some varieties bleed in oil. The synthetic scarlet lakes are much more lightfast than cochineal scarlet but are not sufficiently permanent for use in artists' colors.

scarlet vermilion. The bluish, or least yellowish, variety of VERMILION. Variants of true vermilion do not differ greatly.

scauper. See SCORPER.

scenic color. Paint made by mixing dry, opaque pigment with a hot glue solution, and with oil or casein to make it dry to a film insoluble in water; used to paint stage scenery. It is similar to DISTEMPER and POSTER COLORS. Scenic color is easily applied to large areas, can be used on cheap paper or on canvas requiring little or no preparation, and, since it is opaque, can be altered or painted over easily when dry. It is not used for permanent, serious painting. In Britain, scenic color is called size color.

Scheele's green. Copper arsenite; a bright-green, poisonous pigment discovered in Sweden (1778) by C. W. Scheele, a German chemist. Although it may be produced in a wide range of green shades, Scheele's green is inferior in properties to EMERALD GREEN, which has always been preferred. Scheele's green is not suitable for use as an artists' pigment, since it has the same defects and hazards as emerald green.

schema. In drawing, a simple, generalized depiction or diagram employed as a guide to correct composition and proportion. Geometric schemata are often used to instruct students in figure drawing, indicating by means of spheres, cubes, and lines the relative shapes and proportions of the head, torso, and limbs. A head is often schematized as an ovoid; a vertical line shows the location of the centers of the nose, mouth, and chin, while transverse curves indicate the placement of the eyes, the tip of the nose, and the lips.

schizzo. Italian for preliminary sketch. See ESQUISSE.

Schnitzer's green. An early variety of CHROMIUM OXIDE GREEN made by a special process.

school. A term used in art to identify the national origin (e.g., Flemish school), artistic tendency (e.g., naturalist school), or adherence to a movement (e.g., Impressionist school) of an artist or his work. It may also identify a work whose artist is unknown, indicating the master (e.g., school of Giotto) or locality and period (e.g., Sienese school), whose influence is most apparent.

School of Cologne. A group of painters working in Cologne from the late 14th to the mid-16th century. The majority of these artists are unknown by name. Their work was done chiefly in the decoration of churches and maintained its preference for idealized and refined representations of the subject matter long after the Flemish and Dutch schools had devoted themselves to a more realistic approach. The influence of Dirk Bouts did, however, make itself felt in the late 15th century. The best-known painter of the Cologne school was Stefan Lochner, who worked there in the mid-15th century. The last significant painter of the school, Bartholomaeus Bruyn, died there in 1555.

School of Paris. A term used broadly to designate all the painters working in Paris in the 20th century up to World War II, with the possible exception of abstract and Surrealist painters. The "school" reached its peak in the 1920's and 1930's, when artists from all over the world seemed to feel that Paris was the only possible place to be. The term does not denote a particular style, but is applied to the Fauves, the Cubists

(one of whom, Picasso, is often considered the outstanding figure of the school), and a host of other artists, including Amedeo Modigliani (1884–1920), Jules Pascin (1885–1930), Chaim Soutine (1894–1943), Marc Chagall (1887–), Maurice Utrillo (1883–1955), and Moïse Kisling (1891–1953). American artists who, either at home or in Paris, limited themselves to following these trends, were also categorized as a part of the School of Paris by those who supported the vigorously indigenous American painters of the time.

Schweinfurt green. A European name for EMERALD GREEN.

scooper. See SCORPER.

scorper. In WOOD ENGRAVING, a solid metal tool with a beveled, rounded point used to scoop out wood from the block so as to create nonprinting spaces, leaving on the level of the original plane only the lines and areas that will print. The scorper is also known as a scauper and a scooper.

Scotch stone. See AYR STONE.

Scotch tape. Trade name for a line of PRESSURE-SENSITIVE TAPES.

scotia. A concave molding with a wide, flaring curve whose profile resembles a parabola. The scotia is used especially in bases of classical columns.

SCOTIA MOLDING

scrambled colors. Oil colors lightly mixed on the palette with the brush so that the original hues can still be seen in streaks or swirls, as distinguished from colors thoroughly mixed to a homogeneous tint. Loosely mixed col-

ors tend to produce a more lively or vibrant effect than those whose ingredients are fully and carefully blended, although smoothly mixed colors are more appropriate to certain styles and techniques.

scraper. 1. In ENGRAVING and other metal-plate techniques in which the plate is incised, an implement used to remove the burr or other unwanted roughness, to reduce the darkness of the printing of an area, and to create

SCRAPER. A triangular steel scraper used in engraving and other metal-plate printmaking techniques.

light spots or highlights on the plate. It consists of a triangular steel blade with three concave sides that form three sharp edges the length of the blade and taper to a point at its tip. The blade is fitted into a knife handle.
2. In a LITHOPRESS, the leather-covered wooden bar under which the lithograph stone passes. The scraper applies the pressure that effects a transfer of ink from the stone to the paper that lies on it.

scraperboard. British term for SCRATCHBOARD.

scratchboard. A specially coated cardboard used to create white-line-on-black drawings that, when reproduced, resemble wood engravings; known as scraperboard in England. The board usually has a smooth GESSO coating that the artist coats with drawing ink. A white-line drawing is executed by scraping away lines and areas of the ink, exposing the white board underneath. Special scratchboard tools known as scratch knives are used for this purpose. These are either separate

tools or interchangeable blades, some made to fit in a standard pen holder, others sold in sets with a special metal handle. The standard blade is triangular. With a curved-edge blade, fine lines can be scratched with the point and broad lines drawn with the edge, while a razor-sharp straight-edge blade may be used not only as a scratchboard tool but also as a cutter and an eraser for other kinds of work. A MULTILINER TOOL, with which several parallel lines can be drawn with one stroke, is frequently used for hatching and crosshatching. Scratched areas can be re-inked and drawn on again if the artist wants to change or correct his drawing. Large areas of ink can be scraped away to create what is essentially a black-line drawing on white, resembling a WOODCUT rather than a wood engraving. Scratchboard tools may be used to create highlights on Ross boards and other textured drawing boards.

Scratchboard drawing, which was introduced in the 19th century, has widespread use in the commercial arts. Because the technique produces excellent originals for reproduction, it is used for nearly every published illustration or commercial art design done in the manner of wood engraving. Scratchboard is not often used as a medium for unique works of art, because the original has an irregular, scratchy appearance. This irregularity does not appear, however, in reproductions.

scratch coat. The first rough coat of wall plaster. A typical recipe for use in fresco is one part lime putty to one and a half parts coarse sand. If the plaster is to be applied to lath rather than masonry, goat hairs or fibers are added to prevent curls of plaster from dropping away at the rear. The traditional Italian name for scratch coat is *trullisatio.* See also BROWN COAT; IN-TONACO; SAND COAT.

scratch knife. See SCRATCHBOARD.

scrim. A piece of heavy fabric used for reinforcing cast sculpture; also, any strong, coarse cloth used for reinforcement, e.g., glued to a surface to prevent warping or shrinking. A scrim for plaster may be made of a coarse cotton or linen canvas.

scrimshaw. Whale ivory or whalebone, carved or engraved and some-

SCRIMSHAW. Eighteenth-century American jaggers (pastry cutters) of carved whale ivory. (*The Metropolitan Museum of Art, Gift of Mrs. Russell P. Sage, 1909.*)

times tinted, and made into various decorative and useful objects. This folk art form was practiced by American sailors especially during 19th-century whaling days.

scroll. A decorative motif consisting of any of several spiral or convoluted forms, resembling the cross-section of a loosely rolled strip of paper; also, a curved ornamental molding common in medieval work.

scuffing. See DRAGGING STROKE.

sculp. An abbreviation of the Latin word *sculpsit*, meaning "he carved it" or "he engraved it." Sometimes it is inscribed after the artist's signature on a piece of sculpture to indicate that it is an original direct carving rather than a cast or copy. When it appears preceded by a name in a lower corner of the margin of a print, *sculp.* identifies the engraver or etcher; it has the same meaning as *inc.*, an abbreviation for the Latin *incidit*, "he cut it." For an explanation of other terms used for marking proofs, see DEL.

Sculpstone. Trade name for a soft, easily carved, soapstone-like material, usually sold in blocks. It is used by amateur and hobby sculptors.

sculpture. The creation of three-dimensional forms by CARVING, MODELING, or assembly. In carving, the sculptor removes unwanted material and, as Michelangelo expressed it, reveals the form imprisoned in the mass; wood, stone, and other hard materials are used. In modeling, on the other hand, the sculptor creates a form by building it up from an amorphous lump of plastic material. Modeling in clay is often a preliminary step to casting in a more durable material such as metal or plaster. Assembly is the joining of prefabricated elements, as in welded metal constructions. A sculptor's work may take the form of SCULPTURE IN THE ROUND or RELIEF. See LOST-WAX PROCESS; SAND CASTING; WELDING.

sculpture in the round. Freestanding, three-dimensional sculpture, as opposed to RELIEF. Sculpture in the round has form on all sides and may be viewed from any angle.

sculpture painting. An obscure term for low RELIEF.

scumble. 1. A thin layer of opaque or semiopaque color applied over an area of an oil painting without completely obscuring the underpainting. It results in a toning, haziness, or dulling of the total color effect. See OVERPAINTING.

2. A casual rubbing or smearing-over of a dried oil painting with a thin, transparent application of paint—using a brush, a rag, or the ball of the thumb, as distinguished from the controlled placing of a GLAZE.

3. A light coating of charcoal or chalk, rubbed or smeared over the surface of a drawing to make it softer and less linear.

sealer. Industrial paint makers' term for a material used as a sizing to prepare plaster or wood for painting by reducing its absorbency. A wood sealer is a fluid or paste material used to prepare wood for the application of stain, varnish, lacquer, or paint.

sealing wax. A thermoplastic compound used to seal letters and documents; it retains a sharp impression of any embossed object and is also useful as a sealer for general workshop and studio purposes. A traditional recipe is shellac, Venice turpentine, and rosin melted together in proportions of about 4, 3, and 1 and mixed with vermilion or another pigment. Sometimes inert pigments and small amounts of tallow or wax are also called for.

seam line. A line or fold found where two pieces of something have been joined together. In cast sculpture, seam lines indicate where parts of the mold were fitted together. They are carefully polished and removed by the sculptor.

seascape. A painting, drawing, print, or photograph in which the sea is the most prominent feature. When a seascape includes boats and other

nautical features, it is usually called a marine.

season. To cure or treat wood to increase its stability and its resistance to warping, splitting, and shrinking. The usual process is aging under controlled temperature and humidity with free access of air. Properly cured wood can be used to make panels, carved sculpture, and the like.

secco. The art or technique of painting a mural on dried lime plaster; also, a mural so painted. The word "secco" is Italian for "dry"; the technique sometimes goes by the rather contradictory name of fresco ("fresh") secco. It is executed with colors ground in a BINDER (as a casein solution or a tempera emulsion) and applied to set plaster. The result is a pleasing mat surface of moderately bright color that resembles the effects of FRESCO but lacks its brilliance and purity. Secco, furthermore, is a surface coating, and therefore much less permanent than fresco, in which the colors are absorbed into wet, freshly-laid plaster and become an integral part of the wall. Although secco is a technique of great antiquity it is frequently regarded as a substitute or second-best process, for use when limitations of time, working space, and money, or other circumstances, preclude the use of true fresco. (See also MEZZO FRESCO.)

In a widely employed version of the secco technique—described in accounts recorded as early as the 11th century—a finished, dry wall of pure lime plaster is drenched with LIME-WATER or BARYTA WATER the night before work is to start, and again in the morning. Painting is done with CASEIN COLORS, which combine with the lime in a strong, permanent bond. This method is also called limewash painting. In another secco technique, water-ground colors are mixed with milk of lime and, for those pigments (especially blacks and blues) that are apt to powder away, a small amount of weak casein solution. Most painters find it difficult to work on a brilliant white surface and prefer to tint the limewash to a pale tone. The painting itself is usually executed in two coats, the underpainting in lighter values than the final colors.

The word secco (as in the phrase *a secco*) is frequently used by Cennino Cennini (c. 1370–c. 1440) and other Italian authors to denote touching up a dry fresco painting with tempera colors, or applying certain colors that require the protection of a binder (such as genuine ultramarine) to the dried fresco.

secondary color. Any of the three colors that are the result of mixing the three pairs of PRIMARY COLORS. In subtractive coloring, the secondaries are green (blue and yellow), orange (red and yellow), and violet (red and blue). See COLOR and illustration at COLOR CIRCLE.

Section d'Or. See GOLDEN MEAN.

section lines. In mechanical drawing, closely parallel, diagonal lines that conventionally indicate an area shown in cross section. See illustration at CROSS SECTION.

sedimentary rock. See ROCK.

seed lac. See LAC.

seicento. The 17th century. The term is commonly used to designate Italian art of that period.

selenium red. An unstandardized name for CADMIUM REDS, alluding to their selenium content.

self-hardening clay. A prepared mixture of synthetic resin and inert pigments or fillers that dries—by low-temperature baking in a kitchen oven and without kiln firing—to a strong, cohesive hardness superficially resembling that of fired ceramic ware. Sold under various trade names and intended for amateur craft use, this type of mixture is used for decorative items that do not approach the durability or usefulness of kiln-fired pottery. All clay-and-water mixtures harden upon evaporation of the water, but the term self-hardening clay refers only to the specific stype of preparation described.

semiabstract. See ABSTRACT ART.

semidrying oil. A vegetable oil that can be made to dry or form a solid film by chemical treatment, but does not do so on simple exposure to air, as does a drying oil. Among the semidrying oils are corn oil and SOYA BEAN OIL. They are not used in artists' oil paints.

semigloss or **semimat.** See GLOSS; MAT.

semitransparent. See OPACITY; TRANSPARENCY.

Senegal gum. See GUM ARABIC.

sepia. A semitransparent brown pigment obtained from the ink sac of the octopus and other cephalopods. Since sepia, although fairly permanent in dull light, fades rapidly in bright daylight, it is not generally approved for modern use as a watercolor and drawing ink. Sepia does not work well in oil; any oil paints so labeled would contain a mixture of other pigments. Although sepia was one of the inks used by the Romans, it enjoyed its greatest popularity during the hundred-odd years after about 1780, when it largely replaced the older

BISTRE for wash drawings, chiefly because of the greater variety of pleasing tones it yields on dilution. Sepia is a rather warm reddish brown, easily distinguishable from bistre, which is comparatively cool and greenish; the difference is roughly comparable to that between the warm brown of umber and the cooler tone of raw umber. A mixture of sepia and BURNT SIENNA or alizarin crimson is known as ROMAN SEPIA.

seraya. Philippine mahogany. See MAHOGANY.

serif. In calligraphy and typography, a small line or embellishment that finishes off a stroke in a letter. Also, a kind of typeface that has serifs, also known as ROMAN type. Those fonts known as GOTHIC type are also called sans serif, or without serifs.

serigraphy. Creative SILK-SCREEN printmaking, in which the artist designs, makes, and prints his own stencils. All the standard techniques for preparing silk-screen stencils are used in making serigraphs, but the TUSCHE-WASHOUT METHOD, the most popular by far, and the FILM-STENCIL METHOD are especially used.

A serigraph differs from most other graphic-arts proofs in that its color areas are paint films rather than printing-ink stains. It is, in addition, a direct, extremely versatile technique that can simulate, in an unlimited range of colors, the impasto of oil colors, the transparent washes of watercolors, and the effects of gouache and pastel—which justifies the widely held opinion that serigraphy is as much a painter's as a printmaker's medium. When the artist uses the best rag paper, permanent pigments, and a nonyellowing acrylic or alkyd transparent base, the prints are probably as permanent as any other.

It has been said that a commercial silk-screen print is a sterile, literal translation of an artist's sketch, and therefore, a product rather than a creation, while a serigraph is a lively, free translation of the artist's concept and, therefore, a meaningful work of art.

In serigraphy, following standards established for the production of ORIGINAL PRINTS, the artist is expected to execute the entire process himself. If he prints a numbered LIMITED EDITION he destroys his stencils after completing the run or he clearly identifies a RESTRIKE edition. Restrikes, however, are seldom a consideration in serigraphy because, for any edition of a print, most serigraphers use no more than one or two screens, cleaning and restenciling them after each color run. Many serigraphers preserve complete sets of successive and PROGRESSIVE PROOFS.

The use of silk screen as an artist's medium began in 1938 when a group of New York artists under the auspices of the Federal Art Project experimented with silk screening and fully developed all its artistic potentials. This group gave the technique the new name of serigraphy and later formed the nucleus of the National Serigraph Society, which actively promoted the new print form for twenty years. Among those active in the development of serigraphy were Anthony Velonis, who inspired the original project; art critic Carl Zigrosser, who actually coined the name of the technique and arranged some early exhibits; Doris Meltzer, the director of the Society; and many printmakers, including Harry Shokler, Edward Landon, Bernard Steffen, Harry Gottlieb, Leonard Pytlak, and Harry Sternberg.

serpentine. A decorative green stone, consisting of a hydrous magnesium silicate. Common serpentine is usually dull green and mottled like a serpent's skin. Precious serpentine is a rich, translucent green. One compact type of serpentine, used for carving, is often called verd antique or green marble, and is commercially classed as a MARBLE. Another type of serpentine is called MARMOLITE.

set. 1. In painting, to prepare a palette with colors.

2. In ceramics, to load a kiln for firing.

Sezession. See ART NOUVEAU.

sfregazzi. In painting, a fine, delicate glaze of shadows over flesh tones, spread by tapping with the fingertips.

sfumato. In oil painting, the creation of soft, delicately blended effects by the fusion of one tone into another, particularly in glazes. This Italian term is frequently used in reference to the paintings of Leonardo da Vinci, who was the first of the great masters to employ the procedure to secure airy or atmospheric effects.

sgraffito. 1. A method of decorating (known also in the past as GRAFFITO) in which a design is created by incising or cutting lines through one layer of plaster or STUCCO to reveal the contrasting color of an underlayer. Mural decoration by sgraffito was developed during the Italian Renaissance, when it became a common practice to decorate stuccoed facades of buildings with cameolike designs and to incise arabesques over doorways. The usual color of the underlayer was a blackish-brown, produced by mixing burnt straw with the plaster. Sgraffito executed with pigmented cement has been used in modern revivals of the technique.

2. Pottery objects similarly decorated, by incising the slip before

firing. Early pieces of majolica were often partly ornamented by this technique, which was also employed by English potters of the 18th and 19th centuries.

3. A method of drawing on STAINED GLASS by scratching through a thin film of colored glass and revealing the clear glass to which it was fused by FLASHING. This technique was widely used before the methods of painting on glass with grisaille, silver stain, and other materials were fully developed.

shade. 1. In color description or comparison, a full or definite degree of difference between two colors, analogous to the difference between notes in a musical scale. One blue may be a shade darker, lighter, deeper, more reddish, greenish, etc., than another. Also, a chromatic color that has been darkened by the addition of black.

2. In painting, drawing, and the graphic arts, the dark or relatively dark parts of a figure, object, or scene.

shading. 1. Gradation of tone, or the merging of one shade or value into another.

2. The toning or filling in of areas of a picture (as by cross-hatching and by lightening or darkening a color) by means of which shadows, three-dimensional form, and the absence of full illumination are depicted.

shading film. A film or screen in any of a variety of patterns or dots, used for shading areas in drawings, maps, or charts. A piece of adhesive-backed film cut to the shape of the area to be shaded is either adhered directly to the drawing by rubbing it into place or transferred to a transparent overlay. The use of dots gives the shading a HALF-TONE effect.

shadow edge. A fine contour line of brightness on the edge of drawn or painted figures and objects. It is a subtle effect, used to create a natural edge where solid color would give a sharp two-dimensional or papery effect. It is especially used by portrait painters to create a suggestion of back lighting, some small degree of which can be seen on the edges of figures in most light conditions.

shale black. Another name for slate black, one of the SLATE PIGMENTS.

shard or **sherd.** A fragment of broken pottery.

sheen. A dull satiny gleam on a surface, which reflects light but is not sufficiently bright to be called a gloss. Sheen is a more subdued or surface effect than luster, which is generally thought of as a finish that gives the impression of depth.

Sheffield plate. Metalware produced by coating copper with silver by fusing the two metals with heat. The process of making Sheffield plate was discovered in 1741 by Thomas Boulsover of Sheffield, England, and developed during the 18th century in that town, where the finest wares continued to be produced even after the manufacture of Sheffield plate spread in the 19th century to the rest of Europe, to Russia, and, to a lesser extent, to the United States. Essentially, Sheffield plate was made by fusing a sheet of silver to an ingot of copper in a coke furnace, after which the fused metal was cooled, cleaned in an acid bath, and then rolled into thin plate that could be worked in the same way as sheets of solid silver. After the object had been fashioned it was cleaned again and then burnished with agate, hematite, or some other hard substance. Silver-plated wire was also produced by this process.

To protect buyers from the fraudu-

lent representation of Sheffield plate as solid silver, the use of hallmarks on this plate was forbidden until 1784, when an officially regulated system of marks was established. Although Sheffield plate did not have the inherent value of pure silver, the generally fine workmanship with which it was crafted and its softer, richer color made it highly valued. Nearly a century after it began, the manufacture of Sheffield plate was almost entirely superseded by the cheaper ELECTROPLATING process, so that most genuine Sheffield plate now has antique status.

shellac. An alcohol-soluble resin, the most highly refined form of LAC; also, the varnish made by dissolving it in alcohol. Two grades are made, orange shellac and bleached or white shellac. Fluid shellac varnish has a characteristic cloudiness, which is due to waxes that are imperfectly soluble. It dries, however, to a clear finish that is hard and glossy, with a characteristic ORANGE-PEEL EFFECT. Shellac is used mostly for varnishing floors and furniture. It is also used on a mold in plaster casting to separate the plaster mold from the plaster cast. Because of its tendency to darken on aging, shellac is not used on surface layers in permanent painting, but it is valuable for some purposes where it is covered by paint. For example, white shellac diluted with several parts of alcohol is used as a SIZE for gesso.

shell gold; shell silver. A tiny drop or "button" of dried watercolor made of GOLD POWDER or SILVER POWDER ground in a gum-arabic medium and sold in small natural shells. These precious materials are also sold in the form of tablets (more than ten times the size of the drop in a shell).

shell marble. A dark gray-brown MARBLE, closely packed with fossil shells, the nacreous coating of which gives the polished stone a brilliant fire or CHATOYANT gleam; also known as fire marble and lumachelle. Traditionally the choicest varieties of shell marble come from the Tyrol. One American variety is LEPANTO MARBLE.

shield of David. See SOLOMON'S SEAL.

shim. Any bit of material used in sculpture, construction, machine work, or cabinetwork to separate one surface from another, as a leveling device, or to create a snug fit. In sculpture, shims are pieces cut from thin sheet metal (usually brass) and set about a quarter of an inch into a soft model to make a FENCE along the lines of separation of a plaster piece mold. Shims so used are often called tins or, in England, dividing brass.

shing yao. The Chinese term for pure PORCELAIN.

ship curve. See FRENCH CURVE.

Shiva Acrylic. Trade name for an American manufacturer's line of acrylic POLYMER COLORS and their adjuncts.

shivering. A defect of ceramic glazes caused by high compression. The effect is similar to CRAZING but is accompanied by a raising or cleavage of the glaze along the cracks. See SPALL.

short. 1. In artists' oil colors, having a buttery or smooth consistency as distinguished from a sticky, stringy, or fluid consistency.
2. In a clay or body, lacking workability. Short clay may be made more plastic by adding a FAT clay such as BALL CLAY or BENTONITE.

short-oil varnish. See OIL LENGTH.

shot. Changeable or iridescent color, especially in textiles, in which the material appears to have two colors. The effect is achieved by weaving strands of two different colors or undyed strands of two different materials that take dyes differently.

show-card brush. See LETTERING BRUSH.

show card colors. See POSTER COLORS.

shuttering. Wooden molds, constructed in situ, for shaping or casting concrete forms.

siccative. A material added to oil colors to hasten their drying (see DRIER); also, pertaining to the effect produced by such a material. In ceramics, a siccative is used to help dry the oils used in underglaze colors.

Sicilian brown. An old name for raw UMBER.

Sienese school. The painters of Siena, Italy, especially during the late

SIENESE SCHOOL. *The Calling of the Apostles Peter and Andrew,* Duccio di Buoninsegna, c. 1255–1319. (*National Gallery of Art, Washington D.C., Samuel H. Kress Collection.*)

13th and 14th centuries. Sienese tempera painting represented a departure from the medieval tradition of Byzantine art and was notable for its decorative linear element. The *fonda d'oro* or solid gold background is an outstanding characteristic of many Sienese paintings. Important among Sienese artists were Duccio di Buoninsegna (c. 1255–1319), Simone Martini (c. 1284–1344), and the brothers Ambrogio (active 1319–1348) and Pietro (active 1305–1348) Lorenzetti.

sienna. The native earth colors RAW SIENNA and BURNT SIENNA.

Sierra Leone copal. See COPAL.

signal red. A variety of PARA RED used in the early 20th century for railway signals. It was preceded for this purpose by antimony vermilion and realgar, and replaced after 1919 by the more permanent cadmiums.

significant form. A term introduced by Clive Bell in *Art* (1914) to describe a formal attribute possessed by every work of art that evokes a particular aesthetic emotion through its arrangement of line and color. Bell contends that no matter how successful a work may be from a purely technical point of view, if it does not evoke an emotional response based upon the aesthetic significance of its FORM, it should not be called art.

sign paper or **banner paper.** An inexpensive, smooth white paper available in 50-foot rolls, 36 and 42 inches wide. In addition to its use for commercial sign-writing, it is frequently employed by painters for temporary, full-size preliminary drawings or cartoons. Made from wood pulp, it is not suitable for permanent work. Colored sign paper, in a variety of pale and

deep colors, available in rolls up to 107 inches wide, is also known as background paper.

sign-writer's cutter. A flat, white bristle brush of top quality, with a chiseled end (see CHISEL BRUSH) and a

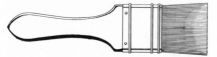

SIGN-WRITER'S CUTTER

short handle made in 1- to 3-inch widths; sometimes simply called a cutter. In addition to its use by sign writers, it is an ideal brush for varnishing paintings, as it deposits a thinner, more controlled layer than the ordinary house painter's varnish brush.

sil. Roman name for YELLOW OCHRE. The Romans had many kinds to choose from, but the most esteemed and most expensive was the Attic sil from Greece.

silex. Another name for SILICA.

silhouette. 1. Any portrait, design, or image in profile in a single hue. Silhouettes were originally profile portraits in black or some other uniform tint, usually taken from a shadow cast by a candle on a sheet of paper. The hair or hairline was sometimes differentiated from the rest by a slightly lighter shade. The French nobility derisively named the technique after Etienne de Silhouette, the unpopular minister of finance in 1759; his detractors claimed that the mere outline portrait was symbolic of his shallow and empty-headed nature. Silhouette portraits were very common during the 18th and 19th centuries, when they were most often freehand cutouts of black paper pasted on a white card-

board mount; sometimes a contrivance called a physionotrace was used to trace the sitter's profile.

2. The outline of a person or thing.

silica. Powdered quartz; an INERT PIGMENT sold in several degrees of fineness. Sometimes called silex, silica has a sharp grain and is useful for imparting TOOTH to coating materials and GROUNDS.

silica gel. A colloidal form of silica, available in the form of pale, amber-colored, highly absorbent granules; used as a dehumidifier. It is kept in little cloth bags near objects that are prone to injury by dampness when put away in storage. By absorbing moisture from the atmosphere, silica gel helps prevent the formation of mold, the warping of materials, and the softening of water-soluble coatings.

silicones. A series of synthetic RESINS that contain silica, useful in industrial coating materials and numerous other products. They belong to a different class of materials from the LIQUID SILICATES, the end product of which is inorganic silica or silicate. The silicones should not be used in permanent creative art.

silicon ester. Any of several organic salts of silicic acid, including ETHYL SILICATE, methyl silicate, and amyl silicate. They have similar properties, but only ethyl silicate has been made available to artists. See also LIQUID SILICATE.

silk screen. A color stencil printing process in which the coloring matter is forced with a SQUEEGEE through a fine screen, on which nonprinting areas have been blocked out, onto the printing surface below. Silk screen is widely used commercially for printing posters and show cards; for creating designs on

cloth, wallpaper; furniture, glass, and ceramic wares; for printing electronic circuits; and for printing instructions on a great variety of manufactured objects. The creation of artists' ORIGINAL PRINTS by the silk-screen method is called SERIGRAPHY.

The screen most commonly used in the process is a fine, open-weave silk BOLTING CLOTH (or, less frequently, organdy or wire-mesh cloth), stretched on and attached to a wooden frame. In a serigrapher's studio the frame is commonly hinged to a flat bed or table, on which the paper or other printing surface is placed. A simple prop bar,

SILK-SCREEN APPARATUS

called a butterfly, keeps the screen raised above the bed while a printed proof is removed and fresh paper is inserted; the prop bar drops by its own weight when the screen is lifted and is flicked aside when the operator is ready to pull another proof. The screen may also be held with a spring that has just enough tension to raise and suspend it and permits it to be lowered with a slight pressure. In commercial shops the screen may be raised and lowered with counterbalances or pulleys.

In preparing the screen for printing, all the nonprinting areas are blocked out by any of the processes referred to below. The margins of the screen are also blocked out to allow free manipulation of the squeegee and to provide space to hold the charge of paint. The printing surface, such as a poster board or a sheet of paper, is inserted on the bed beneath the screen. A special paint is poured along the margin of the screen and is pushed from one side to the other with a SQUEEGEE, which presses it through any area that is not stopped out. Each such pass of the squeegee produces on the printing surface an unreversed duplicate of the original design. In multicolor prints (see COLOR PRINTS) a separate stencil is needed for each color run.

A number of different techniques are used to prepare the screen stencil, and two or more processes may be combined in the making of a single print. The TUSCHE-WASHOUT METHOD, which is the most spontaneous and admits of the greatest variety of creative effects, is the principal technique used in serigraphy. The BLOCK-OUT STENCIL METHOD and the FILM-STENCIL METHOD are also used by serigraphers for simple designs. The PAPER-STENCIL METHOD and especially the film-stencil method (less sensitive processes than the tusche-washout) are most often used for commercial work such as posters and advertisements. The PHOTOGRAPHIC-STENCIL METHOD is a process for reproducing photographs or works of art in any other medium.

A great variety of printing mediums are suitable for silk-screen work: inks, oil and tempera colors, dyes, and lacquers can all be used provided they have the proper viscosity, plasticity, and drying time (if the paint dries too quickly it will clog the screen) to pass through the screen with facility. Silk-screen printing mediums are bought ready-made and contain the proper varnishes, vehicles, driers, etc., in amounts that give the paint the correct consistency. PROCESS OIL COLORS (so called to differentiate them from paints and artists' colors) are by far the most popular medium used for silk screening on paper, although process

tempera colors are also becoming popular. Dyes and lacquers are usually reserved for printing on cloth. Silk-screen paints are sold in a wide range of colors but can also be mixed to produce other tones or hues. The color sensitivity of commercial silk-screen work is usually decidedly inferior to that of serigraphs printed by an artist who mixes his own colors.

Artists' oil colors are mixed with a transparent base to give them the correct degree of plasticity and to achieve transparent printing effects. All the standard water-based paints are rather difficult to use because they dry too quickly and clog the screen. They also share with the process tempera colors several other drawbacks: they cannot be used on screens blocked out with either glue or paper, since they will dissolve glue and cause paper stencils to warp, making sharp impressions impossible; they make an organdy screen limp and unusable; and they cannot be printed on thin paper, for as they dry they will cause the paper to buckle.

Although silk screening has its roots in ancient Oriental stencil printing, its "invention" is sometimes credited to Samuel Simon of Manchester, England, who patented a silk-screen process in 1907. However, as a commercial technique for making posters, signs, and displays, silk screen became popular in New York and San Francisco during and shortly after the First World War. In the period between the First and Second World Wars, its commercial application was perfected, and the medium has since achieved the status of a major industry.

silky oak. See LACEWOOD.

silver-gilt. Silver that has been coated with a thin layer of gold.

silver leaf. Silver beaten into thin leaf for use in GILDING. Because silver is somewhat less malleable than gold, silver leaf is usually about three times as thick as GOLD LEAF and consequently easier to handle. Unlike gold it requires lacquering or varnishing to prevent it from tarnishing and is therefore often replaced by PALLADIUM LEAF. ALUMINUM LEAF, an inexpensive imitation of silver and palladium leaf, is used chiefly in the commercial arts. The use of silver for gilding has not been as extensive as the use of gold. Silver was sometimes used in medieval and Renaissance painting for the armor of figures, and although it was used in 13th- and 14th-century northern European painting for backgrounds and details, it was probably originally coated with a gold-colored varnish. Much early American commercial gilding was done with burnished silver leaf, coated with a clear golden lacquer to make an excellent imitation of gold.

silver point. A pointed rod of silver, which, when drawn across paper that has been specially coated with white pigment, leaves minute particles of the metal embedded in the surface, producing a grayish line that becomes darker in time as the silver tarnishes; also, a drawing so made. The color and delicacy of the lines in silver-point drawings have always been admired. The traditional point is a silver rod about ¼ inch in diameter and 3 to 4 inches long; it frequently has a twisted shaft to give the artist a better grip. A silver point may either be pointed at both ends or have a flat chisel edge at one end for making broader strokes. It can be easily made by a silversmith when it cannot be found in an art-supply store, but most artists use a bit of silver wire instead, inserting it in a mechanical pencil or an etching-needle holder and bringing the wire to

a point by rubbing it on fine sand-paper. In medieval and Renaissance silver point, the paper, parchment, or board was coated with calcined bone in a glue medium. Modern silver-point paper is made by coating rag paper with zinc white in a watercolor or casein binder; a pigment may be added to the coating if tinted paper is desired. Any soft metal, such as cop-per, lead, platinum, and gold, can be used to draw lines on silver-point pa-per. Platinum and gold have been used to a small extent, but since these metals do not tarnish, the lines they make remain quite pale.

Silver point was used extensively during the Renaissance both for the underdrawing in panel painting and as a medium for fine drawings. The latter were done on white or tinted grounds and were commonly highlighted with white watercolor applied with a brush. Silver point remains a standard artist's technique for fine drawings.

silver powder. Pulverized silver, which when ground in a watercolor vehicle is sometimes used in GILDING as silver paint. Unless coated with shellac or varnish after it is applied to a sur-face, silver paint will tarnish rapidly. Its principal use is in painting, where it is used to draw fine lines and create delicate silver highlights. Silver powder is sold in the form of tablets and in shells (see SHELL GOLD).

silver stain. A solution of silver salts formerly used to alter the color of local areas of STAINED GLASS. Painted on the glass, then fired, silver stain imparted a strong yellow or orange tinge to clear glass and could be used on colored glass to produce other colors, e.g., on blue to make a brilliant green. Devel-oped in the Near East in medieval times, silver stain came into common use in Europe in the 14th century. To-gether with JEAN COUSIN, a red stain, it

considerably widened the variety of ef-fects that glaziers could achieve with GRISAILLE, the only form of glass paint hitherto known. It was extensively used until the development in the 16th century of painting on glass with vitreous ENAMELS.

silver white. A translation of blanc d'argent, the French term for FLAKE WHITE. In English, silver white is not a specifically reliable term, since it has been applied to both flake white and ZINC WHITE.

simple-solution varnish. A VARNISH made by dissolving a resin directly in a VOLATILE SOLVENT, as distinguished from the more complex oil varnish, which is made by cooking the resin with a drying oil and a drier. In indus-trial practice simple-solution varnishes are usually called SPIRIT VARNISHES, and are sometimes referred to as cold cuts.

Simultaneism. See ORPHISM.

simultaneity. One of the elements or essential principles of the movement known as FUTURISM. It postulates a joining or association into one creative act of all the emotions, memories, asso-ciations, ideas, and intentions that are in the mind of the artist during the creation of his work. Before the Fu-turists used the word, Apollinaire had applied it to a Cubist principle. It is sometimes used for the technique better called SIMULTANEOUS REPRESENTA-TION.

simultaneous representation. The depiction in a picture of more than one view of the same person or object. A face, for example, may be shown essen-tially in profile but contain elements of a front view. This technique was first widely exploited by the Cubists, al-though painters from the Renaissance

361

SIMULTANEOUS REPRESENTATION. Picasso's *Head of a Woman* (1941), pen-and-ink drawing on paper. (*Collection, The Museum of Modern Art, New York.*)

to the Postimpressionists often used mirror reflections as an excuse to show more of an object than could normally be seen from a single viewpoint. Simultaneous representation has also been called simultaneity, a word used by Apollinaire of the Cubist principle. It should not be confused, however, with the principles of Orphism, a movement that some of its proponents called Simultaneism.

Singapore damar. One of the two principal varieties of DAMAR imported in commercial quantities; the other is Batavia damar. Singapore damar is considered better for artists' varnishes because it is paler and has less tendency to BLOOM. It is sorted into several numbered grades, of which the purest, Number One, consists of pale, sometimes colorless, rounded pebbles, drops, and stalactitic pieces. It appears dull because of resin dust, but actually is perfectly clear, as is apparent if it is

broken into facets. It is held to contain no coloring matter that will darken; its yellowish tinge is from such natural impurities as leaves and bark. It has a characteristic mild odor. See MATA KUCHING DAMAR.

singerie. A depiction of monkeys, engaged in apish tricks or acting out various human roles.

single-fired. A term describing ceramic wares that are fired only once, after the application of glaze to the unfired clay body.

single-stroke brush or **one-stroke brush.** A broad, flat red-sable brush made in sizes varying from ⅛ inch in width up to 1 inch. Originally designed for lettering and sign writing, it is an increasingly popular watercolor brush, used for putting in broad washes and as a versatile flat-and-edge stroking brush that is capable of making very thin lines as well. Some artists

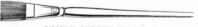

SINGLE-STROKE BRUSH

prefer the cheaper grades of single-stroke brush, in which red sable is mixed with the firmer, more resilient ox hair.

sinking in. The appearance of dull, lusterless spots on an oil painting after it has dried. It is caused by unequal penetration into the ground of areas of different degrees of absorption. The defect is usually remedied by the application of a coat of picture varnish. Few oil paintings will dry without sunken-in spots, and one of the purposes of a picture varnish is to rectify this condition. Sinking in that does not respond to varnishing but requires more extensive conservation measures is commonly due to improper materials

or methods of application. A sunken-in spot is occasionally identified by its French term, *embu*.

sinopia. 1. An obsolete name for native RED IRON OXIDE pigment. Known also as sinope, sinoper, and sinopis, the pigment took its names from the city of Sinope in Asia Minor, an important classical source of red earth. The name sinopia is found in early Latin writings and was used in Italy until the Renaissance (Cennino Cennini speaks in *Il Libro dell'Arte* of its suitability for fresco, tempera, and secco), after which it began to be replaced by other names such as red ochre, Venetian red, Spanish red, rouge, terra rosa, and ruddle. During the Renaissance, chalk pigmented with sinopia was frequently used for a full-scale sketch on plaster made as the artist's preliminary guide for the FRESCO that was to cover it.

2. By extension, the fresco underdrawing itself. Many sinopie for Renaissance frescoes have been uncovered in recent years thanks to modern methods of art conservation. They often show a far greater spontaneity and freedom from the stylistic conventions of the time then the fresco itself. See illustration at FRESCO.

sinter. 1. The natural binder in oölitic ROCKS. Sinters are usually lime or silica that was precipitated by the evaporation of lake and river water when the rocks were formed.

2. In ceramics, to fire a ware above the point at which it can be reconstituted with water to the plastic state, but below the point of fusion.

size; sizing. Size (or sizing, as it is sometimes called) is an extremely dilute solution of a gluey or resinous substance applied to a surface in order to reduce its absorbency or porosity and make it more receptive to application of paint or another coating material. In oil grounds on canvas the application of size is expecially important, since direct contact with oils causes the canvas fibers to become brittle and to decay. Hide glue is commonly used for sizing; on rigid surfaces, such as panels and walls, weak shellac is also used. Size serves to fill pores and to isolate coatings or prepare surfaces to receive them. Sizes are always kept very dilute so as not to complicate the paint structure by forming an appreciable surface layer (as varnish does) and because in most kinds of painting it is not desirable to eliminate completely the absorbency of a surface. The application of size to a surface is called sizing. In Britain the term "size" also means an ordinary glue solution of any strength that may be used as a paint BINDER, a RETARDANT for plaster, and other purposes.

size color. British term for SCENIC COLOR.

sketch. A preliminary drawing, painting, or model, often rough and sometimes rapidly executed, that presents the characteristic lines and feeling of the thing drawn, while it necessarily neglects some of the details. In this respect it differs from a STUDY, which tends to be quite detailed and in no way spontaneous. The sketch may be a CROQUIS, or it may be a rapid NOTE made to capture an ephemeral effect such as the expression of a face or the action of a figure; when such a note catches an atmospheric effect on a landscape it may be called a POCHADE. A sketch may also be a more carefully worked out embodiment of the artist's ideas, such as an ESQUISSE or schizzo, that is closely linked to the ultimate work of art and may be used as a guide for assistants working on the final project; Rubens, who had a large workshop in order to fill his many

commissions, often made such sketches for his apprentices. The word sketch also applies to an early stage in the execution of the ultimate work itself, such as a block of stone that has been reduced to a rough approximation of its intended form or a canvas or wall that has been prepared with an underdrawing or underpainting (see ABBOZZO; ÉBAUCHE; MACCHIA; SINOPIA). See also COLOR SKETCH.

sketch box. A small, compact wood or metal box fitted with a handle, used for carrying oil-painting equipment on field trips. It is fitted with compartments and/or trays for carrying brushes, tubes of paint, and bottles of turpentine and linseed oil. Many commercially sold sketch boxes are equipped with a palette, and some have space in the lid for carrying one or more small canvas panels. A small sketch box is also known as a pochade box.

sketching easel. See EASEL.

skew chisel. A chisel whose cutting edge is at an acute angle to its shank, as distinguished from a regular chisel (or "straight," as it is sometimes called), whose edge is at right angles to its shank. The skew chisel is often called a straight skew and sometimes simply a skew. See illustration at WOOD-CARVING TOOLS.

skim coat. See BROWN COAT.

skin. To overclean an oil painting. When every vestige of the varnish is removed the colors have a frosted appearance. Skinning may also imply the actual removal of color, especially the surface glaze. Use of a RESTRAINER may help prevent skinning during cleaning, but the conservator's skill is of the utmost importance.

sky blue. A hue designation for any azure color. In the past the term was also applied to artists' colors made by combining zinc white and ultramarine blue.

skyphos. Ancient Greek pottery drinking cup with a deeper bowl than that of the kylix and generally made in smaller sizes. The typical skyphos had two short handles attached horizontally to its edge; looped handles were often used. See VASE SHAPES for illustration.

slab. The stone or glass surface on which artists' colors are ground with a MULLER.

slab method. A technique of forming pottery by hand. A mass of wet clay is flattened to a slab with a rolling pin, its thickness determined by the size of the article to be produced. The slab may be bent into various shapes, joined to other slabs with slip, or PADDLED over a wood form. Another manual technique is the COIL METHOD.

slaked lime or slack lime. Calcium hydroxide; also called hydrated lime. See LIME.

slaked plaster of Paris. Inert calcium sulfate, produced by soaking PLASTER OF PARIS overnight in a relatively large amount of water so that it loses its setting power. In medieval times it was used to make gesso, although whiting or chalk had replaced it in most localities by the end of the 15th century.

slant. A slab with one or more wedge-shaped depressions, used to hold ink and watercolors in various dilutions; a palette for wash drawings. A slant with both sloping and circular wells is commonly called a well slant, and a small slant of either type with

WELL SLANT

shallow depressions is sometimes called a tile. All slants were formerly made of porcelain but they are now frequently made of plastic and, occasionally, aluminum. The cover of a typical watercolor box is usually designed to perform the function of a slant. A large, circular slant containing six or eight depressions and with a cup or basin in the center is known as a basin slant.

slate pigments. Powdered slate made in grayish-black, dull-red, ochre-yellow, and dull-green hues; sometimes used as cheap pigments in industrial products. Although slate black, also called shale black, was one of the earliest pigments used in water mediums, it is not in general use by artists. Slate black is gritty and has very low tinctorial and hiding power. Since its hardness is destructive to grinding mills, slate black is never very finely pulverized.

slice. A generic term for spatulate instruments with wide or flaring blades, as the WALL SCRAPER and the broad putty knife.

slicker. A 1-inch CHISEL BRUSH with a short handle, made of bristle and designed as a pick-up brush, i.e., for taking the excess varnish out of corners in finishing furniture and in similar operations. Some artists have found it useful for applying varnish as well.

slip. 1. In ceramics, a very fluid mixture of clay and water, sometimes with color oxides added. It is used for decorating pottery by pouring or dripping, for SLIP CASTING, and as an adhesive for luting sections of a body, e.g., attaching the handle of a teacup. 2. A small, shaped piece of very hard fine-grained OILSTONE, as Arkansas, Ozark, or Burma stone, used for sharpening wood-carving and woodcut tools. A number of rounded, wedge-shaped, and conical carving-tool slips are made, their contours designed to align with the edges of gouges and parting tools.

slip casting. The production of ceramic ware by pouring SLIP into a mold made of absorbent plaster. After the mold has absorbed water from the slip for a few minutes, a wall of clay builds up, the still fluid portion of the slip is poured out, and upon drying, the piece shrinks away from the mold. See also SLUSH MOLDING.

slip clay. A clay which, in its natural state, contains sufficient flux to be used for glazing. One of the most widely used slip clays is ALBANY SLIP.

slip decoration or **slip trailing.** The application of SLIP to a piece of pottery with a syringe device so as to create slightly raised, linear decorations. The slip decorations on Pennsylvania Dutch brown pie-plates and other wares are familiar examples in early American pottery.

slow-drying size. See GOLD SIZE.

slush molding. The technique of producing a hollow plastic cast by pouring a prepared liquid, such as a PHENOLIC RESIN, into a MOLD and stirring it until it sets slightly on the inner surfaces, then pouring out the liquid. The coating left in the mold is allowed

to solidify. This type of casting is somewhat limited in its range of available materials and colors, and the quality of results is below that of other casting techniques. However, it is an efficient and economical method of creating thin-walled or shell casts, especially in amateur or craft work. See also SLIP CASTING.

smalt. An obsolete blue pigment, differing from the usual inorganic coloring material in that it is composed of glass colored with cobalt oxide rather than a straight chemical compound. The special cobalt oxide (or zaffer) obtained by roasting cobalt ores is mixed with molten glass to produce smalt, which appears black in lump or coarse form. As a pigment, smalt was a very difficult material to handle. Developed during the 16th century, it became a standard product during the 17th and 18th, but went out of use in the early 19th century after the introduction of cobalt and ultramarine blues. A cobalt-blue glass paint and ceramic pigment was made in Persia, and is believed to have been exported to China and other eastern lands some centuries before its invention in Europe. In the 20th century, smalt, some of which is said to be still made in the original 300-year-old factories in Saxony, is used as a ceramic color and is also employed to make a type of old-fashioned sign that has a sparkling black crystalline background and gilded wooden letters. Other names for smalt were AZURE BLUE, Dumont blue, HUNGARY BLUE, and Saxon blue. ESCHEL is considered a grade of smalt.

smalto. A glass or glazed ceramic TESSERA.

smaragd green. An alternate name for VIRIDIAN, taken from the Greek word smaragdos, meaning emerald.

Smillie's bath. A solution of hydrochloric acid and potassium chlorate that is used as a MORDANT in AQUATINT. Although it has the same ingredients as DUTCH MORDANT, Smillie's bath is much more concentrated, containing only five parts water to each part hydrochloric acid.

smoking. In ETCHING and DRYPOINT, the process by which a coating of transparent or translucent ETCHING GROUND on the plate is blackened, as the final preparation for drawing on the surface with a NEEDLE. The plate is usually smoked by holding it with a hand vise face-down over the flame of a bunch of thin wax tapers that have been twisted together, producing a coating of soot on the etching ground. Smoking increases the visibility of the design when it is drawn with the needle; lines cut through a light etching ground would be difficult to see. Some etching grounds are already dark in color and do not require smoking.

smooch. A smudged or smeared area in a drawing done with a soft medium such as soft pencil, pastel, or lithographic crayon. When deftly executed with the fingers or the whole hand, smooching is an effective way of shading in a casual or spontaneous manner.

snakestone. See AYR STONE.

snakewood. A reddish-brown hardwood with dark spots that resemble snake markings; also known as letterwood. Snakewood is obtained from the tree *Piratinera guianensis*, native especially to Surinam, French Guiana, and Guyana. It is very durable and heavy, and is used for modeling tools and walking sticks. It comes in logs of 5 to 8 inches in diameter. Several other woods, unrelated to the above are also known as snakewood because of their distinctive markings or shape.

snap. A tacky or adhesive quality in printing inks, as opposed to a smooth or buttery consistency.

soak. In ceramics, to maintain a certain temperature in a kiln during the glaze-firing cycle. This practice allows the melted glaze bubbles to flatten before the temperature is lowered.

soapstone. A metamorphic stone formed from igneous rocks with a high magnesium content; a dark, compact variety of TALC. It is called soapstone because it is smooth and slightly greasy or "soapy" to the touch. It is easily carved and takes a relatively good polish. Types of soapstone used for carving include ALBERENE STONE; POTSTONE; and STEATITE.

Socialist Realism. Official artistic style in the Soviet Union. Its dominant position was established in 1932 when the Party took over the function of patronage and control of the arts, which it had relinquished to the PROLETCULT ten years earlier. Socialist Realism confirmed the end of experimentation and abstraction in Russian art. It called for a conservative, academic art, literary and heroic, devoted to glorifying the State and the people in painting and sculpture, and to functional design within a traditional context in architecture. This doctrine is still in force in the U.S.S.R., although the opposition of the Party to abstract and experimental art has become somewhat less drastic in recent years.

sodium silicate. See WATER GLASS.

softener. See BLENDER.

soft-ground etching or **vernis mou.** A method of ETCHING that produces prints which have a softness of line and a grainy character suggestive of crayon strokes or of the grainy lines characteristic of a lithograph or a crayon-manner print. The plate is coated with an ETCHING GROUND which differs from that used in normal etching in that it is at least half tallow, which imparts a greasy, tacky quality to the ground. When a sheet of paper is laid on a soft-ground plate and firmly drawn on with a pencil, the ground under these strokes adheres to the paper and is lifted away when the paper is pulled off. The plate is then bitten rather slowly, usually in a bath of DUTCH MORDANT. In addition to the crayon effect, the soft-ground line differs from that made with a needle in that it can be made to vary in printing strength through width of biting instead of depth. Less STOPPING OUT and fewer time-consuming operations of other types are required. Different effects can be achieved by using different types of paper and pencils. Various textiles can also be used instead of paper to create special textures in the print. The technique, which is also known by the French term *vernis mou,* was invented in the middle of the 18th century. Although it was at one time rather overshadowed by lithography, it has been somewhat revived in recent years. The soft-ground method is used both alone, as an expeditious yet effective technique, and with other intaglio methods, especially AQUATINT, for which it is an excellent linear preparation.

soft paste; soft-paste porcelain. Any of a number of porcelains, somewhat softer and fired at lower temperatures than "true" porcelain. Soft-paste porcelain is also called artificial porcelain, because it was first made in imitation of Chinese porcelain. The term soft paste also designates the clay mixture used to make a softer porcelain. It usually contains ground glass or ingredients used in making glass. See also HARD PASTE.

soft soap. A liquid soap, usually tincture of green soap, used in sculpture as a PARTING COMPOUND, especially to separate a plaster cast from a plaster mold.

soft solder. A SOLDER that melts readily; it either requires less than the red heat needed to fuse a HARD SOLDER, or acts as an adhesive without heat, like a glue.

soft steel. See MILD STEEL.

softwood. The wood of conifers such as the pines and firs and of a few deciduous trees such as poplar. It is softer and less durable than the hardwood of such trees as the maple, birch, and walnut.

solder. A metallic alloy, usually of lead and tin, used to join two metal surfaces together; also, to join two metal surfaces by means of such an alloy. First the surfaces to be joined are cleaned with a FLUX; then a soldering iron or blowpipe is used to melt the solder. Soldering is done at a much lower temperature than WELDING, although red heat is needed to fuse a hard solder. A soft solder joins with little or no heat. There are many specialty solders, such as silver solder, which contains silver and is used for joining that metal. The solder adheres to both surfaces to be joined, holding them together when it hardens again, like a cement. Soldering does not produce as strong and durable a joint as welding.

solferino. A reddish-violet pigment made from fuchsine (magenta); a fugitive lake sold to artists in the 19th century.

Solnhofen stone. A blue-gray Bavarian LIMESTONE, mined in Solnhofen, Germany, that is used in lithography (see LITHOGRAPH STONE).

Solomon's seal. Two equilateral triangles interlaced to form a six-pointed star. This symbol has been used for centuries as a talisman. The two triangles are often shown with one dark, the other light, to represent the union of body and soul. One source of the figure's magical attributes may be the fact that it can be drawn in a continuous line, as can the PENTACLE. The symbol has long been used as an emblem of Judaism: the Magen (Mogen) David or shield of David. It is also called the star of David.

SOLOMON'S SEAL

soluble blue. A variety of PRUSSIAN BLUE processed so that it is soluble in water. It is not suitable for artists' colors, but is used in printing the lines on ruled paper.

solvent. See VOLATILE SOLVENT.

solvent naphtha. See COAL-TAR SOLVENT.

solvent retention. A defect or shortcoming of some varnishes that dry too slowly or that remain soft and tacky for a long time because remnants of their volatile solvents are entrapped within the lattice-like molecular structures of their films. In general, resins that are less readily soluble have better "solvent release," and sometimes the addition of one of these resins will improve a varnish that dries too slowly. Solvent retention is more frequently encountered in lacquers and complex industrial finishes than in artists' varnishes.

soot brown. An obscure name for BISTRE.

Sorel cement. See OXYCHLORIDE CEMENT.

sotto in sù. In a ceiling painting, extreme FORESHORTENING of figures and scenes, such that they appear to be suspended in space rather than contained within a PICTURE PLANE. *Sotto in sù* is Italian, meaning "from below upwards," referring to the depiction of a painting that is meant to be viewed from directly beneath it. This form of perspective is perhaps most familiar from the frescoes of Giovanni Battista Tiepolo (1696–1770).

soya bean oil. A SEMIDRYING OIL, used in industrial paints and varnishes because of its low cost and its resistance to yellowing, especially in combination with alkyd resins. It is not used in artists' colors.

spackle. To fill in or STOP holes in plaster or other coarse surfaces with stiff plaster, plaster of Paris, putty, or proprietary materials such as crackfiller and patching plaster; also, the material used. Spackle is smoothed with a broad putty knife while it is still wet. The term spackle is derived from the German *spachteln*, "to spread or fill with a spatula."

spall. A chip, splint, shiver, or small fragment with at least one ragged edge broken away from a stone carving, either in process or from a finished work; also, to break off by chipping, splintering, etc. The term can also be applied to ceramics, glass, and other objects prone to chipping.

Spanish black. A variety of VINE BLACK made from charcoal produced by burning cork; also known as cork black.

Spanish red. A relatively dull, coarse RED IRON OXIDE pigment from Spain, or a similar grade produced elsewhere. It is more suitable for the

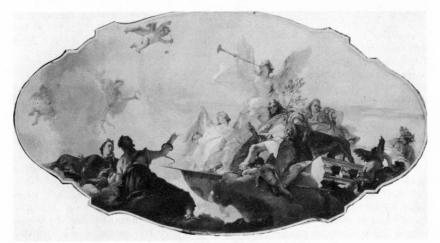

SOTTO IN SÙ: *The Glorification of Francesco Barbaro*, oil on canvas, a ceiling decoration by Giovanni Battista Tiepolo, 1696–1770. (*The Metropolitan Museum of Art, anonymous gift, 1923.*)

cheaper kinds of industrial paints than for artists' colors.

Spanish white. A superfine grade of WHITING.

spar varnish. A waterproof, tough, durable industrial coating designed to resist severe conditions of wear and exposure on boats, floors, etc. The older spar varnishes were made by cooking one of the harder resins such as copal or kauri with linseed or tung oil and driers. The modern ones contain synthetic resins such as phenolic resin. Spar varnishes cannot be used in permanent painting because they turn dark and become brittle with age.

spatter. Paint or ink applied so as to cover a surface with an irregular, usually sparse pattern of fine dots or specks. It may be produced by drawing a stiff brush loaded with paint across the teeth of a comb and allowing the tiny drops to fall on the surface, or by spraying with an AIRBRUSH or SPRAYER adjusted to emit relatively coarse drops rather than the fine mist that produces a homogeneous coating.

spatula. In painting, a large, flexible, very finely tempered steel blade. It is used for mixing, grinding, stirring, and other heavy-duty operations in the studio. The spatula has straight sides, bluntly rounded ends, and, typically, a 6-inch blade.

spectrophotometer. A laboratory device for the measurement of surface color in terms of wavelength, TRISTIMULUS VALUES, and CHROMATICITY coordinates. In a typical model, a beam of light is converted into a spectrum band by being passed through a prism. The spectrum is blocked off by a plate with a narrow slit of adjustable width, and can be moved so that any desired portion is transmitted through the slit and onto the sample. The sample absorbs some of the rays and transmits the rest. The transmitted rays impinge on a sensitive phototube and are changed to an electrical signal, which is amplified and read on a meter. When measurements are made in the ultraviolet and infrared sections of the spectrum, special light sources are used.

spectrum. The band of rainbow colors seen when sunlight is passed through a prism. It represents the visible wavelengths of radiant energy, having violet at the left and red at the right end. The invisible wavelengths beyond violet on the low side of the spectrum band are called ultraviolet and those beyond the red or high side are called infrared. See COLOR; COLOR CIRCLE.

speed of dry. See DRYING TIME.

spermaceti. A clean, white, translucent wax obtained from the head cavity of the sperm whale. It is rather brittle and has a melting range of 41–44° C. Spermaceti was formerly an important material in the arts but has been largely superseded by other waxes or combinations of waxes.

sphinx. A carved image of a recumbent lion with a human or animal head fixed in an inscrutable frontal gaze. It was a popular motif in ancient Egyptian art. The androsphinx, or human-headed sphinx, was the most common; other forms were the criosphinx, with a ram's head, and the hieracosphinx, with the head of a hawk. The most notable sphinx is the huge example near the pyramids of Gizeh. In Greek mythology the sphinx was a monster with the body of a winged lion and the head and breasts of a woman; it appears in the story of Oedipus.

spider wheel. The large outer wheel by which an etching press is operated. The four long protruding spokes of the wheel act as a handle that turns the gears that shunt the bed through the rollers of the press. The spokes offer the printer great leverage in operating the press. See illustration at ETCHING PRESS.

spike lavender. See SPIKE OIL.

spike oil or **oil of spike lavender.** A VOLATILE SOLVENT distilled from a broad-leafed variety of lavender, *Lavandula spica;* not to be confused with the fragrant OIL OF LAVENDER used in perfumery. Spike oil was first produced and used as a thinner for oil paints in the 16th century, and for about two centuries was at least as widely used as turpentine, because of its greater availability. The plant from which it is extracted grows wild in Europe and has been extensively cultivated in Spain. As a paint thinner its action closely resembles that of turpentine, although it tends to oxidize and become gummy more rapidly and evaporate more slowly. Because of the latter property it has been suggested for use in varnishes to improve their flow and LEVELING.

spinning. Shaping a sheet of metal against a wooden form on a lathe. After about 1825 most silver and pewter hollow ware was made this way rather than by the earlier method of hammering the metal into the shape desired.

spirit. A British term for alcohol. The word is also rather loosely applied to other products of distillation, such as beverage liquors and the petroleum solvent white spirit (mineral spirits). It is similarly used in the U.S. for a few volatile liquids, usually in the plural, as in spirits of turpentine and mineral spirits. See also SPIRIT VARNISH.

spirit fresco. Mural painting with colors made by grinding pigments in varnish; a process developed about 1880 in England by T. Gambier-Parry and hence known also as Gambier-Parry spirit fresco. Spirit fresco was devised in an attempt to find a reasonably simple technique for producing paintings with the visual effects of true fresco that could survive rigorous British climatic conditions. The process proved to be unsatisfactory and was soon abandoned, but its recipes are still in circulation.

spirit varnish. Any SIMPLE-SOLUTION VARNISH. The term originally meant one in which alcohol was the solvent, but in the industrial coating-material field it has come to include all such varnishes, whatever the volatile solvent.

spit. A fragment of the firebrick lining of a ceramic kiln, which may fall on the ware, causing a blemish.

spit-out. Blistering of a CERAMIC glaze on firing, a defect caused by air or gas bubbles. See also BLISTER GLAZE.

spitsticks. The three smallest sizes of TINT TOOL; used for fine lines and delicate work in WOOD ENGRAVING.

spline. A narrow strip of flexible transparent plastic that is used in mechanical drawing as a ruler for curved lines. The spline can be bent in any curve desired but, unlike the ADJUSTABLE CURVE RULER, will not hold that position unless specially designed lead spline weights are hooked into the groove that runs the length of the strip; these weights prevent the spline from shifting its position on the paper. The spline is available in lengths up to 10 feet and replaces the adjustable curve

SPLINE

ruler when especially long curves need to be drawn.

spolvero. A secondary CARTOON that has been traced in outline from the original. The spolvero is pricked for POUNCING in order that the original cartoon may be preserved. From the Italian word, which literally means "fine dust," has been derived its other meaning of the dotted outline produced on the wall or canvas by the POUNCE that has been dusted through the cartoon or preparatory sketch. Spolvero is also sometimes used to designate a pounce bag and occasionally the pounce itself.

spoon gouge. See BENT GOUGE.

sprayer. Any device used by artists to deposit a very thin, uniform coating of a fluid material in a spray or mist on a surface. Sprayers are used to apply retouch varnish to oil paintings, fixa-

SPRAYERS. At left, a sprayer with a can of propellant under pressure and a jar holding the liquid to be sprayed. At right, a simple mouth blower, folded.

tive to pastels and drawings, and size to an absorbent surface. The simplest kind of sprayer is the mouth blower, a straight, slender tube joined to a wider tube, collapsible for transport and compact storage; the end of the thin tube is placed in the liquid, and the wider tube is blown through with a steady breath. The air stream blows across the top of the thin tube, lifts the liquid, and then disperses it in a fine spray. The blower is used only on materials that are not adversely affected by the condensation of moisture from the breath. Another type of sprayer is the ordinary drugstore atomizer with a rubber bulb and glass container. The best modern, inexpensive sprayer in art supply shops is a plastic device that holds a replaceable pressure can of propellant and a 4-ounce glass jar to hold the fluid to be sprayed. See also AIRBRUSH; SPRAY GUN.

spray gun. A heavy-duty spraying device for large-scale painting on a flat surface. Artists sometimes use this industrial equipment for preparing walls for painting and for varnishing murals. For varnishing, a power gun with a moisture trap is best, as moisture produced by condensation will spoil the varnish and a powerful spray is necessary to obtain a smooth coating.

sprezzatura. Studied carelessness. In art the term is applied to the effect given by some works of having been done without apparent effort.

sprigging. Applied, raised decoration of pottery. Plastic clay is formed in a press mold and applied to the pot by luting, i.e., using slip as an adhesive. The molded form becomes an embossed element of the ware.

spruce ochre. A variety of YELLOW OCHRE with a reddish cast.

sprue. In casting, the entrance hole and main channel in the wall of a MOLD through which the liquid material is poured; it is joined to the model by smaller channels called GATES. The waste piece of material formed by the channel is also called a sprue.

spurs. See STILTS.

squaring or **squaring off.** A method for transferring a drawing to another surface on a different scale, especially to a larger surface that is to be painted, such as a canvas or a wall. In squaring (also called graticulation), the drawing is ruled off into squares, and the same number of squares are then ruled on the surface to which the drawing is to be transferred. Each square of the drawing is then copied freehand onto the corresponding square of the other surface. When a drawing is to be transferred to a wall, the wall can easily be squared with lines created by dipping a length of twine or cord into powdered charcoal or another dry pigment such as burnt umber, stretching it tightly on the wall between points that have been marked off, and snapping the cord smartly. Squaring was used in ancient Egyptian wall painting and may have been used even earlier.

squeegee. In SILK SCREEN and SERIGRAPHY, the tool used to force paint through the screen onto the printing surface. The squeegee is a thick blade of firm but flexible synthetic rubber, set into and protruding from a hardwood bar. The blade has square corners and must be square-cut along its edges to create clear, sharp impressions. When the edges become dull, they are sharpened by stroking the flat surface of the blade over sandpaper or garnet cloth.

The size of the squeegee (and of the frame) is contingent upon the size of the design or print being made. The squeegee must be at least an inch longer than the width of the design to be printed. The squeegee customarily used by serigraphers has a short, thick handle centered on the back of the tool, but some prefer a handleless type with the back shaped to fit the artist's grip. A long squeegee must be held with both hands; an extremely long squeegee (they are sold in lengths up to eight feet), such as that used in textile or wallpaper printing, is operated by two people. To make a serigraph impression, the squeegee, with its handle inclined forward, is pushed across the screen from one side to the other with a firm, unfaltering stroke; the blade pushes paint before it, and its edge forces the paint through the screen. As soon as the first area has been covered, the pass must be ended by raising the squeegee abruptly. Each pass creates an impression on the printing surface beneath the screen. If several proofs are to be pulled, the passes are made alternately from the left and right sides; the paper is replaced between strokes, and the artist changes hands for each pass. Mastery of this operation comes only with experience, but once the skill is acquired the application of paint with the squeegee can be controlled with great sensitivity.

squeeze. An impression taken from any carved or incised object by pressing a plastic material into its depressions. A positive replica may be made from the negative squeeze.

stabile. See MOBILE.

stabilizer. A term borrowed from emulsion chemistry in 1940 by Ralph Mayer in *The Artist's Handbook,* to denote the additive used in artists' oil colors to help keep the pigment and oil in suspension so that the separation of pure oil from the color is minimized.

White refined beeswax is used for this purpose by artists who make their own oil colors, but the commercial manufacturers use aluminum stearate, a waxlike substance. It is believed that if the volume of such an additive is kept to a small percentage (2% or less), it will have no harmful effect on the longevity and color stability of the resulting paint films. When wax is used as a stabilizer, it serves a dual purpose, for it also acts as a PLASTICIZER.

stacco. A method of transferring a FRESCO painting from its original wall. In the stacco technique the color is removed together with the INTONACO layer of plaster. Layers of cloth are glued with animal glue to the face of the painting, then carefully pulled. The intonaco adheres to the cloth, since it is already loosened from its undercoat of plaster by the conditions that have made the transfer necessary, generally seepage of water and destructive chemicals through the wall. More cloth is attached to the back of the intonaco and the cloth is removed from the face of the painting, which can then be attached to a new support. See STRAPPO for a different method of transfer.

staffage. The addition of human figures and animals to any picture intended primarily to represent a landscape, town view, architectural depiction, or other such general scene. The figures are secondary and are added primarily to enliven the composition. Although most landscape artists people their own landscapes, some, particularly the 17th-century Dutch painters, often employed other artists to perform this function.

stage. See STATE.

stain. 1. To color wood by applying a dye or transparent pigment in such a way that the grain and texture remain visible; also, a dye solution or pigmented fluid or paste so used. A wood stain may be made with an oil, alcohol, or water base. An oil stain does not affect the smoothness of the wood surface, whereas a solvent or water stain is apt to raise the grain. Wood may also be stained by immersion in a hot solution of certain chemicals, such as potassium permanganate or one of the bichromates.
2. Potters' term for the ceramic color ingredient added to a clay, slip, or glaze.

stained glass. Colored glass used in windows; also, the art of creating works in this medium. The designs of stained-glass windows are produced by two distinct methods: juxtaposing differently colored pieces of glass to form patterns, and painting on clear or colored glass. Since the invention of GRISAILLE in the 9th century, the two methods have been used side by side. After the development of other coloring materials, such as SILVER STAIN and JEAN COUSIN, and the invention in the 16th century of a whole palette of colors in vitreous ENAMELS, the older method—a form of the art of mosaic —gave way to the newer, and the making of stained glass became, in effect, a branch of the art of painting.

The *Schedula Diversarum Artium,* by Theophilus Presbyter, gives considerable information about the process of making stained-glass windows in the 12th century. The glass was colored by adding various metallic oxides—such as iron, copper, manganese, and cobalt—to the molten glass. Darker shades tending toward opacity were fused in very thin films with sheets of clear glass by a process called FLASHING. Using a technique of SGRAFFITO, glaziers could scratch or abrade designs through the films to reveal the clear glass.

The glass was carefully cut with a point of hot iron (or, in a later period,

of diamond) into shapes previously drawn on a board whitened with chalk. The pieces were then set into a temporary framework to be painted with grisaille and fired again. Next, the pieces were fastened together by inserting their edges into deep grooves on either side of precast strips of lead. The leading of windows during the great centuries of the art formed an important part of their composition —a function that artists often emphasized by darkening with grisaille the areas bordering the strips. The leaded window was then fitted into an iron frame, or armature, which was fastened into place in the window aperture. In later centuries various inventions refined these techniques and made them more flexible, but did not radically alter them.

Colored glass was used in windows as early as the Roman era. Entire windows, dating from this time, were recently unearthed in the ancient harbor of Corinth. Stained glass was found in Christian churches in the 4th century and was well known in western Europe in the 6th century. Elaborate windows of stucco and colored glass were popular in the Moslem world a century or two later and reached their high point in Egypt in the 12th and 13th centuries. (Silver stain was also widely used in the East, at least by the 8th century.) In the western world many famous artists, from Donatello and Dürer, during the Renaissance, to Rouault and Matisse, in the 20th century, have designed stained-glass windows. The greatest single period in the history of the art is generally considered to be the 13th century, when such masterpieces were produced as the windows of the cathedrals of Bourges and Chartres.

staining power or **coloring power.** British terms for the pigment property known in the U.S. as TINTING STRENGTH.

stamnos. A type of ancient Greek pottery—a large storage urn with a relatively small, covered mouth. See VASE SHAPES for illustration.

stand oil. A BODIED LINSEED OIL of high viscosity, used as an ingredient of oil-painting mediums, tempera emulsions, and varnishes. Modern, pale stand oil is made by heating linseed oil at a temperature of about 550° F in aluminum or glass-lined kettles for 15 hours or more. During this time it undergoes the chemical reaction of polymerization and becomes as thick as honey. In order to minimize oxidation so that the product is a true polymerized oil, air is excluded by cooking the oil in a vacuum or in an atmosphere of carbon dioxide. Stand oil is the least prone to yellowing of any type of linseed oil, produces a tough, flexible film, and tends to level out smoothly. Heavy-bodied oils of all types have been used since medieval times, but the term stand oil does not appear before the 19th century. The Dutch are generally given credit for its introduction.

stanniferous glaze. A ceramic GLAZE opacified with tin oxide.

Stapart's ground. An ETCHING GROUND used in AQUATINT. It is prepared by covering the surface of the plate with a white wax ground on which salt is dusted. When the plate is heated the salt grains penetrate the wax. The plate is then immersed in cold water, which cools it and washes the salt out of the ground, leaving tiny flowerlike pits in the ground and exposing the plate underneath to the action of the mordant. Stapart's ground was invented in Paris in 1773.

stapler or **staple gun.** A hand-held device that drives steel staples into wood, wallboard, and other materials by compression and release of a strong

spring activated by pulling a trigger. Widely used by artists and suppliers of stretched canvas, it can replace the more laborious operation of stretching with hammer and carpet tacks. However, art technicians and conservators disapprove of the use of staples, especially the common lightweight variety with $5/16$-inch points. They do not hold the wood nearly as well as carpet tacks, and their liability to weaken when rusted is a serious hazard. Heavier staple guns or tackers with sturdier and longer staples should give better results, but the museum experts prefer tacks, whose grip lasts for centuries even when they rust.

star. See PENTACLE; SOLOMON'S SEAL.

star drill. A chisel-like steel rod whose point is channeled with radiating lines in a star design; used to drill holes in stone, concrete, and plaster by striking with a hammer, rotating the drill before each blow. See illustration at CHISEL.

star of David. See SOLOMON'S SEAL.

state or **stage.** In the graphic arts, a plate or block in any condition of preparation preliminary to its use in the printing of the regular edition; also, an impression taken from such a plate or block as a guide for further work to be done. When such trial proofs, especially common in intaglio printmaking, are exhibited or leave the artist's possession, he marks them, according to the order of their execution, first state, second state, etc., to distinguish them from the regular edition made from the finished plate. See PROOF.

statuary marble. Any white, crystalline, saccharoidal marble suitable for sculpture, as Parian, Carrara, and Colorado Yule.

statue. Any carved or modeled figure, especially of a person or animal.

statuette. Any carved or modeled figure that is half or less than half life-size; also, a FIGURINE.

steady or **steady rest.** A block, projecting arm, or other simple device used to hold or assist in holding an object firmly in position while it is being worked on, as in carving or in the application of a tool to a piece on a potter's wheel, banding wheel, or other revolving device. See also HOLD-DOWN.

steatite. A kind of grayish-green, tan, or brown SOAPSTONE; also called lard stone. Steatite is soft and easily cut. It has been used for carving, especially by primitive peoples.

stecca. 1. A medieval wood, horn, or metal-edged SLICE used in artists' studios in grinding colors and coating gesso panels, among other purposes. The equivalent French term is *amasette*.
2. The Italian word *stecca* has many other connotations; its primary meaning is stick. In the arts, a pointed implement used to inscribe surface is called a stecca; pottery slip that has been incised or inscribed with such an implement is described as *alla stecca*.

steel. Iron containing a small percentage of carbon and often small amounts of other metals. It is an atypical ALLOY, since carbon is a nonmetallic element. Different kinds of steel are produced by different refining treatments in the molten state. Their properties also vary according to the kinds and amounts of metals alloyed with them. The most malleable steel,

called MILD STEEL or soft steel, has a low carbon content. Carbon steel contains only iron and carbon; alloy steel contains one or more additional metals. Stainless steel is made stain- or rust-resistant by the addition of chromium. In general, steels are harder and have much greater structural strength and resistance to corrosion than iron.

steel blue. Along with Chinese and Milori blues, one of the three best grades of PRUSSIAN BLUE.

steel facing. A nickel or chromium coating that is electroplated on the etched or engraved copper plates used in INTAGLIO printing. Copper plates are so treated in order that they may be used to print larger editions instead of being limited to the relatively few fine proofs that can be pulled before the surface of the plate begins to wear down. Contrary to what is implied by the term steel facing, nickel or chromium, not steel, is used for this purpose. Steel facing has permitted the use of etchings and drypoints as book illustrations and has made possible the large-scale production and sale of popular intaglio prints. The propriety of giving a copper plate a steel facing has been questioned, since treating a plate in this way lowers the value that etching or drypoint proofs would have if printed in a small edition and because steel-faced drypoint plates formerly produced prints inferior to the early proofs pulled from an untreated plate. Now, however, steel facing is considered an acceptable process in the graphic arts. The process itself has been greatly improved to produce delicate effects, and the prevailing view is that prints should be made available to the greatest possible number of collectors.

stellate. Star-shaped or radiating like a star.

stencil cutter or **stencil knife.** A small tempered-steel knife with a slim handle and an oblique cutting edge like the standard X-Acto hatchet-type blade. The stencil knife, used to cut

STENCIL CUTTERS. Top, a standard knife; center, a swivel knife; bottom, a double-blade cutter.

friskets and stencils, is especially designed for cutting silk-screen stencil film (see FILM-STENCIL METHOD), a sensitive operation that requires a delicate, sharp, easily controlled blade. Several types are available, including double-blade cutters for parallel lines, swivel knives with ball-bearing action for irregular curves, and COMPASS CUTTERS for circles and arcs.

stenciling. Any method of creating multiple copies of a design by cutting it out of a thin yet durable sheet (e.g., thin brass, plastic, oil- and waterproof cardboard) and dabbing, pouncing, spraying, or rubbing a color substance through the openings. The small, uncut areas left to join islands in the design are called ties. One artists' technique that employs stencils is POCHOIR, a method of coloring prints. Serigraphy and silk-screen are correctly described as stencil processes, and the draftsman's use of TEMPLATES is similar to stenciling.

stereochromy. See MINERAL PAINTING.

sterling. Term characterizing silver of a legally fixed standard of purity, i.e., 92.5% pure silver and 7.5% copper. Also, American silverware of such a standard.

stick lac. See LAC.

stil-de-grain. The French name for DUTCH PINK.

stile Liberty. Italian name for the ART NOUVEAU movement, from the name of the London firm that supplied textiles decorated in that style.

still. The apparatus used in DISTILLATION. The basic still is a closed metal pot, usually copper, from which a long tapered tube extends at a downward angle, sometimes terminating in a tubular coil. Its laboratory version, made of glass, has a water-cooled delivery tube.

still life. A painting or drawing of a group of inanimate objects contrived by the artist according to some theme, either symbolic or merely aesthetic. The still life is usually set indoors and contains at least one man-made object, be it the table on which the group is arranged or, in a floral still life, the vase that contains a bunch of flowers, thus differing from a drawing from nature, which portrays such objects as rocks and flowers in their natural setting. Although the still life was painted from ancient Roman times on, it was almost always incorporated into a larger composition until the 16th century, when Dutch and Flemish painters adopted it as an independent form. The still life was really brought into its own in the 18th century by the French painter J. B. S. Chardin. It was a favorite form of the Impressionists and such post-Impressionists as Van Gogh and Cézanne.

stilts. In ceramics, small three-pronged supports made of hard-fired clay on which wares are set for firing in a kiln. Smaller supports called spurs, each with a single point, serve the same purpose. Both are inexpensive items intended to be discarded after a single use.

stimulus colors. Color effects perceived when the retina of the eye is excited by means other than looking at a colored object, e.g., a blow or pressure on the eyeball, hallucinatory drugs, or shutting one's eyes in a dark room. The memory of stimulus colors inspires much of PSYCHEDELIC ART.

stipple. In painting, to apply small dots of color with the point of the brush; also, to apply paint in a uniform layer by tapping or pouncing a vertically held brush on the surface in repeated staccato touches.

stipple engraving. ENGRAVING, ETCHING, or wood engraving in which the design areas are made up of small dots or flecks, sometimes in conjunction with engraved or etched lines. The GRAVER, NEEDLE, and ROULETTE can all be manipulated to create stippling on the plate or block or in the etching ground. In a stipple wood engraving, the dots may actually be very short incised lines. The stipple engraving is usually inked and printed as a relief plate (see RELIEF PRINTING), the incised dots showing as whites in the proofs. See also CRAYON MANNER; DOTTED MANNER.

stomp. See STUMP.

stone. 1. Cut ROCK, suitable for carving and building. One of the traditional materials of the sculptor, it has been carved, drilled, and polished since prehistoric times. The most commonly used stones are SANDSTONE,

MARBLE, and LIMESTONE, as well as GRANITE and related types of igneous rock.

2. In commercial usage, any type of stone except marble.

stone green. Another name for GREEN EARTH.

stone ochre or **stone yellow.** Variant names for Oxford ochre, a fine grade of English YELLOW OCHRE.

stone rubbing. See RUBBING.

stoneware. A dense, opaque, durable, nonabsorbent, hard-paste ceramic ware. Heavy-duty items such as crocks, mortars, and utensils for chemical and factory use are made of stoneware. Familiar examples are the salt-glazed jugs and crocks made by 19th-century American potters.

stop. To fill in or plug a hole or depression in a damaged work of art so that the restored area is on the same level and has the same texture as the surrounding area. Some of the materials used for this purpose by conservators are gesso, picture putty, and, on stone or concrete, tinted cement. The term, which is more widely used in Britain and France than in the U.S., refers to small or delicate repairs. For coarser repairs on plaster walls, see SPACKLE.

stopping out. 1. In ETCHING and AQUATINT, the application of stopping-out varnish (a thin and manageable acid-proof RESIST made for the purpose) to certain lines and areas of an etched plate to protect them from deeper BITING when the plate is reimmersed in the MORDANT in order to deepen or strengthen other lines and areas. Because the darkness of the printing of an etching is governed by the depth of the biting, an artist who wants several different intensities of ink in his prints must repeat the stopping-out process several times in order to achieve the tonal gradation that results from successively deeper etches.

2. In SILK SCREEN and SERIGRAPHY, the mechanical blocking out of areas of the screen so that paint will not pass through the mesh and print those areas. All the nonprinting areas of the screen not blocked out by the stencil must be stopped out with paper, lacquer, or glue. A pinhole in the stencil or other defect in the stencil or screen can be repaired by stopping it out with a touch of glue. A fault in a nonprinting area that is discovered while a stencil is being printed may be repaired without halting the run by placing a bit of newspaper under the spot on the underside of the screen. It is held in place by the sticky paint on the screen long enough to finish printing the edition.

storytelling art. See LITERARY.

stoving enamel. See BAKED ENAMEL.

straightedge. Any flat, heavy bar used for ruling and cutting mats, paper, leather, glass, and other materials in a straight line. An ordinary ruler may be used as a straightedge.

strainer. A framework or chassis for mounting canvas that has rigidly joined corners and therefore cannot expand; its opposite, the expansible chassis, is called a STRETCHER. Lightweight strainers on which muslin or thin linen is stretched have been widely used for mounting prints and other works on paper. Museum conservators condemn the use of the strainer or nonexpansible chassis for oil paintings on canvas because of the frequency with which canvases require tightening by expanding the corners of

their stretchers. Canvases become loose for a variety of reasons, and if this condition is ignored or neglected, wrinkles or other irregularities tend to become permanently set and rigid.

straining pincers. Nineteenth-century British term for STRETCHING PLIERS.

strappo. A method of transferring a FRESCO painting from its original wall. In the strappo technique, layers of cloth are attached to the face of the painting with a very strong animal glue. When the cloth is pulled away, the paint layer comes with it and is given a new backing of cloth. This technique is used in preference to the STACCO method when the INTONACO layer of plaster has deteriorated badly.

Strasbourg turpentine. An oleoresin or BALSAM obtained from Central European fir trees, especially *Abies excelsa* and *Albies pectinata;* a product very similar in its properties to VENICE TURPENTINE and, similarly, used by artists for centuries as an ingredient of mediums and mastics and other varnishes. It is the *olio d'Abezzo* mentioned by Italian writers. During the 17th century it was an important item of commerce, and most artists seem to have preferred it to Venice turpentine, which is now in wider use. Strasbourg turpentine is seldom available in the United States. Both Strasbourg turpentine and Venice turpentine are universally approved for use in permanent painting. They are not to be confused with TURPENTINE.

streamlines. A defect that may appear in paint or picture varnish that is applied to a painting while it is in a vertical position. It consists of fine, close, parallel vertical lines or striations. Other such defects are CURTAINS; FRILLING; and TEARDROPS.

stretcher. The chassis or wooden framework on which an artist's canvas is stretched. This is done by pulling it tight and tacking it to the edges of the rectangular framework all around. The usual American stretcher is made of strips of wood 1¾ inches wide, with raised or flanged edges, and mitered and tongue-and-groove corners made by automatic machinery and universally interchangeable. These strips are available commercially in lengths from 8 to 60 inches, and are assembled by the artist. After stretching a canvas, the artist hammers flat, triangular KEYS

STRETCHER STRIPS AND KEYS

or wedges into slots in the inner corners of the chassis to make the canvas more taut. If the canvas subsequently slackens, these keys may be used to tighten it further. Nineteenth-century stretchers were heavier, measured 2½ inches in width, and had crossbars, in the larger sizes, for greater rigidity and protection against warping. Such stretchers are still available from art supply shops on special order, and are preferred by some painters. Museum technicians and conservators require still better equipment: they use custom-made stretchers whose corners are fitted with mechanical tighteners in place of the wooden keys.

The common lightweight stretcher was a turn-of-the-century development. It is notable for its economy and convenience, but is intended to be used only for paintings that are to be well braced in substantial frames; paintings left unframed or with simple stripping should be stretched on 2½-

inch stretchers or they will warp. A chassis in which no room is allowed for expansion is called a strainer rather than a stretcher, and is never recommended for use in permanent painting.

stretching frame. A device for holding a sheet of lightweight watercolor paper taut, as an alternative to mounting it on a board. The paper is held between two rectangular frames of wood or aluminum, the smaller of which fits tightly inside the larger. The stretching frame, employed mostly for outdoor sketching, is used far less frequently than it was in the 19th and early 20th centuries.

stretching pliers. Heavy pliers with elongated jaws for grasping the edges of a piece of canvas in stretching it on a CHASSIS. A squarish extension at the middle of the lower jaw is called the

STRETCHING PLIERS

hammer; its most important function is to supply leverage against the back of the STRETCHER bar. The usual procedure is to grasp the pliers with the left hand, holding the edge of the canvas taut; while the right hand places a tack on the point held and drives it in with a hammer. In Britain, this tool was called straining pincers in the 19th century and is now known as pulling pliers.

stria. In FLUTING, the vertical rib between two adjacent grooves; an arris.

striation. A surface marking consisting of closely parallel lines or grooves, either occurring naturally or applied. The term correctly refers to straight,

narrow lines, but is also applied to broader stripes, such as the linear patterns on stone, especially marble. A stone showing such markings is said to be striated.

strike through. To become visible or partially visible; said of a paint layer, the color or texture of which shows through an overpainting that is intended to hide it. PENTIMENTO is one form of strike-through.

strip. 1. To remove the varnish from an oil painting with solvents. See also SKIN; RESTRAINER.

2. To frame a canvas by nailing lattice strips to its edges, usually running the horizontals full width and fitting the verticals between them. When used on the common lightweight chassis, stripping is a temporary expedient. It is quick, inexpensive, and economizes on space in a group exhibition, but as a permanent method it does not brace the canvas at all.

striper. See LINERS AND STRIPERS; DAGGER STRIPER.

strong drying oil. See BLACK OIL.

strontium white. Strontium sulfate, native or artificial. Similar in its properties to BARYTES and BLANC FIXE, it had some small use as an INERT PIGMENT in Britain during the early 19th century. The white strontium pigments have long since been superseded by the barium sulfates, which are very much cheaper.

strontium yellow. Strontium chromate, a permanent, semiopaque, pale citron-yellow pigment. Strontium yellow is useful to painters for obtaining a pale yellow with a more greenish cast than cadmium yellow, and for securing a different kind of green from those produced by mixing cadmium

yellows with blues and greens. Strontium, barium, and zinc yellows have the same hue; the cheaper barium yellow is much paler, or less intense, than strontium yellow. Zinc yellow, which has color properties identical to those of strontium yellow, is not approved for permanent painting.

stucco. A plaster used as a finishing and protective coating on walls. The term almost always refers to a ROUGH-CAST finish on outdoor walls, but stucco can also be smooth. Its usual composition is Portland cement, lime PLASTER or gypsum plaster, sand, and, for the roughcast finish, pebbles or another aggregate. Limeproof pigments are added if color is desired. In ancient Greece and Rome a smooth, highly finished and polished surface was most admired. Throughout the Renaissance a mixture of lime made from travertine and crushed or powdered marble was used. By careful craftsmanship and selection of the best materials, a fine surface and a stonelike durability were obtained, both on flat areas and in decorations that were modeled or pressed into the surface with hollow-carved wooden molds dusted with powdered marble. Renaissance stuccoed facades were also frequently decorated by SGRAFFITO.

studio easel. See EASEL.

study. In drawing, painting, and sculpture, a preliminary rendition of a projected work or, more often, a detail of that work, such as a head, a figure, or a flower. The artist makes a study to explore an idea for future development, if not for immediate use, and to become familiar with the problems involved in its depiction. He may also use a study to explore a technique or material, either in a purely experimental way or to evaluate its suitability for a projected composition. Because a study is the artist's vehicle for working out his themes and techniques, it is a more carefully detailed representation than a sketch. The French word étude, meaning study, is sometimes used as a title for a picture.

stump or **stomp.** A cigar-shaped implement used in drawing to blend or smudge charcoal, soft pencil, pastel,

STUMP (ABOVE) AND TORTILLON

chalk, or crayon. It is made of tightly rolled paper, leather, or felt and is pointed at both ends. Stumps are usually 4 to 6 inches long. See also TORTILLON.

stumping chalk. See CRAYON SAUCE.

stun. In sculpture, to bruise, discolor, or cause a SPALL or chip in stone by striking with a blunt instrument; also, a flaw so produced. See TERRACE.

S-twist. See TWIST DIRECTION.

style. 1. The singular mode of expression employed in the representation of FORM. Styles are classified according to such categories as historical period, school, nation or locality, or group of artists. Style also refers to the TECHNIQUE and particular characteristics of an individual artist.
2. A variant spelling of STYLUS.

style mécanique, le. An early phase of PURISM. Its best known exponent was Fernand Léger (1881–1955).

stylization. Representation of natural forms more in accordance with artistic ideals or conventions than with

observation of individual examples of those forms. Classical Greek sculpture, for example, showed human bodies as the artists believed they should look ideally, rather than as they looked in reality. Suppression of individual differences often involves intentional distortion of natural forms when universal characteristics are emphasized through exaggeration. Familiar examples are the sleek, elongated cats sculptured in ancient Egypt; the artists deliberately overstated certain characteristics, apparently in pursuit of the essence of "catness." Stylization has been used, for one purpose or another, in every age from the prehistoric to the present.

stylograph. A fountain pen used for drawing that has a tubular, needlelike point, rather than a nib. The ink supply is controlled by a check valve and released only when pressure is placed on the point. The flow of ink is measured and regular, allowing precise, neat lines to be drawn. The stylograph is available in a variety of point sizes, all relatively fine. It is also called a needle-point pen and a stylographic pen, but it is best known by the trade name Rapidograph.

stylus or **style.** Any small, pencil-shaped instrument with a hard point, usually metal, used by artists for incising lines on a soft surface (e.g., clay, wet plaster, gold) or for transferring a drawing with TRACING PAPER or GRAPHITE PAPER. The stylus is the oldest of artists' implements. Those used in ancient Greece and Rome to inscribe wax tablets had a sharp point for writing and a blunt end for eradicating mistakes and smoothing the wax surface.

styrene resin. One of the groups or families of synthetic RESINS, whose properties are similar to those of the ACRYLIC RESINS. Styrene is not used in artists' paints or varnishes because it is not soluble in mild solvents, but it finds uses in sculpture casting materials. See FOAMED PLASTICS.

substrate or **substratum.** In painting, a GROUND or underlayer; also, the base or inert pigment used to make a LAKE. It is a rather outmoded term in art, but is still used in scientific and technical writings.

subtractive color. See COLOR.

successive proofs. See PROGRESSIVE PROOFS.

suede effect. The permanent differences between the color or gloss effects displayed by adjacent horizontal and vertical brushstrokes of the same oil color. Many present-day painters, notably in England, are of the opinion that the suede effect is peculiar to modern oil colors, and that it was not produced, or at least not to such an annoying extent, by colors made before the mid-1930's, which were always made with cold-pressed linseed oil. At the present writing this problem is the subject of intensive laboratory research. The suede effect is an example of DICHROISM.

sumac wax. See JAPAN WAX.

sumi. Japanese ink, sometimes called black watercolor. See INK.

Sunday painter. A person who paints as a hobby; a dilettante. The term implies that he paints only on a day or days free from a regular occupation or in his spare time.

sunflower yellow. In Chinese painting, a brilliant medium-yellow pigment made from ORPIMENT.

sunk relief. Hollow RELIEF.

sun-refined oil; sun-thickened oil.
Two types of BODIED LINSEED OIL.
When linseed oil is placed in a bottle
with water, exposed to the direct rays
of the sun for several weeks, and
shaken occasionally, its viscosity is in-
creased, the oil is bleached, and im-
purities settle out in the water layer;
oil treated in this way is called sun-
refined oil. If it is also exposed to air, as
in a flat tray, it also oxidizes, becoming
as viscous as honey; it is then called
sun-thickened oil. The practice of re-
fining a DRYING OIL by exposure to the
sun is as old as the use of oils in paints;
many of the older manuscripts and
treatises describe it. Sun-refined oil is a
traditional ingredient of painting me-
diums, but modern opinion rates it be-
low stand oil in non-yellowing proper-
ties. It dries much more rapidly than
stand oil. Colors containing sun-
thickened oil tend to hold brushstroke
textures rather than level out as stand-
oil colors do. Sun-thickened oil is sold
in bottles, although, like sun-refined
oil, it can be made at home. These are
the only processes of oil refinement
feasible for artists to attempt.

Superba white. Trade name for a
COMPOSITE WHITE artists' oil color.

superoxol. A concentrated solution
(30%) of hydrogen peroxide. (The ordi-
nary pharmaceutical grade of hydro-
gen peroxide contains no more than 3
or 4%.) Superoxol may be used in the
conservation of art works as a powerful
bleach or oxidizing agent.

superrealism. Infrequently used
English term for SURREALISM.

support. The structure on which the
ground or the paint layer of a painting
is laid. The usual support of oil paint-
ing is stretched linen canvas. Wooden

or hardboard panels are used for
tempera and casein painting, and
sometimes for oil painting. Water-
color, gouache, and pastel paintings
are done on paper.

supra porta. See DESSUS DE PORTE.

Suprematism. An art movement
founded in Russia in 1913 by Kazimir
Malevich (1878–1935); its manifesto
was published in 1915. Suprematist
art, derived from Cubism, was com-
pletely NONOBJECTIVE; it consisted of
basic geometric forms and simple col-

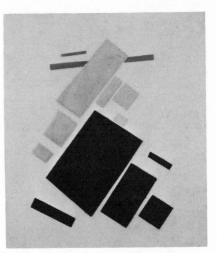

SUPREMATISM. *Suprematist Composition
(Airplane Flying),* oil on canvas (1914), by
Kazimir Malevich. (*Collection, The Mu-
seum of Modern Art, New York.*)

ors, conceived in terms of "pure feel-
ing." Besides Malevich, who achieved
the ultimate expression of his theory in
White on White, exponents of the
movement included Alexander
Rodchenko (1891–), painter of
Black on Black, and many of the artists
associated with CONSTRUCTIVISM.
They continued to contribute to the
development of GEOMETRIC ABSTRAC-
TION in Paris after 1922, when the So-

viet government proscribed abstract and experimental art and the majority of its practitioners left Russia.

surface-active agent or **surfactant.** Any of a group of substances used for cleansing, wetting, or dispersing. These substances operate by reducing surface tension in a fluid or the interfacial tension between two immiscible fluids, such as oil and water. They are especially useful for accomplishing the wetting or penetration of solids by aqueous liquids and serve in this way as detergent, emulsifying, or dispersing agents. They are more effective than soap in certain situations and are used by professional conservators for such purposes as picture cleaning. See WETTING AGENT; PENETRANT.

surface color. 1. The color of a coating or top layer as distinguished from that of a substance that is integrally colored throughout its mass, especially in ceramics.
2. The color effect of a surface viewed by reflected light, especially when associated with metals, as the yellow of gold, the red of copper.

surface tension. The tendency of a liquid to form separate drops rather than flowing and wetting a surface evenly. Water has a high surface tension, alcohol a low one; alcohol added to water, therefore, will improve its wetting power. Watercolor paints contain a special WETTING AGENT so that the colors will take evenly on the paper without CISSING.

Surrealism. An art movement of the 1920's and later. Surrealist artists attempt to give free rein to the subconscious as a source of creativity and to liberate pictorial ideas from their traditional associations. As a successor to DADA, Surrealism is characterized by the use of some of its techniques, such as the employment of the FOUND OBJECT. Artists who participated in both of these movements included Ernst, Arp, and Picabia. An abstract Surrealism is practiced by the painter Joan Miró (1893–). Other aspects of Surrealist art are the juxtaposition of unexpected objects or themes in an atmosphere of fantasy, and a pervasive dreamlike quality. Salvador Dali (1904–) and Giorgio de Chirico (1888–) are among the most important creators of the haunting, irrational, occasionally repellent dream world of Surrealist art. See also AUTOMATISM.

Sussex marble. A type of SHELL MARBLE from Sussex, England; also called Petworth marble. The episcopal chair and altar stones in the cathedral of Canterbury are made of Sussex marble.

swag. See FESTOON.

swastika. See GAMMADION.

Swedish green. Another name for COBALT GREEN.

sweetener. See BLENDER.

swivel knife. See STENCIL CUTTER.

sword liner. See LINERS AND STRIPERS.

sycamore, English. See HAREWOOD.

Synchromism. See ORPHISM.

synthetic organic pigments. Pigments made from intermediates, which are in turn made from raw materials that are products of the distillation of coal tar. These processes are the outgrowths of the intensive development of organic chemistry in the second half of the 19th century, followed by im-

provements and further discoveries in the 20th century. The synthetic dyes are superior to the older, natural dye-stuffs for industrial purposes, and have virtually replaced them, but relatively few have the light-resistance or pigment properties to be suitable for use in pigments for permanent painting. The discovery of the first coal-tar dye-stuff, PERKIN'S VIOLET (1856), was followed by the development of several groups or families of dyes. By the 1950's only three of such organic pigments were generally approved for permanent painting: alizarin crimson, phthalocyanine blue, and phthalocyanine green. The terms coal-tar color and aniline color were frequently used contemptuously. Since that decade, some twenty or more synthetic pigments have been developed that are eligible to be considered for use in permanent painting; the Paint Standard has adopted Hansa yellow and recommended quinacridone red, and other specialists have recommended additional pigments. Because of the disappointments that have followed the premature use of new colors in the past, the Standard proceeds very slowly in its adoptions. Among the most promising of the newer pigments, which some manufacturers do not hesitate to employ, are iso-violanthine violet, thioindigo red-violet B, quinacridone red, indanthrone blue (reddish), and nickel azo yellow (green gold). See COAL TAR COLORS.

synthetic resin. See RESIN.

T

table easel. Any of variously constructed small easels that are designed for use atop a table, desk, or workbench. Table easels have a rectangular or, more commonly, a triangular framework of either wood or metal, and a center post with an adjustable backrest by means of which the easel is given the desired tilt. The simplest models have a narrow tray at the base of the frame to hold a canvas or a board; others have, in addition, a sliding bracket on the center post, to secure the supports at the top. Table easels can be folded flat for carrying

TABLE EASELS

and storage; some double as reading stands.

taboret. A small cabinet kept near an artist's drawing table or easel. Its top surface holds a palette or other implements, and it has drawers for brushes, colors, and other equipment; a storage cupboard; and a rear compartment for pads and boards.

Tachisme. French term that corresponds to ACTION PAINTING. European work of this type is perhaps somewhat more restrained than that of the New York school.

tacker. See STAPLER.

tacking iron. An electrically heated, straight-handled iron of very small dimensions, made to be used in DRY MOUNTING. It is touched briefly to the arranged layers of paper, DRY-MOUNTING TISSUE, and cardboard in order to hold them in place until they are put in the dry-mounting press, where they are thoroughly bound. The tacking iron is a useful instrument for many other purposes where heat is applied in spots, as in the relining of paintings with wax adhesives.

tacky. Sticky or adhesive to the touch, characteristic of a coat of varnish that is not completely dry. The quality of tack or tackiness is the opposite of oiliness, and in this respect it is a significant property of a printing or lithographic ink.

tactile values. A term introduced by Bernard Berenson in *Italian Painters of the Renaissance* (1894–1907) to describe the illusion of three-dimensional form which he postulates as the *sine qua non* of figure-painting as an art.

taille directe. See DIRECT CARVING.

talc. A native magnesium silicate of common occurrence. Pulverized, it is used as a FILLER, or to impart a slippery or soapy quality to dry mixtures. In ceramics, it is a major flux in clay bodies fired at moderate temperatures. French chalk is another name for talc; ASBESTINE and SOAPSTONE are varieties of talc.

tamp. In casting plaster, to press a very heavy plaster mixture into a mold. It is done in order to obtain a dense, hard positive, although casts made in this way tend to be less uni-

TANAGRA FIGURINES. Terra-cotta statuettes, 4th century B.C. or later. (*The Metropolitan Museum of Art, Rogers Fund, 1906 and 1911.*)

form in quality than poured and vibrated casts.

Tanagra figurines. Small painted terra-cloth statuettes from ancient Greece, sometimes representing persons engaged in daily activities. Named for a small town in Boeotia that was an important site of their production in the latter part of the 4th and during the 3rd century B.C., these figurines were made throughout the Greek lands. They have been admired for their grace and subtlety as well as for their depiction of the life of their time.

tape. See PRESSURE-SENSITIVE TAPES.

tapping. In painting, a dabbing, pouncing, or stippling stroke of a brush or dabber.

tar. Any of the dark-colored, viscous, residual products obtained by the distillation of organic materials such as petroleum, coal, and resinous woods.

tarnish. To dull or discolor the surface of a mineral or a metal either by chemical reaction, such as the tarnishing of silver by oxidation by the sulfur in the atmosphere, or by the deposition of a thin film of grime. See also PATINA.

tarsia. See INTARSIA.

tau cross. A cross in the shape of the letter tau, the Greek "T." This cross, the crux commissa, was one type commonly used by Romans in crucifixions. It is often called St. Anthony's cross. See CROSS for illustration.

t-chisel. A chisel with a bar at right angles to the shaft, forming the letter *T*, at its tip; used as a boring drill. See illustration at CHISEL.

teardrops or **tears.** One of the defects that may appear in picture varnish or thin paint that is applied while the painting is in a vertical position. The varnish, flowing down, accumulates in drops and dries to resemble raindrops on a window. Similar defects are STREAMLINES; CURTAINS; and FRILLING.

tecali. Mexican onyx. See ONYX MARBLE.

technical sketching. See MECHANICAL DRAWING.

technique. 1. The manipulative skill an artist employs in use of medium and mastery of material as well as his general knowledge of the mechanical details of his art. The manner in which an artist applies paint or mixes colors is the means by which he achieves a desired aesthetic intention. Therefore, the mastery of technique, although usually associated with apprenticeship or craft, can never be completely separated from the achievement of inventive artistic expression.
2. The whole process of employment of a specific method of painting, sculpture, etc., such as the technique of tempera painting or the technique of glazing.

techtiform. In the shape of a house.

teinte. French for TINT; formerly common in English usage.

telamon. A column of a building carved in the form of a man, as a caryatid is in the form of a woman. The telamon (plural, telamones) may have been named for the father of Ajax or else derived from a Greek word meaning "bearer" or "supporter," although it was coined by the ancient Romans. The Greeks called such col-

umns ATLANTES. See illustration at CARYATID.

temmoku or **tenmoku.** A Japanese slip-glazed black or dark brown pottery originally developed during the Sung Dynasty in China. It is also called hare's fur, since it has streaks of tan and brown. The main coloring agent in temmoku is iron oxide.

temper. 1. During the Renaissance era, to prepare for use, especially artists' pigments, by mixing with a liquid binder or vehicle. Tempered, or "tempera," colors were distinguished from fresco, in which no tempera or binding liquid is used. The term tempera later came to be applied specifically to colors in which the vehicle is egg yolk or another emulsion.
2. To regulate the hardness and strength of a metal. A metal tool is tempered after it is made by reheating it and "quenching" it, i.e., plunging it into water at a moment determined by the appearance of the metal. Tempering results in a tougher, less brittle tool, although tempered metal is softer than untempered metal.

tempera. A technique of painting that employs colors made by dispersing pigments in a water-miscible emulsion vehicle, especially that in which the EMULSION is egg yolk and water. Egg tempera originated in medieval Europe and was the principal process used for easel painting until the development of oil painting during the 15th century.

The pigments used in egg tempera are ground in water to paste consistency and kept, covered with a little water, in screw-top jars. Just prior to use, the painter mixes equal parts of color paste and egg yolk to make enough paint for the day's work. Some painters prefer to use artificial emulsions, such as GUM TEMPERA or egg-and-oil tempera, for the particular qualities and effects that they can produce. The painting is executed on a fully absorbent gesso panel with red sable brushes; the stroking is almost always done with the point of the brush. The point is also used for hatching to make gradations, since tempera colors do not blend. The tempera technique is particularly suited to linear styles of painting, and its soft glowing color quality is not easily duplicated by any other means of painting. The colors dry at once and the paint layer becomes quite water-resistant. After about eight months' aging, the film becomes extraordinarily tough and durable—so much so that no defects develop in a properly mixed color in centuries of aging. A tempera film does not require varnishing; it can be polished to a pleasing satiny finish by rubbing it with absorbent cotton.

The materials of tempera paints were known to the Romans and Egyptians and were used by them as paint binders. It is supposed, in the absence of any evidence, that the Greeks were also acquainted with water paints in which egg, milk, gums, and glues served as binders. But tempera in the forms we know today had its crude beginnings, with relatively intractable materials, in Byzantine painting. It developed, in 14th- and 15th-century Italy, into a refined and standardized technique that served the needs of early Renaissance painters such as Giotto, Cimabue, Duccio, and the Lorenzetti brothers, and reached a culmination of technical mastery with Fra Angelico and Botticelli. The developments in art during the 15th century embraced new requirements that pure egg tempera could not satisfy and artists began to use oil glazes and more unctuous paints in intermediate processes that led eventually to oil painting.

The modern revival of tempera began at the end of the 19th and the beginning of the 20th century in England, Germany, and the United States, when many painters found it most sympathetic to their pictorial aims, especially for BLOND PAINTING. Most recipes for artificial emulsions date from that period. Although a limited supply of ready-made materials is available, most artists who specialize in tempera prefer to make their own from egg yolk or other emulsions. They study written accounts of the traditional techniques that have come down to us, especially the most complete source for Italian tempera practice, *Il Libro dell'Arte* by Cennino Cennini. The knowledge and training of this 14th- and 15th-century painter stemmed directly from Giotto's studio.

The word "tempera" is sometimes incorrectly used. Illustrators and commercial artists are prone to call gouache or other opaque aqueous colors tempera to distinguish them from oils, and the better poster colors sold in jars are sometimes labeled tempera. True tempera colors, however, are sold only in tubes. Translators of French books have frequently confused tempera with distemper, since the word *détrempe* is used for both. See also MIXED TECHNIQUE; OIL TEMPERA.

template. A draftsman's pattern or guide for drawing certain standard shapes and symbols. A template is essentially a flat sheet, usually made of heavy clear plastic, in which holes of the shape or shapes desired have been cut in different sizes. The draftsman uses the template like a stencil, tracing onto a surface the pattern he selects by following the inside contour of the perforated shape with a writing instrument. Commonly, all the cutouts of a single template will be of the same geometric shape in a range of sizes. Circle templates and ellipse guides are

TEMPLATE

widely available and much used by draftsmen. Also available are specialized templates of architects' and engineers' symbols and combination templates of a variety of geometric shapes in a range of sizes. A template with circular, triangular, square, and hexagonal cutouts, for example, is sold in art supply stores. Templates are also made with musical and mathematical symbols and in a variety of lettering styles and foreign alphabets.

tenebrism. The practice or technique of painting in a dark, low key; the figures in such a painting are engulfed in shadow, but the scene is frequently relieved and partially illuminated by a dramatic beam of light. The name, derived from the Italian *tenebroso*, meaning dark or gloomy, was coined by later critics to characterize the work of Michelangelo Marisi da Caravaggio (1573–1610) and his followers in the early 17th century. Among these painters were Georges de La Tour (1593–1652), Jusepe de Ribera (1588–1652), and Francisco Zurbarán (1598–1664). See BAROQUE. See colorplate facing page 150.

Tennessee Pink. A fine American MARBLE, suitable for sculpture. While a pinkish color is characteristic of Tennessee marble, black, reddish, green, and buff varieties are also available. Tennessee marbles are harder and more compact than most other Ameri-

can marbles, and are often chosen for outdoor use. They are more difficult to carve and polish than many other marbles.

term. A quadrangular pillar tapering downward, surmounted by a sculptured head or upper part of a figure; also called terminal figure. In a HERM, only the head or bust is fully carved.

terra alba. Another name for GYPSUM. It is not the same material as the inert pigment WHITE EARTH.

terrace or **terrasse.** In sculpture and stonecutting, any flaw in marble, including a STUN, that can be rectified by excavating and filling in with cement.

terra-cotta. A baked or fired CLAY, usually brownish red; literally, baked earth. It is widely used by ceramic sculptors and potters, as well as by the manufacturers of roof tiles. The term terra-cotta clay, or simply terra-cotta, is often used for any clay suitable for shaping and firing, except for the finest porcelain clays.

terra merita. An obsolete yellow LAKE made from SAFFRON or curcuma root. See TURMERIC.

terra orellana. Another term for ANNATTO.

terra ponderosa. Archaic Latin name for BARYTES.

terra sigillata. A Mediterranean ceramic ware decorated with relief figures, first made about 300 B.C.; also known as Samian pottery. This ware, whose name is Latin for stamped earth, evolved from BUCCHERO WARE fired in an oxidizing atmosphere. The finest terra sigillata, known as Arretine ware, was produced at what is now Arezzo, Italy.

terre verte. French for GREEN EARTH.

tertiary colors. Any hue produced by a mixture of secondary colors. In pigment mixtures, such colors tend to be very dull or blackish. They are usually chromatic variations of grays and browns. They are frequently as useful to the painter as the more brilliant colors.

tessella. A small or miniature TESSERA.

tessellated. Done in the manner of MOSAIC; composed of tesserae.

tessera. A small cuboid of hard, durable material used in making a mosaic. The traditional Venetian tesserae (called *smalti tipo antico*) in use since the Middle Ages are made of opaque glass in an almost limitless variety of colors. They are cubes measuring from ⅜ to ¾ of an inch, cut from flat slabs with chisel blows or broken off with a pincer-like tile cutter. They are usually set with their fractured sides exposed, to give the mosaic surface a sparkle or luster from the reflected light. Flat-surfaced tesserae may be set at slight angles to achieve this effect.

The mosaics of Greece, Rome, and other ancient civilizations were composed of larger tesserae. The earliest ones were naturally-colored pebbles, the later ones, cut marble of many colors, and pottery and ceramic shards. Gold tesserae, made by annealing gold leaf between two layers of clear glass, as well as discs of mother-of-pearl, were used in Byzantine mosaics. Modern mosaicists use, in addition to the antique Venetian tesserae, bits of cut stone, pressed glass, or ceramics, and a variety of pebbles.

A miniature tessera may be called a tessella (pl. tessellae), and any glass tessera is sometimes called a smalto (pl. smalti or smaltos). Another, but in-

frequently used, term for tessera is the Latin abaculus (pl. abaculi). A TILE, used especially in pavement and floor mosaics, is thin and flat, with a greater surface area than a tessera.

test panel. A panel or plate of convenient size (often 3 x 5 inches) used in testing a paint or other coating material. The coating is applied in a layer of controlled thickness, in accordance with the specifications of the test. Cold-rolled 20-gauge sheet steel, 30–31-gauge tin plate, and .020-inch clad aluminum alloy are among the standard metal plates specified by the American Society for Testing Materials. When appropriate, paper, board, glass, or canvas may be used.

Texas limestone. An oölitic LIME-STONE quarried in Williamson County, Texas. It ranges in color from light buff to cream, and has been used for sculpture.

texture. In a work of art, the tactile quality of the surface. The artist determines, by his choice of technique and method of using it, whether a painted or carved surface is to be rough or smooth, regular or irregular. Norms have been established over the centuries to exploit the most desirable characteristics of each technique to its best advantage. For example, the unflawed smoothness of a gesso panel contributes to the successful creation of effects in tempera painting. The rough texture of watercolor paper is needed to perfect the sparkle and brilliance of transparent watercolor. The artist chooses a finely woven portrait linen or a rough, irregular weave depending on whether his paints are smooth and thin or ruggedly impasto; his sculpture may have a flawlessly smooth surface or a roughhewn texture. In oil painting, the artist may choose from a great variety of canvas weaves the one that will best serve his style and technique. In addition to purely technical considerations, he also takes into account the appropriateness of textures to the content of his work. Abstract and experimental painters have frequently sought new textures to complement new ideas, and to enhance and reinforce the expression of developments which they have felt were not sufficiently well served by traditional materials. Other painters, despite the unconventionality of their work, have adhered to time-tested methods.

The painter may create special textures by adding foreign material, such as sand, marble dust, or small gravel, to standard oil colors. Sometimes cement is added to the paint. Sometimes the texture is built up with a ready-made UNDERPAINTING WHITE. The admixture of clean sand should have no ill effect on the longevity of a paint, as its relatively large particles remain outside the physical system of pigment particles dispersed in linseed oil. But the use of organic matter, such as sawdust, coffee grounds, and other substances that change on aging, negates the whole concept of permanent painting by means of permanent materials. Even sand, if more than a moderate amount is used, may be undesirable, as it may produce a dry quality not conducive to permanent adherence to the ground. So far as is known, polymer colors and modeling paste may be built up to any degree of impasto or texture without ill effects.

Thalo blue; Thalo green. American trade names for PHTHALOCYANINE BLUE and PHTHALOCYANINE GREEN.

Thalo Red Rose. A trade name for the yellowish or "scarlet" shade of QUINACRIDONE RED.

Thénard's blue. An early name for COBALT BLUE.

thermocouple. See PYROMETER.

thermoplastic. Capable of being softened by heat and of becoming hard again when cooled. When used as PLASTICS, synthetic resins are broadly classified as either thermoplastic or THERMOSETTING. Examples of thermoplastics are the acrylic and vinyl resins. Such resins, when heated, can be shaped by pressure into forms that they retain upon cooling. Fluid coating materials, or film-formers, are classified as thermoplastic (solidifying by simple evaporation of volatile solvents) or convertible (solidifying by undergoing some internal, irreversible chemical reaction after most of the solvent has evaporated).

thermosetting. Capable of being hardened, or fused and hardened, by heat. Materials that possess this property are called thermosets; once so hardened they cannot be softened by reheating. The synthetic resins, according to the way they react to heat, are classified as either thermosetting or THERMOPLASTIC. Thermosetting resins, such as the phenolic resins, are usually produced in the form of fusible powders.

thimble. A small porcelain support for ceramic wares during firing. It consists of a hook or arm attached either to a tapering cup or to a sleeve that slides over a vertical rod. Several thimbles are stacked vertically so that a number of flat, glazed objects, such as plates, may be placed in the kiln in a vertical pile without touching each other.

thinner. Any volatile liquid used for thinning or diluting paints and varnishes. The two thinners used by artists for diluting oil paints are TURPENTINE and MINERAL SPIRITS.

thioindigo violet. Thioindigo red-violet B: a brilliant, intense, violet SYNTHETIC ORGANIC PIGMENT that was adopted by several American manufacturers in the 1960's as suitable for use in artists' colors for permanent painting. It is sold under various trade names, but the label should carry its identification. It ranks among the most lightfast of organic pigments.

thixotropy. The property possessed by some viscous or gel materials of changing consistency when rubbed, stirred, shaken, or otherwise subjected to shear; the word itself is from Greek roots meaning "change by touch." One example of a thixotropic material is a GEL MEDIUM for painting, which becomes fluid under the stroking of a brush; another is the modern dripless house paint, which behaves the same way. Ultramarine oil color displays thixotropic behavior when its consistency varies between the acceptably smooth and the sticky or stringy, according to the rubbing or grinding that it receives during its preparation.

threading tool. British term for a MULTIPLE GRAVER.

three-point perspective. See OBLIQUE PERSPECTIVE.

throw. To shape on the POTTER'S WHEEL.

thumbnail sketch. A rough sketch of very small proportions. The origin of the term is attributed to the English painter William Hogarth, who, wanting to record a tavern scene that he witnessed but having no paper on which to draw, is said to have sketched the scene on his thumbnail.

thumbtack. A short steel tack with a broad, flat or slightly domed head, used in drawing and painting to fasten

paper to a DRAWING BOARD. It is known in Great Britain as a drawing pin.

tigerwood. A golden-brown African hardwood obtained from the tree *Lavoa klaineana* with a variable bold-figured grain; sometimes called African walnut. It has a glossy surface even without polishing. Available in large logs up to 36 inches in diameter, as well as in planks, tigerwood is used for furniture, veneer, gunstocks, and inlaying.

tile. 1. In creative or decorative ceramics, a thin, flat piece of earthenware or terra-cotta, usually square and frequently decorated with a ceramic glaze in either flat color or a multicolor design. The tile is essentially a unit intended for covering walls, floors, and the like, but the hand-decorated tile, made by an individual potter, is a ceramic specialty.
2. A small slab with shallow depressions for holding ink or watercolor washes; more commonly called a SLANT.

Timonox. Trade name for ANTIMONY WHITE, first introduced in Britain (1920).

tinctorial power. Another term for TINTING STRENGTH.

tincture. In art, archaic term for a TINGE or faint but effective strain of color.

tinge. A staining or permeation by a color; also, a small degree of modification of a color. Two light blues may be close to the same SHADE except that one has a violet tinge. See also CAST.

tins. In sculpture, the thin pieces of sheet metal used as mold dividers. See SHIM.

tint. 1. A color or hue modified by the addition of a relatively small amount of another color. White paint is tinted pink by the addition of a small amount of red oil color. Light blue paint may be made into lavender by tinting it with red, and different amounts of red will produce various tints.
2. In the graphic arts, an area of uniform shade, considerably paler than a solid impression, produced by engraving the surface uniformly with dots, lines, or other repeated marks.

tint block. In printmaking, a block or plate that has a uniform, overall engraved pattern of close hatching or dots so that it will print in a lighter tone than would a solid block or plate. See also TINT; TINT TOOL.

tinting strength. The power of a pigment to tint paints, as measured by its relative strength in coloring a standard white pigment in oil; also called tinctorial power and, in Britain, colouring or STAINING POWER. In the test for tinting strength, one part of the pigment is mixed with ten parts of zinc white and ground (as in RUB-OUTS) with a measured amount of linseed oil. The results are evaluated by laboratory instruments or by skilled visual comparison with a standard color. This test also reveals the nuances of a pigment's undertone. In general, the high tinting strength of a pigment is an indication of its economy, purity, and superiority over lower-strength materials. However, pigments with excessively high tinting strengths, such as pure Prussian and phtalocyanine blues, tend to create imbalances with other colors unless reduced by the addition of an inert pigment.

tint tool. A fine-pointed GRAVER, named for its use in creating a so-called tint of very fine HATCHING or

cross-hatching in line ENGRAVING and WOOD ENGRAVING. Tint tools are available in six different point widths and are the principal gravers used in wood engraving. The three smallest sizes have rounded sides and are known in wood engraving as SPITSTICKS.

tinware, painted. Tin flatware, boxes, trays, and other domestic wares that have been decorated with gay painted or japanned (see JAPAN) designs as a means of giving charm to this otherwise rather prosaic metal. Designs are painted freehand or are stenciled on a usually solid-color background; black, red, and yellow are, in that order, the most popular background colors. Details, highlights, and borders are sometimes gilded. Painted tinware, which is also called tole or toleware, was particularly popular in the 18th and early 19th centuries, when it provided inexpensive, practical (it did not need polishing), and decorative utensils. It was widely made in Europe from c. 1760 to c. 1820. In America the wares of the itinerant tin peddler were first unpainted; later, in the first half of the 19th century, they were usually painted. They were produced and distributed chiefly in New England and Pennsylvania. Toleware is still widely used, and although it is not produced commercially as much as in the past, the decoration of tinware has become a popular handicraft.

tin white. Stannic oxide, used to produce an opaque white in ceramics. It is not a paint pigment.

tip, gilder's. See GILDER'S TIP.

titanium green. A dark green pigment, analogous to Prussian blue, that can be made by using titanium, or iron and titanium compounds, instead of the straight iron salts used for making Prussian blue. Titanium green is not in use, and was probably never made commercially.

titanium pigment. The name given to the type of TITANIUM WHITE made with barium sulfate or some other inert component, as distinguished from pure titanium dioxide.

titanium white. Titanium dioxide; a dense, opaque, white pigment, highly inert chemically, and therefore of the highest permanence in all artists' paints. With the advent of economical hydroelectric power, large-scale production of titanium white became feasible, and it was introduced to artists about 1920. Some titanium whites are pure titanium dioxide; others (such as the type called titanium pigment) are coprecipitated with inert compounds such as barium sulfate, by a method similar to that used for making the cadmium-barium pigments. Although both types are acceptable for artists' use, the pure oxide has far greater TINTING STRENGTH, which is sometimes desirable, but frequently troublesome in mixtures. At one time, titanium whites were subject to yellowing in oil. Since titanium white is so inert, it does not combine intimately with oil (as flake white and zinc white do), and may settle out a bit in the wet paint layer, leaving a microscopic surface layer of oil or underpigmented oil, which would be prone to yellowing. Manufacturers claim that modern titaniums do not have this defect. In aqueous paints, titanium white has no faults. House-paint industry researches have determined that a mixture of titanium and zinc (40 to 60% of either) dries to a paint film with better all-around qualities than either one alone; hence this mixture is used as a PRIMER by many manufacturers of artists' canvases. This mixed white in oil, or COM-

POSITE WHITE, is also sold in tubes under various trade names.

tobacco-seed oil. A valuable drying oil, less susceptible to yellowing than linseed oil. Since the smoking tobacco grown in the U.S. is harvested before it goes to seed, tobacco-seed oil, TSO, is obtained from wild plants in India. The British have been more active than the Americans in its development and application to coating-material purposes, especially as a non-yellowing constituent of alkyd resins and other products. There is little published information as to its applicability to artists' paints.

tole or **toleware.** See TINWARE, PAINTED.

toluidine red. A brilliant, fiery red-yellow SYNTHETIC ORGANIC PIGMENT. It is used in industrial paints and painting inks but not in artists' colors for permanent painting.

toluol. See COAL-TAR SOLVENT.

tondo. A circular painting; also, a relief, plaque, or mural design in the form of a circle.

tone. A term used broadly in reference to a quality of CHROMA (e.g., reddish tone, prevailing yellow tone), VALUE (e.g., light tone, dark tone), SATURATION (e.g., deep tone, pale tone), or brightness (e.g., bright tone, dull tone). Tonal masses are color areas as distinguished from the linear elements of a painting. See also UNDERTONE; MASS TONE.

toned ground. In oil painting, a GROUND whose usual brilliant white color has been modified by the superimposition of a transparent VEIL of color. Use of a toned ground permits an added color effect without sacrific-

ing the brilliance and luminosity caused by the reflection of light from the white ground. An opaquely colored ground will give less brilliant effects.

toner. The most concentrated form of a SYNTHETIC ORGANIC PIGMENT, precipitated with little or no BASE, or a naturally insoluble compound that can be used as a pigment directly.

tongue lac. See LAC.

toning or **toning down.** In oil painting, altering the pervading color of a surface by an all-over GLAZE or SCUMBLE.

tooth. In painting, microscopic roughness or granularity in a ground. It is a desirable quality, as it facilitates brush manipulation and increases the permanence of the paint's adhesion to the ground.

topia. Roman term for a large painting of a landscape or formal garden.

topographic landscape. A landscape in which the terrain and features of a specific scene are accurately depicted. Thomas Cole's *The Oxbow* (a bend in the Connecticut River), 1846, is a good example (see next page).

top tone. See MASS TONE.

torchon board. Cardboard with a facing of TORCHON PAPER.

torchon paper. A coarse-grained paper used for watercolor and gouache painting.

toreutics. The art or technique of working in relief or intaglio, especially on metal. It includes embossing, chasing, engraving, and fine carving.

TOPOGRAPHIC LANDSCAPE. Thomas Cole's *The Oxbow* (the Connecticut River near Northampton), oil on canvas, 1846. (*The Metropolitan Museum of Art, Gift of Mrs. Russell P. Sage, 1908.*)

tormented color. In oil painting, color that has been manipulated excessively. Although such treatment has no significance in some kinds of work, in many styles of painting overworking of the paint detracts from such important qualities as freshness, spontaneity, brilliance, and general effectiveness.

tortillon. A small stump of tightly rolled gray or white paper, usually pointed at one end only, used to blend charcoal and pastel. Tortillons come in varying sizes; the most commonly used one is about 2½ inches long and ⅛ inch in diameter. See illustration at STUMP.

totem. Another name for Mars red, one of the MARS PIGMENTS.

touch. 1. Any stamp or mark on an object that identifies its maker; especially, a maker's or assayer's mark, or both, stamped on PEWTER. Most fre-

quently a pewter touch was merely the maker's name, initials, or cachet; sometimes a town mark was used instead. The touch on a piece of British pewter has, in addition to the maker's name or initials, a symbol identifying the sovereign under whose reign the piece was executed and, on a vessel, a number indicating the capacity of the piece. In early American pewter, the letters or design of the touch were in relief against a depressed background that was stamped into the metal. After 1825 the mark itself was stamped into the surface. Although it was required in England that every article of pewter be so marked, it was not obligatory in America and elsewhere in Europe, and much pewter is therefore unmarked.

2. A single application of paint to a painting surface. For example, a brushstroke is a touch, as is one mark made with a pastel crayon or a palette knife. Color may be built up in a series

of touches. In the expression "the finishing touch," the word is used in a loosely figurative sense.

tracery. Curved or foliated stonework in windows and arched openings, common in Gothic architecture; also, any ornamental work in interlaced foliation or curving lines that is patterned after tracery. See illustration at FOIL.

tracing. A drawing copied from an original with a pencil or other pointed implement, using the original as a guide. A picture or a design is most easily traced on a piece of thin TRACING PAPER held over it, but heavier paper may also be used if it is placed over the original on a TRACING BOX. A drawing can also be transferred directly to another surface by rubbing the back of the original with charcoal or a dry pigment, placing the coated side down on the surface to receive the drawing, and lightly going over the lines to be traced with a pencil or stylus, thus transferring the charcoal or pigment to the new surface. Rather than coating the back of the original, the artist may instead sandwich a piece of carbon paper or GRAPHITE PAPER between it and the receiving surface. In either case, however, the pressure of the pointed implement may somewhat mar the original, and if the artist does not want to risk this, a thin sheet of transparent acetate should be placed over the original, or tracing paper should be used. Such reproducing-enlarging-reducing devices as the CAMERA LUCIDA, the CAMERA OBSCURA, and the PANTOGRAPH employ tracing techniques.

The term tracing also applies to a drawing of the outline of a three-dimensional object made by moving a pencil along its contours so that the pencil point marks the surface against which the object is placed. In this sense, drawing with templates might be considered a form of tracing.

tracing box. An apparatus that makes it possible to trace a drawing through paper that is heavier and more nearly opaque than regular tracing paper. It works on the same principle as placing paper over the drawing to be traced and holding the two against a windowpane. The light coming through the glass causes the lines of the drawing to appear more clearly through the top sheet of paper. The box is low and either slanted or flat, with a frosted-glass top under which a mirror is positioned to throw the light from an artificial source through the glass. The apparatus allows the artist to trace on a flat, level surface.

tracing cloth. A thin, heavily sized muslin that is semitransparent and may be used in place of tracing paper for tracing finished ink drawings such as architects' plans and the work of technical illustrators, engineers, and draftsmen. The sizing, which is a starch solution, gives the cloth stiffness and an even, consistent surface that accepts ink readily. Such cloth will resist a considerable amount of handling without damage, and tracings made on it can be blueprinted. Sold in rolls, tracing cloth may be blue or white, and is glossy on one side, dull on the other. Although it is made of cotton, it is sometimes called tracing linen. Nowadays sheets of Mylar or other synthetic materials are sometimes used instead.

tracing paper. A thin, transparent or semitransparent paper used for tracing, it is sufficiently opaque for pencil drawing and transparent enough to enable one to follow the lines of the original. Tracing papers, in many degrees of transparency, are usually sold by the roll, but pads are also

available. It is useful in developing, refining or improving a drawing or sketch. In drafting, prints may be made from a drawing on tracing paper. It is also used in transfer lithography. Acetate and other plastic sheets, slightly mat on one side, are sold under various trade names such as Traceolene for use when extreme transparency is needed.

tracing wheel. See PERFORATING WHEEL.

traction fissure. A type of crack in the paint film or varnish of old oil paintings. It appears when the film cracks and the edges of the crack recede to form wide gaps with ragged edges, through which the underlying paint layer or ground can be seen. It is sometimes erroneously called creeping or crawling, terms that refer to cissing, a defect of water paints.

trade standard. See PAINT STANDARD.

tragacanth, gum. See GUM TRAGACANTH.

trail, traile, or **trayle.** In Gothic decoration, a running design of grapes, leaves, and tendrils carved on wood or stone; sometimes called a vignette.

TRAIL

trailing. See SLIP DECORATION.

transfer. In the conservation of paintings, to separate the paint film and its ground from an unsound support and remount the picture on a new support. An extraordinarily tedious process, transferring has been practiced since the 18th century and has been executed successfully on paintings supported by linen, canvas, wood, and even plaster walls. Oil paintings on decomposed canvas are most commonly reconditioned by LINING; but occasionally a severe defect in the support makes transfer necessary. In the first step of the operation, special tissue paper is pasted over the face of the painting to prevent the loss of loose pieces of the film. The canvas is then fastened to a temporary frame or holder so that there is a free working margin all around. The old linen is carefully and slowly removed by dampening, abrasion, and scraping. New linen is cemented to the cleaned back of the painting with a thermoplastic wax-resin adhesive. The pasted facing-paper is then dampened and removed. The painting on its new linen is mounted on a stretcher and given its final repairs. Fresco paintings are transferred by either the STACCO or STRAPPO techniques.

transfer lithography. LITHOGRAPHY in which the drawing is not made directly on the stone or plate but is done on paper, after which it is transferred by a rather simple process to the stone or plate by a professional lithographer-printer or, less frequently, by the artist himself. After the stone is prepared for printing in the usual way, the proofs are pulled. Any paper with a grain that takes litho crayon well can be used as the transfer paper. Ordinary tracing paper and charcoal paper are popular. Industrial transfer paper is made for special factory purposes and is not well liked by artists. Transfer lithography is a boon to those who desire the advantage of spontaneous drawing and the convenience of using a portable medium rather than the cumbersome lithograph stone. The artist is also saved the trouble of working on the stone in reverse, since his "positive"

drawing is automatically reversed when transferred from the paper to the stone. Transfer lithography is also used by artists who through choice or inexperience have not mastered the technical processes of preparing and printing the stone but nevertheless want to exploit lithographic effects. Transfer lithography is more suitable for linear work and sketchy techniques than for the creation of subtle gradations and a full range of tones. The quality of the printed areas is far below that produced by direct work on stone, and some manipulations, such as scraping the crayon drawing with blades and lithographic points, must be foregone. The proofs pulled by transfer lithography are entirely acceptable as ORIGINAL PRINTS, since the impressions are taken indirectly from the artist's actual crayon strokes. Tusche is sometimes used with a pen or brush in transfer lithography, but its manipulation on paper is tricky, and great care is required to use it well. Transfer lithography, which was employed by Toulouse-Lautrec and Daumier, has been in use since 1887.

transfer paper. Paper coated with a substance that may be imprinted on a surface by the application of pressure, moisture, or heat and pressure. Carbon paper and GRAPHITE PAPER are examples of transfer paper used by applying pressure, i.e., drawing upon the uncoated or reverse side with a firm pencil or stylus. Artists usually prefer graphite paper, whose marks are erasable, to the greasier carbon paper. They may make improvised transfer paper by rubbing tracing paper or another thin sheet with a soft pencil or chalk or by dusting it with pigment, depending on the nature of the surface to be imprinted. Transfer paper that works by moisture includes decalcomania paper, whose slip film may be applied to china, glass, or marble. Heat

and pressure are applied to a transfer paper coated with gold leaf or a bronze or pigment powder in hot die stamping of paper, cloth, plastics, leather, and other materials. The paper backing of transfer paper is often GLASSINE PAPER. Special papers for transfer lithography are called transfer paper.

Transite. Trade name for a thin ASBESTOS BOARD, sometimes used as a support for painting.

transitional. Pertaining to a style or a set of techniques characteristic of a period when the prevailing styles and methods are gradually giving way to and developing into something new. The term would apply, for example, to the methods that were used while eggtempera was beginning to be modified with oily materials, eventually to be superseded by oil painting. In general, a transitional style can best be conceived of as the earlier of two consecutive styles, with its character significantly altered by elements of the succeeding style.

translucency. The ability of a substance to transmit light without allowing clear visibility. A substance with this property is said to be translucent. See OPACITY; TRANSPARENCY.

transmitted light. Light that passes through a substance; also, the effect perceived when a transparent or translucent object is held up to a light source. See also REFLECTED LIGHT.

transparent. Transmitting light freely; clear and glass-like without any opacity or cloudiness. See OPACITY; TRANSPARENCY.

transparent base. In SILK SCREEN and SERIGRAPHY, a medium or color extender used to reduce the normally opaque artists' colors and PROCESS OIL

401

COLORS to any desired degree of transparency, and to enhance their workability under the squeegee. Two kinds of transparent base are available. The superior, more permanent variety has the consistency and transparent appearance of petroleum jelly; it is made by combining aluminum stearate with a solution of non-yellowing alkyd or acrylic resin and mineral spirits. It can be added to colors in fairly large amounts without altering color effects. A cheaper quality that looks and feels rather like putty does impair the brilliance of the colors to which it is added and is used chiefly as an extender in large-scale commercial silk screening. Transparent base makes possible many interesting effects. A transparent color printed over another color will reveal the undercolor, creating new color effects not otherwise possible with many pigments because of their opacity.

transparent brown. A fine, clear, deep, transparent brown pigment made by calcining GREEN EARTH. It is permanent for all painting techniques and especially useful for glazing. It is also known as Verona brown and burnt green earth.

transparent copper green. A green resinate, made by fusing rosin with a copper compound. It was identified by A. P. Laurie (*The Pigments and Mediums of the Old Masters,* London, 1914), in several illuminated manuscripts from the 8th to the 15th century, where it was used as a transparent green color. There is no other documentation of its use in medieval times.

transparent gold ochre. A rather rare, native YELLOW OCHRE with a dull mass tone and a bright, transparent undertone; sometimes, a tube color made by mixing alumina hydrate with regular opaque ochre. A permanent and useful pigment, transparent gold ochre is not the same as the traditional American industrial pigment golden ochre, which is unsuitable for permanent painting.

transparentizer. 1. An ingredient added to a paint either during or after its manufacture to render it transparent. Examples are GEL MEDIUM and ALUMINA HYDRATE.
2. A commercially prepared liquid which, when applied to ink drawings on heavy drawing paper, will render the paper sufficiently transparent for use in making blueprints. Transparentizer is also used to revive old or soiled tracings and drawings for the same purpose.

trecento. The 14th century. The term is commonly used to designate Italian art of that period.

trefled cross. A cross with three lobes (called buttons) at the end of each arm. This form suggests the trefoil, long a symbol of the Trinity. It is also known as the cross of St. Lazarus, the cross fleuronée, or the cross botonée. See CROSS for illustration.

trefoil. See FOIL.

trial proof. A proof of STATE, pulled from an intaglio plate while the plate is still being etched or engraved or while its inking routine is still being perfected.

triangle. A draftsman's implement of flat plastic, wood, or other material, made in a great number of triangular shapes and sizes as guides for drawing lines at various angles. Two right triangles, one with two 45° angles and one with an angle of 30° and an angle of 60°, are the most basic shapes. When these two triangles are used in

combination with each other and with a T SQUARE, which serves as a base against which they are placed, angles of 15° and 75° can be drawn as well. Pairs of triangles are also used to rule parallel lines by sliding one triangle's edge along an edge of the other. An ADJUSTABLE TRIANGLE obviates the draftsman's need for many differently shaped triangles.

trichlorethylene. A nonflammable solvent which boils at a very high temperature (147° C), used as a

cleaner in industry. It has been suggested as a solvent for copal resin, but cannot be recommended, as its fumes are injurious and some individuals are particularly sensitive to them.

trickling. Literal translation of the German term for CISSING; incorrect in technical usage.

trimetric projection. A projection used in mechanical drawing in which all three axes have different degrees of foreshortening in relation to their

TRIPTYCH. Altarpiece on wood panels (1420–1430), by an unknown Catalan painter. Most of the major paintings and *predelle* (across the bottom) depict scenes from the life of St. Andrew. (*The Metropolitan Museum of Art, Rogers Fund, 1906.*)

403

lengths, causing all three dimensions to be drawn to a different scale. All three of the angles made where the axes meet will be different. See illustration at PROJECTION.

Trinidad asphalt. A soft natural pitch from Trinidad. It is a constituent of some asphalt compounds, such as those used in paving. It can also be used as an ingredient in ETCHING GROUNDS and acid-proof resists.

triptych. A set of three paintings or bas reliefs, related in subject matter, connected side by side, and usually designed as a movable ALTARPIECE; especially, a work on three panels, hinged so that two half-sized flanking panels (called wings or volets) may close over the central panel. Counterparts of the triptych are the diptych, a two-panel work that may be closed like a book, and the polyptych, a work of more than three (usually five) parts. Typically, the principal subject is depicted on the central panel, related subjects on one or both sides of the wings. In addition, the entire work or its principal section is often set on a base or platform called the PREDELLA, which may also be painted or carved (see illustration on preceding page). Altarpieces in these forms were executed in painting, enamel, wood, ivory, and metal for both Byzantine and western churches throughout the medieval and Renaissance periods. Often their frames were elaborately carved, gilded, or polychromed. Among the many important works in triptych form are Andrea Mantegna's *San Zeno Altarpiece* (1459) and Giovanni Bellini's *Frari Madonna* (1488). A modern triptych is Max Beckmann's *Departure* (1937).

tristimulus values. In colorimetry, or color measurement, the chromatic components of a colored surface expressed in terms of three spectrum color stimuli, e.g., red, green, and blue. The CHROMATICITY of a color, when measured with a COLORIMETER or a SPECTROPHOTOMETER, may be recorded by means of a diagram showing the ratios of its tristimulus values expressed as chromaticity coordinates X, Y, and Z.

trompe l'oeil. A French term meaning deception of the eye. It is applied to painting so photographically realistic that it may fool the viewer into thinking that the objects or scene represented are real rather than painted. The term is used to designate a style of painting, sometimes also referred to as illusionism, i.e., creating the illusion of reality. The outstanding 19th-century American trompe l'oeil painter was William Michael Harnett

TROMPE L'OEIL. William Michael Harnett's *Music and Good Luck* (1888), oil on canvas. (*The Metropolitan Museum of Art, Catharine Lorillard Wolfe, Collection, Catharine Lorillard Wolfe Fund, 1963.*)

(1848–1892). Among contemporary American painters in this vein, Aaron Bohrod (1907–) is well known. "Photographic" realism is characteristic of the 20th-century movement known as MAGIC REALISM and is often an element in SURREALISM, as witness some of the meticulously depicted details in painting by Salvador Dali, for example.

One of the more familiar forms of trompe l'oeil is the painted simulation (especially in Baroque buildings) of interior architectural elements such as pilasters, engaged columns, moldings, and even cupolas, executed in extremely realistic perspective. Large murals, such as Raphael's *The School of Athens* and the *Disputà* in the Vatican (1509–1511), have also been "framed" in painted-on architectural settings. Any convincingly real painting on a ceiling or high on a wall that is done in SOTTO IN SÙ perspective is also a kind of trompe l'oeil. Michelangelo's classical nudes and figures of the prophets and sibyls on the ceiling of the Sistine Chapel (begun 1508) are good examples of trompe l'oeil achieved through a mastery of perspective.

trucage. French term for fakery. A forger of works of art is a *truqueur*.

trullisatio. Italian word for the first rough layer of the plasters that make up the support of a FRESCO; in English, the SCRATCH COAT.

TSO. Abbreviation for TOBACCO-SEED OIL.

T square or **tee square.** A long flat ruler of wood or plastic, at one end of which is a crosspiece at a right angle, making the T-shape for which the implement is named. The crosspiece is held against an edge of the drawing board to position the ruler for the drawing of true horizontal or vertical lines or to place it as a base for triangles with which angles are drawn. The T square is one of the draftsman's basic tools.

tube. A collapsible metal container for artists' colors in paste form. In use since the 1840's, tubes are highly effective in preserving colors, protecting them from oxidation, preventing the formation of skins, and delaying evaporation, as other types of container cannot do once they have been opened. Tubes are best when made of pure tin, and prior to World War II this metal was always used for containers of high-quality colors. Since then, however, tin has been in short supply, and most governments prohibit its use for this purpose. Lead, aluminum, alloy, and coated tubes are now in use, although all are inferior to tin on several technical grounds. Polyethylene tubes and squeeze-bottles have not proven very successful. Well prepared oil colors keep indefinitely in tubes, but aqueous paints and paints containing volatile solvents will eventually become hard or dry out completely, especially after the tubes have been opened. The standard or studio-size tube for artists' oil colors measures 1 x 4 inches, and should contain not less than 37 cc. of paint; the so-called pound tube in which whites are packed measures 1½ x 6 inches and should contain 150 cc. of paint. The collapsible tin tube first appeared in dealers' catalogs about 1840 and soon supplanted the BLADDER, in which oil colors had previously been packaged. Its introduction is historically important, for it changed the painter's habits: it relieved him of grinding fresh colors for each painting, and it made possible both the portable paint box and outdoor or *plein air* painting. The Barbizon school of landscape painters was active at this time.

tufa. A porous, microcrystalline LIMESTONE, composed almost entirely of calcium carbonate; also called calcareous tufa. The ancients occasionally used it for sculpture.

tula. NIELLO work done during the 18th and 19th centuries, named for the region in central Russia where it was produced.

tung oil. A semidrying oil expressed from the nuts of *Aleurites fordii,* a tree indigenous to China, and formerly imported under the name China wood oil; since the 1920's it has been extensively cultivated in Florida. Tung oil is an important industrial material in the manufacture of hard-wearing varnishes and enamels. The thermal treatment with resins and driers necessary for its employment as a paint oil disqualifies it for use in artists' materials, especially with regard to color retention. It differs from all other drying and semidrying oils (except oiticica oil) in that its fatty acids are oleic and elaeomargaric instead of linolenic and linolic.

turbith. Another name for TURPETH MINERAL.

Turkey red. A hue designation for a deep, rich red, almost a maroon; not well standardized as a pigment name. Better grades are made with alizarin crimson; less permanent ones are other organic lakes. Sometimes known as Adrianople red, Turkey red was more widely used in the recent past as the name of a textile color than as the name of a pigment; the term is less frequently used today.

Turkey umber or **Turkey brown.** Alternate names for Cyprus umber, the best quality of UMBER.

turmeric. A yellow NATURAL DYE-STUFF prepared from the roots of certain Asiatic plants, especially *Curcuma longa;* also known as curcuma. Formerly used to make colored varnishes and lake pigments, turmeric has been supplanted by modern dyes. It is now used only as a condiment.

Turnbull's blue. A complex ferric ferricyanide; an azure-blue compound produced as an intermediate stage in one process in the manufacture of PRUSSIAN BLUE. Turnbull's blue is not used as a pigment.

Turner's yellow. Lead oxychloride, an obsolete pigment produced in a variety of shades from bright yellow to orange. Patented in England by James Turner, it was widely used in the early 19th century. Turner's yellow has long been discarded, since it is impermanent and frequently turns black. Among its many names are Kassler yellow, mineral yellow, Montpellier yellow, Verona yellow, patent yellow, and Cassel yellow.

turning tool. Any of several similar tools with which clay or plaster are shaped on a revolving potter's wheel.

TURNING TOOLS

Typically, a turning tool has a shaped wooden handle and a steel shank to which is attached, at a right angle, a flat steel plate. The three most common turning tools have plates shaped

like a teardrop, a triangle, and a parabola with a flat side.

turnsole. A violet NATURAL DYESTUFF obtained from the seeds of the European turnsole plant (*Chrozophora tinctoria*). It was used in pigment form by medieval and Renaissance artists, especially in illuminated manuscripts. Turnsole behaves like litmus and archil: it is normally red, but turns blue or violet upon treatment with alkali. It was used to alter the color of azurite.

turntable. See MODELING STAND.

turpentine. A colorless VOLATILE SOLVENT used by artists as a thinner in oil painting. It has an agreeable odor and a rate of evaporation that is highly suitable for the majority of painting manipulations. It is not dangerously flammable or injurious to health in normal use, although some individuals may be allergic to it and suffer skin irritation. In industrial paints it has been almost entirely replaced by MINERAL SPIRITS, and many artists also prefer this petroleum substitute. The best grade of turpentine is sold under the name pure gum spirits of turpentine, which distinguishes it from a less costly and desirable kind called WOOD TURPENTINE. Turpentine is produced by distilling the heavy, viscous oleoresin or BALSAM obtained by tapping pine trees. In the southeastern U.S. it is obtained from crop-grown trees, principally the longleaf yellow pine (*Pinus palustris*), the loblolly pine (*Pinus taeda*), and the Cuban pine (*Pinus caribaea*). Originally, all heavy oleoresins from conifer trees were called turpentines, and this terminology still survives in a few cases, e.g., Venice turpentine and Strasbourg turpentine. The distillate was called oil of turpentine (French: *huile de térébenthine*, German: *Terpentinöl*). In English, turpentine is colloquially shortened to turps and sometimes formally extended to spirits of turpentine.

The ancient Greeks and Romans found they could obtain a volatile liquid by boiling pine pitch with a sheepskin covering the kettle, fleece side down, then wringing the condensed liquid out of the fleece. But neither turpentine, alcohol, nor any of the other volatile solvents were available to artists until the general practice of distillation began about the year 1400.

turpeth mineral. Basic mercuric sulfate—a highly poisonous, bright-yellow pigment. Valued at one time for the fine semipermanent greens made by mixing it with Prussian blue, turpeth mineral has been discarded because it decomposed and turned black in some mixtures. Other names are turbeth, mineral turbith, and mercury yellow.

turquoise blue. A hue designation for a light, greenish blue; not a specific pigment name.

turquoise green. A scarce, clear bluish-green permanent pigment of medium saturation; a FURNACE PRODUCT made by roasting aluminum, chromium, and cobalt oxides. Sometimes used in ceramics, turquoise green is not ordinarily available as a paint pigment because the same hue can easily be made by mixing other greens. Common products sold under this name are synthetic organic lakes of little permanence.

Tuscan red. A rich, maroon LAKE pigment made for industrial use by precipitating a dyestuff on an Indian red base. Tuscan red is permanent only when specifically stated to contain alizarin; otherwise, it may contain any impermanent red dye.

tusche. A water-miscible black fluid that contains the greasy ingredients of LITHOGRAPHIC CRAYON, used in LITHOGRAPHY for drawing the design on the stone or plate with a brush or pen. Tusche is used to create effects that are less readily accomplished with the crayon. Lines and areas applied with a brush or pen tend to print solid black and lack the grainy crayon effect. Tusche is also used in the TUSCHE-WASHOUT METHOD of preparing a SILK-SCREEN stencil, the principal way in which screens are prepared in SERIG-RAPHY. Tusche should never be called ink; the latter term is reserved for the printing ink with which the proofs are made (see LITHOGRAPH INK).

tusche-washout method. A SILK-SCREEN and SERIGRAPHY technique in which areas to be printed are painted directly on the screen with TUSCHE and the nonprinting areas are stopped out with a layer of water-soluble glue, spread over the entire screen with a SQUEEGEE. The glue covers, but does not adhere to, the tusche, which is greasy. In the next step, the screen is washed with mineral spirits; this dissolves the tusche (carrying it away, with its loose covering of glue), but it does not affect the nonprinting areas stopped out with glue. Thus, only the design areas are left open and pervious to the paint that is to be driven through the mesh with a squeegee. As with the glue-cutout method, a tusche-washout stencil cannot be printed with water paints because these would dissolve the glue. The printing areas may also be created partially or entirely with a LITHOGRAPHIC CRAYON, but crayon work is rather difficult to control on silk.

The tusche-washout method, the most popular among serigraphers of all the methods for making silk-screen stencils, allows for great variety in technique and effect. It is a direct, spontaneous process that can reproduce free, loose painting; every brush-stroke of tusche, every sketchy stroke of the litho crayon, will be re-created in paint in the prints. Textured surfaces may be reproduced on the silk by laying the screen on a rough surface such as Ross board, canvas, or sandpaper, and drawing upon it with a litho crayon. Tusche may be manipulated with a toothbrush, a comb, or any number of different tools; it can be stippled or spattered on, and if the screen is first sized with diluted starch paste, it can be applied with a thin brush or a pen, to create fine lines and cross-hatching.

twill canvas. Canvas that has a diagonal weave rather than a square one. Twill weaves were popular in the 18th and 19th centuries, and were used by many of the early American portrait painters.

twist direction. The direction in which strands of linen or any other textile fiber are twisted when woven. In an S-twist, the strands follow the curve of the letter S; in a Z-twist, they conform to the direction of the curve in the letter Z. The S-twist is also known as a lefthand or crossband twist, the Z-twist is known as a righthand or openband twist. In the preparation of artists' canvas, if a piece of tightly stretched linen of the S-twist type is wet with water or size, it will lose tautness, and on drying it will sag and need to be re-tightened before the ground may be applied. With the Z-twist type, the linen remains taut or becomes even tighter on drying. Much of the linen available to artists is S-twist.

two-point perspective. See ANGULAR PERSPECTIVE.

tympan. See LITHO-PRESS.

type-high. A term designating a printing block or plate that is made .9186 inch thick, the height of type used in commercial letterpress printing. Printmaking blocks of this thickness can be printed in a standard flatbed printing press. Linocut and woodcut blocks are usually made type-high.

typography. The art of printing with movable type, especially with regard to design and skill in composition, as the typesetting process is called. An important aspect of design is the selection of the typeface—the font, size, and spacing to be used—as well as the particular alphabet or alphabets, i.e., ROMAN, ITALIC, boldface, small capitals, etc. Design is concerned not only with the configuration of the individual letters, but also with such considerations as the proportions of the height and width of the text to be set, the relationship of the margins to the text and to each other, and the division of the page into one or more columns. Closely related to these aspects of type design is the use of illustration in a text, its placement, etc. The elaborate initial letters that sometimes begin a body of text are a good example of integrated text illustration.

Type is divided roughly into two categories according to its use: text faces, which are used for the main body of a manuscript; and display faces, which are used extensively in the commercial arts for headlines, advertising slogans, and the like, and in books for the front matter and chapter headings. As a rule, display faces are bolder than text faces and more stylized, sometimes derived from or patterned after some calligraphic hand. To serve its purpose of attracting attention, display type is usually set in large sizes and is leaded, or spaced, so that there is more room between lines of type. It is often letterspaced as well,

Garamond: old-style roman

Bodoni: modern roman

Bodoni: italic roman

Futura: gothic

Futura: italic gothic

Old English: black letter

TYPOGRAPHY. "Roman" designates those typefaces made with serifs; "gothic," the sans-serif faces. Black-letter faces derive from various Gothic styles of handwriting.

so that the space between the individual characters is widened.

Most typefaces fall into one of two main categories: SERIF or roman type, and sans-serif or GOTHIC type. Both serif and sans-serif fonts have a slanting italic alphabet as well as an upright roman one. A third group of typefaces is known as black-letter type, although it might better be designated as "authentic" gothic, since the elaborate fonts of the black-letter variety are directly derived from the Gothic calligraphic hand. Black-letter faces do not have an italic alphabet.

The technique of printing with movable type was invented in the 15th century by Johann Gutenberg and almost entirely superseded copying by hand (see CALLIGRAPHY) and printing by wood engraving (see BLOCK BOOK), the common methods of duplicating a manuscript prior to that time. Probably the most notable improvement in typography since the invention of movable type has been the invention of machines to set type. The monotype and linotype machines, perfected at

the turn of this century, are both faster and more economical than setting type by hand. For this reason the standard smaller sizes of type are set today almost entirely by machine. The less frequently used larger type, such as that used for display purposes, is still usually set by hand.

Tyrian purple. The celebrated purple dye of the Roman period and later; a natural dyestuff made from several varieties of murex shellfish, principally *Murex brandaris.* Used in ancient Rome to dye emperors' togas, Tyrian purple came in many shades, the most desirable of which varied from reddish or pinkish to bluish (known as Byzantium purple) or violet, depending on the fashion of the times. In 1908 the coloring matter of Tyrian purple was discovered to be identical to that of a synthetic dye invented in 1904; both have been superseded by more satisfactory dyes. Other names for Tyrian purple are Grecian purple, murex purple, purple of the ancients, and whelk red. The Romans called it ostrum, the lake pigment made from it purpurissum.

Tyrolean green earth. One of the best commercial grades of GREEN EARTH.

Tyrrhenian. Etruscan. The term was used in Classical times for the Etruscans or the unknown people from whom their civilization developed. It is still the name of the sea that borders the western coast of ancient Etruria.

U

U-gouge. See GOUGE.

uintaite. See GILSONITE.

ultraism. A term that lumps together all the radical concepts of 20th-century art movements, as opposed to the traditional or academic principles preceding them. The word is usually used pejoratively by traditionalists rather than as a meaningful classification.

ultramarine ash. A by-product of the refining of natural ULTRAMARINE BLUE consisting of a remnant of lapis lazuli mixed with the grayish rock with which it is associated; a weak, neutral grayish-blue pigment, in limited use as a permanent watercolor pigment. Old names for ultramarine ash are mineral gray, sanders blue (or saunders blue), and vein stone.

ultramarine blue. A brilliant blue pigment, whose mass tone is a bright middle blue (sometimes called true blue) that is neither notably greenish nor purplish, but whose undertone is the most purplish, or least greenish, of

all the permanent blues. Ultramarine blue is a FURNACE PRODUCT; it is permanent for all easel-painting techniques but is not used in FRESCO, since it is susceptible to acid impurities in the atmosphere when not protected by a film or binder.

The original ultramarine was made from the semiprecious stone lapis lazuli. Processes for making the pigment in the West date from the 12th century, but it was being made six centuries earlier in Eastern countries. Its name is from the Italian *azzurro oltremarino* (blue from beyond the sea), so called because lapis originally came from Afghanistan and other parts of the Orient. It was manufactured by a complex and arduous flotation process that separated the lapis from the gray gangue rock with which it is associated in nature. Genuine ultramarine was the costliest of all painting materials, worth more than twice its weight in gold. Princes doled it out to their painters, who are said to have continually washed their brushes in water in order to recover a pinch of the precious pigment for themselves. Inferior blues were used for ordinary paintings.

Several accidental observations led to the discovery of artificial ultramarine blue. The first of these was recorded in 1787 by Goethe, who reported from Sicily that a blue crust formed in lime kilns was used locally as a pigment. During the last years of the 18th century and the first two decades of the 19th, bright blue crusts resembling ultramarine were observed in furnaces where the Leblanc process for making soda (introduced in 1791) was being carried out. Making these observations a starting point in an earnest search for a way to synthesize ultramarine, chemists and colormakers in France and Germany were at first misled by the prevalent conception that its coloring principle was iron. In 1806 Desormes and Clement established the composition of native ultramarine to be sulfur, soda, silica, and alumina. In 1814 N. L. Vauquelin published a very similar analysis of blue material supplied by M. Tessaert from a disused soda furnace at St. Gobain.

All colormakers were then convinced that a process for making artificial ultramarine was imminent; and in November 1824 the Société d'Encouragement pour l'Industrie National posted a prize of 6,000 francs for the first practical method of producing it at a cost of under 300 francs per kilogram. In December 1828 the prize was awarded to J. B. Guimet, who had made ultramarine in 1826 but had withheld its introduction pending the perfection of details and the results of trials by artists in Paris to whom he had supplied the new blue. Among these painters were J. A. D. Ingres (1780–1867), who had used the pigment in a ceiling painting (*The Apotheosis of Homer*), and Horace Vernet (1789–1863), who had used it throughout the large *Battle of Fontenoy*. The Guimet process remained unpublished for decades after the award. Immediately afterward, however, and entirely independently, Christian Gmelin of Tübingen, Germany, published a process, which was closely followed by others. By the 1830's factories were established throughout Europe and America, and ultramarine came to be the common blue of industry and the arts. Curiously, two other blue pigments, Prussian blue and phthalocyanine blue, were discovered through similar accidental observations.

Other names for ultramarine blue are artificial ultramarine, French ultramarine, French blue, Gmelin's blue, and, occasionally, ROYAL BLUE. NEW BLUE is an unstandardized name applied to special shades of ultramarine. Armenian blue and lazuline blue are

old names for genuine lapis ultramarine. See also ULTRAMARINE GREEN; ULTRAMARINE VIOLET.

ultramarine green. A pale green similar in composition and manufacture to ULTRAMARINE BLUE. Introduced in Germany in 1828, it never became popular, although it is still used in some low-cost watercolors and oil colors. In oil it is a dull moss-green and has extremely weak tinctorial power.

ultramarine violet. An extremely weak pigment, pale lavender in the dry state, dark and rather dull in oil; identical in pigment properties to ULTRAMARINE BLUE, of which it is a variant. Other names for ultramarine violet include violet ultramarine and mineral violet, a name formerly shared by manganese violet.

ultraviolet light. The part of light that lies beyond the visible SPECTRUM at its violet end, and whose wavelengths are shorter than those of visible light. Light that contains ultraviolet radiations is actinic; that is, it produces photochemical reactions such as those involved in the fading of pigments and dyes, the embrittlement of paints, and the formation of an image on photographic film or paper. Concentrated ultraviolet light sources are used in the laboratory in ACCELERATED TEST procedures. The ultraviolet component of direct sunlight has a powerfully destructive effect on all organic painting materials. The standard of permanence in normal artists' materials is predicated on the assumption that the work of art in which they are used will be preserved under indoor conditions of diffuse daylight or artificial light.

umber. The artist's two principal brown pigments, raw umber and burnt umber; EARTH COLORS containing manganese as well as iron oxides. Raw umber is a cool greenish brown; burnt umber, made by calcining raw umber, is a darker reddish brown. Both have good HIDING POWER, although burnt umber is somewhat more transparent than raw. Both are permanent, have excellent color properties, and yield a variety of subtle, clear tints with white. In oil, they tend toward chalkiness in mixtures of dark tones. Since they are among the most rapid driers in oil and produce tough, flexible, leathery films, painters avoid using them full-strength in underpaintings, where a less flexible overpainting would be dangerous (see FAT OVER LEAN).

Although umber was undoubtedly employed as a pigment in very early times, the name—which derives from the Latin umbra (shade or shadow)— does not appear to have been in use prior to the late Renaissance. The best umber, mined on the island of Cyprus, is known as Cyprus umber, Turkey umber, or Turkey brown. Old names for burnt umber are chestnut brown, jacaranda brown, and euchrome. Sicilian brown is an old name for raw umber. Van Dyke umber is a variety of burnt umber resembling Van Dyke brown.

uncial. One of the earliest Greek book hands, characterized by rounded capital, or majuscule, letters. It was later adopted in the West and used for the finest Biblical codices. As a Latin book hand it flourished until the 10th century, and a number of manuscripts copied in this beautiful hand are still extant. It was usually written with a reed pen on soft paper or parchment, to which the rounded letters were well suited; angular letters would have torn the surface of the parchment. Some Latin codices of the same period were written in a HALF-UNCIAL hand—a smaller, more cursive form of the uncial.

undercut. A part of a piece of sculpture that protrudes and curves under. The term may also be used for the corresponding part of the MOLD in which the sculpture is encased. A piece with complex undercuts is difficult to remove from a plaster mold. Although it can be handled in a well-sectioned PIECE MOLD, a rubber mold is recommended for casting such a piece.

underglaze. In ceramics, color applied to the surface of the clay body before the application of a transparent GLAZE.

underpainting. The preliminary layer or layers of color on a painting surface, beneath the OVERPAINTING or final coat. Many types of underpainting exist, from the VEIL used to tint a white ground to the multi-layered surface that is finally covered by a transparent GLAZE. The first layer of color may be blocked out in dilute oil colors as a guide for the artist when he builds up his composition and color effects. See ABBOZZO; SINOPIA; MACCHIA; ÉBAUCHÉ; GRISAILLE; DEAD COLORING.

underpainting white or **textural white.** A specially prepared oil paint used for building up textures and for adding crisp impasto touches to a picture. It was developed in the U.S. in the 1950's and is sold in pound tubes. The ingredients used in the various brands of underpainting white are known only to the manufacturers, and there is no information on their permanence and ultimate behavior either alone or in combination with oil colors. A traditional white for crisp touches is made by mixing three parts of flake white in oil with one part of zinc or titanium egg-tempera white.

undertint. A thin, transparent first coating over a white ground; a VEIL or imprimatura.

undertone. The color effect of a pigment when viewed by TRANSMITTED LIGHT; also, the color characteristics of a paint or pigment when it is diluted with white. The undertone of a pigment may have different color characteristics than its MASS TONE. For example, alizarin crimson has a bluish undertone; cobalt yellow oil color has a dull tan mass tone, and is a bright, transparent golden yellow when spread out thinly. Burnt sienna exhibits three color effects: a mahogany mass tone; a fiery orange undertone by transmitted light; and a salmon pink undertone when mixed with white. In other pigments, such as the cadmiums, the undertone as seen when mixed with white has the same color characteristics as the mass tone. See color-plate facing page 118.

United States Pharmacopoeia. See U.S.P.

unlettered proof. See PROOF.

Upson board. See WALLBOARD.

uranium yellow. Uranium oxide, a permanent bright yellow that is too expensive for practical use as a pigment. Prior to their employment in atomic fission, uranium compounds were used to some extent in ceramics and glass, where they typically imparted a bright transparent yellow with a green fluorescence.

U.S.P. United States Pharmacopoeia. When these letters accompany the name of a chemical or drug, it indicates that the material meets the standards of purity and potency of the United States Pharmacopoeia and is suitable for pharmaceutical use. U.S.P. grades are not necessarily chemically pure (see C.P.). In Britain, the initials B.P., for British Pharmacopoeia, are used in a similar fashion.

413

V

value. Artists' term for degree of lightness on a scale of grays running from black to white. Chromatic colors can be similarly evaluated; the darker ones are said to be lower in value or in a lower KEY. The scientist's term for value is lightness.

Van Dyke brown. A brown earth-color popular in the 18th and 19th centuries but no longer used by artists concerned with permanence. In addition to the inorganic oxides or silicates of the usual earth color, Van Dyke brown contains a percentage of humus (partially decomposed vegetable matter from leaves, roots, etc.) that renders it unstable in paints, causing oil paintings to crack and watercolors to fade. Originally valued for its extraordinarily clear, nonchalky character, especially in mixtures, Van Dyke brown has been replaced by transparent brown and burnt sienna in mixtures. A once-popular mixture of Van Dyke brown and emerald green has been replaced by phthalocyanine blue and burnt sienna. Cassel earth, also known as cologne earth, is a variant that closely resembles Van Dyke brown; Rubens brown is a variety of Van Dyke brown.

Van Dyke red. Copper (cupric) ferrocyanide; a bright brownish-red to reddish-brown pigment. Van Dyke red is not widely used because it is poisonous and of doubtful stability in contact with polluted air. Brown shades have been called Hatchett's brown or Florentine brown.

Van Dyke umber. A variety of burnt UMBER, the hue of which somewhat resembles that of the impermanent Van Dyke brown.

vanishing point. In linear perspective, a point at an infinite distance on the HORIZON LINE at which any two or more lines that represent parallel lines will converge. The principle of convergence to a vanishing point is based upon the observable phenomenon that receding parallel lines, such as the rails of a railroad track, do appear to come together on the horizon. Depending upon the number and the orientation of axes in the composition of a picture, a drawing in perspective may have one or more vanishing points, all on the horizon line or on the extensions of that line beyond the PICTURE PLANE. A rectangular solid drawn in OBLIQUE PERSPECTIVE, as in a BIRD'S-EYE VIEW or a WORM'S-EYE VIEW, will have three vanishing points, one of which will not be on the horizon line but rather below or above it, respectively. See illustrations at LINEAR PERSPECTIVE and PERSPECTIVE.

vaporization casting. Another name for LOST PATTERN CASTING.

varnish. A solution of a resin in a volatile solvent that, brushed or sprayed on a surface, dries to a hard, glossy, and usually transparent film, which serves as a protective and/or decorative coating; also, the coating itself. There are two basic types of varnish: SIMPLE-SOLUTION VARNISH, in which the resin is dissolved directly in the solvent, and OIL VARNISH, in which the resin is cooked or melted with a drying oil and a drier, then thinned with the solvent. Industrial varnishes such as COACH VARNISH and SPAR VARNISH were once made by this cooking process, as was COPAL varnish, once widely used as a picture varnish and in painting mediums. Most modern industrial varnishes are made with synthetic resins. Modern varnishes for use by artists are all of the simple-solution type, as DAMAR VARNISH, MASTIC VARNISH, and acrylic varnish. In industrial practice a simple-solution varnish is also called a cold cut, even though steam or mild heat may be used to expedite the solution. Many types of simple-solution varnish are called spirit varnish—an imprecise term, since the solvent used may be "spirit" (alcohol), or another substance, such as spirits of turpentine or amyl acetate.

During their manufacture varnishes may be colored red, yellow, or orange with moderately permanent resinous dyestuffs, such as accroides, gamboge, or dragon's blood, and a whole range of brilliantly colored varnishes may be created by the use of oil- or alcohol-soluble synthetic dyes. While such varnishes are sufficiently lightfast and permanent for use on industrial products and in decorative work, they cannot be recommended for the artist. They have been used to make transparent glazes, but more permanent results are obtained by glazing with such permanent pigments as cobalt yellow, Hansa yellow, and alizarin crimson. Specific uses of varnishes in the arts are discussed at PICTURE VARNISH; ISOLATING VARNISH; and MIXING VARNISH. See also INTERMEDIATE VARNISH; MAT VARNISH; RETOUCH; FIXATIVE.

varnishing day. A private viewing of an exhibition by a group or society of artists, or in a museum or comparable institution. It is usually held on the afternoon or evening preceding the public opening. Admission is by invitation and the occasion is usually in the nature of a reception. The term "varnishing day" has been virtually replaced in modern times with "opening," which applies also to a corresponding private viewing of a one-man show.

Originally varnishing day was granted to artists to apply finishing touches and the final coat of varnish to their paintings, after they were hung in place for the exhibition. Critics were often invited and the word gradually took on its present meaning. VERNISSAGE is the French equivalent.

varnish size. See GOLD SIZE.

Varnolene. Trade name for a widely distributed brand of MINERAL SPIRITS, sold in paint and hardware stores.

vase shapes. Ancient Greek pottery was made in a large number of conventional shapes, more or less standardized in general form but with wide variations in different periods and localities. Each was designed for a specific use or function. See ALABASTRON; AMPHORA; ASKOS; BLACK-FIGURED POTTERY; CANTHARUS; HYDRIA; KIATHOS; KRATER; KYLIX; LAGYNOS; LECYTHUS; LOUTROPHOROS; OENOCHOE; OLPE; PITHOS; PSYKTER; PYXIS; RED-FIGURED POTTERY; RHYTON; SKYPHOS; STAMNOS. (See also illustration on next page.)

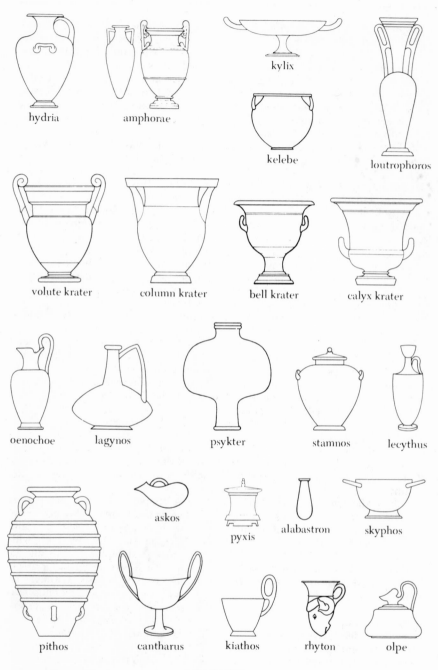

hydria

amphorae

kylix

kelebe

loutrophoros

volute krater

column krater

bell krater

calyx krater

oenochoe

lagynos

psykter

stamnos

lecythus

pithos

askos

pyxis

alabastron

skyphos

cantharus

kiathos

rhyton

olpe

VASE SHAPES

VEDUTE. Above, view of a town (perhaps Padua) by Canaletto (Antonio Canale, 1697–1768); a typical veduta. (*The Metropolitan Museum of Art, Rogers Fund, 1918.*) Right, a *veduta ideata:* an etching (1750) from the series *Carceri d'invenzione* (imaginary dungeons) by Giovanni Battista Piranesi, 1720–1778. (*The Metropolitan Museum of Art, Harris Brisbane Dick Fund, 1937.*)

veduta. A painting, drawing, or print of the whole or a considerable portion of a town or city. Piranesi's engraved series on Rome is an outstanding example. A *veduta ideata* is a scene which is realistically conceived but whose elements are completely imaginary. See also CAPRICCIO.

vegetable black. An unstandardized term variously applied to good grades of LAMPBLACK, VINE BLACK, and CHARCOAL BLACK.

vegetable oil or **vegetal oil.** Any oil extracted from nuts and seeds. The vegetable oils are obtained in various parts of the world, and may be classified as DRYING OILS; SEMIDRYING OILS; and NONDRYING OILS. They are close to the fats and waxes chemically and undergo comparable reactions. They are to be distinguished from the chemically inert minerals oils and waxes, with which they have nothing in common except what could be a broadly called oiliness or waxiness.

vegetable violet. A highly fugitive, bright violet lake made from LOGWOOD.

vegetable wax. See JAPAN WAX.

vehicle. The liquid in which pigments are dispersed to make paint; so called because it carries the color. Paint vehicles have an *executive* function: they put the color in liquid or plastic form, so that it can be spread out and manipulated; a *binding* function: they lock the pigments together in a cohesive mass or film; an *adhesive* function: they act as a glue or cement as they dry, attaching the colors to the ground; and, sometimes, an *optical* function: they may bring out the depth and intensity of the pigment colors, giving them a different color quality than they have in the dry state. The vehicles used in oil colors, polymer colors, and encaustic possess this last property to a marked degree, while the vehicles of gouache and casein paints have little or no visual effect on the pigment colors. See also FILM-FORMER.

veil. 1. A thin, transparent layer or glaze of oil color applied over a white ground. It adds color to the ground while allowing it to retain its brilliant reflective power, a result that is not obtained when the ground is tinted by mixing color with it. A veil is also called an undertint and, sometimes, imprimatura.

2. In the graphic arts, a wad of cotton gauze or muslin used in WIPING an inked intaglio plate.

vein stone. An old name for ULTRAMARINE ASH.

velatura. In painting, a VEIL or very thin GLAZE of color over a dried underpainting; the word usually implies an extremely attenuated layer, such as may be applied by lightly tapping a trace of oil color over the surface with the fingertips.

vellum. A fine PARCHMENT, traditionally made from the skins of newborn calves, but also from skins of newborn kids or lambs and occasionally of stillborn animals (uterine vellum). Parchment and vellum have been almost entirely superseded by heavy papers with the same names.

vellum paper. 1. A heavy, high-grade paper, natural or cream-colored, used for certificates and diplomas.

2. Any paper with a finish resembling that of VELLUM. It is smoother than PARCHMENT PAPER, with excellent surface and writing qualities, and is widely used for stationery.

velvet brown. A COMPOSITE PIGMENT composed of ochre (preferably dark) and either burnt umber or burnt sienna; also known as fawn brown.

veneda. A grayish-black color made by mixing black pigment with lime for fresco, and with white lead for tempera on gesso panels or parchment. It was recommended by early writers for underpainting greens, especially foliage, in fresco and tempera painting. Veneda is mentioned in the manuscripts of Theophilus Presbyter (*An Essay Upon Various Arts,* 11th cen-

tury) and of Jehan le Begue (15th century). In *Il Libro dell'Arte* (15th century), Cennino Cennini also instructs the artist to underpaint greens with black or blackish mixtures, but gives no specific name to these mixtures.

veneer. A sheet of wood of attractive color and grain, sliced or cut from the log as thinly as is practical. It is used in lumber for furniture or to face thicker wood that is less costly and attractive. Most veneer is sliced from the log in a continuous spiral cut and must be flattened. On the theory that such veneer tends to reassume its original curves and so may pull away from the adhesive that attaches it to the base wood, veneer sawn from the log has been recommended as more stable for fine work than sliced veneer. Sawn veneer, however, is much more costly because the saw produces as much sawdust as veneer.

Venetian blue. Another name for ITALIAN BLUE.

Venetian red. Formerly, a native earth pigment mined in various localities; now, light red of which about 25% is added gypsum, making it inferior to pure light red and not satisfactory as a permanent pigment for oil painting.

Venetian school. The painters who pioneered in the development of oil painting in Venice during the 16th century. Paintings of this school were characterized by a rich, glowing tone that was created by building up colors of varying warmth and solidity layer by layer. This pervasive golden glow, and the Venetians' structural use of color in general, departed from the earlier attitude toward color as merely a decorative element of the design. It marked, as well, a revolutionary change from the linear or dry quality of 15th-century painting to the more opulent and billowing forms for which artists turned to oil painting. The Venetian painters were also pioneers in the painting of secular subjects, and in the use of the landscape background as an integral part of the subject matter. Among the leading figures of this school were Giorgione (1478–1510), Giovanni Bellini (1430–1516), Titian (c. 1490–1576), and Tintoretto (1518–1594).

Venice turpentine. The thick, very viscous exudation from the Austrian larch (*Larix decidua*); a traditional ingredient of oil painting and glazing mediums. It is permanent and acceptably non-yellowing. Venice turpentine is very similar to STRASBOURG TURPENTINE but is currently in greater favor with artists.

vent or **riser.** An opening or channel in a MOLD, made to allow air and gases to escape easily when the mold is filled with molten metal or another liquid substance; also known as an air jet, or air drain.

ventilago. A red NATURAL DYESTUFF obtained from the East Indian plant *Ventilago maderaspatana*. Ventilago fades badly on rather short exposure to daylight.

verdaccio. A mixture of burnt sienna, ochre, lampblack, and chalk with a neutral or greenish-brown color resembling raw umber. As described by Cennino Cennini (*Il Libro dell' Arte*), verdaccio was used by early Italian fresco and tempera painters for outlining, shading, and underpainting.

verd antique. See SERPENTINE.

verdet. Copper acetate crystals; a brilliant, dark-green, poisonous pigment of doubtful permanence, soluble

in water, and formerly used in water-color.

verdigris. 1. Hydrated copper acetate; a light bluish-green pigment, permanent to light but unreliable in paints because it reacts with some pigments and is affected by the atmosphere. One of the earliest artificial pigments, verdigris was made by the Greeks and Romans; it became obsolete during the 19th century. Verdigris was also used as a drier for linseed oil in the 17th and 18th centuries, especially in Spain. Other names for verdigris are Montpellier green, viride aeris (Latin), and verderame (Italian).

2. The green PATINA formed on copper and bronze by oxidation; also called aerugo.

verditer, blue; verditer, green. Other names for BREMEN BLUE and its greenish variant, Bremen green.

verism. 1. The 20th-century concept that the subject matter of art need not be confined to previously accepted standards of beauty, nobility, or heroism, but that everyday, even vulgar or repugnant subjects can have aesthetic value.

2. The clinically objective type of painting associated with the NEUE SACHLICHKEIT school.

vermeil. 1. A golden finish on a base metal or a surface that has been silvered, produced by coating that surface with a transparent red or orange-red lacquer; also the lacquer used for this purpose. The application of vermeil is essentially a 19-century "gilding" process, which is little-used today.

2. In the 17th and 18th centuries, a term for FIRE GILDING.

3. A red color, somewhat paler than vermilion. The word is also sometimes used loosely or poetically to describe any vermilion-like color.

vermilion. Manufactured mercuric sulfide; a brilliant, pure light-red pigment, very opaque and very heavy, which brushes out well in oil. Vermilion (called chu sha) was made and used in China at an early date; the earliest European use dates from about the 8th century. Vermilion replaced the inferior CINNABAR (native mercuric sulfide ore). An important, widely used artists' color from medieval times to the 20th century, vermilion was unreliably permanent, especially when not protected by varnish, wax, or glazes. Although it has survived for centuries on many paintings, vermilion has occasionally turned dark in spots on others, reverting to the black form of mercuric sulfide for reasons still unknown to science. Vermilion was replaced in the 1920's by the completely reliable light cadmium red. Varieties of vermilion include CHINESE VERMILION, English vermilion, SCARLET VERMILION, and ORANGE VERMILION. The term ethiop refers to amorphous black mercuric sulfide, an intermediate stage in one method of making vermilion.

vermilionette. Another name for AMERICAN VERMILION.

vermilion wood. See PADOUK.

Vermont White Statuary. A fine-grained American white MARBLE, prized by sculptors. Vermont marbles often have bluish-gray clouds and veins, and are also available in a large number of richly colored varieties.

vernalis. The name given by the Society of Tempera Painters (British) to the ceramic color Victoria green when used as a fresco pigment. Made by heating chalk and viridian, vernalis

is permanent, but not ordinarily available.

Vernet green. A variety of Bremen green (see BREMEN BLUE) named for Horace Vernet, the French 19th-century painter; also known as Horace Vernet green.

vernice liquida. A dark, viscous, cooked oil and resin compound used as a picture varnish by medieval and early Renaissance tempera painters; the earliest such material mentioned in Italian writings. Warmed vernice liquida was rubbed on the picture surface with the palm of the hand. Its use as a protective coating ceased during the 15th century after the introduction of volatile solvents made possible the mixing of thin, flowing varnishes comparable to those we know today. It is believed probable that the "transitional" tempera painters of the 15th and 16th centuries used vernice liquida as one of the oily ingredients in their paints.

vernis martin. A warm-toned or reddish, widely available shade of BRONZE POWDER. It is named for an 18th-century French varnish that was mixed with bronze powder or applied over gold leaf on fine furniture, decorative panels, and objets d'art of the period.

vernis mou. Another name for SOFT-GROUND ETCHING, literally meaning in French "soft varnish."

vernissage. See VARNISHING DAY.

Verona brown. Another name for TRANSPARENT BROWN.

Verona green. One of the best commercial grades of GREEN EARTH.

Verona yellow. Another name for TURNER'S YELLOW.

Veronese green. An unstandardized name given to a wide variety of green pigments; named after the 16th century Venetian painter, whose greens were probably palette mixtures of blue and yellow. It is sometimes called Paolo Veronese green.

vert antique. A finish used for BRONZING plaster casts and other surfaces to simulate the natural green PATINA of old bronze or copper. A vert-antique finish is usually produced by applying to the surface a ground coat of casein paint the color of an old penny and then stippling on a coat of semiopaque green copper carbonate. Vert antique is also used commercially; e.g., the roof of a house might be given a vert-antique finish to simulate patinated copper.

vert émeraude. French for VIRIDIAN.

vesica piscis. See AUREOLE.

Vesperbild. German for PIETÀ.

Vestorian blue. Another name for EGYPTIAN BLUE.

V-gouge. See PARTING TOOL.

vibrate. In sculpture, to shake a mold and its fluid contents rhythmically in order to distribute the cast materials evenly in the mold, thus insuring maximum definition of detail in the positive cast.

Victoria green. A COMPOSITE PIGMENT supposed to contain 80 parts viridian, 40 zinc yellow, and 10 zinc white, although inferior grades may also contain inert pigment. The label is not a reliable index. The name Victoria

green was formerly applied to the ceramic color VERNALIS.

Victoria red. One of several trade names for chrome red. See CHROME YELLOW.

Vienna blue; Vienna ultramarine. Old names for COBALT BLUE, which was produced in Vienna soon after its discovery in France in 1802.

Vienna green. Another name for MITTIS GREEN.

Vienna lake. Another name for CARMINE.

Vienna red. A variety of chrome red. See CHROME YELLOW.

Vienna white. Chalk made by air-slaking lime putty, as in the production of BIANCO SANGIOVANNI. It was once used as a polishing powder for metals, not as a pigment.

Vierge de Pitié. French for PIETÀ.

vignette. 1. In painting and photography, a picture without defined borders, whose edges shade off or merge into a background.
2. In architecture, a TRAIL or design of grapes, vine leaves, and tendrils used on the capitals of columns.
3. In book printing, the vine-grape-tendril design used as a decoration on the title page or as a tailpiece.

vine black. An impure CARBON PIGMENT with a bluish undertone; made by burning selected vegetable materials, such as grapevines and other substances. Vine black is greatly inferior in intensity, tinting strength, and chemical purity to lampblack, ivory black, and Mars black. Although vine black was offered to artists during the 19th century, it is seldom encountered today. Other names for vine black are grape black, mare black, and yeast black. Good grades of vine black are sometimes known by the unstandardized term vegetable black. Varieties of vine black include KERNEL BLACK and Spanish or cork black. DROP BLACK, also known as Frankfort or German black, is an industrial grade of vine black.

vinyl resin. Any of a family of thermoplastic synthetic resins derived by polymerization or copolymerization of various vinyl compounds, chiefly vinyl acetate, vinyl chloride, and vinylidine chloride. Vinyl resins are clear, water-white, non-yellowing products, some of which are used to make coating materials. Few of the vinyl products are practicable for use in artists' materials, because they can be put into solution only with powerful solvents that emit obnoxious and toxic fumes. One exception is a polyvinyl isolating varnish containing isopropyl alcohol that thins with alcohol. Vinyl acetate is sometimes used as a copolymer with acrylic resins in the water-dispersed polymer colors. See POLYVINYL ACETATE; POLYVINYL CHLORIDE.

violet carmine. A COMPOSITE PIGMENT, formerly made from various natural-dyestuff lakes. A modern permanent variety, made from alizarin crimson and cobalt blue, is not widely sold. Violet carmine has been replaced in permanent painting by light cobalt violet and several SYNTHETIC ORGANIC PIGMENTS.

violet madder-lake. Another name for ALIZARIN VIOLET.

violet pigments. The following are approved for use in oil paints by the PAINT STANDARD, and are generally acceptable in all other easel-painting techniques: MARS VIOLET; light (red-

dish) COBALT VIOLET; deep (bluish) cobalt violet; and MANGANESE VIOLET.

violet ultramarine. Another name for ULTRAMARINE VIOLET.

viride aeris. Latin for VERDIGRIS.

viridian. Hydrated chromium hydroxide; a bright-green pigment with a transparent, cool, emerald-green undertone and a dark mass tone that tends to be blackish at full strength. Viridian is absolutely permanent in all artists' colors and for all industrial uses except high-temperature work, since it is a furnace product that reverts to chromium oxide green when roasted above a dull red heat. Viridian was discovered in Paris (1838) by Pannetier and his protégé, Binet, who kept their method secret until a process was published by Guignet in 1859; it is said to have been introduced in England by the firm of Winsor and Newton (1862). Prior to the standardization of pigment nomenclature by the Paint Standard (1942) and the British Pigment Standard (1957), viridian was sometimes called by its French name, vert émeraude, of which the literal English translation is emerald green, an entirely different pigment. Similarly confusing names for viridian are emeraude green and emerald chromium oxide. Some obsolete names are Pannetier's green, FRENCH VERONESE GREEN, and transparent oxide of chromium; smaragd green is an alternate name. Casali's green and Mittler's green are varieties named for early workers on viridian. Guignet's green, another of its names, identifies the pigment made by the standard process.

viscosity. In a liquid, resistance to flow, the opposite of mobility. Thick, heavy-bodied liquids like stand oil have high viscosity. See CONSISTENCY.

vitreous. Of or pertaining to glass; also, glass-like; having the external properties of glass, such as hardness, high gloss, and resistance to chemical attack. Hard-glazed porcelain and porcelain enamel are vitreous substances. All pottery that has been fired in a kiln may be said to be vitrified.

vitreous enamel. Another name for porcelain enamel. See ENAMEL.

Vitruvian scroll or **wave scroll.** A decorative motif found especially in Roman friezes, consisting of a series of convoluted forms resembling a succession of waves. See SCROLL.

VITRUVIAN SCROLL

volatile solvent. Any of a group of organic liquids which evaporate readily at normally low temperatures and which are used, according to their individual properties, as solvents for resins and as thinners or diluents for oil paints, varnishes, mediums, and lacquers. Most of them are immiscible with water; most are flammable to various degrees. In order for a solvent to qualify as a thinner for artists' materials, its odor must not be obnoxious, its fumes must not be toxic, its rate of evaporation must meet the requirements of the technique or process in which it is to be used, it must be miscible with the other ingredients in every proportion, and it must not react chemically with them or have a destructive effect on their dry films when applied over them. The volatile solvents widely used in artists' paints and varnishes are TURPENTINE and MIN-

423

ERAL SPIRITS. Among the other solvents used in industry and sometimes by artists or manufacturers of artists' materials are ACETONE; BANANA OIL; BENZINE; BUTYL LACTATE; CARBON BISULFIDE; CARBON TETRACHLORIDE; COAL-TAR SOLVENT; DIACETONE ALCOHOL; ETHYL ACETATE; ETHYL ALCOHOL; KEROSENE; NAPHTHA; and SPIKE OIL. See also DISTILLATION; MUTUAL SOLVENT.

volet. One of the wings or folding panels of a TRIPTYCH or polyptych.

Vorticism. A British art movement founded by the painter and writer Wyndham Lewis (1882–1957) in 1912 and ended by World War I in 1915. Its art was abstract and sometimes entirely nonobjective. Although short-lived and confined to the activities of Lewis and his intimate circle of painters, sculptors, and writers, Vorticism was important in that it embraced French Cubist and Italian Futurist concepts and exposed British painters to their influence. Two issues of a publication called *Blast* contained its manifestos and other statements. Actively associated with the movement were the sculptors Jacob Epstein (1880–1959) and Henri Gaudier-Brzeska (1891–1915) and the painters William Roberts, Edward Wadsworth (1889–1949), and C. R. Nevinson.

W

wad clay or **wadding clay.** A low grade of FIRECLAY. It is usually used to level the setter shelves or bungs of SAGGERS in a KILN. Wads may also be used to lute or seal the lids of saggers.

wallboard. General term for a variety of rigid boards made of composition materials and used primarily in the construction of interior walls, ceilings, and partitions. Since the introduction of wallboards over a century ago, artists have attempted to use them as supports for painting. The term wallboard was first applied specifically to a soft, laminated pasteboard made of wood pulp and/or waste paper. It is still being made in such well known brands as Beaverboard and Upson board; the term beaver board is sometimes used as a general synonym for this type of board. It is used in art classes and for temporary purposes but is not durable or stable enough for permanent painting. Other boards which lack the structural stability and durability for use as permanent supports are the loose-textured insulating boards, compo board, and plasterboard. The successful adaptation of wallboard to artists' purposes occurred with the introduction in the late 1920's of the MASONITE process, a patented method of creating a dense board from

exploded and compressed wood fibers. Wallboards of this dense, hard quality are called hardboards. Many are now on the market, but none performs as well or is as popular as Masonite Presdwood. Hardboards made by other processes may contain added binders that make them prone to warping, especially when gesso is applied to them. Large hardboard panels are usually braced at the rear by a framework of wooden strips, glued on to prevent the support from bending or becoming curved by its own weight.

walling wax or **bordering wax.** Beeswax, which when warmed to plastic consistency is used to build a raised border or "wall" around the edges of an ETCHING plate, thus forming a container around the surface of the plate so that the MORDANT can be applied directly to it. The use of walling wax eliminates the necessity of immersing the entire plate in an ACID BATH, which would be both awkward and expensive to use, for example, when etching an extra-large plate.

wall of Troy pattern. See FRET.

wall painting. See MURAL.

wall primer. See PLASTER PRIMER.

wall scraper. A well-tempered, flexible steel SLICE, about 3 inches wide at its edge. It somewhat resembles the spatula or AMASETTE originally used to gather oil color during its grinding, and is a generally useful studio implement. One of its special uses is in the DRAW-OUT.

WALL SCRAPER

walnut. Any of the common hardwoods obtained from trees of the genus *Juglans.* American or black walnut (from *Juglans nigra*) is a dark- or medium-brown hardwood of such desirable texture, grain, durability, uniformity, and working properties that it is the standard wood for carving. Variations in coloring, or in straightness or curliness of grain, are never very far from an average. Butternut (from *Juglans cinerea*), sometimes called white walnut, is a yellowish-gray wood that closely resembles American walnut, although it is softer and less durable; it is also much used by wood carvers. Other trees of this genus include California walnut (*Juglans californica* or *J. hindsii*), the wood of which is used chiefly for veneer, and Circassian or French walnut (*Juglans regia*), which has a tawny wood with dark streaks, used chiefly for furniture and veneer. For African walnut, see TIGERWOOD.

walnut oil. A vegetable DRYING OIL, expressed from the common or English walnut. It has been known as a paint oil since medieval times, but, although used from time to time in artists' colors, it never achieved the popularity of linseed oil. Leonardo da Vinci valued it, and 18th-century writers recommended it for use with some pigments. Modern scientific opinion rates it definitely less desirable than linseed oil. Although it is produced in quantity for commercial use in California, few specialists in our time have investigated its possibilities for oil colors. Like other nut oils, it becomes rancid on aging.

Wanderers, The. A Russian art movement organized by Nicholas Kramskoy in 1872. The realistic paintings of the Wanderers were social and propagandistic in purpose, expressing growing dissatisfaction with the absolute czarist regime. The group implemented its desire to enlighten and

educate the people through art by sending exhibitions to many provincial cities. It included V. V. Vereshagin, Ilya Repin, Vladimir Makovsky, W. Polenov, and Lebediew.

warm colors. Those colors in which red and yellow are dominant. Yellowish or brownish grays are called warm grays. All warm colors lie in the red-yellow half of the COLOR CIRCLE. See also COOL COLORS.

warning coat. A colored layer of plaster included in a WASTE MOLD to indicate how close the cast is when the mold is being destroyed by chipping out, in order to avoid damaging the cast.

warping of pictures. The bending or arching of a support that should be flat, as a result of unequal contraction due to moisture, heat, or drying. Expert framing in sturdy frames helps prevent warping of panels. Museums find that the best environment for the survival of wood panels includes a constant atmospheric humidity of about 55%. Professional conservation treatments are required for the restoration of warped panels to a flat condition. (See CRADLING, PARQUETAGE.) Paintings on canvas mounted on ordinary, lightweight stretchers are likely to warp if they are hung unframed; such paintings will not warp if they are braced in substantial picture frames. Canvases mounted on heavy 2½-inch stretchers do not warp.

wash. An application of dilute watercolor to paper. Although any transparent touch of thinned-out watercolor, as distinguished from full-strength or concentrated colors, can be called a wash, the term usually refers to a uniform broad area such as a sky, applied quickly with a large, full brush. Sometimes dilute watercolor, applied very wet, is allowed to run down to one end of the paper by tilting the board to a vertical position. This creates a gradated tone, as the paper dries sooner at the upper part, and the color, flowing down, becomes more concentrated at the bottom. See also WASH DRAWING.

wash drawing. A brush drawing done on paper with multiple dilutions or washes of India ink or MONOCHROME watercolor. Most wash drawings include linear elements, and are sometimes called pen-and-wash drawings, especially in Britain.

waste mold. In casting sculpture or ceramics, a plaster MOLD that can be used only once, because it must be broken up in order to remove the cast from it.

watercolor. The technique of painting with pigments dispersed in a GUM ARABIC solution; a work of art so produced; also, the paint used in this technique. Besides the gum, which acts as a BINDER, the ingredients in watercolor paint include a PLASTICIZER such as HYDROMEL or sugar-water, GLYCERIN to keep the paint moist, a WETTING AGENT to obtain a uniform flow of paint on surfaces, and a PRESERVATIVE such as phenol. Watercolors are applied to special handmade WATERCOLOR PAPER with hair brushes, the finest of which are made of red sable (see BRUSH, RED SABLE).

Watercolors are characterized by a luminous transparency, although GOUACHE is sometimes considered an opaque watercolor technique. True watercolors are most often applied with free, loose strokes and broad WASHES; the grain and whiteness of the paper add to the brilliance and sparkle of the finished work.

Water paints were used throughout the Middle Ages in the ILLUMINATION

426

of parchment manuscripts. During the 16th, 17th, and 18th centuries they were little used except in MINIATURE painting, which was commonly done on card or ivory, although parchment and porcelain were also used. Chinese and Japanese painters have made extensive use of watercolor on fine textiles such as silk, as well as on paper made of bark or rice.

The modern technique of transparent watercolor painting was developed in England during the late 18th and early 19th centuries. At the beginning of this period, watercolor drawing, in which sepia or blue tints were superimposed on pen-and-ink designs, gave way to monochrome. This in turn was superseded by a more versatile technique in which color was applied with ever greater freedom and imagination. Today a broad, fluid handling of masses of color characterizes watercolor technique.

Watercolor paints were being made commercially by the late 1700's. They were at first hard, dry cakes about ¾" x 1¼" x ¼", or half-cakes, embossed with the maker's trademark. Moist watercolors, obtained by adding glycerin and sold in pans, were introduced about 1835; they are still used by many painters. The glycerin prevents the paint from caking in the pan and, by slightly delaying the setting of the colors, facilitates their application. Watercolors in paste form, sold in collapsible tubes, appeared about 1900; they are easy to handle and are the most popular kind.

Many of the finest watercolorists of modern times have been English and American. Among the British painters who contributed to the flowering of the art in the late 18th and 19th centuries were John Robert Cozens (1752–1797), William Blake (1757–1827), Thomas Girtin (1775–1802), Joseph Mallord Turner (1775–1851), and John Sell Cotman (1782–1842).

The Americans who followed them include Winslow Homer (1836–1910), John Marin (1872–1953), Edward Hopper (1882–1967), Charles Demuth (1883–1935), and Charles Burchfield (1893–1967).

watercolor paper. Paper used as both ground and support for watercolor painting. For permanence and best performance, artists select a handmade paper, especially prepared from linen rag, sometimes with a small percentage of cotton, and containing no residual bleach or other added material except a bit of glue size to reduce absorbency. Although a small quantity of fine watercolor paper is produced in the U.S., artists usually depend on European sources. Watercolor paper is available in several weights designated by numbers that indicate the weight of a ream (500 sheets) of imperial size (see PAPER DIMENSIONS). The lightest-weight paper is 72 pounds; 140-pound paper is twice as costly. Papers of both these common weights are stretched on a drawing board for use in serious work. The heavier grades, from 280 to 400 pounds, may be used without stretching; their bold textures, sparkling effects, and ability to withstand vigorous treatment, such as scraping with a knife and repeated scrubbing, make them highly esteemed by watercolorists.

Handmade papers are available in several textures. Cold pressed (C.P.) is the usual moderately coarse grade. Rough (R) or "not pressed" (N.P.) papers have decidedly rough textures and are more frequently available in heavy than in lightweight varieties. Hot pressed (H.P.) is rather dense and smooth; it is not generally used for transparent watercolor painting, but is useful for gouache and for many drawing purposes. Fine, handmade water-

color paper is also sold in blocks or pads of various sizes.

Because the working qualities of watercolor paper improve with age, artists have traditionally sought out old stocks, especially those that are watermarked with the maker's name or trademark and the year of manufacture. Traditionally, in those papers that are stamped or watermarked the legible side is considered the "right" side, without flaws and even in texture; but top-quality watercolor paper seldom has any blemishes, and may therefore be used on either side.

water gilding. The technique of adhering precious-metal leaf to a gesso or bole ground that is moistened with water immediately before each leaf is laid. Water gilding, which is an older method for laying leaf than MORDANT GILDING, is used chiefly for fine frames and decorative work and for small flat work such as the illumination of manuscripts, the decoration of book covers, gilding in tempera on gesso panels, and gilding the edges of book pages. Water gilding can, if desired, be burnished to a high mirror finish, whereas mordant gilding cannot. See also GOLD SIZE.

water glass. Sodium silicate, a thick, viscous LIQUID SILICATE with alkaline properties, unsuccessfully tried as a paint binder during the 19th century.

water-glass painting. See MINERAL PAINTING.

water-in-oil emulsion. See EMULSION.

watermark. A design, pattern, or mark on paper, usually produced by a raised area in the roll on which the paper is made. The marked area is thinner than the rest of the sheet, so the watermark is easily seen when the paper is held up to the light. Watermarks on handmade papers are made by very low relief molds or designs of fine wire set on the screen on which the moist pulp collects. See also LAID PAPER.

water-of-Ayr. See AYR STONE.

water paints. See AQUEOUS PAINT.

water-white. A term used in reference to colorless, transparent materials, as glycerin or window glass.

wave scroll. See VITRUVIAN SCROLL.

wax. A plastic substance secreted by bees, also called BEESWAX, or any of the many substances resembling it in physical properties. CHINESE INSECT WAX and beeswax are animal in origin; among the many vegetable waxes are CARNAUBA WAX, CANDELILLA WAX, and JAPAN WAX; PARAFFIN, CERESIN, MONTAN WAX, and OZOKERITE are examples of mineral waxes. Waxes are related to oils, but are not fluid at normal temperatures. Since they have a lower degree of permeability to moisture than resins or oils, they are useful as protective coatings wherever their relative softness is not a disadvantage. Animal and vegetable waxes behave much like animal and vegetable oils; they enter into the same reactions, including saponification and emulsification. Mineral waxes are chemically inert, as are mineral oils. A wax does not have a precise melting point; its melting range is usually expressed in maximum and minimum figures stated in degrees Centigrade. All waxes melt at less than $100°$ C, the boiling point of water, and can therefore be liquefied in boiling water. Each wax used in the arts is chosen for a specific purpose according to its properties, the most significant of which are its melting range and its hardness when in a solid state.

When a recipe for artists' materials calls for wax without specifying the variety, bleached white beeswax is always meant.

Weather Ometer. Trade name for a laboratory accelerated testing device in which samples of coating materials are exposed to a carbon arc as in the FADE OMETER, but with the addition of intermittent cycles of a water spray to simulate the conditions of outdoor weathering. Since few works of art are required to resist outdoor exposure, the device's use with artists' materials is limited to testing paints that might be used in outdoor murals. See also ACCELERATED TEST.

wedge. 1. In ceramics, to prepare a lump of clay for use by alternately cutting it (usually on a taut wire) and pounding it vigorously (on a slab) until it is in a homogeneous, plastic condition, free from air bubbles. See also PUG.
2. The KEYS in a canvas stretcher are sometimes called wedges.

weld. A bright-yellow NATURAL DYESTUFF made from dyer's rocket (*Reseda luteola*), a plant formerly cultivated extensively in England, France, and Germany. Weld has been used since medieval times to dye fabrics and to make lake pigments. It became commercially important during the 15th century but was replaced in the 19th by synthetic dyes of superior properties. Weld is one of the more permanent of the natural dyestuffs and a small quantity is still grown in Normandy for use in dyeing silk. The coloring principle of weld (luteolin) has been made synthetically. Other names for weld are arzica and gaude yellow.

welding. The process of joining together two pieces of metal by fusion. Intense heat is supplied by an oxyacetylene torch in gas or OXYACETYLENE WELDING and by electrical means in ARC WELDING. Sometimes a FILLER ROD is melted along the joint, in the process known as BRAZING. The direct welding of two pieces by combining the molten edges is called fusion welding. Welding is done at much higher temperatures than soldering (see SOLDER) and results in stronger, more durable joints. It is used in making DIRECT METAL SCULPTURE. Welding assures permanence of adhesion because the heat breaks down the molecular structure of the surfaces, which recombine as a solid piece by molecular cohesion when the metal cools and hardens.

well slant. See SLANT.

wet clay. Sculptor's CLAY that is mixed with water before use, as distinguished from MODELING CLAY.

wet-into-wet. The application of paint to a surface that already has a wet coating on it. One form of wet-into-wet consists of painting tempera paint into wet oil paint or vice versa. See MIXED TECHNIQUE.

wetting agent. A liquid added in very small amounts to watercolor or another water paint in order to reduce the surface tension of the water in it, so that the paint will flow freely and take evenly on the paper. Water has a tendency to form drops, which is further encouraged by the tendency of some surfaces to repel water. A good wetting agent breaks down the surface tension of the water and eliminates the resistance of the paper. The standard wetting agent formerly used in the manufacture of watercolors was oxgall, a by-product of meat packing. The modern wetting agent is a clear, colorless synthetic product related to detergents. It is sold in small dropper bottles in art supply shops, and also in

larger bottles in photographic supply shops (it is used in developing film).

wetting down. Flooding a stone with water in order to discover veins and patterns or to bring out the grain before carving or polishing.

whelk red. Another name for TYRIAN PURPLE.

whetstone. A hard stone used for sharpening edged tools. Relatively coarse-grained whetstones are used dry for basic sharpening and are usually made of artificial abrasives such as ALUNDUM and CARBORUNDUM. Hard, fine-grained stones for finishing the edges of carving knives, gouges, etc., are usually oiled before use. See OIL-STONE.

white earth. A pure white variety of clay, whose major components and pigment properties are similar to those of GREEN EARTH. Because of its clarity and high absorbency, white earth is well suited for, and in limited use as, a BASE for certain LAKES. White earth is not the same material as terra alba.

white lead. Basic lead carbonate. The use of white lead, one of the oldest of the artificial or manufactured pigments, dates back to the earliest recorded civilizations in Europe and China. Used in oil paints, it has the best pigment properties of any of the permanent pigments, since it is a good drier, has superior brushing qualities, and forms the toughest and most durable of paint films. Two defects, which have been greatly exaggerated by proponents of other white pigments, are its toxic nature and the fact that it will yellow or turn brownish on contact with sulfur. The latter defect is of slight consequence in oil paintings, where the pigment is locked in by the oil and protected from the action of

sulfur gases in the atmosphere. In any case, artists' paintings are usually preserved under conditions that preclude the exposure of white lead paint films to harmful concentrations of sulfur. White lead in oil will not react with any of the other approved permanent pigments, including the cadmiums and ultramarine blue, unless these are of low quality and contain free sulfur. Since lead is a cumulative poison, whose toxic effects increase as small amounts build up in the body, white lead is not used in aqueous paints, pastels, or the types of colors used by children. However, mature artists do not readily contract lead poisoning if they obey the simple rules of cleanliness and do not swallow white lead paint or breathe in its dust.

White lead is manufactured in a variety of ways, but the grade most suitable for use in artists' oil paints is made largely by what is called the "old Dutch process" (see DUTCH-PROCESS WHITE LEAD). The artists' pigment is called FLAKE WHITE. Also acceptable, but less frequently available, is another variety of white lead called CREMNITZ WHITE. White lead was the only opaque white pigment used in the entire history of artistic oil painting up to the twentieth century; its good properties are responsible, in part, for the survival and success of the oil technique. ZINC WHITE and TITANIUM WHITE, which are nontoxic and nonyellowing, are entirely acceptable pigments for use in artists' colors, but they are inferior to flake white as oil colors in most respects.

Several names were used in England during the 19th century for different grades and variants of white lead, such as Flemish white, London white, Nottingham white, and Roman white. The Latin term cerussa was applied to white lead rather than to flake white. French white and silver white are unstandardized terms that have

been used for both flake and zinc whites.

In ceramics, white lead is a common flux for glazes fired at low temperatures.

white lead in oil. WHITE LEAD dispersed in raw LINSEED OIL to make a stiff paste. This product, which is widely available in paint and hardware stores, is made for house paint and other industrial uses. It cannot be employed as a substitute for artists' FLAKE WHITE because of its tendency to turn yellow and to wrinkle if applied in brushstrokes of uncontrolled thickness. Applied thinly and evenly, white lead in oil is useful as a GROUND or PRIMER on canvas or panel; it is also used as a mural adhesive (see MAROUFLAGE).

white-line cut. A relief print (see RELIEF PRINTING) in which the non-printing engraved (or, in anastatic printing, etched) lines form the subject, producing a design in white lines and areas on a black ground. Most WOOD ENGRAVINGS are white-line cuts. The process of engraving or etching a white-line cut is known as working from black to white. Most prints are black design lines and areas on white paper and are developed on the plate, block, or stone from white to black.

white mahogany. See PRIMA VERA.

white pigments. The following are approved for use in oil paints by the PAINT STANDARD, and are generally acceptable (except as noted) in all easel-painting techniques: FLAKE WHITE (except in water mediums and pastel), TITANIUM WHITE, and ZINC WHITE. White pigments that do not retain their whiteness and full opacity in oil are classed as INERT PIGMENTS. Some inert pigments serve as whites in some coatings, e.g., BLANC FIXE in GOUACHE COLORS.

white spirit. British term for MINERAL SPIRITS.

white walnut. Another name for butternut. See WALNUT.

whitewash. An inexpensive white coating for rough work on walls or ceilings. It is neither permanent nor waterproof. The term usually refers to lime mixed with water, but CALCIMINE and other cheap water paints may also be called whitewash. Whitewash has been used in the past to impose artistic censorship by hiding mosaic and fresco mural decoration for religious or political reasons. Many such works have been reclaimed in modern times, by simply washing away the coating.

white wax. White refined BEESWAX.

whiting. Native calcium carbonate mined in various parts of the world and used as an INERT PIGMENT in such products as GESSO. It is also the major flux used in ceramic glazes that are fired at high temperatures. The standard grade of whiting, called "extra gilder's," is grayish or creamy off-white in color, uniformly fine, and free from impurities. A cheaper, more grayish variety, called "commercial," is suitable only for less demanding uses, such as making window putty. A superfine, purified grade of whiting, known as Spanish or Paris white, is not ordinarily obtainable from most retail paint stores. Whiting is also called English white, since much of it comes from the chalk cliffs of England. Artificially prepared calcium carbonate, known as PRECIPITATED CHALK, is much whiter than whiting.

whole length. See FULL LENGTH; CANVAS SIZES, PORTRAIT.

Winsor blue; Winsor green. British trade names for PHTHALOCYANINE BLUE and PHTHALOCYANINE GREEN.

wiping. The process of removing ink from the plane surface (the nonprinting areas) of INTAGLIO plates, so that the ink will remain only in the etched or engraved lines. The plate must be wiped to obtain distinct lines and clean white areas in the proofs. This is usually accomplished with the palm of the hand (hand-wiped) or with tarlatan, an open-weave fabric (rag-wiped). Some graphic artists prefer to leave a trace of ink on the surface of the plate to haze lines and soften contrasts, thus toning down the cold, bare appearance of a print pulled from a cleanly wiped plate. One method of doing this is to blot the plate with "veils" (balls of cotton gauze or muslin), a technique known as retroussage. The object of retroussage (or dragging, or pumping, as the technique is also called) is to deposit a uniform trace of ink on the surface of the plate with a minimum disturbance of the full charge of ink in the intaglio lines. Veils may also be used on plates that have already been hand- or rag-wiped to draw a little ink from the incised lines and deposit it on the edge of the etch or furrow; when an engraved plate is so treated, the slightly smudged lines in the proofs resemble somewhat the lines produced by the BURR in DRYPOINT. Veils may also be used to create highlights by removing ink from certain areas. Because retroussage also tends to conceal in the prints slight defects that may be on the plate, such as those caused by FOUL BITING, some purists do not approve of the technique and insist on a perfectly clean black-on-white print.

wire-end tool. See MODELING TOOLS.

woad. A blue NATURAL DYESTUFF made from the woad plant (*Isatis tinctoria*), which was extensively cultivated in England and other European countries from very early times. Woad was replaced by the more durable and efficient INDIGO after the latter was imported from India. The two products are so similar in chemical composition that indigo and woad pigments cannot be differentiated in old paintings.

wood alcohol. See METHANOL.

wood-carving knife. Any of a number of steel knives with variously shaped blades used for chip carving in wood sculpture and as a supplement to chisels for cleaning up cut-away areas. The steel from which these knives are made is tough and durable but may be sharpened to a keen cutting edge. The blades are set in sturdy wood handles. The knives used in woodcutting, known as carvers, are somewhat smaller than wood-carving knives. They have a short angular blade set in a cord-wrapped handle for a better grip. See illustration at WOOD-CARVING TOOLS.

wood-carving tools. An assortment of sculptors' CHISELS, GOUGES, PARTING TOOLS, and WOOD-CARVING KNIVES, set in wooden handles that are sturdy enough to be struck with a MALLET. The ADZE and the RASP are also used in wood carving. These cutting tools, extensively used in wood sculpture, average between 8 and 10 inches in length and are available in a wide range of blade sizes, so that lines from about $\frac{1}{16}$ of an inch to an inch in width may be incised. The different kinds of blades (straight, curved, "U," and "V") incise lines and areas of different depths and shapes. Approximately half-size versions of these sculptors' cutting tools are used in the graphic arts for woodcutting. Wood-

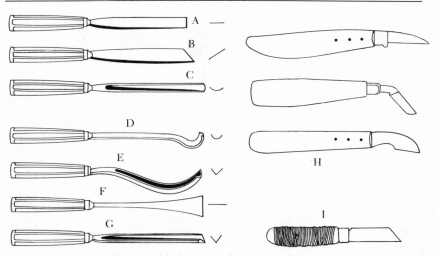

WOOD-CARVING TOOLS. (A) Straight chisel; (B) skew chisel; (C) straight gouge; (D) short bent gouge; (E) long bent V-gouge; (F) fishtail tool; (G) parting tool or V-gouge; (H) wood-carving knives; (I) carver for woodcut.

carving and WOODCUT TOOLS are sharpened by whetting them on a SLIP.

woodcut. A RELIEF PRINTING technique in which the printing surface is carved with special WOODCUT TOOLS from a block of wood; also, an ORIGINAL PRINT made by this method. The woodcut block is cut from a smoothed plank cut longitudinally from the tree trunk so that the grain runs in parallel lines in the block. This is the most significant way in which the woodcut differs from the WOOD ENGRAVING, in which end-grain blocks, cut transversely from a log, are used. The traditional woodcut block is seasoned hardwood, such as apple, pear, beech, or sycamore. A mid-20th century trend toward large color prints made from wood blocks has brought into use planks of inexpensive, more readily obtained softwoods, such as pine. Softwood blocks are not used in traditional woodcuts because they cannot be carved in every direction with the same freedom as wood blocks of more compact grain and because the wood-

grain pattern of the plank shows in the prints. Contemporary printmakers exploit the latter feature to good effect, however, creating large prints in which the grained pattern is an integral part of the work. Heavily grained surfaces such as weathered or wire-brushed wood are also sometimes used today in direct RELIEF BLOCK PRINTING.

In many woodcuts a great deal of wood must be cut away; today graphic artists often expedite this process by using a small electric drill with various routing attachments. Woodcuts are inked with BRAYERS. Before the 19th century they were inked with a leather dabber. If the block is TYPE-HIGH it may be printed in a regular flatbed printing press. The hand method for printing wood blocks, still widely used in artists' studios, consists of placing the proof paper on the face-up inked block, covering it with another piece of paper or a thin card, and effecting the transfer of ink by rubbing the whole surface with some smoothly gliding implement, such as a BAREN

or the bowl of a large wooden spoon.

Woodcut, which developed from the process of printing textile patterns with wood blocks, began to be used in Europe toward the end of the 14th century. The oldest extant woodcuts are playing cards. The BLOCK BOOKS of the 15th century were illustrated with simple linear designs, and most were hand-colored. Although these early prints, which were chiefly of religious subjects, were technically and pictorially crude, by the early 16th century the art of woodcutting had been elevated in Germany to the highest degree of technical and aesthetic accomplishment by craftsmen woodcarvers. These skilled artisans carried out the designs of such artists as Albrecht Dürer (1472–1528), Lucas Cranach (1472–1553), and Hans Holbein the Younger (1498–1543)—whose *Dance of Death* was cut by a great master of the craft, Hans Lützelberger. So accomplished were these craftsmen that the artists were content merely to supervise the actual cutting of the blocks. The woodcut developed simultaneously in Italy, where the Mannerist artist Francesco Parmigianino (1503–1540) did many drawings that were cut by Ugo da Carpi, and in the Netherlands, where Lucas van Leyden (1494–1533)—who was greatly influenced by Dürer—worked. Although woodcuts continued to be used in the 16th century to illustrate books, they also came into their own as original prints during this period. In the 17th century the use of line engraving and etching for fine-arts prints relegated woodcut to the status of a reproductive technique. It was supplanted in turn in this reproductive function in the 18th century by wood engraving but began to be revived as an artistic medium in France in the last half of the 19th century, when it was used by Gauguin and Millet. Edvard Munch, who designed, cut, and printed his own woodcuts, experimented extensively with the medium and did much to spur its revival. See also CHIAROSCURO WOODCUT.

woodcut tools. Chisels, gouges, parting tools, knives (carvers), etc., that are used to incise a woodcut block. These shorter versions of sculptors' WOOD-CARVING TOOLS are between 5 and 6 inches in length and have proportionately smaller cutting edges than wood-carving tools. Since woodcut tools are not intended to be struck with a mallet, they have straight wooden handles that are easily grasped.

wood engraving. A RELIEF PRINTING technique in which a block of wood is incised with a GRAVER, TINT TOOL, or SCORPER to create a printing surface; also, an ORIGINAL PRINT pulled from such a surface. The blocks used in wood engraving are transverse cuts, or the end grain, of the hardest hardwoods, differing in this way from the blocks used for WOODCUTS, which are longitudinal cuts and have a parallel grain. Boxwood is preferred for wood engraving, but red maple is also used. Since the trees from which boxwood is obtained are not very large in diameter, large blocks are made by bolting smaller ones together. Before the block is incised, the design is drawn with a pencil on the surface, which is first coated with very dilute Chinese-white watercolor; this serves as a background on which the pencil markings will be visible and as a surface that has enough tooth to take the drawing. The block may be held on a small sand-filled leather cushion while it is engraved. Once the drawing has been cut in the surface, the watercolor ground is washed away and the block is inked and printed the same way as a woodcut block, either in a press if it is TYPE-HIGH or by hand. Wood engraving is

essentially a direct, white-line technique; the design in the proofs is made by the nonprinting areas of the block.

Wood engraving was developed in England during the last half of the 18th century. Its first master was Thomas Bewick (1753–1828), whose book illustrations of nature subjects are widely admired. William Blake (1757–1827) also used the process, sometimes sketching directly on the block with the graver. By the mid-19th century wood engraving had become a standard method for illustrating books and magazines, and a large number of engravers, especially in America, became highly skilled in reproducing drawings, paintings, and photographs. The use of wood engraving for these purposes came to an end with the advent of photoengraving, but during the 20th century it has been revived as a fine-arts process for making original prints. SCRATCHBOARD work imitates the effects of wood engraving; virtually all commercial illustration that displays the white-line effect of wood engraving has been done on scratchboard.

wood turpentine. A kind of TURPENTINE made by distilling the stumps and scraps of pine trees; sold as a cheaper substitute for gum turpentine. Although wood turpentine is an excellent solvent and thinner, it is generally rejected for artists' use because of its pungent odor, which resembles that of pine sawdust, and because some individuals suffer headaches from its vapors under indoor conditions.

workable fixative. See FIXATIVE.

World of Art or **Mir Iskusstva.** A Russian art movement. Founded in 1890 in reaction to the didactic realism of The Wanderers, it embraced the doctrine of "art for art's sake" and was influenced by French Impressionism.

After the revolution of 1905 the artists of this movement turned from interpretation of the natural world to a decorative, linear style that influenced mural painting, book illustration, graphics, and the art of the theater, especially sets for the Russian ballet. Led by Alexander Benois, the group included Leon Bakst, Golovin, Sudeikine, and Nicholas Roerich, among others, as well as Konstantin Somov, of the prerevolutionary Blue Rose group.

worm's-eye view. A scene drawn or painted as if observed from a point below it. Any correctly drawn worm's-eye view will be in OBLIQUE PERSPECTIVE (see illustration at LINEAR PERSPECTIVE). The HORIZON LINE is placed or imagined close to the bottom of the picture or even below it, so that there

WORM'S-EYE VIEW. *St. James Led to Execution*, fresco (destroyed in 1944) by Andrea Mantegna (1431–1506) from the Church of the Eremitani, Padua. The horizon line is below the painting, and the principal vanishing point is on that unseen line, a bit to the right of center. There is only a very slight upward convergence of vertical lines. (*Courtesy, Alinari–Art Reference Bureau.*)

435

is an upward convergence of all vertical lines parallel to the picture plane. The lowered horizon line, corresponding to a low POINT OF STATION, causes most or all of the composition to lie above the horizon line. The worm's-eye view is useful for accurately depicting things that are typically seen by looking up. See also BIRD'S-EYE VIEW.

wove. See LAID PAPER.

wrinkles. A defect of oil colors, polymer colors, varnishes, and lacquers, consisting of irregular ridges and furrows which form in the paint or surface film after a certain amount of aging when faulty materials or improper methods of application have been employed. Induced by shrinkage and compression, wrinkling occurs most frequently in under-pigmented paints and lacquers in which the films are insufficiently reinforced by masses of pigment particles. Under-pigmented glazes, however, do not wrinkle, because of the thinness of their layers. Clear coatings may develop wrinkles when applied so thickly that loss of volume through evaporation is a greater factor than it would be in a thin coating. Compression caused by rolling a canvas with the painted face inward may cause wrinkles in a flexible coating; the same action causes a brittle coating to crack. On further aging and loss of elasticity, wrinkles commonly develop into cracks, and when there is less than normal adhesion between film and ground, cleavage occurs. Some materials, such as asphaltum, megilp, and binders with an overabundance of drier, have an inherent tendency to wrinkle. Blistering in long, thin lines may be mistaken for wrinkles.

X

xanthorrhoea. See ACCROIDES.

xylene. See COAL-TAR SOLVENT.

xylography. A little-used term for WOODCUT and WOOD ENGRAVING.

Y

yachting style. Term used in France as a synonym for ART NOUVEAU.

yeast black. Another name for VINE BLACK.

yellow berries. Another name for BUCKTHORN BERRIES.

yellow carmine. A very fugitive yellow LAKE pigment of vegetable origin and transparent olive hue; it is similar to, and probably a variant of, DUTCH PINK.

yellow earth. Another name for YELLOW OCHRE.

yellowing. The discoloration or tonal degradation of a painting. It may be caused by the use of oils and varnishes that are inherently prone to become yellowish or brownish on aging; by the excessive use of linseed oil, the slight yellowing of which would be masked by pigment in a well-proportioned paint; or, most frequently, by the accumulation of grime, which encrusts the surface and becomes embedded in the varnish. It is sometimes called after-yellowing. Most badly yellowed oil paintings can be restored to their original colors by removing the old varnish and applying a fresh coat.

yellow lake. A term that has been applied to transparent yellow lake colors of various kinds—formerly, those made from natural dyestuffs; today, those made from synthetic dyes. No artists' color so labeled is permanent.

yellow ochre. An opaque pigment, refined and processed from bright-yellow earths usually containing clay, and colored by hydrous iron oxide (limonite). It is one of the artists' basic colors, employed in every culture and civilization since prehistoric times. Ochres are mined the world over; the highest grades come from those areas where the best ores occur and where the most efficient methods for producing a uniform and economical product have been developed. Most of the best kinds of ochre come from southern France in well-defined standard grades. Another fine grade, OXFORD OCHRE, is produced in limited quantities in England. Like all iron-bearing earth colors, ochre becomes red when calcined; burnt ochres and RED OCHRES have been largely replaced by light red. Among the many varieties of yellow ochre are ROMAN OCHRE (also called Italian ochre); FLESH OCHRE; BROWN OCHRE; SPRUCE OCHRE; and TRANSPARENT GOLD OCHRE. Another name for yellow ochre is yellow earth. Chamois and minette are obsolete

names for yellow ochre; sil was the name used by the ancient Romans. Yellow ochre is often simply called ochre.

yellow oxide of iron. Another name for Mars yellow, one of the MARS PIGMENTS.

yellow pigments. The following are approved for use in oil paints by the PAINT STANDARD, and are generally acceptable (except as noted) in all other easel-painting techniques: (dull) YELLOW OCHRE, RAW SIENNA, and TRANSPARENT OCHRE; (bright opaque) CADMIUM YELLOW (light, medium, deep) and NAPLES YELLOW (except in pastel and water mediums); (semi-opaque) STRONTIUM YELLOW; (transparent) COBALT YELLOW and HANSA YELLOW.

yellow ultramarine. An obsolete name for BARIUM YELLOW.

yellow varnish. Damar resin dissolved in linseed oil with the aid of heat. The name was given to this product by Jacques Maroger, who in the 1940's introduced a painting medium that was a reverse, or water-in-oil, emulsion. The pigments were dispersed in yellow varnish, then mixed into the emulsion, a paste made by lightly whipping a gum-arabic solution into the same varnish. This medium was discarded, and the name MAROGER MEDIUM was applied to another one.

yellow weed. Dyer's rocket (*Reseda luteola*); the source of the yellow natural dyestuff WELD. In the U.S. several other weeds are sometimes called yellow weed.

young fustic. A yellow NATURAL DYESTUFF extracted from the wood of the Venetian sumac (*Rhus cotinus*), which grows in southern Europe and the Near East. The coloring extract, continin, was formerly used to dye textiles but is not sufficiently lightfast for use in pigments. Young fustic is also known as fustet; another yellow dyestuff called FUSTIC (or old fustic) is a different material.

Z

zaccab. A white earth mixed with lime, used in Yucatán as a building and plastering material, and for sculpture.

zaffer or **zaffre.** Cobalt oxide prepared for use in the manufacture of the blue pigment SMALT. Also considered to be partially processed smalt, zaffer was sometimes mixed with the finished product to produce another grade of smalt called eschel. The term zaffer was frequently distorted to safflower by workers in the U.S. and Britain.

Zapon. German trade name for cellulose LACQUERS.

zebrano. See ZEBRAWOOD.

zebrawood. 1. An African wood (from the tree *Brachystegia fleuryana*) with a grain of fairly evenly spaced parallel light straw-colored and dark brown stripes; also known as zebrano or zingana. It comes in large logs, sometimes over 36 inches in diameter, and is usually available in planks 1 or 2 inches thick.
2. A striped, hard South American wood (from *Connarus guianensis*) used in cabinetwork.

zinc chromate or **zinc chrome.** Alternate names for ZINC YELLOW.

zinc green. Another name for CO-BALT GREEN; also, an industrial COM-POSITE PIGMENT that is a mixture of zinc yellow, Prussian blue (steel or Milori), and barytes.

zinc oxide. A white powder produced in many grades for various uses such as ZINC WHITE pigments, pharmaceuticals, and cosmetics. It is sometimes used as an ingredient of ceramic glazes. Although zinc ores were used in ancient times to make brass, zinc was not known as a metal until it was identified as an element by Margraaf in Germany in 1746.

zinc white. The artists' term for a variety of ZINC OXIDE made by the fume, or French, process (see FRENCH-PROCESS ZINC OXIDE). Zinc white is a brilliant, snow-white pigment, without fault in watercolor and other aqueous paints. Although it excels in whiteness, zinc white is in other respects inferior in oil to FLAKE WHITE. It is only semiopaque, has poor drying qualities, and tends to produce weak films. On the other hand, unlike flake white, zinc white is not discolored by the action of sulfur gases in the atmosphere, since the resulting zinc sulfide is also white.

As early as 1782 chemists began their efforts to adapt zinc oxide for use as a pigment to replace white lead. Zinc white was first introduced to artists in 1834, when the English firm of Winsor & Newton put it out as a watercolor under the name Chinese white. Zinc white began to appear as an artists' oil color in the second half of the 19th century. By the first quarter of the 20th century it had become sufficiently improved for artists to find it a satisfactory alternative to flake white. Despite the all-around superiority of flake white, zinc white is widely used by painters, especially by those who fear flake white's toxic properties. FLORENCE ZINC OXIDE is an American trade name for pure zinc oxides made by the French process. Mixtures of zinc and titanium whites are sold under various names (see COMPOSITE WHITE). French white and silver white are unstandardized terms that have been used for both flake and zinc whites.

zinc yellow. Zinc chromate, a pale citron-yellow pigment not approved for use in permanent painting because of its partial solubility in water and the tendency of most samples to turn greenish on exposure to light. It is perfectly replaced by its "color twin," strontium yellow. Other names for zinc yellow are zinc chromate or zinc chrome.

zingana. See ZEBRAWOOD.

zinnober green. One of many synonyms for the industrial pigment CHROME GREEN.

zirconium drier. A DRIER made from a zirconium compound. It is used to balance the drying action of cobalt drier by promoting drying from within; cobalt tends to dry more rapidly on the surface. The effect is a

glossier surface, because rapid surface drying tends to make a paint duller than one that has dried evenly throughout.

zirconium oxide. A white powder produced by treating zircon and used in ceramic and glass manufacture. Zirconium oxide is frequently included in lists of paint pigments, although its indifferent pigment properties and high cost scarcely qualify it for artists' use.

Zircopax. Trade name for an opacifier used in ceramic glazes.

zones of recession. The foreground, middle distance, and background in any composition that attempts to represent spatial depth. In LEGITIMATE CONSTRUCTION the area of a picture's surface is apportioned among the three zones according to strict rules of LINEAR PERSPECTIVE. Hazing the middle distance in order to differentiate better between the foreground and the background is a technique employed in AERIAL PERSPECTIVE, particularly for Chinese landscapes. The exaggerated foreground is a characteristic of Baroque painting, particularly with such Northern painters as Rubens and Vermeer. Perspective reduction in their works is often very sudden, causing a striking contrast between the dimensions of the foreground and background.

Z-twist. See TWIST DIRECTION.

Books for
Further Reference

An asterisk preceding an entry denotes a book that has an extensive bibliography.

Art History

CHENEY, SHELDON. *A New World History of Art.* The Viking Press, Inc., New York, 1962.

° GARDNER, HELEN. *Art Through the Ages,* 4th ed., revised under the editorship of Sumner McK. Crosby by the Dept. of History of Art, Yale University. Harcourt, Brace & World, Inc., New York, 1959.

° JANSON, HORST W., with Janson, Dora Jane. *History of Art: A Survey of the Major Visual Arts from the Dawn of History to the Present Day.* Prentice-Hall, Inc., Englewood Cliffs, N.J.; Harry N. Abrams, Inc., New York; and Thames and Hudson, Ltd., Aldershot, Hants. All editions 1962.

Praeger Picture Encyclopedia of Art. Original German edition, Georg Westermann Verlag, Brunswick, 1958; English edition, Frederick A. Praeger, Inc., New York, 1958.

° ROBB, DAVID METHENEY, and GARRISON, JESSE JAMES. *Art in the Western World,* 4th ed. Harper & Row, Publishers, New York, 1963.

° UPJOHN, EVERARD MILLER; WINGERT, PAUL S.; and MAHLER, JANE GASTON. *History of World Art,* 2nd ed. Oxford University Press, New York and London, 1958.

Accounts of Early Techniques and Materials

CENNINI, CENNINO D'ANDREA. *The Craftsman's Handbook* ("Il Libro dell'-Arte"). Translated by Daniel V. Thompson, Jr. Yale University Press, New

Haven, Conn., 1933; paperback reprint, Dover Publications, Inc., New York, 1954, and Constable and Company, Ltd., London.

EASTLAKE, CHARLES LOCKE. *Materials for a History of Oil Painting* (1847, 1869). Paperback reprint entitled *Methods and Materials of the Great Schools and Masters*, 2 vols., Dover Publications, Inc., New York, 1960, and Constable and Company, Ltd., London.

° LAURIE, ARTHUR P. *The Materials of the Painter's Craft in Europe and Egypt, from Earliest Times to the End of the XVII Century, with Some Account of Their Preparation and Use.* J.B. Lippincott Co., Philadelphia, and T.N. Foulis, Edinburgh, 1910.

MERRIFIELD, MARY P. *The Art of Fresco Painting as Practised by the Old Italian and Spanish Masters, With a Preliminary Inquiry into the Nature of the Colours Used in Fresco Painting, With Observations and Notes* (1846). New illustrated edition with an introduction by A. C. Sewter; Alec Tiranti, London, 1952; facsimile reprint, Transatlantic Arts, Inc., New York, 1953.

MERRIFIELD, MARY P. *Original Treatises, Dating from the Twelfth to the Eighteenth Centuries on the Arts of Painting, in Oil, Miniature, Mosaic, and on Glass; of Gilding, Dyeing, and the Preparation of Colours and Artificial Gems; Preceded by a General Introduction; With Translations, Prefaces, and Notes* (1849). Paperback reprint entitled *Original Treatises on the Arts of Painting*, 2 vols., with an introduction and glossary by S.M. Alexander; Dover Publications, Inc., New York, 1967, and Constable and Company, Ltd., London.

PLINY THE ELDER. *Natural History*, 10 vols. Harvard University Press (Loeb Classical Library), Cambridge, Mass. See especially books XXXII to XXXVII.

THOMPSON, DANIEL V. *The Materials of Medieval Painting*, 2nd ed. George Allen and Unwin, Ltd., London, 1956. Paperback reprint entitled *The Materials and Techniques of Medieval Painting*, Dover Publications, Inc., New York, 1958, and Constable and Company, Ltd., London.

VASARI, GIORGIO. *Vasari on Technique.* Translated by Louisa S. Maclehose, edited with an introduction and notes by G. Baldwin Brown. J.M. Dent & Sons, Ltd., London, 1907; paperback reprint, Dover Publications, Inc., New York, 1960, and Constable and Company, Ltd., London.

VITRUVIUS POLLIO, MARCUS. *Vitruvius: The Ten Books on Architecture.* Translated by Morris Hicky Morgan and edited by Albert Andrew Howard and Herbert Langford Warren. Harvard University Press, Cambridge, Mass., 1926; paperback reprint, Dover Publications, Inc., New York, 1960, and Constable and Company, Ltd., London.

Modern Painting Materials and Methods

DEHN, ADOLF. *Water Color, Gouache, and Casein Painting: A Handbook of Techniques.* The Studio Publications, Inc., New York and London, 1955.

DOERNER, MAX. *The Materials of the Artist and Their Use in Painting, With Notes on the Techniques of the Old Masters.* Translated and revised by Eugen Neuhaus. Harcourt, Brace & World, Inc., New York, 1949; Rupert Hart-Davis, Ltd., London, 1963.

° GETTENS, RUTHERFORD J., and STOUT, GEORGE L. *Painting Materials; A Short Encyclopedia.* D. Van Nostrand Co., Inc., New York, 1942; paperback reprint, Dover Publications, Inc., New York, 1966, and Constable and Company, Ltd., London.

GUPTILL, ARTHUR L. *Oil Painting Step-by-Step,* 3rd ed. Watson-Guptill Publications, New York, 1965; Pitman & Sons, Ltd., London, 1966.

GUTIÉRREZ, JOSÉ, and ROUKES, NICHOLAS. *Painting with Acrylics.* Watson-Guptill Publications, New York, 1965.

JENSEN, LAWRENCE N. *Synthetic Painting Media.* Prentice-Hall, Inc., Englewood Cliffs, N.J., 1964.

LAURIE, ARTHUR P. *The Painter's Methods and Materials.* J.B. Lippincott Co., Philadelphia, 1926; Seeley, Service & Co., Ltd., London, 1935, 1960; paperback reprint, Dover Publications, Inc., New York, 1967, and Constable and Company, Ltd., London, 1968.

° MAYER, RALPH. *The Artist's Handbook of Materials and Techniques,* 3rd rev. ed. The Viking Press, Inc., New York, and Faber & Faber, Ltd., London, 1970.

MAYER, RALPH. *The Painter's Craft,* rev. ed. D. Van Nostrand Co., Inc., Princeton, N.J., 1966; D. Van Nostrand Co., Ltd., London, 1967.

NORDMARK, OLLE. *Fresco Painting: Modern Methods and Techniques for Painting in Fresco and Secco.* American Artists Group, New York, 1947.

O'HARA, ELIOT. *Making the Brush Behave: Fourteen Lessons in Watercolor.* Minton, Balch & Co., New York, 1935.

O'HARA, ELIOT. *Making Watercolor Behave.* Minton, Balch & Co., New York, 1932.

SEARS, ELINOR LATHROP. *Pastel Painting Step-by-Step.* Watson-Guptill Publications, New York, 1947.

THOMPSON, DANIEL V., JR. *The Practice of Tempera Painting.* Yale University Press, New Haven, Conn., 1936; paperback reprint, Dover Publications, Inc., New York, 1962, and Constable and Company, Ltd., London.

WILLIAMS, TERRICK. *The Art of Pastel.* Pitman & Sons, Ltd., London, and Pitman Publishing Corp., New York, 1937.

WOODY, RUSSELL O. *Painting With Synthetic Media, With a Technical Appendix by Henry W. Levison.* Reinhold Publishing Corp., New York, 1965.

Color

FOSS, C. E., and JACOBSON, E. *Color Harmony Manual.* (The Ostwald System.) Container Corporation of America, Chicago, 1949.

GRAVES, MAITLAND E. *The Art of Color and Design,* 2nd ed. McGraw-Hill Book Co., New York and London, 1951.

ITTEN, JOHANNES. *The Art of Color.* Translated by E. Van Haagen. Reinhold Publishing Corp., New York, 1961.

KELLY, KENNETH L., and JUDD, DEANE B. *The ISCC-NBS Method of Designating Color and a Dictionary of Color Names.* National Bureau of Standards Circular 553, Government Printing Office, Washington, D.C., 1955.

MUNSELL, ALBERT H. *The Munsell Book of Color*, 2 vols. Munsell Color Co., Baltimore, Md., 1947.

Drawing, Perspective

ABBOTT, W. *The Theory and Practice of Perspective*. Blackie & Son, Ltd., Glasgow, 1950.

COLE, REX VICAT. *Perspective as Applied to Pictures*. J.B. Lippincott Co., Philadelphia; Seeley, Service & Co., Ltd., London.

D'AMELIO, JOSEPH. *Perspective Drawing Handbook*. Tudor Publishing Co., New York, 1965.

MEDWORTH, FRANK. *Perspective*. Charles Scribner's Sons, New York, 1937.

MORANZ, JOHN. *Mastery of Drawing*. The Richard R. Smith Co., Inc., Peterborough, N.H., 1950.

Anatomy

BRIDGMAN, GEORGE B. *Constructive Anatomy*. E. C. Bridgman, Pelham, N.Y., 1924; rev. ed., Sterling Publishing Co., Inc., New York, 1961; paperback eds., Oak Tree Press, Ltd., London, 1965, and Barnes & Noble, Inc., New York, 1966.

ELLENBERGER, W.; BAUM, H.; and DITTRICH, H. *An Atlas of Animal Anatomy for Artists*. Translated by Helene Weinbaum; enlarged edition revised by Lewis S. Brown. Paperback editions, Dover Publications, Inc., New York, 1956, and Constable and Company, Ltd., London, 1966.

RUBINS, DAVID K. *The Human Figure: An Anatomy for Artists*. The Viking Press, Inc., New York, 1953; Peter Owen, Ltd., London, 1964.

VANDERPOEL, JOHN H. *The Human Figure*. The Inland Printer Co., Chicago, 1930; paperback reprint, Dover Publications, Inc., New York, 1958; Constable and Company, Ltd., London.

Lettering and Calligraphy

BRINKLEY, JOHN. *Lettering Today: A Survey and Practical Handbook*. Reinhold Publishing Corp., New York, 1961; Studio-Vista, Ltd., London, 1965.

GOUDY, FREDERIC. *The Alphabet and Elements of Lettering* (1918). University of California Press, Berkeley, 1952; paperback reprint, Dover Publications, Inc., New York, 1963, and Constable and Company, Ltd., London.

LAKER, RUSSELL. *Anatomy of Lettering*, new ed. The Studio Publications, Inc., New York and London, 1960.

Wotzkow, Helm. *The Art of Hand Lettering, Its Mastery & Practice*. Watson-Guptill Publications, New York, 1952; paperback reprint, Dover Publications, Inc., New York, 1967, and Constable and Company, Ltd., London.

Commercial Art Techniques

Cardamone, Tom. *Advertising Agency and Studio Skills*. Watson-Guptill Publications, New York, 1959; Chapman & Hall, Ltd., London.

Maurello, S. Ralph. *Commercial Art Techniques*. Tudor Publishing Co., New York, 1952.

* Nelson, Roy Paul, and Ferris, Byron. *Fell's Guide to Commercial Art*. Frederic Fell, Inc., New York, 1966.

Stone, Bernard, and Eckstein, Arthur. *Preparing Art for Printing*. Reinhold Publishing Corp., New York, 1965.

Sculpture

Cheney, Sheldon. *Sculpture of the World: A History*. The Viking Press, Inc., New York, 1968.

Hale, Nathan Cabot. *Welded Sculpture*. Watson-Guptill Publications, New York, 1968.

Newman, Thelma R. *Plastics as an Art Form*. Chilton Book Co., Philadelphia, 1964; Thomas Yoseloff, Ltd., London, 1967.

* Rich, Jack C. *The Materials and Methods of Sculpture*. Oxford University Press, New York and London, 1947.

Roukes, Nicholas. *Sculpture in Plastics*. Watson-Guptill Publications, New York, 1968.

Slobodkin, Louis. *Sculpture, Principles and Practice*. The World Publishing Co., Cleveland, Ohio, 1949.

Toft, Albert. *Modelling and Sculpture; A Full Account of the Various Methods and Processes Employed in These Arts*, 3rd ed. The Macmillan Co., New York, and Seeley, Service & Co., Ltd., London, 1950.

Printmaking

Arnold, Grant. *Creative Lithography and How to Do It*. Harper & Row, Publishers, 1941; paperback reprint, Dover Publications, Inc., New York, 1964; Constable and Company, Ltd., London, 1965.

Biegeleisen, J.I., and Cohn, Max Arthur. *Silk Screen Stencilling as a Fine Art*. McGraw-Hill Book Co., New York, 1942. Corrected and enlarged version en-

titled *Silk Screen Techniques,* Dover Publications, Inc., New York, 1958, and Constable and Company, Ltd., London.

HAYTER, STANLEY W. *New Ways of Gravure,* 2nd ed. Oxford University Press, New York and London, 1966.

° HIND, ARTHUR M. *A History of Etching and Engraving From the Fifteenth Century to the Year 1914,* 3rd rev. ed. Houghton Mifflin Co., New York, 1923; paperback reprint, Dover Publications, Inc., New York, 1963, and Constable and Company, Ltd., London.

° HIND, ARTHUR M. *An Introduction to a History of Woodcut.* Houghton Mifflin Co., New York, 1935; paperback reprint, 2 vols., Dover Publications, Inc., New York, 1963, and Constable and Company, Ltd., London.

LUMSDEN, ERNEST S. *The Art of Etching.* Seeley, Service & Co., Ltd., London, 1924; J.B. Lippincott Co., Philadelphia, 1925; paperback reprint, Dover Publications, Inc., New York, 1962, and Constable and Company, Ltd., London.

MORROW, B. F. *The Art of Aquatint.* G.P. Putnam's Sons, New York, 1935.

ROTHENSTEIN, MICHAEL. *Frontiers of Printmaking: New Aspects of Relief Printing.* Reinhold Publishing Corp., New York, and Studio-Vista, Ltd., London, 1966.

ROTHENSTEIN, MICHAEL. *Linocuts and Woodcuts.* Studio-Vista, Ltd., London, 1962; Watson-Guptill Publications, New York, 1964.

SHOKLER, HARRY. *Artists' Manual for Silk Screen Print Making,* 3rd ed. Tudor Publishing Co., New York, and Heffer & Sons, Ltd., Cambridge, England, 1960.

TREVELYAN, JULIAN. *Etching; Modern Methods of Intaglio Printing.* Studio-Vista, Ltd., London, 1963; Watson-Guptill Publications, New York, 1967.

TRIVICK, HENRY. *Autolithography: The Technique.* Faber & Faber, Ltd., London, 1960.

Ceramics

BILLINGTON, DORA M. *The Technique of Pottery.* B.T. Batsford, Ltd., London, and Hearthside Press, New York, 1962.

COX, WARREN EARLE. *The Book of Pottery and Porcelain.* Crown Publishers, Inc., New York, 1944.

° NELSON, GLENN C. *Ceramics, A Potter's Handbook,* 2nd ed. Holt, Rinehart & Winston, Inc., New York and London, 1966.

NORTON, F. H. *Ceramics for the Artist Potter.* Addison-Wesley Publishing Co., Inc., Reading, Mass., 1956.

Mosaic

ANTHONY, EDGAR WATERMAN. *A History of Mosaics.* Porter Sargent, Publisher, Boston, 1935.

446

POWERS, HARRY HUNTINGTON. *The Art of Mosaic.* The University Prints, Newton, Mass., 1938.

YOUNG, JOSEPH L. *Course in Making Mosaics: An Introduction to the Art and Craft.* Reinhold Publishing Corp., New York, 1957.

Conservation

KECK, CAROLINE K. *A Handbook on the Care of Paintings.* Watson-Guptill Publications, New York, published for the American Association for State and Local History, 1967.

PLENDERLEITH, HAROLD JAMES. *The Conservation of Antiquities and Works of Art: Treatment, Repair, and Restoration.* Oxford University Press, New York and London, 1956.

° RUHEMANN, HELMUT. *The Cleaning of Paintings: Problems and Potentialities.* Frederick A. Praeger, Inc., New York, and Faber & Faber, Ltd., London, 1968.

STOUT, GEORGE LESLIE. *The Care of Pictures.* Columbia University Press, New York, and Oxford University Press, London, 1948.

Industrial Paint Technology

GARDNER, HENRY A., and SWARD, GEORGE G. *Paint Testing Manual: The Physical Examination of Paints, Varnishes, Lacquers and Colors,* 12th ed. Gardner Laboratory, Inc., Bethesda, Md., 1962.

PARKER, DEAN H. *Principles of Surface Coating Technology.* Interscience Publishers, Inc., New York, 1965.

° PAYNE, HENRY FLEMING. *Organic Coating Technology.* John Wiley & Sons, Inc., New York and London. Vol. 1, 1954, oils, resins, varnishes, polymers; vol. 2, 1961, pigments and pigmented coatings.

PRATT, LYDE STUART. *Chemistry and Physics of Organic Pigments.* John Wiley & Sons, Inc., New York, and Chapman & Hall Ltd., London, 1949.